book for digital photographers

Scott Kelby

The Adobe Photoshop Lightroom 3 Book for Digital Photographers Team

CREATIVE DIRECTOR Felix Nelson

TECHNICAL EDITORS Cindy Snyder Kim Doty

TRAFFIC DIRECTOR Kim Gabriel

PRODUCTION MANAGER **Dave Damstra**

DESIGNER Jessica Maldonado

COVER PHOTOS BY Scott Kelby

Published by New Riders

Copyright ©2010 by Scott Kelby

All rights reserved. No part of this book may be reproduced or transmitted in any form, by any means, electronic or mechanical, including photocopying, recording, or by any information storage and retrieval system, without written permission from the publisher, except for the inclusion of brief quotations in a review.

Composed in Cronos, Helvetica, Myriad Pro, and Blair ITC by Kelby Media Group, Inc.

Trademarks

All terms mentioned in this book that are known to be trademarks or service marks have been appropriately capitalized. New Riders cannot attest to the accuracy of this information. Use of a term in the book should not be regarded as affecting the validity of any trademark or service mark.

Photoshop Lightroom is a registered trademark of Adobe Systems, Inc.

Photoshop is a registered trademark of Adobe Systems, Inc.

Macintosh, Mac, and Mac OS X Leopard and Snow Leopard are registered trademarks of Apple Inc.

Windows is a registered trademark of Microsoft Corporation.

Warning and Disclaimer

This book is designed to provide information about Adobe Photoshop Lightroom for digital photographers. Every effort has been made to make this book as complete and as accurate as possible, but no warranty of fitness is implied.

The information is provided on an as-is basis. The author and New Riders shall have neither liability nor responsibility to any person or entity with respect to any loss or damages arising from the information contained in this book or from the use of the discs or programs that may accompany it.

THIS PRODUCT IS NOT ENDORSED OR SPONSORED BY ADOBE SYSTEMS INCORPORATED, PUBLISHER OF ADOBE PHOTOSHOP LIGHTROOM 3.

ISBN13: 978-0-321-70091-9 ISBN10: 0-321-70091-0

98765432

www.kelbytraining.com www.newriders.com

This seal indicates that all content provided herein is produced by Kelby Training, Inc. and follows the most stringent standards for educational resources. Kelby Training is the premier source for instructional books, DVDs, online classes, and live seminars for creative professionals. For my totally awesome, totally hilarious, fun-loving, big-hearted, teenage son Jordan. I'm the luckiest guy in the world to be your dad!

ACKNOWLEDGMENTS

start the acknowledgments for every book I've ever written the same way—by thanking my amazing wife, Kalebra. If you knew what an incredible woman she is, you'd totally understand why.

This is going to sound silly, but if we go grocery shopping together, and she sends me off to a different aisle to get milk, when I return with the milk and she sees me coming back down the aisle, she gives me the warmest, most wonderful smile. It's not because she's happy that I found the milk; I get that same smile every time I see her, even if we've only been apart for 60 seconds. It's a smile that says, "There's the man I love."

If you got that smile, dozens of times a day, for 20 years of marriage, you'd feel like the luckiest guy in the world, and believe me—I do. To this day, just seeing her puts a song in my heart and makes it skip a beat. When you go through life like this, it makes you one incredibly happy and grateful guy, and I truly am.

So, thank you, my love. Thanks for your kindness, your hugs, your understanding, your advice, your patience, your generosity, and for being such a caring and compassionate mother and wife. I love you.

Secondly, a big thanks to my son, Jordan. I wrote my first book when my wife was pregnant with him (13 years ago), and he's literally grown up around my writing. Maybe that's why he's so patient as he waits for me to finish a page or two so we can go play *Call of Duty: Modern Warfare 2* with all his friends, and my buddies Matt, Brad, Corey, and RC. He's such a great "little buddy" to me, and it's been a blast watching him grow up into such a wonderful young man, with his mother's tender and loving heart. (You're the greatest, little buddy!)

Thanks to our wonderful daughter, Kira, for being the answer to our prayers, for being such a blessing to your older brother, and for proving once again that miracles happen every day. You are a little clone of your mother, and believe me, there is no greater compliment I could give you. You're my little sweetie!

A special thanks to my big brother, Jeff. I have so much to be thankful for in my life, and having you as such a positive role model while I was growing up is one thing I'm particularly thankful for. You're the best brother any guy could ever have, and I've said it a million times before, but one more surely wouldn't hurt—I love you, man!

My heartfelt thanks go to my entire team at Kelby Media Group. I know everybody thinks their team is really special, but this one time—I'm right. I'm so proud to get to work with you all, and I'm still amazed at what you're able to accomplish day in, day out, and I'm constantly impressed with how much passion and pride you put into everything you do.

A warm word of thanks goes to my in-house Editor Kim Doty. It's her amazing attitude, passion, poise, and attention to detail that has kept me writing books. When you're writing a book like this, sometimes you can really feel like you're all alone, but she really makes me feel that I'm not alone—that we're a team. It often is her encouraging words or helpful ideas that keep me going when I've hit a wall, and I just can't thank her enough. Kim, you are "the best!"

I'm equally as lucky to have the immensely talented Jessica Maldonado working on the design of my books. I just love the way Jessica designs, and all the clever little things she adds to her layouts and cover designs. She's not just incredibly talented, and a joy to work with, she's a very smart designer and thinks five steps ahead in every layout she builds. I feel very, very fortunate to have her on my team.

www.kelbytraining.com

Also, a big thanks to my in-house tech editor Cindy Snyder, who helps test all the techniques in the book (and makes sure I didn't leave out that one little step that would take the train off the tracks), and she catches lots of little things others would have missed.

Thanks to "Big Dave" Damstra and his team, who do the layout work once the text and graphics start coming in, and they do such a great job, on such a tight deadline, yet still turn out books with a tight, clean layout that people love. You rock!

The guy leading this crew of creative superstars is none other than my friend (and Creative Director), Felix Nelson, whose limitless talent, creativity, input, and flat-out great ideas make every book we do that much better.

To my best buddy and book-publishing powerhouse, Dave Moser (also known as "the guiding light, force of nature, miracle birth, etc."), for always insisting that we raise the bar and make everything we do better than anything we've done before.

Thanks to my friend and business partner, Jean A. Kendra, for her support and friendship all these years. You mean a lot to me, to Kalebra, and to our company.

A huge, huge thanks to my Executive Assistant, and general wonder woman, Kathy Siler. Without her fielding a lot of balls for me, and taking so much off my plate, I wouldn't have the time to write books in the first place. Each year I appreciate her more and more, and her amazing attitude, and MacGyver-like qualities make coming into the office an awful lot of fun. So much so, that I now actually root for the Redskins (unless, of course, they're playing the Bucs, in which case we're bitter mortal enemies for four quarters).

Thanks to my Editor Ted Waitt at Peachpit Press. Like Kim Doty does in-house, you do outside by helping me feel connected to "the mothership." Thanks for all your hard work and dedication to making the kind of books that make a difference. Also, thanks to my Publisher Nancy Aldrich-Ruenzel, and her team, including Sara Jane Todd and Scott Cowlin. (Lest we forget Gary-Paul.)

Thanks to Lightroom Product Manager Tom Hogarty for answering all my late-night emails, and to Bryan O'Neil Hughes for helping out in such an impactful way. My personal thanks to Kevin Connor at Adobe for his help, support, and for totally "getting "us.

I owe a special debt of gratitude to my buddy, Matt Kloskowski, for being such an excellent sounding board (and sometimes tech editor) during the development of this latest version of the book. Your input made this book better than it would have been.

Thanks to my friends at Adobe Systems: John Loiacono, Terry White, Cari Gushiken, Julieanne Kost, and Russell Preston Brown. Gone but not forgotten: Barbara Rice, Rye Livingston, Bryan Lamkin, Addy Roff, and Karen Gauthier.

I want to thank all the talented and gifted photographers who've taught me so much over the years, including: Moose Peterson, Joe McNally, Bill Fortney, George Lepp, Anne Cahill, Vincent Versace, David Ziser, Jim DiVitale, Helene Glassman, and Monte Zucker.

Thanks to my mentors, whose wisdom and whip-cracking have helped me immeasurably, including John Graden, Jack Lee, Dave Gales, Judy Farmer, and Douglas Poole.

Most importantly, I want to thank God, and His son Jesus Christ, for leading me to the woman of my dreams, for blessing us with two amazing children, for allowing me to make a living doing something I truly love, for always being there when I need Him, for blessing me with a wonderful, fulfilling, and happy life, and such a warm, loving family to share it with.

OTHER BOOKS BY SCOTT KELBY

The Digital Photography Book, vols. 1, 2 & 3

Scott Kelby's 7-Point System for Adobe Photoshop CS3

The iPod Book

The Photoshop CS5 Book for Digital Photographers

The Photoshop Channels Book

The iPhone Book

Photoshop Down & Dirty Tricks

Photoshop Killer Tips

Photoshop Classic Effects

The Mac OS X Leopard Book

Mac OS X Leopard Killer Tips

ABOUT THE AUTHOR

Scott Kelby

Scott is Editor, Publisher, and co-founder of *Photoshop User* magazine, Editor-in-Chief of *Layers* magazine (the how-to magazine for everything Adobe), and is the host of *D-Town TV*, the weekly videocast for DSLR shooters, as well as the top-rated weekly video podcast *Photoshop User TV*.

He is President of the National Association of Photoshop Professionals (NAPP), the trade association for Adobe[®] Photoshop[®] users, and he's President of the training, education, and publishing firm, Kelby Media Group, Inc.

Scott is a photographer, designer, and award-winning author of more than 50 books, including *The* Photoshop Book for Digital Photographers, Photoshop Down & Dirty Tricks, Scott Kelby's 7-Point System for Adobe Photoshop, The Photoshop Channels Book, Photoshop Classic Effects, The iPhone Book, The iPod Book, and The Digital Photography Book, vols. 1, 2 & 3.

For six years straight, Scott has been honored with the distinction of being the world's #1 best-selling author of all computer and technology books, across all categories. His book, *The Digital Photography Book*, vol. 1, is now the best-selling book on digital photography in history.

His books have been translated into dozens of different languages, including Chinese, Russian, Spanish, Korean, Polish, Taiwanese, French, German, Italian, Japanese, Dutch, Swedish, Turkish, and Portuguese, among others, and he is a recipient of the prestigious Benjamin Franklin Award.

Scott is Training Director for the Adobe Photoshop Seminar Tour and Conference Technical Chair for the Photoshop World Conference & Expo. He's featured in a series of Adobe Photoshop training DVDs and online courses at KelbyTraining.com and has been training Adobe Photoshop users since 1993.

For more information on Scott, visit his daily blog, Photoshop Insider, at www.scottkelby.com.

TABLE OF CONTENTS

CHAPTER 1	1
Importing GETTING YOUR PHOTOS INTO LIGHTROOM	
Before You Do Anything, Choose Where to Store Your Photos	2
Next, Do This: Set Up Your Folder Organization (It's Really Important)	3
Getting Photos from Your Camera Into Lightroom	5
Importing Photos Already on Your Computer	16
Save Time Importing Using Import Presets (and a Compact View)......	18
Importing Video from Your DSLR	20
Shooting Tethered (Go Straight from Your Camera, Right Into Lightroom)	22
Creating Your Own Custom File Naming Templates	26
Choosing Your Preferences for Importing Photos	30
The Adobe DNG File Format Advantage	33
Creating Your Own Custom Metadata (Copyright) Templates	34
Four Things You'll Want to Know Now About Getting Around Lightroom	36
Viewing Your Imported Photos	38
Using Lights Dim, Lights Out, and Other Viewing Modes	40

	CHAPTER 2 47
W	Library How to organize your photos
	ders and Why I Don't Mess with Them nis Is Really Important!)...............48
So	rting Your Photos Using Collections
Or	ganizing Multiple Shoots Using Collection Sets 64
	ing Smart Collections for tomatic Organization
W	nen to Use a Quick Collection Instead 68
Ad	ding Specific Keywords for Advanced Searching 70
Re	naming Photos Already in Lightroom
	lding Copyright Info, Captions, d Other Metadata
	/our Camera Supports GPS, epare to Amaze Your Friends
Fin	ding Photos Fast!
Cre	eating and Using Multiple Catalogs
	om Laptop to Desktop: ncing Catalogs on Two Computers86
	cking Up Your Catalog his Is VERY Important)
Re	linking Missing Photos
De	aling with Disasters

CHAPTER 3

Customizing HOW TO SET UP THINGS YOUR WAY

Choosing What You See in Loupe View	•				100
Choosing What You See in Grid View .					102

99

www.kelbytraining.com

Make Working with Panels Faster & Easier	106
Using Two Monitors with Lightroom	107
Choosing What the Filmstrip Displays	111
Adding Your Studio's Name or Logo for a Custom Look	112

CHAPTER 4

Editing Essentials HOW TO DEVELOP YOUR PHOTOS	
Upgrading from an Earlier Version of Lightroom? Read This First!	120
Making Your RAW Photos Look More Like JPEGs	122
Setting the White Balance	124
Setting Your White Balance Live While Shooting Tethered	129
Seeing Befores and Afters	131
Applying Changes Made to One Photo to Other Photos	132
How to Set Your Overall Exposure	134
Adding "Punch" to Your Images Using Clarity	140
Making Your Colors More Vibrant	141
Using the Tone Curve to Add Contrast	142
Adjusting Individual Colors Using HSL	147
Adding Vignette Effects	149
Getting That Trendy, Gritty High-Contrast Look	153
Virtual Copies —The "No Risk" Way to Experiment	155
Editing a Bunch of Photos at Once Using Auto Sync	157

Save Your Favorite Settings as One-Click Presets							158
Using the Library Module's Quick Develop Panel							162
Adding a Film Grain Look .							164

CHAPTER 5

▼ Local Adjustments HOW TO EDIT JUST PART OF YOUR IMAGES	
Dodging, Burning, and Adjusting Individual Areas of Your Photo	170
Five More Things You Should Know About Lightroom's Adjustment Brush	177
Getting Creative Effects Using the Adjustment Brush	178
Retouching Portraits	180
Fixing Skies (and Other Stuff) with a Gradient Filter	182

CHAPTER 6

W	FIXING COMMON PROBLEMS
Fix	ing Backlit Photos (Using Fill Light)
Re	ducing Noise
Ur	doing Changes Made in Lightroom
Cr	opping Photos
Lig	hts Out Cropping Rocks!
Str	aightening Crooked Photos
Gr	eat Trick for "Dust Spotting" Your Photos 200
Re	moving Spots and Other Nasty Junk 20
Re	moving Red Eye

TABLE OF CONTENTS

Fixing Lens Distortion Problems					ļ				206
Fixing Edge Vignetting									210
Sharpening Your Photos									211
Fixing Chromatic Aberrations (a.k.a. That Annoying Color Fring	ge)).							216
Basic Camera Calibration in Ligh	tre	00	m						217

CHAPTER 7

221

249

Exporting Images SAVING IPEGS TIEFS AND MORE

SAVING JEEGS, TIFFS, AND MORE							
Saving Your Photos as JPEGs							222
Adding a Watermark to Your Images							230
Emailing Photos from Lightroom							234
Exporting Your Original RAW Photo					•	•	238
Publish Your Images with Just Two Cl	icl	ks					240

CHAPTER 8

Jumping to Photoshop HOW AND WHEN TO DO IT

							250
							251
							259
							265
							270
							273
	· · ·	· · · ·	· · · · ·	· · · · · · · · · · · · · · · · · · ·	· · · · · · · ·	· · · · · · · · · · · · · · · · · · ·	· · · · · · · · · · · · · · · · · · ·

CHAPTER 9 279 In Black & White CONVERTING FROM COLOR TO BLACK AND WHITE How to Find Which Photos Better Black and White How to Tweak Individual Areas The Trick for Getting Great-Looking

CHAPTER 10 295 Slideshow CREATING PRESENTATIONS OF YOUR WORK Creating a Quick, Basic Slide Show Customizing the Look Getting Creative with Working with Drop Shadows Adding Additional Lines of Text Adding Opening and Choosing Your Slide Duration Sharing Your

www.kelbytraining.com

	CHAPTER 11	 323	
W	The Big Print PRINTING YOUR PHOTOS		
Pri	nting Individual Photos		324
Cr	eating Multi-Photo Contact Sheets		328
	eating Custom Layouts 19 Way You Want Them		336
Ad	lding Text to Your Print Layouts		340
Pri	nting Multiple Photos on One Page		342
Sav	ving Your Custom Layouts as Templates		347
	iving Lightroom Remember ur Last Printing Layouts		348
Cr	eating Backscreened Wedding Book Pages		350
Th	e Final Print and Color Management Settings .		356
Sav	ving Your Page Layout as a JPEG		364
Ac	lding Custom Borders to Your Prints		366
	ere Are Some of My Own Print Layouts You to Use		369

CHAPTER 12 Web Galleries GETTING YOUR PHOTOS ON THE WEB

Building a Quick, Simple, Online Photo Gallery					382
Adding an Email or Website Link					386
Customizing Your Gallery Layout			•	•	388
Changing the Colors of Your Gallery .					392
Using Cooler Flash Templates			•	•	394
Putting Your New Gallery on the Web.					396

CHAPTER 13						4	01	
My Portrait Workflow MY STEP-BY-STEP PROCESS FR THE SHOOT TO THE FINAL PRIN		1						
kflow Step One: It All Starts the Shoot						•		402
• kflow Step Two: Right After Shoot, Do This First								404
kflow Step Three: Finding the pers" & Making a Collection .								405
'kflow Step Four: ing Your Selects								408
rkflow Step Five: Letting Your of on the Web.								410
r kflow Step Six: Making the I Tweaks & Working with Phot	os	no	р					412
rkflow Step Seven: vering the Finished Images								418

CHAPTER 14									4	23	
	лс	٨									
e 7-Point System: Project One .											424
e 7-Point System: Project Two .	•			•		•			•	•	429
e 7-Point System: Project Three											434
e 7-Point System: Project Four .											438
											442
	7-Point System MY SEVEN POINTS IN LIGHTROO e 7-Point System: Project One . e 7-Point System: Project Two . e 7-Point System: Project Three e 7-Point System: Project Four . here to Go Next	7-Point System MY SEVEN POINTS IN LIGHTROON e 7-Point System: Project One e 7-Point System: Project Two e 7-Point System: Project Three . e 7-Point System: Project Four mere to Go Next	7-Point System MY SEVEN POINTS IN LIGHTROOM e 7-Point System: Project One e 7-Point System: Project Two e 7-Point System: Project Three e 7-Point System: Project Four here to Go Next	7-Point System MY SEVEN POINTS IN LIGHTROOM e 7-Point System: Project One e 7-Point System: Project Two e 7-Point System: Project Three e 7-Point System: Project Four here to Go Next	7-Point System MY SEVEN POINTS IN LIGHTROOM e 7-Point System: Project One e 7-Point System: Project Two e 7-Point System: Project Three e 7-Point System: Project Four e 7-Point System: Project Four	7-Point System MY SEVEN POINTS IN LIGHTROOM e 7-Point System: Project One	7-Point System MY SEVEN POINTS IN LIGHTROOM e 7-Point System: Project One	7-Point System MY SEVEN POINTS IN LIGHTROOM e 7-Point System: Project One	7-Point System MY SEVEN POINTS IN LIGHTROOM e 7-Point System: Project One	7-Point System MY SEVEN POINTS IN LIGHTROOM e 7-Point System: Project One	7-Point System MY SEVEN POINTS IN LIGHTROOM e 7-Point System: Project One

381

Seven Things You'll Wish You Had Known Before Reading This Book

(1) If you don't want to read this, then go right now to www.kelbytraining .com/books/LR3 and watch the short video I made to explain these seven things in more detail. It's short, it's quick, and it will help you read this book in half the time (okay, the "half the time" thing is marketing hype, but you'll get a lot out of the video, so head over there first. I'll make it worth your while).

(2) You can download many of the key photos used here in the book, so you can follow along using many of the same images that I used, at **www.kelbytraining.com/books/LR3**. See, this is one of those things I was talking about that you'd miss if you skipped over this and jumped right to Chapter 1. Then you'd send me an angry email about how I didn't tell you where to download the photos. You wouldn't be the first.

(3) If you've read my other books, you know they're usually "jump in anywhere" books, but with Lightroom, I wrote the book in the order you'll probably wind up using the program, so if you're new to Lightroom, I would really recommend you start with Chapter 1 and go through the book in order. But hey—it's your book if you decide to just hollow out the insides and store your valuables in there, I'll never know. Also, make sure you read the opening to each project, up at the top of the page. Those actually have information you'll want to know, so don't skip over them. I really want to make sure you get the absolute most out of reading this book, and if you take two minutes and read these seven things now, I promise it will make a big difference in your success with Lightroom 3, and with this book (plus, it will keep you from sending me an email asking something that everyone who skips this part will wind up doing). By the way, the captures shown below are just for looks. Hey, we're photographers—how things look really matters.

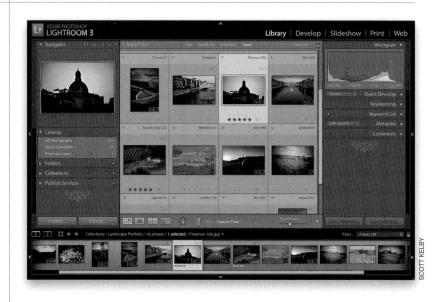

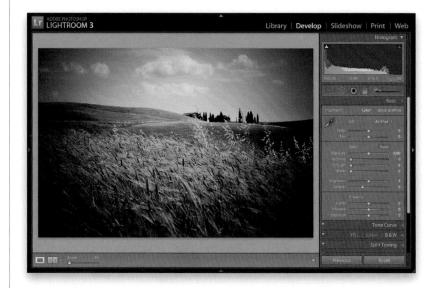

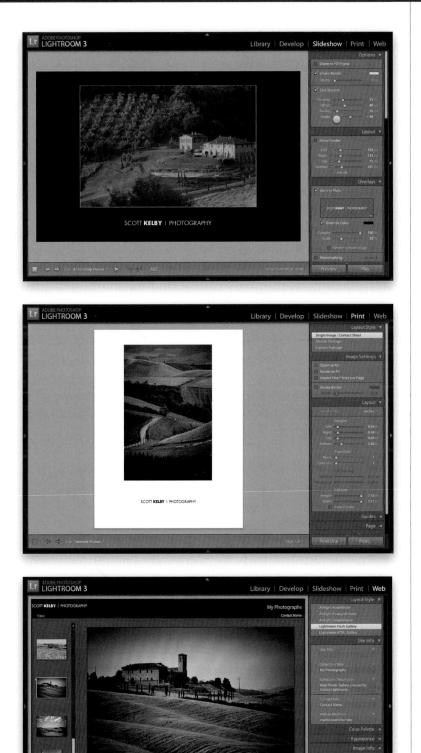

(4) The official name of the software is "Adobe Photoshop Lightroom 3" because it's part of the Photoshop family, but if every time I referred to it throughout the book, I called it "Adobe Photoshop Lightroom 3," you'd eventually want to strangle me (or the person sitting nearest you), so from here on out, I usually just refer to it as "Lightroom" or "Lightroom 3" Just so you know.

(5) The intro page at the beginning of each chapter is designed to give you a quick mental break, and honestly, they have little to do with the chapter. In fact, they have little to do with anything, but writing these quirky chapter intros is kind of a tradition of mine (I do this in all my books), but if you're one of those really "serious" types, you can skip them, because they'll just get on your nerves.

(6) At the end of the book are two special bonus chapters. The first is where I share my own complete portrait workflow—from beginning to end—starting with the shoot, then working with the images in Lightroom, right through to the final output. However, don't read it until you've read the entire book first, because I put those last for a reason—you have to have read the rest of the book for them to make sense. Also, for the first time ever, I included my "7-Point System for Lightroom," which breaks things down to just the seven things you really need to know for editing your images in the Develop module.

(7) There are a couple bonus videos I created just for you. One video shows you step by step how to create Identity Plate graphics with transparency (which you'll learn about in Chapters 10, 11, and 12) and the other video shows you how I do my initial image retouching in my workflow (this you'll learn about in Chapter 13). You can find these videos at **www.kelbytraining.com/books/LR3**.

Okay, now turn the page and let's get to work.

Chapter 1 Getting Your Photos Into Lightroom

Importing getting your photos into lightroom

Okay, if you're reading this chapter intro, then it's safe to assume that you read my brief warning (given just a page earlier), that these chapter intros have little, if anything, to do with what's actually in the chapter ahead. These are here strictly to give you a quick mental break from all the learning. Of course where it kind of falls apart is right here at the beginning of the book, because...well...you haven't really learned anything at this point, so you probably don't need a metal break quite yet. Of course, this concerns me, but clearly not enough to actually skip having a chapter intro for Chapter One, because then this page would be blank, and if there's one thing I've learned-people don't like blank pages. That's why in some books when you see a blank page, it says, "This page intentionally left blank." This fascinates me, partly because they never tell you why it's intentionally left blank and

partly because, since they've printed the sentence "This page intentionally left blank," the page isn't actually blank anymore. So really, the whole thing's a big blank page scam, but if you call them on it, they start talking about "printers' spreads" and "pagination for press" and "propaganda spread by subversive antigovernment organizations" and a dozen other technical reasons why sometimes a page has to be left blank. Well, I don't want you to think that this page was part of a their larger conspiracy, so even though you didn't actually need a mental break at this point (but probably do now), you're still getting one. In the publishing world, this is called "paying it forward." By the way, that's not what it's really called, but what it's really called can only be included on pages that were intentionally left blank. (Hey, I warned you these intros would be like this.)

Before You Do Anything, Choose Where to Store Your Photos

Before you dive into Lightroom and start importing photos, you need to make a decision about where you're going to store your photo library. This isn't as easy a decision as you might think, because you have to consider how many photos you've taken so far (and want to manage with Lightroom), and how many you think you might take in the next few years, and you need to make sure you have enough room to store thousands of photos, wherever you decide to store them on your computer or on an external hard drive. Here's where to start:

For Desktop Computer Users:

Lightroom assumes you're going to store your photos on your computer's internal hard disk, so by default, it automatically chooses your Mac's or PC's Pictures folder to store all your photos. So, unless you choose differently (in Lightroom's Import window, which you'll learn about in just a few minutes), it's going to always choose to save your photos in this folder. As long as you've got a lot of free hard disk space available on your computer (and I mean a lot!), then you're all set. (Note: If you're wondering how much is "a lot," consider this: if you shoot just once a week, and fill up nothing more than a single 4-GB card with each shoot, in one year alone, you'll eat up more than 200 GB of drive space. So when it comes to hard drive storage space, think big!) If you don't have enough free hard disk space on your computer, then you'll need to buy an external hard drive to store all your photos (don't worry, Lightroom will still manage all your images, you're just storing them on a separate hard drive. You'll learn how to set this all up in the next few pages).

For Laptop Users:

If you primarily use a laptop computer for editing your images, then I would definitely recommend using an external hard drive to store your photo library because of the limited hard disk space on most laptops. Think about it. You're going to need to manage literally thousands (or tens of thousands) of images, and your laptop is going to get really full, really fast (believe me, it gets there faster than you'd think), so using an external drive (they're surprisingly inexpensive these days) has become the choice for many photographers using Lightroom. (You can find 500-GB external hard drives for around \$80 these days, but if you can spend just a little more [around \$110], go for the now popular 1-TB [terabyte] drives, which hold 1,000 GB.) Lightroom can do a brilliant job of keeping you organized, as long as you start out being organized, and that means sticking to this one simple, but critical, rule: keep all your photos inside one main folder. It doesn't matter how many other folders you have inside that main folder, just make sure all your photos reside within it. This is the key ingredient to making everything work smoothly. If, instead, you import photos from folders in different locations all over your computer, you're headed for trouble. Here's how to set things up right from the start:

Next, Do This: Set Up Your Folder Organization (It's Really Important)

Print

Step One:

As you read above, our goal is to get all our photos inside one main folder, right? Well, if you decided to store all your photos on your computer, then the rest is pretty easy. By default, Lightroom automatically chooses your Pictures (or My Pictures) folder as your main photo folder, and when you go to import photos from a memory card, it will automatically choose that folder for you. However, I'm going to recommend doing one extra thing now to make your life much easier: go inside your Pictures folder, create a new empty folder, and name it "My Lightroom Photos" (you don't have to name it that exactly, but just to make things consistent here in the book, that's what I've named my main folder). That way, when that day comes when you run out of hard disk space (and it will come way sooner than you might imagine), you can move, copy, or back up your entire photo library by simply moving one folder-your My Lightroom Photos folder. This is one of those things that if you do it now, there will come a day when it will save you not just hours, but literally days, worth of work.

Continued

Step Two:

If you already have folders full of photos on your computer, before you start importing them into Lightroom, you'll want to dragand-drop those folders inside your My Lightroom Photos folder. That way, all your photos reside inside that one My Lightroom Photos folder before you import them into Lightroom. Although it doesn't seem like it now, again, it's amazing how this one little bit of organization will make your life that much easier down the road. If you chose to store your photos on an external hard drive, then you'll set things up pretty much the same way (that's in the next step).

Step Three:

On your external hard drive, just create a new folder, name it My Lightroom Photos (or whatever you'd like), then drag-anddrop any photos on your computer that you want managed by Lightroom into that My Lightroom Photos folder on your external drive. Of course, keep them in their original folders when you drag-anddrop them over into your My Lightroom Photos folder (after all, you don't want to just drag-and-drop thousands of photos into one big empty folder). Do all this before you start importing them into Lightroom (which we'll talk about in detail on the next page, along with how to tell Lightroom how to use that new folder you created to store all your imported photos).

The photos you bring into Lightroom are probably coming from either your camera (well, your camera's memory card), or they're already on your computer (everybody's got a bunch of photos already on their computer, right?). We'll start here with importing photos from your camera's memory card (importing photos already on your computer is on page 16).

Getting Photos from Your Camera Into Lightroom

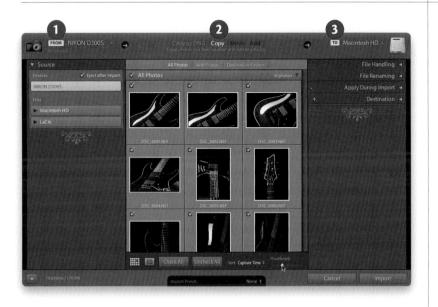

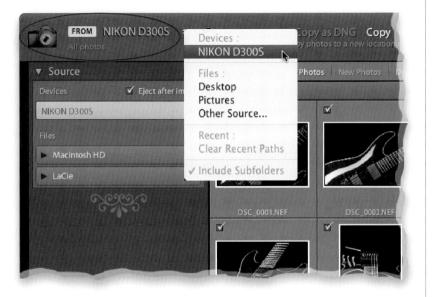

Step One:

If you have Lightroom open, and connect your camera or memory card reader to your computer, the Import window you see here appears over your Lightroom window. The top section of this Import window is important because it shows you what's about to happen. From left to right: (1) it shows where the photos are coming from (in this case, a memory card); (2) what's going to happen to these images (in this case, they're getting copied from the card); and (3) where they're going to (in this case, onto your computer, into your Pictures folder). If you don't want to import the photos from your memory card right now. just click the Cancel button and this window goes away. If you do this, you can always get back to the Import window by clicking on the Import button (at the bottom of the left side Panels area in the Library module).

Step Two:

If your camera or memory card reader is still connected, it assumes you want to import photos from that card, and you'll see it listed next to "From" in the top-left corner of the window (circled here). If you want to import from a different card (you could have two card readers connected to your computer), click on the From button, and a pop-up menu will appear (seen here) where you can choose the other card reader, or you can choose to import photos from somewhere else, like your desktop, or Pictures folder, or any recent folders you've imported from.

Continued

The Adobe Photoshop Lightroom 3 Book for Digital Photographers

Step Three:

There is a Thumbnails size slider below the bottom-right corner of the center Preview area that controls the size of the thumbnail previews, so if you want to see them larger, just drag that slider to the right.

TIP: See a Photo Larger

If you want to see any photo you're about to import at a large, full-screen size, just double-click on it to zoom in or press the letter **E**. Double-click to zoom back out, or press the letter **G**.

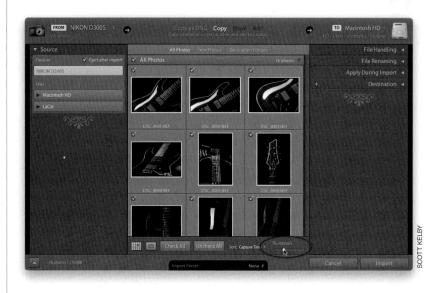

Step Four:

The big advantage of getting to see the thumbnail previews of the photos you're about to import is that you get to choose which ones actually get imported (after all, if you accidentally took a photo of the ground while you were walking, which for some inexplicable reason I seem to do on nearly every location shoot, there's no reason to even import that photo at all, right?). By default, all the photos have a checkmark beside them (meaning they are all marked to be imported). If you see one or more photos you don't want imported, just turn off their checkboxes.

Library

Develop SI

Slideshow Print

Web

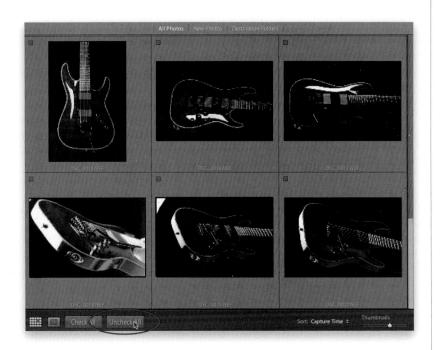

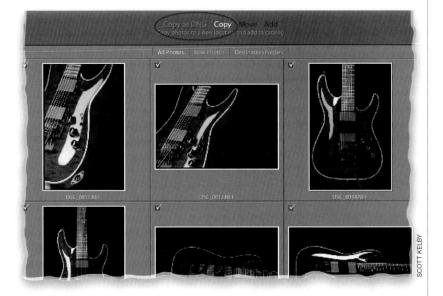

Step Five:

Now, what if you have 300+ photos on your memory card, but you only want a handful of these imported? Then you'd click the Uncheck All button at the bottom left of the Preview area (which unchecks every photo), and **Commandclick (PC: Ctrl-click)** on just the photos you want to import. Then, turn on the checkbox for any of these selected photos, and all the selected photos become checked and will be imported. Also, if you choose **Checked State** from the Sort popup menu (beneath the Preview area), all of the images you checked will appear together at the top of the Preview area.

TIP: Selecting Multiple Photos

If the photos you want are contiguous, then click on the first photo, press-andhold the Shift key, scroll down to the last photo, and click on it to select all the photos in between at once.

Step Six:

At the top center of the Import window, you get to choose whether you want to copy the files "as is" (Copy) or Copy as DNG to convert them to Adobe's DNG format as they're being imported (if you're not familiar with the advantages of Adobe's DNG [digital negative] file format, turn to page 33). Luckily, there's no wrong answer here, so if at this point you're unsure of what to do, for now just choose the default setting of Copy, which copies the images off the card onto your computer (or external drive) and imports them into Lightroom. Neither choice moves your originals off the card (you'll notice Move is grayed out), it only copies them, so if there's a serious problem during import (hey, it happens), you still have the originals on your memory card.

Continued

Step Seven:

Below the Copy as DNG and Copy buttons are three handy view options. By default, it displays all the photos on your card, but if you shoot to a card, then download those photos, pop the card back into the camera, shoot some more, then download again (which is pretty common), you can click New Photos, and now it only shows the photos on the card that you haven't imported yet, and hides the rest from view (sweet-I know). There's also a Destination Folders view, which hides any photos with the same name as photos that are already in the folder you're importing into. These last two buttons are just there to clear up the clutter and make it easier for you to see what's going on as you move files from one place to another, so you don't have to use them at all if you don't need them.

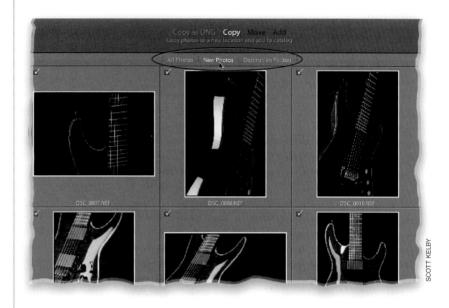

Step Eight:

Now we've come to the part where you tell Lightroom where to store the photos you're importing. If you look in the topright corner of the window, you'll see the To section, which shows where they'll be stored on your computer (in my case here, on the left, they're going into my Pictures folder on my hard drive). If you click-andhold on To, a menu pops up (as seen far right) that lets you choose your default Pictures folder, or you can choose another location, plus you can choose any recent folders you've saved into. Whatever you choose, if you look in the Destination panel below, it now displays the path to that folder on your computer, just so you can see where your photos are going. So now, at this point, you know three things: (1) the photos are coming from your memory card; (2) they're being copied from that card, not just moved; and (3) they're going into a folder you just chose in the To section. So far, so good.

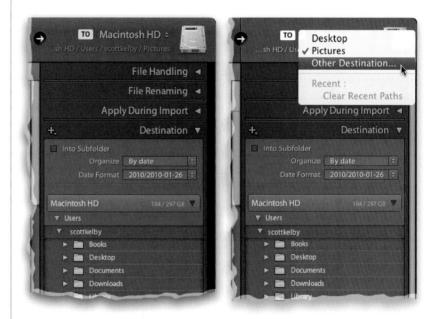

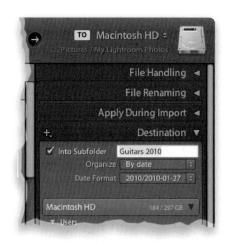

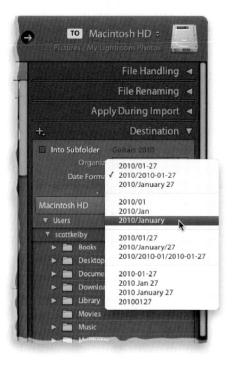

Step Nine:

Now, if you choose Pictures as the place to store your photos—don't worry—it's not just going to toss your images in there scattered all over the place. Instead, it will either put them in a folder organized by date, or you can have it create a folder for you, and name it whatever you like (which is what I do, so we'll start with that). Go to the Destination panel on the right side of the window, and turn on the Into Subfolder checkbox (as shown here), and then a text field appears to the right where you can type in whatever name you want for your folder. So, in my case, I'd be importing my photos into a folder called "Guitars 2010" inside the My Lightroom Photos folder we created earlier. Personally, it makes it easy for me to keep track of my images by just naming my shoots exactly what they are, but some folks prefer to have everything sorted by year, or by month, and that's cool, too (and we'll cover that option in the next step).

Step 10:

To have Lightroom organize your photos into folders by date, first make sure the Into Subfolder checkbox is turned off, then just click on the Date Format pop-up menu, and choose which date format you like best (they all start with the year first, because that is the main subfolder. What appears after the slash [/] is what the folder inside the 2010 folder will actually be named). So, if I chose the date format shown here, then my photos would be stored inside the My Lightroom Photos folder, where I'd find a folder named 2010, and inside of that there would be another folder named "January." So, what you're really choosing from this list is the name of the folder that appears inside your new 2010 folder. By the way, if you choose a date option with no slash, it doesn't create a 2010 folder with another folder inside. Instead, it just creates one folder with that exact name (automatically using today's date, of course).

Continued

Step 11:

Okay, so now that you know where your files are coming from, and going to, you can make a few important choices about what happens along the way in the File Handling panel (at the top right of the Import window). You choose, from the Render Previews pop-up menu, just how fast larger previews (larger sizes than just your thumbnails) will appear when you zoom in on a photo once it's in Lightroom. There are four choices:

(1) Minimal

Minimal doesn't worry about rendering previews of your images, it just puts 'em in Lightroom as quickly as it can, and if you double-click on a photo to zoom in to Fit in Window view, it builds the preview right then, which is why you'll have to wait just a few moments before this larger, higher-quality preview appears onscreen (you'll literally see a message appear onscreen that says "Loading"). If you zoom in even closer, to a 100% view (called a 1:1 view), you'll have to wait a few moments more (the message will read "Loading" again). That's because it doesn't create a higher-quality preview until you try to zoom in.

(2) Embedded & Sidecar

This method grabs the low-res JPEG thumnails that are embedded in the files you're importing, too (the same ones you see on the back of your camera on the LCD screen), and once they load, it starts to load higher-resolution thumbnails that look more like what the higher-quality zoomed-in view will look like (even though the preview is still small).

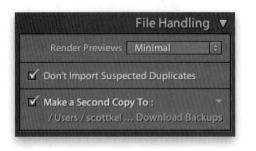

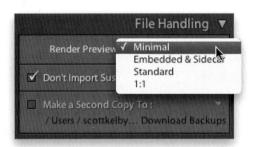

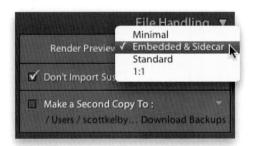

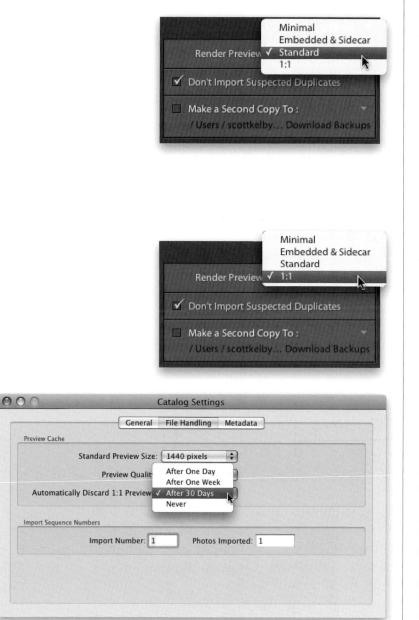

(3) Standard

The Standard preview takes quite a bit longer, because it renders a higher-resolution preview as soon as the low-res JPEG previews are imported, so you don't have to wait for it to render the Fit in Window preview (if you double-click on one in the Grid view, it zooms up to a Fit in Window view without having to wait for rendering). However, if you zoom in even closer, to a 1:1 view or higher, you'll get that same rendering message, and you'll have to wait a few seconds more.

(4) 1:1

The 1:1 (one-to-one) preview displays the low-res thumbnails, then starts rendering the highest-quality previews, so you can zoom in as much as you want with no waiting. However, there are two downsides: (1) It's notoriously slow. Basically, you need to click the Import button, then get a cup of coffee (maybe two), but you can zoom in on any photo and never see a rendering message. (2) These large, high-quality previews get stored in your Lightroom database, so that file is going to get very large. So large that Lightroom lets you automatically delete these 1:1 previews after a period of time (up to 30 days). If you haven't looked at a particular set of photos for 30 days, you probably don't need the high-res previews, right? You set this in Lightroom by going under the Lightroom (PC: Edit) menu and choosing Catalog Settings, then clicking on the File Handling tab and choosing when to discard (as shown here).

Note: Which one do I use? Minimal. I don't mind waiting a couple of seconds when I zoom in on an image. Besides, it only draws previews for the ones I double-click on, and I only double-click on the ones I think might be good (an ideal workflow for people who want instant gratification, like me). However, if you charge by the hour, choose 1:1 previews—it will increase your billable hours. (You know I'm joking, right?)

Continued

Step 12:

Below the Render Previews pop-up menu is a checkbox you should turn on to keep you from accidentally importing duplicates (files with the same name), but right below that is a checkbox that I feel is the most important one: Make a Second Copy To, which makes a backup copy of the photos you're importing on a separate hard drive. That way, you have a working set of photos on your computer (or external drive) that you can experiment with, change, and edit, knowing that you have the untouched originals (the digital negatives) backed up on a separate drive. I just can't tell you how important it is to have more than one copy of your photos. In fact, I won't erase my camera's memory card until I have at least two copies of my photos (one on my computer/external drive and one on my backup drive). Once you turn on the checkbox, click right below it and choose where you want your backup copies saved (or click the down-facing arrow on the right to choose a recent location).

Step 13:

The next panel down is File Renaming, which you use if you want to have your photos renamed automatically as they're imported. I always do this, giving my files a name that makes sense (in this case, something like Red Guitar, which makes more sense to me than _DSC0399.NEF, especially if I have to search for them). If you turn on the Rename Files checkbox, there's a popup menu with lots of different choices. I like to give my files a name, followed by a sequence of numbers (like Red Guitar 001, Red Guitar 002, etc.), so I choose Custom Name - Sequence, as seen here. Just by looking at the list, you can see how it will rename your files, so choose whichever one you like best, or create your own by choosing Edit at the bottom of the menu (I take you through that whole process on page 26).

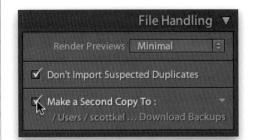

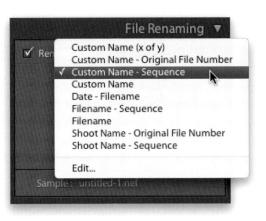

Slideshow

Print

Web

Develop Settir	vg ✓ None
	BW Creative - Look 1
Metad	at BW Creative - Look 2 🕟
	BW Creative - Look 3
Keywords	BW Creative - Look 4
	BW Creative - Creamtone
	BW Filter - Blue Filter
	BW Filter - Blue Hi-Contrast Filter
	BW Filter - Green Filter
	BW Filter - Infrared
	BW Filter - Infrared Film Grain
	BW Filter - Orange Filter
	BW Filter - Red Filter
	BW Filter - Red Hi-Contrast Filter
	BW Filter - Yellow Filter
	Color Creative - Bleach Bypass

iolor Gett

Millior CP 1

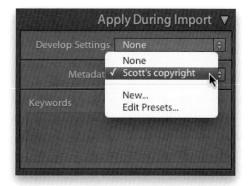

Step 14:

Right below that is a panel called Apply During Import, which is where you can apply three things to your images as they're imported. Let's start at the top. The Develop Settings pop-up menu lets you apply special effects or corrections automatically as your photos are imported. For example, you could have all your photos appear in Lightroom already converted to black and white, or they could all already be adjusted to be more red, or blue, or...whatever. If you click on the Develop Settings pop-up menu, you'll see a list of built-in presets that come with Lightroom and if you choose one, that look gets applied to your images as they're imported (you'll learn how to create your own custom Develop presets in Chapter 4, so for now, just leave the Develop Settings set to None, but at least you know what it does).

Step 15:

The next pop-up menu, Metadata, is where you can embed your own personal copyright and contact info, usage rights, captions, and loads of other information right into each file as it's imported. You do this by first entering all your info into a template (called a metadata template), and then when you save your template, it appears in the Metadata pop-up menu (as shown here). You're not limited to just one template—you can have different ones for different reasons if you like (like one of just your copyright info, and another with all your contact info, as well). I show you, step by step, how to create a metadata template on page 34 of this chapter, so go ahead and jump over there now and create your first metadata template, then come right back here and choose your copyright template from this pop-up menu. Go ahead. I'll wait for you. Really, it's no bother. (Note: I embed my copyright info into every photo [well, at least the ones I actually shot] using a metadata template like this while importing.)

Continued

Step 16:

At the bottom of the Apply During Import panel is a field where you can type in keywords, which is just a fancy name for search terms (words you'd type in if, months later, you were searching for the photos you're now importing). Lightroom embeds these keywords right into your photos as they're imported, so later you can search for (and actually find) them by using any one of these keywords. At this stage of the game, you'll want to use very generic keywordswords that apply to every photo you're importing. For example, for these guitar photos, I clicked in the Keywords field, and typed in generic keywords like Guitars, Product Shots, Red, Black Background, and Schecter (the make of guitar). Put a comma between each search word or phrase, and just make sure the words you choose are generic enough to cover all the photos (in other words, don't use Whammy Bar, because you don't see the whammy bar in every photo).

Step 17:

I mentioned this earlier, but at the bottom right of the Import window is the Destination panel, which just shows again exactly where your photos are going to be stored once they're imported from your memory card. At the top left of this panel is a + (plus sign) button and if you click on it, there's a pop-up menu (shown here) where you can choose to Create New Folder, which actually creates a new folder on your computer at whatever location you choose (you can click on any folder you see to jump there). While you're in that menu, try the Affected Folders Only command to see a much simpler view of the path to the folder you've chosen (as seen here-this is the view I use, since I always store my photos within the My Lightroom Photos folder. I don't like to see all those other folders all the time, so this just hides them from view until I choose otherwise).

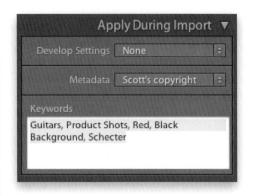

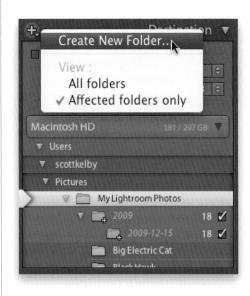

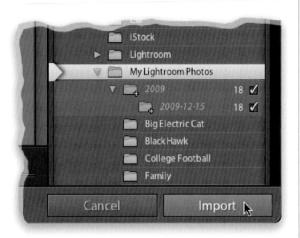

Step 18:

Now you're set—you've chosen where the images are coming from and where they're going, and how fast you'll be able to view larger previews when they appear in Lightroom. You've added your own custom name to the images, embedded your copyright info, added some search terms, and even saved a preset so you don't have to go through all these decisions each and every time. All that's left to do is click the Import button in the bottom-right corner of the Import window (as shown here) to get the images into Lightroom. If this seems like a lot of work to go through, don't worry—you created a preset, remember? (You'll be surprised at how many presets you can create in Lightroom to make your workflow faster and more efficient. You'll see as we go on. Presets rule!)

Importing Photos Already on Your Computer

Importing photos that are already on your computer is a breeze compared to importing them from a memory card, because so many decisions have already been made (after all, they're already on your computer, so you don't have to worry about where to store them, they're already named, etc.). Plus, since your computer's hard drive is much faster than even the fastest memory card, they zoom into Lightroom faster than a greased pig (I've been waiting for a legitimate way to work "greased pig" into a sentence for quite some time now).

Step One:

If the images are already on your computer, just go under Lightroom's File menu and choose Import Photos or press Command-Shift-I (PC: Ctrl-Shift-I) to bring up the Import window. In the Source list on the left side, find the folder on your computer that has the photos you want to import. When you click on that folder, you'll see thumbnails of the images in that folder (if you see a much smaller version of the window shown here, just click the arrow in the bottom-left corner to expand it to what you see here, complete with thumbnails). To change the size of the thumbnails, drag the Thumbnails slider at the bottom right of the Preview area. By default, all the photos in that folder will be imported, but if there are any you don't want imported, just turn off the checkbox at the top left of each of those photos.

Step Two:

Lightroom assumes you're going to leave your photos right where they currently are on your computer, and just import them into Lightroom, so by default the Add option is selected at the top (shown circled here), since you're just adding these photos to Lightroom. Now, back at the beginning of this chapter, I talked about how important it was to have your images all within one main folder. If, for some reason, these photos are somewhere else on your computer, click on Move instead, and then over in the Destination panel on the right side of the window, choose your My Lightroom Photos folder.

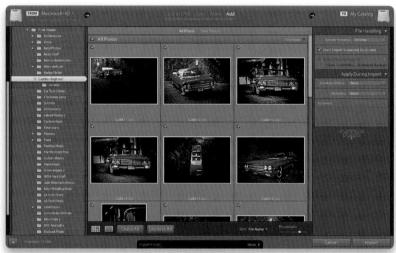

Slideshow Print Web

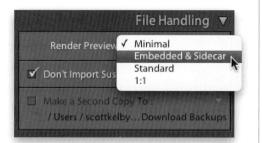

Apply During Import ▼ Develop Settings None ‡ Metadata Scott's copyright ‡ Keywords Caddies, Cadillac, red car, Savannah, Georgia, alley, convertible

Step Three:

Since the photos are already on your computer, there's very little you have to do in the rest of the Import window (in fact, most of the other stuff you'd have to do when importing from your camera's memory card is hidden). However, you should go to the File Handling panel on the right and decide how quickly you want your images to appear once they're in Lightroom and you zoom in on them. You do this in the Render Previews popup menu. If you jump back to page 10, Step 11, I describe what these four Render Previews choices do, and how to choose the one that's right for you. Also, I recommend leaving the checkbox turned on for Don't Import Suspected Duplicates, just so you don't import two copies of the same image.

Step Four:

There's one other set of options you need to know about: the Apply During Import panel settings (also on the right side of the window). I explain these on page 13, starting in Step 14, so jump back there, check those out, make your choices, and that's about it—you're ready to hit the Import button and bring those photos into Lightroom faster than a....well...ya know.

Save Time Importing Using Import Presets (and a Compact View)

If you find yourself using the same settings when importing images, you're probably wondering, "Why do I have to enter this same info every time I import?" Luckily, you don't. You can just enter it once, and then turn those settings into an Import preset that remembers all that stuff. Then, you can choose the preset, add a few keywords, maybe choose a different name for the subfolder they've being saved into, and you're all set. In fact, once you create a few presets, you can skip the full-sized Import window altogether and save time by using a compact version instead. Here's how:

Step One:

We'll start by setting up your import settings, just like always. For this example, we'll assume you're importing images from a memory card attached to your computer, and you're going to copy them into a subfolder inside your Pictures folder, and then have it make a backup copy of the images to an external hard drive (a pretty common import setup, by the way). We'll have your copyright info added as they're imported, and we'll choose Minimal Render Previews, so the thumbnails show up fast. Go ahead and set that up now (or just set it up the way you actually would for your own workflow).

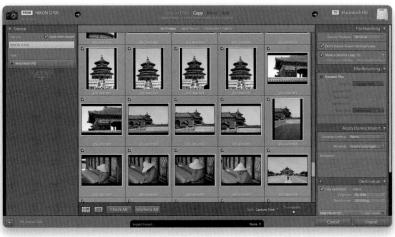

Step Two:

Now go to the bottom center of the Import window, where you'll see a thin black bar, and the words "Import Preset" on the far left. On the far right, click-and-hold on None and, from the pop-up menu that appears, choose **Save Current Settings as New Preset** (as shown here). You might want to save a second preset for importing images that are already on your hard drive, too. Okay, that's the hard part. Now let's put it to work.

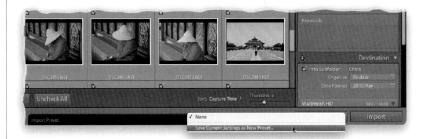

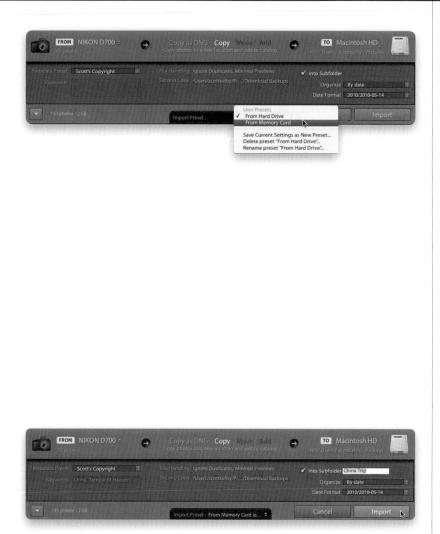

Step Three:

Click the Show Fewer Options button (it's the up-facing arrow) in the bottomleft corner of the Import window, and it switches to the compact view (as seen here). The beauty of this smaller window is: you don't need to see all those panels, the grid, and all that other stuff, because you've already saved most of the info you'll need to import your photos as a preset. So, from now on, your Import window will appear like this (in the compact view), and all you have to do is choose your preset from the pop-up menu at the bottom (as shown here, where I'm choosing my From Memory Card preset), and then enter just the few bits of info that do change when you import a new set of photos (see the next step).

Note: You can return to the full-size Import window anytime by clicking the Show More Options button (the downfacing arrow) in the bottom-left corner.

Step Four:

Across the top of the Minimal Import window, you can see that same visual 1-2-3 roadmap we saw in the full-size Import Window on page 5 of where your images are coming from, what's going to happen to them, and where they're going, complete with arrows leading you from left to right. The images here are (1) coming from your card reader, (2) then they are being copied, and (3) these copies are being stored in a folder on your hard drive. In the middle section, you can add any keywords that would be specific to these images (which is why I leave this field blank when I save my Import presets. Otherwise, I'd see keywords here from the previous import). Then, it shows your preferences for file handing and backing up a second copy of your images. On the right, you can name the subfolder these images are going to be saved into. So, how does this save you time? Well, now you only have to type in a few keywords, give your subfolder a name, and click the Import button. That's fast and easy!

Importing Video from Your DSLR

You can hardly find a new DSLR these days that doesn't include the ability to shoot high-definition video, so we're lucky that Lightroom 3 is the first version of Lightroom that lets you import this video. Besides adding metadata, sorting them in collections, adding ratings, labels, Picks flags, and so on, you really can't do any video editing per se (so no trimming the length of clips, or putting clips together, etc.), but at least now these are no longer invisible files in our workflow (plus you can easily preview them). Here's how it works:

Step One:

When you're in the Import window, you'll know which files are video files because they'll have a little movie camera icon in the bottom-left corner of the thumbnail (shown circled here in red). When you click the Import button, these video clips will import into Lightroom and appear right alongside your still images (of course, if you don't want these videos imported, turn off their checkboxes in the top-left corner of their thumbnail cell).

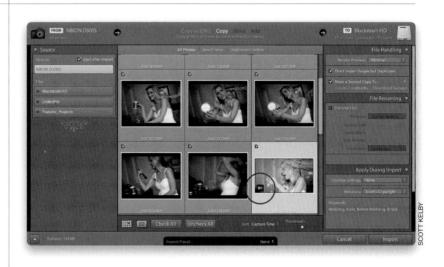

Step Two:

Once the video clip has been imported into Lightroom, in the Grid view, you'll still see the movie camera icon, but you'll also see the length of the clip to the right of it. You can see a larger view of the first frame by just selecting the video, then pressing the Spacebar on your computer.

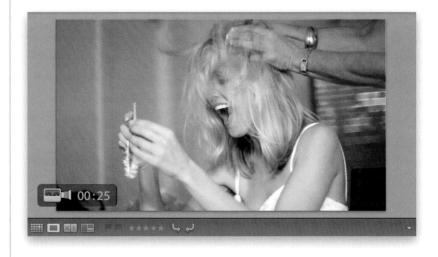

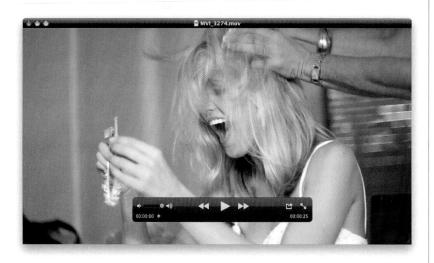

lame: Videos			ndal alaran pakai de
Set: None			ş
atch all 🗘 of	the following rules:		
File Type	is	Video	+

Step Three:

If you want to see a preview of the video, just click once on the little movie camera icon, and it launches your default video player and plays the video clip. Also, you can export your video clips from Lightroom (just be sure to turn on the Include Video Files checkbox in the File Settings section of the Export dialog), but of course it only exports the original unedited clip, since you can't do any editing in Lightroom 3.

TIP: Program for Editing DSLR Video

Adobe's latest version of Premiere Pro has built-in support for editing DSLR video, so if you're really into this stuff, at least go download the free 30-day trial from www.adobe.com.

Step Four:

If you want to organize all your video clips into one central location, create a Smart Collection to do it for you. In the Collections panel, click on the + (plus sign) button on the right side of the panel header and choose Create Smart Collection from the pop-up menu. When the dialog appears, from the first pop-up menu on the left choose File Type, from the second menu choose Is, and from the third choose Video. Name your Smart Collection and click the Create button, and it gathers all your video clips and puts them in a Smart Collection, but best of all, this collection updates live—anytime you import a video clip, it's also added to your new Smart Collection of video clips.

Shooting Tethered (Go Straight from Your Camera, Right Into Lightroom)

One of my favorite new features in Lightroom 3 is the built-in ability to shoot tethered (shooting directly from your camera into Lightroom), without using third-party software, which is what we've had to do until now. The advantages are: (1) you can see your images much bigger on your computer's screen than on that tiny LCD on the back of the camera, so you'll make better images; and (2) don't have to import after the shoot—the images are already there. *Warning*: Once you try this, you'll never want to shoot any other way.

Step One:

The first step is to connect your camera to your computer using that little USB cable that came with your camera. (Don't worry, it's probably still in the box your camera came in, along with your manual and some other weird cables that come with digital cameras. So, go look there for it.) Go ahead and connect your camera now. In the studio, and on location, I use the tethered setup you see here (which I learned about from world-famous photographer Joe McNally). The bar is the Manfrotto 131DDB Tripod Accessory Arm, with a Gitzo G-065 monitor platform attached.

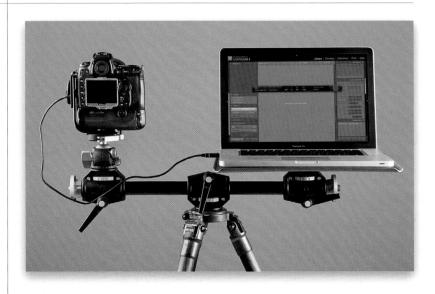

Step Two:

Now go under Lightroom's File menu, under Tethered Capture, and choose Start Tethered Capture. This brings up the dialog you see here, in the Import Window where you enter pretty much the same info as you would (you type in the name of your shoot at the top in the Session Name field, and you choose whether you want the images to have a custom name or not. You also choose where on your hard drive you want these images saved to, and if you want any metadata or keywords added-just like usual). However, there is one important feature here that's different-the Segment Photos By Shots checkbox (shown circled in red here)-which can be incredibly handy when you're shooting tethered (as you'll see).

	Tethered Capture Settings	
Session		
Session Name:	Studio Session 106	
<	Segment Photos By Shots	
Naming		
Sample:	High key fashion-1.DNG	
Template:	Custom Name - Sequence	•
Custom Text:	High key fashion	Start Number: 1
Destination Location:	/Users/scottkelby/Pictures/Studio Session	Choose
Information		
Metadata:	None	÷
Keywords:	Fashion, Headshot, white background	
		Cancel OK

	Initial Shot	Name	
Initial Shot Name:	Blue Earrings		
		Cancel	ок
1/	f/ ISO WB:	Develop Settings:	
17 36 Blue Earrings 160		Develop Settings : None e	
96 Blue Earrings 160			
	11 200 Auto		
35 Blue Earlings 160 1 Common in the data for each to be t	11 200 Auto	None :	
36 Blue Earlings 160 1 Common in the data for each to be t	11 200 Auto	None :	
8 Blue Earlings 160	11 200 Auto	None :	
8 Blue Earlings 160	11 200 Auto 11 200 Auto	None :	

Step Three:

The Segment Photos By Shots feature lets you organize your tethered shots as you go. For example, let's say you're doing a fashion shoot, and your subject changes outfits. You'll be able to separate each of these different looks into different folders by clicking the Shot Name (this will make more sense in a moment). Try it out by turning on the Segment Photos By Shot checkbox. When you do this, a naming dialog appears (shown here), where you can type in a descriptive name for the first shoot of your session.

Step Four:

When you click OK, the Tethered Capture window appears (seen here), and if Lightroom sees your camera, you'll see your camera model's name appear on the left (if you have more than one camera connected, you can choose which camera you want to use by clicking on the camera's name and choosing from the pop-up menu). If Lightroom doesn't see your camera, it'll read "No Camera Detected," in which case you need to make sure your USB cable is connected correctly, and that Lightroom supports your camera's make and model. To the right of the camera's model, you'll see the camera's current settings, including f-stop, shutter speed, and ISO. To the right of that, you have the option of applying a Develop module preset (see Chapter 4 for more on those, but for now just leave it set at None).

TIP: Hiding the Tethered Bar Press Command-T (PC: Ctrl-T) to show/ hide the Tethered Capture window.

Step Five:

The round button on the right side of the Tethered Capture window is actually a shutter button, and if you click on it, it'll take a photo just as if you were pressing the shutter button on the camera itself (pretty slick). When you take a shot now, in just a few moments, the image will appear in Lightroom. The image doesn't appear quite as fast in Lightroom as it does on the back of the camera, because you're actually transferring the entire file from the camera to the computer over that USB cable (or a wireless transmitter, if you have one connected to your camera), so it takes a second or two. Also, if you shoot in JPEG mode, the file sizes are much smaller, so your images will appear in Lightroom much faster than RAW images. Here is a set of images taken during a tethered shoot, but the problem is if you view them in the Library module's Grid view like this, they're not much bigger than the LCD on the back of your camera.

Note: Canon and Nikon react to tethering differently. For example, if you shoot Canon, and you have a memory card in the camera while shooting tethered, it writes the images to your hard drive and the memory card, but Nikon's write only to your hard drive.

Step Six

Of course, the big advantage of shooting tethered is seeing your images really large (you can check the lighting, focus, and overall result much easier at these larger sizes, and clients love it when you shoot tethered when they're in the studio, because they can see how it's going without looking over your shoulder and squinting to see a tiny screen). So, double-click on any of the images to jump up to Loupe view (as shown here), where you get a much bigger view as your images appear in Lightroom. (Note: If you do want to shoot in Grid view, and just make your thumbnails really big, then you'll probably want to go to the toolbar and, to the left of Sort Order, click on the A-wZ button, so your most recent shot always appears at the top of the grid.

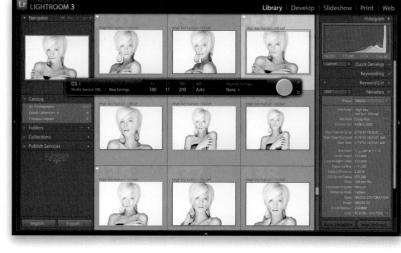

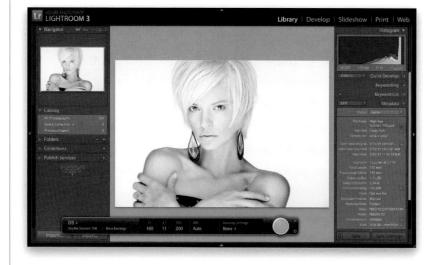

D3 ‡ Studio	Session 106	and the second se	Blue Earrings	17 160
		S	hot Name	
hot Name:	Black Hat	****		
			Cancel	ОК

Step Seven:

Now let's put that Segment Photos By Shot feature to use. Let's say you finish this round of shots with your subject wearing blue earrings, and in the next set, your subject will be wearing a hat. Just click directly on the word "Blue Earrings" in the Tethered Capture window (or press **Command-Shift-T [PC: Ctrl-Shift-T]**) and the Shot Name dialog appears. Give this new set of shots a name (I named mine "Black Hat") and then go back to shooting. Now these images will appear in their own separate folders, but all within my main Studio Session 106 folder.

Step Eight

When I'm shooting tethered (which I always do when I'm in the studio, and as often as I can on location), rather than looking at the Library module's Loupe view, I switch to the Develop module, so if I need to make a quick tweak to anything, I'm already in the right place. Also when shooting tethered, my goal is to make the image as big as possible onscreen, so I hide Lightroom's panels by pressing **Shift-Tab**, which enlarges the size of your image to take up nearly the whole screen. Then lastly, I press the letter L twice to enter Lights Out mode, so all I see is the full-screen-sized image centered on a black background, with no distractions (as shown here). If I want to adjust something, I press L twice, then Shift-Tab to get the panels back.

Creating Your Own Custom File Naming Templates

Staying organized is critical when you have thousands of photos, and because digital cameras generate the same set of names over and over, it's really important that you rename your photos with a unique name right during import. A popular strategy is to include the date of the shoot as part of the new name. Unfortunately, only one of Lightroom's import naming presets includes the date, and it makes you keep the camera's original filename along with it. Luckily, you can create your own custom file naming template just the way you want it. Here's how:

Step One:

Start in the Library module, and click on the Import button on the bottom-left side of the window (or use the keyboard shortcut **Command-Shift-I [PC: Ctrl-Shift-I]**). When the Import window appears, click on Copy as DNG or Copy at the top center, and the File Renaming panel will appear on the left side. In that panel, turn on the Rename Files checkbox, then click on the Template pop-up menu and chose **Edit** (as shown here) to bring up the Filename Template Editor (shown below in Step Two).

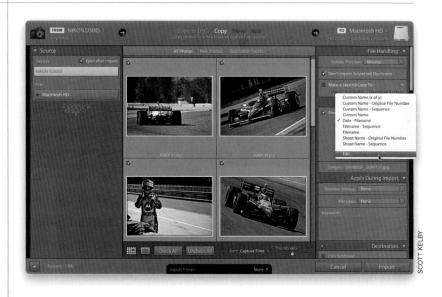

Step Two:

At the top of the dialog, there is a pop-up menu where you can choose any of the built-in naming presets as a starting place. For example, if you choose Custom Name -Sequence, the field below shows two blue tokens (that's what Adobe calls them; on a PC, the info appears within braces) that make up that preset: the first represents the text, the second represents the auto numbering. To remove either token, click on it, then press the Delete (PC: Backspace) key on your keyboard. If you want to just start from scratch (as I'm going to do), delete both tokens, choose the options you want from the pop-up menus below, then click the Insert buttons to add them to the field.

Preset: (Custom Name - Sequence	e	
Example:	untitled-1.raw		
Custom	n Text 🔵 – 🕘 Sequence # ((1)	
Image Name			
	Filename	Insert)
Numbering			
	Import # (1)	t Insert)
	[Image # (1)	Insert)
	Sequence # (1)	t Insert)
Additional			
	Date (YYYY)	(Insert)
Custom			
	Shoot Name	Insert)
	Custom Text	Insert)
		Cancel	Done

Preset:	Custom Name - Sequence (ed	lited)	alinita animinina anima 🖥
Example: 1	0 ing		
Date (Y)			
And a state of the			
Image Name			
inage Name	Filename	•	(Insert)
	Filename		Insert
Numbering			
	(Import # (1)		Insert
	[Image # (1)	\$	Insert
	Date (Month DD, YYYY)	R	(Insert)
	Date (YYYYMMDD) Date (YYMMDD)	1	Concernent and the second
Additional	Date (YYYY)		
E.	/ Date (YY)		Insert
Custom	Date (Month) Date (Mon)		
Custom	Date (MM)		
	Date (DD)		Insert
	Julian Day of the Year		Insert
	Hour Minute		
	Second	ce	Done

Preset:	Custom Name - Sequence (ed	ited)	
Example: 1	.002.jpg		
Date (Y)	r) 🕜 🕜 Date (MM) ⊘		
Image Name			
	Filename	insert	
Numbering			
Additional	Date (Month DD, YYYY) Date (YYYYMMDD) Date (YYMMDD) Date (YYY) Date (YY) Date (Month) Date (Mon) / Date (MM) Date (DD) Julian Day of the Year	Insert Insert Insert	
	Hour Minute Second	Insert Insert	

Step Three:

I'm going to show you the setup for a popular file naming system for photographers, but this is only an example—you can create a custom template later that fits your studio's needs. We'll start by adding the year first (this helps keep your filenames together when sorted by name). To keep your filenames from getting too long, I recommend using just the last two digits of the year. So go to the Additional section of the dialog, click on the pop-up menu, and choose Date (YY), as shown here (the Y lets you know this is a year entry, the YY lets you know it's only going to display two digits). The Date (YY) token will appear in the naming field and if you look above the top-left side of it, you'll see a live example of the name template you're creating. At this point, my new filename is 10.jpg, as seen here.

Step Four:

After the two-digit year, we add the twodigit month the photo was taken by going to the same pop-up menu, but this time choosing Date (MM), as shown here. (Both of these dates are drawn automatically from the metadata embedded into your photo by your digital camera at the moment the shot was taken.) By the way, if you had chosen Date (Month), it would display the entire month name, so your filename would have looked like this: 10February, rather than what we want, which is 1002.

Step Five:

Before we go any further, you should know there's a rule for file naming, and that's no spaces between words. However, if everything just runs together, it's really hard to read. So, after the date you're going to add a visual separator—a thin flat line called an underscore. To add one, just click your cursor right after the Date (MM) token, then press the Shift key and the Hyphen key to add an underscore (seen here). Now, here's where I differ from some of the other naming conventions: after the date, I include a custom name that describes what's in each shoot. This differs because some people choose to have the original camera-assigned filename appear there instead (personally, I like to have a name in there that makes sense to me without having to open the photo). So to do that, go to the Custom section of the dialog and to the right of Custom Text, click the Insert button (as shown here) to add a Custom Text token after your underscore (this lets you type in a one-word text description later), then add another underscore (so it looks like _Custom Text_. In your example up top, though, it will say "untitled" until you add your custom text).

Step Six:

Now you're going to have Lightroom automatically number these photos sequentially. To do that, go to the Numbering section and choose your numbering sequence from the third pop-up menu down. Here I chose the Sequence # (001) token, which adds three-digit auto-numbering to the end of your filename (you can see the example above the naming field).

Preset:	Custom Name - Sequence	(edited)	in an
Fxample	1002_untitledjpg		
	Y) O Date (MM) _ (Custom Text	ananda sa ana ana ana ana ana ana ana ana ana
Image Nam			
	Filename	(Insert)
Numbering			
	Import # (1)	Insert)
	Image # (1)	t Insert)
	Sequence # (1)	t) (Insert)
Additional			
	Date (MM)	1 Insert)
Custom			
	Shoot Name	Insert)
	Custom Text	Insert)

Example: 1	002_untitled_001.jpg		
	Y) Date (MM) (ce # (001)	Custom Text	L
Image Name			
	Filename	•	Insert
Numbering			
Additional	Import # (1) Sequence # (1) Sequence # (01) ✓ Sequence # (001) Sequence # (0001) Sequence # (00001)	() k	Insert Insert Insert
Custom	Total # (1) Total # (01) Total # (001) Total # (0001) Total # (00001))	Insert
	Custom Text		Insert

Develop

Slideshow Print

Web

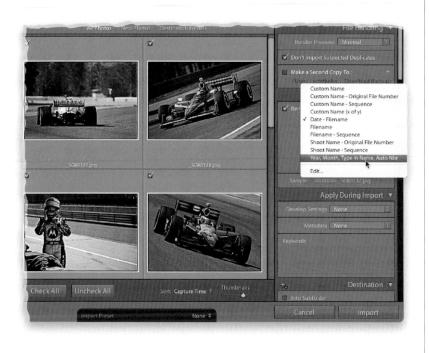

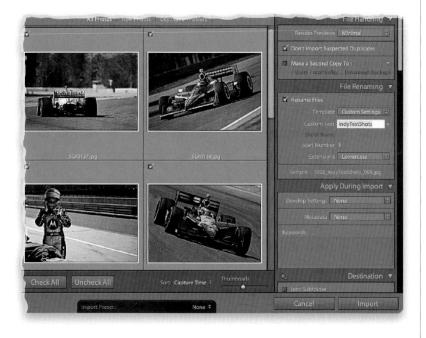

Step Seven:

Once the little naming example looks right to you, go under the Preset pop-up menu, and choose **Save Current Settings as New Preset**. A dialog will appear where you can name your preset. Type in a descriptive name (so you'll know what it will do the next time you want to apply it— I chose "Year, Month, Type in Name, Auto Nbr"), click Create, and then click Done in the Filename Template Editor. Now, when you go to the Import window and click on the File Renaming panel's Template pop-up menu, you'll see your custom template as one of the preset choices (as shown here).

Step Eight:

Now, after you choose this new naming template from the Template pop-up menu, click below it in the Custom Text field (this is where that Custom Text token we added earlier comes into play) and type in the descriptive part of the name (in this case, I typed in "IndyTestShots," all one word no spaces between words). That custom text will appear between two underscores, giving you a visual separator so everything doesn't all run together (see, it all makes sense now). Once you type it in, if you look at the Sample at the bottom of the File Renaming panel, you'll see a preview of how the photos will be renamed. Once you've chosen all your Apply During Import and Destination panel settings, you can click the Import button.

Choosing Your Preferences for Importing Photos

I put the import preferences toward the end of the Importing chapter because I figured that, by now, you've imported some photos and you know enough about the importing process to know what you wish was different. That's what preferences are all about (and Lightroom has preference controls because it gives you lots of control over the way you want to work).

Step One:

The preferences for importing photos are found in a couple different places. First, to get to the Preferences dialog, go under the Lightroom menu on a Mac or the Edit menu on a PC, and choose **Preferences** (as shown here).

Lightroom File Edit	Library Photo	Metadata	View
About Adobe Photosho	p Lightroom 3		
Preferences	æ,		
Catalog Settings Identity Plate Setup Edit Watermarks	₹¥,		
Services	1		
Hide Lightroom	жн	4	
Hide Others Show All	187	1	
Quit Lightroom	жc	2	

Step Two:

When the Preferences dialog appears, first click on the General tab up top (shown highlighted here). Under Import Options in the middle, the first preference lets you tell Lightroom how to react when you connect a memory card from your camera to your computer. By default, it opens the Import window. However, if you'd prefer it didn't automatically open that window each time you plug in a camera or card reader, just turn off its checkbox (as shown here).

, ,		Preferences	
	General Presets	External Editing File Handling	Interface
	Settings:	Show splash screen during startu	p
		Automatically check for updates	
Default Catalog			
When sta	arting up use this catalog:	Load most recent catalog	•
Import Options			
Show imp	oort dialog when a memory	y card is detected	
🗍 Ignore ca	mera-generated folder na	mes when naming folders	
Treat JPE	G files next to raw files as	separate photos	
Completion Soun	ds		
When finish	ed importing photos play:	No Sound	
When finish	ed exporting photos play:	No Sound	÷
Prompts			
		Reset all warning dialogs	
Catalog Settings			
Some setting	gs are catalog-specific and	are changed in Catalog Settings.	Go to Catalog Settings

)0			Preferences	
	General	Presets	External Editing File Handling Interface	
			☑ Show splash screen during startup ☑ Automatically check for updates	
Default Catalog				
When sta	urting up use thi	s catalog:	Load most recent catalog	\$
Import Options				
Show imp	ort dialog when	a memory	card is detected	
🗌 lonore ca	mera-generated	folder nar	mes when naming folders	
			separate photos	
Completion Sound	ds			
When finishe	ed importing ph	otos pla 🗸	No Sound)
When finish	ed exporting ph	otos pla	Basso	0
			Blow	
Prompts			Bottle Frog	
			Funk	
			Glass	
			Hero	
Catalog Settings			Morse	
Some setting	are catalog-si	pecific a	Ping)
			Pop Purr	1
			Sosumi	
			Submarine	

General Presets	External Editing File Handling Interface
Sattings	Show splash screen during startup
	Automatically check for updates
Default Catalog	
When starting up use this catalog:	Load most recent catalog
mport Options	
Show import dialog when a memory	y card is detected
Ignore camera-generated folder na	mes when naming folders
Treat JPEG files next to raw files as	
_	
Completion Sounds	
When finished importing photos play:	Funk
When finished exporting photos play:	Ping
rompts	
	Reset all warning dialogs
Tatalog Settings	
Some settings are catalog-specific and	are changed in Catalog Settings. Go to Catalog Settings

Step Three:

There are two other importing preference settings I'd like to mention that are also found on the General tab. In the Completion Sounds section, you not only get to choose whether or not Lightroom plays an audible sound when it's done importing your photos, you also get to choose which sound (from the pop-up menu of system alert sounds already in your computer, as seen here).

Step Four:

While you're right there, directly below the menu for choosing an "importing's done" sound is another pop-up menu for choosing a sound for when your exporting is done. I know, this isn't an importing preference, but since we're right there, I thought...what the heck. I'll talk more about some of the other preferences later in the book, but since this chapter is on importing, I thought I'd better tackle it here.

Step Five:

Now, at the bottom of the General tab, click the Go to Catalog Settings button (also found under the Lightroom [PC: Edit] menu). In the Catalog Settings dialog, click on the Metadata tab. Here you can determine whether you want to take the metadata you add to your RAW photos (copyright, keywords, etc.) and have it written to a totally separate file, so then for each photo you'll have two files one that contains the photo itself and a separate file (called an XMP sidecar) that contains that photo's metadata. You do this by turning on the Automatically Write Changes into XMP checkbox, but why would you ever want to do this? Well, normally Lightroom keeps track of all this metadata you add in its database file-it doesn't actually embed the info until your photo leaves Lightroom (by exporting a copy over to Photoshop, or exporting the file as a JPEG, TIFF, or PSD-all of which support having this metadata embedded right into the photo itself). However, some programs can't read embedded metadata, so they need a separate XMP sidecar file.

Step Six:

Now that I've shown you that Automatically Write Changes into XMP checkbox, I don't actually recommend you turn it on, because writing all those XMP sidecars takes time, which slows Lightroom down. Instead, if you want to send a file to a friend or client and you want the metadata written to an XMP sidecar file, first go to the Library module and click on an image to select it, then press Command-S (PC: Ctrl-S), which is the shortcut for Save Metadata to File (which is found under the Metadata menu). This writes any existing metadata to a separate XMP file (so you'll need to send both the photo and the XMP sidecar together).

	General File Handling Metadata
	General File Handling Metadata
diting	
Offer sugge	stions from recently entered values Clear All Suggestion Lists
Include Dev	elop settings in metadata inside JPEG, TIFF, and PSD files
Automatical	ly write changes into XMP
N	Changes made in Lightroom will not automatically be visible in other applications.
EXIF	
Write date o	r time changes into proprietary raw files.
- mile date o	a unic changes into proprietary ran mes.

I mentioned that you have the option of having your photos converted to DNG (Digital Negative) format as they're imported. DNG was created by Adobe because today each camera manufacturer has its own proprietary RAW file format, and Adobe is concerned that, one day, one or more manufacturers might abandon an older format for something new. With DNG, it's not proprietary—Adobe made it an open format, so anyone can write to that specification. While ensuring that your negatives could be opened in the future was the main goal, DNG brings other advantages, as well.

0	Preferences	
	General Presets External Editing Fi	ile Handling Interface
mport DNG Crea	tion	·
	File Extension: (dng	+
	Compatibility: Camera Raw 5.4 and late	er 🔹
	JPEG Preview: Medium Size	•
	Embed Original Raw Fi	le
Reading Metadata		
Treat '.' a	dot, forward slash, and b	ading metadata Lightroom can recognize ackslash separated keywords as keyword
Treat '/'	as a keyword separator hierarchies instead of flat recognized as a hierarchy	t keywords. The vertical bar is automatically y separator.
ïle Name Genera	tion	
Treat the fo	ollowing characters as illegal: (/ :	
Replace illeg	gal file name characters with: Dashes (-)	•
W	/hen a file name has a space: Leave As-Is	•
Camera Raw Cach	ie Settings	
Locati	on: /Users/csnyder/Library/Caches/Adobe Camer	ra Raw Choose)
	ize: 1.0 GB	(Purge Cache)
Maximum S	12C. [1.0] GB	
Maximum S		
Maximum Si		

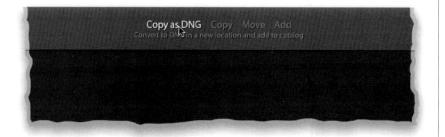

The Adobe DNG File Format Advantage

Setting Your DNG Preferences: Press Command-, (comma; PC: Ctrl-,) to bring up Lightroom's Preferences dialog, then click on the File Handling tab (as shown here). In the Import DNG Creation section at the top, you see the settings I use for DNG conversion. Although you can embed the original proprietary RAW file, I don't (it adds to the file size, and pretty much kills Advantage #1 below). By the way, you choose Copy as DNG at the top center of the Import window (as shown below).

Advantage #1: DNG files are smaller

RAW files usually have a pretty large file size, so they eat up hard disk space pretty quickly, but when you convert a file to DNG, it's generally about 20% smaller.

Advantage #2: DNG files don't need a separate sidecar

When you edit a RAW file, that metadata is actually stored in a separate file called an XMP sidecar file. If you want to give someone your RAW file and have it include the metadata and changes you applied to it in Lightroom, you'd have to give them two files: (1) the RAW file itself, and (2) the XMP sidecar file, which holds the metadata and edit info. But with a DNG, if you press **Command-S (PC: Ctrl-S)**, that info is embedded right into the DNG file itself. So, before you give somebody your DNG file, just remember to use that shortcut so it writes the metadata to the file first.

Creating Your Own Custom Metadata (Copyright) Templates

At the beginning of this chapter, I mentioned that you'll want to set up your own custom metadata template, so you can easily and automatically embed your own copyright and contact information right into your photos as they're imported into Lightroom. Well, here's how to do just that. Keep in mind that you can create more than one template, so if you create one with your full contact info (including your phone number), you might want to create one with just basic info, or one for when you're exporting images to be sent to a stock photo agency, etc.

Step One:

You can create a metadata template from right within the Import window, so press **Command-Shift-I (PC: Ctrl-Shift-I)** to bring it up. Once the Import window appears, go to the Apply During Import panel, and from the Metadata pop-up menu, choose New (as shown here).

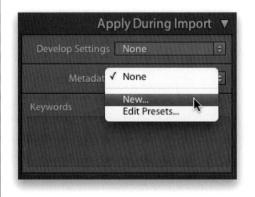

Step Two:

A blank New Metadata Preset dialog will appear. First, click the Check None button at the bottom of the dialog, as shown here (so no blank fields will appear when you view this metadata in Lightroom—only fields with data will be displayed).

Preset Name: Untitled Pres	et	
Preset: Custom		:
🖲 Basic Info		Í
Copy Name		
Rating	· · · · ·	
Label		
Caption		
V 🖂 IPTC Content		
Headline		
IPTC Subject Code		Θ
Description Writer		Θ
Category		Θ.
Other Categories		
🖲 IPTC Copyright		
Copyright		
Copyright Status	Unknown 🗘	
Rights Usage Terms		Θ
Copyright Info URL		Θ
V 📄 IPTC Creator		
Creator		Θ
Creator Address		Θ
Creator City		
Creator State / Province		
Creator Postal Code		Let
Check All Check None	Check Filled Cancel Cr	reate

yright (Full)	HIGHEREN
	(diliti)
ч	0
	-
Copyright © 2010 Scott Kelby	Ø
Copyrighted	ø
No reproduction of any kind without prior written	Ø
http://www.scottkelby.com/usageterms	
Scott Kelby	Ø
333 Douglas Road East	M
Oldsmar	M
FL .	
34677	ø
USA	ø
813-433-5000	ø
skelby@kelbymediagroup.com	Ø
http://www.scottkelby.com	ø
	Copyright © 2010 Scott Kelby Copyright © 2010 Scott Kelby Copyrighted No reproduction of any kind without prior written http://www.scottkelby.com/usageterms Scott Kelby 333 Douglas Road East Oldsmar FL 34677 USA 813-433-5000 skelby@kelbymediagroup.com

rese ✓ Scott's Copyright (F	ull)	
Save Current Settin	~	
Sector Contraction and a strain and the sector of the sect	t's Copyright (Full)"	
III Commence	ott's Copyright (Full)"	
Label		0
Caption		
🔻 🖂 IPTC Content		
Headline		
IPTC Subject Code		
Description Writer		
Category		
Other Categories		
🖲 IPTC Copyright		
Copyright	Copyright © 2010 Scott Kelby	
Copyright Status	Copyrighted	Ø
Rights Usage Terms	No reproduction of any kind without prior written	
Copyright Info URL	http://www.scottkelby.com/usageterms	Ø
🖲 IPTC Creator		
Creator	Scott Kelby	₫
Creator Address	333 Douglas Road East	Ø
Creator City	Oldsmar	
Creator State / Province	FL	ø
Creator Postal Code	34677	1
Check All) Check None	Check Filled	one

Step Three:

In the IPTC Copyright section, type in your copyright information (as shown here). Next, go to the IPTC Creator section and enter your contact info (after all, if someone goes by your website and downloads some of your images, you might want them to be able to contact you to arrange to license your photo). Now, you may feel that the Copyright Info URL (Web address) that you added in the previous section is enough contact info, and if that's the case, you can skip filling out the IPTC Creator info (after all, this metadata preset is to help make potential clients aware that your work is copyrighted, and tell them how to get in contact with you). Once all the metadata info you want embedded in your photos is complete, go up to the top of the dialog, give your preset a name-I chose "Scott's Copyright (Full)"—and then click the Create button, as shown.

Step Four:

As easy as it is to create a metadata template, deleting one isn't much harder. Go back to the Apply During Import panel and, from the Metadata pop-up menu, choose Edit Presets. That brings up the Edit Metadata Presets dialog (which looks just like the New Metadata Preset dialog). From the Preset pop-up menu at the top, choose the preset you want to delete. Once all the metadata appears in the dialog, go back to that Preset pop-up menu, and now choose Delete Preset [Name of Preset]. A warning dialog will pop up, asking if you're sure you want to delete this preset. Click Delete, and it is gone forever.

Four Things You'll Want to Know Now About Getting Around Lightroom

Now that your images have been imported, there are some tips about working with Lightroom's interface you're going to want to know about right up front that will make working in it much easier.

Step One:

There are five different modules in Lightroom, and each does a different thing. When your imported photos appear in Lightroom, they always appear in the center of the Library module, which is where we do all our sorting, searching, keywording, etc. The Develop module is where you go to do your photo editing (like changing the exposure, white balance, tweaking colors, etc.), and it's pretty obvious what the other three do (I'll spare you). You move from module to module by clicking on the module's name up in the taskbar across the top, or you can use the shortcuts Command-Option-1 for Library, Command-Option-2 for Develop, and so on (on a PC, it would be Ctrl-Alt-1, Ctrl-Alt-2, and so on).

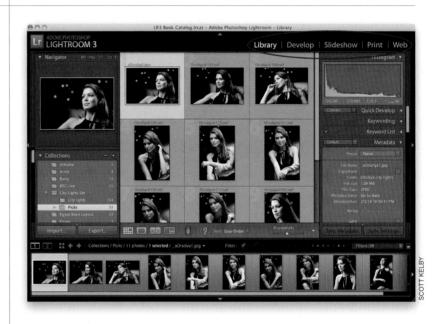

Step Two:

There are five areas in the Lightroom interface overall: that taskbar on the top, the left and right side Panels areas, and a Filmstrip across the bottom (your photos always appear in the center Preview area). You can hide any panel (which makes the Preview area, where your photos are displayed, larger) by clicking on the little gray triangle in the center edge of the panel. For example, go ahead and click on the little gray triangle at the top center of the interface, and you'll see it hides the taskbar. Click it again; it comes back.

Slideshow Print

Step Three:

The #1 complaint I hear from Lightroom users about working with panels is they hate the Auto Hide & Show feature (which is on by default). The idea behind it sounds great: if you've hidden a panel, and need it visible again to make an adjustment, you move your cursor over where the panel used to be, and it pops out. When you're done, you move your cursor away, and it automatically tucks back out of sight. Sounds great, right? The problem is one pops out anytime you move your cursor to the far right, left, top, or bottom of your screen. It really drives them nuts, and I've had people literally beg me to show them how to turn it off. You can turn Auto Hide & Show off by Right-clicking on the little gray triangle for any panel. A pop-up menu will appear (shown here) where you'll choose Manual, which turns the feature off. This works on a per-panel basis, so you'll have to do it to each of the four panels.

Step Four:

I use the Manual mode, so I can just open and close panels as I need them. You can also use the keyboard shortcuts: F5 closes/opens the top taskbar, F6 hides the Filmstrip, F7 hides the left side Panels area, and **F8** hides the right side (on a newer Mac keyboard or a laptop, you may have to press the Fn key with these). You can hide both side Panels areas by pressing the Tab key, but the one shortcut I probably use the most is Shift-Tab, because it hides everything-all the panels-and leaves just your photos visible (as shown here). Also, here's an insight into what is found where: the left side Panels area is used primarily for applying presets and templates, and showing you a preview of the photo, preset, or template you're working with. Everything else (all adjustments) is found on the right side. Okay, on the next page: tips on viewing.

Viewing Your Imported Photos

Before we get to sorting our photos and separating the winners from the losers (which we cover in the next chapter), taking a minute just to learn the ins and outs of how Lightroom lets you view your imported photos is important. Learning these viewing options now will really help you make the most informed decisions possible about which photos make it (and which ones don't).

Step One:

When your imported photos appear in Lightroom, they are displayed as small thumbnails in the center Preview area (as seen here). You can change the size of these thumbnails using the Thumbnails slider that appears in the toolbar (the dark gray horizontal bar that appears directly below the center Preview area). Drag it to the right, and they get bigger; drag to the left, and they get smaller (the slider is circled here).

Step Two:

To see any thumbnail at a larger size, just double-click on it, press the letter **E** on your keyboard, or press the Spacebar. This larger size is called Loupe view (as if you were looking at the photo through a loupe), and by default it zooms in so you can see your entire photo in the Preview area. This is called a Fit in Window view, but if you'd prefer that it zoomed in tighter, you can go up to the Navigator panel at the top left, and click on a different size, like Fill, and now when you double-click, it will zoom in until your photo literally fills the Preview area. Choosing 1:1 will zoom your photo in to a 100% actual size view when it's doubleclicked, but I have to tell you, it's kind of awkward to go from a tiny thumbnail to a huge, tight zoom like that.

The default cell view is called Expanded and gives you the most info

The Compact view shrinks the size of the cell and amount of info, but numbers each cell

If you press J again, it hides all the info and just shows the photos

Step Three:

I leave my Navigator panel setting at Fit, so when I double-click I can see the entire photo fitting in the center Preview area, but if you want to get in closer to check sharpness, you'll notice that when you're in Loupe view, your cursor has changed into a magnifying glass. If you click it once on your photo, it jumps to a 1:1 view of the area where you clicked. To zoom back out, just click it again. To return to the thumbnail view (called Grid view), just press the letter **G** on your keyboard. This is one of the most important keyboard shortcuts to memorize (so far, the ones you really need to know are: Shift-Tab to hide all the panels, and now G to return to Grid view). This is a particularly handy shortcut, because when you're in any other module, pressing G brings you right back here to the Library module and your thumbnail grid.

Step Four:

The area that surrounds your thumbnail is called a cell, and each cell displays information about the photo from the filename, to the file format, dimensions, etc.-you get to customize how much or how little it displays, as you'll see in Chapter 3. But in the meantime, here's another keyboard shortcut you'll want to know about: press the letter J. Each time you press it, it toggles you through the three different cell views, each of which displays different groups of info-an expanded cell with lots of info, a compact cell with just a little info, and the last one hides all that distracting stuff altogether (great for when you're showing thumbnails to clients). Also, you can hide (or show) the dark gray toolbar below the center Preview area by pressing T. If you press-and-hold T, it only hides it for as long as you have the T key held down.

Using Lights Dim, Lights Out, and Other Viewing Modes

One of the things I love best about Lightroom is how it gets out of your way and lets your photos be the focus. That's why I love the Shift-Tab shortcut that hides all the panels. But if you want to really take things to the next level, after you hide those panels, you can dim everything around your photo, or literally "turn the lights out," so everything is blacked out but your photos. Here's how:

Step One:

Press the letter L on your keyboard to enter Lights Dim mode, in which everything but your photo(s) in the center Preview area is dimmed (kind of like you turned down a lighting dimmer). In this mode, a thin white border also appears around your thumbnails, so they really stand out. Perhaps the coolest thing about this dimmed mode is the fact that the Panels areas, taskbar, and Filmstrip all still work—you can still make adjustments, change photos, etc., just like when the "lights" are all on.

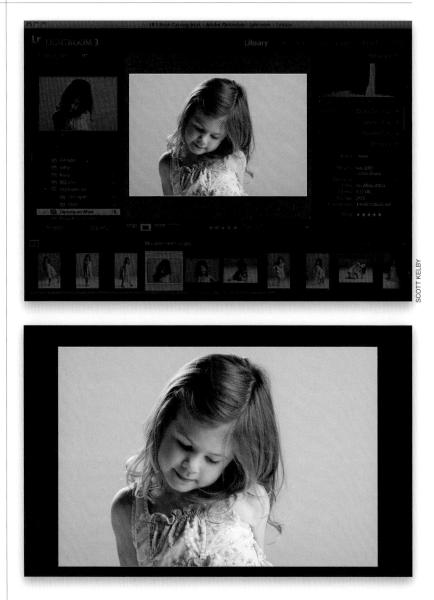

Step Two:

The next viewing mode is Lights Out (you get Lights Out by pressing L a second time), and this one really makes your photos the star of the show because everything else is totally blacked out, so there's nothing (and I mean nothing) but your photos onscreen (to return to regular Lights On mode, just press L again). To get your image as big onscreen as possible, right before you enter Lights Out mode, press Shift-Tab to hide all the panels on the sides, top, and bottom—that way you get the big image view you see here. Without the Shift-Tab, you'd have the smaller size image you see in Step One, with lots and lots of empty black space around it.

Library Deve

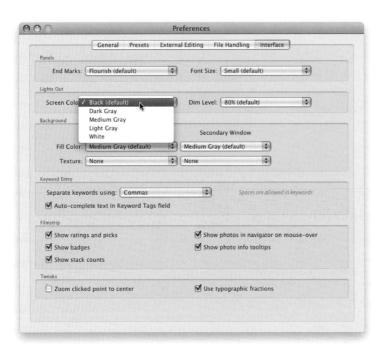

TIP: Controlling Lights Out Mode

You have more control over Lightroom's Lights Out mode than you might think: just go to Lightroom's preferences (under the Lightroom menu on a Mac or the Edit menu on a PC), click on the Interface tab, and you'll find pop-up menus that control both the Dim Level and the Screen Color when you're in full Lights Out mode.

Step Three:

If you want to view your grid of photos without distractions in the Lightroom window, press the F key on your keyboard twice. The first time you press F, it makes the Lightroom window fill your screen and hides the window's title bar (directly above the taskbar in Lightroom's interface). The second F actually hides the menu bar at the very top of your screen, so if you combine this with Shift-Tab to hide your panels, taskbar, and Filmstrip, and **T** to hide the toolbar, you'll see just your photos on a solid top-to-bottom gray background. I know you might be thinking, "I don't know if I find those two thin bars at the top really that distracting." So, try hiding them once and see what you think. Luckily, there's an easy shortcut to jump to the "super-clean, distraction-free nirvana view" you see here: you press Command-Shift-F (PC: Ctrl-Shift-F), then T. To return to regular view, use the same shortcut. The image on top is the gray layout you just learned, and on bottom, I pressed L twice to enter Lights Out mode.

Lightroom Killer Tips > >

Drag-and-Drop Straight Into Lightroom 3

If you have photos on your desktop, or in a folder, that you want to import into Lightroom, you can drag-and-drop the photo (or a folder full of photos) right on the Lightroom icon (or the Dock icon if you're using a Mac), and it will launch Lightroom (if it's not already running), and bring up Lightroom's Import window automatically.

Lightroom Won't Let You Import Duplicates

If you go to import some photos, and
some (or all) of them are already found
in your Lightroom catalog (in other words,
these are duplicates), and the Don't
Import Suspected Duplicates checkbox
is turned on, any images already in Light-
room will be grayed out in the Import
window. If all the images are duplicate,
the Import button will also be grayed
out, so you can't import them.

Using Separate Catalogs to Make Lightroom Faster

Although I keep one single catalog for all the photos on my laptop, and just three catalogs for my entire collection in the studio, I have a friend who's a fulltime wedding photographer who uses a different Lightroom catalog strategy that freaked me out when I first heard it, but really makes perfect sense (in fact, it may be just what you need). He creates a separate Lightroom catalog (go under the File menu and choose **New Catalog**) for every single wedding. At each wedding, he shoots more than a thousand shots, and often he has one to two other photographers shooting with him. His way, Lightroom really screams, because each catalog has only a thousand or so photos (where for many folks, it's not unusual to have 30,000 or 40,000 images, which tends to slow Lightroom down a bit). Hey, if you're a high-volume shooter, it's worth considering.

When the Import Window Doesn't Appear Automatically

If you connect a memory card reader to your computer, Lightroom's Import window should appear automatically. If for some reason it doesn't, press **Command-, (comma; PC: Ctrl-,)** to bring up Lightroom's Preferences, then click the General tab up top, and make sure the checkbox is turned on for Show Import Dialog When a Memory Card Is Detected.

Why You Might Want to Wait to Rename Your Files

As you saw in this chapter, you can rename your files as you import them into Lightroom (and I definitely think you should give your files descriptive names), but you might want to wait until after you've sorted your photos (and deleted any out-of-focus shots, or shots where the flash didn't fire, etc.), because Lightroom auto-numbers the files for you. Well, if you delete some of these files, then your numbering will be out of sequence (there will be numbers missing). This doesn't bother me at all, but I've learned that it drives some people crazy (you know who you are), so it's definitely something to consider.

Getting Back to Your Last Imported Images

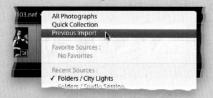

Lightroom keeps track of the last set of images you imported, and you can get back to those images anytime by going to Catalog panel (in the Library module's left side Panels area) and clicking on Previous Import. However, I think it's faster (and more convenient) to go down to the Filmstrip, and on the left side, where you see the current collection's name, click-and-hold, and from the pop-up menu that appears, choose Previous Import.

▼ Using Lightroom in 32-Bit

O O Adobe Lightroom 3 Info
Adobe Lightroom 3 85.5 MB Modified: Today at 9:46 AM
► Spotlight Comments:
▼ Ceneral:
Kind: Application (Intel)
Size: 85.5 MB on disk (81,043,201 bytes)
Where: /Applications
Created: Wednesday, April 28, 2010 5:13 AM
Modified: Today at 9:46 AM
Version: Adobe Lightroom 3.0 (671907), Copyright 2006–2010 Adobe Systems Incorporated.
Label: 🗙 🗃 🔤 🗌 🗰 📾
Open in 32 Bit Mode

Lightroom 3 is 64-bit capable, and if you're working on a Mac, it runs in 64-bit mode by default. If you want to run it in 32-bit, go to the Applications folder, click on the icon for Lightroom

Develop

Slideshow

Web

Print

Lightroom Killer Tips > >

3, and press **Command-I** to bring up the Get Info window, then turn on the Open in 32 Bit Mode checkbox. That's it. In Windows Vista and Windows 7 64-bit, by default, only the 64-bit version of Lightroom is installed.

Organize Multiple Shoots by Date

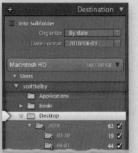

If you're like me, you probably wind up having multiple shoots on the same memory card (for example, I often shoot one day and then shoot a few days later with the same memory card in my camera). If that's the case, then there's an advantage to using the Organize By Date feature in the Import window's Destination panel, and that is it shows each of the shoots on your memory card by their date. The folders will vary slightly, depending on the Date Format you choose, but you will have a folder for each day you shot. Only the shoots with a checkmark beside them will be imported into Lightroom, so if you only want to import shots from a particular date, you can turn off the checkbox beside the dates you don't want imported.

▼ Multiple Cards from One Shoot If you shot two or three memory cards of the same subject, you'll want to choose **Custom Name - Sequence** from the File Renaming panel's Template pop-up menu, which adds a Start Number field, where you can type in which number you want to start with as you import each card (rather than always starting with the number 1, like the Custom Name template). For example, if you imported 236 photos from your first card, you'd want the second card to start numbering with 237, so these shots of the same subject stay sequential. Once that card is imported (let's say you had 244 shots on that card), then you'd want the start number for the third card's photos to be 481. (By the way, I don't do the math, I just look at the file number of the last photo I imported, and then add one to it in the Start Number field.)

▼ Your Elements Library

le Edit Library Photo Metadata View	Window	Help
New Catalog		
Open Catalog		Ctrl+O
Open Recent		
Optimize Catalog		
Import Photos	Ctr	rl+Shift+I
Import from Catalog		
Tethered Capture		,
Upgrade Photoshop Elements Catalog	N	
Auto Import	NE	,

If you're moving to Lightroom 3 from the Windows version of Elements 5 or later, you can have Lightroom import your Elements catalog. Just go under Lightroom's File menu, choose **Upgrade Photoshop Elements Catalog**, and then choose your Elements catalog from the dialog's pop-up menu. You may need to upgrade your Elements catalog for Lightroom, so just click Upgrade if prompted to. Lightroom will close and then reopen with your Elements catalog imported.

Hard Drive Space an Issue? Convert to DNG on Import

Copy as DNG

If you're working on a laptop, and you'd like to save between 15% and 20% (in most cases) of your hard drive space when importing RAW files, click on Copy as DNG at the top center of the Import window. ▼ Back Up to an External Drive For the Make a Second Copy To feature to work properly, you've got to save those copies onto a separate external hard drive. You can't just back up your photos to a different folder on the same computer (or the external hard drive you are storing your photos on), because if your computer's hard drive (or your storage hard drive) crashes, then you lose both your working copies and the backup copies, too. That's why you've got to make sure the backups go to a completely separate external hard drive.

Using Two External Hard Drives If you're already storing your original photos on an external hard drive, it means you now have two external hard drivesone for your working photos, and one for your backups. A lot of photographers buy two small, stackable external hard drives (small hard drives that can stack one on top of the other), and then connect one with a FireWire cable (called an IEEE 1394 on a PC), and the other with a USB 2 cable (hey, I never said this was going to be cheap, but think of it this way: if, one day, you lost all your photos, you'd pay anything to get them back, right? Instead, just pay a fraction now for a backup hard drive-believe me, you'll sleep better at night).

Changing Your Grid View Thumbnail Size

You don't have to have the toolbar at the bottom of the center Preview area visible to change your thumbnail size in the Library module's Grid view—just use the + (plus sign) and – (minus sign) keys on your keyboard to change sizes. The cool thing is that this works in the Import window, too.

Lightroom Killer Tips > >

 Save Time Importing into Existing Folders

If you're going to import some photos into a folder you've already created, just go to the Folders panel in the Library module, Right-click on the folder, and choose **Import into this Folder** from the pop-up menu. This brings up the Import window with this folder already chosen as the destination for your imported photos.

Converting Photos to DNG

If you didn't choose Copy as DNG at the top center of the Import window, and you want your imported photos saved in this file format, you can always convert any photo you've imported into Lightroom into a DNG by just clicking on the photo(s), going to Lightroom's Library menu, and choosing Convert Photo to DNG (although, technically, you can convert JPEGs and TIFFs into DNG format, converting them into DNG doesn't really offer any advantages, so I only convert RAW photos to DNG). This DNG replaces the RAW file you see in Lightroom, and the RAW file remains in the same folder on your computer

(Lightroom, though, gives you the option of deleting the original RAW file when you make the conversion. This is what I choose, since the DNG can include the RAW photo within it).

Organizing Your Images in Folders

🖌 Into :	Subfolder	Caddy
	Organize	Into one folder 🗦
Macinto	sh HD	149/ 297 GB 🖪
LaCie		39.9/465 GB 🚽
		<u>)</u> १९२/२

You get to choose how your images are organized, as they're imported, in the Destination panel. If you don't turn on the Into Subfolder checkbox and you choose Into One Folder from the Organize pop-up menu, Lightroom tosses the loose photos into your Pictures or My Lightroom Photos folder (whichever folder you chose in the To section at the top right of the Import window), and they're not organized within their own separate folder. So, if you choose the Into One Folder option, I recommend that you turn on the Into Subfolder checkbox and then name the folder. That way, it imports them into their own separate folder inside your Pictures or My Lightroom Photos folder. Otherwise, things will get very messy, very quickly.

Lightroom 3 Handles Your Backup Better

In previous versions of Lightroom, when you copied images to a backup hard drive, it didn't include any custom file names, or metadata, or keywords that you added—it just made an exact copy of what was on the memory card. Now, it renames these second copies, includes your metadata, and keeps your file structure, as well.

Choosing Keywords

Here's how I choose my keywords: I ask myself, "If months from now, I was trying to find these same photos, what words would I most likely type in the Find field?" Then I use those words. It works better than you'd think.

▼ Now You Can Import and Edit PSDs and more!

In previous versions of Lightroom, you could only import and edit RAW images, TIFFs, and JPEGs, but in Lightroom 3, you can now import PSDs (Photoshop's native file format), along with images in CMYK mode or Grayscale mode.

▼ Ejecting Your Memory Card

If you decide not to import anything and want to eject your camera's memory card, just Right-click directly on it in the Import Window's Source panel, then choose **Eject** from the pop-up menu that appears. If you pop in a new card, click on the From button at the top left of the window, and choose it from the pop-up menu that appears.

Print Web

Lightroom Killer Tips > >

 See How Many Images and How Much Room They'll Take

If you look in the bottom-left corner of the Import window, you'll see the total number of images you have checked to import, along with how much space they're going to take up on your hard drive.

Choosing Your Preview Rendering

I ran a Lightroom preview time trial, importing just 14 RAW images off a memory card onto a laptop. Here's how long it took to import them and render their previews:

Embedded & Sidecar: 19 seconds Minimal: 21 seconds Standard: 1 minute, 15 seconds 1:1: 2 minutes, 14 seconds

You can see that the 1:1 preview took seven times as long as Embedded & Sidecar. That may not seem that bad with 14 photos, but what about 140 or 340 photos? Yikes! So, armed with that info, you can make a decision that fits your workflow. If you're the type of photographer that likes to zoom in tight on each and every photo to check focus and detail, then it might be worth it for you to wait for the 1:1 previews to render before working on your images. If you're like me, and want to quickly search through them, and just zoom in tight on the most likely keepers (maybe 15 or 20 images from an import), then Embedded & Sidecar makes sense. If you look at them mostly in full-screen view (but don't zoom in really tight that often), then Standard might work, and if you want thumbnails that more closely represent what your photo will

look like when it is rendered at high quality, choose Minimal instead.

▼ Hiding Folders You Don't Need If you're importing photos that are already on your computer, that long list of folders in the Source panel can get really long and distracting, but now you can hide all those extra folders you don't need to see. Once you find the folder you're importing from, just

▼ Source	
Files	🗹 Include Subfolders
Macintosh HD	
▼ Users	
scottkelby	
Desktop	
🔍 Studio Shoot	
Crsolya 📄	
► LaCle	
Editorial	

double-click on it, and everything else tucks away leaving just that folder visible. Try this once and you'll use it all the time.

▼ If Your Nikon Won't Tether

If your Nikon camera is supported for tethered shooting in Lightroom (like the D90, D5000, D300, D300s, D700, D3, D3X, and D3s thus far), but it just doesn't work, chances are your camera's USB settings aren't set up to work with tethering. Go to your camera's Setup menu, click on USB, and change the setting to MTP/PTP.

▼ Seeing Just Your Video Clips First choose **All Photographs** from the path pop-up menu at the top-left side of the Filmstrip. Then, in the Library module go up to the Library Filter at the top of the window (if it's not visible, press the \ [backslash] key), and click on Attribute. Over on the far-right side, to the right of Kind, click on the Videos button (its icon is a filmstrip and it's the third icon from the left) and now it displays nothing but all the video clips you have in Lightroom (pretty handy if you want to make a regular collection of just your video clips).

▼ To Advance or Not to Advance When I'm shooting tethered, as soon as a new image comes in, I like to see it onscreen at full size. But if you'd prefer to control which image appears onscreen, and for how long (remember, if you see one onscreen you like, it

Jom	File Edit Library Photo	Metadata View	v Wir
	New Catalog Open Catalog	ФЖO	
	Open Recent	+	
	Optimize Catalog		
	Import Photos Import from Catalog	£ %I	
	Tethered Capture		Stop Tethered Capture
	Auto Import	Þ	Hide Tethered Capture Window %T
	Export Export with Previous Export with Preset	O%E S%O√ ₩	New Shot © 36T Auto Advance Selection
	the second		

may only stay there a moment or two until the next shot comes in), go under the File menu, under Tethered Capture, and turn off **Auto Advance Selection**. Now, you'll use the Left/ Right Arrow keys on your keyboard to move through your images, rather than always seeing the image you just took onscreen.

Chapter 2 How to Organize Your Photos

Library how to organize your photos

It's been a tradition in all my books to name each chapter with either a song title, TV show title, or movie title. For example, in one of my books on Photoshop, I had a chapter on Sharpening, and I called it "Sharp Dressed Man" (a nod to the 1983 hit of the same name from the Texas-based rock band ZZ Top). Under the chapter name, I would put a subhead that explains what the chapter is actually about, because sometimes from the name it wasn't quite as obvious. For example, in another book, I had a chapter called "Super Size Me" (from the movie of the same name), about how to resize your images. But for the previous edition of this book, I dispensed with those titles and just gave each chapter a regular boring ol' name, and now that I'm writing the Lightroom 3 version, I'm kinda wishing I hadn't done away with it (even though I guess this way does make it easier). See, I

was thinking that people who buy books on Lightroom are photographers, and that means they're creative people, which to me means that if I named the chapters after things that in themselves are creative (like songs, TV shows, and movies...well...songs and movies anyway), they'd totally dig it. Well, as luck would have it, I just checked on the iTunes Store and there actually is a song named "Library" by a band called Final Fantasy from their album Has a Good Home. Anyway, I listened to the song and I have to say, it was mind numbingly bad-bad on a level I haven't heard in years, yet the album has 12 five-star reviews, so either these people are criminally insane, or they were basing their review on their general love of one of Final Fantasy's other songs, titled "He Poos Clouds." Man. I wish I could have used that name for a chapter. My 13-year-old son would still be giggling.

Folders and Why I Don't Mess With Them (This Is Really Important!)

Step One:

If you quit Lightroom and on your computer look inside your Pictures folder, you'll see all the subfolders containing the files of your actual photos. Of course, you can move photos from folder to folder (as seen here), add photos, or delete photos, and so on, right? Well, you don't actually have to leave Lightroom to do stuff like that—you can do those things from within the Folders panel in Lightroom. You can see all those same folders, and move and delete real files just like you do on your computer. When you import photos, you have to choose a folder in which to store them on your hard drive. This is the only time I really do anything with folders because I think of them as where my negatives are stored, and like with traditional film negatives, I store them someplace safe, and I really don't touch them again. I use the same type of thinking in Lightroom. I don't really use the Folders panel (I use something safer—collections, which is covered next). So, here I'm only going to briefly explain folders, and show one instance where you might use them.

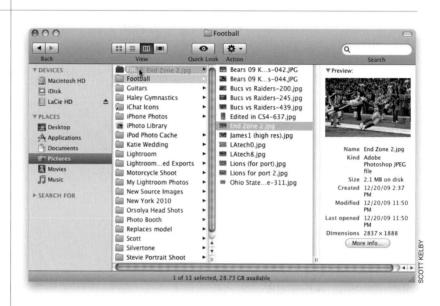

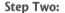

Go to the Library module, and you'll find the Folders panel in the left side Panels area (shown here). What you're seeing here are all the folders of photos that you imported into Lightroom (by the way, they're not actually in Lightroom itself—Lightroom is just managing those photos—they're still sitting in the same folders you imported them into from your memory card).

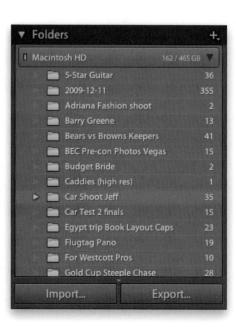

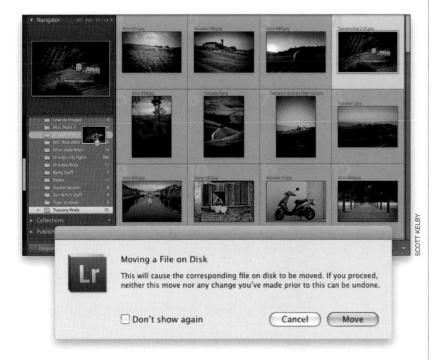

Step Three:

There's a little triangle to the left of each folder's name. If the triangle is solid gray, it means there are subfolders inside that folder, and you can just click on that triangle to see them. If it's not solid gray, it just means there are no subfolders inside. (*Note:* These little triangles are officially called "disclosure triangles," but the only people who actually use that term are...well...let's just say these people probably didn't have a date for the prom.)

Step Four:

When you click on a folder, it shows you the photos in that folder that have been imported into Lightroom. If you click on a thumbnail and drag it into another folder (like I'm doing here), it physically moves that photo on your computer from one folder to another, just as if you moved the file on your computer outside of Lightroom. Because you're actually moving the real file here, you get a "Hey, you're about to move the real file" warning from Lightroom (see here below). The warning sounds scarier than it is-especially the "neither this move nor any change you've made prior to this can be undone" part. What that means is, you can't just press Command-Z (PC: Ctrl-Z) to instantly undo the move if you change your mind. However, you could just click on the folder you moved it to (in this case, the Misc photos folder), find the photo you just moved, and drag it right back to the original folder (here, it's the Tuscany finals folder), so the dialog's bark is worse than its bite.

Step Five:

If you see a folder in the Folders panel with a question mark on it, that's Lightroom's way of letting you know it can't find this folder of photos (you either probably just moved them somewhere else on your computer, or you have them stored on an external hard drive, and that drive isn't connected to your computer right now). So, if it's the external drive thing, just reconnect your external drive and it will find that folder. If it's the old "moved them somewhere else" problem, then Right-click on the graved-out folder and choose Find Missing Folder from the pop-up menu. This brings up a standard Open dialog, so you can show Lightroom where you moved the folder. When you click on the moved folder, it re-links all the photos inside for you.

Step Six:

Now, there's one particular thing I sometimes use the Folders panel for, and that's when I add images to a folder on my computer after I've imported. For example, let's say I imported some photos from a trip to Italy and then, later, my brother emails me some shots he took. If I drag his photos into my Tuscany finals folder on my computer, Lightroom doesn't automatically suck them right in. In fact, it ignores them unless I go to the Folders panel, Right-click on my Tuscany finals folder, and choose **Synchronize Folder**.

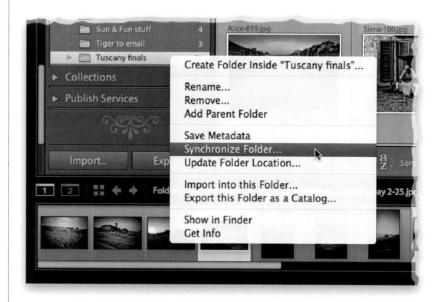

Slideshow Print

Web

-r	Synchronizing keeps your Lightroom catalog up to date with the latest changes you may have made to your photos in other applications.
	✓ Import new photos (9) □ Show import dialog before importing
	☑ Remove missing photos from catalog (0)
	☑ Scan for metadata updates
	Show Missing Photos Cancel Synchronize

Step Seven:

Choosing Sychronize Folder brings up the Synchronize Folder dialog for that folder. I dragged the nine new photos my brother sent me into my Tuscany finals folder, and you can see it's ready to import nine new photos. There is a checkbox to have Lightroom bring up the standard Import window before you import the photos (so you can add your copyright, and metadata and stuff like that if you like), or you just bring them in by clicking Synchronize and adding that stuff once the images are in Lightroom (if you even want to. Since my brother took these, I won't be adding my copyright info to them. At least, not while he's looking). So, that's pretty much the main instance where I use folders—when I drag new images into an existing folder. Other than that, I just leave that panel closed pretty much all the time, and just work in the Collections panel (as you'll learn about in the next tutorial).

TIP: Other Folder Options

When you Right-click on a folder, and the pop-up menu appears, you can choose to do other things like rename your folder, create subfolders, etc. There's also a Remove option, but in Lightroom, choosing Remove just means "remove this folder of photos from Lightroom." However, this folder (and the photos inside it) will still be right there in your Pictures folder on your computer. Just so you know.

Sorting Your Photos Using Collections

Sorting your images can be one of the most fun, or one of the most frustrating, parts of the editing process—it just depends on how you go about it. Personally, this is one of the parts I enjoy the most, but I have to admit that I enjoy it more now than I used to, and that's mostly because I've come up with a workflow that's fast and efficient, and helps me get to the real goal of sorting, which is finding the best shots from your shoot—the "keepers"—the ones you'll actually show your client, or add to your portfolio, or print. Here's how I do it:

Step One:

When you boil it down, our real goal is to find the best photos from our shoot, but we also want to find the worst photos (those photos where the subject is totally out of focus, or you pressed the shutter by accident, or the flash didn't fire, etc.), because there's no sense in having photos that you'll never use taking up hard drive space, right? Lightroom gives you three ways to rate (or rank) your photos, the most popular being the 1-to-5-star rating system. To mark a photo with a star rating, just click on it and type the number on your keyboard. So, to mark a photo with a 3-star rating, you'd press the number 3, and you'd see three stars appear under the photo (shown here at the top). To change a star rating, type in a new number. To remove it altogether, press 0 (zero). The idea is that once you've got your 5-star photos marked, you can turn on a filter that displays only your 5-star photos. You can also use that filter to see just your 4-star, 3-star, etc., photos. Besides stars, you can also use color labels, so you could mark the worst photos with a Red label, slightly better ones with Yellow, and so on. Or, you could use these in conjunction with the stars to mark your best 5-star photo with a Green label (as shown here at the bottom).

Step Two:

Now that I've mentioned star ratings and labels, I want to talk you out of using them. Here's why: they're way too slow. Think about it—your 5-star photos would be your very best shots, right? The only ones you'll show anybody. So your 4-star ones are good, but not good enough. Your 3-star ones are just so-so (nobody will ever see these). Your 2-star ones are bad shotsnot so bad that you'll delete them, but bad, and your 1-star shots are out-of-focus, blurry, totally messed up shots you're going to delete. So what are you going to do with your 2- and 3-star photos? Nothing. What about your 4-star photos? Nothing. The 5-stars you keep, the 1-stars you delete, the rest you pretty much do nothing with, right? So, all we really care about are the best shots and the worst shots, right? The rest we ignore.

Step Three:

So instead, I hope you'll try flags. You mark the best shots as Picks and the really bad ones (the ones to be deleted) as Rejects. Lightroom will delete the Rejects for you when you're ready, leaving you with just your best shots and the ones you don't care about, but you don't waste time trying to decide if a particular photo you don't care about is a 3-star or a 2-star. I can't tell you how many times I've seen people sitting there saying out loud, "Now, is this a 2-star or a 3-star?" Who cares? It's not a 5-star; move on! To mark a photo as a Pick, just press the letter P. To mark a photo as a Reject, press the letter X. A little message will appear onscreen to tell you which flag you assigned to the photo, and a tiny flag icon will appear in that photo's grid cell. A white flag means it's marked as a Pick. A black flag means it's a Reject.

Step Four:

So here's how I go about the process: Once my photos have been imported into Lightroom, and they appear in the Library module's Grid view, I double-click on the first photo to jump to Loupe view so I can get a closer look. I look at the photo, and if I think it's one of the better shots from the shoot, I press the letter P to flag it as a Pick. If it's so bad that I want to delete it, I press the letter X instead. If it's just okay, I don't do anything; I just move on to the next photo by pressing the Right Arrow key on my keyboard. If I make a mistake and mis-flag a photo (for example, if I accidentally mark a photo as a Reject when I didn't mean to), I just press the letter U to unflag it. That's it-that's the process. You'll be amazed at how quickly you can move through a few hundred photos and mark the keepers and rejects. But you've still got some other things to do once you've done this first essential part.

Step Five:

Once you've got your Picks and Rejects flagged, let's get rid of the Rejects and delete them from your hard drive. Go under the Photo menu and choose Delete Rejected Photos. This displays just the photos you've marked as Rejects, and a dialog appears asking if you want to delete them from your disk or just remove them from Lightroom. I always choose Delete from Disk, because if they were bad enough for me to mark them as Rejects, why would I want to keep them? What could I possibly use them for? So, if you feel the same way, click the Delete from Disk button and it returns you to the Grid view, and the rest of your photos. (Note: Because we just imported the photos into Lightroom, and they're not in a collection yet, it gives you the option to delete the images from the disk. Once they're actually in a collection, doing this just removes the photos from the collection, and not from your hard disk.)

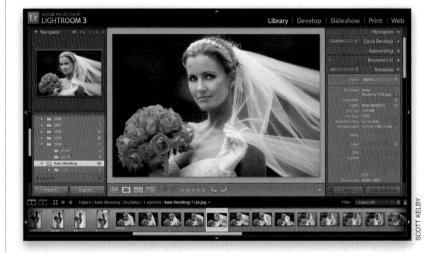

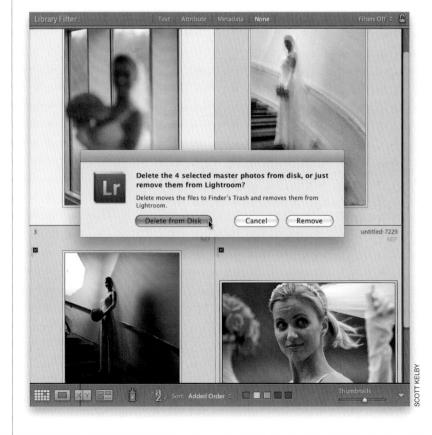

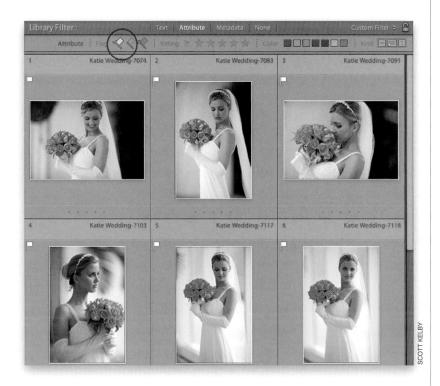

Step Six:

Now to see just your Picks, click on the word Attribute up in the Library Filter bar that appears at the top of the center Preview area (if you don't see it, just press the \ [backslash] key on your keyboard), and a little Attribute bar pops down. Click on the white Picks flag (shown circled here), and now just your Picks are visible.

TIP: Use the Other Library Filter

You can also choose to see just your Picks, Rejects, or your unflagged photos from down on the top-right side of the Filmstrip. There's a Library filter there too, but just for attributes like flags, star ratings, and color labels.

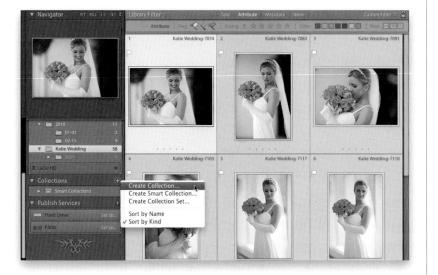

Step Seven:

What I do next is put these Picks into a collection. Collections are the key organizational tool we use, not just here in the sorting phase, but throughout the Lightroom workflow. You can think of a collection as an album of your favorite photos from a shoot, and once you put your Picks into their own collection, you'll always be just one click away from your keepers from the shoot. To get your Picks into a collection, press Command-A (PC: Ctrl-A) to select all the currently visible photos (your Picks), then go over to the Collections panel (in the left side Panels area), and click on the little + (plus sign) button on the right side of the panel header. A pop-up menu will appear, and from this menu, choose Create Collection (as shown here).

Step Eight:

This brings up the Create Collection dialog you see here, where you type in a name for this collection, and below it you can assign it to a set (we haven't talked about sets yet, or created any sets, or even admitted that they exist. So for now, leave the Set pop-up menu at None, but don't worry, sets are coming soon enough). In the Collection Options section, you want your collection to include the photos you selected (your Picks) in the previous step, and because you made a selection first, this checkbox is already turned on for you. For now, leave the Make New Virtual Copies checkbox turned off, then click the Create button.

Name:	Katie Wedding Picks
Set:	None \$
Collect	ion Options
🗹 Incl	ude selected photos
	Make new virtual copies
	Cancel

Step Nine:

Now you've got a collection of just your keepers from that shoot, and anytime you want to see these keepers, just go to the Collections panel and click on the collection named Katie Wedding Picks (as seen here). Just in case you were wondering, collections don't affect the actual photos on your computer—these are just "working collections" for our convenience, so we can delete photos from our collections and it doesn't affect the real photos (they're still in their folder on your computer, except for the Rejects we deleted earlier, before we created this collection).

Note: If you're an Apple iPod or iPhone owner, then you're familiar with Apple's iTunes software and how you create playlists of your favorite songs (like big hair bands of the '80s, or party music, or classic rock, etc.). When you remove a song from a playlist, it doesn't delete it from your hard disk (or your main iTunes Music Library), it just removes it from that particular playlist, right? Well, you can think of collections in Lightroom as kind of the same thing, but instead of songs, they're photos.

56 🔶

Chapter 2 / How to Organize Your Photos

Web

Step 10:

Now, from this point on, we'll just be working with the photos in our collection. Out of the 498 bridal shots that were taken that day, only 58 of them were flagged as good shots, and that's how many wound up in our Picks collection. But here are some questions: Are you going to print all 58 of these keepers? Are all 58 going in your portfolio, or are you going to email 58 shots of this one bridal shoot to the bride? Probably not, right? So, within our collection of keepers, there are some shots that really stand out-the best of the best, the ones you actually will want to email to the client, or print, or add to your portfolio. So, we need to refine our sorting process a little more to find our best shots from this group of keepers-our "Selects."

Step 11:

At this stage, there are three ways to go about viewing your photos to narrow things down. You already know the first method: double-click on a photo to jump to Loupe view, move through the photos using the Arrow keys on your keyboard, and when you see one that you know is one of the best of the bunch, you press the letter **P** to flag it as a Pick (when you created this collection, Lightroom removed the old Picks flags for you). The second view that you might find helpful is called Survey view, and I use this view guite a bit when I have a number of shots that are very similar (like a number of shots of the same pose) and I'm trying to find the best ones from that group. You enter this view by first selecting the similar photos, as seen here (click on one, then press-and-hold the Command [PC: Ctrl] key and click on the others).

Step 12:

Now press the letter **N** to jump to Survey view (I don't know which is worse, this view being named Survey or using the letter N as its shortcut. Don't get me started). This puts your selected photos all onscreen, side by side, so you can easily compare them (as shown here). Also, anytime I enter this Survey view, I immediately press **Shift-Tab** to hide all the panels, which makes the photos as large as possible on my screen.

TIP: Try Lights Out Mode

Survey view is a perfect place to use the Lights Out feature that blacks out everything but your photos. Just press the letter **L** on your keyboard twice to enter Lights Out mode and you'll see what I mean. When you're done in Lights Out, to return to the regular view, just press L again.

Step 13:

Now that my photos are displayed in Survey view, I start the process of elimination: I look for the weakest photo of the bunch and get rid of it first, then the next weakest, and the next, until I'm left with just the best two or three shots of that pose. To eliminate a photo, just move your cursor over the photo you want to remove from contention (the weakest photo of the bunch) and click on the small X that appears in the bottom-right corner of the image (as seen here), and it's hidden from view. It doesn't remove the photo from your collection, it just hides it to help with your process of elimination. Here, I removed one photo and the others automatically readjusted to fill in the free space. As you continue to eliminate images, the remaining images get larger and larger as they expand to take up the free space.

TIP: Changing Your Survey Order

While you're in Survey view, you can change the order of the images displayed onscreen by just dragging-and-dropping them into the order you want.

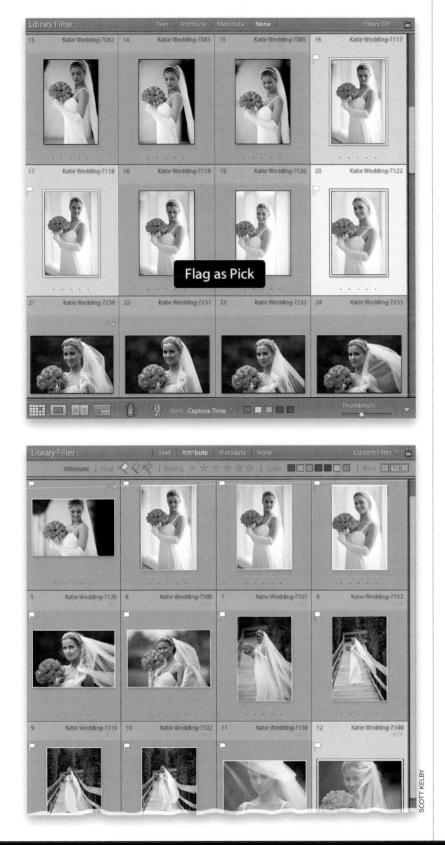

Step 14:

Once you narrow things down to just the ones you want to keep of this pose, press G to return to the thumbnail Grid view and those photos that were left onscreen will automatically be the only ones selected (see the three final photos I wound up leaving onscreen-they're the only ones selected). Now, just press the letter P to flag those as Picks. Once they're flagged, press Command-D (PC: Ctrl-D) to deselect those photos, then go and select another group of photos that are similar, press N to jump to Survey view, and start the process of elimination on that group. You can do this as many times as you need, until you've got the best shots from each set of similar shots or poses tagged as Picks.

Note: Remember, when you first made your collection from flagged Picks, Lightroom automatically removed the Picks flags. That's why you're able to use them again here.

Step 15:

Now that you've gone through and marked the very best shots from your Picks collection, let's put just those "best of the best" in their own separate collection (this will make more sense in just a minute). At the top of the center Preview area, in the Library Filter bar, click on Attribute, and when the Attribute bar pops down, click on the white Picks flag to display just the Picks from your Picks collection (as seen here).

Step 16:

Now press Command-A (PC: Ctrl-A) to select all the Picks displayed onscreen, and then press Command-N (PC: Ctrl-N), which is the keyboard shortcut for New Collection. This brings up the Create Collection dialog. Here's a tip: name this collection by starting with the name of your keepers collection, then add the word "Selects" (so in my case, I would name my new collection "Katie Wedding Selects"). Collections appear listed in alphabetical order, so if you start with the same names, both collections will wind up together, which makes things easier for you in the next step (besides, you can always change the name later if you like).

Name:	Katie Wedding Selects
Set:	None
	ion Options ude selected photos
	Make new virtual copies

Step 17:

Just to recap, now you have two collections: one with your keepers from the shoot (the Picks), and a Selects collection with only the very best images from the shoot. When you look in the Collections panel, you'll see your keepers collection with the Selects one right below (as shown here).

Note: We still have one more method to cover for narrowing things down, but just so you know, after that you'll learn how to use Collection Sets, which make things easy when you have multiple collections from the same shoot—like we do here with a Picks collection and Selects collection.

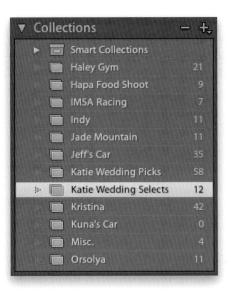

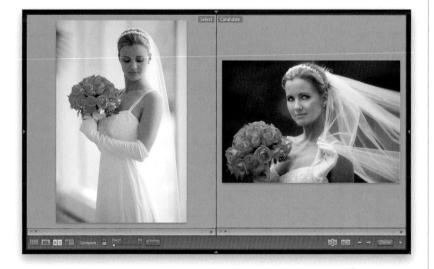

Step 18:

There's a third view you can use to view your images that can help you in situations where you need to find the one single, solitary, best shot from a shoot (for example, let's say you want to post one single shot from your bridal shoot on your studio's blog, so you need to find that one perfect shot to run with your post). That's when you use Compare view—it's designed to let you go through your photos and find that one, single, best shot. Here's how it works: First, select the first two photos in your Selects collection (click on the first photo, then Command-click [PC: Ctrl-click] on the second image, so they're both selected). Now press the letter C to enter Compare view, where the two photos will appear side by side (as shown here), then press Shift-Tab to hide the panels and make the photos as large as possible. Also, you can enter Lights Out mode now, if you like (press the letter L twice).

Step 19:

So, here's how this works, and this is a battle where only one photo can win: On the left is the current champion (called the Select), and on the right is the contender (called the Candidate). All you have to do is look at both photos, and then decide if the photo on the right is better than the photo on the left (in other words, does the photo on the right "beat the current champ?"). If it doesn't, then press the Right Arrow key on your keyboard and the next photo in your collection (the new contender) appears on the right to challenge the current champ on the left (as seen here, where a new photo has appeared on the right side).

Step 20:

If you press the Right Arrow key to bring up a new Candidate, and this new photo on the right actually does look better than the Select photo on the left, then click the Make Select button (the X|Y button with a single arrow, on the right side of the toolbar below the center Preview area, shown circled here in red). This makes the Candidate image become the Select image (it moves to the left side), and the battle starts again. So, to recap the process: You select two photos and press C to enter Compare view, then ask yourself the question, "Is the photo on the right better than the one on the left?" If it's not better, press the Right Arrow key on your keyboard. If it is better, click the Make Select button and continue the process. Once you've gone through all the photos in your Selects collection, whichever photo remains on the left (as the Select photo) is the best image from the shoot. When you're done, click the Done button on the right side of the toolbar.

Step 21:

Although I always use the Arrow keys on my keyboard to "do battle" in Compare view, you can also use the Previous and Next buttons in the toolbar. To the left of the Make Select button is the Swap button, which just swaps the two photos (making the Candidate the Select, and vice versa), but I haven't found a good reason to use this Swap button, and just stick to the Make Select button. So, which of the three views do you use when? Here's what I do: (1) the Loupe view is my main view when making Picks, (2) I use Survey view only when comparing a number of shots of a similar pose or scene, and (3) I use Compare view when I'm trying to find a single "best" image.

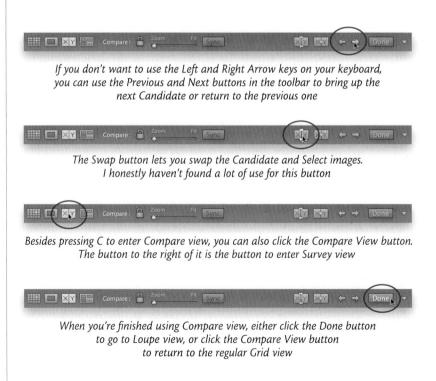

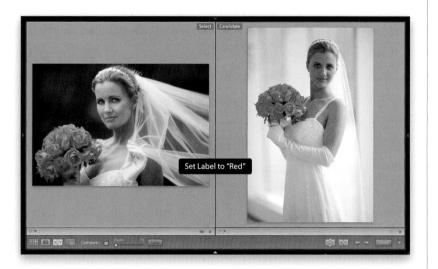

Step 22:

One last thing about Compare view: once I've determined which photo is the single best photo from the shoot (which should be the image on the left side when I get through all the images in my Selects collection—what I call "the last photo standing"), I don't make a whole new Selects collection for just this one photo. Instead, I mark this one photo on the left as the winner by pressing the number **6** on my keyboard. This assigns a Red label to this photo (as shown here).

Step 23:

Now anytime I want to find the single best photo out of this shoot, I can go to the Library module's Grid view (G), click on Attribute in the Library Filter bar, and then in the Attribute bar below it, I can click the Red label (as shown circled here), and bang-there's my "Best of Show." So, in this tutorial, you've just learned a key part of the organization process—creating collections—and using collections puts both "your keepers" and your very best photos from each shoot just one click away. Next, we'll look at how to organize related shoots that will have multiple collections (like a wedding or vacation).

Organizing Multiple Shoots Using Collection Sets

If you spent a week in New York and went out shooting every day, once you got all your shoots into Lightroom, you'd probably have collections with names like Times Square, Central Park, 5th Avenue, The Village, and so on. Because Lightroom automatically alphabetizes collections, these related shoots (they're all in New York, taken during the same trip) would be spread out throughout your list of collections. This is just one place where collection sets come in handy, because you could put all those shoots under one collection set: New York.

Step One:

To create a collection set (which just acts like a folder to keep related collections organized together), click on the little + (plus sign) button on the right side of the Collections panel header (in the left side Panels area), and choose **Create Collection Set**, as shown here. This brings up the Create Collection Set dialog where you can name your set. In this example, we're going to use it to organize all the different shoots from a wedding, so name it "Patterson Wedding," for Set choose None, and click the Create button.

	Haley Gym Hapa Food Shoot IMSA Racing Indy Jade Mountain Jeff's Car Katie Wedding Picks Katie Wedding Selects	21 Create Collection Set Sort by Name ✓ Sort by Kind
	Kristina	42
	Create (Collection Set
Name: Set:	Patterson Wedding	
Set.	None	
		Cancel Create
	and the second	
	Create	e Collection
Name:	Create Bride Formals	e Collection
		e Collection
	Bride Formals	
	Bride Formals	

Step Two:

This empty collection set now appears in the Collections panel. When you go to create a new collection of shots from this wedding, before you choose Create Collection, just click once on the Patterson Wedding set, then choose **Create Collection** from the little + (plus sign) button's pop-up menu. What this does is brings up the Create Collection dialog with the Patterson Wedding collection set already chosen (in the Set pop-up menu) as the set to save this collection into. If you forget to do this, it's no big deal, you can always just choose Patterson Wedding from the Set pop-up menu.

▼ Collections	- &
🔻 💼 Patterson Wedding	
Bride Formals	70
💼 Bridesmaids &	90
Ceremony	310
Family Formals	210
First Dance	70
Groom Portraits	20
Leaving the Ch	21
Pre-Wedding S	110
Reception	580
📄 💼 Rehearsal Dinner	350
👘 📄 Wedding Band	10
Smart Collections	
🔋 🔚 Haley Gym	21
📨 💼 Hapa Food Shoot	9

Here's the collection set expanded, so you can see all the collections you saved inside it

)
21
9
7
11
11
35
ks 58

Here's the same collection set collapsed, and you can see how much shorter this makes your list of collections

▼ Collections	- +
Smart Collections	
🔻 🔚 Weddings	
 Concepcion We 	
Derezin Wedding	
Fortney Wedding	
Gard Wedding	
Hazelwood We	
Kendra Wedding	
Moser Wedding	
🔻 📻 Patterson Wed	
💼 Bride Formals	70
Bridesmaid	90
Ceremony	310
Family For	210
First Dance	70
🕞 🔚 Groom Por	20
Leaving th	21
Pre-Weddi	110
Reception	580
📄 Rehearsal	350
🔲 Wedding B	10
Revell Wedding	
Ziser Wedding	
🔲 Indy	11
Jade Mountain	11

Here, all your weddings are contained within one main Weddings collection set. If you want to see the individual collections inside a particular wedding, then you click on the triangle that appears before its name to reveal its contents

Step Three:

When you look in the Collections panel, you'll see the collections you've added to the Patterson Wedding collection set appearing directly under it (well, they actually are grouped with it). With something like a wedding, where you might wind up creating a lot of separate collections for different parts of the wedding, you can see how keeping everything organized under one header like this really makes sense. Also, here we created the collection set first, but you don't have to—you can create one whenever you want, and then just drag-and-drop existing collections right onto that set in the Collections panel.

Step Four:

If you want to take things a step further, you can even create a collection set inside another collection set (that's why, back in Step One, when you created your first collection set, the Set pop-up menu appeared in that dialog—so you could put this new collection set inside an existing collection set). An example of why you might want to do this is so you can keep all your wedding shoots together. So, you'd have one collection set called Weddings (as shown here), and then inside of that you'd have separate collection sets for individual weddings. That way, anytime you want to see, or search through, all your wedding photos from all your weddings, you can click on that one Weddings collection set.

Using Smart Collections for Automatic Organization

Step One:

To understand the power of Smart Collections, simply build one, and you'll totally get it. Let's build one that creates a collection of all your best landscape photos. In the Collections panel, click on the + (plus sign) button on the right side of the panel header, and choose Create Smart Collection from the pop-up menu. This brings up the Create Smart Collection dialog. In the Name field at the top, name your Smart Collection and from the Match pop-up menu, choose Any. Now, the default criterion is to create a collection based on the star rating, but in keeping with what you just learned, we'll start with making one that contains just your Selects (the best of the best from each shoot). So, from the first pop-up menu, choose Collection, from the second choose Contains, and in the text field, type "Selects." It's now set to gather all the photos in all your Selects collections.

Step Two:

Let's add another criterion in case you labeled one Select photo red, rather than just putting that one photo in a collection. Click on the little + (plus sign) button to the right of the text field, and another line of criteria appears. From the first popup menu, choose Label Color, from the second choose Is, and choose Red from the third. If you clicked the Create button now, it would make a Smart Collection of all the photos in any Select collection, along with any photos labeled red. Say you wanted to create a collection of your 5-star bridal portraits from the past three years. You could search through all your collections, or you could have Smart Collections find them all for you, and put them in a collection automatically. Just choose the criteria and Lightroom will do the gathering, and in seconds, it's done. Best of all, Smart Collections update live, so if you create one of just your red-labeled images, any time you rate a photo with a Red label, it's automatically added to that Smart Collection. You can create as many of these as you'd like.

Set: None	ortfolio		
Set. Hone			
latch any 🗊 of th	e following rules:		
Collection	contains	Selects	+
			Cancel Creat
0	Cri	eate Smart Collection	
		eate Smart Collection	
Iame: Landscape Po Set: None		eate Smart Collection	
lame: Landscape Po Set: None	rtfolio	ate Smart Collection	
lame: Landscape Po Set: None latch any ; of th	rtfolio	eate Smart Collection	- •
lame: Landscape Po Set: None latch any 🗘 of th Collection	rtfolio e following rules:		+ +
lame: Landscape Po Set: None atch any 🗘 of th Collection	rtfolio e following rules:	Selects	
lame: Landscape Po Set: None latch any 🗘 of th Collection	rtfolio e following rules:	Selects	
lame: Landscape Po	rtfolio e following rules:	Selects	
lame: Landscape Po Set: None latch any 🗘 of th Collection	rtfolio e following rules:	Selects	
lame: Landscape Po Set: None latch any 🗘 of th Collection	rtfolio e following rules:	Selects	
lame: Landscape Po Set: None latch any 🗘 of th Collection	rtfolio e following rules:	Selects	

atch any 🗘 of the fo	llowing rules:	
Collection	contains Selects	
Label Color	(is red	•
Pick Flag	is flagged	•
Rating	is greater than or equal to 🚯 ★ ★ ★ ★	-
All of the following are tru	e 🗘	- 4
Keywords	Contains Landscape	
Capture Date	is in the last	•
Capture Date	is in the last 12 months	

If you've been using Picks flags (and not creating collections for those images, because once you do, the Picks flags will be removed) or the 1-to-5-star rating system, you can also add additional lines of criteria for these, as well, to pick up any Picks or 5-star rated photos that you have. Now, to really narrow things down, press-and-hold the Option (PC: Alt) key and the + buttons will turn into # (number sign) buttons. Click on the one to the right of your last line of criteria to get additional criteria choices. From the first pop-up menu, choose All of the Following Are True. Then, choose Keywords from the popup menu beneath it, Contains from the one to the right, and in the text field, type "Landscape." Lastly, if you just want your latest work included, create one more line of criteria, choose Capture Date from the first pop-up menu, Is in the Last from the second, type "12" in the text field, and then choose Months from the last popup menu.

Web

Step Four:

Now when you hit the Create button, it compiles all of this for you and best of all, it will constantly be updated. New photos with the Landscape keyword in any Selects collection, or labeled red, or 5-star, or flagged with a Picks flag, will automatically be added to this collection and any images older than 12 months will automatically be removed. Also, say you remove the Red label from a photo meeting this criteria, it gets removed from this Smart Collection without you having to do anything, because it no longer matches all the criteria. You can edit the criteria for any existing Smart Collection anytime by just doubleclicking directly on it in the Collections panel. This brings up the Edit Smart Collection dialog with all your current criteria in place, where you can add additional criteria (by clicking the + button), delete criteria (by clicking the – [minus sign] button), or change the criteria in the pop-up menus.

When to Use a Quick Collection Instead

When you create collections, they're a more permanent way of keeping your photos organized into separate albums (by permanent, I mean that when you relaunch Lightroom months later, your collections are still there—but of course, you can also choose to delete a collection, so they're never really that permanent). However, sometimes you want to just group a few photos temporarily, and you don't actually want to save these groupings long term. That's where Quick Collections can come in handy.

Step One:

There are a lot of reasons why you might want a temporary collection, but most of the time I use Quick Collections when I need to throw a quick slide show together, especially if I need to use images from a number of different collections. For example, let's say I get a call from a potential client, and they want to see some examples of football games I've shot. I'd go to a recent football game shoot, click on its Selects collection, and then double-click on an image to look at them in Loupe view. When I see one I want in my slide show, I just press the letter **B** to add it to my Quick Collection (you get a message onscreen to show you that it has been added).

Now I go to another football game collection and do the same thing-each time I see an image that I want in my slide show, I press B and it's added, so in no time I can whip through 10 or 15 "Best of" collections and mark the ones I want in my slide show as I go. (You can also add photos to your Quick Collection by clicking on the little round circle that appears in the top-right corner of each thumbnail in the Grid view when you move your cursor over the thumbnail—it'll turn gray when you click on it. You can hide the gray dot by pressing Command-J [PC: Ctrl-J], clicking on the Grid View tab up top, then turning off the checkbox for Quick Collection Markers, as shown on the right here.)

2

SCOTT KELBY

To see the photos you put in a Quick Collection, go to the Catalog panel (in the left side Panels area), click on Quick Collection (as shown here), and now just those photos are visible. To remove a photo from your Quick Collection, just click on it and press the **Delete (PC: Backspace) key** on your keyboard (it doesn't delete the original, it just removes it from this temporary Quick Collection).

Step Four:

Now that your photos from all those different collections are in a Quick Collection, you can press **Command-Return** (**PC: Ctrl-Enter**) to start Lightroom's Impromptu Slideshow feature, which plays a full-screen slide show (as shown here) of the photos in your Quick Collection, using the current settings in Lightroom's Slideshow module. So, if the last slide show you created in the Slideshow module had background music and a cool slide template, that's what you'll get now just by pressing those two keys. To stop the slide show, just press the Esc key.

TIP: Saving Your Quick Collection

If you decide you want your Quick Collection to be saved as a regular collection, just go to the Catalog panel, Right-click on Quick Collection, choose **Save Quick Collection** from the pop-up menu, and a dialog appears where you can give your new collection a name.

Adding Specific Keywords for Advanced Searching

Most of the time, finding images you want in Lightroom will be easy. Want to look at photos from your vacation to New York? Just click on your New York collection. If you want to see all your photos from all your New York trips, then you could search by the keyword New York (remember those generic keywords you added when you first imported your photos?). But what if you want just photos of the Empire State Building, and just photos of it at night? If that sounds like something you'd wind up doing fairly regularly, than this is for you.

Step One:

Before we go into all this, I just want to say up front that most folks won't need to do the level of keywording I'm about to go into. But if you're a commercial photographer, or if you work with a stock photo agency, keywording all your images is pretty much what you have to do. Luckily, Lightroom makes the process fairly painless. There are a few ways to add specific keywords, and there are different reasons why you might choose one way over another. We'll start with the Keywording panel in the right side Panels area. When you click on a photo, it will list any keywords already assigned to that photo near the top of the Keywording panel (as shown here). By the way, we don't really use the word "assigned," we say a photo's been "tagged" with a keyword, as in, "It's tagged with the keyword Indy."

Step Two:

I tagged the photo selected in Step One with three generic keywords when I imported it—Indy, Racing, and Track. To add another keyword, you'll see a text field below the keyword field where it literally reads, "Click here to add keywords." Just click in that field, and type in the keyword you want to add (if you want to add more than one keyword, just put a comma between them), then press the **Return (PC: Enter) key**. In this case, I added the keywords "Close up," "red," "#18," and "Sonny's Real Pit BBQ" (the main sponsor of this car). Easy enough.

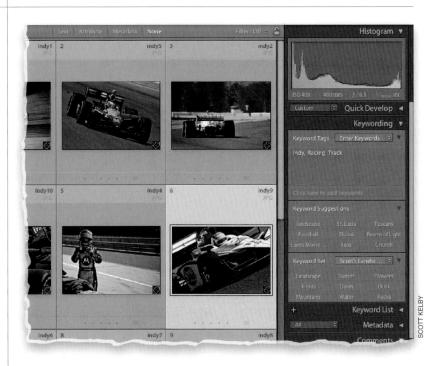

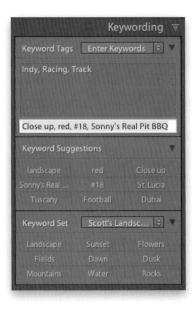

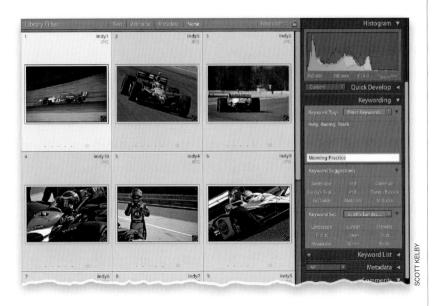

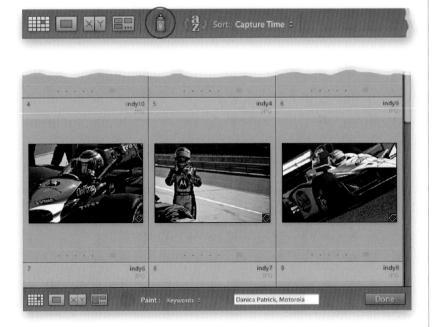

The Keywording panel is also ideal if you want to add the same keywords to a bunch of photos at once. For example, let's say that 71 photos from your full shoot were taken at a morning practice run. You'd select those 71 photos first (click on the first one, press-and-hold the Shift key, then scroll down to the last one, and click on it—it'll select all the photos in between), then in the Keywording panel, add your keywords in the Keyword Tags text field. For example, here I typed "Morning Practice" and it added "Morning Practice" to all 71 selected photos. So, the Keywording panel is my first choice when I need to tag a number of photos from a shoot with the same keywords.

Step Four:

Say you wanted to add some specific keywords to just certain photos, like those of one particular driver. If it's just three or four photos kind of near each other, you can use the Keywording panel technique I just showed you. But if it's 20 or 30 spread throughout a shoot, then try the Painter tool (in Grid view, it's found down in the toolbar—it looks like a spray paint can), which lets you "paint" on keywords as you scroll through your images. First, click on the Painter tool, then to the right, make sure Keywords appears after Paint, then in the field to the right, type in "Danica Patrick" or any other specific keywords that relate to just those photos.

Step Five:

Scroll through your images and any time you see a Danica Patrick photo, just click once on it and it "paints" those keywords onto your photo (you can add as many as you want—just remember to put a comma between them). As you click the Painter tool, a white highlight border will appear around the tagged photo, and a dark rectangular box appears with the keywords you've just assigned (as seen here). If you see multiple photos in a row you want to tag, just press-and-hold your mouse button and paint right across them, and they'll all be tagged. When you're done with the Painter tool, just click back where you found it in the toolbar. The Painter tool is what I use when I have a lot of photos in a shoot, but just need to tag some individual photos with a particular keyword.

TIP: Create Keyword Sets

If you use the same keywords often, you can save them as a Keyword Set, so they're just one click away. To create a set, just type the keywords in the Keyword Tags text field, then click on the Keyword Set pop-up menu at the bottom of the panel. Choose **Save Current Settings as New Preset** and they're added to the list, along with built-in sets like Wedding, Portrait, etc.

Step Six:

The next panel down, Keyword List, lists all the keywords you've created or that were already embedded into the photos you've imported. The number to the right of each keyword tells you how many photos are tagged with that keyword. If you hover your cursor over a keyword in the list, a white arrow appears on the far right. Click on it and it displays just the photos with that keyword (in the example shown here, I clicked on the arrow for Danica Patrick, and it brought up the only three photos in my entire catalog tagged with that keyword). This is why specific keywords are so powerful.

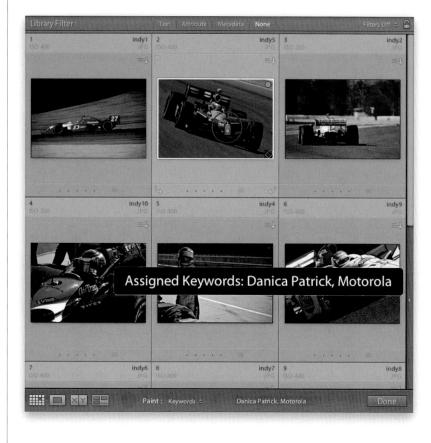

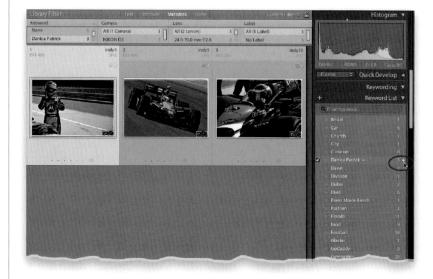

	GoDaddy		
	Gymnastics		
Remove this Keyword from	Selected Photo	∶k +	
Edit Keyword Tag Rename			
Create Keyword Tag Create Keyword Tag inside	"Indy" 📐		
Delete			
Put New Keywords Inside t Use this as Keyword Shorte			
Export these Photos as a C	atalog		
	Sync Metadata	Sync Settin	0

Step Seven:

Now, it doesn't take very long for your list of keywords to get really long. So, to keep things organized, you can create a keyword that has sub-keywords (like Indy as the main keyword, then inside that is Racing, Open Wheel, Motorsports, and so on). Besides having a shorter keyword list, it also gives you more sorting power. For example, if you click on Indy (the top-level keyword) in the Keyword List panel, it will show you every file in your catalog tagged with either Racing, Motorsports, etc. But, if you click on Racing, it will show you only the photos tagged with Racing. This is a huge time saver and I'll show you how to set this up in the next step.

TIP: Drag-and-Drop and Delete Keywords

You can drag-and-drop keywords in the Keyword List panel right onto photos to tag them and vice-versa—you can dragand-drop photos right onto keywords. To remove a keyword from a photo, in the Keywording panel, just delete it from the Keyword Tags field. To delete a keyword entirely (from all photos and the Keyword List panel itself), scroll down to the Keyword list panel, click on the keyword, then click the – (minus sign) button on the left side of the panel header.

Step Eight:

To make a keyword into a top-level one, just drag-and-drop other keywords directly onto it. That's all you have to do. If you haven't added the keywords you want as sub-keywords yet, do this instead: Rightclick on the keyword you want as a toplevel keyword, then from the pop-up menu, choose **Create Keyword Tag Inside** (as shown here) to bring up a dialog where you can create your new sub-keyword. Click the Create button, and this new keyword will appear under your main keyword. To hide the sub-keywords, click the triangle to the left of your main keyword.

Renaming Photos Already in Lightroom

In Chapter 1, you learned how to rename photos as they're imported from your camera's memory card, but if you're importing photos that are already on your computer, they keep the same names they had (because you're just adding them to Lightroom). So, if they're still named with those cryptic names assigned by your digital camera, like "_DSC0035.jpg," here's how to rename them to something that makes sense.

Step One:

Click on the collection of photos you want to rename. Press **Command-A (PC: Ctrl-A)** to select all of the photos in this collection. Go under the Library menu and choose **Rename Photos**, or press **F2** on your keyboard to bring up the Rename Photos dialog (shown here). Here, it gives you the same File Naming presets as the Import window does. Choose whichever File Naming preset you want to use. In this case, I chose the Custom Name–Sequence preset, which lets you enter a custom name, and then it starts the automatic numbering at 1.

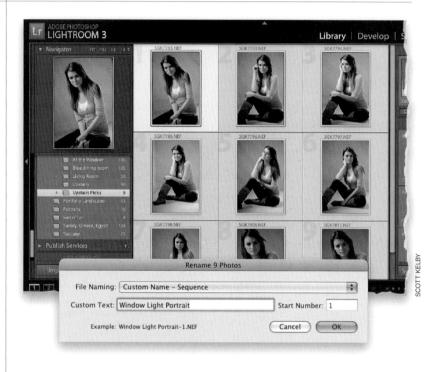

Step Two:

Now just click OK, and all the photos are renamed in an instant. This whole process takes just seconds, but makes a big difference when you're searching for photos not only here in Lightroom, but especially outside of Lightroom in folders, in emails, etc., plus it's easier for clients to find photos you've sent them for approval.

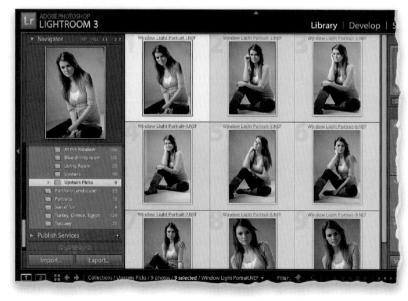

Your digital camera automatically embeds all kinds of info right into the photo itself, including everything from the make and model of the camera it was taken with, to the type of lens you used, and even whether your flash fired or not. Lightroom can search for photos based on this embedded information, called EXIF data. Beyond that, you can embed your own info into the file, like your copyright info, or photo captions for uploading to news services.

Adding Copyright Info, Captions, and **Other Metadata**

State of the state	ALL SAL
	Did not fire
Exposure Program	Aperture priority
Metering Mode	Pattern
ISO Speed Rating	
	400 mm
Focal Length 35mm	240 mm
	200.0-4mm f/4.0 🔿
Date Time Original	12/20/09 1:50:08>
Date Time Digitized	12/20/09 1:50:08 PM
Date Time	12/20/09 7:06:36 PM
Make	NIKON CORPORATION
Model	NIKON D3
Serial Number	2004600
	Scott Kelby
Software	
	Contact
Creator	Scott Kelby
	333 Douglas Road E.
City	Oldsmar
	FL

Step One:

You can see the info embedded in a photo (called metadata) by going to the Metadata panel in the right side Panels area in the Library module. By default, it shows you some of the different kinds of data embedded in your photo, so you see a little bit of the stuff your camera embedded (called EXIF data—stuff like the make and model of camera you took the photo with, which kind of lens you used, etc.), and you see the photo's dimensions, any ratings or labels you've added in Lightroom, and so on, but again, this is just a small portion of what's there. To see all of just what your camera embedded into your photo, choose **EXIF** from the pop-up menu in the left side of the panel header (as shown here), or to see all the metadata fields (including where to add captions and your copyright info), choose EXIF and IPTC.

TIP: Get More Info or Search

While in Grid view, if you see an arrow to the right of any metadata field, that's a link to either more information or an instant search. For example, scroll down to the EXIF metadata (the info embedded by your camera). Now, hover your cursor over the arrow that appears to the right of ISO Speed Rating for a few seconds and a little message will appear telling you what that arrow does (in this case, clicking that arrow would show you all the photos in your catalog taken at 4000 ISO).

Step Two:

Although you can't change the EXIF data embedded by your camera, there are fields where you can add your own info. For example, if you need to add captions (maybe you're going to be uploading photos to a wire service), just go to the Caption field, click your cursor inside the field, and start typing (as shown here). When you're done, just press the **Return (PC: Enter) key**. You can also add a star rating or label here in the Metadata panel, as well (though I usually don't do that here).

Step Three:

If you created a Copyright Metadata preset (see Chapter 1), but didn't apply it when you imported these photos, you can apply that now from the Preset menu at the top of the Metadata panel. Or if you didn't create a copyright template at all, you can add your copyright info manually. Scroll down to the bottom of the Metadata panel to the Copyright section, and just type in your copyright info (and make sure you choose Copyrighted from the Copyright Status pop-up menu). By the way, you can do this for more than one photo at a time. First, Command-click (PC: Ctrl-click) to select all the photos you want to add this copyright info to, then when you add the information in the Metadata panel, it's instantly added to every selected photo.

Note: This metadata you're adding is stored in Lightroom's database, and when you export your photos from Lightroom as either JPEGs, PSDs, or TIFFs, this metadata (along with all your color correction and image editing) gets embedded into the file itself at that moment. However, it's different when working with RAW photos (as you'll see in the next step).

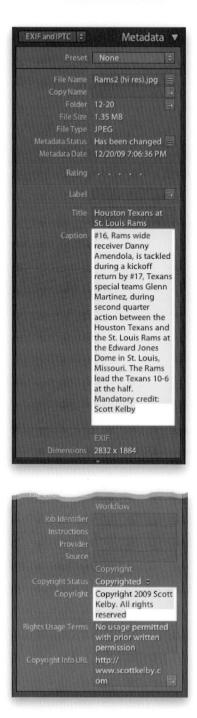

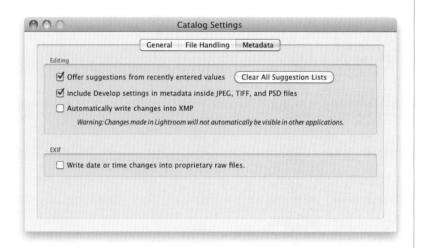

Step Four:

If you want to give someone your original RAW file (maybe a client or co-worker) or if you want to use your original RAW file in another application that processes RAW images, the metadata you've added in Lightroom (including copyright info, keywords, and even color correction edits to your photo) won't be visible because you can't embed info directly into a RAW file. To get around that, all this information gets written into a separate file called an XMP sidecar file. These XMP sidecar files aren't created automatically—you create them by pressing Command-S (PC: Ctrl-S) before you give someone your RAW file. After you press this, if you look in the photo's folder on your computer, you'll see your RAW file, then next to it an XMP sidecar file with the same name, but with the .xmp file extension (the two files are circled here in red). These two files need to stay together, so if you move it, or give the RAW file to a co-worker or client, be sure to grab both files.

Step Five:

Now, if you converted your RAW file into a DNG file when you imported it, then when you press Command-S, it does embed the info into the single DNG file (a big advantage of DNG—see Chapter 1), so there will be no separate XMP file. There actually is a Lightroom catalog preference (choose **Catalog Settings** from the Lightroom menu, then click on the Metadata tab. as shown here) that automatically writes every change you make to a RAW file to the XMP sidecar, but the downside is a speed issue. Each time you make a change to a RAW file, Lightroom has to write that change into XMP, which slows things down a bit, so I leave the Automatically Write Changes into XMP checkbox turned off.

If Your Camera Supports GPS, Prepare to Amaze Your Friends

Step One:

Import a photo into Lightroom that was taken with a digital camera that has the built-in (or add-on) ability to record GPS data (camera companies like Ricoh make GPS-enabled digital cameras, and many Nikon DSLRs [like the D300s, D700, and D3s, for example] have a GPS-compatible connector port, which can make use of add-ons like Sony's GPS CS1KASP unit, with a street price of around \$100 [at the time of writing]). This is more of a "Wow, that's cool!" feature than an incredibly useful one, but if your camera has built-in GPS (which embeds the exact latitude and longitude of where the photo was shot), or if you bought one of the GPS units now available for digital cameras, then gather your friends around Lightroom and prepare to blow them away, because it not only displays this GPS information, but one click will actually bring up a map pinpointing the location where you took the photo. Amazing! Next thing you know they'll put a man on the moon.

Step Two:

In the Library module, go to the Metadata panel in the right side Panels area. Near the bottom of the EXIF section, if your photo has GPS info encoded, you'll see a metadata field labeled GPS with the exact coordinates of where that shot was taken (shown circled here in red).

	EXIE
	3872 x 2592
	1/40 sec at f / 7.1
Exposure Bias	
	Did not fire
	Aperture priority
Metering Mode	
	150 100
Focal Length	
Focal Length 35mm	
	70.0-20mm f/2.8
Subject Distance	
	9/9/07 6:39:41 PM
Date Time Digitized	
Date Time	9/9/07 6:39:41 PM
	NIKON CORPORATION
Model	NIKON D200
Software	Ver.1.00
10000000000000000000000000000000000000	38°53'43°2'11" W
Altitude	
	Contact

Contractory and the second	
Dimensions	3872 x 2592
Exposure	1/40 sec at f / 7.1
Exposure Bias	0 EV
Flash	Did not fire
Exposure Program	Aperture priority
Metering Mode	Pattern
ISO Speed Rating	ISO 100 🔤
Focal Length	70 mm
Focal Length 35mm	105 mm
Lens	70.0-20mm f/2.8 🛶
Subject Distance	
Date Time Original	9/9/07 6:39:41 PM 🔤
Date Time Digitized	9/9/07 6:39:41 PM
Date Time	9/9/07 6:39:41 PM
Make	NIKON CORPORATION
Model	NIKON D200
	Ver.1.00
GP5	. h.
Altitude	-1.0 m
	Contact

Just seeing that GPS info is amazing enough, but it's what comes next that always drops jaws whenever I show this feature live in front of a class. Click on the little arrow that appears to the far right of the GPS field (it's shown circled here in red).

When you click on that little arrow, if you're connected to the Internet, Lightroom will automatically launch your default Web browser, connect to Google Maps, and it will display a full-color photographic satellite image with your exact location pinpointed on the map (as shown here). Seriously, how cool is that!? Now, in all honesty, I've never had even a semi-legitimate use for this feature, but I've found that despite that fact, I still think it's just so darn cool. All guys do. We just can't explain why.

Finding Photos Fast!

Okay, so to make finding our photos easier we gave them names that make sense when we imported them, and we applied a few keywords to help make searching easier, and now we finally get the pay-off: we can put our hands on exactly the photo (or photos) we need, in just seconds. This has been our goal from the very start—to set things up the right way from the beginning, so we have a fast, organized, streamlined catalog of our entire photo collection, and now we're ready to take 'er out for a spin.

Step One:

Before you start searching, first you need to tell Lightroom where you want it to search. If you want to search just within a particular collection, go to the Collections panel and click on that collection. If you want to search your entire photo catalog, then look down on the top-left side of the Filmstrip and you'll see the path to the current location of photos you're viewing. Click-and-hold on that path and from the pop-up menu that appears choose **All Photographs** (other choices here are to search the photos in your Quick Collection, your last import of photos, or any of your recent folders or collections).

Step Two:

Now that you've chosen where to search, the easiest way to start a search is to use a familiar keyboard shortcut: Command-F (PC: Ctrl-F). This brings up the Library Filter bar across the top of the Library module's Grid view. Chances are you're going to search by text, so just type in the word you're searching for in the search field, and by default it searches for that word everywhere it can-in the photo's name, in any keywords, captions, embedded EXIF data, you name it. If it finds a match, those photos are displayed (here, I searched for the word "window"). You can narrow your search using the two pop-up menus to the left of the search field. For example, to limit your search to just captions, or just keywords, choose those from the first pop-up menu.

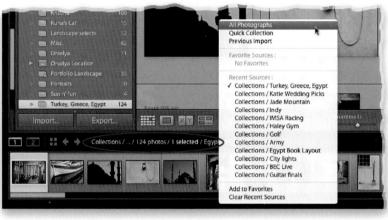

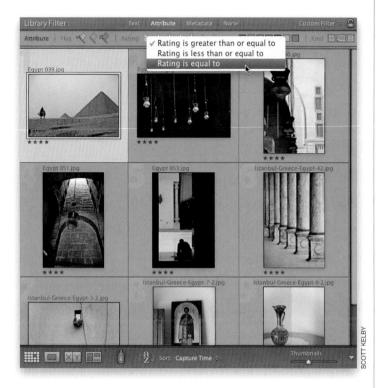

Library Filter				Metadata None			ilter 🗧 🔒
Date	3	Camera		Lens		Label	
All (95 Dates)	2078	All (13 Cameras)	2078	All (20 Lenses)	2078	All (6 Labels)	2078
▶ 2004	1	Canon EOS 50D	4	10.0-24.0 mm f	5	Client Selects	1
▶ 2005	3	iPhone 3GS	1	10.5 mm f/2.8	3	Red	1
▶ 2006	3	NIKON D2X	3	12.0-24.0 mm f	7	Select	1
• 2007	24	NIKON D2Xs	14	14.0-24.0 mm f		Selects	5
▶ 2008	46	NIKON D3	1318	17.0-55.0 mm f		Yellow	1
• 2009	1798	NIKON D60	7	18.0-55.0 mm f	23	No Label	2069

					Em		
Egypt 040 jpg		Egypt 0	41.jpg			Apt 042.jpg	

Another way to search is by attribute, so click on the word Attribute in the Library Filter and those options appear. Earlier in this chapter, we used the Attribute options to narrow things down to where just our Picks were showing (you clicked on the white Picks flag), so you're already kind of familiar with this, but I do want to mention a few things: As for the star ratings, if you click on the fourth star, it filters things so you just see any photos that are rated four stars or higher (so you'd see both your 4-star and 5-star images). If you want to see your 4-star rated images only, then click-and-hold on the \geq (greater than or equal to) sign that appears to the immediate right of the word Rating, and from the pop-up menu that appears, choose Rating is Equal to, as shown here.

Step Four:

Besides searching by text and attributes, you can also find the photos you're looking for by their embedded metadata (so you could search for shots based on which kind of lens you used, or what your ISO was set to, or what your f-stop was, or a dozensother settings). Just click on Metadata in the Library Filter, and a series of columns will pop down where you can search by date, camera make and model, lenses, or labels (as shown here). However, I have to tell you, if the only hope you have of finding a photo is trying to remember which lens you used the day you took the shot, you've done a really lame job of naming and/or keywording your shots (that's all I'm sayin'). This should truly be your "search of last resort."

Step Five:

Again, there are four default ways to search using the Metadata options:

By Date:

If you think you can remember which year the photo you're looking for was taken, in the Date column, click on that year, and you'll see just those photos appear. If you want to narrow it down further, click the right-facing arrow to the left of the year, and you'll find each month, and then you can drill down to the individual days (as shown here).

By Camera Body:

If you don't remember the year you took the photo, but you know which camera body you took the shot with, then just go straight to the Camera column and click directly on the camera (you'll see how many photos you took with that camera listed to the right of the camera body). Click on the body, and those photos appear.

By Lens:

If the shot you took was a wide angle, then go right to the Lens column, click on the lens you think it was taken with, and those images will appear. This helps if you know the photo was taken with a speciality lens, like a fisheye—you can just click right on that lens (as shown here), and you'll probably find the shot you're looking for pretty quickly. By the way, you don't have to start with the Date column, then Camera, then Lens. You can click on any column you'd like, in any order, as all of these columns are always "live."

By Label:

The last column seems somewhat redundant to the Attribute search options, but it actually is helpful here if you've found 47 photos taken with a fisheye, and you know you have the best ones marked with a label. This will narrow things down even further.

Library De

Develop

Slideshow Print Web

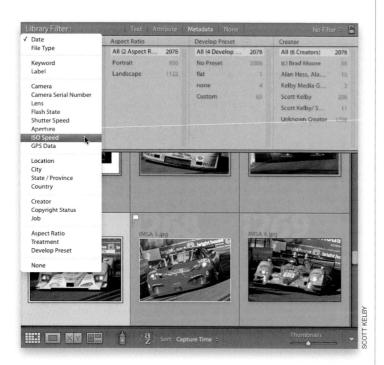

SO Speed	R. I.		C X X	Lens		Kind E	
All (1 ISO Speed)	1 []	All (1 Camera)	1 [3	All (1 Lens)	1 22	Aspect Ratio All (1 Aspect R	1
ISO 800	1	NIKON D5000	1	70.0-300.0 mm	1	Landscape	1
Pisa-116.ipg							

Step Six:

Let's say you don't really ever need to search by date, but you do a lot of lowlight shooting, so instead, searching by ISO might be more helpful. Luckily, you can customize each column, so it searches for the type of metadata you want, by clicking on the column header and choosing a new option from the pop-up menu (as shown here, where I've chosen ISO Speed for the first column). Now, all my ISOs will be listed in the first column, so I know to click on 800, 1600, or higher to find my low-light shots. Another helpful choice (for me anyway) is to set one column to Creator (the copyright info), so I can quickly find shots in my catalog taken by other people with just one click.

Step Seven:

Want to take things up one last notch? (Sure ya do!) If you Command-click (PC: Ctrl-click) on more than one of the three search options in the Library Filter, they're additive (go ahead, Command-click on Text, then Attribute, then Metadata, and they just pop down one after another). Now you can search for a photo with a specific keyword (in this case, "Italy,") that's marked as a Pick, with a Red label, that was taken at ISO 800, with a Nikon D5000, using a 70-300mm lens, and is in Landscape (wide) orientation (the result of that search is shown here). Ya know what else is cool? You can even save these criteria as a preset. You have to admit, although you shouldn't have to resort to this type of metadata search in the first place, it's still really amazing.

Creating and Using Multiple Catalogs

Lightroom is designed for managing a library of literally tens of thousands of images, and I know photographers that have 50,000 and 60,000 images in their catalog, and Lightroom can handle it. However, once your catalog gets that large, Lightroom can start to take a performance hit, but luckily you can create more than one catalog and switch between them any time you like, so you can keep your catalog sizes manageable and Lightroom running at full speed.

Step One:

So far, we've been working with a catalog of photos that was created for you when you launched Lightroom for the first time. However, if you wanted to, for example, create a separate catalog for managing all your travel photos, family photos, or sports photos, then you'd go under Lightroom's File menu and choose **New Catalog** (as shown here). This brings up the Create Folder with New Catalog dialog. Give your catalog a simple name (like "Sports Catalog,") and pick a place to save it to (just to keep things straight, I save all of my catalogs in my Lightroom folder, so I always know where they are).

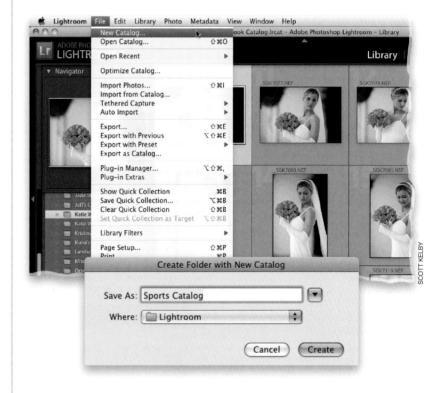

Step Two:

Once you click the Create button, Lightroom closes your database, then Lightroom itself quits and automatically relaunches with your brand new, totally empty catalog, with no photos in it whatsoever (as seen here). So, click on the Import button (near the bottomleft corner), and let's bring in some sports photos to get the ball rolling.

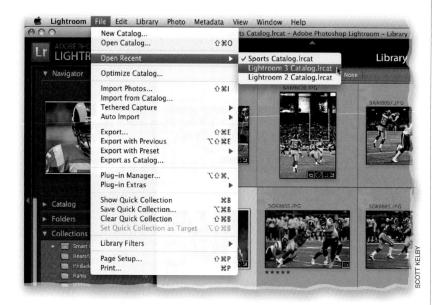

C Sports Catalog.Ircat	/Users/scottkelby/Pictures/Lightroom/Sports Catalog
📷 LR3 Book Catalog.Ircat	/Users/scottkelby/Pictures/Lightroom/LR3 Book Catalog
T LR2Tour Catalog.lrcat	/Users/scottkelby/Pictures/Lightroom/LR2Tour Catalog
📷 Test catalog.lrcat	/Users/scottkelby/Desktop/Stuff on PB Desktop/Test catalog
1 2009 LR2 Tour Catalog.Ircat	/Users/scottkelby/Pictures/Lightroom/2009 LR2 Tour Catalog
T LR2Tour Catalog.lrcat	/Users/scottkelby/Pictures/Lightroom/LR2Tour Catalog/LR2Tour Catalog
📷 Lightroom 2 Main Catalog.Ircat	/Users/scottkelby/Pictures/Lightroom/Lightroom 2 Main Catalog
📷 Sports 3.Ircat	/Users/scottkelby/Pictures/Lightroom/Sports 3
📷 Lightroom 2 Catalog.lrcat	/Users/scottkelby/Pictures/Lightroom
📸 Trash me.Ircat	/Users/scottkelby/Pictures/Lightroom/Trash me
Always load this catalog on startup	Test integrity of this catalog

You know what to do from here, as far as building a catalog of images (import more photos, add keywords, make your collections, etc., just like always). When you're done working with this new Sports catalog, and you want to return to your original main catalog, just go under the File menu, under Open Recent, and choose Lightroom 3 Catalog (your original catalog, as shown here). Click Relaunch in the Open Catalog dialog and Lightroom will save your sports photos catalog, and once again, quit, and relaunch with your main catalog. I know it's kinda weird that it has to quit and relaunch, but luckily it's pretty darn quick about it.

Step Four:

You can actually choose which catalog you want to work with when you launch Lightroom. Just press-and-hold the Option (PC: Alt) key while you launch Lightroom, and it will bring up the Select Catalog dialog you see here, where you can choose which catalog you want it to open. Note: If you want to open a Lightroom catalog you created, but it doesn't appear in the Select a Recent Catalog to Open section (maybe you didn't save it in your Lightroom folder when you created it or you haven't opened it recently), then you can click the Choose a Different Catalog button at the bottom left of the dialog and locate the catalog using a standard Open (PC: Browse) dialog. Also, I know I probably don't have to say this, but if you want to create a brand new empty catalog, just click the Create a New Catalog button.

TIP: Always Launch the Same Catalog

If you always want to launch Lightroom with a particular catalog, click on the catalog in the Select Catalog dialog, then turn on the Always Load This Catalog on Startup checkbox (which appears beneath your catalog list).

From Laptop to **Desktop:** Syncing **Catalogs on Two Computers**

If you're running Lightroom on a laptop during your location shoots, you might want to take all the edits, keywords, metadata, and of course the photos themselves, and add them to the Lightroom catalog on your studio computer. It's easier than it sounds: basically, you choose which catalog to export from your laptop, then you take the folder it creates over to your studio computer and import it—Lightroom does all the hard work for you, you just have to make a few choices about how Lightroom handles the process.

SCOTT KELBY

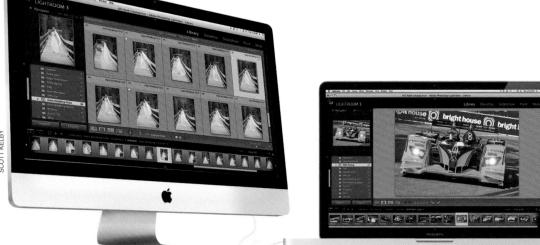

Step One:

Using the scenario described above, we'll start on the laptop. The first step is to decide whether you want to export a folder (all the imported photos from your shoot), or a collection (just your Picks from the shoot). In this case, we'll go with a folder, so go to the Folders panel and click on the folder you want to merge with your main catalog back in your studio. (If you had chosen a collection, the only difference would be you'd go to the Collections panel and click on the collection from that shoot instead. Either way, all the metadata you added, and any edits you made in Lightroom, will still be transferred over to the other machine.)

Step Two:

Now go under Lighroom's File menu and choose Export as Catalog (as shown here).

Save As:	IMSA Racing	
	Desktop	a search
Desktop	Family Photos 🛛 🖻	D
Applicati		
Pictures		▲
🗄 Movies 🎽		<u>×</u>
🖌 Music 🔻		
	Exporting a catalog with	17 photos.
	Export selected pho	tos only
	Export negative file:	
	Include available pr	eviews

When you choose Export as Catalog, it brings up the Export as Catalog dialog (shown here), where you type in the name you want for your exported catalog at the top, but there are some very important choices you need to make at the bottom. By default, it assumes that you want to include the previews that Lightroom created when you imported the photos into Lightroom, and I always leave this option turned on (I don't want to wait for them to render all over again when I import them into my studio computer). If you turn on the top Export Selected Photos Only checkbox, then it will only export photos in that folder that you had selected before you chose Export as Catalog. But perhaps the most important choice is the center checkbox—Export Negative Files. With this off, it only exports previews and metadata, it doesn't really export the actual photos themselves, so if you do indeed want to export the actual photos (I always do), then turn the center checkbox on.

Step Four:

When you click the Export Catalog button, it exports your catalog (it usually doesn't take very long, but of course the more photos in your collection or folder, the longer it will take), and when it's done exporting, you'll see the folder on your computer that you exported (as seen here). I usually save this file to my desktop, because the next step is to copy it onto an external hard drive, so you can move this folder full of images over to your studio computer. So, go ahead and copy this folder onto an external hard drive now.

Step Five:

When you get to your studio, connect your hard drive to your studio computer, and copy that folder to the location where you store all your photos (which should be that My Lightroom Photos folder we created in Chapter 1). Now, on your studio computer, go under Lightroom's File menu and choose Import from Catalog to bring up the dialog you see here. Navigate to that folder you copied onto your studio computer, and then inside that folder, click on the file that ends with the file extension LRCAT (as shown here), and click the Choose button. By the way, if you look at the capture shown here, you can see that Lightroom created three items inside this folder: (1) a file that includes the previews, (2) the catalog file itself, and (3) a folder with the actual photos.

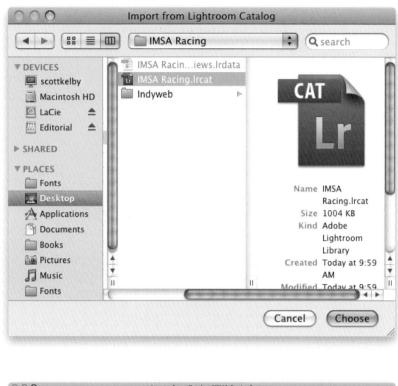

Step Six:

When you click the Choose button, it brings up the Import from Catalog dialog (seen here). Any photos in the Preview section on the right that have a checkbox turned on beside them will be imported (I always leave all of these turned on). In the New Photos section on the left is a File Handling pop-up menu. Since we already copied the photos into the proper folder on our studio computer, I'm using the default setting which is Add New Photos to Catalog Without Moving (as shown here), but if you want to copy them directly from your hard drive into a folder on your computer, you could choose the Copy option instead. There's a third option, but I have no idea why at this point you'd choose to not import the photos. Just click Import, and these photos will appear as a folder, with all the edits, keywords, etc., you applied on your laptop.

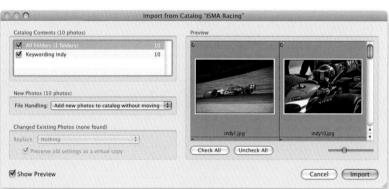

SCOTT KELBY

Develop

Web

All the changes, edits, keywords, etc., you add to your photos in Lightroom are stored in your Lightroom catalog file, so as you might imagine, this is one incredibly important file. Which is also why you absolutely need to back up this catalog on a regular basis, because if for some reason or another your catalog database gets corrupted—you're completely hosed. (Of course, unless you backed up your catalog, in which case you're not hosed at all.) The good news is Lightroom will back up this catalog database for you, but you have to tell it to. Here's how:

	General File Handling Metadata		
nformation			
Location:	/Users/scottkelby/Pictures/Lightroom/LR3 Book Catalog Show		
File Name:	LR3 Book Catalog.Ircat		
Created:	1/11/10		
Last Backup:			
Last Optimized:			
Size:	50.31 MB		
lackup Back up catalo	Never Once a month, when exiting Lightroom Once a week, when exiting Lightroom / Once a day, when exiting Lightroom Every time Lightroom exits		

	log" indicate it should be backed up once a day. talog file, not the photos referenced by it.
Backup Folder: /Volumes/LaCie	Choose
Also: 🗹 Test integrity befo	pre backing up
Ø Optimize catalog a	after backing up
Skip until tomorrow	(Skip this time) Backup

Backing Up Your Catalog (This Is VERY Important)

Step One:

Start by going under the Lightroom (PC: Edit) menu and choosing Catalog Settings. When the Catalog Settings dialog appears, click on the General tab up top (shown highlighted here). At the bottom of this dialog is a Backup section, and a Back Up Catalog pop-up menu with a list of options (shown here) for having Lightroom automatically back up your current catalog. Choose how often you want that to be, but I recommend that you choose Once a Day, When Exiting Lightroom. That way, it backs up each time you're done using Lightroom, so if for some reason the catalog database becomes corrupt, you'd only lose a maximum of one day's editing.

Step Two:

The next time you quit Lightroom, a dialog will appear reminding you to back up your catalog database. Click the Backup button (as shown here), and it does its thing. It doesn't take long at all, so don't be tempted to click Skip Until Tomorrow or Skip This Time (those are sucker bets). By default, these catalog backups are stored in separate subfolders inside the Backup folder, which lives inside your Lightroom folder. To be safe, in case your computer crashes, you should really store your backups on an external hard drive, so click the Choose button, navigate to your external drive, then click Choose (PC: OK).

So now that you've got a backup of your catalog, what happens if your catalog gets corrupted or your computer crashes? How do you restore your catalog? First you launch Lightroom, then you go under the File menu and choose **Open Catalog**. In the Open dialog, navigate to your Backups folder (wherever you chose to save it in Step Two), and you'll see all your backups listed in folders by date and 24-hour time. Click on the folder for the date you want, then inside, click on the LRCAT file (that's your backup), click the Open button, and you're back in business.

TIP: Optimizing Your Catalog if Things Start to Get Kinda Slow

Once you accumulate a lot of images in Lightroom (and I'm talking tens of thousands here), things can eventually start to get a little slow. If you notice this happening, go under the File menu and choose Optimize Catalog. This optimizes the performance of the currently open catalog, and while it might take a few minutes now, you'll get that time back really quickly with much faster performance. Even if you don't have tens of thousands of images in Lightroom, it's a good idea to optimize your catalog every couple of months or so to keep everything running at full speed. You can also do this when you back up your catalog by turning on the Optimize Catalog After Backing Up checkbox.

Web

If you work for any amount of time in Lightroom, at some point you're going to see a little question mark icon appear to the right of a thumbnail, which means Lightroom can't find the original photo. You'll still be able to see the photo's thumbnail and even zoom in closer to see it in Loupe view, but you won't be able to do any serious editing (like color correction, changing the white balance, etc.), because Lightroom needs the original photo file to do those things, so you'll need to know how to relink the photo to the original.

Relinking Missing Photos

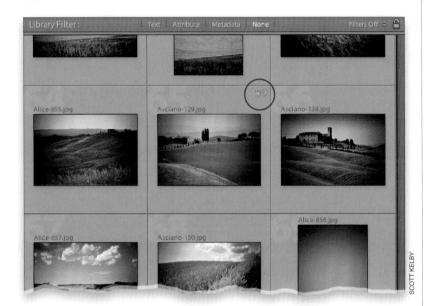

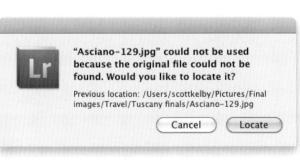

Step One:

In the thumbnails shown here, you can see one of them has a little question mark icon. letting you know it's lost its link to the original photo. There are two main reasons why this probably happened: (1) The original photo is stored on an external hard drive and that hard drive isn't connected to your computer right now, so Lightroom can't find it. So, just reconnect the hard drive, and Lightroom will see that drive is connected, instantly re-link everything, and all goes back to normal. But if you didn't store your photos on an external hard drive, then there's a different problem: (2) You moved or deleted the original photo, and now you've got to go and find it.

Step Two:

To find out where the missing photo was last seen, click on that little question mark icon and a dialog will pop up telling you it can't find the original file (which you already knew), but more importantly, under the scary warning it shows you its previous location (so you'll instantly be able to see if it was indeed on a removable hard drive, flash drive, etc.). So, if you moved the file (or the whole folder), you just have to tell Lightroom where you moved it to (which you'll do in the next step).

Click on the Locate button, and when the Locate dialog appears (shown here), navigate your way to where that photo is now located. (I know you're thinking to yourself, "Hey, I didn't move that file!" but come on-files just don't get up and walk around your hard drive. You moved it—you just probably forgot you moved it, which is what makes this process so tricky) Once you find it, click on it, then click the Select button, and it relinks the photo. If you moved an entire folder, then make sure you leave the Find Nearby Missing Photos checkbox turned on, so that way when you find any one of your missing photos, it will automatically relink all the missing photos in that entire folder at once.

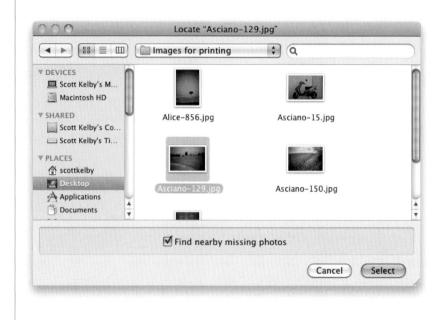

TIP: Keeping Everything Linked

If you want to make sure that all your photos are linked to the actual files (so you never see the dreaded question mark icon), go to the Library module, under the Library menu up top, and choose **Find Missing Photos**. This will bring up any photos that have a broken link in Grid view, so you can relink them using the technique we just learned here.

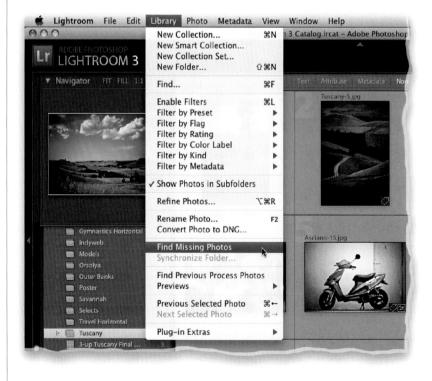

It's pretty unlikely that you'll have a major problem with your Lightroom catalog (after all these years of using Lightroom, it's only happened to me once), and if it does happen, chances are Lightroom can repair itself (which is pretty handy). However, the chances of your hard drive crashing, or your computer dying, or getting stolen (with the only copy of your catalog on it) are much higher. Here's how to deal with both of these potential disasters in advance, and what to do if the big potty hits the air circulation device:

Corrupt Catalog Detected Image: Corrupt Catalog "Sports" is corrupt and cannot be used or backed up until it is repaired. A message with further instructions will be displayed when the repair process is complete. See Adobe TechNote Show in Finder Quit Repair Catalog Cannot Repair Corrupt Catalog The catalog "Sports" is corrupt and cannot be repaired at this time. See Adobe TechNote Show in Finder Quit Repair Catalog

Dealing with Disasters

Step One:

If you launch Lightroom and you get a warning dialog like you see here (at top), then go ahead and give Lightroom a chance to fix itself by clicking the Repair Catalog button. Chances are pretty likely it'll fix the catalog and then you're all set. However, if Lightroom can't fix the catalog, you'll see the bottom warning dialog instead, letting you know that your catalog is so corrupt it can't fix it. If that's the case, it's time to go get your backup copy of your catalog (ya know, the one we talked about a couple pages ago).

Step Two:

Now, as long as you've backed up your catalog, you can just go restore that backup catalog, and you're back in business (just understand that if the last time you backed up your catalog was three weeks ago, everything you've done in Lightroom since then will be gone. That's why it's so important to back up your catalog fairly often, and if you're doing client work, you should back up daily). Luckily, restoring from a backup catalog is easy. First, go to your backup hard drive (remember, your backup catalog should be saved to a separate hard drive. That way, if your computer crashes, your backup doesn't crash along with it), and locate the folder where you save your Lightroom catalog backups (they're saved in folders by date, so double-click on the folder with the most current date), and inside you'll see your backup catalog (as seen here).

Next, go and find the corrupt Lightroom 3 catalog on your computer (on my computer, it's in my Lightroom folder that's in my Pictures folder), and delete that file (drag it into the Trash on a Mac, or into the Recycle Bin on a PC). Now, dragand-drop your backup catalog file into the folder on your computer where your corrupt file used to be (before you deleted it).

TIP: Finding Your Catalog

If you don't remember where you chose to store your Lightroom catalogs—don't worry—Lightroom can tell you. Go under the Lightroom (PC: Edit) menu and choose **Catalog Settings**. Click on the General tab, then under Location it will show the path to your catalog.

Step Four:

The final step is simply to open this new catalog in Lightroom 3 by going under the File menu and choosing **Open Catalog**. Now, go to where you placed that backup copy of your catalog (on your computer), find that backup file, click on it, then click OK, and everything is back the way it was (again, provided you backed up your catalog recently. If not, it's back to what your catalog looked like the last time you backed it up). By the way, it even remembers where your photos are stored (but if for some strange reason it doesn't, go back to the last project to relink them).

TIP: If Your Computer Crashed...

If, instead of a corrupt catalog, your computer crashed (or your hard drive died, or your laptop got stolen, etc.), then it's pretty much the same process—you just don't have to find and delete the old catalog first, because it's already gone. So, you'll start by just dragging your backup copy of the catalog into your new, empty Lightroom folder (which is created the first time you launch Lightroom on your new computer, or new hard drive, etc.).

velop

Slideshow

Web

Lightroom Killer Tips > >

Deleting a Collection

If you want to delete a collection, just click on it in the Collections panel and then click the – (minus sign) button on the right side of the panel header. This deletes just the collection, not the real photos themselves.

Adding Photos to an Existing Collection

You can add photos to any existing collection by just dragging a photo from the grid (or Filmstrip) and dropping it onto your collection in the Collections panel.

Renaming a Collection

To rename a collection, Right-click on the collection and choose **Rename** from the pop-up menu.

How to Share Smart Collections Settings

If you Right-click on a Smart Collection, you can choose **Export Smart Collec**tion Settings from the pop-up menu to save the Smart Collection's criteria, so you can share it with a friend. After you send it to them, they can import it using the **Import Smart Collection Settings** command from the same pop-up menu.

Sharing Keywords

If you want to use your keywords in a copy of Lightroom on a different

computer, or share them with friends or co-workers, go under the Metadata menu and choose **Export Keywords** to create a text file with all your keywords. To import these into another user's copy of Lightroom, go under the Metadata menu and choose **Import Keywords**, then locate that keyword file you exported earlier. Also, you can copy-and-paste keywords from text files directly into the Keywording panel.

 Quickly Apply Keywords to Your Selected Photo

When you hover your cursor over a keyword in the Keyword List panel, a checkbox appears that lets you assign it to your selected photo.

▼ Quickly Create Sub-keywords If you Right-click on a keyword in the Keyword List panel, there's a menu item called **Put New Keywords Inside This Keyword** and until you turn it off (by

choosing it again in the pop-up menu), all keywords you create are created as sub-keywords of this keyword.

▼ Auto Hide the Top Taskbar As I mentioned, the first thing I do is turn the Auto Hide feature off (so the panels

Print

stop popping in/out all day long), and instead I show/hide them manually as needed. But you might consider turning on Auto Hide just for the top taskbar. It's the most rarely used panel, but people do seem to like clicking to jump from module to module, rather than using the keyboard shortcuts. With Auto Hide turned on, it stays tucked out of sight until you click on the gray center triangle to reveal it. Then you can click on the module you want to jump to, and as soon as you move away from the top taskbar, it tucks away. Try it once, and I bet you'll totally dig it.

▼ Removing Unused Keywords Any grayed-out keywords in the Keyword List panel are not being used by any photos in Lightroom, so you can delete these orphaned keywords (which makes your keyword list cleaner and shorter) by going under the Metadata menu and choosing **Purge Unused Keywords**.

▼ Making Your Panels Larger If you want your panels to be wider (or thinner for that matter), just move your cursor right over the edge closest to the center Preview area and your cursor will change into a two-headed cursor. Now you can just click-and-drag your panels out wider (or drag them in to make them thinner). This also works for the Filmstrip at the bottom.

▼ Turning Your Filters On/Off Just press **Command-L (PC: Ctrl-L)** to turn your filters (flags, ratings, metadata, etc., in the Library Filter bar) on/off.

Lightroom Killer Tips > >

More Options for the Toolbar

Modes r Synv ng Label e ate how

By default, Lightroom displays a number of different tools and options on the toolbar below the center Preview area, but you can choose which ones you want (including some you may not have realized were available) by clicking on the little triangle at the toolbar's far right side. A menu will pop up with a list of toolbar items. The ones with checks beside them will be visible—to add one, just choose it.

▼ Zooming In/Out

You can use the same keyboard shortcuts used by Photoshop to zoom in and out of your image when it's in Loupe view. Just press **Command-+** (**PC: Ctrl-+**) to zoom in, and **Command--** (**PC: Ctrl--**) to zoom back out.

 Finding Out Which Collection a Particular Photo Is In

If you're scrolling through your entire Lightroom catalog (you've clicked on All Photographs in the Catalog panel), and you see a photo and want to know which collection it lives in, just Rightclick on the photo, and from the popup menu that appears, choose **Go to Collection**. If it's not in any collection, it will tell you so in the submenu. ▼ The "Flag and Move" Trick If you want to speed up the flaggingof-Picks process, try this: instead of just pressing P to flag a photo, and then using the Arrow key to move to the next photo, press Shift-P. This flags the photo as a Pick, but then automatically moves to the next photo for you.

 Filter Your Picks from the Filmstrip

Back in the original version of Lightroom, there wasn't a Library Filter bar at the top; instead, you showed your Picks and Rejects by clicking on little flag icons on the right side of the Film-

strip. Well, if you miss that way of doing things, Adobe left those filters there. So, you have your choice: do it from the top (which offers more features than just filtering by flags, stars, or colors), or the Filmstrip version. However, here's a tip within a tip: you're better off Rightclicking directly on the Filmstrip flags and making your choice from the pop-up menu, than you are trying to click on them, because they toggle back and forth, and it can get real confusing as to what you're actually seeing, real fast.

 How Much Space Is Left on Your Hard Drive for More Photos

If you're using one or more external hard drives to store your Lightroom photos, you can quickly find out exactly how much storage space you have left on those drives without leaving Lightroom. Just go to the Folders panel

(in the left side Panels area), and in the Volume Browser, you'll see a volume for each drive that you have Lightroom managing photos on (including your internal hard drive), and beside each name, it displays how much space is still available, followed by how much total space there is. If you hover your cursor over a volume, a message will pop up telling you exactly how many photos are stored on that drive that are managed by Lightroom.

▼ Where Collection Sets Live When you create collection sets, by default they appear at the top of the Collections panel in alphabetical order. Then, after your collection sets come your Smart Collections, then your collections.

Add Metadata to Multiple Photos at Once

Sync Metadata 📐 Sync Settings

If you manually entered some IPTC metadata for a photo, and you want to apply that same metadata to other photos, you don't have to type it all in again-you can copy that metadata and paste it onto other photos. Click on the photo that has the metadata you want, then Command-click (PC: Ctrl-click) on the other photos you want to add the metadata to, to select them. Now, click the Sync Metadata button (at the bottom of the right side Panels area), which brings up the Synchronize Metadata dialog. Click the Synchronize button to update those other photos with this metadata.

Slideshow

Web

Lightroom Killer Tips > >

▼ Switching to the Painter Tool You can switch to the Painter tool by pressing **Command-Option-K (PC: Ctrl-Alt-K)**. When you're done, either click it back on its gray circular home in the toolbar or just press the same keyboard shortcut again.

Saving a Collection as a Favorite

Collections / Ourer Banks
 Collections / Rams
 Collections / Rams
 Collections / Selects
 Collections / Selects
 Collections / Selects
 Collections / Jup Tuscany Final Print
 Collections / Tuscany
 Collections / Tuscany
 Collections / Savemanh
 Collections / Models
 Collections / Models
 Collections / Models
 Collections / Porster
 Collections / Ornalskis Herizantal
 Collections / Connaskis Herizantal
 Collections / Connaskis Herizantal
 Collections / Consolva

SCOTT KELBY

If you find yourself using a particular collection fairly often (maybe your portfolio collection, or a client proofs collection), you can save it so it's always just one click away: Start by clicking on that collection in the Collections panel, then from the pop-up menu at the top left of the Filmstrip, choose **Add to Favorites**. That collection will appear in this pop-up menu from now on. To remove a favorite, click on the collection, then chose **Remove From Favorites** from that same menu.

Removing Photos from Survey View

There's a little-known shortcut for removing a selected photo from contention when you're looking at them in Survey view: just press the / (forward slash) key on your keyboard.

Locking In a Filter

In previous versions of Lightroom, when you turned on a filter in the Library Filter bar (let's say you turned on the filter to show just your 5-star photos, that filter was only turned on for the current collection or folder you were in. When

you changed collections or folders, it stopped filtering. Now, if you want to move from collection to collection and only see your 5-star images, just click on the padlock icon at the right end of the Library Filter (at the top of the Grid view; if you don't see the Library Filter, press the **Backslash key**).

Backing Up Your Presets

If you've created your own presets (anything from Import presets to Develop or Print module presets), you need to back these up at some point, too. If your hard drive crashes, or you lose your laptop, you'll have to create them all from scratch (if you can even remember what all the settings were). To find the folder where all the presets are on your computer,

ents	
st converting to black and wh	ite
camera serial number	
camera ISO setting	
Reset all default Dev	elop settings
Reset all default Dev	elop settings
a	Show Lightroom Presets Folder

go to Lightroom's Preferences (under the Lightroom menu on a Mac or the Edit menu on a PC), click on the Presets tab, and then click the Show Lightroom Presets Folder button in the middle. Now drag that entire folder onto a separate hard drive (or a DVD) to back it up. That way, if things go horribly wrong, you can just drag-and-drop the contents of this backup folder into your new presets folder.

▼ The Auto Advance Advantage You can have Lightroom automatically advance to the next image when you're adding a Pick flag, or star rating to a photo—just go under the Photo menu and choose Auto Advance. ▼ Making Collections in a Set The quickest way to create a collection inside an existing collection set is to Right-click on the set (in the Collections

panel) and choose Create Collection. This automatically chooses that collection set in the Create Collection dialog's Set popup menu, so all you have to do is name your new collection and click Create.

♥ Use Keyword Suggestions When you click on a photo and Lightroom sees you've tagged it with a keyword, it instantly looks to see if you've tagged any other photos with that keyword. If you did, it lists the other keywords you applied to those photos as Keyword Suggestions (in the middle of the Keywording panel) figuring you're likely to use some of these same keywords again for the current photo. To add these suggested keywords, just click on 'em (it even adds the comma for you).

Keyword Sug	gestions	
NFL	Chicago Bears	Oakland Raiders
Ohio State	Tuscany	Raymond Ja
Tampa Bay B	LA Tech	Rams

▼ Create Search Presets At the far-right end of the Library Filter is a pop-up menu with handy filtering presets. If you find yourself using a particular type of search often, you can save your own custom search presets here, too, by choosing **Save Current Settings as New Preset** from this same menu.

Chapter 3 How to Set Up Things Your Way

Customizing how to set up things your way

A great name for this chapter would have been "Pimp My Ride" (after the popular MTV show of the same name), seeing as this chapter is all about customizing Lightroom 3 to your own personal tastes. Kids these days call this "pimping" (by the way, I just checked with a nearby kid to confirm this and apparently that is correct. I said, "Hey, what does it mean if something is pimped?" and he said, "It means it's been customized." But then I called my older brother Jeff, who had spent a number of years in the U.S. Navy, and asked him what it means if something is pimped and, surprisingly enough, he had an entirely different answer, but I'm not so sure our mom would be pleased with him for telling this to his impressionable younger brother). So, at this point, I wasn't sure if using the word "pimped" would be really appropriate,

so I did a Google search for the word "pimped" and it returned (I'm not making this up) more than 2,700,000 pages that reference the word "pimped." I thought I would go ahead and randomly click on one of those search result links, and I was pleasantly surprised to see that it took me to a page of totally customized cars. So, at that point, I felt pretty safe, but I realized that using the term "pimped" was kind of kind of "past tense," so I removed the "ed" and got a totally different result, which led me to a webpage with a "Pimp Name Generator" and, of course, I couldn't leave without finding out what my pimp name would be (just in case I ever wrote a book about customizing cars or my brother's life), and it turned out to be "Golden Brown Scott Slither" (though personally I was hoping for something more like "Snoop Scotty Scott").

Choosing What You See in Loupe View

When you're in Loupe view (the zoomed-in view of your photo), besides just displaying your photo really big, you can display as little (or as much) information about your photo as you'd like as text overlays, which appear in the top-left corner of the Preview area. You'll be spending a lot of time working in Loupe view, so let's set up a custom Loupe view that works for you.

Step One:

Step Two:

In the Library module's Grid view, click on a thumbnail and press **E** on your keyboard to jump to the Loupe view (in the example shown here, I hid everything but the right side Panels area, so the photo would show up larger in Loupe view).

Press **Command-J (PC: Ctrl-J)** to bring up the Library View Options dialog and then click on the Loupe View tab. At the top of the dialog, turn on the Show Info Overlay checkbox. The pop-up menu to the right lets you choose from two different info overlays: Info 1 overlays the filename of your photo (in larger letters) in the upperleft corner of the Preview area (as seen here). Below the filename, in smaller type, is the photo's capture date and time, and its cropped dimensions. Info 2 also displays the filename, but underneath, it displays the exposure, ISO, and lens settings.

Develop

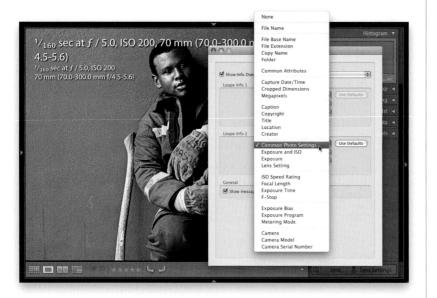

	00	Library View Options	
		Grid View Loupe View	
	Show Info Overlay	info 2	:
	Loupe Info 1		
		File Name	(Use Defaults)
		Capture Date/Time	19
		Cropped Dimensions	st
		Show briefly when photo changes	
			10
	Loupe Info 2		Its
×3/6		Common Photo Settings	Use Defaults
MAC 19	(Exposure and ISO	
		Lens Setting	
THE NEW A	6	Show briefly when photo changes	
	General		
		when loading or rendering photos	
	C show message v	nen isaung or renzening protos	

Step Three:

Luckily, you can choose which info is displayed for both info overlays using the pop-up menus in this dialog. So, for example, instead of having the filename show up in huge letters, here for Loupe Info 2, you could choose something like Common Photo Settings from the popup menu (as shown here). By choosing this, instead of getting the filename in huge letters, you'd get the same info that's displayed under the histogram (like the shutter speed, f-stop, ISO, and lens setting found in the top panel in the right side Panels area), even though you're in the Library module. You can customize both info overlays separately by simply making choices from these popup menus. (Remember: The top pop-up menu in each section is the one that will appear in really large letters.)

Step Four:

Any time you want to start over, just click the Use Defaults button to the right and the default Loupe Info settings will appear. Personally, I find this text appearing over my photos really, really distracting most of the time. The key part of that is "most of the time." The other times, it's handy. So, if you think this might be handy, too, here's what I recommend: (a) Turn off the Show Info Overlay checkbox and turn on the Show Briefly When Photo Changes checkbox below the Loupe Info pop-up menus, which makes the overlay temporary-when you first open a photo, it appears for around four seconds and then hides itself. Or, you can do what I do: (b) leave those off, and when you want to see that overlay info, press the letter I to toggle through Info 1, Info 2, and Show Info Overlay off. At the bottom of the dialog, there's also a checkbox that lets you turn off those little messages that appear onscreen, like "Loading" or "Assigned Keyword," etc.

Choosing What You See in Grid View

Those little cells that surround your thumbnails in Grid view can either be a wealth of information or really distracting (depending on how you feel about text and symbols surrounding your photos), but luckily you get to totally customize not only how much info is visible, but in some cases, exactly which type of info is displayed (of course, you learned in Chapter 1 that you can toggle the cell info on/off by pressing the letter **J** on your keyboard). At least now when that info is visible, it'll be just the info you care about.

Step One:

Press **G** to jump to the Library module's Grid view, then press **Command-J** (PC: **Ctrl-J)** to bring up the Library View Options dialog (shown here), and click on the Grid View tab at the top (seen highlighted here). At the top of the dialog, there's a pop-up menu where you can choose the options for what's visible in either the Expanded Cells view or the Compact Cells view. The difference between the two is that you can view more info in the Expanded Cells view.

Show Grid Extr	Grid View Compact Ce ras ✓ Expanded C	ells	upe View	
Options			₩.	
Show clickab	le items on mouse	e over o	nly	
Tint grid cell	s with label colors	1		
Show image	info tooltips			
Cell Icons				
Flags			Unsaved Metadata	
🗹 Thumbnail B	adges		Quick Collection Marke	rs
Compact Cell Ex		el:	File Name	÷
Rotation	Bottom I		Rating	
Expanded Cell E				
Show Heade	with Labels:		Usel	Defaults
Index	Number	=	File Base Name	
Croppe	ed Dimensions	+	File Extension	
	Footer			

Step Two:

We'll start at the top, in the Options section. You can add a Pick flag and left/right rotation arrows to your cell, and if you turn on the Show Clickable Items on Mouse Over Only checkbox, it means they'll stay hidden until you move your mouse over a cell, then they appear so you can click on them. If you leave it unchecked, you'll see them all the time. The Tint Grid Cells with Label Colors checkbox only kicks in if you've applied a color label to a photo. If you have, turning this on tints the gray area around the photo's thumbnail the same color as the label.

Options

- Show clickable items on mouse over only
- Tint grid cells with label colors
- Show image info tooltips

The thumbnail badges show you (from L to R) that a keyword has been applied, the photo has been cropped, added to a collection,z and edited

The gray circle in the upper-right corner is actually a button—click on it to add this photo to your Quick Collection

Click the flag icon to mark it as a Pick

Click the Unsaved Metadata icon to save the changes

Step Three:

The next section down, Cell Icons, has two options for things that actually appear right over your photo's thumbnail image, and two that appear just in the cell. Thumbnail badges appear in the bottom-right corner of a thumbnail itself to let you see if: (a) the photo has had keywords added, (b) the photo has been cropped, (c) the photo has been added to a collection, or (d) the photo has been edited in Lightroom (color correction, sharpening, etc.). These tiny badges are actually clickable shortcuts, so for example, if you wanted to add a keyword, you could click the Keyword badge (whose icon looks like a tag), and it opens the Keywording panel and highlights the keyword field, so you can just type in a new keyword. The other option on the thumbnail, Quick Collection Markers, adds a gray circle-shaped button to the top-right corner of your photo when you mouse over the cell. Click on this dot to add the photo to (or remove it from) your Quick Collection.

Step Four:

The other two options don't put anything over the thumbnails-they add icons in the cell area itself. When you turn on the Flags checkbox, it adds a Picks flag to the top-left side of the cell, and you can then click on this flag to mark this photo as a Pick (shown here on the left). The last checkbox in this section. Unsaved Metadata, adds a little icon in the top-right corner of the cell (shown here on the right), but only if the photo's metadata has been updated in Lightroom (since the last time the photo was saved), and these changes haven't been saved to the file itself yet (this sometimes happens if you import a photo, like a JPEG, which already has keywords, ratings, etc., applied to it, and then in Lightroom you added keywords, or changed the rating). If you see this icon, you can click on it to bring up a dialog that asks if you want to save the changes to the file (as shown here).

Step Five:

We're going to jump down to the bottom of the dialog to the Expanded Cell Extras section, where you choose which info gets displayed in the area at the top of each cell in Expanded Cells view. By default, it displays four different bits of info (as shown here): It's going to show the index number (which is the number of the cell, so if you imported 63 photos, the first photo's index number is 1, followed by 2, 3, 4, and so on, until you reach 63) in the top left, then below that will be the pixel dimensions of your photo (if the photo's cropped, it shows the final cropped size). Then in the top right, it shows the file's name, and below that, it shows the file's type (JPEG, RAW, TIFF, etc.). To change any one of these info labels, just click on the label pop-up menu you want to change and a long list of info to choose from appears (as seen in the next step). By the way, you don't have to display all four labels of info, just choose None from the pop-up menu for any of the four you don't want visible.

Step Six:

Although you can use the pop-up menus here in the Library View Options dialog to choose which type of information gets displayed, check this out: you can actually do the same thing from right within the cell itself. Just click on any one of those existing info labels, right in the cell itself, and the same exact pop-up menu that appears in the dialog appears here. Just choose the label you want from the list (I chose ISO Speed Rating here), and from then on it will be displayed in that spot (as shown here on the right, where you can see this shot was taken at an ISO of 200).

<u>س</u> الد ا	ow Header with Labels:	Use D	Defaults
	Index Number	\$ File Base Name	+
	ISO Speed Rating	\$ File Extension	

Compact Cell Extra:	5		
🗹 Index Number	🗹 Top Label:	File Name	
Rotation	Bottom Label:	Rating	•

Step Seven:

At the bottom of the Expanded Cell Extras section is a checkbox, which is on by default. This option adds an area to the bottom of the cell called the Rating Footer, which shows the photo's star rating, and if you keep both checkboxes beneath Show Rating Footer turned on, it will also display the color label and the rotation buttons (which are clickable).

Step Eight:

The middle section we skipped over is the Compact Cell Extras section. The reason I skipped over these options is that they work pretty much like the Expanded Cell Extras, but with the Compact Cell Extras, you have only two fields you can customize (rather than four, like in the Expanded Cell Extras): the filename (which appears on the top left of the thumbnail), and the rating (which appears beneath the bottom left of the thumbnail). To change the info displayed there, click on the label pop-up menus and make your choices. The other two checkboxes on the left hide/show the index number (in this case, it's that huge gray number that appears along the topleft side of the cell) and the rotation arrows at the bottom of the cell (which you'll see when you move your cursor over the cell). One last thing: you can turn all these extras off permanently by turning off the Show Grid Extras checkbox at the top of the dialog.

Make Working with Panels Faster & Easier

Lightroom has an awful lot of panels, and you can waste a lot of time scrolling up and down in these panels just searching for what you want (especially if you have to scroll past panels you never use). This is why, in my live Lightroom seminars, I recommend: (a) hiding panels you find you don't use, and (b) turning on Solo mode, so when you click on a panel, it displays only that one panel and tucks the rest out of the way. Here's how to use these somewhat hidden features:

Step One:

Start by going to any side panel, then Right-click on the panel header and a pop-up menu will appear with a list of all the panels on that side. Each panel with a checkmark beside it is visible, so if you want to hide a panel from view, just choose it from this list and it unchecks. For example, here in the Develop module's right side Panels area, I've hidden the Camera Calibration panel. Next, as I mentioned in the intro above, I always recommend turning on Solo mode (you choose it from this same menu, as seen here).

Step Two:

Take a look at the two sets of side panels shown here. The one on the left shows how the Develop module's panels look normally. I'm trying to make an adjustment in the Split Toning panel, but I have all those other panels open around it (which is distracting), and I have to scroll down past them just to get to the panel I want. However, look at the same set of panels on the right when Solo mode is turned on-all the other panels are collapsed out of the way, so I can just focus on the Split Toning panel. To work in a different panel, I just click on its name, and the Split Toning panel tucks itself away automatically.

The Develop module's right side Panels area with Solo mode turned off

The Develop module's right side Panels area with Solo mode turned on

Lightroom supports using two monitors, so you can work on your photo on one screen and also see a huge, full-screen version of your photo on another. But Adobe went beyond that in this Dual Display feature and there are some very cool things you can do with it, once it's set up (and here's how to set it up).

Using Two Monitors with Lightroom

Step One:

The Dual Display controls are found in the top-left corner of the Filmstrip (shown circled in red here), where you can see two buttons: one marked "1" for your main display, and one marked "2" for the second display. If you don't have a second monitor connected and you click the Second Window button, it just brings up what would be seen in the second display as a separate floating window (as seen here).

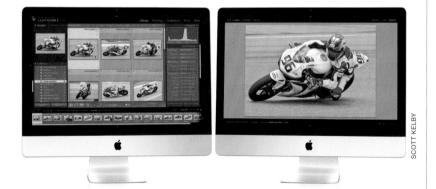

Step Two:

If you do have a second monitor connected to your computer, when you click on the Second Window button, the separate floating window appears in Full Screen mode, set to Loupe view, on the second display (as seen here). This is the default setup, which lets you see Lightroom's interface and controls on one display, and then the larger zoomed-in view on the second display.

Step Three:

You have complete control over what goes on the second display using the Secondary Window pop-up menu, shown here (just click-and-hold on the Second Window button and it appears). For example, you could have Survey view showing on the second display, and then you could be zoomed in tight, looking at one of those survey images in Loupe view on your main display (as shown at bottom). By the way, just add the **Shift key** and the Survey view, Compare view, Grid view, and Loupe view shortcuts are all the same (so, **Shift-N** puts your second display into Survey view, etc.).

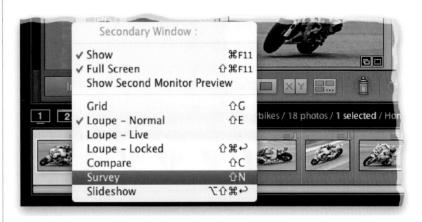

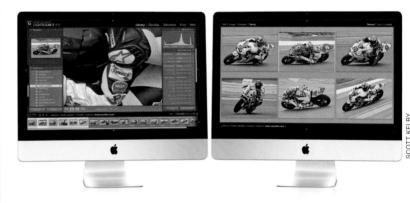

TIP: Swapping Screens

If you want to swap displays (where your main screen, panels, etc., appear on the second display and the Loupe view screen appears on your main display), if you're in Full Screen mode on your main display, press **F** to leave Full Screen mode, which lets you see the main display's title bar at the top. Now just drag-and-drop that title bar over to the right, right off the main display and onto the second display, and the two automatically swap positions.

Develop Sli

Slideshow Print Web

Step Four:

Besides just seeing things larger with the Loupe view, there are some other pretty cool Second Window options. For example, click on the Second Window button and choose **Loupe – Live** from the Secondary Window pop-up menu, then just hover your cursor over the thumbnails in the Grid view (or Filmstrip) on your main display, and watch how the second display shows an instant Loupe view of any photo you pass over (here, you can see on my main display the first photo is selected, but the image you see on my second display is the one my cursor is hovering over—the fifth image).

Step Five:

Another Secondary Window Loupe view option is called **Loupe – Locked** and when you choose this from the Secondary Window pop-up menu, it locks whatever image is currently shown in Loupe view on the second display, so you can look at and edit other images on the main display (to return to where you left off, just turn Loupe – Locked off).

Step Six:

The navigation bars at the top and bottom of your image area will be visible on the second display. If you want those hidden, click on the little gray arrows at the top and bottom of the screen to tuck them out of sight, and give you just the image onscreen.

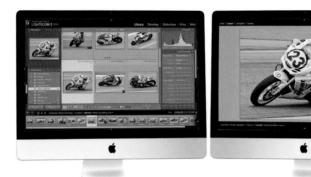

Here's the second display default view, with the navigation bars at the top and bottom visible

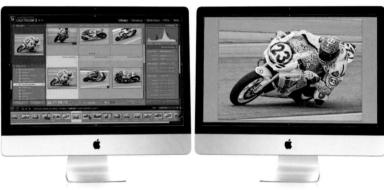

Here's the second display with the navigation bars hidden, which gives a much larger view

TIP: Show Second Monitor Preview There's a feature found under the Secondary Window pop-up menu called Show Second Monitor Preview, where a small floating Second Monitor window appears on your main display, showing you what's being seen on the second display. This is pretty handy for presentations, where the second display is actually a projector, and your work is being projected on a screen behind you (so you can face the audience), or in instances where you're showing a client some work on a second screen, and the screen is facing away from you (that way, they don't see all the controls, and panels, and other things that might distract them).

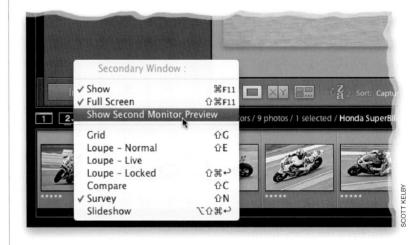

Web

Just like you can choose what photo information is displayed in the Grid and Loupe views, you can also choose what info gets displayed in the Filmstrip, as well. Because the Filmstrip is pretty short in height, I think it's even more important to control what goes on here, or it starts to look like a cluttered mess. Although I'm going to show you how to turn on/off each line of info, my recommendation is to keep all the Filmstrip info turned off to help avoid "info overload" and visual clutter in an already busy interface. But, just in case, here's how to choose what's displayed down there:

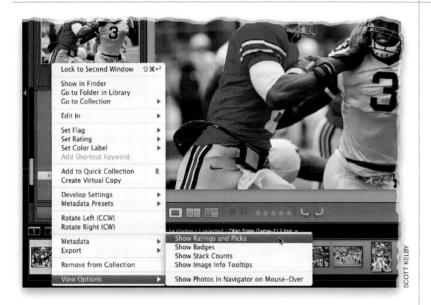

Choosing What the Filmstrip Displays

Print

Step One:

Right-click on any thumbnail down in the Filmstrip and a pop-up menu will appear (seen here). At the bottom of this menu are the View Options for the Filmstrip. There are four options: Show Ratings and Picks will add tiny flags and star ratings to your Filmstrip cells. If you choose Show Badges, it adds mini-versions of the same thumbnail badges you can see in the Grid view (which show if the photo is in a collection, whether keywords have been applied, whether the photo has been cropped, or if the image has been adjusted in Lightroom). Show Stack Counts will add a stack icon with the number of images inside the stack. The last choice, Show Image Info Tooltips, kicks in when you hover your cursor over an image in the Filmstrip-a little window pops up telling you the file's name, the time and date it was taken, and its size (in pixels).

Step Two:

Here's what the Filmstrip looks like when these options are turned off (top) and with all of them turned on (bottom). You can see Picks flags, star ratings, and thumbnail badges (with unsaved metadata warnings), and I hovered my cursor over one of the thumbnails, so you can see the little popup window appear giving me info about the photo. The choice is yours—clean or cluttered.

Adding Your Studio's Name or Logo for a Custom Look

The first time I saw Lightroom, one of the features that really struck me as different was the ability to replace the Adobe Photoshop Lightroom logo (that appears in the upper-left corner of Lightroom) with either the name of your studio or your studio's logo. I have to say, when you're doing client presentations, it does add a nice custom look to the program (as if Adobe designed Lightroom just for you), but beyond that, the ability to create an Identity Plate goes farther than just giving Lightroom a custom look (but we'll start here, with the custom look).

Step One:

First, just so we have a frame of reference, here's a zoomed-in view of the top-left corner of Lightroom's interface, so you can clearly see the logo we're going to replace starting in Step Two. Now, you can either replace Lightroom's logo using text (and you can even have the text of the modules in the taskbar on the top right match), or you can replace the logo with a graphic of your logo (we'll look at how to do both).

Step Two:

Go under the Lightroom menu (the Edit menu on a PC) and choose Identity Plate **Setup** to bring up the Identity Plate Editor (shown here). By default, the name you registered your software in shows up highlighted in the large black text field in the middle of the dialog, in a font you'd never actually use. To have your name replace the Adobe Photoshop Lightroom 3 logo seen above, turn on the Enable Identity Plate checkbox at the top left of the dialog. If you don't want your name as your Identity Plate, just type in whatever you'd like (the name of your company, studio, etc.), then while the type is still highlighted, choose a font, font style (bold, italic, condensed, etc.), and font size from the pop-up menus (directly below the text field).

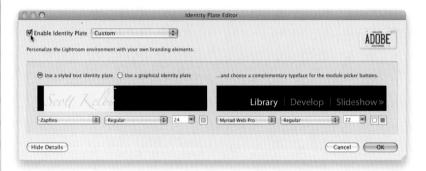

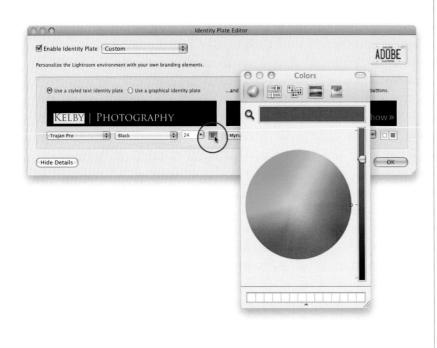

Enable Identity Plate	✓ Custom	9	ADOBE
Personalize the Lightroom	Save As Remove	lements.	
Use a styled text id	entity plate 🔘 Use a gr	raphical identity plate	and choose a complementary typeface for the module picker buttons.
Kelby	Photogra	PHY	Library Develop Slideshow»
Trajan Pro	Black	¢ 24 •	Myriad Web Pro 🗘 Regular 🔅 22 🔹 🗆

Step Three:

If you want to change only part of your text (for example, if you wanted to change the font of one of the words, or the font size or color of a word), just highlight the word you want to adjust before making the change. To change the color, click on the little square color swatch to the right of the Font Size pop-up menu (it's shown circled here). This brings up the Colors panel (you're seeing the Macintosh Colors panel here; the Windows Color panel will look somewhat different, but don't let that freak you out. Aw, what the heckgo ahead and freak out!). Just choose the color you want your selected text to be, then close the Colors panel.

Step Four:

If you like the way your custom Identity Plate looks, you definitely should save it, because creating an Identity Plate does more than just replace the current Adobe Photoshop Lightroom 3 logo—you can add your new custom Identity Plate text (or logo) to any slide show, Web gallery, or final print by choosing it from the Identity Plate pop-up menu in all three modules (see, you were dismissing it when you just thought it was a taskbar, feel good feature). To save your custom Identity Plate, from the Enable Identity Plate pop-up menu, choose Save As (as shown here). Give your Identity Plate a descriptive name, click OK, and now it's saved. From here on out, it will appear in the handy Identity Plate pop-up menu, where you can get that same custom text, font, and color with just one click.

Step Five:

Once you click the OK button, your new Identity Plate text replaces the Adobe Photoshop Lightroom 3 logo that was in the upper-left corner (as shown here).

Step Six:

If you want to use a graphic (like your company's logo) instead, just go to the Identity Plate Editor again, but this time, click on the radio button for Use a Graphical Identity Plate (as shown here), instead of Use a Styled Text Identity Plate. Next, click on the Locate File button (found above the Hide/Show Details button near the lower-left corner) and find your logo file. You can put your logo on a black background so it blends in with the Lightroom background, or you can make your background transparent in Photoshop, and save the file in PNG format (which keeps the transparency intact). Now click the Choose button to make that graphic your Identity Plate.

Note: To keep the top and bottom of your graphic from clipping off, make sure your graphic isn't taller than 57 pixels.

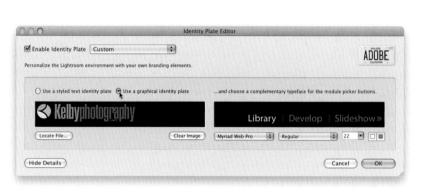

Ste	p	S	e١	ve	n	

When you click OK, the Adobe Photoshop Lightroom 3 logo (or your custom text whichever was up there last) is replaced by the new graphic file of your logo (as shown here). If you like your new graphical logo file in Lightroom, don't forget to save this custom Identity Plate by choosing Save As from the Enable Identity Plate pop-up menu at the top of the dialog.

000	Identity Pl	ate Editor
Enable Identity Plate Custom Personalize the Lightroom environment with your o	wn branding elements.	ADOBE
O Use a styled text identity plate (a) Use a g	raphical identity plate	and choose a complementary typeface for the module picker buttons. Library Develop Slideshow >>
Locate File	Clear Image	Myriad Web Pro
Hide Details		Cancel

Step Eight:

If you decide, at some point, that you'd like the original Lightroom logo back instead, just go back to the Identity Plate Editor and turn off the Enable Identity Plate checkbox (as shown here). Remember, we'll do more with one of your new Identity Plates later in the book when we cover the three later modules.

Lightroom Killer Tips > >

▼ Spacebar Loupe Tricks

If you want to see your currently selected photo zoomed in to Loupe view, just press the **Spacebar**. Once it's zoomed in like that, press the Spacebar again, and it zooms in to whatever magnification (zoom factor) you chose last in the Navigator panel's header (by default, it zooms to 1:1, but if you click on a different zoom factor, it will toggle back and forth between the view you were in first and the zoom factor you clicked on). Once zoomed in, you can move around your image by just clickingand-dragging on it.

Hiding the Render Messages

If you chose Minimal or Embedded & Sidecar in the Render Previews pop-up menu in the Import window, Lightroom is only going to render higherresolution previews when you look at a larger view, and while it's rendering these higher-res previews, it displays a little "Loading" message. You'll see these messages a lot, and if they get on your nerves, you can turn them off by pressing Command-J (PC: Ctrl-J) and, in the View Options dialog that appears, click on the Loupe View tab (up top), then in that section, turn off the checkbox for Show Message When Loading or Rendering Photos.

Opening All Panels at Once

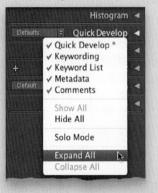

If you want every panel expanded in a particular side panel, just Right-click on any panel's header, then choose **Expand All** from the pop-up menu.

▼ Jump to a 100% View

Any time you want to quickly see your image at a 100% full-size view, just press the letter **Z** on your keyboard.

Changing Where Lightroom Zooms

Show ratings and picks	Show ph
Show badges	Show phy
Show stack counts	
Turraks	
Zoom clicked point to center	Use type

When you click to zoom in on a photo, Lightroom magnifies the photo, but if you want the area that you clicked on to appear centered on the screen, press **Command-, (comma; PC: Ctrl-,)** to bring up Lightroom's Preferences dialog, then click on the Interface tab, and at the bottom, turn on the checkbox for Zoom Clicked Point to Center.

▼ Give Your Labels Names

You can change the default names Lightroom uses for its Color Label feature from the standard names of Red, Blue, Green, etc. (for example, you might want to name your Green label "Approved," and your Yellow label "Awaiting Client Approval," and so on). You do this by going under the Metadata menu, under Color Label Set, and choosing **Edit** to bring up the Edit Color Label Set dialog. Now, just type in your new names (right over the old names). The numbers to the right of the first four color labels are the keyboard shortcuts for applying those labels

	1 - d	6
Cancel		0
Awaiti	ng Client Approval	7
Approv	ved	8
In Prod	ofing	9
Retou	hing Needed	
	to maintain compatibility wit	th labels in Adobe Bridge, use the same names in
		New Preset
you wish oth appli	000	New Preset

(Purple doesn't have a shortcut). When you're done, choose **Save Current Settings as New Preset**, from the Preset pop-up menu at the top of the dialog, and give your preset a name. Now, when you apply a label, onscreen you'll see "Approved" or "In Proofing" or whatever you choose (plus, the Set Color Label submenu [found under the Photo menu] updates to show your new names).

How to Link Your Panels So They Close Simultaneously

If you set your side panels to Manual (you show and hide them by clicking on the little gray triangles), you can set them up to where if you close one side, the other side closes, too (or if you close the top, the bottom closes, too). To do this, Right-click on one of those little gray triangles, and from the pop-up menu that appears, choose **Sync With Opposite Panel**. Library

Develop

Slideshow

Print

Web

Lightroom Killer Tips > >

You Can Change Those Little Ornaments Under the Last Panel

Ya know that little flourish thingy at the bottom of the last panel in the left and right side Panels areas that lets you know you're at the last panel? Well, it's called an end mark and luckily, you can change it to one of the other built-in graphics (which are much cooler) or add your own. To pick a different end mark, just Right-click on the current end mark, and then from the pop-up menu, under **Panel End Mark**, pick any one of the other choices (I like Tattoo, Atom, and Yin Yang). You can also

create your own custom end marks (make sure they're on a transparent background, and saved in PNG format), then choose Go to Panel End Marks Folder from the Panel End Mark submenu. This is the folder you'll drop them in and where you'll choose them from.

Downloading More End Marks

Besides creating your own custom end marks, you can download some pretty cool, free, custom Lightroom end marks from the folks at Lightroom Extra at www.lightroomextra.com. Click on Download at the top, then Show Me next to Panel End Markers. Once downloaded, it's as easy as putting them in your Panel End Marks folder (follow the instructions on the website). *Note:* We cannot guarantee the fitness of this website, so please download at your own risk.

See Common Attributes

If you want to see if your image is flagged or has a star rating, Adobe added a new Common Attributes feature in Lightroom 3 to the view pop-up menu (just Right-click at the top of a thumbnail cell), and if you choose it as one of your view criteria, it'll show those along the top of the image cell.

Changing Lightroom's Background Color

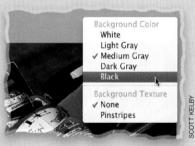

You can change that medium gray background color that appears behind your photos by Right-clicking anywhere on that gray area, and from the pop-up menu that appears, you can choose different background colors and/or a pinstripe texture.

Delete Old Backups to Save Big Space

I usually back up my Lightroom catalog once a day (when I'm done for the day

and am closing Lightroom; see Chapter 2 for more on this). The problem is that after a while, you've got a lot of backup copies—and before long you've got months of old, outdated copies taking up space on your hard drive (I really only need one or two backup copies. After all, I'm not going to choose a backup from three months ago). So, go to your Lightroom folder from time to time and delete those outdated backups.

The Secret Identity Plate Text Formatting Trick

It's surprisingly hard to format text inside the Identity Plate Editor window, especially if you want multiple lines of text (of course, the fact that you can have multiple lines of text is a tip unto itself). But, there's a better way: Create your text somewhere else that has nice typographic controls, then select and copy your text into memory. Then come back to the Identity Plate Editor and paste that already formatted text right into it, and it will maintain your font and layout attributes.

▼ New Collection Badge

In Lightroom 3, Adobe added a new thumbnail badge (it looks like two overlapping rectangles), which if you see it at the bottom right corner of a thumbnail, it lets you know the image is in a collection. Click on it, and a list of collections that photo appears within shows up, and you can click on any one to jump directly to that collection.

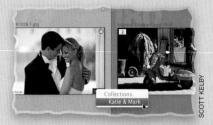

Chapter 4 How to Develop Your Photos

Editing Essentials how to develop your photos

I kinda like that subhead above—How to Develop Your Photos—because even though it sounds like a direct reference to Lightroom's Develop module, the name of that module itself is a direct reference to what we used to do in the darkroom—develop our prints. Of course, this chapter isn't about prints, which pretty much throws that whole line of thought out the window, but we're not going to look that closely at things like that (or grammar, spelling, or ending sentences with a preposition), because instead we're going to bask in the fact that now we can develop our photos without having to mix dangerous chemicals. Now, of course, back in the old days (which was only about 10 years ago), we didn't realize these chemicals were dangerous, so we'd be in the darkroom, developing some T-MAX P3200, and somebody

would get thirsty, so we'd just take a big swig of some Hypo Clearing Agent (which was a chemical we used to remove the fixing agent from fiber-based paper, but doggone it if that stuff didn't taste just like Welch's grape juice, so we'd usually finish off a bag or two before coming out and grabbing a Reuben and a bag of Doritos). Anyway, it seemed like a pretty good idea at the time, but then my darkroom buddy Frank got this huge goiter in the shape of the Transamerica building, so we backed off on the Hypo Clear, and just stuck to chugging the Indicator Stop Bath (we loved those little salmon-colored bottles. We'd keep 'em in the fridge and even take them on picnics). Anyway, that was a different time. Now we know better, and so we stick to chain smoking and strutting around in our asbestos photo vests.

Upgrading from an Earlier Version of Lightroom? Read This First!

Up until Lightroom 3, Lightroom (and Adobe Camera Raw for that matter) has been using a processing technology developed back in 2003. In Lightroom 3, Adobe did a pretty sweeping update to how it processes your images, which is great in and of itself. But if you're bringing over images that you edited in an earlier version of Lightroom, there are some important things you need to know now, before you start editing your images, so you can choose whether to take advantage of these changes or not.

Step One:

New images you import (ones you didn't edit in an earlier version of Lightroomimages coming off your camera's memory card, for example) use the new processing technology, so you get the benefits right off the bat (and it doesn't matter if you shot in RAW, TIFF, or JPEG, or even if you're importing PSDs or DNGs). At this point, it's all good. No problems, no decisions to make, and you get to take advantage of the latest processing technology automatically. Things are different, though, if you're working with images you edited in an earlier version of Lightroom, but this is not apparent when viewing the image in the Library module's Loupe view.

Step Two:

When you've imported an image edited in an earlier version of Lightroom, and you switch to the Develop module, you'll see an alert icon appear below the bottomright corner of the image (it looks like an exclamation point and is shown circled here in red). If you click on that icon, it brings up the Update Process Version dialog, giving you the option to update this photo with the latest processing technology (Adobe calls this new version the "Process Version 2010") or hit Cancel to stick with the old "Process Version 2003." If you decide to update, and you click the Update button, it just updates that individual photo, but if you just imported a number of photos, and want to update them all at once, instead click the Update All Filmstrip Photos button.

Web

CIGHTROOM 3	rocess sopy Settings aste Settings from Previous ync Copies ync Copies ync Copies ync Copies ync Snapshots latch Total Exposures nable Auto Sync uto White Balance	↑ ↑ ↑ ↑ % ↓ * * * * * * * * * * * * *	
C P P S S S S M M E I A A A	aste Settings aste Settings from Previous ync Settings ync Snapshots latch Total Exposures nable Auto Sync	○第∨ ▽第∨ ○第5 ○第5	• • •
Pa Sv Sv Sv M M Ei A A A	aste Settings from Previous ync Settings ync Copies ync Snapshots latch Total Exposures nable Auto Sync	\ \ אי ג 2 איני ערטאש	· · ·
Si S	ync Settings ync Copies ync Snapshots Iatch Total Exposures nable Auto Sync	0#5 70#M	•••
Si S	ync Copies ync Snapshots Iatch Total Exposures nable Auto Sync	N%07	•••
Er A	nable Auto Sync		•••
A		A%OT	
A	uto White Balance		*
		∂ ∺U	
[1] S. Danish and S. Santa, "Second States," Advantage of the second states, "Second States," in the second states, "Second States, "Second States," in the second states, "Second States, "S Second States, "Second Stat	uto Tone	χn	1.200 1
	onvert to Black & White	v	
R	eset Crop	Σ₩R	1. A.
	onstrain Aspect Ratio	A	M. MA
	rop to Same Aspect Ratio	ŶΑ	1. 1. 1. 1.
NIN KA	otate Crop Aspect	X	
	opy After's Settings to Before	℃ �∺↔	JA V.
	opy Before's Settings to After wap Before and After Settings	℃企業→	C () WER
		1807	

Step Three:

In the middle of the Update Process Version dialog, there's a Review Changes via Before/ After checkbox. With this turned on, it automatically gives you a before/after look at how the update to the Process Version 2010 looks. This is helpful because if for whatever reason you don't like the result, you can just press Command-Z (PC: Ctrl-Z) to undo the update at this point. Here's the before and after for the photo I'm working with, and although the change looks fairly minor, I like the richer look of the color in the After photo. The tones look warmer to me, but again, it's fairly minor (and I'm not sure how much of that will even be visible when this is actually printed using a printing press to create this page in the book). I can tell you this: I haven't had a single image that resulted in a very dramatic change when updating to the new Process Version 2010, and in many cases, I couldn't see a change at all.

Step Four:

If you decide to wait and make your Process Version decision later, you can always just update your photo by going under the Settings menu and choosing **Update to Current Process (2010)**, as shown here. There's also a Process submenu, found right below, where you can choose which process you want—2003 or 2010.

TIP: Collections Panel in Develop Lightroom 3 is the first version to have

the Collections panel available within the Develop module. This keeps you from having to jump back and forth between the Develop module and the Library module when you want to work on a different collection, and this now makes the Collections panel available in every module. Now, I haven't had a big effect on how Lightroom has been developed over the years, but this is one I finally convinced Adobe to add, and they sent me an email that same day and told me, "OK, we added it." They also told me not to expect that sort of fast turnaround again. ;-)

Making Your RAW Photos Look More Like JPEGs

The #1 complaint I hear at my Lightroom seminars is "When my RAW photos first appear in Lightroom, they look great, but then they change and look terrible." What's happening is when you shoot in JPEG, your camera adds contrast, sharpening, etc., right in the camera. When you shoot in RAW, you're telling the camera to turn all that contrast, sharpening, and stuff off. So, when your RAW image first comes into Lightroom, you're seeing a sharp, contrasty preview first, but then it draws the real preview and you see the actual RAW image. Here's how to get a more JPEG-like starting place:

Step One:

To get a more JPEG-like starting place for your RAW images, here's what to do: Go to the Develop module and scroll down to the Camera Calibration panel. There's a Profile pop-up menu near the top of this panel, where you'll find a number of profiles based on your camera's make and model (it reads the image file's embedded EXIF data to find this. Not all camera brands and models are supported, but most recent Nikon and Canon DSLRs are, along with some Pentax, Sony, Olympus, Leica, and Kodak models). These profiles mimic camera presets you could have applied to your JPEG images in camera (but are ignored when you shoot in RAW). The default profile is Adobe Standard, which looks pretty average (well, if you ask me).

Step Two:

Now all you have to do is try out each of the different profiles, and see which one looks good to you (which to me is, which one looks the most like a JPEG—a profile that looks more contrasty, with richer looking colors). I usually start by looking at the one called Camera Standard (rather than the default Adobe Standard). I rarely see a photo using Camera Standard that I don't like better than using the default Adobe Standard setting, so this is usually my preferred starting place.

Note: If you're shooting Canon, or Pentax, etc., you'll see a different list of profiles, as they're based on the names the camera manufacturer gives to their in-camera picture styles.

Slideshow Print Web

Step Three:

If you're shooting landscapes (and you want that Fuji Velvia film look), or you just have a subject where you really want vivid colors, try the Camera Vivid profile, which mimics the Vivid color preset you could have chosen in your camera. I love this one for landscapes, but I'll also try the Camera Landscape profile and compare the two, to see which one looks best for the particular photo I'm looking at, because I've learned that it really depends on the photo as to which profile looks best. That's why I recommend trying a few different profiles to find the one that's right for the photo you're working with.

Note: Don't forget, you only get a choice of these camera profiles if you shot in RAW. If you shot in JPEG mode, you'll only see one profile: Embedded.

TIP: Create Your Own Profiles You can create your own custom profiles using Adobe's free DNG Profile Editor, available from Adobe at http://labs.adobe .com/wiki/index.php/DNG_Profiles.

Step Four:

Here's a Before/After, where the only thing I did was choose the Camera Vivid profile. By the way, Adobe doesn't claim that these profiles will give you the look of a JPEG image, but in my opinion these surely can get you fairly close. I use these profiles anytime I want my starting point to be closer to the JPEG-like image I saw on the back of my camera.

TIP: Apply Profiles Automatically

If you find that you like a particular profile, and you always want it applied to your images, you can go to the Develop module, choose the profile (don't do anything else in the Develop module), and create a Develop preset with that name. Now, you can apply that look automatically to every photo you import by choosing that preset from the Develop Settings pop-up menu in Lightroom's Import window. (For more on creating presets, see page 158.)

Setting the White Balance

I always start editing my photos by setting the white balance first, because if you get the white balance right, the color is right, and your color correction problems pretty much go away. You adjust the white balance in the Basic panel, which is the most misnamed panel in Lightroom. It should be called the "Essentials" panel, because it contains the most important, and the most used, controls in the entire Develop module.

Step One:

In the Library module, click on the photo you want to edit, and then press the letter **D** on your keyboard to jump over to the Develop module. By the way, you're probably figuring that since you press D for the Develop module, it must be S for Slideshow, P for Print, and W for the Web module, right? Sadly, no—that would make things too easy. Nope, it's just Develop that uses the first letter. (Arrrrgggh!) Anyway, once you're in the Develop module, all the editing controls are in the right side Panels area, and the photo is displayed using whatever you had the white balance set on in your digital camera (called "As Shot").

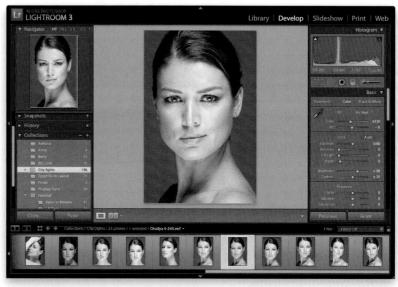

Step Two:

The white balance controls are near the top of the Basic panel, and there you'll see a White Balance (WB) pop-up menu where you can choose the same white balance presets you could have chosen in your camera, as seen here. (*Note:* The one big difference between processing JPEG and TIFF images, and those shot in RAW, is that you only get this full list of presets if you shoot in RAW. If you shoot in JPEG, you only get one preset choice—Auto—and that's it.)

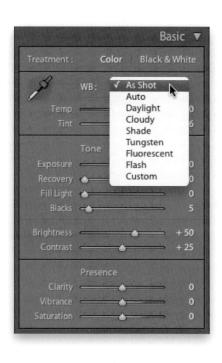

SCOTT KELI

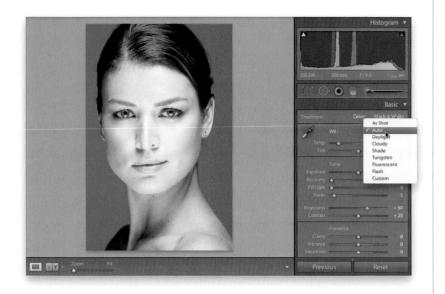

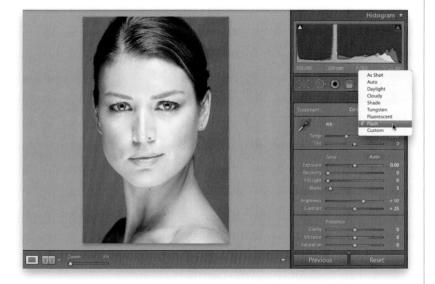

Step Three:

In our photo shown in Step One, her skin looks a bit yellowish, and the whole tone of the photo looks a bit too warm, so it definitely needs a white balance adjustment. (*Note:* If you want to follow along here using this same image, you're welcome to download it from www.kelbytraining .com/books/LR3.) So, go ahead and choose Auto from the White Balance pop-up menu and you'll see how that would look (as you can see here, her skin actually looks somewhat better, but the gray background behind her is blue, and the highlights in her hair are blue, and well, her skin, while a little better, is kinda...bluish). The next three White Balance presets down will all be warmer (more yellow), with Daylight being a bit warmer, Cloudy being warmer still, and Shade being a lot warmer. Go ahead and choose Cloudy, and you can see the whole photo is much too warm.

Step Four:

If you choose either of the next two down— Tungsten or Fluorescent—they're going to be way crazy blue, so you don't want either of those, but Flash (shown here) while not perfect is at least decent (take a moment and try each of those, just so you see how they affect the photo). The last preset isn't really a preset at all—Custom just means you're going to create the white balance manually using the two sliders beneath the pop-up menu. Now that you know what these presets look like, here's what I recommend when you're working with your own images: First, quickly run through all the presets and see if one of them happens to be "right on the money" (it happens more than you might think). If there isn't one that's right on the money, choose the preset that looks the closest to being right (in this case, I felt it was the Flash preset, which isn't nearly as warm or as blue as any of the others, but the gray background behind her now looks a tad brownish to me).

Step Five:

So now that you've chosen a preset that's kind of "in the ballpark," you can use the Temp and Tint sliders to dial in a better looking final White Balance setting. I zoomed in here on the Basic panel so you can get a nice close-up of the Temp and Tint sliders, because Adobe did something really great to help you out here—they colorized the slider bars, so you can see what will happen if you drag in a particular direction. See how the left side of the Temp slider is blue, and the right side graduates over to yellow? That tells you exactly what the slider does. So, without any further explanation, which way would you drag the Temp slider to make the photo more blue? To the left, of course. Which way would you drag the Tint slider to make the image more magenta? See, it's a little thing, but it's a big help.

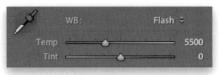

Here's the White Balance temperature settings when you choose the Flash preset

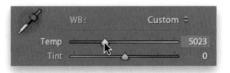

To make the gray background look less brown (warm), I dragged the Temp slider away from yellow toward blue (see Step Six)

Step Six:

Again, after choosing the Flash preset, the background looks a little brownish (too warm), so click-and-drag the Temp slider slowly to the left (toward blue), until the brown is removed from the background and it looks gray (of course, don't drag too far to the left, or it will turn blue again). In the example you see here, I dragged to the left until it looked right (I started with the temperature at 5500. When I was done, the Temp reading was 5023, as seen in Step Five). That's all there is to it—use a White Balance preset as your starting place, then use the Temp slider to tweak it until it looks right. Now, if you feel the image is too magenta, then try dragging the Tint slider away from magenta, toward green (again, drag slowly and don't go too far).

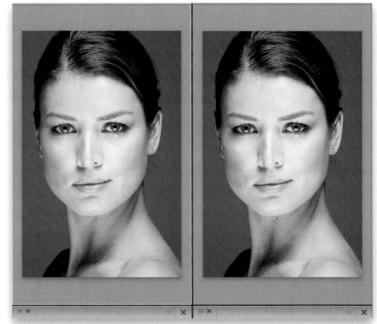

The Flash preset's temperature setting of 5500 makes the background look brownish

After dragging a little bit toward blue, to a temperature setting of 5023, the brown background turns gray

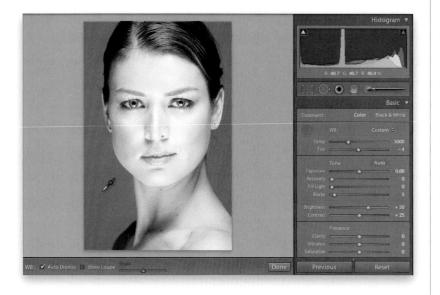

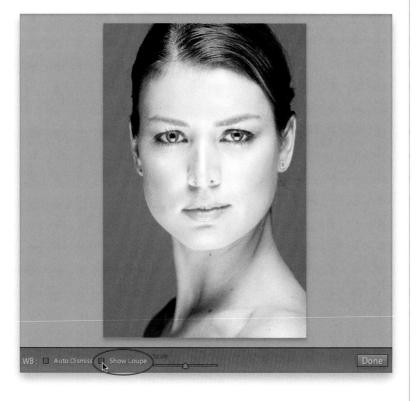

Step Seven:

Now that you've learned those two ways to adjust your white balance (the preset alone, and then the preset with Temp and Tint slider tweaks), I want to show you my personal favorite way, and the way I think you'll usually get the best, most accurate results, and that is to use the White Balance Selector tool (it's that huge eyedropper on the top-left side of the White Balance section). First, choose As Shot from the White Balance pop-up menu, so we're starting from scratch with this. Now click on the tool to get it, then click it on something in your photo that's supposed to be light gray (that's right-don't click on something white—look for something light gray. Video cameras white balance on solid white, but digital still cameras need to white balance on a light gray instead). In the example shown here, I clicked on the background, and just clicking once with this tool set the right white balance for me (you can see the Temp is now set to 5000, and the Tint to -4, which added a tiny bit of green to balance things out).

Step Eight:

Before we go any further, that big pixelated grid that appears while you're using the White Balance Selector tool is supposed to magnify the area your cursor is over to help you find a neutral gray area. To me, it just gets in the way, and if it drives you crazy (like it does me), you can get rid of it by turning off the Show Loupe checkbox down in the toolbar (I've circled it here in red, because my guess is you'll be searching for that checkbox pretty quickly). Now you get just the eyedropper (as shown in Step Seven), without the huge annoying pixel Loupe (which I'm sure is fine for some people, so if that's you, replace "annoying" with the term "helpful").

Step Nine:

Although I'm not a fan of the "helpful" pixel Loupe, there is a feature that's a really big help when you use the White Balance Selector tool, and that's the Navigator panel on the top of the left side Panels area. What's cool about this is, as you hover the White Balance Selector tool over different parts of your photo, it gives you a live preview of what the white balance would look like if you clicked there. This is huge, and saves you lots of clicks, and lots of time, when finding a white balance that looks good to you. For example, set the White Balance to Auto, then hover the White Balance Selector tool over the background area (as shown here), and then look at the Navigator panel to see how the white balance would look if you clicked there. Pretty sweet, eh? You could click the tool as many times as you'd like to try out different white balance looks, but honestly, just looking over in the Navigator panel is quicker and easier.

Step 10:

A couple of last things you'll want to know about white balance: (1) When you're finished using the tool, either click it back where you got it from (that round, dark gray circle in the Basic panel), or click the Done button down in the toolbar. (2) In the toolbar, there's an Auto Dismiss checkbox. If you turn this on, it means that after you click the tool once, it automatically returns to its home in the Basic panel. I leave this turned off, so I can easily just click in a different area without having to retrieve the tool each time. (3) To return to the original As Shot white balance, just choose As Shot from the White Balance (WB) presets pop-up menu. (4) If you're in the Library module, and you know you need to get the White Balance Selector tool, you can press W, which will switch you over to the Develop module and give you the tool.

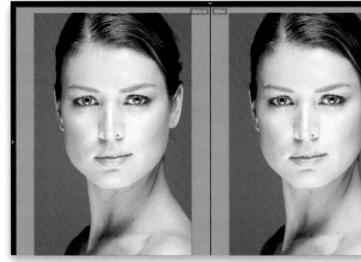

The original As Shot white balance setting, which looks too warm and yellowish overall, and the gray background looks kinda brownish

Here's the image after just one click with the White Balance Selector tool. The gray background is gray again, and her skin tone looks good

Web

The fact that you can now shoot tethered directly from your camera, straight into Lightroom, is one of my favorite features in Lightroom 3, but when I learned the trick of having the correct white balance applied automatically, as the images first come into Lightroom, it just put me over the top. So much so that I was able to include a free, perforated tear-out 18% gray card in the back of this book, so you can do the exact same thing (without having to go out and buy a gray card. A big thanks to my publisher, Peachpit Press, for letting me include this). You are going to love this!

Setting Your White Balance Live While Shooting Tethered

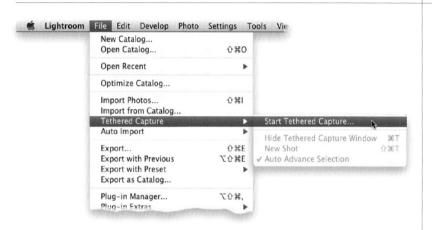

Step One:

Start by connecting your camera to your computer (or laptop) using a USB cable, then go under Lightroom's File menu, under Tethered Capture, and choose **Start Tethered Capture** (as shown here). This brings up the Tethered Capture Settings dialog, where you choose your preferences for how the images will be handled as they're imported into Lightroom (see page 22 in Chapter 1 for more details on this dialog and what to put in where).

Step Two:

Once you get your lighting set up the way you want it (or if you're shooting in natural light), place your subject into position, then go to the back of this book, and tear out the perforated 18% gray card. Hand the gray card to your subject and ask them to hold it while you take a test shot (if you're shooting a product instead, just lean the gray card on the product, or somewhere right near it in the same light). Now take your test shot with the gray card clearly visible in the shot (as shown here).

Step Three:

When the photo with the gray card appears in Lightroom, get the White Balance Selector tool (W) from the top of the Develop module's Basic panel, and click it once on the gray card in the photo (as shown here). That's it—your white balance is now properly set for this photo. Now, we're going to take that white balance setting and use it to automatically fix the rest of the photos as they're imported.

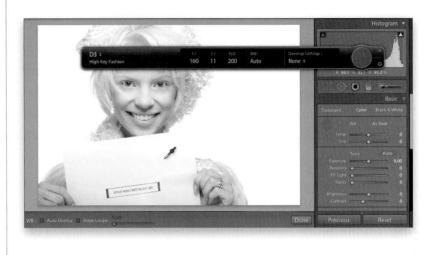

Step Four:

Go back to the Tethered Capture window (press Command-T [PC: Ctrl-T] if it's no longer visible) and on the right side, from the Develop Settings pop-up menu, choose Same as Previous. That's it—now you can take the gray card out of the scene (or get it back from your subject, whose probably tired of holding it by now), and you can go back to shooting. As the next photos you shoot come into Lightroom, they will have that custom white balance you set to the first image applied to the rest of them automatically. So, now not only will you see the proper white balance for the rest of the shoot, that's just another thing you don't have to mess with in postproduction afterwards. Again, a big thanks to my publisher, Peachpit Press, for allowing me to include this gray card in the book for you.

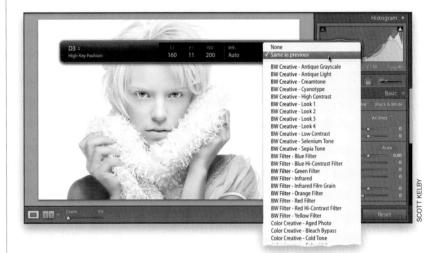

Web

In that last project, I ended with a before and after, but I didn't get a chance to show you how. I love the way Lightroom handles the whole before and after process because it gives you a lot of flexibility to see these the way you want to see them. Here's how.

Seeing Befores and Afters

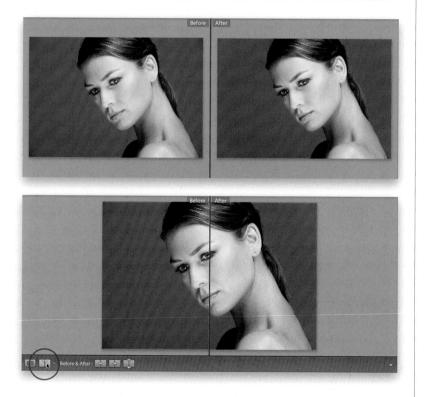

Step One:

Any time you're working in the Develop module and you want to see what your image looked like before you started tweaking it (the "before" image), just press the \ **(backslash) key** on your keyboard. You'll see the word "Before" appear in the upperright corner of your image, as seen here. In this image (from the same series we used for white balance), you're seeing the overly warm original image. This is probably the Before view I use the most in my own workflow. To return to your After image, press the \ key again (it doesn't say "After;" the Before just goes away).

Step Two:

To see a side-by-side Before and After view (shown here on top), press the letter **Y** on your keyboard. If you prefer a split screen view, then click the little Before and After Views button in the bottom-left corner of the toolbar under your preview (as shown here on the bottom. If you don't see the toolbar for some reason, press the letter **T** to make it visible). If you click the Y button again, instead of a side-by-side before and after, you get a top/bottom before and after. Click it again, and you get a top/bottom split screen before and after. To return to Loupe view, just press the letter **D** on your keyboard.

Note: Just so you know, our model here, Orsolya, is wearing an off-the-shoulder top, so we could shoot this beauty-style headshot. I mention this so you don't think she's (ahem) less than clothed. Come on, you know you were thinking it!

Applying Changes Made to One Photo to Other Photos

This is where your workflow starts to get some legs, because once you've edited one photo, you can apply those exact same edits to other photos. For example, in that last project, we fixed the white balance for that one photo. But what if you shot 260 photos during one shoot? Well, now you can make your adjustments (edits) to one of those photos, then apply those same adjustments to as many of the other photos as you'd like. Once you've selected which photos need those adjustments, the rest is pretty much automated.

Step One:

We're going to finish up with our final images from that beauty headshot shoot; let's start by fixing the white balance. In the Library module, click on a photo then press **W**, which is the Adjust White Balance shortcut (it takes you to the Develop module and gives you the White Balance Selector tool), so all you have to do now is click on something light gray in the photo (I pressed **Shift-Y**, so you could see a before/after split view here). So, that's the first step—fix the white balance, then press **D** to return to Loupe view (just a reminder, you can download this photo and follow along at **www** .**kelbytraining.com/books/LR3**).

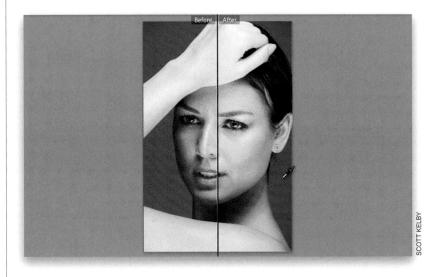

Step Two:

Now click the Copy button at the bottom of the left side Panels area. This brings up the Copy Settings dialog (shown here), which lets you choose which settings you want to copy from the photo you just edited. By default, it wants to copy a bunch of settings (several checkboxes are turned on), but since we only want to copy the white balance adjustment, click on the Check None button at the bottom of the dialog, then turn on just the checkbox for White Balance, and click the Copy button.

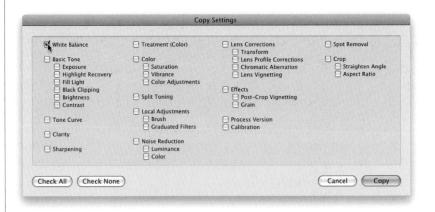

elop Slic

eshow Print V

Web

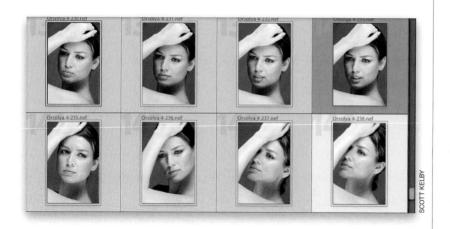

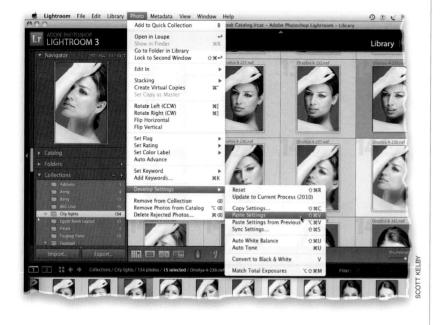

Step Three:

Now press **G** to return to the Grid view, and select the photos you want to apply this white balance change to (as shown here). If you look in the top row of the grid here, you can see that the fourth photo is the one I corrected the white balance on, so it's the only photo not selected. By the way, if you want to apply the correction to all your photos from the shoot at once, you can just press **Command-A (PC: Ctrl-A)** to Select All your photos. It doesn't matter if your original gets selected again—won't hurt a thing.

TIP: Choosing Other Adjustments

Although here we're just copying-andpasting a White Balance setting, you can use this function to copy-and-paste as many attributes as you want. If I've made a few edits in an area, I would just turn on the checkbox for that entire area in the Copy Settings dialog (in other words, I'd turn on the Basic Tone checkbox for my Basic panel edits, which automatically turns on all the tonal edit checkboxes. It just saves time).

Step Four:

Now go under the Photo menu, under Develop Settings, and choose **Paste Settings** (as shown here), or use the keyboard shortcut **Command-Shift-V** (**PC: Ctrl-Shift-V**), and the White Balance setting you copied earlier will be applied to all your selected photos (as seen here, where the white balance has been corrected on all those selected photos).

TIP: Fixing Just One or Two Photos

If I'm in the Develop module, fixing just one or two photos, I fix the first photo, then in the Filmstrip, I move to the other photo I want to have the same edits and I click the Previous button at the bottom of the right side Panels area, and all the changes I made to the previously selected photo are now applied to that photo.

How to Set Your Overall Exposure

Now that your white balance is set, the next thing we adjust is our overall exposure. Although there is an Exposure slider, it takes three sliders (and sometimes four) to set the overall exposure. Luckily, not only is this much easier than it sounds, Lightroom has all kinds of tools to help make your job easier.

Step One:

To set your overall exposure, you use the Tone section of the Basic panel (that section is shown within a red rectangle here). The photo shown here looks underexposed, and if you look up in the Histogram panel at the top of the right side Panels area, you can see there's virtually no data on the right side of the histogram (that's where all the highlights should be). So if you were wondering, "Is it underexposed?" well, there's your answer.

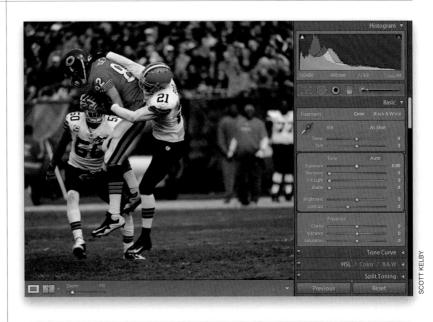

Step Two:

To make the overall photo brighter, just click-and-drag the Exposure slider to the right, as shown here (just like with the White Balance sliders, you get a visual cue of which way to drag by looking at the slider itself-white is on the right side of the slider, so dragging right [toward white] would make this adjustment lighter, and dragging left [toward black] would make things darker). Easy enough. However, there's one critically important thing to watch out for: if you drag too far to the right, you run the risk of losing detail in your highlights (in other words, your highlights get so bright that they literally "blow out" and you lose all detail in those areas). This is called "clipping" your highlights, and luckily Lightroom not only warns you if this happens, but in most cases, you can also fix it.

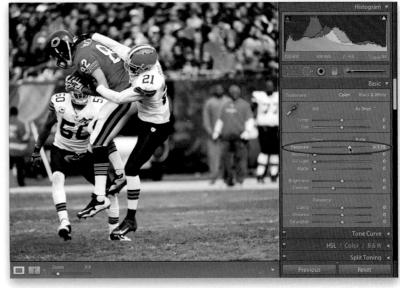

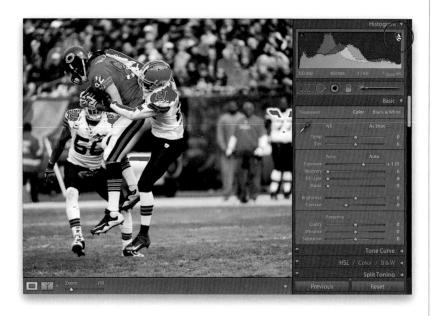

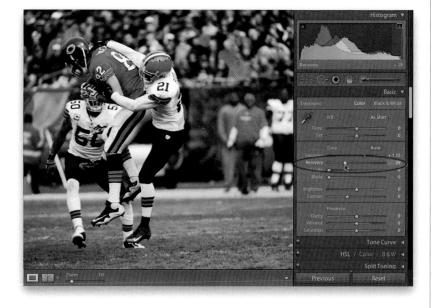

Step Three:

If you look again at the Histogram panel at the top of the right side Panels area, you'll see a triangle in the top-right corner. That is the highlight clipping warning triangle, and ideally, this triangle should always stay solid black. If it turns blue, it means you're losing highlight detail, but just in the Blue channel (which isn't great, but it's not the worst thing in the world). If it's red or green, you're losing detail in that channel. However, the worst-case scenario is that it appears solid white (as shown here), which means all three channels have lost detail, and your highlights are totally clipped (I call this the "Triangle of Death!"). But here's the critical question: Are you clipping off highlights in an area of important detail? If not, you can ignore the warning (for example, if you have a shot where you can see the sun, that sun is going to clip, but there's no detail there anyway, so we ignore it). To find out where you're clipping, click on that white triangle, and the areas that are clipping will appear in solid red (as seen here, where #21's and #50's white football jerseys have lots of clipped areas).

Step Four:

In our example here, those jerseys definitely should have detail. If you lower the Exposure slider, the clipping will go away, but your exposure will be too dark again. If this happens to you (and believe me, it will), then grab the Recovery slider—one of the most brilliant features in all of Lightroom. As you click-and-drag the Recovery slider to the right, it only pulls back the very brightest highlights (those super-bright areas that were clipping), so it doesn't trash your overall exposure—you just drag to the right until the red warnings on your photo go away, and your triangle is black again (as shown here). This is a double-win-you get the brighter exposure the photo needs, but you avoid the clipped highlights that it would normally bring.

Step Five:

I always start by adjusting the Exposure slider first, and then if I see a clipping warning, I go to the Recovery slider and drag it to the right until my highlights come back into line. By the way, if you don't like seeing the clipped areas appear in red (or if you're working on a photo with a lot of red in it already, so the red clipping warnings get lost), instead, you can press-and-hold the Option (PC: Alt) key as you click-and-drag the Exposure slider. The screen turns solid black, and any areas that are clipping will show up in white (as seen here). You can also hold this same key as you click-and-drag the Recovery slider, and you just keep dragging until all the areas turn solid black again.

TIP: Toggling the Warnings On/Off You don't have to go up there and click on that triangle every time. If you press the letter **J** on your keyboard, it toggles that red clipping warning that appears over the clipped highlights in your photo on/off.

Step Six:

We're going to jump over to a different photo for a just a moment, to tell you about another hidden benefit of using the Recovery slider: it works wonders in adding detail and drama to skies in landscape shots (especially ones with lots of clouds). Just click-and-drag the Recovery slider all the way over to the right (to 100), and watch what it does for your skies. Give it a try and see what you think.

TIP: Speed Editing

This may be my favorite shortcut in all of Lightroom: to jump to the next slider in the Basic panel, just press the **. (period) key** on your keyboard (you'll see the adjustment name highlight) and use the **+ (plus sign) key** and **- (minus sign) key** to increase or decrease the amount; press the **, (comma) key** to move back. I love it!

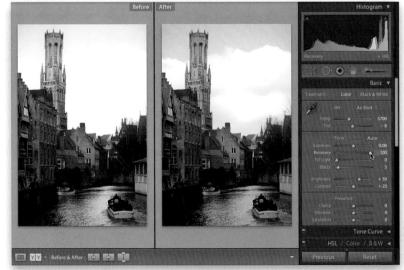

COTT KELBY

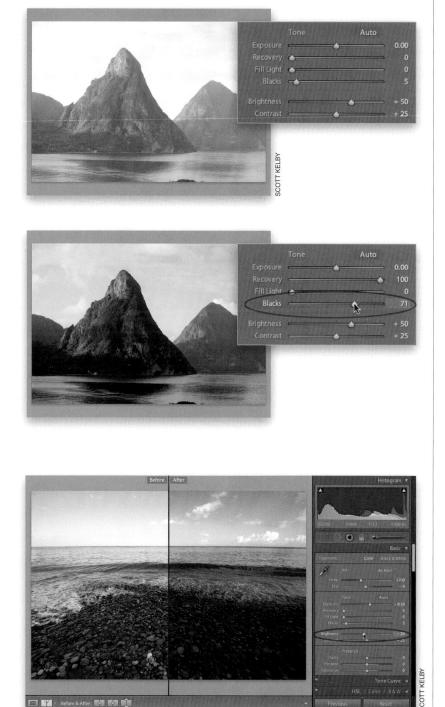

Step Seven:

I'm switching to a different photo for the next step in adjusting our overall exposure, where we'll use the Blacks slider (we're skipping over the Fill Light slider until Chapter 6, because it's for when you have trouble with a backlighting situation). The Blacks slider adjusts the darkest shadow areas in your photo, and dragging to the right increases the amount of black in the shadows-dragging to the left lightens them. I drag this slider to the right any time my photo looks washed out, because it can bring back color and depth to shadow areas (the original image is shown on top here, and in the bottom, I increased the Blacks and the Recovery amount to bring back detail in the sky). I'm not nearly as concerned with losing shadow detail as I am highlight detail, but if you're a "shadow detail freak", you can use the histogram's top-left corner triangle as your shadow clipping warning, or press J, and any shadow areas that are clipping will appear in blue on your photo.

Step Eight:

The Brightness slider (circled here) acts as a midtones slider (if you're familiar with Photoshop's Levels control, it's like the center midtones slider). To brighten the midtones, click-and-drag to the right (to darken the them, drag to the left). I grab this slider anytime I have a washed-out sky—lowering the amount of brightness can make the sky look rich and blue again (in the before/after shown here, I lowered the Brightness amount to -20, but then it looked a little dark, so I increased the Exposure amount a little bit to brighten things back up). We ignore the Contrast slider here (dragging it to the right makes the bright areas brighter and the darker areas darker), because we add contrast with a more powerful tool (the Tone Curve), which you'll learn about shortly.

Step Nine:

The Histogram panel at the top of the right side Panels area is helpful because, by just looking at it, you can tell if your highlights are blown out. For example, if your histogram shows a bunch of pixels stacked up against the far right-side wall, it tells you right there that plenty of your highlights are clipped (ideally, you'd have a little gap at the right end of your graph, with nothing touching the right-side wall). But beyond just giving you a readout, it can help you figure out which slider adjusts which part of the histogram. Try this: move your cursor over part of the histogram and then look directly below the histogram itself, and you'll see not only the name of the slider which affects that part of the histogram, it even highlights the number field of that slider down in the Tone section for you to make it easier to find (as seen here). Here, my cursor is over the far-right side, and you can see that the Recovery slider is what would affect that far-right side of the histogram. Pretty helpful-but there's more.

Step 10:

You can actually click-and-drag anywhere right on the histogram itself, and as you drag left or right, it literally moves that part of the histogram (and the accompanying slider) as you drag. That's right, you can do your corrections by just dragging the histogram itself. You gotta try this—just move your cursor up over the histogram, click, and start dragging. By the way, in all honesty, I don't personally know anyone that actually corrects their photos by dragging the histogram like this, but it sure is fun just to give it a try.

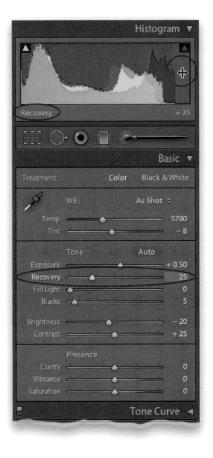

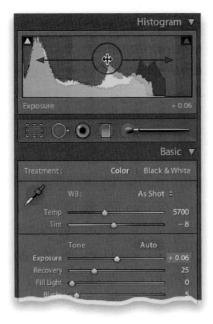

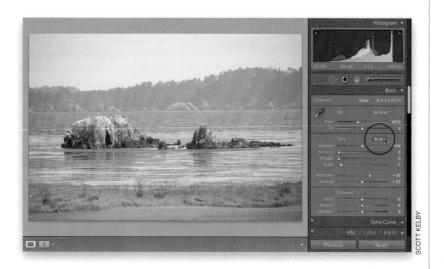

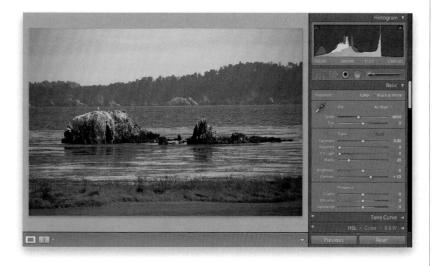

Step 11:

One thing we haven't talked about thus far is the Auto Tone button, which appears above the Exposure slider (shown circled here in red). This function has been getting better and better since Lightroom 1 (where clicking it was a huge mistake), and now in Lightroom 3, they've made it even better by adding in the ability to also adjust the Fill Light amount when it does an auto toning of your image. Anytime you're stuck not knowing what to do with a photo, at least give Auto Tone a try. It's now a lot better than you'd think.

TIP: Resetting Your Sliders

You can reset any slider to its original setting by double-clicking on the little slider "nub" (that thing that you drag), but I find it's easier just to double-click on the name of the slider—that resets it, too.

Step 12:

Here's the image after clicking the Auto Tone button. You can see that while it doesn't do a totally kick-butt job, it doesn't do a rotten job either (so it's at least usable as a starting point, if you're stuck about where to start). Sometimes it works great, other times...not so much, but at least now it's usable. One thing to watch out for: I can't explain why, but sometimes when you use it, it will actually tweak the image, so it now has clipped highlights. I knowideally it should know better, but sometimes it just doesn't, so keep an eye out for that, and if it does clip your highlights, drag the Recovery slider to the right until they go away.

Okay, that's the basic three sliders you'll use to adjust your exposure. I wind up using the Exposure slider the most, the Blacks second most, and the Brightness the least of the three. You'll find that some images need just a tweak of the Exposure slider, and some need all three, but luckily now you know what they do.

Adding "Punch" to Your Images Using Clarity

When Adobe was developing the Clarity control, they had actually considered calling the slider "Punch," because it adds midtone contrast to your photo, which makes it look, well...more punchy. So, when you see an image that needs more snap or punch (I use it on almost every photo), then get some clarity.

Step One:

Here's the original photo, without any clarity being applied. Now, because (as I said above) clarity adds midtone contrast to your photo, it makes the photo appear to have had the midtones sharpened, and that's what gives it its punch. But before you apply any clarity, to really see the effects of the slider, you should zoom in to a 1:1 view, so head over to the Navigator panel and click on 1:1 first to get you to a 100% view of your image (shown below).

Now, just click-and-drag the Clarity slider to the right to add more punch and midtone contrast (dragging to the left actually decreases midtone contrast, so you might want to try a Clarity setting of -100 to soften and diffuse a portrait). I apply between +25 and +50 clarity to nearly every photo I process, with the only exception being photos that I intentionally want to be softer and less contrasty (so, for a portrait of a mother and baby, or a closeup portrait of a woman, I leave the Clarity slider set to 0 or use a negative number). For images that can really "eat up" the clarity, like architectural shots (like the one you see here) or sweeping landscapes, I'll sometimes go as high as +75, but as always, you just have to look at the photo, apply some clarity, and see which amount looks best to you. You can really see the effect of clarity in the example here, where I took the amount to 100, but as I said, +75 is about my top end limit (if you go too high, you'll sometimes see a dark glow around the edges of your subject).

Web

Photos that have rich, vibrant colors definitely have their appeal (that's why professional landscape photographers got so hooked on Velvia film and its trademark saturated color), and although Lightroom has a Saturation slider for increasing your photo's color saturation, the problem is it increases all the colors in your photo equally—while the dull colors do get more saturated, the colors that are already saturated get even more so, and well...things get pretty horsey, pretty fast. That's why Lightroom's Vibrance control may become your Velvia.

Making Your Colors More Vibrant

Step One:

In the Presence section (at the bottom of the Basic panel) are two controls that affect the color saturation. I avoid the Saturation slider for the reasons mentioned aboveeverything gets saturated at the same intensity (it's a very coarse adjustment). If you click-and-drag the Saturation slider to the right, your photo does get more colorful, but in a clownish, unrealistic kind of way (the over-saturation won't show up here in the printed book because the photos here get converted to CMYK for a printing press, so I'm just showing the original photo here, untouched). But, go ahead and try it yourself-drag the Saturation slider to the far right and you'll see what I mean. Now, return the Saturation amount back to 0.

Step Two:

Now try the Vibrance slider—it affects dull colors the most (like the pink flowers), and it affects already saturated colors the least (like the yellow capitulum and the grass behind them), and lastly, it does try to avoid affecting fleshtones as much as possible (which doesn't come into play in this particular photo). This gives a much more realistic-looking color saturation across the board, without trashing your skin tones, which makes this a much more usable tool. Here's the same photo using the Vibrance slider instead. The petals look much more vibrant, but without looking "clowny" (I bet that word throws my spell checker for a loop). So, unless I'm desaturating an overly colorful photo, I pretty much avoid the Saturation slider altogether.

Using the Tone Curve to Add Contrast

Once we've made our edits in the Basic panel, next we head down to the Tone Curve panel to adjust the overall contrast in our photos (I recommend doing your basic edits in the Basic panel, then using the tone curve to finish things off). We use this tone curve rather than the Contrast slider (in the Basic panel, which we intentionally skipped over earlier), because this gives us much more control, plus the tone curve (1) helps keep you from blowing out your highlights, (2) actually helps you see which areas to adjust, and (3) lets you adjust the contrast interactively.

Step One:

If you scroll down past the Basic panel, you'll find the Tone Curve panel (shown here), which is where we apply contrast to our photo (rather than using the Contrast slider in the Basic panel, which seems too broad in most cases). If the photo you're viewing was shot in JPEG or TIFF mode, there's no Tone Curve contrast applied (look at the bottom of the Tone Curve panel, and you'll see the word Linear [shown circled here in red], which just means the curve is flat-there's no contrast applied). If you shot it in RAW, by default, it already has a medium amount of contrast applied to it, so that pop-up menu would say "Medium" instead (the reason is when you shoot in IPEG, your camera applies contrast. When you shoot in RAW, you're telling your camera not to add stuff like contrast).

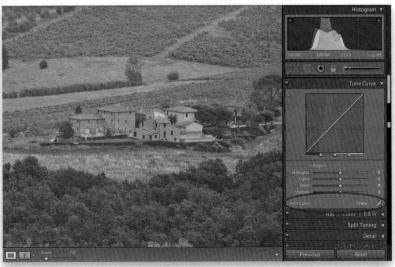

Step Two:

The fastest and easiest way to apply contrast is just to choose one of the presets from the Point Curve pop-up menu. For example, choose Strong Contrast and then look at the difference in your photo (I clicked the Before and After Views button in the toolbar a couple of times to get this split screen view). Look how much more contrasty the photo now looks—the shadow areas are stronger, and the highlights are brighter, and all you had to do was choose this from a pop-up menu. You can see the contrast curve that was applied in the graph at the top of the panel.

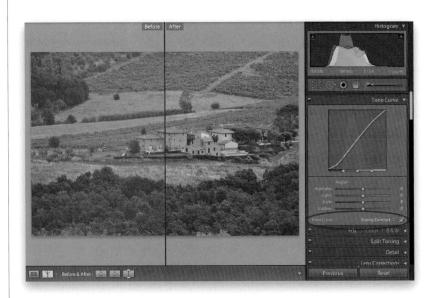

Develop

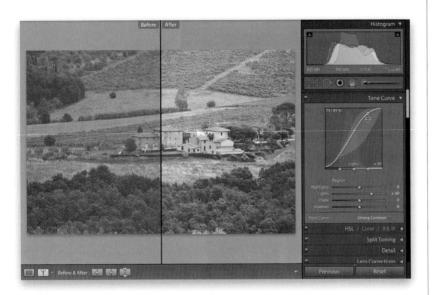

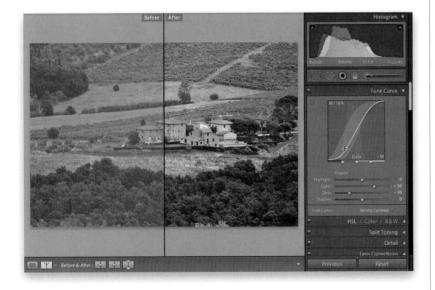

Step Three:

If you think that the Strong Contrast preset isn't quite strong enough (and in this case, I still think it needs a lot more contrast), you can edit this curve yourself, but it's helpful to know this rule: the steeper the curve, the stronger the contrast. So to make this curve steeper, you'd move the top of the curve (the highlights) upward, and the bottom of the curve (the darks and shadows) downward. To do this, just move your cursor right over the graph (as shown here), and you'll see a little round "point" appear on the curve. As you move your cursor in the graph, you'll see the point slide up and down the curve line. So, when it's at the top, you can click-and-drag it upward, but I think it's actually easier to just use the **Up Arrow key** on your keyboard to nudge it upward a bit (it's easier than trying to click right on that moving point).

Step Four:

Here, I've nudged it up by pressing the Up Arrow key on my keyboard. The curve is now steeper, and I have more contrast in the highlights. I can do the same thing in the bottom left of the curve—I would just nudge the curve downward instead, which would give me a much steeper curve (as seen here), and a much more contrasty image, as you can see. Also, as you're moving your cursor over the graph, you'll notice that at the bottom of the graph itself, it tells you which part of the curve you'd be adjusting if you moved the point now.

TIP: Moving in Different Increments Using the Up/Down Arrow keys moves the point in small 5-point increments. To move in 20-point increments, press-andhold the Shift key while using the Arrow keys. For really precise adjustments (1-point increments), press-and-hold the Option (PC: Alt) key while you use the Arrow keys.

Step Five:

Another way to adjust the contrast using the tone curve is to use the Targeted Adjustment tool (or TAT, for short). The TAT is that little round target-looking icon in the top-left corner of the Tone Curve panel (when you move your cursor over it, two triangles pointing up and down will show. It's shown circled here in red). When you click on that little target icon, your cursor changes to the cursor seen here on the right-a precise crosshair cursor to the top left of a little target icon with triangles on the top and bottom. This tool lets you interactively adjust the tone curve by clicking-and-dragging it right within your photo. The crosshair part is actually where the tool is located—the target with the triangles is there just to remind you which way to drag the tool, which (as you can see from the triangles) is up and down.

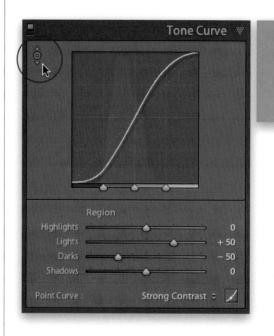

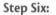

Now, let's put it to use. Take the TAT and move it out over your photo (over the brown grass, in this case). Look over at the tone curve and you'll see two things: (1) there's a point on the curve where the tones you're hovering over are located, and (2) the name of the area you'll be adjusting appears at the bottom of the graph (in this case, it says Lights). To darken the grass, just click on that area (as shown here) and drag straight downward (if you had dragged straight upward, it would have brightened the grass instead). You can move around your image and click-anddrag straight upward to adjust the curve to brighten those areas, and drag straight downward to have the curve darken those areas. When you're done, click the TAT back where you found it. By the way, the keyboard shortcut to get the TAT is Command-Option-Shift-T (PC: Ctrl-Alt-Shift-T).

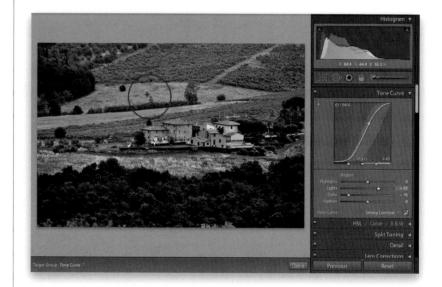

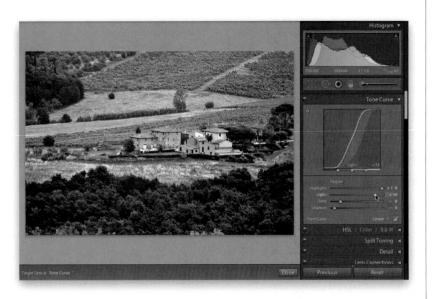

Step Seven:

The final method of adjusting the tone curve is to simply click-and-drag the four Region sliders (Highlights, Lights, Darks, and Shadows) near the bottom of the panel, and as you do, it adjusts the shape of the curve. Here, I dragged the Highlights slider to the far right to brighten the highlights. I dragged the Darks and Shadows sliders pretty far to the left to make the trees and grass much darker, and I moved the Lights slider quite a bit to the right to bring out some upper midtones and lower highlights. Also, if you look at the sliders themselves, they have the same little gradients behind them like in the Basic panel, so you know which way to drag (toward white to make that adjustment lighter, or toward black to make it darker). By the way, when you adjust a curve point (no matter which method you choose), a gray shaded area appears in the graph showing you the curve's boundary (how far you can drag the curve in either direction).

Step Eight:

So, that's the scoop. To adjust your photo's contrast, you're going to either: (a) use a preset contrast curve from the Point Curve pop-up menu, (b) use the TAT and click-and-drag up/down in your photo to adjust the curve, (c) use either one of those two, then move the point up/down using the **Arrow keys** on your keyboard, or (d) manually adjust the curve using the Region sliders. Note: If you find that you're not using the sliders, you can save space by hiding them from view: click on the Point Curve button to the right of the Point Curve pop-up menu (shown circled here in red). If you decide you want them back one day, click that same button again.

Step Nine:

There are three more things you'll need to know about the Tone Curve panel, and then we're set. The first is how to use the three slider knobs that appear at the bottom of the graph. Those are called Range sliders, and essentially they let you choose where the black, white, and midpoint ranges are that the tone curve will adjust (you determine what's a shadow, what's a midtone, and what's a highlight by where you place them). For example, the Range slider on the left (shown circled here in red) represents the shadow areas, and the area that appears to the left of that knob will be affected by the Shadows slider. If you want to expand the range of what the Shadows slider controls, click-and-drag the left Range slider to the right (as shown here). Now your Shadows slider adjustments affect a larger range of your photo. The middle Range slider covers the midtones. Clicking-and-dragging that midtones Range slider to the right decreases the space between the midtone and highlight areas, so your Lights slider now controls less of a range, and your Darks slider controls more of a range. To reset any of these sliders to their default position, just double-click directly on the one you want to reset.

Step 10:

The second thing you'll want to know is how to reset your tone curve and start over. Just double-click directly on the word Region and it resets all four sliders to 0. Lastly, the third thing is how to see a before/after of just the contrast you've added with the Tone Curve panel. You can toggle the Tone Curve adjustments off/on by using the little switch on the left side of the panel header (shown circled here). Just click it on or off. As we finish this off, here's a before/after with no adjustments whatsoever except for the Tone Curve. It's more powerful than it looks.

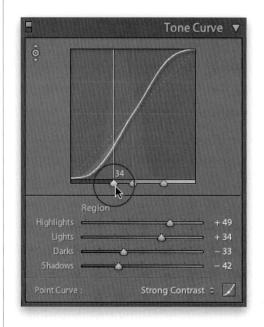

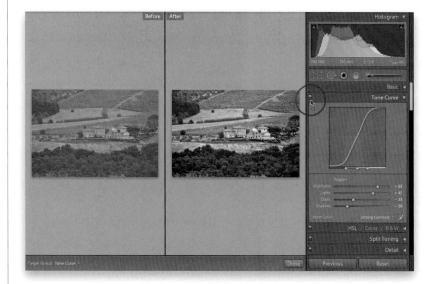

If you want to make a global change to a particular color in your image (for example, let's say you want all the reds to be redder, or the blue in the sky to be bluer), one place to do that would be the in the HSL panel (HSL stands for Hue, Saturation, and Luminance), and/or the Color panel (these are grouped with the B&W panel, but since we're just focusing on boosting [or reducing] individual colors, we'll cover the black-and-white part later in the book). Here's how this works:

Adjusting Individual Colors Using HSL

Print

Step One:

When you want to adjust an area of color, scroll down to the HSL panel in the right side Panels area (by the way, those words in the panel header, HSL/Color/B&W, are not just names, they're buttons, and if you click on any one of them, the controls for that panel will appear). Go ahead and click on HSL (since this is where we'll be working for now), and four buttons appear in the panel: Hue, Saturation, Luminance, and All. The Hue panel lets you change an existing color to a different color by using the sliders. Just so you can see what it does, click-and-drag the Yellow slider all the way to the left, and you'll see it turns the yellow tachometer on this Ferrari orange. (In case you're wondering, this isn't my Ferrari. Mine's much newer. Totally kidding—sadly, I don't have a Ferrari.) Now press the Reset button (at the bottom of the Panels area) to undo your change.

Step Two:

In this photo, the interior of this convertible Ferrari was in the shade, so there's kind of a blue color cast on the steering wheel. If I changed the white balance, it would change the entire color of the image-I just want the blue out of the steering wheel. A perfect task for the HSL panel. So, to remove that blue, you'd click on the Saturation button at the top of the HSL panel. The same eight sliders stay in place, but now those sliders control the saturation of colors in your image. Just click-and-drag the Blue slider to the left until the blue is removed from the steering wheel (as shown here, where I dragged it all the way to the left).

Step Three:

If you know exactly which color you want to affect, you can just grab the slider and click-and-drag it. But if you're not sure which colors make up the area you want to adjust, then you can use the TAT (the same Targeted Adjustment tool you used back in the Tone Curve panel, but now you're using it to adjust color, instead of contrast). Click on the TAT (shown circled in red here), then move your cursor over the yellow logo in the center of the steering wheel and click-and-drag upward to increase the color saturation. You'll notice that it doesn't just move the Yellow slider, but it also increases the Green Saturation slider, as well. You probably wouldn't have realized that there was any green in the logo, and this is why this tool is so handy here. In fact, I rarely use the HSL panel without using the TAT!

Step Four:

Now click on Luminance, at the top of the panel (this panel's sliders control the overall lightness or darkness of the colors). To brighten up just the tachometer, take the TAT, move it over the tachometer, then click-and-drag straight upward, and the tach will start to brighten (the Luminance for the Orange and Yellow both increased). If you're a Photoshop user, by now you've probably realized that this is pretty much a version of Photoshop's Hue/Saturation feature, with the only real differences being that it uses two extra color sliders (Orange and Purple), Lightroom calls "L" Luminance, whereas Hue/Saturation in Photoshop calls it Lightness, and Lightroom has an Aqua slider rather than Cyan. Plus, of course, Lightroom has the TAT (which is nice). Two last things: Clicking the All button (at the top of the panel) puts all three sections in one scrolling list, and the Color panel breaks them all into sets of three for each color—a layout more like Photoshop's Hue/ Saturation. But, regardless of which layout you choose, they all work the same way.

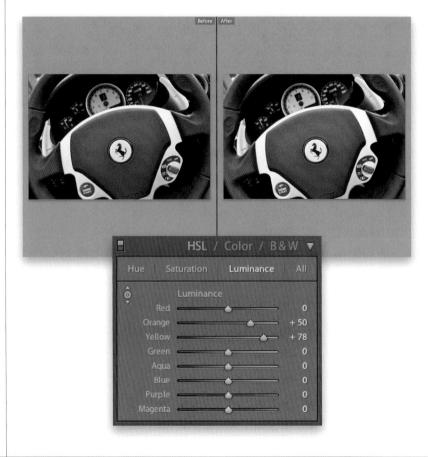

An edge vignette effect (where you darken all the edges around your image to focus the attention on the center of the photo) is one of those effects you either love or that drives you crazy (I, for one, love 'em). Here we're going to look at how to apply a simple vignette; one where you crop the photo and the vignette still appears (called a "post-crop" vignette), and how to use the new options just introduced in Lightroom 3.

Adding Vignette Effects

Step One:

To add an edge vignette effect, go to the right side Panels area and scroll down to the Lens Corrections panel (the reason it's in the Lens Corrections panel is this: some particular lenses darken the corners of your photo, even when you don't want them to. In that case, it's a problem, and you'd go to the Lens Corrections panel to fix a lens problem, right? There you would brighten the corners using the controls in this panel. So, basically, a little edge darkening is bad, but if you add a lot intentionally, then it's cool. Hey, I don't make the rules—I just pass them on). Here's the original image without any vignetting (by the way, we'll talk about how to get rid of "bad vignetting" in Chapter 6-the chapter on how to fix problems).

Step Two:

We'll start with regular full-image vignetting, so click on Manual at the top of the panel, then drag the Lens Vignetting Amount slider all the way to the left. This slider controls how dark the edges of your photo are going to get (the further to the left you drag, the darker they get). The Midpoint slider controls how far in the dark edges get to the center of your photo. So, try dragging it over quite a bit too (as I have here), and it kind of creates a nice, soft spotlight effect, where the edges are dark, your subject looks nicely lit, and your eye is drawn right where you want to look.

Step Three:

Now, this works just fine, until you wind up having to crop the photo, because cropping will crop away the edge vignette. To get around that problem, Adobe added a control called "Post-Crop Vignetting," which lets you add vignetting effects after you've cropped. I'm cropping that same photo in tight here, and now most of the edge vignetting I added earlier will be cropped off. So, scroll down to the Effects panel and at the top you'll see Post-Crop Vignetting. Before we try that, reset your Lens Vignetting Amount slider to 0 (zero), so we don't add the post-crop vignetting on top of the little bit of original vignetting still in our photo.

Step Four:

Before we get to the sliders, let's talk about the Style pop-up menu. You have three choices: (1) Highlight Priority, (2) Color Priority, and (3) Paint Overlay. We'll start with Highlight Priority, which is my favorite of the three. The reason I like it is the results are more like you get with the regular vignette. The edges get darker, but the color may shift a bit, and I'm totally okay with the edges looking more saturated. This choice gets its name from the fact that it tries to keep as much of the highlights intact, so if you have some bright areas around the edges, it'll try and make sure they stay bright. Again, this is my favorite choice, and is a big improvement on the old post-crop vignetting from Lightroom 2. I made the edges pretty darn dark here-darker than I would make mine, but I wanted you to really see the effect on the cropped image (just for example purposes).

Step Five:

The Color Priority style is more concerned with keeping your color accurate around the edges, so the edges do get a bit darker, but the colors don't get more saturated (as seen here—the edges also aren't as dark as the ones you saw in Step Four). Color Priority isn't a bad choice. It's a little more subtle in most cases (even when using the same Amount setting), and I think it's also better than the old Lightroom 2 post-crop look.

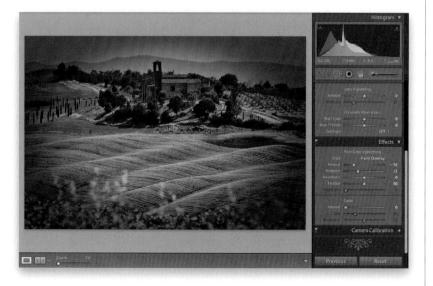

Step Six:

And finally Paint Overlay, seen here, gives you the same look we had back in Lightroom 2 for post-crop vignetting, which just painted the edges dark gray. I don't think this looks nearly as good (or realistic) as the other choices, which is why I don't use Paint Overlay at all (yeech!). Okay, so that's the styles thing. The Post-Crop Vignetting Amount and Midpoint sliders do the same thing as the standard Lens Vignetting feature (the Amount controls how dark the edges get, and the Midpoint determines how far in the darkening goes). Even though we've cropped the image in tight, when you drag the Amount slider over to the left quite a bit, and the Midpoint slider to the left a little bit, you can see the results.

Step Seven:

The next two sliders were added to make your vignettes look more realistic than the ones you applied in Lightroom 2. For example, the Roundness setting controls how round the vignette is (try leaving it set to 0, and then drag the Feather amount, which we'll talk about in a moment, all the way to the left). You see how it creates a very defined oval shape? Well, the Roundness setting controls how round that oval gets (drag the slider back and forth and you'll instantly get it).

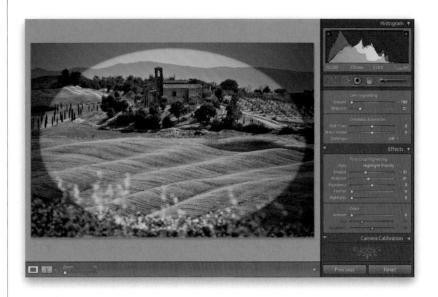

Step Eight:

The Feather slider controls the amount of softness of the oval's edge, so dragging this slider to the right makes the vignette softer and more natural looking. Here I clicked-and-dragged the Feather amount to 33, and you can see how it softened the edges of the hard oval you saw in the previous step. So, in short, the farther you drag, the softer the edges of the oval get. The bottom slider, Highlights, helps you to maintain highlights in the edge areas you're darkening with your vignette. The father to the right you drag it, the more the highlights are protected. The Highlights slider is only available if your Style is set to either Highlight Priority or Color Priority.

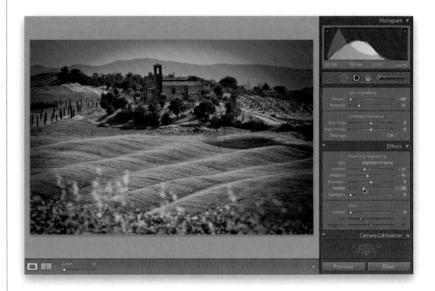

Web

There's a Photoshop effect that started making the rounds last year, and now it's one of the hottest and most requested looks out there, and you see it everywhere from big magazine covers to websites to celebrity portraits to album covers. Anyway, you can get pretty darn close to that look right within Lightroom itself. Now, before I show you the effect, I have to tell you, this is one of those effects that you'll either absolutely love (and you'll wind up over-using it), or you'll hate it with a passion that knows no bounds. There's no in-between.

Step One:

Before we apply this effect, I have a disclaimer: this effect doesn't look good on every photo. It looks best on photos that have lots of contrast, and if it's a portrait, it looks best to have multiple light sources (in particular, one or more bright lights lighting your subject's side from behind). Think gritty, because that's the look you're going for (not soft and glamorous). Here's a contrasty, broad-daylight shot taken in Bruges, Belgium.

Step Two:

Now you're going to really crank just about everything up. Start in the Develop module's Basic panel and drag (1) the Recovery slider, (2) the Fill Light slider, (3) the Contrast slider, and (4) the Clarity slider all the way to the right (until they all read +100, as shown here). I know, it looks terrible, but we're not done yet.

Step Three:

Dragging the Fill Light slider all the way to the right will usually make the image way too bright in the shadow areas, so you'll need to drag the Blacks slider quite a bit to the right until the image looks fairly balanced again. This brings back the shadows and the color saturation to the shadow areas. The problem is that saturation in the shadows usually makes the image look to colorful and punchy, which isn't the worst thing in the world (in fact, it looks like a fake HDR at this point), but the key to this look is an overall desaturated feel (if that makes any sense).

Step Four:

So, you do that by going to the Vibrance slider and dragging it quite a bit to the left (as shown here. If this was a portrait, you'd drag it left until there's just a little color left in the portrait). You can see how doing these two steps brings out incredible details in everything from the bricks to the planters.

Step Five:

The final step is to add an edge vignette to darken the edges of your photo, and put the focus on your subject. So, go to the Lens Corrections panel (in the right side Panels area), click on Manual at the top, and drag the Lens Vignetting Amount slider nearly all the way to the left (making the edges really dark). Then drag the Midpoint slider pretty far to the left, as well, but not quite as far as the Amount slider (the Midpoint slider controls how far the darkened edges extend in toward the middle of your photo. The farther you drag this slider to the left, the farther in they go). At this point, you could save this as a preset, but just understand that because each photo is different, the preset is just a starting place—you'll always have to dial in the right amount of desaturation yourself using the Vibrance slider.

Remember the beauty headshot image we edited earlier? Well, what if you wanted to see a version in black and white, and maybe a version with a color tint, and then a real contrasty version, and then maybe a version that was cropped differently? Well, what might keep you from doing that is having to duplicate a high-resolution file each time you wanted to try a different look, because it would eat up hard drive space and RAM like nobody's business. But luckily, you can create virtual copies, which don't take up space and allow you to try different looks without the overhead.

Virtual Copies— The "No Risk" Way to Experiment

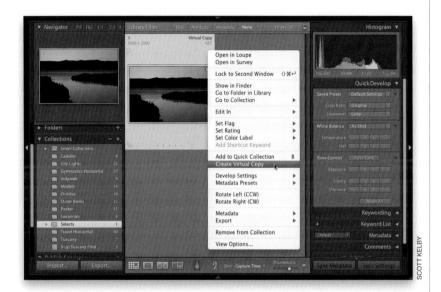

Step One:

You create a virtual copy by just Rightclicking on the original photo and then choosing **Create Virtual Copy** from the pop-up menu (as shown here), or using the keyboard shortcut **Command-' (apostrophe; PC: Ctrl-')**. These virtual copies look and act the same as your original photo, and you can edit them just as you would your original, but here's the difference: it's not a real file, it's just a set of instructions, so it doesn't add any real file size. That way, you can have as many of these virtual copies as you want, and experiment to your heart's content without filling up your hard disk.

Step Two:

When you create a virtual copy, you'll know which version is the copy because the virtual copies have a curled page icon in the lower-left corner of the image thumbnail (circled in red here) in both the Grid view and in the Filmstrip. So now, go ahead and process this virtual copy in the Develop module (adjust the white balance, exposure, shadows, etc.) and when you return to the Grid view, you'll see the original and the edited virtual copy (as seen here).

Step Three:

Now you can experiment away with multiple virtual copies of your original photo, at no risk to your original photo or your hard drive space. So, click on your first virtual copy, then press Command-' (PC: Ctrl-') to make another virtual copy (that's right—you can make virtual copies of your virtual copy), and then head over to the Develop module, and make some adjustments (here I made changes to the White Balance and Vibrance settings). Now, make some more copies to experiment with (I made a few more copies and made some more White Balance and Vibrance setting changes). Note: When you make a copy, you can hit the Reset button at the bottom of the right side Panels area to return the virtual copy to its original unedited look. Also, you don't have to jump back to the Grid view each time to make a virtual copy-that keyboard shortcut works in the Develop module, too.

Step Four:

Now, if you want to compare all your experimental versions side by side, go back to the Grid view, select your original photo and all the virtual copies, then press the letter **N** on your keyboard to enter Survey view (as shown here). If there's a version you really like, of course you can just leave it alone, and then delete the other virtual copies you didn't like. (Note: To delete a virtual copy, click on it and press the Delete [PC: Backspace] key, and it's gone-no warning dialog, no nuthin'.) If you choose to take this virtual copy over to Photoshop or export it as a JPEG or TIFF, at that point, Lightroom creates a real copy using the settings you applied to the virtual copy.

So you learned earlier how to edit one photo, copy those edits, and then paste those edits onto other photos, but there's a "live-batch editing" feature called Auto Sync that you might like better (well, I like it better, anyway). Here's what it is: you select a bunch of similar photos, and then any edit you make to one photo is automatically applied to the other selected photos, live, while you're editing (no copying-and-pasting necessary). Each time you move a slider, or make an adjustment, all the other selected photos update right along with it.

Editing a Bunch of Photos at Once Using Auto Sync

Step One:

Start in the Library module by clicking on the photo you want to edit, then go down to the Filmstrip and Command-click (PC: Ctrl-click) on all the other photos you want to have the same adjustments as the first one (as shown here, where I've selected 14 photos that all need a Fill Light adjustment). You see the first photo you clicked on in the center Preview area (Adobe calls this first-selected photo the "most selected" photo). Now, if you take a look at the bottom of the right side Panels area, it used to say "Previous," but when you select multiple photos, it changes to "Sync..." (as shown circled here in red). If you press-and-hold the Command (PC: Ctrl) key, it changes to Auto Sync.

Step Two:

You can also click on the little switch to the left of the Sync button and it turns on Auto Sync (you can see here the button now says "Auto Sync"). Now, increase the Fill Light amount to around 25 (which makes the shadow areas brighter). As you make these changes, look at the selected photos in the Filmstrip—they all get the exact same adjustments, but without any copying-and-pasting, or dealing with a dialog, or anything. By the way, Auto Sync stays on until you turn off that little switch to the left of the Auto Sync button.

Note: Remember, you won't see the Sync or Auto Sync buttons until you select multiple photos. Otherwise, it will say Previous.

Save Your Favorite Settings as One-Click Presets

Lightroom comes with a number of built-in tonal correction presets that you can apply to any photo with just one click. These are found in the Presets panel over in the left side Panels area, where you'll find two different collections of presets: Lightroom Presets (the built-in ones put there by Adobe) and User Presets (ones you create to apply your favorite combinations of settings with just one click). Some of the built-in ones are pretty decent, and some are, well...well...let's just say that I haven't had an instance to use them yet. Here's how to put presets to work for you:

Step One:

We'll start by looking at how to use the built-in presets, then we'll create one of our own, and apply it in two different places. First, let's look at the built-in presets by going to the Presets panel (found in the left side Panels area), and clicking on the right-facing arrow to the left of Lightroom Presets to expand the set, and see the built-in presets within it (as shown here). Adobe named these built-in presets by starting each name with the type of preset it was, so those that start with "B&W Creative" are black-and-white special effect presets, those starting with "General" are just standard tone control presets, and those that start with "Sharpening" are...do I even have to explain this one?

You can see a preview of how any of these presets will look, even before you apply them, by simply hovering your cursor over the presets in the Presets panel. A preview will appear above the Presets panel in the Navigator panel (as shown here, where I'm hovering over a Color Creative preset called Aged Photo, and you can see a preview of how that color effect would look applied to my photo, up in the Navigator panel, at the top of the left side Panels area).

Step Three:

To actually apply one of these presets, all you have to do is click on it. In the example shown here, I clicked on the Color Creative preset, Cold Tone, which gives the effect you see here.

TIP: Renaming Presets

To rename any preset you created (a user preset), just Right-click on the preset and choose **Rename** from the pop-up menu.

Step Four:

Once you've applied a preset, you can apply more presets and those changes are added right on top of your current settings, as long the new preset you chose doesn't use the same settings as the one you just applied. So, if you applied a preset that set the Exposure, Fill Light, and Shadows, but didn't use Clarity, if you then chose a preset that just uses Clarity, it adds this on top of your current preset. Otherwise, it just moves those sliders again. For example, after I applied the Cold Tone preset, I felt it looked kind of flat and lacked contrast. So. I scrolled down toward the bottom of the built-in presets and clicked on the Tone Curve -Medium Contrast preset. Then, I clicked on the General - Punch preset to give us the image you see here. Just three clicks and I was able to add a special effect tinting, more contrast, and an overall sharper, punchier look.

Step Five:

Now, of course you can use any built-in preset as a starting place to build your own preset, but let's just start from scratch here. Click the Reset button at the bottom of the right side Panels area (shown circled here in red) to reset our photo to how it looked when we started. Now we'll create our own look from scratch: Increase the Exposure amount to +1.00, set the Recovery amount to 100, the Fill Light to 40, Blacks to 5, the Brightness to +50, and then lower the Contrast to -12. Now, increase the Vibrance amount to +30, and then lower the Saturation to -60, which gives us the look you see here. We're not finished yet ('cause this looks kinda lame).

Step Six:

Now go the Tone Curve panel (in the right side Panels area), choose Strong Contrast from the Point Curve pop-up menu, then drag the Highlights slider to +75, and the Shadows slider to -85 to add some mega contrast. Lastly, go to the Lens Corrections panel, click on Manual at the top, drag the Lens Vignetting Amount slider to -100, and set the Midpoint to 5 to complete the effect (that looks better. Kind of a contrasty, washed-out, yet snappy color effect). Okay, now that we've got our look, let's save it as a preset. Go back to the Presets panel and click on the + (plus sign) button on the right side of the Presets panel header to bring up the New Develop Preset dialog (shown here). Give your new preset a name (I named mine "Desaturate with Contrast Snap"), click the Check None button at the bottom of the dialog (to turn off the all the checkboxes), then turn on the checkboxes beside all the settings you edited to create this preset (as seen here). Now, click the Create button to save all the edits you just made as your own custom preset.

Note: To delete a User Preset, just click on the preset, then click on the – [minus sign] button, which will appear to the left of the + button on the right side of the Presets panel header.

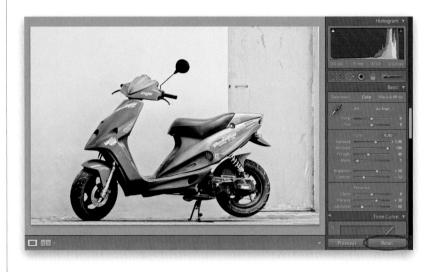

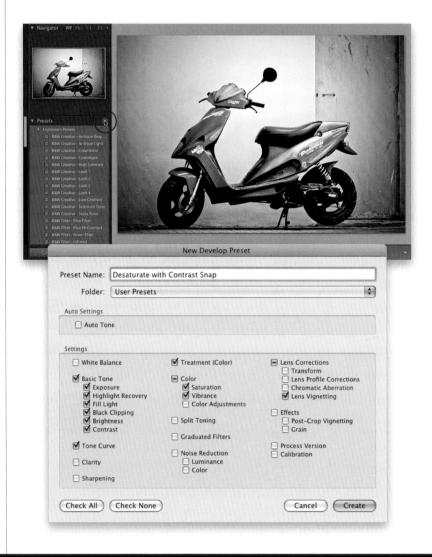

Step Seven:

Now click on a different photo in the Filmstrip, then hover your cursor over your new preset (I'm hovering over my Desaturate with Contrast Snap preset), and if you look up at the Navigator panel, you'll see a preview of the preset (as seen here, where you're seeing what your current color photo would look like if you applied the custom preset we just made). Seeing these instant live previews is a huge time saver, because you'll know in a split second whether your photo will look good with the preset applied or not, before you actually apply it.

Step Eight:

You can even put these presets (the built-in ones that come with Lightroom, and the ones you create yourself) to use from right within the Import window. For example, if you knew you wanted to apply the Desaturate with Contrast Snap preset to a group of photos you were about to import, inside the Import window, over in the Apply During Import panel, you'd choose this preset from the Develop Settings pop-up menu (as shown here), and that preset would automatically be applied to each photo as it's imported. There's one more place you can apply these Develop presets, and that's in the Saved Preset pop-up menu, at the top of the Quick Develop panel, in the Library module (more about the Quick Develop panel on the next page).

TIP: Importing Presets

There are lots of places online where you can download free Develop module presets (like my buddy, Matt Kloskowski's LightroomKillerTips.com). Once you've downloaded some, to get them into Lightroom, go to the Presets panel, then Right-click on the User Presets header, and choose **Import** from the pop-up menu. Locate the preset you downloaded and click the Import button, and that preset will now appear under your User Presets list.

Using the Library Module's Quick Develop Panel

There's a version of the Develop module's Basic panel right within the Library module, called the Quick Develop panel, and the idea here is that you'd be able to make some quick, simple edits right there in the Library module, without having to jump over to the Develop module. The problem is, the Quick Develop panel stinks. Okay, it doesn't necessarily stink, it's just hard to use, because there are no sliders—there are buttons you click instead (which makes it frustrating to get just the right amount)—but for just a quick edit, it's okay (you can see I'm biting my tongue here, right?)

Step One:

The Quick Develop panel (shown here) is found in the Library module, under the Histogram panel at the top of the right side Panels area. Although it doesn't have the White Balance Selector tool, outside of that, it has pretty much the same controls as the Develop module's Basic panel (including the Recovery, Fill Light, Clarity, and Vibrance controls). Also, if you press-and-hold the Option (PC: Alt) key, the Clarity and Vibrance controls change into the Sharpening and Saturation controls (as seen on the right). Instead of sliders (which give us precise control over our adjustments), the Quick Develop panel uses one-click buttons (just to make us crazy). If you click a single-arrow button, it moves that control a little. If you click a double-arrow button, it moves it a lot.

Quick Develop Default Settings 🗧 🕷 Brightness 🕢 🖌 🕨

	Q	uick	Dev	elop	V
Saved Preset	Defa	ult S	etting	s 🖯	¥
Crop Ratio	Original 🗧				
Treatment	Color				
White Balance	As Shot 😫				Ŧ
Temperature		<	Þ	00	
Tint	00	<	Þ	DD	
Tone Control	Auto Tone				
Exposure	00		Þ	20	
Recovery	বর	Q.,	()	DD	
Fill Light	DD.	<	>	DD.	
Blacks	44	<	>	00	
Brightness	04	¢	D	DD	
Contrast	44	5	>	20	
Sharpening	40	<	>	22	1
Saturation	44	<	Þ	DD)
	{	K	eset /	SII .	

Step Two:

There are only two situations where I'll use the Quick Develop panel: One is where I see a messed-up thumbnail, and I want to see if it can easily be fixed, before I invest any time into it in the Develop module. For example, in the Grid view, click on an underexposed photo, then go over to the Quick Develop panel and click the Exposure double right-arrow button two times to get it closer to being properly exposed. Now you can make a better decision about its fate, without having to pause your sorting process by leaving the Library module and jumping over to the Develop module.

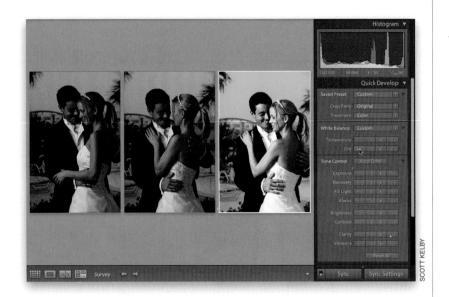

White Balance	Treatment (Color)	Lens Corrections	Spot Removal
Sasic Tone Stopsure	Color Saturation Vibrance Color Adjustments Split Toning Local Adjustments Birush Gradwated Filters Noise Reduction Luminance	Instructions Instructions Chromatic Aberration Chromatic Aberration Lens Vignetting Fffects Post-Crop Vignetting Grain Process Version Calibration	Crop Straighten Angle Aspect Ratio
neck All) (Check None	Color		Cancel Synchronize

Step Three:

The other time I use the Quick Develop panel is when I'm in Compare or Survey view (as shown here), because you can apply Quick Develop edits while in these side-by-side views (just be sure to click on the photo you want to edit first). For example, there's a magenta color cast on these photos, so her gown looks kind of pinkish. So, while in Survey mode, click on the third photo, then keep an eye on the color of her gown. To get it back to white, I had to click the Temperature double left-arrow button two times, and then click the Tint double left-arrow button once. Now that I know the adjustments I need, I could return to Grid view, select all those similar photos, and fix them all at once with just those three clicks. Also, when you're correcting multiple photos using Quick Develop, every image gets the exact same amount of correction (so if you increase the exposure by $^{2}/_{3}$ of a stop, all the selected photos go up by $^{2}/_{3}$ of a stop, regardless of what their current exposure is). But, it's not that way when you do the same thing in the Develop module using Auto Sync. There, if you set the exposure of one photo to +0.50, every selected photo's exposure is also set to +0.50.

Step Four:

If you've selected a bunch of photos, but only want certain edits you made applied to them (rather than all your Quick Develop edits), then click the Sync Settings button at the bottom of the right side Panels area. This brings up a dialog (shown here) where you can choose which Quick Develop settings get applied to the rest of the selected photos. Just turn on the checkboxes beside those settings you want applied, and then click the Synchronize button.

TIP: Undo Quick Develop Changes You can undo any individual change in the Quick Develop panel by double-clicking on that control's name.

Adding a Film Grain Look

One complaint you hear from traditional film photographers is that digital images look "too clean." That's probably why plug-ins that add a film grain look have gotten so popular. The workaround we used to use was to jump over to Photoshop and use the Add Noise filter, which didn't do a terribly bad job, but in Lightroom 3 there's a now dedicated feature that brings more realistic film grain effects without having to leave Lightroom.

Step One:

The film grain effect is popular when processing B&W photos, so we'll start by converting to black and white. In the Basic panel, click on Black & White at the topright, then increase the Recovery amount to 100 (to bring back some sky), and the Clarity amount to +75. In the Tone Curve panel, choose **Strong Contrast** from the Point Curve pop-up menu

TIP: Navigating Panels Using Keyboard Shortcuts

Want to jump right to a panel without scrolling? Press **Command-1** to jump to the Basic panel, **Command-2** for the Tone Curve panel, **Command-3** for the HSL/Color/Grayscale panel, and so on (on a PC, you'd use **Ctrl-1**, **Ctrl-2**, etc., and these shortcuts will work in each of the module's right side Panels areas).

Step Two:

Now, go down to the Effects panel (to really see the grain, you'll first want to zoom in to a 100% [1:1] view). The Grain Amount slider does what you'd imagine the higher the amount, the more grain is added to your photo (go easy here— I don't generally go over 40 as a maximum, and I usually try to stay between 15 and 30). Here I moved it over to 34.

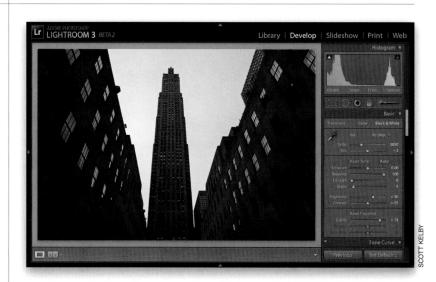

Develop

Step Three:

The Size slider lets you choose how large the grain appears. I think it looks more realistic at fairly small size, but if you're working on super high-resolution images, you might want to bump it up a bit. The Roughness slider lets yw ou vary the consistency of the grain. By default, the noise pattern looks pretty consistent, so the farther to the right you drag the Roughness slider, the more it's varied. But I gotta tell ya, when you increase it too much, it starts getting really contrasty and kind of funkylooking, so I usually leave the Roughness amount at its default setting of 50.

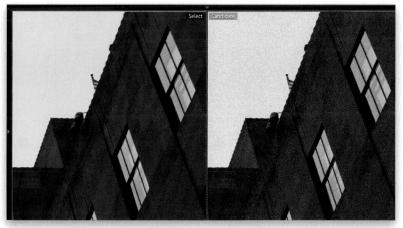

The image with no grain applied

The image with grain applied

TIP: Add More, If You're Printing Grain tends to disappear a bit when you make a print, so while the amount may look right onscreen, don't be surprised if it's barely visible in a print. So, if your final output is print, you might have to use a little more grain than you think you should.

Lightroom Killer Tips > >

Resetting the White Balance

To reset both the Temperature and Tint White Balance sliders to their original As Shot settings, just double-click directly on the letters WB in the Basic panel.

 Panel Trick for Impatient People

Have you noticed that when you expand or collapse a panel, it gently (and arguably slowly) animates this sequence (in other words, they don't snap open—they "glide" open). If you'd like to skip the fancy gliding and have those panels snap open/ closed the moment you click on them, just **Command-click (PC: Ctrl-click)** on them instead.

Picking Zooms in the Detail Panel

If you Right-click inside the little preview window in the Detail panel, a little pop-up menu will appear where you can choose between two zoom ratios for the preview—1:1 or 2:1—which kick in when you click your cursor inside the Preview area.

Hiding the Clipping Warning Triangles

If you don't use the two little clipping warning triangles in the top corners of the histogram (or you want them turned off when you're not using them), then just Right-click anywhere on the histogram itself and choose **Show Clipping Indicators** from the pop-up menu to turn it off, and they'll be tucked out of sight. If you want them back, go back

to that same pop-up menu, and choose Show Clipping Indicators again.

Copy What You Last Copied

When you click the Copy button in the Develop module (at the bottom of the left side Panels area), it brings up a Copy Settings dialog asking which edits you want to copy. However, if you know you want to copy the same edits as you had previously (maybe you always copy everything), then you can skip having that Copy Settings dialog pop-up up completely by pressing-and-holding the Option (PC: Alt) key, then clicking the Copy button (it will change from Copy... to Copy).

Make it Easier to Choose Camera Profiles

To make things easier when choosing your Camera Calibration panel profiles, try this: Set your DSLR to shoot RAW+JPEG Fine, so when you press the shutter button it takes two photos—one in RAW and one in JPEG. When you import these into Lightroom, you'll have the RAW and JPEG photos side-by-side, making it easier to pick the profiles for your RAW photo that matches the JPEG your camera produces.

Choosing What Will Be Your Before and After

By default, if you press the \ (**backslash**) **key** in the Develop module, it toggles you back and forth between the original untouched image (the Before view) and the photo as it looks now with your edits. However, what if you don't want your Before photo to be the original? For example, let's say you did some Basic panel edits on a portrait, and then you used the Adjustment Brush to do some

portrait retouching. Maybe you'd like to see the Before photo showing the Basic panel edits after they were applied, but before you started retouching. To do that, go to the History panel (in the left side Panels area), and scroll down until you find the step right before you started using the Adjustment Brush. Right-click on that history state and choose **Copy History Step Settings to Before**. That now becomes your new Before photo when you press the \ key. I know—that's totally cool.

 Making Your Current Settings the New Defaults for That Camera

When you open a photo, Lightroom applies a default set of corrections based on the photo's file format and the make and model of the camera used to take the shot (it reads this from the built-in EXIF data). If you want to use your own custom settings (maybe you think it makes the

Web

Lightroom Killer Tips > >

shadows too black, or the highlights too bright), go ahead and get the settings the way you want them in Lightroom, then press-and-hold the Option (PC: Alt) key and the Reset button at the bottom of the right side Panels area changes into a Set Default button. Click on it and it brings up a dialog showing you the file format or the camera make and model of the current image. When you click Update to Current Settings, from now on, your current settings will be your new starting place for all images taken with that camera, or in that file format. To return to Adobe's default settings for that camera, go back to that same dialog, but this time click on the Restore Adobe Default Settings button.

Get Different Versions of Photos Without Making Virtual Copies

Snapshots Vignette

I briefly mentioned snapshots earlier in this chapter, but I want to give you another way to think of them. Think of them as another way to have one-click access to multiple versions of your photo. When you're working in the Develop module and see a version of your photo you like, just press Command-N (PC: Ctrl-N) and how your photo looks at that moment is saved to your Snapshots panel (you just have to give it a name). So, that way, you could have a B&W version as a snapshot, one version as a duotone, one version in color, one with an effect, and see any of those in one click, without having to scroll through the History panel to try to figure out where each look is.

 Create White Balance Presets for JPEG and TIFF Images
 I mentioned earlier that with JPEG or TIFF images the only White Balance preset

available to you is Auto. However, here's a cool workaround to get you more choices: Open a RAW image and only make one edit—choose the White Balance preset Daylight. Now, save just that change as a preset and name it White Balance Daylight. Then do that for each of the White Balance presets, and save them as presets. When you now open a JPEG or TIFF image, you'll have these one-click White Balance presets you can use to get a similar look.

One of My Most-Used Presets The intentional vignette look is really hot right now, and it's an ideal effect

Pr	eset	ts in the second se	-
	Ligh	ntroom Presets	
	Use	r Presets	
		Desaturate with Contrast	Snap
		Matt's Sin City - Dark Red	
	Ē	Vignette	Ν
	Ē	Yellow/Cyan Split Tone	15

to save as a one-click preset. Just go to the Lens Corrections panel, click on Manual at the top, click-and-drag the Lens Vignetting Amount slider all the way to the left (to –100), then clickand-drag the Midpoint slider to the left to 10, and then go to the Presets panel and save that as a vignette preset. Now you can just move your cursor over this preset and you'll get an instant preview of how your image would look with a vignette applied up in the Navigator panel at the top of the left side Panels area. ▼ Updating Your Presets If you start your editing by using a Develop module User Preset, and you like the new changes, you can

update your preset by Right-clicking on the old preset and choosing **Update** with Current Settings from the popup menu.

▼ Fix Underexposed Photos Fast with Match Exposure If you see a series of photos of the same subject, and some of these photos are underexposed, try this quick trick to fix those fast: Click on a properly exposed photo from that series, then while it's selected, also select the underexposed photos, then go under the Settings menu and choose **Match Total Exposures**. It will evaluate the overall exposure from your "most-selected" photo (your properly exposed photo) and use that to fix the underexposed photos.

0	Settings	Tools	View	Window	Help
		Il Setting to Curre		ess (2010)	企器R
	Process				►
	Copy Se	ettings			企業C
	Paste Se	ettings			☆ ¥V
	Paste Se	ettings f	rom Pre	vious	Z#A
	Sync Se Sync Co				企器S
	Sync Sn	apshots			
	Match 1	fotal Exp	osures	•	℃企業M
	Enable	Auto Syr	nc	dillama anna	て企業A

Chapter 5 How to Edit Just Part of Your Images

Local Adjustments how to edit just part of your images

I'll be the first to admit that "Local Adjustments" isn't a great name for a chapter on using the Adjustment Brush (and the other local adjustment tools), but it's an "Adobe-ism" for editing just one section of your image. Here's how they describe it: Everything you do in Lightroom is a global adjustment. It affects your entire image globally. So, if you're affecting just one part of your image, it's not global. It's local. So what you're making is a local adjustment. This would all make perfect sense if anyone in the world actually thought that way, but of course nobody does (not even the engineer who thought up this term). You see, we regular non-software-engineer people refer to adjustments that affect the entire photo as "adjustments that affect the entire photo" and we refer to adjustments that affect just one part as "adjustments that affect just one part."

But, of course, Adobe can't actually name functions with those names, because then we'd clearly understand what they do. Nope, when it comes to stuff like this, it has to go before the official Adobe Council of Obscure Naming Conventions (known internally as ACONC, which is a powerful naming body whose members all wear flowing robes, carry torches, and sing solemn chants with their heads bowed). The ACONC types a simple, understandable phrase into the "Pimp Name Generator" (see page 99), and out comes an overly technical name that their sacred emissary (brother Jeff Schewe) will carry forward into the world (after which there is a great celebration where they sacrifice an intern from the marketing department, and a temp from accounting). And that's how I met your mother.

Dodging, Burning, and Adjusting Individual Areas of Your Photo

Step One:

In the Develop module, in the toolbox right above the Basic panel, click on the Adjustment Brush icon (shown circled here), or just press the letter **K** on your keyboard. An options panel will pop down below the toolbox with all the controls for using the Adjustment Brush (as seen here). Everything we've done in the Develop module so far affected the entire image. For example, if you drag the Temperature slider, it changes the white balance for the entire image (Adobe calls this a "global adjustment"). But what if you want to adjust one particular area (a "local" adjustment)? You'd use the Adjustment Brush, which lets you paint changes just where you want them, so you can do things like dodging and burning (lightening and darkening different parts of your photo), but Adobe added more to this than just lightening and darkening. Here's how it works:

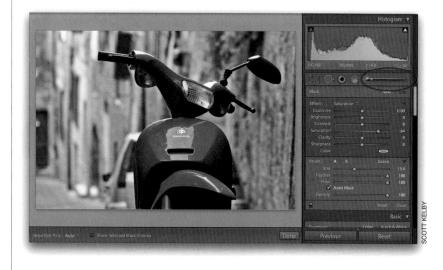

Step Two:

With the Adjustment Brush, you start by choosing which effect you want to paint with from the Effect pop-up menu (shown here). In our example, we basically want to re-light the photo, making some areas brighter (the scooter), and other areas darker (the background). We'll also make some areas more colorful and others sharper. We'll start with making the scooter brighter, so choose **Exposure** from the pop-up menu (if it's not already selected).

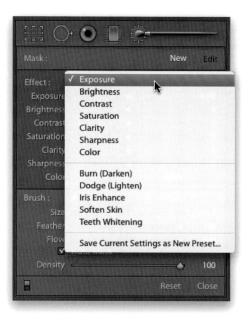

Slideshow Print Web

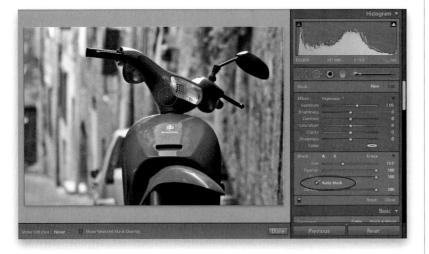

Step Three:

Now, this is going to sound weird at first, but at this point, you make a guess at how much brighter you think you might want the area you're going to paint over by dragging the Exposure slider to the right (here I've increased the Exposure to 1.05). Of course, I have no way of knowing whether that's going to be exactly the right amount or not, but it really doesn't matter, because you have full control over the amount *after* the fact. Because of that, I usually intentionally drag the Exposure slider to the right farther than I know I need to. That way, I can easily see my brush strokes as I paint, and I'm not worried about messing things up, because I can always lower the Exposure there later.

Step Four:

So, go ahead and choose Exposure from the Effect pop-up menu, set your Exposure to around 1.05, and start painting over the blue part of the scooter (as shown here) to brighten that area. Again, it doesn't matter if it's too bright, or not bright enough, because you can always change it later (and don't worry-we will). To help make painting specific areas like this easier, there's an Auto Mask feature (shown circled here in red) that senses where the edges of what you're painting are (based on color), and it helps keep you from spilling paint outside the area you're trying to affect. This Auto Mask actually works pretty well more often than not, so I leave it on all the time, except if (a) it's just not working (and paint is spilling everywhere) or (b) I'm painting a large background area where I don't need to find the edges (it paints faster for stuff like this with Auto Mask turned off-you can press the letter A to toggle it on/off).

Continued

Step Five:

Now that we've painted over the scooter, drag the Exposure slider over to the left (to around -1.00), and watch how it darkens the scooter. This is what I was talking about earlier when I said that after you paint, you can still choose how light (or dark) you want the area you painted over. It's pretty handy to be able to paint, and then decide after the fact how you want things to look.

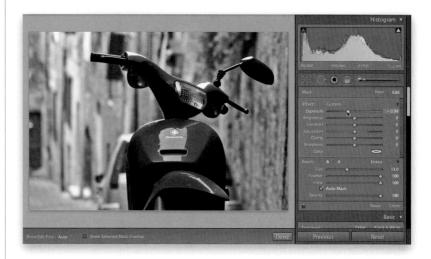

TIP: Changing Brush Sizes

To change your brush size, you can use the **Left and Right Bracket keys** (they're to the right of the letter P on your keyboard). Pressing the Left Bracket key makes your brush smaller; the Right Bracket key makes it bigger.

Step Six:

Drag the Exposure slider back up to where it brightens the scooter again. One of the most powerful things about the Adjustment Brush is that once you've painted over an area (like you did with the front of the scooter), you can add other effects over that same area by just dragging the other Effect sliders. For example, so far you've brightened the front of the scooter, but if you wanted it to be more colorful too, you don't have to paint again—just drag the Saturation slider to the right. Want it sharper, as well? Drag the Clarity and Sharpness sliders to the right, and these effects stack right on top, but only on the area you painted over (the front of the scooter).

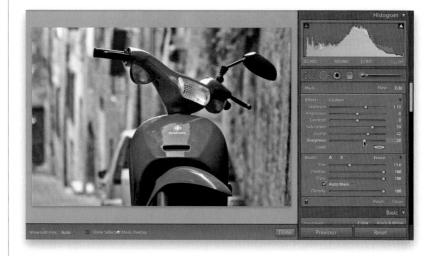

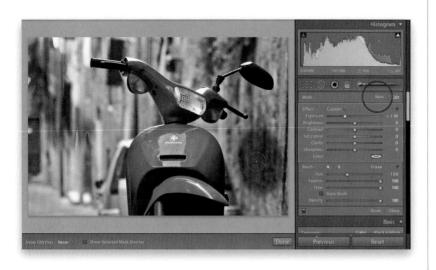

Step Seven:

Now that we've brightened the scooter, we're going to darken the background, but we can't just continue dragging sliders around, because that would just change the scooter, since it's the only area we've painted over. To paint over a new area, and have separate control over it, you'll need to click the New button (shown circled here in red). Now, you have to choose what you want to do with this new area you're going to paint in. Choose Exposure from the Effect pop-up menu, and then drag the Exposure slider to the left, to darken the area. Again, it doesn't matter how far you drag the slider to the left, because you'll change it later. Now start painting over the background to the right of the scooter, as shown here, and as you paint, it darkens that area.

Step Eight:

For painting a large background like this, here's what I do: I turn off the Auto Mask checkbox, then I quickly paint in all the areas in the background that aren't right up close to the scooter (in other words, areas where I don't have to worry about accidentally painting over the scooter). Then, when it's time to get up close to the edge of the scooter, I turn the Auto Mask checkbox back on, and paint right up to the edge of it (as shown here) without darkening it. The key is to keep the little + (plus sign) in the center of the brush from crossing over onto the scooter. That little plus sign determines which colors to paint over. If it strays over the blue, it figures its okay to paint over it, so as long as you keep that off the blue, it keeps the darkening off it, too.

Continued

Step Nine:

When you first start painting, the Adjustment Brush lays down an Edit Pin which marks the area you're editing. You started by painting on the scooter (that's your first pin), then you clicked the New button and painted over the background (which added your second Edit Pin), so now you have two different Edit Pins for this photo. These pins are important because by clicking on one (or the other) you're telling Lightroom which area you want to adjust. You can tell which area you're editing by looking at the Edit Pins themselves. If the pin has a round circled filled with black, that means it's the currently active pin, so changes you make to the sliders affect the area you painted with that pin. The other Edit Pin will be a plain white circle. To switch to this other pin, just click on it, and it's now filled with black (as seen here), letting you know the scooter's pin is now active, and changes you make will now affect just the scooter.

Step 10:

Let's add another Edit Pin, so you can get used to working with multiple areas. Click the New button, then paint over the headlight. Since the last thing you did was darken the background, it assumes you want to do that again (which we don't), so drag the Exposure slider to the right to brighten the headlight, then drag the Clarity and Sharpness sliders way over to the right to make the headlight nice and sharp. Move your cursor anywhere out over your image area and you'll see three Edit Pins now: (1) on the front of the scooter, which lets you edit the scooter (by the way, click on that one, and brighten the Exposure a bit); (2) the background; and (3) the headlight (click on that one, and make it a little brighter, as well).

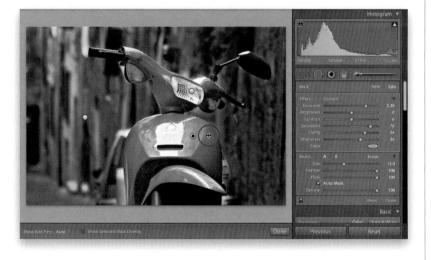

Step 11:

So, how do you know if you've really painted over an entire area? How do you know whether you've missed a spot? Down in the toolbar, across the bottom of the Preview area, you'll find a checkbox for Show Selected Mask Overlay. Turn that on and it shows a red mask over the area you painted (as seen here). This is incredibly handy for making sure you didn't miss any areas. If you did miss an area, just paint over it. If you painted outside of where you wanted, press-and-hold the Option (PC: Alt) key and paint over that area to remove it (the red mask will go away where you painted). When you're done editing your mask, turn the Show Selected Mask Overlay checkbox off. If you just want a quick look at the mask, as a shortcut you can move your cursor directly over a pin and it shows you the red mask overlay for exactly where you painted.

Step 12:

Another nice feature of the Adjustment Brush is that you can make onscreen interactive adjustments, kind of like you do with the Targeted Adjustment tool (which you learned about in Chapter 4). So, to adjust the Exposure amount for the scooter, just move your cursor directly over the Edit Pin on the scooter, and your cursor changes to a bar with two arrows—one pointing left and one pointing right (shown circled here in red). Those are letting you know that you can now click-and-drag left or right to make changes (try it-click-and-drag to the right to increase all the effects you applied to that Edit Pin).

Continued

Step 13:

There are a set of brush options at the bottom of the panel. The Size slider changes the brush size (but it's faster to use the Bracket key shortcuts I mentioned earlier). The Feather slider controls how soft the brush edges are-the higher the number, the softer the brush (I paint with a soft brush about 90% of the time). For a hardedged brush, lower the Feather slider to 0. The Flow slider controls the amount of paint that comes out of the brush (I usually leave the Flow set at 100). Also, you get two custom brush settings—Brush A and Brush B—so you could set one up to be a large, soft-edged brush (shown at the top), and the other to be a small, hard-edged brush (shown at bottom here). It's totally up to you—just click on the letter, choose your settings, and it remembers them, so next time you can just click on the letter.

	A B	Erase	Ţ
Size			8.0
Feather			
Flow	Constanting of the second seco	<u> </u>	100
2	Auto Mask		
Density	distanti and a state of the sta	<u> </u>	100

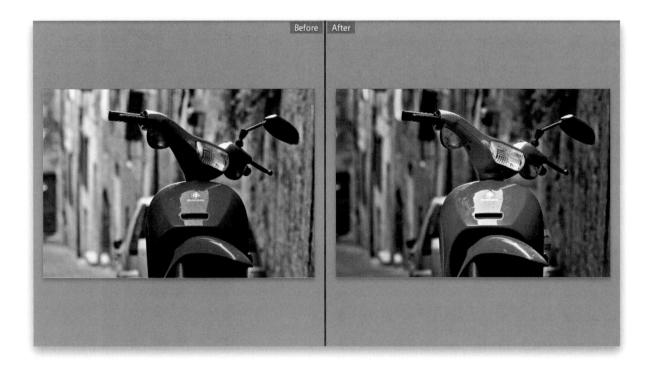

There are a few others things you need to know that will help you get more comfortable with the Adjustment Brush, and once you learn these (along with the rest of the stuff in this chapter), you'll find yourself making less trips over to Photoshop, because you can do so much right here in Lightroom.

Five More Things You Should Know About Lightroom's Adjustment Brush

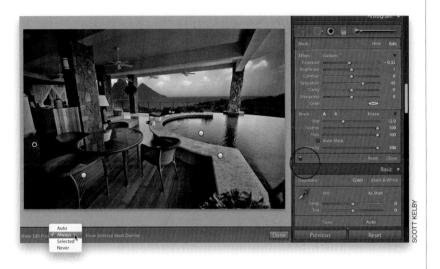

	• 🛈 🚺 🐲		
Mask :		New	Edit
Effect :	Custom \$		4
Amount			68
Brush :	A B	Erase	Y
Size			12.0
Feather	Constant of the local division of the local	<u> </u>	100
Flow	Charles and the second s	O	100
	Auto Mask		
Density			100
		Reset	Close

#1: You have a choice of how Lightroom displays the Edit Pins, and you make that choice from the Show Edit Pins pop-up menu down in the toolbar beneath the Preview area (as shown here). Choosing Auto means when you move your cursor outside the image area, the pins are hidden. Always means they're always visible and Never means you never see them. Selected means you only see the currently active pin.

#2: To see your image without the edits you've made with the Adjustment Brush, click the little switch on the bottom left of the panel (circled here in red).

#3: If you press the letter **O**, the red mask overlay stays onscreen, so you can easily see, and fix, areas you've missed.

#4: If you click on the little down-facing triangle to the far right of the Effect pop-up menu, it hides the Effect sliders, and instead gives you an Amount slider that provides a single, overall control over all the changes you make to the currently active Edit Pin (as shown here).

#5: Below the Auto Mask checkbox is the Density slider, which kind of simulates the way Photoshop's Airbrush feature works, but honestly, the effect is so subtle when painting on a mask, that I don't ever change it from its default setting of 100.

Getting Creative Effects Using the Adjustment Brush

Now that we know how the Adjustment Brush works, we can use it for more than just dodging and burning—we can use it for creative effects. We'll start with a technique that is very popular in wedding photo albums, and that is the classic "bride's in black and white, but her bouquet stays in color" effect (which, as lame as it may sound, clients absolutely love).

Step One:

In the Develop module, start by clicking on the Adjustment Brush in the toolbox near the top of the right side Panels area, then from the Effect pop-up menu, choose Saturation, set the Saturation slider to -100 (as shown here), and begin painting over the areas you want to be black and white (here, we're painting over everything but the bouquet). This is one instance (painting over a large background area with different colors) where I recommend turning the Auto Mask checkbox off (at the bottom of the Brush section). Otherwise, it will try to keep you from painting outside the original area you clicked in-it will let you paint over other areas, but it will fight you along the way.

Step Two:

When you get close to the bouquet, that's when I'd do two things: (1) lower the size of your brush (you can use the Size slider in the Brush section or the **Bracket keys** on your keyboard), and (2) turn the Auto Mask checkbox back on. That way, it will try to keep your brush from painting on the flowers, because their color will be much different than the white dress color and fleshtone colors you'll be painting over. The final effect is shown here.

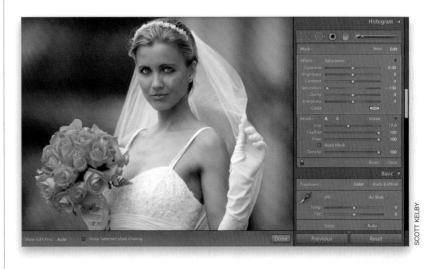

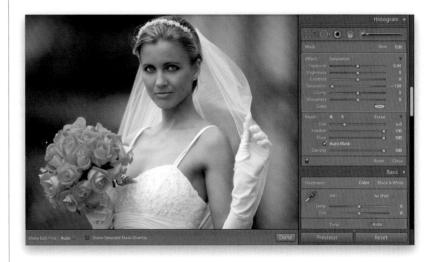

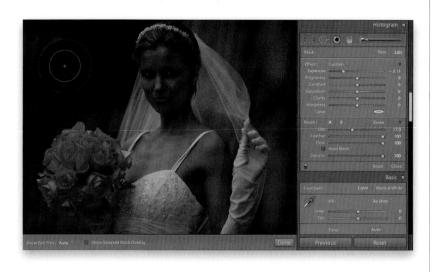

Click the Reset button in the bottomright corner of the right side Panels area to reset the photo to its original full-color look. Now, let's use the Adjustment Brush to create a soft spotlight effect. Choose **Exposure** from the Effect pop-up menu, then drag the Exposure slider to the left to -2.13. Turn off the Auto Mask checkbox, and then paint over the entire image, which darkens the overall exposure (as seen here).

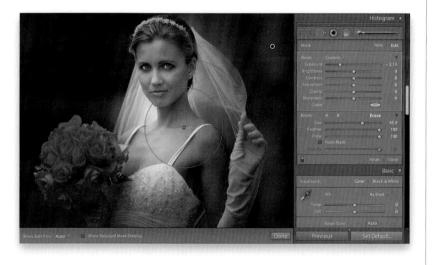

Step Four:

Now, press-and-hold the Option (PC: Alt) key to switch to the Erase tool. Increase the size of the brush big time (make the brush really huge), make sure the Feather and Flow amounts are both set to 100 (as seen here), and then paint over just the area of the photo where you want the spotlight to appear. Here, we're just going to paint over the bride's head and the top of her shoulders, to create our spotlight effect.

Retouching Portraits

Back in the original version of Lightroom, when it came to retouching, you basically had one thing you could do: remove blemishes. Hey, I was thankful we could do that, because in many cases that was all I needed to do and it saved me a trip to Photoshop. But now, you can use the Adjustment Brush to do a number of different common retouching tasks (just remember to do these after you've already toned the image in the Basic panel and then removed any blemishes— always do those first, before you use the Adjustment Brush for retouching).

Step One:

Here I've zoomed in to a 1:3 view, so we can really see what we're doing. Click on the Adjustment Brush (in the toolbox near the top of the right side Panels area), then from the Effect pop-up menu, choose Soften Skin. Increase the size of your brush (use the Size slider in the Brush section, or the Bracket keys on your keyboard), and turn off the Auto Mask checkbox. Now, paint over her skin, avoiding any detail areas like the eyebrows, eyelids, lips, nostrils, hair, etc. (as shown here). This softens the skin by giving you a negative Clarity setting (if you look, you'll see it's at -100). (Note: Before softening the skin, I always start by removing any blemishes on it using the Spot Removal tool. We haven't covered that tool yet, but we will in the next chapter. What you'll learn there is exactly what I did here, but instead of just removing spots or specks of dust, I removed blemishes—it works exactly the same way.)

Step Two:

To make her eyes pop (that's retouching speak), you're going to increase the exposure, color saturation, and clarity of her irises. First, click the New button (near the top of the panel), then choose **Iris Enhance** from the Effect pop-up menu. Now, paint over the iris in each eye with the Auto Mask checkbox turned on (this helps keep you from painting outside the iris). Next, click the New button again (clicking this button is really important), then choose **Teeth Whitening**, from the Effect pop-up menu (as shown here), and paint over the whites of her eyes (this preset desaturates the color, which helps hide any red in the eyes).

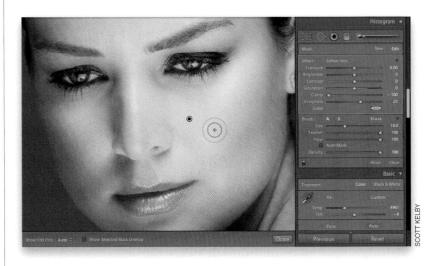

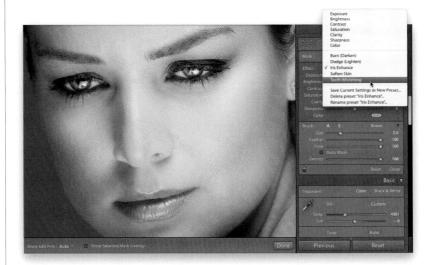

Slideshow Print

Web

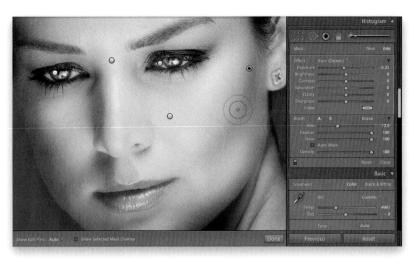

There are five Edit Pins here, from L to R:

(1) the Iris Enhance pin (on the left eye);

- (2) the Dodge (Lighten) pin;
- (3) the Teeth Whitening pin (used to whiten the eyes);
- (4) the Soften Skin pin to the right of her nose; and
- (5) the Burn (Darken) pin on her cheek up near her ear

Step Three:

Now, we're going to dodge and burn to sculpt her face (a very popular portrait retouching technique, where you make shadow areas darker and highlight areas brighter). Start by clicking the New button and choosing Burn (Darken) from the Effect pop-up menu, and then paint over the shadow areas, making them slightly darker (here I painted over the shadow areas on her cheek, neck, and the left side of her nose). Click the New button once more, choose **Dodge (Lighten)** from the Effect pop-up menu, and then paint over the highlight areas of her face (like down the bridge of her nose, the top of her cheeks near her eyes, and anywhere there's a bright highlight). Just remember, you can control the adjustment amounts after the fact using the sliders. A before and after is shown below.

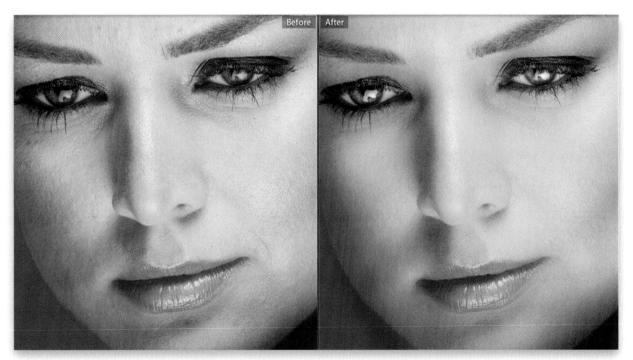

The After photo (right) has sharper, more colorful irises, the whites of the eyes are brighter, her skin is softer, and dodging and burning has slimmed and sculpted her face

Fixing Skies (and Other Stuff) with a Gradient Filter

The Graduated Filter (which is actually a tool) lets you recreate the look of a traditional neutral density gradient filter (these are glass or plastic filters that are dark on the top and then graduate down to fully transparent). They're popular with landscape photographers because you're either going to get a perfectly exposed foreground or a perfectly exposed sky, but not both. However, the way Adobe implemented this feature, you can use it for much more than just neutral density gradient filter effects (though that probably will still be its number one use).

Step One:

Start by clicking on the Graduated Filter tool in the toolbox (it's just to the left of the Adjustment Brush, or press \mathbf{M}), near the top of the right side Panels area. When you click on it, a set of options pops down that are similar to the effects options of the Adjustment Brush (shown here). Here we're going to replicate the look of a traditional neutral density gradient filter and darken the sky. Start by choosing **Brightness** from the Effect pop-up menu and then drag the Brightness slider to the left to -70 (as shown here). Just like with the Adjustment Brush, at this point we're just kind of guessing how dark we're going to want our gradient, but we can darken or lighten it later.

Step Two:

Press-and-hold the Shift key, click on the top center of your image, and drag straight down until you nearly reach the bottom quarter of the photo (the reason I'm dragging this low is because our horizon line is near the center of the photo. You can see the darkening effect it has on the sky and its reflection in the water, and the photo already looks more balanced). You might need to stop dragging the gradient before it reaches the horizon line, if it starts to darken your properly exposed foreground. By the way, the reason we held the Shift key down was to keep our gradient straight as we dragged. Not holding the Shift key down will let you drag the gradient in any direction.

The Edit Pin shows where the center of your gradient is, and in this case, I think the darkening of the sky stopped a little short. Luckily, you can reposition your gradient after the fact—just click-and-drag that pin downward to move the whole gradient down (as shown here). Now, once we've dragged out the Graduated Filter, we can add other effects to that same area. For example, go ahead and increase the Saturation to 42 (to make it more punchy), then decrease the Brightness to -109 (a before and after is shown below). Note: You can have more than one gradient (click the New button near the top right of the panel), and to delete a gradient, click on its pin and press the Delete (PC: Backspace) key.

Lightroom Killer Tips > >

▼ Hiding Your Pins

You can hide the Adjustment Brush pins anytime by pressing the letter **H** on your keyboard. To bring them back, press H again.

▼ Shortcut for Adding New Edits When you're using the Adjustment Brush, if you want to quickly add a new pin (without going back to the panel to click on the New button), just press the **Return (PC: Enter) key** on your keyboard, then start painting.

V Shrinking the Brush Options

Once you've set up your A/B brushes, you can hide the rest of the brush options by clicking on the little downward-facing triangle to the right of the Erase button.

▼ Scroll Wheel Trick

If you have a mouse with a scroll wheel, you can use the scroll wheel to change the Size amount of your brush.

▼ Controlling Flow

The numbers **1** through **0** on your keyboard control the amount of brush Flow (**3** for 30%, **4** for 40%, and so on).

▼ The Erase Button

Brush :	A B	Erase	np.
Size		K	10.0
Feather			100
Flow	<u></u>		100
	Auto Mask		
Density	<u></u>		100

The Erase button (in the Brush section), doesn't erase your image, it just changes your brush, so if you paint with it selected, it erases your mask instead of painting one.

Choosing Tint Colors

If you want to paint with a color that appears in your current photo, first choose **Color** as your Effect, then click on the Color swatch, and when the color picker appears, click-and-hold the eyedropper cursor and move out over your photo. As you do, any color you move over in your photo is targeted in your color picker. When you find a color you like, just release the mouse button. To save this color as a color swatch, just Right-click on one of the existing swatches and choose **Set this Swatch to Current Color**.

Seeing/Hiding the Adjustment Mask

By default, if you put your cursor over a pin, it shows the mask, but if you'd prefer to have it stay on while you're painting (especially handy when you're filling in spots you've missed), you can toggle the

mask visibility on/off by pressing the letter **O** on your keyboard.

 Changing the Color of Your Mask

When your mask is visible (you've got your cursor over a pin), you can change the color of your mask by pressing **Shift-O** on your keyboard (this toggles you through the four choices: red, green, white, and black).

Scaling the Graduated Filter from the Center

By default, your gradient starts where you click (so it starts from the top or the bottom, etc.). However, if you pressand-hold the **Option (PC: Alt) key** as you drag the gradient, it draws from the center outward instead.

▼ Inverting Your Gradient

Once you've added a Graduated Filter to your image, you can invert that gradient by pressing the ' (**apostrophe**) **key** on your keyboard.

Changing the Intensity of the Effects

Once you've applied either a Graduated Filter or an effect with the Adjustment Brush, you can control the amount of the last-adjusted effect by using the **Left and Right Arrow keys** on your keyboard. Library

Develop

Slideshow

Web

Lightroom Killer Tips > >

 Switching Between the A and B Brushes

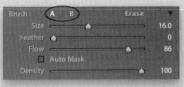

The A and B buttons are actually brush presets (so you can have a hard brush and a soft brush already set up, if you like, or any other combination of two brushes, like small and large). To switch between these two brush presets, press the */* (forward slash) key on your keyboard.

▼ Increasing/Decreasing Softness To change the softness (Feather) of your brush, don't head over to the panel just press Shift-] (right bracket key) to make the brush softer, or Shift-[(left bracket key) to make it harder.

Auto Mask Tip

Brush: A B Erase Size 16.0 Feather 0 Flow Auto Mask Density 100

When you have the Auto Mask checkbox turned on, and you're painting along an edge to mask it (for example, you're painting over a sky in a mountain landscape to darken it), when you're done, you'll probably see a small glow right along the edges of the mountain. To get rid of that, just use a small brush and paint right over those areas. The Auto Mask feature will keep what you're painting from spilling over onto the mountains. Auto Mask Shortcut
 Pressing the letter A toggles the Auto
 Mask feature on/off.

▼ Painting in a Straight Line Just like in Photoshop, if you click once with the Adjustment Brush, then pressand-hold the **Shift key** and paint somewhere else, it will paint in a straight line between those two points.

Resetting the Adjustment Brush

Reset	Custom \$	¥
Exposure		0.80
Contrast	<u></u>	76
Saturation	<u> </u>	
Clarity	<u> </u>	44
	<u> </u>	

If you want to reset the Adjustment Brush (or the Graduated Filter, for that matter), so that everything is set back to 0 (zero), just press-and-hold the Option (PC: Alt) key, and the word Effect changes to Reset. Click on that, and everything zeroes out.

▼ No More Basic Button Mode Back in Lightroom 2, Adobe had two modes for the Adjustment Brush and the Gradient Filter: a button mode and a slider mode. People hated the button mode. I mean everybody. Even mean people. So, thankfully, Adobe spared us all and got rid of the basic button mode in Lightroom 3, and now there are just sliders. Now, if we could just get them to do that to the Library module's Quick Develop panel, we'd all live happier, more productive lives.

▼ A Gaussian Blur in Lightroom?

Print

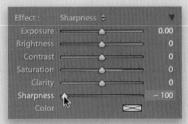

If you need a subtle blurring effect, kind of like a light amount of Gaussian Blur (well, probably more like a subtle version of the Lens Blur filter), just get the Adjustment Brush, choose Sharpness from the Effect pop-up menu (to reset the sliders), then drag the Sharpness slider all the way to the left (to –100), and now you're painting with a little blur. Great for creating a quick shallow-depth-of-field look.

Deleting Adjustments

If you want to delete any adjustment you've made, click on the pin to select that adjustment (the center of the pin turns black), then press the Delete (PC: Backspace) key on your keyboard.

Chapter 6 Fixing Common Problems

Problem Photos fixing common problems

Of all the chapter names, this one is probably the most obvious, because what else could this chapter be about, right? I mean, you wouldn't name it "Problem Photos" and then have it be about creating problems with your photos, or the book would never sell. Well, the book might sell, but this chapter certainly wouldn't help sales. You know what does help sales? Using the word "pimp" not just once, but three times (in three chapter intros). Here's why: Google started this thing a few years back where they index all the pages to printed books, and then add that information to their search database (deep inside Cheyenne Mountain), so if what you're searching for only appears within the pages of a printed book (rather than a webpage), it would still appear as a Google search result, and it would lead you directly to that book. Of course, you'd have to buy the book, but as an author, I can tell you that's not the worst outcome of

a search. Anyway, now when people search for the word "pimp," this book will appear as one of Google's search results. Of course, people looking for a pimp will see that this is, in fact, a Lightroom 3 book, which will probably initially dissuade them from buying it, but what I'm hoping is that they'll start to wonder why a book about Lightroom contains the word "pimp" at all, and that curiosity will start to eat at them. They'll be dying to know the mystery that lies deep within its crumpled pages, so they'll wind up buying the book anyway to unearth it's hidden pimpy agenda, but then of course, they'll realize that's not the way I was using the word "pimp," and while they'll still be somewhat disappointed, we know from more than a fiftieth of a century's research that approximately 6.7% of those people will start learning Lightroom. Hey, serves the rest right for trying to find a pimp using Google. They should have tried Craigslist.

Fixing Backlit Photos (Using Fill Light)

One of the most common digital photography problems is photos where the subject is backlit, so it appears almost as a black silhouette. I think the reason it's so common is because the human eye adjusts for backlit situations so well, that to our naked eye, everything looks great, but the camera exposes much differently and that shot that looked very balanced when you took it, really looks like what you see below. The Fill Light slider, found in the Basic panel, does the best job of fixing this problem of anything I've ever seen, but there is one little thing you need to add.

Step One:

Here's an image, taken out in Nevada's Valley of Fire, and while the rocks in the foreground looked pretty well exposed while I was standing there looking at the scene, of course, the camera didn't agree—it exposed for just the sky, leaving the rocks and the road below in shadows. Before we fix the backlit problem, increase the Recovery amount to 100% to tame some of the overly bright sky.

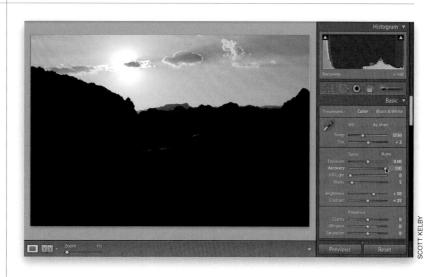

Step Two:

To open up the foreground area, just click-and-drag the Fill Light slider to the right. Unfortunately, in most cases you just can't crank it up to 100, because not only would the photo not looked balanced, but any noise in the image (which is usually the most prevalent in the shadow areas) will get amplified big time, and any noise that was hiding out in the dark shadows won't be hiding anymore. So, just keep an eye out for noise as you drag. If you do wind up adjusting the Fill Light slider to something as high as around 65 (like I did here), then the photo will probably look kind of washed out (as seen here), but in the next step, we'll fix that with just one simple move.

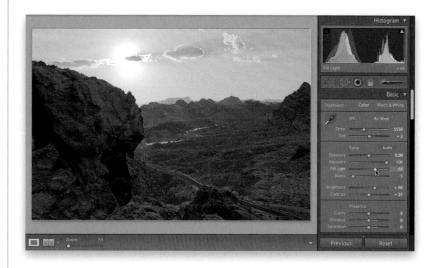

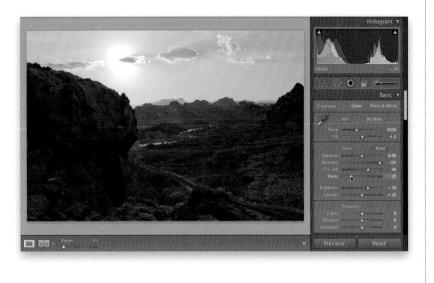

The way to get rid of that washed-out look is simply to push a little bit of deep shadows into the image by clicking-anddragging the Blacks slider to the right just a little bit. In most cases, you'll be able to move it just one or two ticks (so, you'll generally move it from its RAW image default setting of 5 to around 6 or 7), but in this case, with such a broad move of the Fill Light slider, I had to drag it all the way to 20 to bring back the saturation and keep the photo from looking washed out. Go ahead and increase the Clarity amount while you're here. Since this is a landscape photo with lots of well-defined edges, you can crank it up a little higher than usual (I went to 75).

Step Four:

Here, I used Lightroom's Before/After view (press **Y**) to show what a big difference this technique (using Fill Light, then bringing back the deep shadows by increasing the Blacks slider) can do for our backlit photos.

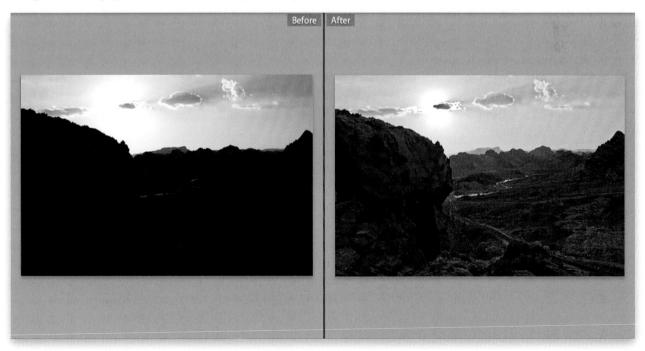

Reducing Noise

Step One:

To reduce the noise in a "noisy" image like this (shot at 1600 ISO, handheld, at night), go to the Develop module's Detail panel, where you'll find a Noise Reduction section. To really see the noise, start by zooming in to a 1:1 view.

Step Two:

I usually work on reducing the color noise first, simply because it's so distracting (if you shoot in RAW, it automatically applies some noise reduction. The image shown here is a JPEG, so there's no noise reduction added whatsoever). Dragging the Color slider to the right reduces the color noise (easy enough). So, start with the slider over to the far left, and as soon as the color goes away, stop, because once it's gone, it doesn't get "more gone." Here, there's no visible improvement between a Color setting of 30 (where the color first went away) and 100. The Detail slider controls how the edges in your image are affected by the noise reduction. If you drag it way over to the right, it does a good job of protecting color details in edge areas, but you run the risk of having color speckles. If you keep this setting really low, you avoid the speckles, but you might get some colors bleeding (expanding, like they're glowing a bit). So, since both have downsides, where do you set the Detail slider? Look at a colorful area of your image, and try both extremes. I tend to stay at 50 and below for most of the images I've worked with, but you may run across an image where 70 or 80 works best, so don't be afraid to try both ends. Luckily, it's the Color slider itself that makes the most visible difference.

If you wind up shooting at a high ISO or in very low light, chances are your image is going to have some noise—either luminance noise (a visible graininess throughout the photo, particularly in shadow areas) or color noise (those annoying red, green, and blue spots). Although the noise reduction in previous versions of Lightroom was kind of weak, in Lightroom 3 Adobe completely reworked the Noise Reduction feature so now, it's not just good, it absolutely rocks. Not only is it more powerful, but it maintains more sharpness and detail than ever before.

Web

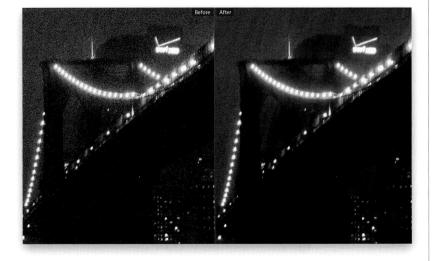

Step Three:

Now that the color noise has been dealt with, chances are your image looks grainy. So to reduce this type of noise (called luminance noise), drag the Luminance slider to the right until the noise is greatly reduced (as shown here). I gotta tell you, this baby works wonders all by itself, but you have additional control with the other two sliders beneath it. The "catch" is this: your image can look clean, or it can have lots of sharp detail, but it's kinda tricky to have both. The Detail slider (in Adobe speak the "luminance noise threshold") really helps with seriously blurry images (like this one). So, if you think your image looks a little blurry now, drag the Detail slider to the right—just know this may make your image a little more noisy. If, instead, you want a cleaner looking image, drag the Detail slider to the left—just know that you'll now be sacrificing a little detail to get that smooth, clean look (there's always a trade-off, right?).

Step Four:

The other slider under Luminance is the Contrast slider. Again, this one really makes a difference on seriously noisy images. Of course, it has its own set of trade-offs. Dragging the Contrast slider to the right protects the photo's contrast, but it might give you some blotchy-looking areas (the key word here is "might"). You get smoother results dragging the slider to the left, but you'll be giving up some contrast. I know, I know, why can't you have detail and smooth results? That's coming in Lightroom 9. The real key here is to try to find that balance, and the only way to do that is experiment on the image you have onscreen. For this particular image, most of the luminance noise was gone after dragging the Luminance s lider to around 55 (dragging much higher didn't yield better results). I wanted to keep more detail (because of the lights on the bridge), so I increased the Detail amount to around 70. I left the Contrast slider as is. The before/after is shown here.

Undoing Changes Made in Lightroom

Lightroom keeps track of every edit you make to your photo and it displays them as a running list, in the order they were applied, in the Develop module's History panel. So if you want to go back and undo any step, and return your photo to how it looked at any stage during your editing session, you can do that with just one click. Now, unfortunately, you can't just pull out one single step and leave the rest, but you can jump back in time to undo any mistake, and then pick up from that point with new changes. Here's how it's done:

Step One:

Before we look at the History panel, I just wanted to mention that you can undo anything by pressing **Command-Z** (PC: Ctrl-Z). Each time you press it, it undoes another step, so you can keep pressing it and pressing it until you get back to the very first edit you ever made to the photo in Lightroom, so it's possible you won't need the History panel at all (just so you know). If you want to see a list of all your edits to a particular photo, click on the photo, then go to the History panel in the left side Panels area (shown here). The most recent changes appear at the top. (Note: A separate history list is kept for each individual photo.)

▼ History × Brightness +3 3 Black Clipping -2 0 Black Clipping +2 2 Highlight Recovery -3 0 Exposure +0.20 0.10 Exposure 0.10 0.10 Vibrance +4 4 Clarity -2 2 Tint +2 0 Fill Light +3 3 Highlight Recovery +3 3 Tint +2 -2 Tint +2 -2 Tint +2 -2 Tint +3 -3 Highlight Recovery +3 -3 Tint -2 -2 Tint -2 -2 Tint -2 -2 Tint -2 -2 Tint -4 -4 Temperature -6 -2 Temperature -6 6 Import (4/26/10 10:32:24 AM) -4

Step Two:

If you hover your cursor over one of the history states, the small Navigator panel preview (which appears at the top of the left side Panels area) shows what your photo looked like at that point in history. Here, I'm hovering my cursor over the point a few steps back where I had converted this photo to black and white, but since then I changed my mind and switched back to color.

If you actually want to jump back to what your photo looked like at a particular stage, then instead of hovering over the state, you'd click once on it and your photo reverts to that state. By the way, if you use the keyboard shortcut for your undos (instead of using the History panel), the edit you're undoing is displayed in very large letters over your photo (as seen here). This is handy because you can see what you're undoing, without having to keep the History panel open all the time.

Step Four:

During your editing process, if you come to a point where you really like what you see and you want the option of quickly jumping back to that point, go to the Snapshots panel (it's right above the History panel), and click on the + (plus sign) button on the right side of the panel header (as shown here). That moment in time is saved to the Snapshots panel, and it appears with its name field highlighted, so you can give it a name that makes sense to you (I named mine "Black & White with Exposure Adjusted," so I'd know that if I clicked on that snapshot, that's what I'd get-a black-and-white photo with the exposure tweaked. You can see my snapshot highlighted in the Snapshots panel shown here). By the way, you don't have to actually click on a previous step to save it as a snapshot. Instead, in the History panel you can just Right-click on any step and choose Create Snapshot from the pop-up menu. Pretty handy.

Cropping Photos

When I first used the cropping feature in Lightroom, I thought it was weird and awkward—probably because I was so used to the Crop tool in Photoshop but once I got used to it, I realized that it's probably the best cropping feature I've ever seen in any program. This might throw you for a loop at first, but if you try it with an open mind, I think you'll wind up falling in love with it. If you try it and don't like it, make sure you read on to Step Six for how to crop more like you do in Photoshop (but don't forget that whole "open mind" thing).

Step One:

Here's the original photo. The shot is so wide the action kind of gets lost, so we're going to crop in tight to isolate the action. Go to the Develop module and click on the Crop Overlay button (circled here in red) in the toolbox above the Basic panel, and the Crop & Straighten options will pop down below it. This puts a "rule of thirds" grid overlay on your image (to help with cropping composition), and you'll see four cropping corner handles. To lock your aspect ratio (so your crop is constrained to your photo's original proportion), or unlock it if you want a non-constrained freeform crop, click on the lock icon near the top right of the panel (as shown here).

Step Two:

To crop the photo, grab a corner handle and drag inward to resize your Crop Overlay border. Here, I grabbed the top-left corner handle and dragged diagonally inward and I stopped just before I cut off the top of the referee's hat near the right side of the image.

Now the bottom-right corner needs to be tucked in a bit to get us nice and tight in on the action (you did download this photo, right? The URL for the downloads is in the book's introduction). So, grab the bottom-right corner and drag it diagonally inward to eliminate as much of the excess field as possible for a nice, tight crop (as seen here). If you need to reposition the photo inside the cropping border, just click-and-hold inside the Crop Overlay border and your cursor will change into the "grabber hand" (shown here).

TIP: Hiding the Grid

If you want to hide the rule-of-thirds grid that appears over your Crop Overlay border, press Command-Shift-H (PC: **Ctrl-Shift-H)**. Also, there's not just a rule of thirds grid, there are other grids—just press the letter **O** to toggle through the different ones.

Step Four:

When the crop looks good to you, press the letter **R** on your keyboard to lock it in, remove the Crop Overlay border, and show the final cropped version of the photo (as seen here). But there are two other choices for cropping we haven't looked at yet.

TIP: Canceling Your Crop

If, at any time, you want to cancel your cropping, just click on the Reset button at the bottom-right side of the Crop & Straighten options panel.

Continued

Step Five:

If you know you want a particular size ratio for your image, you can do that from the Ratio pop-up menu in the Crop & Straighten section. Go ahead and click the Reset button, below the right side Panels area, so we return to our original image, and then click on the Crop Overlay button, again. Click on the Aspect pop-up menu at the top-right side of the Crop & Straighten options panel, and a list of preset sizes appears (seen here). Choose 4x5/8x10 from the pop-up menu, and you'll see the left and right sides of the Crop Overlay border move in to show the ratio of what a 4x5" or 8x10" crop would be. Now you can resize the cropping rectangle and be sure that it will maintain that 4x5/8x10 aspect ratio.

Step Six:

The other, more "Photoshop-like," way to crop is to click on the Crop Overlay button, then click on the Crop Frame tool (shown circled here in red) to release it from its home near the top left of the Crop & Straighten section. Now you can just click-and-drag out a cropping border in the size and position you'd like it. Don't let it freak you out that the original cropping border stays in place while you're dragging out your new crop, as seen herethat's just the way it works. Once you've dragged out your cropping border, it works just like before (grab the corner handles to resize, and reposition it by clicking inside the cropping border and dragging. When you're done, press R to lock in your changes). So, which way is the right way to crop? The one you're most comfortable with.

When you crop a photo using the Crop Overlay tool in the Develop module, the area that will get cropped away is automatically dimmed to give you a better idea of how your photo is going to look when you apply the final crop. That's not bad, but if you want the ultimate cropping experience, where you really see what your cropped photo is going to look like, then do your cropping in Lights Out mode. You'll never want to crop any other way.

Lights Out Cropping Rocks!

Step One:

To really appreciate this technique, first take a look at what things look like when we normally crop an image—lots of panels and distractions, and the area we're actually cropping away appears dimmed (but it still appears). Now let's try Lights Out cropping: First, click on the Crop Overlay button to enter cropping mode. Now press **Shift-Tab** to hide all your panels.

Step Two:

Press the letter **L** twice to enter Lights Out mode, where every distraction is hidden, and your photo is centered on a black background, but your cropping border is still in place. Now, try grabbing a corner handle and dragging inward, and watch the difference—you see what your cropped image looks like live as you're dragging the cropping border. It's the ultimate way to crop (it's hard to tell from the static graphic here, so you'll have to try this one for yourself—you'll never go "dim" again!).

Straightening Crooked Photos

If you've got a crooked photo, Lightroom's got three great ways to straighten it. One of them is pretty precise, and with the other two you're pretty much just "eyeing it," but with some photos that's the best you can do.

Step One:

The photo shown here has a crooked horizon line, which is pretty much instant death for a landscape shot. To straighten the photo, start by clicking on the Crop Overlay button, found in the toolbox, right under the histogram in the Develop module's right side Panels area (as shown here). This brings up the Crop Overlay grid around your photo, and while this grid might be helpful when you're cropping to recompose your image, it's really distracting when you're trying to straighten one, so I press **Command-Shift-H (PC: Ctrl-Shift-H)** to hide that grid.

Step Two:

As I mentioned above, there are three different ways to straighten your photo and we'll start with my favorite, which uses the Straighten tool. I think it's the fastest and most accurate way to straighten photos. Click on the Straighten tool, found in the Crop & Straighten options panel (it looks like a level), then click-and-drag it left to right along something that's supposed to be level in the image (as shown here, where I've dragged it along the edge of the water). See why I like straightening like this? However, there is one catch: you have to have something in the photo that's supposed to be level-like a horizon, or a wall, or a window frame, etc.

When you drag that tool, it shrinks and rotates the cropping border to the exact angle you'd need to straighten the photo (without leaving any white gaps in the corners). The exact angle of your correction is displayed in the Crop & Straighten options panel next to the Angle slider. Now all you have to do is press **R** to lock in your straightening. If you decide you don't like your first attempt at straightening, just click the Reset button at the bottom of the options panel, and it resets the photo to its unstraightened and uncropped state. So, to try again, grab the Straighten tool and start dragging.

Step Four:

To try the two other methods, we need to undo what we just did, so click the Reset button at the bottom of the right side Panels area, then click on the Crop Overlay button again (if you locked in your crop after the last step). The first of the two methods is to just drag the Angle slider (shown circled here in red)-dragging it to the right rotates the image clockwise; dragging left, counterclockwise. As soon as you start to drag, a rotation grid appears to help you line things up (seen here). Unfortunately, the slider moves in pretty large increments, making it hard to get just the right amount of rotation, but you can make smaller, more precise rotations by clicking-and-dragging left or right directly over the Angle amount field (on the far right of the slider). The second method is to just move your cursor outside the Crop Overlay border (onto the gray background), and your cursor changes into a two-sided arrow. Now, just clickand-drag up/down to rotate your image until it looks straight.

Great Trick for "Dust Spotting" Your Photos

When you're searching for any dust spots or specks on your images, it's important to make sure you don't miss any areas while you're searching around an image that can easily be 50" wide or more. That's why I fell in love with this trick, which I learned while reading an interview with Mark Hamburg (known as the "Father of Photoshop Lightroom"). He mentioned an undocumented feature that helps ensure that when you're checking an image to remove specks and dust, you don't miss any areas.

Step One:

Start in the Develop module (that way, if you do find dust or specks, you can fix it right there). Now, go to the Navigator panel (at the top of the left side Panels area) and click on the 1:1 (100% size) view (shown circled here in red). If you look in the panel's small preview window, you'll see a little square (or rectangle) in the center of your photo preview, which shows the area you've zoomed into, and that's what will be displayed in your center Preview area, as well. Click on that square, and drag it to the top-left corner of the Navigator preview (as shown here).

If you see any spots or dust in this upperleft corner of your photo, use the Spot Removal tool to remove them (more on this tool on the next page). Once you've cleaned up ("spotted") that area, press the Page Down key on your keyboard to move straight down by the exact size of that small white navigator square. When you've gone all the way down the far-left side (cleaning as you go) and you hit the bottom of your image, it automatically wraps you back up to the top of the photo, but exactly one column over, so you can begin "spotting" this area. If you keep doing this until you reach the bottom-right corner, you're guaranteed not to miss any areas.

Library Dev

Develop

leshow Print

Web

If you've got spots, dust, specks, and other nasty junk on your lens or on your camera's sensor, it's going to show up on your photos, in the same exact place on every single photo. Luckily, a lot of simple dust and spot removal chores can be done right within Lightroom (if they're tricky, then you'll have to head over to Photoshop). However, the advantage of doing it here is once you remove the spots from one photo, you can automatically fix all the other photos from that shoot based on the one you fixed.

Removing Spots and Other Nasty Junk

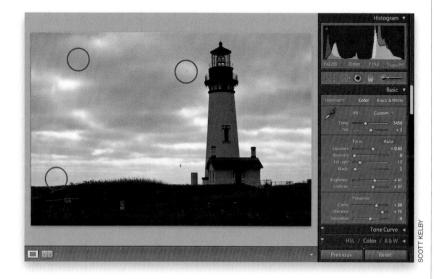

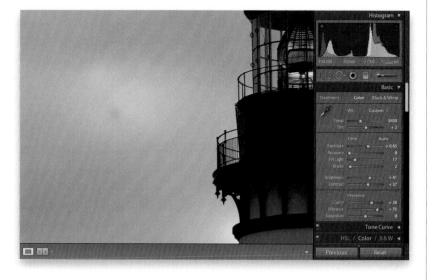

Step One:

If you find a photo that has visible dust, spots, or any other artifacts (stuff we call "nasty junk"), then head to the Develop module, because there's a tool there that can help. In the photo shown here, there are a number of different spots visible in the sky, and they're caused by dust on my digital camera's sensor (I'm really bad about keeping my sensor clean). Of course, as I pointed out above, if they're on this photo, then those spots are in the same place on every photo from this shoot. I've circled some of the most obvious spots in this photo in red, just so you can see what we have to deal with.

Step Two:

The first step in getting rid of these artifacts is to zoom in tight, so you can really see what you're working on (and so you don't create a new problem really obvious retouching). To zoom in, just double-click on the image, or you could click the 1:1 button at the top of the Navigator panel, or press **Command-+ (PC: Ctrl-+)** a couple of times until you're zoomed in nice and tight (as seen here, where I zoomed in to a 1:1 [100%] view). It doesn't matter how you get zoomed in—just get there. Now you can really see those spots. Yeech!

Continued

Click on the Spot Removal tool in the toolbox right below the histogram at the top of the right side Panels area, and the options for this tool will pop down below it. There are two choices for how this tool fixes your spots-Clone or Healbut you get the best results by leaving it set on Heal. The only reason ever to switch it to Clone is if the spot you're trying to remove is either on, or very near, the edge of something (like the edge of a building, or a car, etc.), or it's near the outside edge of the image itself. The reason is the Heal function doesn't like edges and it will often smudge, rather than hide, the spot, so if that happens, I switch to Clone and try again. Other than that, I'm a healer (so to speak).

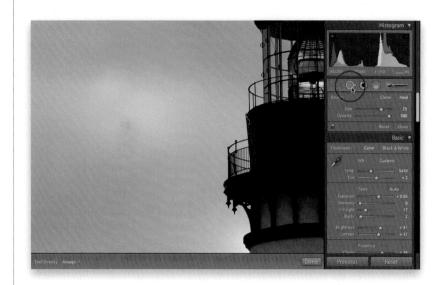

Step Four:

Now, take the Spot Removal tool and move it directly over the spot you want to remove. Use the Size slider to make the round brush cursor just a little larger than the spot itself. You can also use the Left and Right Bracket keys, found to the immediate right of the letter P on your keyboard, to change the size. Each time you press the Right Bracket (]) key, it makes the circle larger; the Left Bracket ([) key makes it smaller. Now don't paint with this tool, just click it once and it will quickly search for a clean nearby area, then it samples that area to make your fix (and it's pretty darn clever about choosing the right area—it's not perfect, but it does a surprisingly good job).

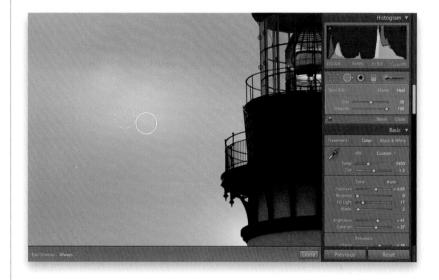

Slideshow Print

Web

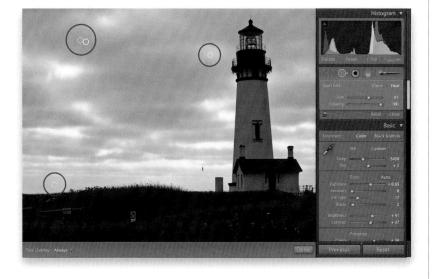

Step Five:

When you click with this tool, you'll see two circles appear: (1) a thinner one that shows the area being fixed, and (2) a thicker one that shows the clean area that the tool is sampling from to make the repair. If your background is pretty simple, like the one shown here, this one-click-and-you're-done method works pretty well, because Lightroom can find lots of open areas nearby. But, if you don't like the place it sampled from (you see an obvious change in tone or texture), you can click-and-drag that thicker sampling circle to a new spot, and as you drag, you'll see the area inside the first circle update live, so you can find a clean spot that will work pretty quickly. Also, if you think Lightroom will have a hard time finding a clean area nearby, you can lead it there—instead of just clicking once, click over the spot, hold, and drag your cursor to the area you'd like to have it sample from. When you first start dragging, a line connects both circles, and as you move further away, an arrow appears that points back to the area you're repairing.

Step Six:

To remove more spots, either click directly over them, or if they're in trickier locations, move the Spot Removal tool over the spot, click, hold, and drag out your sampler, and when you release the mouse button, the fix is in! I used that trick from the previous tutorial to make sure I didn't miss any spots in my image. You can see all the little repair circles here (I've really got to get that sensor cleaned!).

TIP: Hiding the Circles To hide all those circles, press **Q**, which disengages the tool.

Step Seven:

Back in the first step, I mentioned that the dust on my camera's sensor created these annoying spots in the exact same position in every shot from that shoot. If that's the case (and with spots like this, it often is), then once you've removed all the spots, click the Copy button at the bottom of the left side Panels area. This brings up the Copy Settings dialog, shown here. First, click the Check None button, so everything it would copy from your photo is unchecked. Then, turn on just the checkbox for Spot Removal (as shown here) and click the Copy button.

White Balance	Treatment (Color)	Lens Corrections	Spot Removal
Basic Tone Exposure Highlight Recovery Fill Light	Color Saturation Vibrance Color Adjustments	Lens Profile Corrections Chromatic Aberration Lens Vignetting	Crop Straighten Angl Aspect Ratio
Black Clipping Brightness Contrast	 Split Toning Local Adjustments 	 Effects Post-Crop Vignetting Grain 	
Tone Curve	Brush Graduated Filters	Process Version Calibration	
Clarity			
Sharpening	Noise Reduction		

Step Eight:

Now, go to the Filmstrip (or the Library module's Grid view) and select all the horizontal photos (photos in the same orientation) from that shoot, then click the Paste button at the bottom of the left side Panels area, and it applies that same spot removal you did to the first photo, to all these selected photos-all at once (as shown here). To see these fixes applied, click on the Spot Removal tool again. I also recommend you take a quick look at the fixed photos, because depending on the subject of your other shots, the fixes could look more obvious than on the photo you just fixed. If you see a photo with a spot repair problem, just click on that particular circle, hit the Delete (PC: Backspace) key on your keyboard to remove it, then use the Spot Removal tool to redo that one spot repair manually.

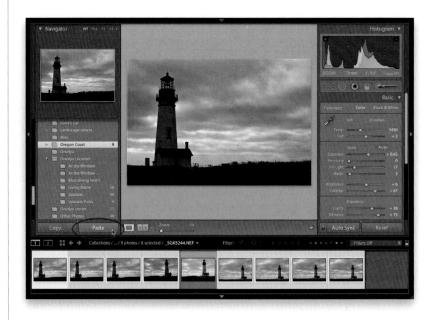

Library Deve

Develop

Slideshow

Web

If you wind up with red eye in your photos (point-and-shoots are notorious red-eye generators thanks to the flash being mounted so close to the lens), Lightroom can easily get rid of it. This is really handy because it saves you from having to jump over to Photoshop just to remove red eye from a photo of your neighbor's six-year-old crawling through a giant hamster tube at Chuck E. Cheese. Here's how it works:

Removing Red Eye

Print

Step One:

Go to the Develop module and click on the Red Eye Correction tool, found in the toolbox right under the Histogram panel (its icon looks like an eye, and it's circled here in red). Click the tool in the center of one of the red eyes and drag down and to the side to make a selection around the eye (I used the term "selection," but it's not really a selection in the Photoshop senseit's more a box with crosshairs in it). When you release the mouse button, it removes the red eye. If it doesn't fully remove all the red, you can expand how far out it removes it by going to the Red Eye Correction tool's options (they appear in the panel once you've released the mouse button), and dragging the Pupil Size slider to the right (as shown here).

Step Two:

Now do the same thing to the other eye (the first eye you did stays selected, but it's "less selected" than your new eye selection-if that makes any sense). As soon as you click-and-drag out the selection and release your mouse button, this eye is fixed too. If the repair makes it look too gray, you can make the eye look darker by dragging the Darken slider to the right (as shown here). The nice thing is that these sliders (Pupil Size and Darken) are live, so as you drag, you see the results right there onscreen—you don't have to drag a slider and then reapply the tool to see how it looks. If you make a mistake and want to start over, just click the Reset button at the bottom right of the tool's options panel.

Fixing Lens Distortion Problems

Ever shoot some buildings downtown and they look like they're leaning back? Or maybe the top of the building looks wider than the bottom. These types of lens distortions are really pretty common, but in previous versions of Lightroom, to fix these types of problems you had to jump over to Photoshop and manually try to tweak your image there. Luckily, Lightroom 3 can not only fix your lens distortion problem, it can often do it automatically (but of course, you can do it manually if you want to, or if your lens isn't supported).

Step One:

Open an image that has a lens distortion problem (by the way, this feature also automatically corrects edge vignetting problems and chromatic aberrations as well, which I'll cover later, but here we're just going to be focusing on geometric distortion). In this case, I'm using a photo taken with a 10.5mm fisheye lens, and while there are third-party plug-ins you can buy to address the fisheye distortion caused by the lens, since it's now built in to Lightroom, we don't have to use them (wild cheers ensue!). Take a look at the image shown here, and the rounding of the court (and the word "Bulls").

Step Two:

Scroll down to the Lens Corrections panel. You have two options here at the top: Profile (it fixes the problem automatically) or Manual (you fix it yourself). We'll start with the auto method, so click on Profile, then turn on the checkbox for Enable Profile Corrections. When you do this-Bam!your image is fixed (look at how it straightened out the image shown here). It can pull off this mini-miracle because it reads the EXIF data embedded into the photo at the moment you took the shot, so it knows which lens make and model you used to take the image (Adobe included lots of camera and lens profiles for popular Nikon, Canon, Tamron, and Sigma lenses. Take a look under the Lens Profile section and you'll see your lens' make and model, and the type of lens profile applied). This is pretty amazing stuff if you ask me, and it all happens all in a split second.

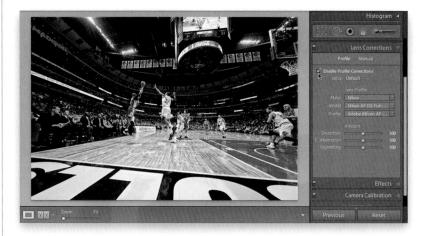

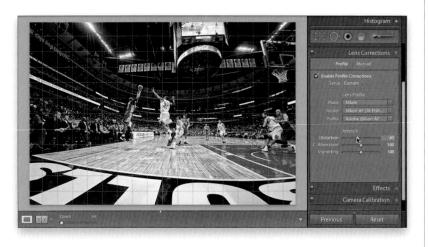

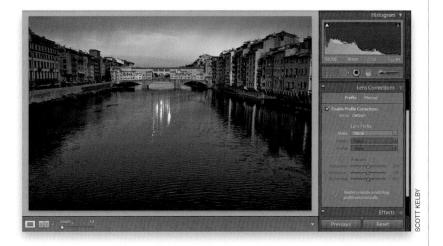

Step Three:

You can tweak the automatic correction a bit by using the Amount sliders at the bottom of the panel. For example, if you thought it removed too much of the distortion, you can drag the Distortion slider to the left a little (as shown here), and it lessens the amount of rectilinear correction it applied to the photo (notice how the foreground area has a little bit of curve back in it, and there's less distortion around the far-left and far-right sides? You can see more of the backboard, as well). Having this simple slider to tweak the automatic result is pretty handy (and you'll probably use it more than you think).

Step Four:

Now, let's look at another photo. In this case, the image looks bloated (look at the bridge in the middle-it's bowed), and look how the buildings on the banks look like they're leaning back. When you turn on the checkbox for Enable Profile Corrections, you'll find out that nothing happens, and where it would normally list my lens' make and model, it reads "None." That's because for whatever reason, this image doesn't have any embedded EXIF data (maybe the image was copied-andpasted into a blank document, or maybe when it was exported from Lightroom, the Minimize Embedded Metadata checkbox was turned on, so it stripped out that EXIF data, or maybe Lightroom just doesn't have this lens profile in its database). Whatever the reason, you need to help it out and tell it which brand of lens was used, and which lens it was taken with, and then it can apply an automatic correction.

Step Five:

In the Lens Profile section of the panel, from the Make pop-up menu, choose the brand of lens you shot with (in this case, it was a Nikon, so I chose Nikon). Then choose the type of lens it was shot with from the Model pop-up menu (this was actually shot with the lens the camera came withcalled a "kit lens"—which is an 18-55mm lens, and not a particularly good one at that). Lightroom didn't have a profile for that exact lens, so I chose the closest match (the 18–200mm), and it actually did a pretty decent job fixing the distortion in the image. If you want the exact profile for your lens, you can do a Google search for it, and find it in all of about 10 seconds, because Adobe released a free Lens Profile Creator utility and people are already filling in the missing lenses, and posting them online for free download (you can download the creator and start making your own custom profiles at http://labs.adobe.com/technologies/lensprofile_creator/).

Step Six:

Once I chose the closest profile from the Model pop-up menu to the lens I had actually used, it tried to tweak the automatic correction. It wasn't half bad, but it wasn't right on the money either. I tried dragging the Amount Distortion slider, but it didn't do enough. That's when you click on Manual (at the top of the panel) to reveal the Transform sliders. I wound up having to drag the Distortion slider to +23 to remove the bend and bloating from the bridge in the center, but the buildings were still leaning back. To fix that, I dragged the Vertical slider to +25, and that fixed the leaning problem and made the buildings straight (as seen here). By the way, as soon as you move your cursor over the Transform sliders, the grid you see here over the photo appears to help you with lining everything up (particularly helpful if you're fixing a bowed horizon line, or rotating the photo using the Rotate slider).

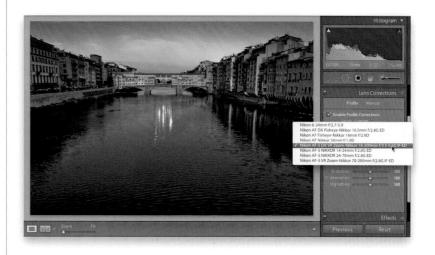

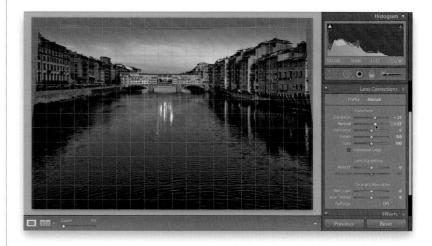

Slideshow Print Web

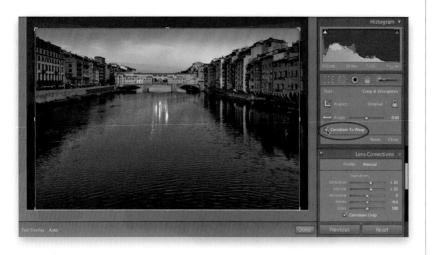

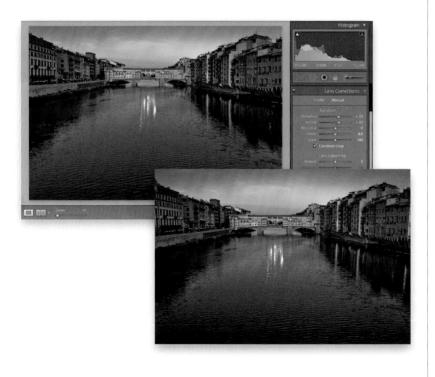

Step Seven:

Look at the image in the previous step, and you'll see an area above the top of the image that's filled with gray. That's because when you use the Vertical or Horizontal Transform sliders, it tilts the plane of the image, and that's going to leave a gray gap somewhere (depending on which slider you moved). In this case, because we dragged the Vertical slider to the right, that gray gap is at the top of the image, so the photo will have to be cropped. Luckily, that process can be automated now, too. If you click on the Crop Overlay tool (up in the toolbar near the top in the right side Panels area—right below the Histogram panel), it displays the Crop Overlay options below it. Turn on the checkbox for Constrain To Warp and it automatically adjusts the size of the cropping border, so it crops away all the gray junk (that's the technical term for it, but Adobe would never admit it).

Step Eight:

All you have to do now is press the **Return (PC: Enter)** key to lock in your crop, and your image is fixed (as seen here). I included the original image below, so you can see how the bridge was bowed and the buildings were leaning back.

Note: Since the profile wasn't available for the particular lens that I used to take this shot, I also tried a few other Nikon lens profiles (from the Model pop-up menu) to see if any of them did the trick. Although this wasn't taken with a fisheye lens, I tried the fisheye profile anyway, and it worked surprisingly well (though I still had to use the Vertical Transform slider in Manual mode to get the buildings right). Go ahead and give it a try and see what you think.

Fixing Edge Vignetting

Vignetting is a lens problem that causes the corners of your photo to appear darker than the rest of the photo. This problem is usually more pronounced when you're using a wide-angle lens, but can also be caused by a whole host of other lens issues. Now, a little darkness in the edges is considered a problem, but many photographers (myself included) like to exaggerate this edge darkening and employ it as a lighting effect in portraits, which we covered in Chapter 4. Here's how to fix it if it happens to you:

Step One:

In the photo shown here, you can see how the corner areas look darkened and shadowed. Scroll down to the Lens Corrections panel in the Develop module's right side Panels area, click on Profile at the top, then turn on the Enable Profile Corrections checkbox, and Lightroom will try to automatically remove the edge vignetting, based on the make and model of the lens you used (it learns all this from the EXIF data embedded in your image. See page 206 for more on how it reads this data). If the image still needs a little correction (as this one did), you can try the Vignetting slider under Amount. If you still think the automatic way isn't working well enough, you can do it manually by clicking on Manual (next to Profile), and you'll see a section for Lens Vignetting in the middle.

Step Two:

There are two vignetting sliders here: the first controls the amount of brightening in the edge areas, and the second slider lets you adjust how far in toward the center of your photo the corners will be brightened. In this photo, the edge vignetting is pretty much contained in the corners, and doesn't spread too far into the center of the photo. So, start to slowly click-and-drag the Amount slider to the right and as you do, keep an eye on the corners of your image. As you drag, the corners get brighter, and your job is to stop when the brightness of the corners matches the rest of the photo (as shown here). If the vignetting had extended further into the center of the photo, then you'd drag the Midpoint slider to the left to make your brightening cover a larger area. That's how easy removing this problem is.

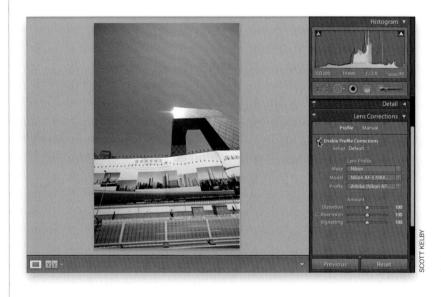

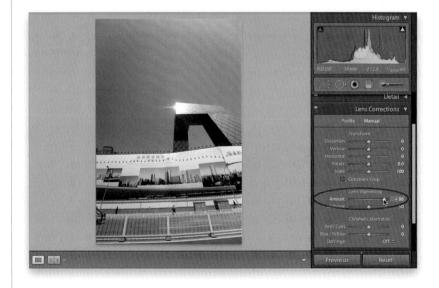

Web

There are two types of sharpening you can do in Lightroom: The first is called capture sharpening (covered here), which is sharpening that would normally happen in your camera if you're shooting JPEG. If you shoot RAW, the sharping in your camera is turned off, so we apply it in Lightroom instead (by default, all RAW photos have sharpening applied in Lightroom, but if you want more sharpening, or if you want to control which type of

sharpening is applied, and how, then you definitely want to read this).

Sharpening Your Photos

Step One:

In previous versions of Lightroom, you had to view your image at a 1:1(100%)view to be able to see the effects of sharpening, but in Lightroom 3, not only can you view it at other magnifications, but they've also improved the sharpening technology itself, so you can apply more sharpening without damaging your image. To sharpen your image, go to the Detail panel in the Develop module. There's a preview window in this panel that lets you zoom in tight on one area of the image, while you see the normalsize image in the main Preview area (if you don't see the preview window, click on the left-facing triangle to the right of Sharpening at the top of the panel).

Step Two:

To zoom in on an area in the preview window, just click your cursor on the spot you want to zoom in on. Once you've zoomed in, you can navigate around by clicking-and-dragging inside the preview window. Although I use just the default 1:1 zoom, if you want to zoom in even tighter, you can Right-click inside the preview window, and choose a 2:1 view from the pop-up menu (shown here). Also, if you click the little icon in the upper-left corner of the panel (shown circled here in red), you can move your cursor over your main image in the center Preview area, and that area will appear zoomed in the preview window (to keep the preview on that area, just click on the area in the main image). To turn this off, click that icon again.

Step Three:

The Amount slider does just what you think it would—it controls the amount of sharpening applied to your photo. Here I increased the Amount to 91, and while the photo in the main Preview area doesn't look that much different, the Detail panel's preview looks much sharper (which is why it's so important to use this zoomed in preview). The Radius slider determines how many pixels out from the edge the sharpening will affect, and personally I leave this set at 1 (as seen here), but if I really need some mega sharpening I'll bump it up to 2.

TIP: Toggling Off the Sharpening

If you want to temporarily toggle off the changes you've made in the Detail panel, just click on the little switch on the far left of the Detail panel's header.

Step Four:

One of the downsides of traditional sharpening in Photoshop is that if you apply a lot of sharpening, you'll start to get little halos around the edge areas within your photos (it looks like somebody traced around the edges with a small marker), but luckily here in Lightroom, the Detail slider acts as kind of a halo prevention control. At its default setting of 25, it's doing quite a bit of halo prevention, which works well for most photos (and is why it's the default setting), but for images that can take a lot of sharpening (like sweeping landscape shots, architectural images, and images with lots of sharply defined edges, like the one you see here), you would raise the Detail slider up to around 75, as shown here (which kind of takes the protection off quite a bit and gives you a more punchy sharpening). If you raise the Detail slider to 100, it makes your sharpening appear very much like the Unsharp Mask filter in Photoshop (that's not a bad thing, but it has no halo avoidance, so you can't apply as much sharpening).

Step Five

The last sharpening slider, Masking, is to me the most amazing one of all, because what it lets you do is control exactly where the sharpening is applied. For example, some of the toughest things to sharpen are things that are supposed to be soft, like a child's skin, or a woman's skin in a portrait, because sharpening accentuates texture, which is exactly what you don't want. But, at the same time, you need detail areas to be sharp-like their eyes, hair, eyebrows, lips, clothes, etc. Well, this Masking slider lets you do just that—it kind of masks away the skin areas, so it's mostly the detail areas that get sharpened. To show how this works, we're going to switch to a portrait.

Step Six:

First, press-and-hold the Option (PC: Alt) key and then click-and-hold on the Masking slider, and your image area will turn solid white (as shown here). What this solid white screen is telling you is that the sharpening is being applied evenly to every part of the image, so basically, everything's getting sharpened.

Step Seven:

As you click-and-drag the Masking slider to the right, parts of your photo will start to turn black, and those black areas are now not getting sharpened, which is our goal. At first, you'll see little speckles of black area, but the farther you drag that slider, the more non-edge areas will become black—as seen here, where I've dragged the Masking slider over to 82, which pretty much has the skin areas in all black (so they're not being sharpened), but the detail edge areas, like the eyes, lips, hair, nostrils, and outline, are being fully sharpened (which are the areas still appearing in white). So, in reality, those soft skin areas are being automatically masked away for you, which is really pretty darn slick if you ask me.

Step Eight:

When you release the Option (PC: Alt) key, you see the effects of the sharpening, and here you can see the detail areas are nice and crisp, but it's as if her skin was never sharpened. Now, just a reminder: I only use this Masking slider when the subject is supposed to be of a softer nature, where we don't want to exaggerate texture. Okay, on the next page, we're going to switch back to the old brick building photo and finish up our sharpening there.

Develop

Slideshow Print

Web

Step Nine:

Here, I reopened the old brick building photo and, at this point, you know what all four sliders do, so now it's down to you coming up with the settings you like. But if you're not comfortable with that quite vet, then take advantage of the excellent sharpening presets that are found in the Presets panel in the left side Panels area. If you look under the Lightroom Presets (the built-in ones), you'll find two sharpening presets: one called Sharpening - Narrow Edges (Scenic) and one called Sharpening - Wide Edges (Faces). Clicking the Narrow Edges (Scenic) preset sets your Amount at 40, Radius at 0.8, Detail at 35, and Masking at 0 (see how it raised the detail level because the subject matter can take punchier sharpening?). The Wide Edges (Faces) one is much more subtle—it sets your Amount at 35, Radius at 1.4, Detail at 15, and Masking at 60.

Step 10:

Here's the final before/after image. I started by clicking on the Sharpening - Narrow Edges (Scenic) preset, then I increased the Amount to 125 (which is more than I usually use, but I pumped it up so you could see the results more easily here in the book). I set the Radius at 1.0 (which is pretty standard for me), the Detail at 75 (because a detailed photo like this can really take that punchy sharpening), and I left the Masking at 0 (because I want all the areas of the photo sharpened evenly—there are no areas that I want to remain soft and unsharpened). Now, at this point I'd save this setting as my own personal "Sharpening - High" preset, so it's always just one

click away.

Fixing Chromatic Aberrations (a.k.a. That Annoying Color Fringe)

Sooner or later, you're going to run into a situation where some of the more contrasty edges around your subject have either a red, green, or more likely, a purple color halo or fringe around them (these are known as "chromatic aberrations"). You'll find these sooner (probably later today, in fact) if you have a really cheap digital camera (or a nice camera with a really cheap wide-angle lens), but even good cameras (and good lenses) can fall prey to this problem now and again. Luckily, it's easy enough to fix in Lightroom.

Step One:

If you look closely here, it looks like someone traced around the edges with a very thin red magic marker (it looks like a thin reddish fringe along the bottom of the car, the side of the tire, and the front of the shadow). If this is happening to one of your images, first go to the Lens Corrections panel and click on Profile at the top, then zoom in on an edge area with the color fringe (I zoomed in to 2:1), so you can see how your adjustments affect the edge.

Step Two:

Turn on the Enable Profile Corrections checkbox, and Lightroom tries to remove the color fringe based on your lens' make and model (it learns this from your image's EXIF data. See page 206 for more info). If the image still needs correction, try the C. Aberration slider under Amount. If the automatic way still isn't working, try clicking on Manual at the top, and once you've identified which color the fringe is (here it's red), go to the Chromatic Aberration section of the panel and you'll see two sliders-Red/Cyan and Blue/Yellow. Here, since our problem is red, click-and-drag the Red/Cyan slider to the right, away from red, until the fringe is gone (if the fringe was blue or yellow, you'd use the next slider down and click-and-drag away from the problem color). That being said, the few times I've had to adjust for this problem, I just chose All Edges from the Defringe pop-up menu-it usually removes that edge fringe without having to move any sliders (I did move the Red/Cyan slider a little bit to the right, though). You can see in the before/ after, it greatly reduced the red edge fringe.

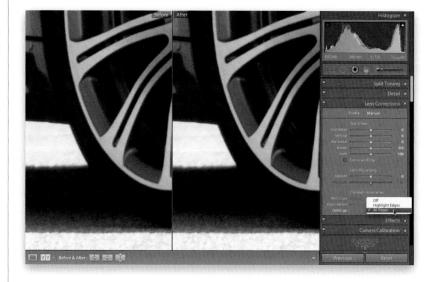

Library

Develop

Slideshow

Web

Some cameras seem to put their own color signature on your photos, and if yours is one of those, you might notice that all your photos seem a little red, or have a slight green tint in the shadows, etc. Even if your camera produces accurate color, you still might want to tweak how Lightroom interprets the color of your RAW images. The process for doing a full, accurate camera calibration is kinda complex and well beyond the scope of this book, but I did want to show you what the Camera Calibration panel is used for, and give you a resource to take things to the next level.

Basic Camera Calibration in Lightroom

Step One:

Before we start, I don't want you to think that camera calibration is something everybody must do. In fact, I imagine most people will never even try a basic calibration, because they don't notice a big enough consistent color problem to worry about it (and that's a good thing. However, in every crowd there's always one, right?). So, here's a quick project on the very basics of how the Camera Calibration panel works: Open a photo, then go to the Develop module's Camera Calibration panel, found at the very bottom of the right side Panels area, as shown here (see, if Adobe thought you'd use this a lot, it would be near the top, right?).

Step Two:

The topmost slider is for adjusting any tint that your camera might be adding to the shadow areas of your photos. If it did add a tint, it's normally green or magenta look at the color bar that appears inside the Tint slider itself. By looking at the color bar, you'll know which way to drag (for example, here I'm dragging the Tint slider away from green, toward magenta, to reduce any greenish color cast in the shadow areas, but the change in this particular photo is very subtle).

Step Three:

If your color problems don't seem to be in the shadows, then you'll use the Red, Green, and Blue Primary sliders to adjust the Hue and Saturation (the sliders that appear below each color). Let's say your camera produces photos that have a bit of a red cast to them. You'd drag the Red Primary Hue slider away from red, and if you needed to reduce the overall saturation of red in your photo, you'd drag the Red Primary Saturation slider to the left until the color looked neutral (by neutral, I mean the grays should look really gray, not reddish gray).

Step Four:

When you're happy with your changes, press **Command-Shift-N (PC: Ctrl-Shift-N)** to bring up the New Develop Preset dialog. Name your preset, click the Check None button, then turn on only the Calibration checkbox, and click Create. Now, not only can you apply this preset in the Develop module and Quick Develop panel, you can have it applied to all the photos you import from that camera by choosing it from the Develop Settings pop-up menu in the Import window (also shown here).

Note: If you want to tackle the full camera calibration process (which is not for wusses by the way, as it's got quite a few steps and hoops you have to jump through), go to **www.LightroomKillerTips.com** and in the search field, enter "Camera Calibration" and you'll find a link to Matt Kloskowski's article (which he created for me as a supplement to this book), which covers the entire process in detail.

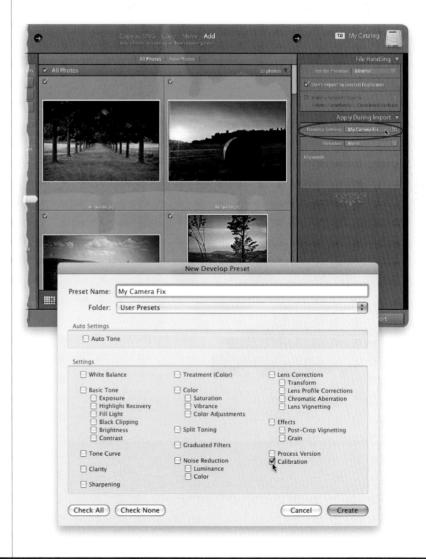

Slideshow

Web

Lightroom Killer Tips > >

 Using the Detail Panel's Preview for Cleaning Up Spots

The Detail panel's preview window was designed to give you a 100% (1:1) view of your image, so you can really see the effects of your sharpening and noise adjustments. But it's also great to keep it open when you're removing spots, because you leave the main image at Fit in Window size, and still see the area you're fixing up close in the Detail panel's preview window.

Another Noise Reduction Strategy

The Noise Reduction section, in the Detail panel, does a much better job in Lightroom 3, but if you're not happy with it or it's not working for you, try what I've done in previous versions of Lightroom: jump over to Photoshop and use a plug-in called Noiseware Professional, which does just an amazing job. You can download a trial copy from their website at www.noiseware.com and install it in Photoshop (so, you'd jump from Lightroom to Photoshop, run the Noiseware plug-in using their excellent built-in presets, and then save the file to come back into Lightroom).

Choosing Brush Size

When using the Spot Removal tool, you can press-and-hold the Command

(PC: Ctrl) key and click-and-drag out a selection around your spot (start by clicking just to the upper left of the spot, then drag across the spot at a 45° angle). As you do, it lays down a starting point and then your circle drags right over the spot.

Undos That Last Forever

If you use Photoshop, you probably already know that the History panel there just keeps track of your last 20 steps (so, you basically have 20 undos), and if you close the document, those

undos go away. However, in Lightroom, every single change you make to your photo inside Lightroom is tracked and when you change images, or close Lightroom, your unlimited undos are saved. So even if you come back to that photo a year later, you'll always be able to undo what you did.

▼ What to Do If You Can't See Your Adjustment Brush

Tools View Window Hel Crop Spot Removal Q Red Eye Graduated Filter M Adjustment Brush K W White Balance Selector Target Adjustment ь Tool Overlay Auto Show In Crop Guide Overlay Always Show Adjustment Brush Overlay Þ Show Selected Never Show

If you start painting and can't see the brush or the pins it creates, go under the Tools menu, under Tool Overlay, and choose **Auto Show**. That way, the pins disappear when you move the cursor outside your photo, but then if you move your cursor back over it again to start painting, they reappear.

Print

You Can Always Start Over— Even with Virtual Copies

Since none of your edits in Lightroom are applied to the real photo, until you actually leave Lightroom (by jumping over to Photoshop, or exporting as a JPEG or TIFF), you can always start over by pressing the Reset button at the bottom of the right side Panels area. Better yet, if you've been working on a photo and make a virtual copy, you can even reset the virtual copy to how the image looked when you first brought it into Lightroom.

	Clarity Vibrance Saturation	Hresence	e • •		0 0 0
8			Tone	e Curve	4
		HSL	/ Color /	′ B&W	4
			Split	Toning	<1
				Detail	<
8			Lens Corr	ections	<
	Previo	15	Re	eset	k

▼ Tool Overlay (Grid) Options When using the Crop Overlay tool, you can have the grid that appears over your image only appear when you're actually moving the crop border itself (which is really the only time you need to see that grid anyway, right?). Just go to the toolbar, below the Preview area, and from the Tool Overlay pop-up menu choose **Auto**.

Chapter 7 Saving JPEGs, TIFFs, and More

Exporting Images saving JPEGs, TIFFs, and more

Man, if there's a more exciting chapter than one on how to save a JPEG, I can't wait to see it, because this has to be some really meaty stuff. Okay, I'll be the first to admit that while this may not seem like an incredibly exciting chapter, it's about much, much more than saving JPEGs. That's right-it's also about saving TIFFs. Okay, I gotcha on that one (come on—you know I did), but in reality there is more to this process than you might think, so if you spend just a few minutes now reading this short chapter, I promise you it will pay off in saved time and increased productivity in the future. Now, at this point you might be thinking, "Hey Scott, that last part was actually somewhat helpful. What's that doing in a chapter intro?" I honestly don't know how that snuck in here, but I can tell you this (and I'm being totally

truthful here), it's really late at night as I write this, and sometimes if I'm not really paying attention, some actual useful information winds up sneaking into one of these chapter intros, rendering them totally useless. I do my best to make sure that these chapter intros are completely unfettered (I can't tell you how few times I've been able to use the word "unfettered" in a sentence, so I'm pretty psyched right now), but sometimes, against my better judgment, everything just starts to make sense, and before you know itsomething useful happens. I try to catch these in the editing process by copying-andpasting the entire chapter intro into the Pimp Name Generator (that's four times in one book. Cha-ching!), and then those results get copied-and-pasted back here as the final edited version for print. See, I do care. Pimp!

Saving Your Photos as JPEGs

Since there is no Save command for Lightroom (like there is in Photoshop), one of the questions I get asked most is, "How do you save a photo as a JPEG?" Well, in Lightroom, you don't save it as a JPEG, you export it as a JPEG (or a TIFF, or a DNG, or a Photoshop PSD). It's a simple process, and Lightroom has added some automation features that can kick in once your photo is exported.

Step One:

You start by selecting which photo(s) you want to export as a JPEG (or a TIFF, PSD, or DNG). You can do this in either the Library module's Grid view or down in the Filmstrip in any other module by Command-clicking (PC: Ctrl-clicking) on all the photos you want to export (as shown here).

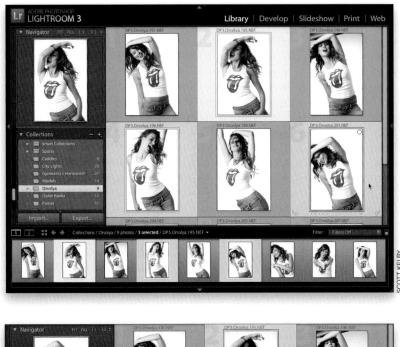

Step Two:

If you're in the Library module, click on the Export button at the bottom of the left side Panels area (circled here in red). If you're in a different module and using the Filmstrip to select your photos for export, then use the keyboard shortcut **Command-Shift-E** (PC: Ctrl-Shift-E). Whichever method you choose, it brings up the Export dialog (shown in the next step).

Lightroom Presets	V Export Location	
Burn Full-Sized JPEGs	Export To: Specific folder	•
Export to DNG For E-Mail	Folder: /Users/scottkelby/Desktop	* (Choose)
User Presets	Put in Subfolder: Lightroom Burned	
	Add to This Catalog	o Stack: Below Original
	Existing Files: Ask what to do	•
	▼ File Naming	
	Rename To: Custom Name	······································
	Custom Text	Start Number:
	Example: DP3.Orsolya.199.jpg	Extensions: Lowercase
	V File Settings	
	Format: JPEG Qu	ality: 100
	Color Space: sRGB 🛛 🗘	imit File Size To: 100 K
	🗹 Include Video Files 🛛 🔻	About Video File Support
	Video files are always exported in the of the file format selected above. Ima metadata, and watermarking options	age sizing, output sharpening,
	V Image Sizing	
	Resize to Fit: Width & Height \$	🗌 Don't Enlarge
	W: 640 H: 640 pixels \$	Resolution: 240 pixels per inch
	V Output Sharpening	
	Sharpen For: Screen	nount: Standard 🛟
	▼ Metadata	
	Minimize Embedded Metadata	
	Write Keywords as Lightroom Hierarc	hy

Export Location		
Export T 🗸	Specific folder	
Folde	Choose folder later (handy for presets)	▼ Choose)
	Home folder	
	Documents folder	
	Pictures folder Desktop	ack: Below Original 🗘
Existing File	Desktop	•
	Same folder as original photo	

Choose where to save your exported images from the Export To pop-up menu

Export Location		
Export To: Specific folder		
Folder: /Users/scottkelby/Desktop	0	Choose
Put in Subfolder: Rolli	ng Stones Shirt	
Add to This Catalog	Add to Stack: Below Orig	inal 🛟
Existing Files: Ask what to do		

Turn on the Put in Subfolder checkbox to save your images in a separate subfolder

Step Three:

Along the left side of the Export dialog, Adobe put some Export presets, which are basically designed to keep you from having to fill out this entire dialog every time from scratch. It ships with a few presets from Adobe, but the real power of this is when you create your own (those will appear under the User Presets header). The builtin Lightroom Presets are at least a good starting place to build your own, so for now click on Burn Full-Sized JPEGs, and it fills in some typical settings someone might use to export their photos as JPEGs and burn them to a disc. However, we'll customize these settings so our files are exported where and how we want them, then we'll save our custom settings as a preset, so we don't have to go through all this every time. If, instead of burning these images to disc, you just want to save these JPEGs in a folder on your computer, go to the top of the dialog, and from the Export To pop-up menu, choose Hard Drive, shown circled here in red.

Step Four:

Let's start at the top of the dialog: First, you need to tell Lightroom where to save these files in the Export Location section. If you click on the Export To pop-up menu (as shown here, at top), it brings up a list of likely places you might choose to save your file. The second choice (Choose Folder Later) is great if you're making presets, because it lets you choose the folder as you go. If you want to choose a folder that's not in this list. choose Specific Folder, then click the Choose button to navigate to the folder you want. You also have the option of saving them into a separate subfolder, like I did here, at the bottom. So, now my images will appear in a folder named "Rolling Stones Shirt" on my desktop. If you want these exported JPEGs added into Lightroom, turn on the Add to This Catalog checkbox.

Step Five:

The next section down, File Naming, is pretty much like the file naming feature you already learned about back in the Importing chapter. If you don't want to rename the files you're exporting, but want to keep their current names, leave the Rename To checkbox turned off or turn it on and then choose Filename from the pop-up menu. If you do want to rename the files, choose one of the built-in templates, or if you created a custom file naming template (which we learned how to do back in Chapter 1), it will appear in this list, too. In our example, I chose Custom Name - Sequence (which automatically adds a sequential number, starting at 1, to the end of my custom name). Then, I simply named these shots "StonesShirt," so the photos will wind up being named StonesShirt-1, StonesShirt-2, and so on. New in Lightroom 3 is a pop-up menu for choosing whether the file extension appears in all uppercase (.JPG) or lowercase (.jpg).

Step Six:

Under File Settings, you choose which file format to save your photos in from the Format pop-up menu (since we chose the Burn Full-Sized JPEGs preset, JPEG is already chosen here, but you could choose TIFF, PSD, DNG, or if you have RAW files, you could choose Original to export the original RAW photo). Since we're saving as a JPEG, there's a Quality slider (the higher the quality, the larger the file size), and I generally choose a Quality setting of 80, which I think gives a good balance between quality and file size. If I'm sending these files to someone without Photoshop, I choose sRGB as my color space. If you chose a PSD, TIFF, or DNG format, their options will appear (you get to choose things like the color space, bit depth, and compression settings).

File Naming			
🗹 Rename To:	Custom Name - Sequence		
Custom Text:	StonesShirt	Start Number:	1
Example:	StonesShirt-1.jpg	Extensions:	Lowercase

Format:	JPEG	Quality:
Color Space:	sRGB	Limit File Size To: 100 K
	🗹 Include Video Files	▼ About Video File Support

Format:	JPEG	 Quality:
Color Space:	sRGB	\$ Limit File Size To: 100 K
	🕅 Include Video Files	🖲 About Video File Support

metadata, and watermarking options are not applied to video files.

Image Sizing					
🗌 Resize to Fit:	Width	& Height		🗍 Don't Enlarge	
W:	640	H: 640	pixels 🛟	Resolution: 240	pixels per inch 🛟

You can skip the Image Sizing section altogether, unless you need to make the image you're saving smaller than its original size

Step Seven:

Let's say you're exporting an entire collection of images, and inside that collection are some video clips that were shot with your DSLR. If you want those videos included in your export, make sure you turn on the Include Video Files checkbox (shown here), which is new in Lightroom 3. Just below that checkbox, it lets you know that when it comes to exporting those video clips, they won't have any of those things like output sharpening, watermarking, file format changes, etc., because Lightroom doesn't edit video. Now that you know that, you can click on the little gray triangle to the right of the checkbox (my cursor is pointing at it) and that warning text will be hidden from view.

Step Eight:

By default, Lightroom assumes that you want to export your photos at their full size. If you want to make them smaller, in the Image Sizing section, turn on the Resize to Fit checkbox, then type in the Width, Height, and Resolution you want. Or you can choose to resize by pixel dimensions, the long edge of your image, the short edge of your image or the number of megapixels in your image from the top pop-up menu.

Step Nine:

Also, if these images are for printing in another application, or will be posted on the Web, you can add sharpening by turning on the Sharpen For checkbox in the Output Sharpening section. This applies the right amount of sharpening based on whether they're going to be seen only onscreen (in which case, you'll choose Screen) or printed (in which case, you'll choose the type of paper they'll be printed on—glossy or matte). For inkjet printing, I usually choose High for the Amount, which onscreen looks like it's too much sharpening, but on paper looks just right (for the Web, I choose Standard).

Voutput Sharpening Low Sharpen For: Glossy Paper Amoun High

You can add Output Sharpening for wherever these images will be viewed, either onscreen (on the Web or in a slide show), or on a print

Step 10:

If you'd prefer to remove all your personal EXIF camera data from these files, while keeping your copyright info still intact, go to the Metadata section and turn on the Minimize Embedded Metadata checkbox (as shown here). This hides all your exposure settings, your camera's serial numbers, and other stuff your clients probably don't need to know.

The next section down lets you add a visible watermark to the images you're exporting (watermarking is covered in detail in the next project), and to add your watermark to each image you're exporting, turn on the Watermark checkbox, then choose a simple copyright or your saved watermark from the pop-up menu.

<	Minimize Embedded Metadata
Watermarking	
Watermark:	Simple Copyright Watermark

Slideshow Print Web

Post-Processing		
After Expor	Do nothing	1
	Show in Finder	
Applicatio	Open in Adobe Photoshop CS5	and the second second
	Open in Viveza 2	
	Open in Other Application	
	Go to Export Actions Folder Now	

Export Location	Specific folder Choose folder later (handy for resets)	
Folde	Home folder Documents folder	port" button)
	Pictures folder Desktop	ack: Below Original 💠
Existing File	Same folder as original photo	

Step 11:

The final section, Post-Processing, is where you decide what happens after the files are exported from Lightroom. If you choose Do Nothing (from the After Export pop-up menu), they just get saved into that folder you chose back in the beginning. If you choose Open in Adobe Photoshop, they'll automatically be opened in Photoshop after they're exported. You can also choose to open them in another application (gasp!) or in a Lightroom plug-in (like Nik Software's Viveza 2, as you can see here). The Go to Export Actions Folder Now is covered later in this chapter (under emailing from Lightroom).

Step 12:

Now that you've customized things the way you want, let's save these settings as your own custom preset. That way, the next time you want to export a JPEG, you don't have to go through these steps again. Now, there are some changes I would suggest that would make your preset more effective. For example, if you saved this as a preset right now, when you use it to export other photos as JPEGs, they'll be saved in that same Rolling Stones Shirt folder. Instead, this is where it's a good idea to select **Choose Folder Later**, like we discussed back in Step Four (as shown here).

Step 13:

If you know you always want your exported JPEGs saved in a specific folder, go back up to the Export Location section, click the Choose button, and choose that folder. Now, what happens if you go to export a photo as a JPEG into that folder, and there's already a photo with the same name in it (maybe from a previous export)? Should Lightroom just automatically overwrite this existing file with the new one you're exporting now, or do you want to give this new file a different name, so it doesn't delete the file already in that folder? You get to choose how Lightroom handles this problem using the Existing Files pop-up menu (shown here). I pick Choose a New Name for the **Exported File** (as seen here). That way, I don't accidentally overwrite a file I meant to keep. By the way, when you choose Skip, if it sees a file already in that folder with the same name, it doesn't export the JPEG image-instead, it just skips it.

TIP: Rename Files When Using a Preset

Before you export your photos, make sure you give your files a new custom name, or the shots from your hockey game will be named StonesShirt-1.jpg, StonesShirt-2.jpg, and so on.

Step 14:

Now you can save your custom settings as a preset: click the Add button at the bottom-left corner of the dialog (shown circled here in red), and then give your new preset a name (in this case, I used Hi-Res JPEGs/Save to Hard Drive. That name lets me know exactly what I'm exporting, and where they're going).

Export To: Specific folder		
Folder: /Users/scottkelby/D	esktop	* Choose
Put in Subfolder:	JPEGs from Lightroom	
Ask what to do	c: Belo	w Original 💠
Existing File 🗸 Choose a new nam	e for the exported file 💫	
Existing File ✓ Choose a new nam Overwrite WITHOU		

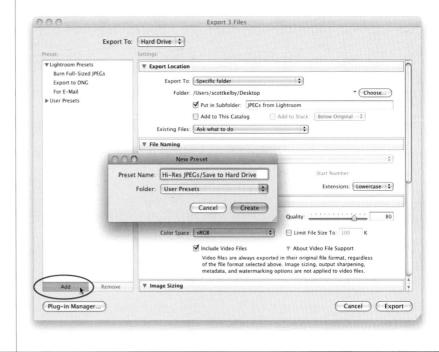

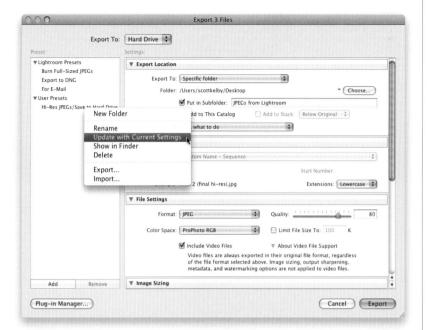

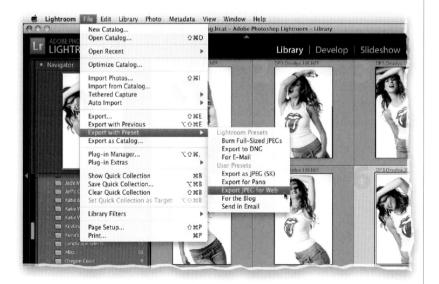

Step 15:

Once you click the Create button, your preset is added to the Preset section (on the left side of the dialog, under User Presets), and from now on you're just one click away from exporting JPEGs your way. If you decide you want to make a change to your preset (as I did in this case, where I changed the Color Space to ProPhoto RGB, and I turned the Watermark checkbox off), you can update it with your current settings by Right-clicking on your preset, and from the pop-up menu that appears, choosing **Update with Current Settings** (as shown here).

While you're here, you might want to create a second custom preset—one for exporting JPEGs for use in online Web galleries. To do that, you might lower the Image Sizing Resolution setting to 72 ppi, change your sharpening to Screen, set Amount to Standard, and you might want to turn the Watermark checkbox back on to help prevent misuse of your images. Then you'd click the Add button to create a new preset named something like Export JPEG for Web.

Step 16:

Now that you've created your own presets, you can save time and skip the whole Export dialog thing altogether by just selecting the photos you want to export, then going under Lightroom's File menu, under **Export with Preset**, and choosing the export preset you want (in this example, I'm choosing the Export JPEG for Web preset). When you choose it this way, it just goes and exports the photos with no further input from you. Sweet! 000

Adding a Watermark to Your Images

If your images are going on the Web, there's not much to keep folks from taking your images and using them in their own projects (sadly, it happens every day). One way to help limit unauthorized use of your images is to put a visible watermark on them. That way, if someone rips them off, it'll be pretty obvious to everyone that they've stolen someone else's work. Also, beyond protecting your images, many photographers are using a visible watermark as branding and marketing for their studio. Here's how to set yours up:

Export One File

Step One:

To create your watermark, press **Command-Shift-E (PC: Ctrl-Shift-E)** to bring up the Export dialog, then scroll down to the Watermarking section, turn on the Watermark checkbox, and choose **Edit Watermarks** from the pop-up menu (as shown here). *Note:* I'm covering watermarking here in the Export chapter, because you can add your watermark when you're exporting your images as JPEGs, TIFFs, etc., but you can also add these watermarks when you print an image (in the Print module), or put it in a Web gallery (in the Web module).

Export To: Hard Drive Video files are always exported in their original file format, regardless ▼ Lightroom Presets of the file format selected above. Image sizing, output sharpening metadata, and watermarking options are not applied to video files Burn Full-Sized JPEGs Export to DNG For E-Mail ▼ Image Sizing WUser Presets Resize to Fit: Width & Height Don't Enlarge Hi-Res JPEGs/Save to Hard Drive W: 1000 H: 1000 (pixels \$ Resolution: 240 pixels per inch ▼ Output Sharpening Amount: High **▼** Metadata Minimize Embedded Metadata - Write Keywords as Lightroom Hierarchy Watermarking Scott's Copyright 09 ₩ Watermark: ✓ Simple Copyright Watermark V Post-Processir Edit Watermarks... After Export: Do nothing 4 Application: Choose an application Add Rem Plug-in Manager.. Cancel Export

Step Two:

This brings up the Watermark Editor (seen here), and this is where you either (a) create a simple text watermark, or (b) import a graphic to use as your watermark (maybe your studio's logo, or some custom watermark layout you've created in Photoshop). You choose either Text or Graphic up in the top-right corner (shown circled here in red). By default, it displays the name from your user profile on your computer, so that's why it shows my copyright down in the text field at the bottom of the dialog. The text is also positioned right up against the bottom and left borders of your image, but luckily you can have it offset from the corners (I'll show you how in Step Four). We'll start by customizing our text.

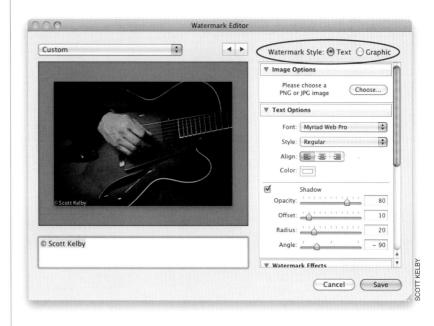

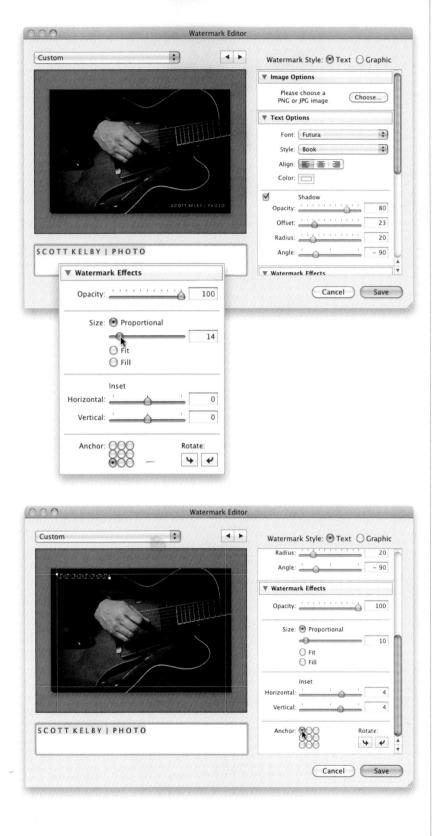

Step Three:

Type in the name of your studio in the text field at the bottom left, then choose your font in the Text Options section on the right side of the dialog. In this case, I chose Futura Book. (By the way, the little line that separates SCOTT KELBY from PHOTO is a text character called a "pipe," and you create one by pressing Shift-Backslash.) Also, to put some space between the letters, I just pressed the Spacebar after each one. You also can choose the text alignment (left justified, centered, or right justified) here, and you can click on the Color swatch to choose a font color. To change the size of your type, scroll down to the Watermark Effects section, where you'll find a Size slider (seen in the inset) and radio buttons to Fit your watermark to the full width of your image, or Fill it at full size. You can also move your cursor over the type on the image preview and little corner handles appear—click-and-drag outward to scale the text up, and inward to shrink it down. Here, I moved it to the bottomright corner, and I'll show you how to do that next.

Step Four:

You get to choose the position of your watermark in the Watermark Effects section. At the bottom of the section, you'll see an Anchor grid, which shows where you can position your watermark. To move it to the upper-left corner, click the upper-left Anchor point (as shown here). To move it to the center of your image, click the center anchor point, and so on. To the right of that are two Rotate buttons if you want to switch to a vertical watermark. Also, back in Step Two I mentioned there's a way to offset your text from being tucked right up against the sides of your image—just drag the Horizontal and Vertical Inset sliders (right above the Anchor grid). When you move them, little positioning guides will appear in the preview window, so you can easily see where your text will be positioned. Lastly, the Opacity slider at the top of the section controls how seethrough your watermark will be.

Step Five:

If your watermark is going over a lighter background, you can add a drop shadow using the Shadow controls in the Text Options section. The Opacity slider controls how dark the shadow will be. The Offset is how far from the text your shadow will appear (the farther you drag to the right, the farther away the shadow will be). The Radius is Adobe's secret code name for softness, so the higher you set the Radius, the softer your shadow will become. The Angle slider is for choosing where the shadow appears, so the default setting of -90 puts the shadow down and to the right. A setting of 145 puts it up and to the left, and so on. Just drag it, and you'll instantly see how it affects the position of your shadow. The best way to see if the shadow really looks better or not is to toggle the Shadow checkbox on/off a couple of times.

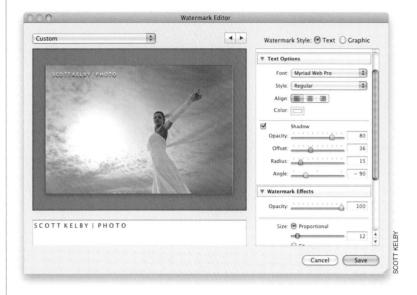

Step Six:

Now let's work with a graphic watermark, like your studio's logo. The Watermark Editor supports graphic images in either JPEG or PNG format, so make sure your logo is in one of those two formats. Scroll back up to the Image Options section, and where it says Please Choose a PNG or JPEG Image, click the Choose button, find your logo graphic, then click Choose, and your graphic appears (unfortunately, the white background behind the logo is visible, but we'll deal with that in the next step). It pretty much uses the same controls as when using text—go to the Watermark Effects section and drag the Opacity slider to the left to make your graphic seethrough, and use the Size slider to change the size of your logo. The Inset sliders let you move your logo off the edges, and the Anchor grid lets you position the graphic in different locations on your image. The Text Options and Shadow controls are graved out, since you're working with a graphic.

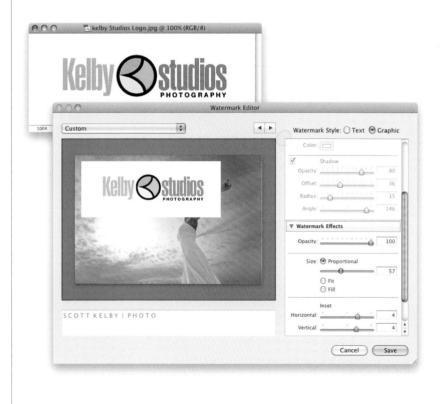

Print W

Web

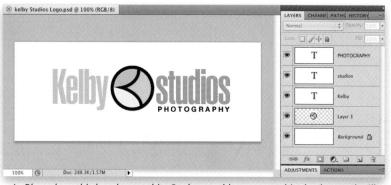

In Photoshop, this logo has a white Background layer, so a white background will appear behind your logo when you bring it into Lightroom's Watermark Editor

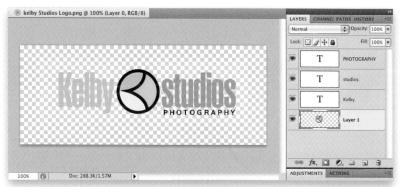

Drag the Background layer onto the Trash icon, then save the file in PNG format, and the logo now has a transparent background

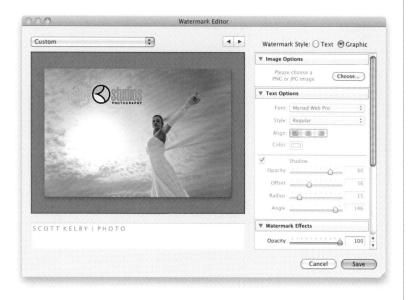

Step Seven:

To make that white background transparent, you have to open the layered file of your logo in Adobe Photoshop and do two things: (1) Delete the Background layer by dragging it onto the Trash icon at the bottom of the Layers panel, leaving just your text and graphics on their own transparent layers (as shown here at the bottom). Then, (2) save the Photoshop document in PNG format. This saves a separate file, and the file appears flattened, but the background behind your logo but will be transparent.

Step Eight:

Now choose this new PNG logo file (in the Image Options section of the Watermark Editor), and when you import it, it appears over your image without the white background (as seen here). Now you can resize, reposition, and change the opacity of your logo graphic in the Watermark Effects section. Once you get it set up the way you want it, you should save it as a watermark preset (so you can use it again, and you can apply it from the Print and Web modules). You do that by clicking the Save button in the bottom right or choosing Save Current Settings as New Preset from the pop-up menu in the top-left corner of the dialog. Now your watermark is always just one click away.

Emailing Photos from Lightroom

Lightroom does have an export to email feature, but it only processes your photos as small-sized JPEGs, so they're easier for emailing, and sticks them in a folder. However, if you take just a minute to tweak this feature, it can do so much more. In fact, it can process the photos as JPEGs for emailing, then launch your email application, and attach your photos to the email—all automatically. Then you're really emailing from Lightroom, not just getting a folder full of small JPEGs. Here's how to set it up (luckily, it's surprisingly easy):

Step One:

The key to getting the full automation I just mentioned in the introduction to this tutorial is to create what's called an Export action, which is basically telling Lightroom what to do after it exports the photos as small JPEGs. In our case, we're going to ask Lightroom to launch our default email application and attach our photos. You set this up in two places: (1) in the Export dialog, and (2) on your computer itself (don't worry—it's easy). Start by going to the File menu and choosing Export (as shown here), or press **Command-Shift-E (PC: Ctrl-Shift-E)**.

Step Two:

When the Export dialog appears, first click on the For E-Mail preset (under the Lightroom Presets in the Preset section on the left) to see some of the basic email settings. Then scroll to the bottom of the dialog to the Post-Processing section, and from the After Export pop-up menu, choose **Go to Export Actions Folder Now** (as shown here). *Note:* On a PC, this will only allow you to attach one photo to your email. For a better solution, see Step Seven.

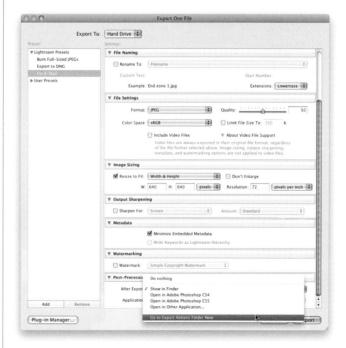

Step Three:

This brings up the folder on your computer where Lightroom's Export actions are stored (as shown here).

Step Four:

Leave that window with your Export Actions folder open, and in another window, go to the folder on your computer where your applications are stored (on a Mac, it's your Applications folder; on a PC, it's your Program Files folder). Find your email application, and what you're going to do next is create an alias (on a Mac) or a shortcut (on a PC) to that application (basically, these are pointer icons that point to the real application). To create an alias on a Mac, you'd Rightclick on your email application icon, and from the pop-up menu that appears, choose Make Alias (as shown here). Your alias icon will appear right beside your real email application's icon and it will have the word "alias" added to the name. On a PC, to create a shortcut, you'd Rightclick on your email application icon and choose Create Shortcut from the popup menu. Your shortcut will appear in the same folder and will have "Shortcut" added to the name.

Step Five:

Now, click-and-drag that alias (or shortcut) into Lightroom's Export Actions folder, then open that folder, and you should see your alias (as shown here). The name of this alias is what you're going to see in the After Export pop-up menu in the Export dialog, so I usually rename my alias (in this case, I renamed it "Email Photo"). Next, you're going to create a custom Export preset that processes your photos as small JPEGs, then launches your email program, and attaches these smaller JPEG photos automatically (it's easier than it sounds, especially since you've done all the hard parts of this process already).

Step Six:

Now, go back to the Export dialog. When you clicked on For E-mail, in the Preset section on the left, under Lightroom Presets, it loaded some settings that work well for emailing photos (it chose a lower Quality setting, the right color space [sRGB], the proper resolution, size, etc., for emailing photos), however you can override any of these if you like (if you want a higher quality, just click-and-drag the Quality slider to the right in the File Settings section). Next, go to the Post-Processing section at the bottom, and from the After Export pop-up menu, choose the Export action we just created (mine was called Email Photo, as shown here). Lastly, you want to save all this as a preset, so click the Add button at the bottom left of the Preset section. When the New Preset dialog appears, give your preset a name (I chose "Send in Email") and click the Create button. Now, click Cancel in the Export dialog, because we only came here to create a preset, and we did, and it's saved.

Export To:	Hard Drive		
Preset:	Settings:		
▼ Lightroom Presets	♥ File Naming		
Burn Full-Sized JPEGs Export to DNG	Custom Text	Filename	Start Number:
▶ User Presets		Virtual Copy.jpg	Extensions: Lowercase
	▼ File Settings		
	Format:	(JPEG 😜	Quality: 50
	Color Space:	sRGB	Limit File Size To: 100 K
		of the file format selected above	About Video File Support in their original file format, regardless Image sizing, output sharpening, tions are not applied to video files.
	▼ Image Sizing		
	Resize to Fit: W:	Width & Height	Don't Enlarge Resolution: 72 pixels per inch
	▼ Output Sharpen	ing	
	Sharpen For:	Screen	Amount: Standard
	▼ Metadata		
		Minimize Embedded Metadata	erarchy
	▼ Watermarking	Do nothing	
	🖸 Watermark:	Show in Finder Open in Adobe Photoshop CS4 Open in Adobe Photoshop CS5	
	♥ Post-Processie	Open in Other Application	
	After Export	Go to Export Actions Folder Now	k
Add Remove			

Step Seven:

Now, if you're using a PC, there's a plugin you'll have to download to get this to work. So, go to www.sbsutherland .com, click on Lightroom Related near the top, then under Export Plugins, click on MapiMailer Email Export Plugin for Lightroom. Download the MapiMailer file, and install it on your PC. If you aren't sure how to install a plug-in, there is a link to the installation instructions on the download page. (Note: We cannot guarantee the veracity of this website. Please download at your own risk.) Now, when you create your preset, you'll choose MapMailer from the Export To pop-up menu at the top of the Export dialog. You don't need an Export action, so make any other changes you want and add it as a new preset as I explained at the end of Step Six. Let's try it out: In Lightroom, Command-click (PC: Ctrl-click) on the photos you want to send to select them. Once they're selected, go under the File menu, under Export with Preset, and choose Send in Email, as shown here (that's the Export preset you created in the previous step).

Step Eight:

Lightroom takes it from there, and the next thing you'll see onscreen is a new email message window open, with all your selected photos resized and attached to the email. All you have to do now is enter the email address of the person you want to send this to, add a subject line, and hit Send. Now that you've created this Export preset, and its email Export action, the whole process will be just two steps: select the photos, and choose Send in Email. See, it was worth that little extra effort this one time to set up such an effortless Lightroom emailing system.

Exporting Your Original RAW Photo

So far, everything we've done in this chapter is based on us tweaking our photo in Lightroom and then exporting it as a JPEG, TIFF, etc. But what if you want to export the original RAW photo? Here's how it's done, and you'll have the option to include the keywords and metadata you added in Lightroom—or not.

Step One:

First, click on the RAW photo you want to export from Lightroom. When you export an original RAW photo, the changes you applied to it in Lightroom (including keywords, metadata, and even changes you made in the Develop module, like white balance, exposure, etc.) are saved to a separate file called an XMP sidecar file, since you can't embed metadata directly into the RAW file itself (we talked about this earlier in Chapter 2), so you need to treat the RAW file and its XMP sidecar file as a team. Now press Command-Shift-E (PC: Ctrl-Shift-E) to bring up the Export dialog (shown here). Click on Burn Full-Sized JPEGs just to get some basic settings in place. From the pop-up menu up top, choose Hard Drive, like we did when creating the Hi-Res JPEGs preset. Then, in the Export Location section, choose where you want this original RAW file saved to (I chose my desktop), and then in the File Settings section, in the Format pop-up menu, choose Original (shown circled here in red). When you choose to export the original RAW file, most of the rest of your choices are pretty much grayed out.

Export To:	Hard Drive			
eset	Settings:			
▼ Lightroom Presets	▼ Export Location			
Burn Full-Sized JPEGs Export to DNG For E-Mail VUser Presets HI-Res JPEGs/Save to Hard Drive Send in Email	Folder	Specific folder /Users/scottkelby/Desktop Put in Subfolder:PEGs Add to This Catalog Ask what to do	from Lightroom	v Choose
	🗹 Rename To:	Filename		ananananan 💽
	Custom Text		Start Number	
	Example:	_DSC1454.nef	Extensions	Lowercase 🗘
	▼ File Settings		NANANANAN'I NANANAN'I NANANAN'I NANA	
	Format	Original	About Video File Suppo	rt
	▼ Image Sizing			ning dan
Add Remove	Resize to Fit:	Width & Height	Don't Enlarge	

Develop

Here's the despotted, black-and-white conversion, when you include the XMP sidecar file

Here's the spotty original image in color, when you don't include the XMP sidecar file

Step Two:

Now click Export, and since there's no processing to be done, in just a few seconds your file appears on your desktop (or wherever you chose to save it)-you'll see your file and its XMP sidecar (with the same exact name, but XMP as its file extension) right nearby (as seen here, on my desktop). As long as these two stay together, other programs that support XMP sidecar files (like Adobe Bridge and Adobe Camera Raw, for example) will use that metadata, so your photo will have all the changes you applied to it. If you send this file to someone (or burn it to disc), make sure you include both files. If you decide you want the file to not include your edits, just don't include the XMP file with it.

Step Three:

Once you've exported the original RAW file and sent it to someone, if they doubleclick on it, it will open in Photoshop's Camera Raw, and if you provided the XMP file, they'll see all the edits you made in Lightroom, as seen in the top image shown here, where the photo was converted to black and white, spots were removed, and I added some clarity and more sharpening. The bottom image shown here is what they'll see in Camera Raw when you don't include the XMP file—it's the untouched original file with none of the changes I made in Lightroom (so it's back to the color original, it has spots, and has none of the clarity or sharpening).

Publish Your Images with Just Two Clicks

In Lightroom 3, Adobe added a handy drag-and-drop way to get your images from Lightroom directly to online photo sharing sites like Flickr.com, to other hard drives, or even to your iPhone. Beyond that, it also helps you keep track of your published images, so the most recent versions of them are the ones that are published. This feature is called "Publish Services," and if you take just a few minutes to set this up now, it'll save you a load of time whenever you want to post images online, or save images to your hard drive or external hard drive.

Step One:

The Publish Services panel is in the left side Panels area of the Library module. By default, it has two templates waiting for you to set them up: (1) your hard drive, and (2) Flickr (the online photo sharing site). You set up either of these by clicking on the Set Up button on the right side of each (it doesn't exactly look like a button, but it does say Set Up, and you can click on it, so technically-it's a button). If you want to create a new one, click on the + (plus sign) button that appears on the right side of the panel header and choose Go to Publishing Manager (as shown here). For this project, let's just go ahead and click on Set Up next to Flickr.

Step Two:

The main section of the Lightroom Publishing Manager dialog looks pretty much like the regular Export dialog, with two exceptions: (1) near the top, there are Publish Service, and Flickr Account and Title sections, and (2) at the bottom there are Flickr account options for how your photos will be displayed (Privacy and Safety). We'll start up top with the Log In button. Click on it and a dialog appears (shown on the bottom left) asking you to click the Authorize button to jump over to the Flickr website, so you can give Flickr permission to work with Lightroom, so go ahead and click Authorize. Now the dialog changes to tell you that once you're done at Flickr.com, you'll need to come back to Lightroom to finish setting everything up (as shown on the bottom right).

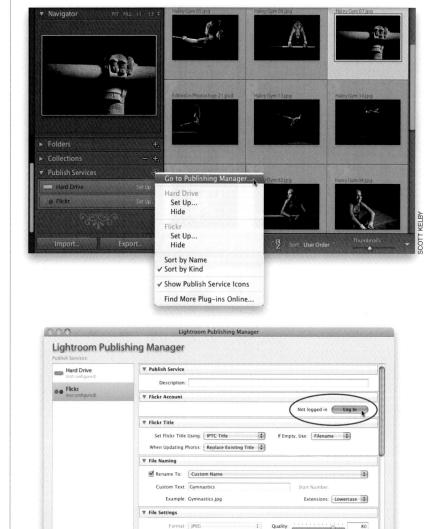

Include Video File

ed in to Flickr yet

Limit File Size To: 100

Return to this window once you've

authorized Lightroom on flickr.com.

Once you've granted permission for Lightroom (in your web browser), click the Done button below.

Cancel Done

Add

Lightroom needs your permission to

If you click Authorize, you will be taken to a web page in your web browser where you can log in. When you're finished, return to Lightroom to complete the authorization.

(Cancel) (Authorize

upload images to Flickr.

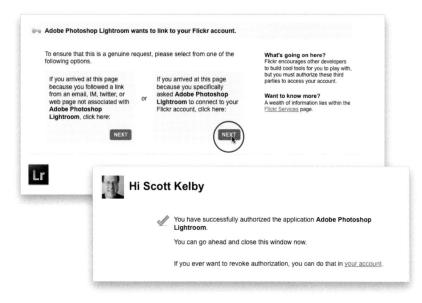

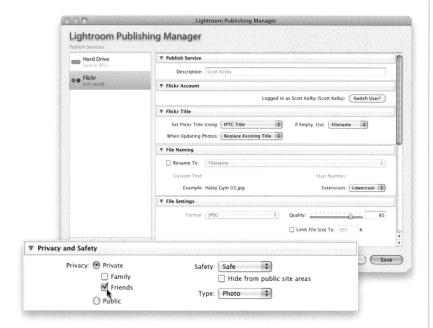

Step Three:

Once you log into your Yahoo account and get to Flickr (if you don't already have a Flickr account, and want to use this feature, go ahead and at least sign up for their free account through Yahoo), you'll find a page with something similar to what you see at the top here, asking if you got there from a separate webpage, or if you got there directly from Lightroom (which you did). So, click the blue Next button on the right (shown circled here in red) and it takes you to a page where you authorize Flickr to talk back and forth to Lightroom. Once you do, you'll get a confirmation page like the one you see at the bottom here (but of course, it won't say "Hi Scott Kelby." If it does, you have an entirely different problem). ;-) Now, back to the Lightroom part.

Step Four:

Once you're done on the Flickr approval page, go back to Lightroom, and now all you have to do is set up the export options like usual (choosing your file format, whether you want sharpening added, watermarking added, etc.), but when you get to the bottom, you'll see options for Flickr's Privacy and Safety control (shown here at the bottom) for the images you're going to upload, so make your choices there now, then click the Save button to save this setup as your Flickr Publish Service.

Step Five:

Now select the photos that you'd like to publish to Flickr, and drag-and-drop them onto the Flickr Photostream in the Publish Services panel (you'll see Photostream appear right underneath Flickr, as shown here). Once you've dragged them into this collection (yup, it's a collection), click directly on Photostream (as shown here) and you'll see that the images you just dragged there are waiting to be published (they're not actually published to Flickr until you click the Publish button at the bottom of the left side Panels area or the top of the center Preview area). What's nice about this is it lets you gather up as many photos, from as many different collections as you'd like, and then publish them all at once with just one click. But for our example here, we'll assume that you just want to publish these four final images.

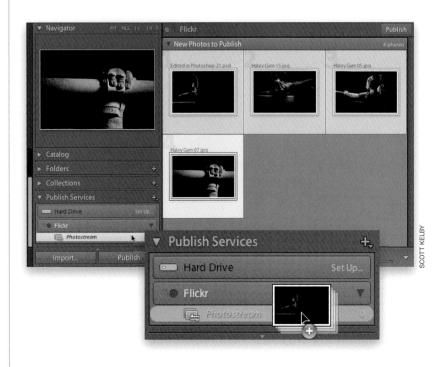

Step Six:

Click the Publish button now, and a splitscreen appears in the Preview area, with the four New Photos to Publish appearing in the section on top first. One by one, they'll move down to the Published Photos section below (here, three of the four images have been published). Once all your photos have been published, the New Photos to Publish section disappears, because there are no photos waiting to be published. (By the way, while your photos are being published, a small status bar will appear at the top-left corner to let you know how things are moving along.)

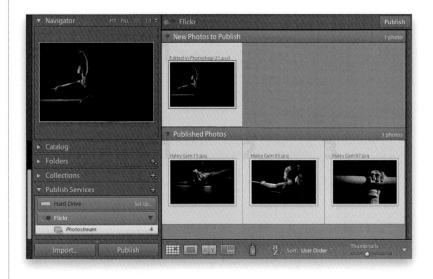

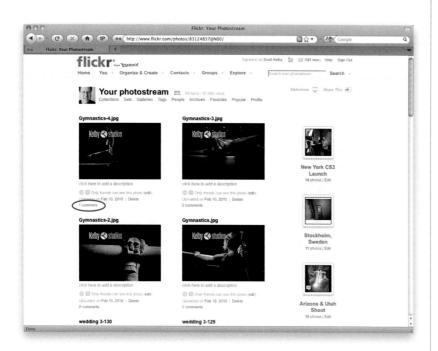

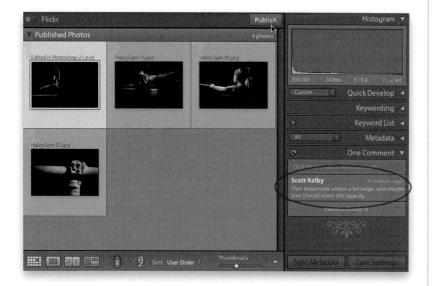

Step Seven:

Switch to your Web browser, go to your Flickr photostream page, and you'll see your images have now been published there (as seen here). Now, you can take things a step further, because the comments that people post online about your published photos can be synced back to Lightroom, so you can read them right there in the Comments panel (in the right side Panels area). For example, on the Flickr website itself, I clicked on the comment field below the first image and wrote: "That watermark seems a bit large, and maybe you should lower the opacity." (Both of which are true, by the way.)

Step Eight:

To see the comments in Lightroom, go to the Publish Services panel, click on your Flickr Photostream, and it displays your published photos. Then, Right-click on your Photostream and choose Publish **Now** from the pop-up menu, and it goes and checks your Flickr account to see if any comments have been added, and downloads them into Lightroom. Now, click on the first photo, and then look in the Comments panel (at the bottom of the right side Panels area), and any comments that were added to that image in Flickr will appear there. Also, it displays how many people have tagged that published photo as one of their favorites on Flickr.

Step Nine:

Okay, so far so good, but what if you make a change to one of those published photos in Lightroom? If you have a standard Flickr account, you'll have to delete it from your Flickr Photostream in Lightroom, then add it back and click Publish. If you have a Flickr Pro account, here's what to do (and here's where this Publish Services thing works so well): First, click on the Flickr Photostream to display the photos you've already published to Flickr, then click on the photo you want to edit, and press D to jump over to the Develop module. In our case, we'll adjust two things here: (1) we'll drag the White Balance Temp slider to the left a little, so the photo isn't so warm, then (2) we'll bring up the Fill Light quite a bit to see more of the athlete, as shown here. Now that are edits are done, it's time to get this edited version of the photo back up to our Flickr photostream.

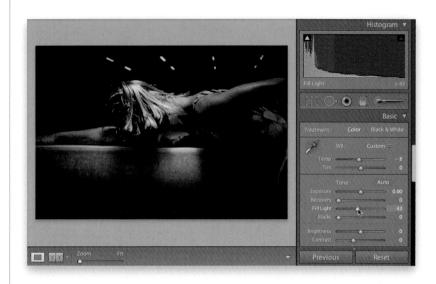

Step 10:

Go back to the Library module, to the Publish Services panel, and click on your Photostream (as shown here), and you'll see a split screen again, but this time it's showing your edited photo up top waiting to be republished. Click the Publish button and it updates the image on Flickr, so your most recent changes are reflected there. Of course, once you do this, the Modified Photos to Re-Publish section goes away, because now all your photos are published. Okay, so that's the Flickr Publish Services, and now that you've learned how that works, setting up your hard drive for dragand-drop publishing is a cinch, so we'll do that next.

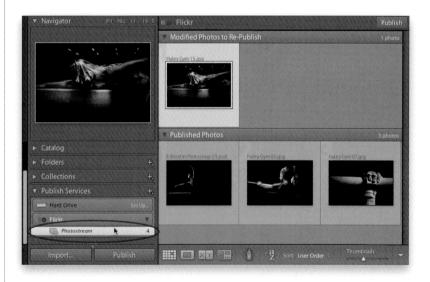

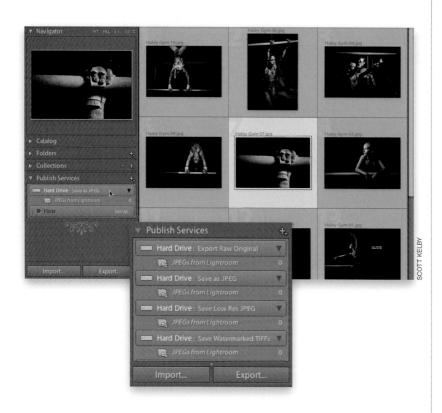

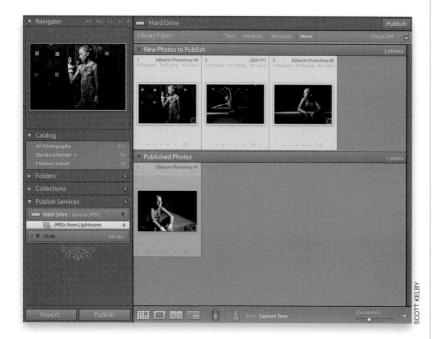

Step 11:

Start by clicking on the Set Up button next to Hard Drive in the Publish Services panel. We'll configure this one so it saves any files we drag onto it as high-resolution JPEGs to your hard drive (so think of this as a drag-and-drop shortcut to make JPEGs, rather than having to go through the whole Export dialog). Give this publish service a name now-call this one "Save as JPEG" (as shown here)-then fill out the rest just like you would for exporting a high-res JPEG to your hard disk (like we did back on page 222). When you click Save, it replaces Set Up with the name of your service (in this case, now it reads: "Hard Drive: Save as JPEG," so you know at a glance that it's going to save images you drag-and-drop on it to your hard drive as JPEGs). You can add as many of these as you'd like, so you can have some that export your images as originals, or some for emailing, or...well...you get the idea (look at the Publish Services panel here where I published a few extra setups, just so you can see what they'd look like).

Step 12:

Now that you've got at least one configured, let's put it to work. In the Library module, go ahead and select four RAW files you want saved as JPEGs (they don't have to be RAW files—they can already be JPEGs that you just want exported from Lightroom), and drag-and-drop those selected photos onto your Hard Drive: Save as JPEG publish service. From here, it's pretty much the same as you just learned with Flickr-the images appear in a New Photos to Publish section until you click the Publish button, then it writes them as JPEGs into whichever folder you chose when you set this publish service up (here, three of the four images being saved as JPEGs are in progress). Keep an eye on my daily blog at www.scottkelby.com, as I'll post when other online Publish Services (like Flickr) are released.

Lightroom Killer Tips > >

Exporting Your Catalog Shortcut

If, instead of just exporting a photo, you want to export an entire catalog of photos, press-and-hold the Option (PC: Alt) key, and the Export button in the Library module changes into the Export Catalog button.

Using Your Last Export Settings

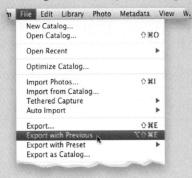

If you want to export some photos and use the same export settings you used the last time, you can skip the whole Export dialog and, instead, just go under the File menu and choose **Export with Previous**, or use the keyboard shortcut **Command-Option-Shift-E (PC: Ctrl-Alt-Shift-E)**, and it will immediately export the photos with your last used settings.

▼ Using Export Presets Without Going to the Export Dialog

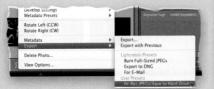

If you've created your own custom Export presets (or you want to use the built-in ones, as is), you can skip the Export dialog by Right-clicking on the photo, and from the pop-up menu, going under **Export**, and you'll see both the built-in and custom Export presets listed. Choose one from there, and off it goes.

Getting Your Exported Photos Back Into Lightroom Automatically

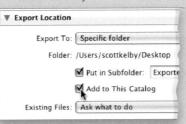

One very cool little Export feature Adobe added in Lightroom 2 is the ability to add your exported photos back into your Lightroom catalog (so, if you exported some finished images as JPEGs for a client, you can have them automatically reimported and put with your other images). To do that, go to the Export dialog, and in the Export Location section up top, turn on the checkbox for Add to This Catalog.

Sharing Your Export Presets

If you've come up with a really useful Export preset that you'd like to share with co-workers or friends (by the way, if you're sharing Export presets with friends, maybe you need some new friends), you can do that by pressing **Command-Shift-E (PC: Ctrl-Shift-E)** to bring up the Export dialog. Then, in the list of presets on the left side, Right-click on the preset you want to save as a file, then choose **Export** from the pop-up menu. When you give this Export preset to a co-worker, have them choose **Import** from this same pop-up menu.

▼ My "Testing Panos" Trick

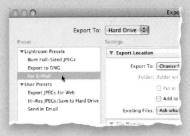

If you shoot multi-photo panoramas, you know that once they get to Photoshop for stitching, it can take...well... forever (it feels like forever, anyway). And sometimes you wait all this time, see your finished pano, and think, "Ah, that's nothing special." So, if I shot a pano I'm not 100% sure is going to be a keeper,

Develop

Slideshow

Web

Lightroom Killer Tips > >

I don't use the direct Merge to Panorama in Photoshop command in Lightroom 3. Instead, I go to the Export dialog and use the For E-mail preset to export the files as small, low-resolution JPEGs, with a low Quality setting. Then, once they're exported, I open them in Photoshop, run the Photomerge feature, and because they're small, low-res files, they stitch together in just a couple of minutes. That way, I can see if it's going to be a good-looking pano (one worth waiting 20 or 30 minutes to stitch at high resolution). If it does look good, that's when I use the Merge to Panorama in Photoshop feature in the Photo menu in the Library and Develop modules, which sends over the full-size, full-resolution, full-quality images. Then I go get a cup of coffee. And maybe a sandwich.

Exporting Directly to a Photo-Sharing Website

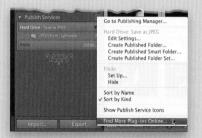

In this chapter, we talked about how you can publish images directly from Lightroom to Flickr.com, but there are now Export plug-ins available for most of the major photo-sharing sites (including Smugmug, Picasa Web Albums, and a dozen others) on Adobe's Exchange site. Click on the + (plus sign) button at the top of the Publish Services panel and choose **Find More Plug-ins Online** from the pop-up menu.

Installing Export Plug-Ins in Lightroom 3

itro

om	File Edit Library Photo	Metadata View
	New Catalog Open Catalog	0¥0
	Open Recent	Þ
	Optimize Catalog	
	Import Photos Import from Catalog Tethered Capture Auto Import	습위:
	Export Export with Previous Export with Preset Export as Catalog	ዕже ጚዕже ▶
	Plug-in Manager Plug-in Extras	₹0.₩. ►
	Show Quick Collection	See B

Although Adobe introduced Export plug-ins back in Lightroom 1.3, they've made the process of installing them much easier since then. Just go under the File menu and choose **Plug-in Manager**. When the dialog appears, click the Add button below the left column to add your Export plug-in (I told you it was easier).

✓ Yes, You Sharpen Twice I get asked this question all the time, because, by default, Lightroom adds sharpening to your RAW photos. So, do you sharpen again when you export the photos? Absolutely!

 Making Your Files Look Right on Somebody Else's Computer

I get emails from people all the time who have exported their photos as JPEGs, emailed them to somebody, and when they see them on the other person's machine, they're shocked to find out the photos don't look anything like they did on their computer (they're washed out, dull looking, etc.). It's a color space problem, and that's why I recommend that if you're emailing photos to someone, or that photo is going to be posted on a webpage, make sure you set your color space to sRGB in the File Settings section of the Export dialog.

Print

No XMP with DNG Files

dit	Library	Photo	Metadata	View	W
	New C	ollection		ЖN	
		mart Coll			
		ollection	Set		
	New Fe	older		☆ ℃N	
	Find			₩F	
	Enable	Filters		۶L	
	Filter b	y Preset		•	
	Filter b	by Flag	and the second	•	
	Filter b	y Rating		Þ	
	Filter b	y Color	Label	4	
	Filter b	by Kind		•	
	Filter b	by Metad	ata	- F	
	✓ Show I	Photos in	Subfolder	5	
	Refine	Photos		ĩжR	
		e Photo.		F2	
	Conve	rt Photo 1	to DNG	k	
	End M	lesir Db	*05		

If you convert your RAW image to DNG format before you export your original (go under the Library menu and choose **Convert Photo to DNG**), your changes are embedded in the file, so you don't need an XMP file at all. There's more about DNG format in Chapter 1.

Creating Flickr Photosets

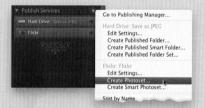

If you want your published images to appear in their own Flickr Photoset or Smart Photoset, click on the + (plus sign) button on the right side of the Publish Services panel header and, in the popup menu, you'll see a Flickr section where you can choose **Create Photoset** or **Create Smart Photoset**. Choose one and it adds it underneath your Flickr collection, so you can drag-and-drop to publish to those sets directly.

Chapter 8 How and When to Jump to Photoshop

Jumping to Photoshop how and when to do it

Even though this book was written so you can jump in anywhere, I can tell you right now that if this is the first chapter intro you're reading, you probably should turn back to the Chapter 1 intro and start by reading that first, then work your way back to here, just reading chapter intros (not the whole chapters). Actually, go back a page or two further (to the part where I tell you not to read these chapter intros if you're a Mr. Fussypants), and then you can determine if you should take the mental break imposed by these chapter intros or not. Now, the chapter you're about to embark upon is about using Adobe Photoshop with Lightroom, and there are still a bunch of reasons why we still need to use Photoshop (or Photoshop Elements) to get the job done. For example, Lightroom doesn't have things like layers, or

filters, or blend modes, or pro-level type control, or the Quick Selection tool, or HDR, or serious portrait retouching, or the ability to stitch panoramas (I could go on and on), so we still need it. We don't need Photoshop for every image, but you'll know when you need it, because you'll hit that moment when you realize what you want to do can't be done in Lightroom. Let's take creating counterfeit currency, for example. Lightroom kind of stinks for that, but if you're going to buy the full version of Photoshop (which runs around \$700 U.S.), you're just about going to need to be printing your own money. The Catch-22 is that you need counterfeit money to buy Photoshop, but you need Photoshop first to create realistic counterfeit money. It's this conundrum that has kept so many of us out of the Federal prison system.

Choosing How Your Files Are Sent to Photoshop

When you take a photo from Lightroom over to Photoshop for editing, by default, Lightroom makes a copy of the file (in TIFF format), embeds it with the ProPhoto RGB color profile, sets the bit depth to 16 bits, and sets the resolution to 240 ppi. But if you want something different, you can choose how you'd like your files sent over to Photoshop—you can choose to send them as PSDs or TIFFs, and you can choose their bit depth (8 or 16 bits) and which color profile you want embedded when your image leaves Lightroom.

Step One:

Press Command-, (comma; PC: Ctrl-,)

to bring up Lightroom's preferences, and then click on the External Editing tab up top (as seen here). If you have Photoshop on your computer, it chooses it as your default External Editor, so in the top section, choose the file format you want for photos that get sent over to Photoshop (I set mine to PSD, because the files are much smaller than TIFFs), then from the Color Space pop-up menu, choose your file's color space (Adobe recommends Pro-Photo RGB, and if you keep it at that, I'd change your Photoshop color space to ProPhoto RGB, as well-whatever you do choose, just use the same color space in Photoshop so they're consistent). Adobe also recommends choosing a 16-bit depth for the best results (although, I personally use an 8-bit depth most of the time). You also get to choose the resolution (I leave mine set at the default of 240 ppi). If you want to use a second program to edit your photos, you can choose that in the Additional External Editor section.

Step Two:

Lastly, you can choose the name applied to photos sent from Lightroom over to Photoshop. You choose this from the Edit Externally File Naming section at the bottom of the Preferences dialog, and you have pretty much the same naming choices as you do in the regular Import window.

	General Presets	Exter	nal Editing File Handling Interface
Edit in Adobe Photos	hop CS5		
File Format:	PSD	•	15-bit ProPhoto RGB is the recommended choice for best preserving color details from Lightroom. PSD can be less efficient than TIFF with
Color Space:	ProPhoto RGB		respect to metadata updates. When saving from Photoshop, please be sure to use the "Maximize Compatibility" option in Photoshop.
Bit Depth:	16 bits/component	•	Failure to do so will result in images that cannot be read by Lightroom.
Resolution	and the second se	_	
Additional External E	ditor		
Preset:	Photoshop CS4	minini	•
Application:	Adobe Photoshop CS4		Choose Clear
File Format:	PSD	•	16-bit ProPhoto RGB is the recommended choice for best preserving color details from Lightroom. PSD can be less efficient than TIFF with
Color Space:	ProPhoto RGB	•	respect to metadata updates. When saving from Photoshop, please be sure to use the "Maximize Compatibility" option in Photoshop.
Bit Depth:	16 bits/component	•	Failure to do so will result in images that cannot be read by Lightroom.
Resolution:	240		
		1	
Edit Externally File N	aming: IMG_0002-Edit.psd		
Template:	Custom Settings		•
Custom Text:			Start Number:

While Lightroom is great for organizing your photos, processing your images, making slide shows, and printing, it's not Photoshop. Lightroom doesn't do special effects or major photo retouching; there are no layers, no filters, or many of the bazillion (yes, bazillion) things that Photoshop does. So, there will be times during your workflow where you'll need to jump over to Photoshop to do some "Photoshop stuff" and then jump back to Lightroom for printing or presenting. Luckily, these two applications were born to work together.

How to Jump Over to Photoshop, and How to Jump Back

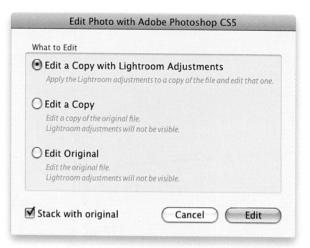

Step One:

If you need to do some things Lightroom can't do, it's time to jump over to Photoshop. For example, in this photo, we added some fill light (so you can see the detail in the photo better), set the Clarity to +44 (to give the image more punch), and cropped this wide image into a tall image (as seen here, where the crop borders have been dragged in tight). But, we need to add some text, create a more compelling background, and a couple of other tweaks. So, go under the Photo menu and choose Edit In, and then **Edit in Adobe Photoshop** (as shown here), or use the keyboard shortcut **Command-E (PC: Ctrl-E)**.

Step Two:

Now, if you're working on a JPEG or TIFF photo, this brings up the Edit Photo with Adobe Photoshop dialog, where you choose (1) to have Lightroom make a copy of your original photo, with all the changes and edits you made in Lightroom applied to the file before it goes over to Photoshop, (2) to have Lightroom make a copy of your original untouched photo and send that over to Photoshop, or (3) to edit your original photo in Photoshop without any of the changes you've made thus far in Lightroom. If you're working on a RAW photo, you won't get this dialog—your RAW photo will just open in Photoshop.

Step Three:

Before you click the Edit button, there's a checkbox called Stack with Original, and I recommend leaving this on, because what it does is puts this copy right beside your original file, so it's easy to find later when you're done editing in Photoshop and return to Lightroom. Now, go ahead and click the Edit button, and a copy of your image, with the changes you made in Lightroom (like cropping), opens in Photoshop (as seen here). Also, to help you distinguish this copy from the original, Lightroom by default adds "Edit" to the end of the filename, so you'll know at a glance, once you bring the photo back into Lightroom later (for RAW photos, once you save the photo in Photoshop, "Edit" will appear at the end of the filename, as you see here, where I've saved the file).

Step Four:

The first thing we have to do is get the phone off the background onto its own separate layer. Get the Quick Selection tool **(W)** in Photoshop, and paint with the tool over just the phone, and it selects just the phone (I know—the Quick Selection tool rocks!). Chances are it will select the shadow just below the phone, as well, but we only want the phone itself selected, so press-and-hold the Option (PC: Alt) key and paint over the shadow, and it becomes deselected (if you look in the image shown here, you can see my cursor removing the shadow from the selection at the bottomright corner of the phone).

Print Wel

Step Five:

Now press Command-Shift-J (PC: Ctrl-Shift-J) to cut the phone off the Background layer, and put it on its own separate layer above the background. Go to the Lavers panel, click on the Background layer, press Command-A (PC: Ctrl-A) to select the entire background, then press the Delete (PC: Backspace) key. which brings up the Fill dialog. Change the Use pop-up menu to **White** and click OK to delete the original background, and leave your phone sitting on a pure white background, like you see here. Press Command-D (PC: Ctrl-D) to deselect the background. Now, click on the Foreground color swatch to bring up the Color Picker, choose a light gray color, and fill the Background layer with this light gray by pressing **Option-Delete** (PC: Alt-Backspace).

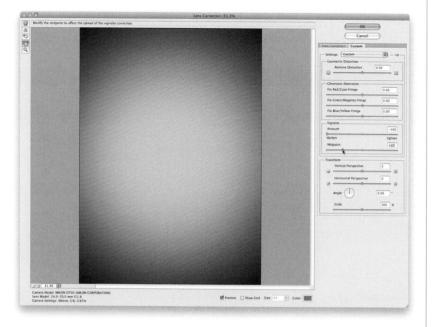

Step Six:

Go under the Filter menu, and right near the top of the menu, choose **Lens Correction**. When the Lens Correction dialog appears, click on the Custom tab (over on the top-right side of the dialog), and then in the Vignette section, drag the Amount slider to -100 (to darken the corners), then set the Midpoint at +22 to extend that darkening further in toward the center of your image. What you get by doing this is the spotlight effect you see here. Now click OK to apply this edge darkening effect to your background.

Step Seven:

When you click OK, it automatically turns your Background layer into a regular layer, which is handy for what we're going to do next. Start by duplicating the Background layer by pressing **Command-J** (PC: Ctrl-J). Now press **Command-T** (PC: Ctrl-T) to bring up Free Transform for this new layer. Grab the top-center handle (right at the top of the image) and drag straight downward, squeezing it down until only about ¼ of it shows (as seen here). This helps create the effect of a table for your phone to sit on. Press the **Return (PC: Enter) key** to lock in your transformation.

Step Eight:

Now click on the Background layer (actually, now it's called "Layer 0"), and press Command-T (PC: Ctrl-T) to bring up Free Transform for this layer (which is already unlocked so we can transform it). Drag the bottom-center point straight upward until it reaches the top of the other layer (as shown here, where you can see the two layers now meet). Press the Return (PC: Enter) key to lock in your transformation.

Web

Step Nine:

The great thing about building our background in the color gray is that you can now change it to any color using Photoshop's Hue/Saturation adjustment controls. Click on your Layer 0 copy layer in the Layers panel, then go to the Adjustments panel, and click on the Hue/Saturation icon (it's the second icon in the second row). When its controls appear in the panel, turn on the Colorize checkbox, then drag the Hue slider to pick the color you want. By default, the colors are pretty bright, so if you want something more subtle (like what you see here), just lower the Saturation amount by quite a bit (as you can see in my Adjustments panel here).

Step 10:

Now let's create a reflection for the phone. Click on the phone layer (Layer 1), then press Command-J (PC: Ctrl-J) to duplicate the layer. Now press Command-T (PC: Ctrl-T) to bring up Free Transform once again, but this time Right-click on the phone and a pop-up menu appears with a list of transformations. Choose **Flip Vertical** (as shown here) to flip this duplicate layer upside down.

Step 11:

Click-and-drag this flipped layer straight downward so the bottoms of the phones touch (press-and-hold the Shift key while you do this to keep the two phones lined up as you drag). Press Return (PC: Enter) to lock in your changes. Now to go the Layers panel and lower the Opacity of this flipped layer to 25% (as shown here), which creates a reflected look below the phone.

Step 12:

Now open the screen capture that you want to appear inside the phone (it works much better to use a screen capture, rather than trying to photograph the phone's actual screen). Get the Move tool (V), and click-and-drag this capture (you can download this image from the Web address given in the book's introduction) into place (as shown here). If you look at our phone image, you'll notice that the area surrounding the screen capture looks a little washed out, but that's an easy fix, since it's supposed to be solid black. Click on the Create a New Layer icon at the bottom of the Layers panel to create a new blank layer just below your screen capture layer, then get the Brush tool (B), choose a small, hard-edged brush, and paint over those black areas so they look nice and solid black (as seen here).

Step 13:

Now that our screen capture is in place, the color we had chosen for our background earlier doesn't work that well, but that's what is so great about using adjustment layers—we can easily go and change the color. Click on the adjustment layer in the Layers panel (shown highlighted here), then go down to the Adjustments panel and click-and-drag the Hue slider to the right until the background looks green (as seen here).

Step 14:

We're going to finish off by adding a couple of Type layers—one at the top, and one at the bottom—using the font Trebuchet (but you can use any modern-looking sans-serif font, like Myriad Pro, which comes with Photoshop). So grab the Horizontal Type tool **(T)**, choose your font, font size, and text color up in the Options Bar, and type away.

Step 15:

Now we're done editing in Photoshop and it's time to send this image back to Lightroom. There are just two super-simple things you need to do to get this image back to Lightroom: press **Command-S** (PC: Ctrl-S) to Save the image, then simply close it (press **Command-W** on a Mac, or **Ctrl-W** on a PC to close the document window). That's it. Don't do anything else don't choose Save As, don't change the name, just Save and Close. That's it. Once you do that, when you go to the Library module's Grid view to look at your thumbnails, you'll see that your new copy is found right beside the original (as shown here).

Step 16:

Now that your photo is back in Lightroom, you can treat it like any other image, and in this case, we want to darken the keys on the keyboard a bit, so switch to the Develop module, click on the Adjustment Brush, then choose **Exposure** from the Effect pop-up menu (so all the sliders get reset to 0). Click-and-drag the Exposure slider to the left to -0.99, then take the Adjustment Brush and paint over just the keyboard area to darken it in (as shown here), which creates the final image.

TIP: Saving Your Layers

If you have multiple layers (like we did with this image), and you save and close the document without flattening it first, Lightroom keeps all those layers intact (Lightroom doesn't let you work in layers, though). What you see looks like a flattened image, but there is a trick that lets you reopen this image in Photoshop with all the layers still there. When you click on the layered image in Lightroom and press Command-E (PC: Ctrl-E) to open it in Photoshop, when that little dialog appears asking you if you want to edit a copy with your Lightroom changes, without, or edit the original, you need to choose Edit Original. It's the only time I ever open the original.

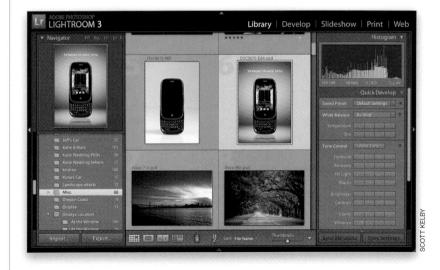

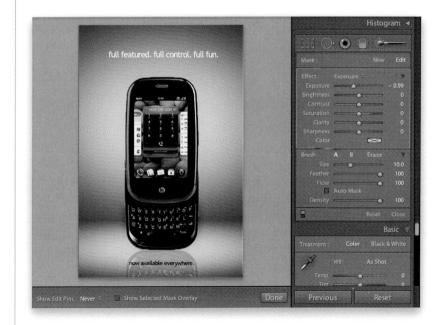

Web

If there's a "finishing move" you like to do in Photoshop (after you're done tweaking the image in Lightroom), you can add some automation to the process, so once your photos are exported, Photoshop launches, applies your move, and then resaves the file. It's based on you creating an action in Photoshop (an action is a recording of something you've done in Photoshop, and once you've recorded it, Photoshop can repeat that process as many times as you'd like, really, really, fast). Here's how to create an action, and then hook that directly into Lightroom:

Adding Photoshop Automation to Your Lightroom Workflow

Step One:

We start this process in Photoshop, so go ahead and press Command-E (PC: Ctrl-E) to open an image in Photoshop (don't forget, you can follow along with the same photo I'm using here, if you like, by downloading it from the site I gave you back in the book's introduction). What we're going to do here is create a Photoshop action that adds a nice, simple softening effect to the image, and you can use it on everything from landscapes to portraits. (When I post a photo using this technique on my blog, I always get emails asking: "How is it that the image looks soft, but it still looks sharp?") Because this technique is repetitive (it uses the same steps in the same order every time), it makes it an ideal candidate for turning into an action, which you can apply to a different photo (or group of photos) much faster.

Step Two:

To create an action, go to the Window menu and choose **Actions** to make the Actions panel visible. Click on the Create New Action icon at the bottom of the panel (it looks just like the Create a New Layer icon in the Layers panel and is circled here). This brings up the New Action dialog (shown here). Go ahead and give your action a name (I named mine "Soften Finishing Effect") and click the Record button (notice the button doesn't say OK or Save, it says Record, because it's now recording your steps).

Step Three:

Make two duplicates of the Background layer by pressing **Command-J (PC: Ctrl-J)** twice. Then go to the Layers panel and click on the center layer (shown highlighted here). Now go under the Filter menu, under Sharpen, and choose **Unsharp Mask**. This is a low-resolution image we're working on, so apply an Unsharp Mask with the Amount set at 85%, the Radius set to 1, and the Threshold set to 4 levels, and click OK to apply the sharpening. (*Note:* If this had been a full-resolution image from a digital camera, I would have used Unsharp Mask settings of Amount 120, Radius 1, and Threshold 3.)

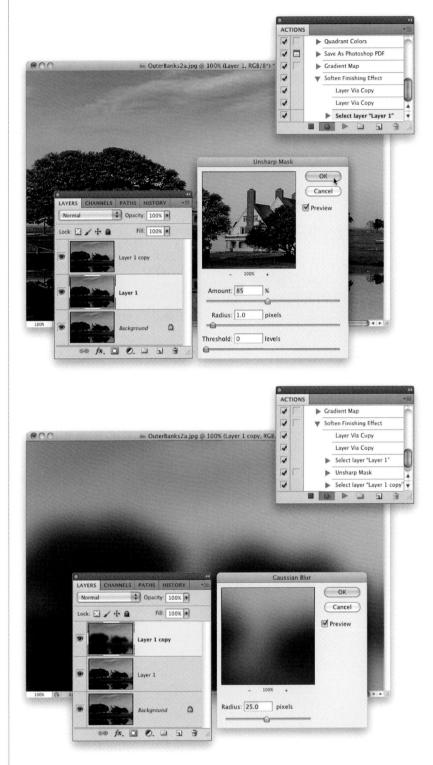

Step Four:

Now, after the sharpening, you're going to apply a huge blur to this image. So, click on the top layer in the Layers panel (Layer 1 copy). Go under the Filter menu, under Blur, choose **Gaussian Blur**, and enter 25 pixels as the Radius, so it's really blurry (like you see here).

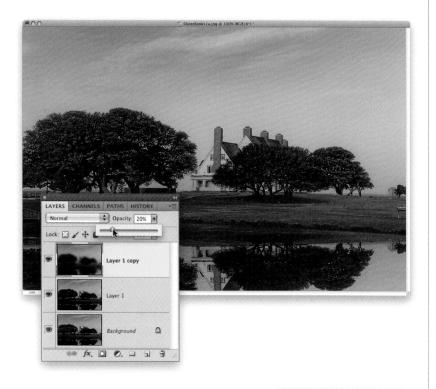

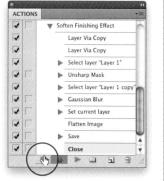

Step Five:

In the Layers panel, lower the Opacity of this blurry layer to 20%, which gives us our final look (as seen here). Now, go to the Layers panel's flyout menu (near the top-right corner of the panel) and choose Flatten Image to flatten the layers down to just the Background layer. Next, save the file by pressing Command-S (PC: Ctrl-S) and close it by pressing Command-W (PC: Ctrl-W).

Step Six:

You may have forgotten by now, but we've been recording this process the whole time (remember that action we created a while back? Well, it's been recording our steps all along). So, go back to the Actions panel and click the Stop icon at the bottom left of the panel (as shown here). What you've recorded is an action that will apply the effect, then save the file, and then close that file. Now, I generally like to test my action at this point to make sure I wrote it correctly, so open a different photo, click on the Soften Finishing Effect action in the Actions panel, then click the Play Selection icon at the bottom of the panel. It should apply the effect and close the document.

Step Seven:

Now we're going to turn that action into what's called a droplet. Here's what a droplet does: If you leave Photoshop and find a photo on your computer, and you drag-and-drop the photo right onto this droplet, the droplet automatically launches Photoshop, opens that photo, and applies that Soften Finishing Effect action to the photo you dropped on there. Then it saves and closes the photo automatically, because you recorded those two steps as part of the action. Pretty sweet. So, to make a droplet, go under Photoshop's File menu, under Automate, and choose **Create Droplet** (as shown here).

Open Recent Þ Share My Screen... Create New Review ... Device Central... Close ¥W ¥ N#7 Close All Close and Go To Bridge ... Ω ₩ W Save ¥ S ΰ¥S Save As... Check In て合発ら Save for Web & Devices... Revert Place... Import þ Þ Automat 1 Batch. Scripts Create Droplet... . File Info 1807 Crop and Straighten Photos Print. 38 P Conditional Mode Change.. Print One Copy TOXP Fit Image. Lens Correction... Merge to HDR Pro... Photomerge...

₩N

¥0

180

Photoshop File Edit Image Layer Select Filter

Browse in Bridge...

Browse in Mini Bridge ...

Open As Smart Object...

New...

Open.

Step Eight:

This brings up the Create Droplet dialog (shown here). At the top of the dialog, click the Choose button, choose your desktop as the destination for saving your droplet, and then name your droplet "Soften." Now, in the Play section of this dialog, make sure to choose **Soften Finishing Effect** (that's what we named our action earlier) from the Action pop-up menu (as shown here). That's it—you can ignore the rest of the dialog, and just click OK.

	Create Droplet	and the second	and the second states
Save Droplet In Choose Macintosh HD:Users:scot	ttkelby :Desktop:Soften		OK Cancel
Play Set: Default Actions Action: Soften Finishing Effect Override Action "Open" Commands Include All Subfolders Suppress File Open Options Dialogs Suppress Color Profile Warnings	() ()		
Destination: None Choose			
– File Naming Example: MyFile.gif			
Document Name	+ extension	<u>[</u>] +	
	(¢) +	(¢) +	
1	(¢/) +	 \$	
Starting serial#: 1			
Compatibility: Windows Mac O	S Unix		
	S Unix		

reset:	Settings:	
# Lightroom Presets Burn Full-Sized JPEGs	Example: DSC_0412.jpg	Extensions: Lowercase 🔹
Export to DNG	▼ File Settings	
For E-Mail VUser Presets	Format: JPEG	Quality:50
Hi-res JPEGs/Save to Hard Drive Send This in Email	Color Space: sRGB	Limit File Size To: 100 K
	Include Video Files	About Video File Support
	♥ Image Sizing	
	Resize to Fit: Width & Height	Don't Enlarge
	W: 640 H: 640 pixels	Resolution: 72 pixels per inch
	▼ Output Sharpening	
	Sharpen For: Screen	Amount: Standard
	₩ Metadata	
	Minimize Embedded Metadata	erarchy
	▼ Watermarking	
	Watermark: Simple Copyright Watermark	
	V Post-Processia Do nothing	
	After Expor ✓ Show in Finder Open in Adobe Photoshop CS5	9
Add Remove	Application Open in Adobe Photoshop CS4 Open in Other Application	2
Plug-in Manager	Go to Export Actions Folder Now	
riug-in Manager		tt

Export One File

Step Nine:

If you look on your computer's desktop, you'll see an icon that is a large arrow, and the arrow is aiming at the name of the droplet (as shown here).

Step 10:

Now that we've built our Soften droplet in Photoshop, we're going to add that to our Lightroom workflow. Back in Lightroom, go under the File menu and choose **Export**. When the Export dialog appears, go down to the Post-Processing section, and from the After Export pop-up menu, choose **Go to Export Actions Folder Now** (as shown here).

Step 11:

This takes you to the folder on your computer where Lightroom stores Export Actions (and more importantly, where you can store any you create). All you have to do is click-and-drag that Soften droplet right into that Export Actions folder to add it into Lightroom. Now you can close this folder, head back to Lightroom, and click Cancel to close the Export dialog (after all, you only needed it open to get you to that Export Actions folder, so you could drag that droplet in there).

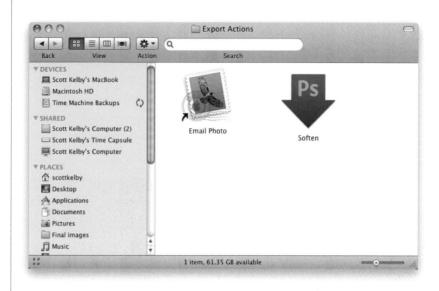

Step 12:

Okay, now let's put it to work: In Lightroom's Grid view, select the photo (or photos) you want to have that effect applied to, then press Command-Shift-E (PC: Ctrl-Shift-E) to bring back the Export dialog. From the Preset section on the left, click on the right-facing triangle to the left of User Presets, and then click on the Export JPEGs for Web preset we talked about creating in Chapter 7 (if you didn't create that one, go ahead and do it now). In the Export Location section, click on the Choose button and select the destination folder for your saved JPEG(s) (if you want to change it). Then, in the File Naming section, you can give your photo(s) a new name, if you like. Now, in the Post-Processing section at the bottom, from the After Export pop-up menu, you'll see Soften (your droplet) has been added, so choose it (as shown here). When you click Export, your photo(s) will be saved as a JPEG, then Photoshop will automatically launch, open your photo, apply your Soften Finishing Effect, then save and close the photo. Pretty slick stuff! (Note: Droplets will not work with 64-bit in Mac OS X Leopard, so you'll have to switch to 32-bit. See the tips at the end of Chapter 1 for how to do this. If you have Snow Leopard, you may have to install Apple's Rosetta.)

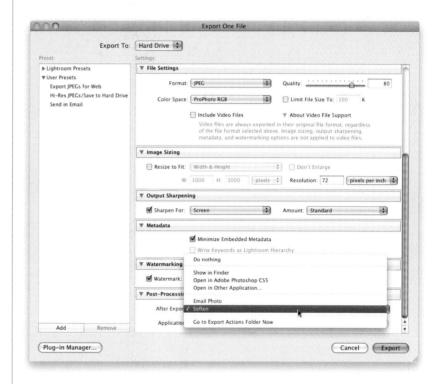

In Lightroom 3, we have the ability to jump to Photoshop and have a RAW image open as a Smart Object (actually, it would work with JPEGs and TIFFs, too). We can take advantage of the Smart Object feature for "double-processing" a photo, which is where we create two versions of our photo—one exposed for the shadows and one exposed for the highlights—and then we combine them to get the best of both worlds. We get an image that has a range that is beyond what even the best digital cameras could capture.

Image: Sector Sector

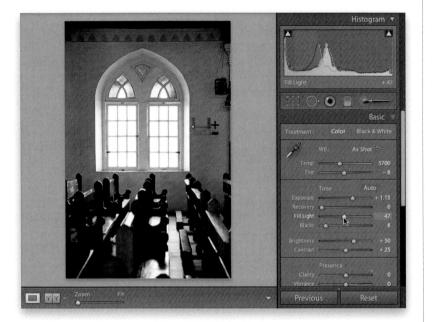

Double-Processing by Opening Photos in Photoshop as a Smart Object

Step One:

Here's the original image (shown here in Lightroom), which we want to doubleprocess in Photoshop, leveraging its Smart Object feature. The photo has two problems: (1) the interior is too dark, and (2) the windows are totally blown out (clipped), so we don't see the detail in the glass or what's outside the windows at all. So, our plan is to double-process the photo, with one version processed to make the interior of the old church look good, and the other processed to bring back the detail in the glass windows. Then we'll combine the two into one single image.

Step Two:

We'll start with our interior fix: in the Develop module, drag the Exposure slider to the right until the interior looks good (here, I dragged to +1.15), then increase the Fill Light amount to 47 to open the shadows areas. Things may start to look a little washed out, so you should probably increase the Blacks a little to keep that from happening (here, I increased them to 8). Okay, so at this point, we have a version of the photo exposed for the interior, but of course, brightening everything just made our windows problem even worse, so we'll deal with that in just a minute.

Step Three:

To take our image over to Photoshop as a Smart Object, go under Lightroom's Photo menu, under Edit In, and choose **Open as Smart Object in Photoshop** (as shown here). Because this photo was taken in RAW format, it will actually open the RAW photo in Photoshop (just like when you normally export to Photoshop), but Lightroom will create a copy in TIFF or PSD format when you save it. So, don't worry, your original RAW file is still in Lightroom.

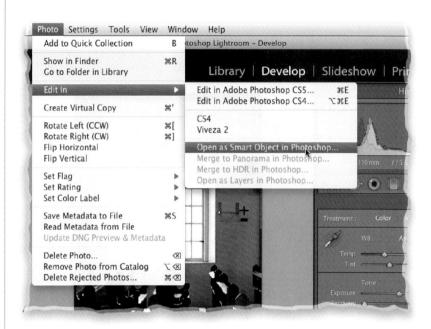

Step Four:

Here's the processed photo open in Photoshop as a Smart Object (you know it's a Smart Object by its name in the title bar and by the little page icon that appears in the bottom-right corner of the layer's thumbnail in the Layers panel). Now that we're here, I want to briefly talk about the advantage of using Smart Objects: in this case, the main advantage is you can reprocess your image anytime in Adobe Photoshop's Camera Raw (which has the exact same sliders and controls as the Develop module in Lightroom, so you'll feel right at home), so you can make your adjustments there, and when you click OK, your changes are applied to the photo. This will make more sense in a moment as we put this to use. Now we need to create a second version of this image-one exposed for the windows-so Right-click on the Smart Object layer, and from the pop-up menu that appears, choose New Smart Object via Copy (as shown here).

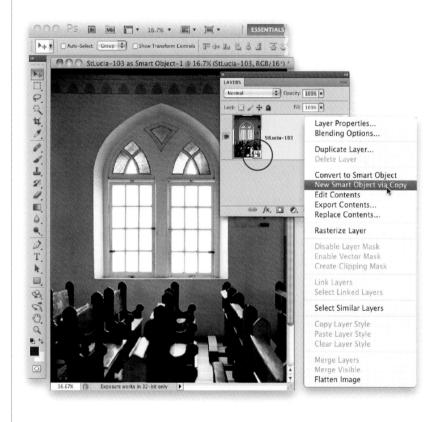

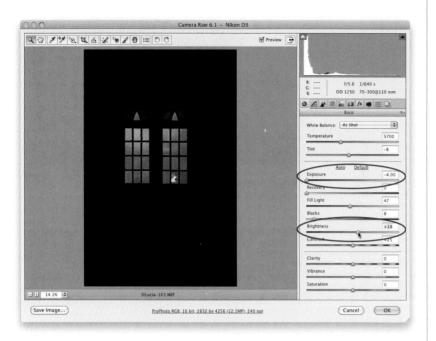

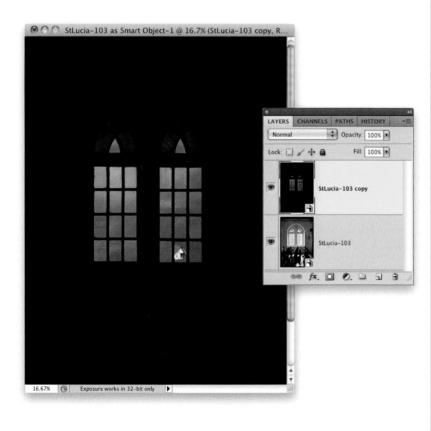

Step Five:

By the way, the reason I had you choose New Smart Object via Copy, rather than just duplicating the layer like always, is this: when you duplicate a Smart Object layer, the duplicate is tied to the original layer, so if you edit the duplicate, the original updates with the same changes (they're essentially linked together). But when you choose New Smart Object via Copy instead, it does duplicate the layer, but it breaks that link, and now you can edit each one separately. So now, go to the Layers panel and double-click on the duplicate layer's thumbnail, which brings up the Camera Raw window. Click-and-drag the Exposure slider all the way to the left (like you see here) and you start to see the detail that actually is in the windows (you can now see a raised pattern on the windows, and that part of one of the panes is broken, where you can see out to the street). Now lower the Brightness, as well, until the detail really comes out (as seen here). By the way, did you notice that the sliders are the same ones, in the same order, as those in Lightroom's Basic panel in the Develop module?

Step Six:

When you click OK, it applies those changes, but just to the duplicate layer (as seen here, in the Layers panel, where the bottom layer is the Smart Object exposed for the interior, and the top layer is the darker one exposed for the windows and what's outside). They are perfectly aligned with one anotherpixel for pixel-right in the same position, so now we'll be able to blend the two together (in the next step).

Step Seven:

Press-and-hold the Option (PC: Alt) key, and click on the Add Layer Mask icon at the bottom of the Layers panel (it's the third icon from the left). This adds a black mask over your darkened layer, hiding it from view. Now, we can reveal just the parts of the darker layer that we want revealed by painting. So, press D to set your Foreground color to white, then get the Brush tool from the Toolbox (or just press B), choose a soft-edged brush from the Brush Picker in the Options Bar, zoom in close (like you see here), and begin painting over the window panes (as shown here). As you do, it paints in the darkened window panes. Don't worry about "painting outside the lines" at this point-just paint it all in, and we'll deal with the spillover in the next step. For now, just paint over both windows, and the two clear arches up top, too.

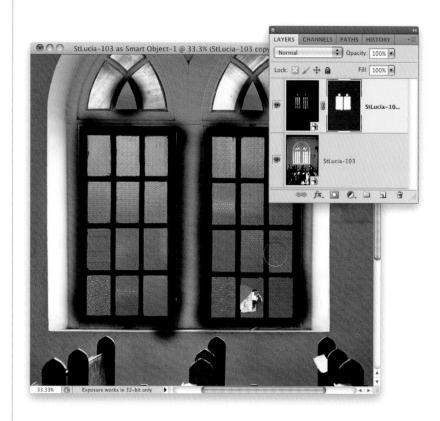

Step Eight:

Now press the letter **X** on your keyboard to switch your Foreground color to black. Shrink your brush size way down (using the Left Bracket key on your keyboardit's to the right of the letter P), then start painting over the areas where you spilled over, and it hides them. Here's a tip to make this cleanup easier (especially when you get to the dividers between the panes): press-and-hold the Shift key to make your brush draw straight lines. You can also just move your cursor to the top of a divider, press-and-hold the Shift key, then click at the bottom, and it will draw a straight line between the two spots where you clicked. It's going to take a few minutes to clean up the mess, but I found that it's easier to just paint it all in first, then go back and do a quick cleanup (of course, quick being a relative term, eh?).

Original

Double-Processed

Step Nine:

A couple of other tips for masking away the spillover: (1) Once you paint over one of the wood separators between the panes (pressing-and-holding the Shift key to paint straight lines), try going back the other way (so, paint a straight line in one direction, and then paint right back over it in the opposite direction). In fact, you can probably do this back-and-forth a few times, and each time you do, it expands the area you're masking away a little bit at a time. And, (2) Use a much smaller brush tip than you think you need. As I said, it builds up as you go back and forth over an area, so start small and you'll get better results. Here's what it looks like after you've fully painted over the spillover from both windows.

Step 10:

Now you can either save the file with its layers intact (if you think you might want to go back later and edit the layers individually), or if you're completely done, just go to the Layers panel's flyout menu (near the top-right corner of the panel), and choose Flatten Image to remove the layers and flatten it down to just a single Background layer. (Note: When you use this Open in Photoshop as Smart Object feature, the image doesn't go back to Lightroom when you save and close it. If you want it back in Lightroom, you'll have to re-import the photo after you save it out of Photoshop.) Now you can finish things off by adding an edge vignette to darken the edges of the photo, leaving the center nice and bright. You can see the original image at left, with the dark interior and blown-out detail-less windows, and you can see the final doubleprocessed image on the right, where you can see the interior clearly and we've brought back the detail in the windows, as well. So that's how you double-process Lightroom images in Photoshop. Pretty cool, isn't it?

Stitching Panoramas Using Photoshop

One of my favorite features in Lightroom 3 makes it easy to use one of my favorite features in Photoshop—the Photomerge feature, which automatically and seamlessly stitches panoramas together.

Step One:

In Lightroom's Grid view, select the photos you want to stitch together (the images shown here are of the Red Bull Flugtag competition in Tampa, Florida). Here I've selected a series of 19 photos, and when I shot these, I made sure each photo overlapped the next one by around 20%, because that's about how much overlap Photoshop needs between images to stitch these 19 photos into one single panoramic image. Once the photos are selected, go under the Photo menu, under Edit In, and choose **Merge to Panorama in Photoshop**.

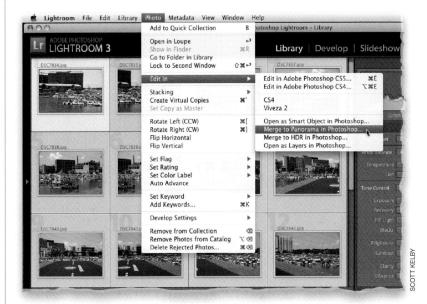

Step Two:

The dialog that will appear is Photoshop's Photomerge dialog (shown here), and in the center of the dialog, you'll see the names of the 19 images you selected in Lightroom. In the Layout section on the left side, leave it set at Auto, so Photomerge will automatically try to align and blend the images together for you, then click the OK button in the upper-right corner of the dialog.

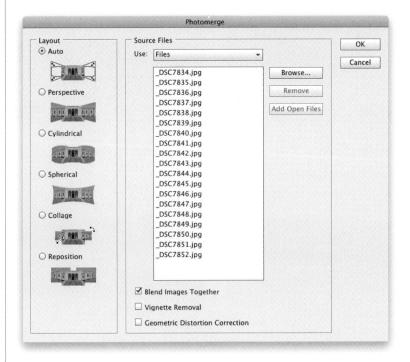

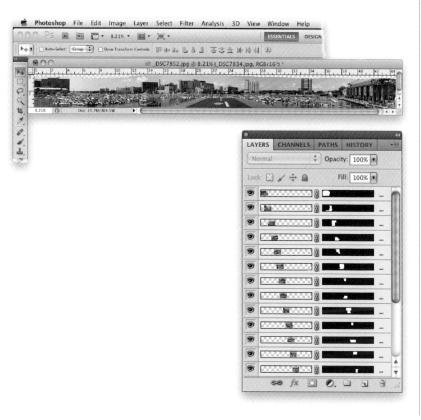

Step Three:

When Photoshop is done aligning and blending your photos, a new document will appear with your 19 images combined into a single panoramic image (as seen here). Parts of each photo wind up in this document as a separate layer (as seen in the Layers panel here), so if you wanted to tweak the masks created by Photomerge, you could (but we don't). Let's go ahead and flatten the image by choosing **Flatten Image** from the Layers panel's flyout menu near the top-right corner of the panel.

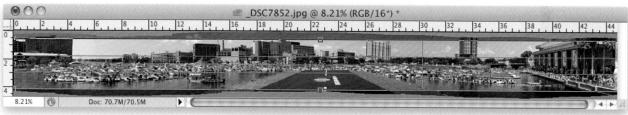

LATERS	CHANNELS	PATHS	HISTORY		
Normal		Opacity:	100%	•	
Lock: 🖸	1/40	Fill:	100%		
	a the cord	Backgroun	d	۵	
			1		

Step Four:

Now that we've flattened the image, we'll need to crop it down to size to get rid of the areas that were adjusted to make the image stitch together properly. Sometimes this is pretty minor, other times it's more pronounced, like this, but either way, you're just a simple crop away from having your pano look right. Get the Crop tool (from the Toolbox, or just press **C**) and click-and-drag it out over the area you want to keep, as shown here (I drag it out as far as I can, without having any white areas show up on the edges after I crop). Once your cropping border is in place, press the Return (PC: Enter) key to lock in your crop.

Step Five:

To finish things off, go under the Filter menu, under Sharpen, and choose Unsharp Mask. When the dialog appears: for Amount, enter 85; for Radius, enter 1; and for Threshold, enter 4; then click OK (as shown here). Then go under the Edit menu, and choose Fade Unsharp Mask. Now, in that dialog, change the blend mode (in the Mode pop-up menu) to Luminosity, and then click OK to apply this sharpening just to the detail areas of the image, and not the color areas. Below is the final cropped image, and although it looks pretty small here, the actual finished size is just short of four feet wide.

		Unsharp Mask	and a state of the state
			OK Cancel
APPENDAGE SID	Carles .	and the second second	
- Amount:	100%	* + %	
Amount: Radius:	85		

The finished pano is nearly four feet long!

Web

HDR (High Dynamic Range) images (a series of shots of the same subject taken at different exposures to capture the full tonal range) have become really popular, and you can take the images you shot for HDR straight from Lightroom over to Photoshop's Merge to HDR Pro feature. You start by shooting bracketed on your camera. Here, I set up my camera to shoot five bracketed shots with one stop between each shot—one with the standard exposure, one 2 stops darker, one 1 stop darker, one 1 stop brighter, and one 2 stops brighter (for five shots total).

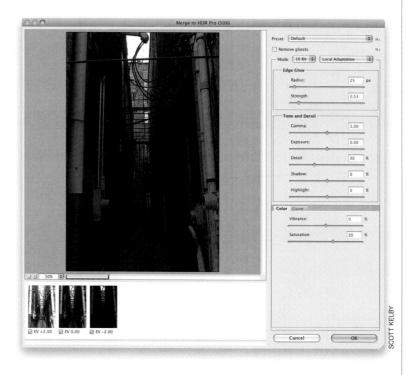

Creating HDR Images in Photoshop

Step One:

In Lightroom, select your bracketed shots. Here, I've taken five bracketed shots (with a 1-stop difference between each), but you really only need three of these (the original, the one that's 2 stops brighter, and the one that's 2 stops darker—five takes much longer to process and doesn't add to the final effect), so here I selected just those three in the Library module. Once you've selected them, go under the Photo menu, under Edit In, and choose **Merge** to HDR Pro in Photoshop.

Step Two:

This launches Photoshop, and brings up the Merge to HDR Pro dialog (shown here). Chances are your image will look pretty blah with just the Default preset settings, but don't worry—it's about to take a wild turn. For this image, we're going to push the HDR effect quite a bit, so it looks more surreal than realistic, but Merge to HDR Pro will do both the real and the unreal. At the bottom of the dialog, you'll see the images used to create this one single HDR image (it also shows the exposure difference between each one listed below them. and here you can see we have one that's 2 stops brighter than the regular exposure, then one that's 2 stops darker).

Step Three:

If you're new to HDR, I recommend that you choose one of the built-in presets from the Preset pop-up menu at the top as a starting place. I like to start with the one called More Saturated (as shown here) and use that as a starting point to additional tweaking. The good news is that if you come up with a look you like, you can add your own custom presets to this menu by clicking on the flyout menu at the top right and choosing Save Preset. Note: Near the top of the dialog, you'll see a pop-up menu with Local Adaptation. This is the "new and improved" HDR in Photoshop CS5. If you choose any of the other methods, you're reverting to the old HDR from Photoshop CS3 or CS4, which were... well...I'm not sure if you could really call what they did HDR. Well, maybe technically, but you couldn't call anything they did "good," so I would ignore those other choices in that menu completely and just stick with Local Adaptation.

Step Four:

Now let's start tweaking this puppy. If you hover your cursor over any of the sliders, it tells you what each one does (for example, hover your cursor over Radius, and it lets you know it controls the spread of the glow effect, but you'll find that it seems to control more than that). In the image shown here, I set the Edge Glow Radius at 176 and the Strength at 0.47 (I just dragged the sliders until I saw something that looked good). The controls under Tone and Detail are somewhat similar to the ones in Lightroom. So, think of Gamma like Lightroom's Brightness slider (here, I dragged it to 0.76). The Exposure slider does what you'd expect, so drag it to the right to brighten the overall image. Detail is kind of like Lightroom's Clarity slider, and the farther you push it, the crisper the image gets. The Shadow slider is kind of like Lightroom's Fill Light, and Highlight is similar to Recovery. The Vibrance and Saturation are similar, as well.

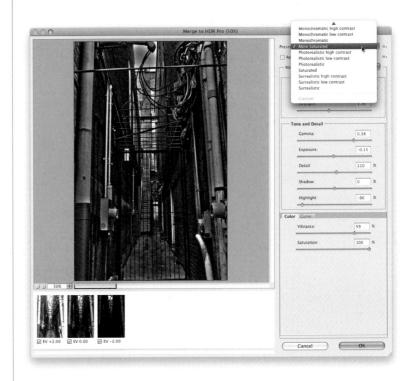

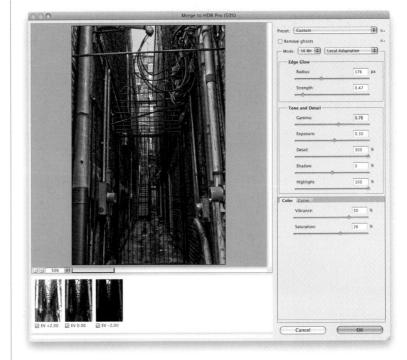

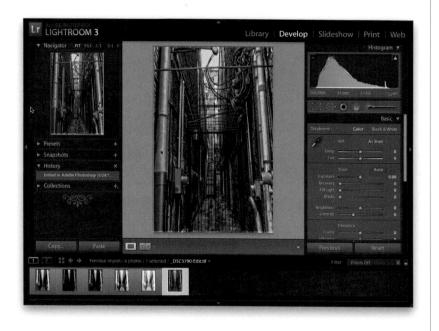

. Clarity

Step Five:

Once you're done tweaking the HDR controls, and the image looks pretty good to you (it doesn't have to look finished yet, because you'll actually do the finishing touches in Lightroom), click OK to close the dialog, and just save and close the image. Don't rename it, and don't choose Save As—just press **Command-S** (PC: Ctrl-S) to Save, then **Command-W** (PC: Ctrl-W) to Close the image, and the single HDR image will be sent back to Lightroom, where it will appear right next to the originals (as seen here).

Step Six:

In the Develop module, increase the Fill Light amount quite a bit (until it looks a bit washed out), then increase the Blacks amount quite a bit until it kind of balances out again (the Fill Light kind of has a look all its own when you push it way over to the right, like we did here). Now, increase the Clarity amount to +46 (as shown here), which really brings out the detail and helps add to the HDR look of the image. If things look too colorful at this point (which is mighty likely), then lower the Vibrance amount.

Step Seven:

A trademark look of the surreal HDR is a very heavy edge vignette, so go to the Lens Corrections panel, click on Manual at the top of the panel, then go down to Lens Vignetting, and lower the Amount to –93 to get the vignette as dark as possible. Then, lower the Midpoint almost as far to get the heavy darkened-edge effect you see here.

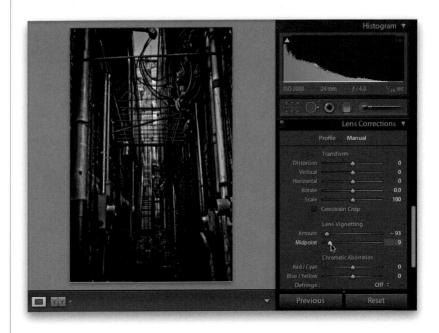

Step Eight:

Here's a side-by-side with the original (the normal exposure) image on the left, and the maxed-out HDR tone-mapped look on the right. Now, if you want to create a more realistic-looking HDR image, it's actually much easier than what we did here. It all starts the same, with you selecting the three images, and going under Lightroom's Photo menu, under Edit, and choosing Merge to HDR Pro in Photoshop. When the dialog appears, there's a preset in the popup menu at the top called Photorealistic. It's a great starting place because it doesn't enhance the detail greatly or pump up the colors; it just combines them into a single image capturing a wide dynamic range. Don't be surprised if the image that it creates doesn't bowl you over-it's not supposed to. It's supposed to be more representative of what your eye would see (if you had taken the photo used here, when you took it, your eyes wouldn't have seen all these wacky colors or the crazy detail we created in this project, but it would capture the range between the brightest parts of the image and the darkest shadows, and that's what the Photorealistic setting does).

Slideshow

Wel

Lightroom Killer Tips > >

 Choosing the Name of Your Photoshop Edited Files

Back in Lightroom 1, it automatically added "Edit in CS3" to end of any photo you edited over there, but now you get to choose exactly what these edited files are named. Just go to Lightroom's preferences (press **Command-, [comma; PC: Ctrl-,]**), and then click on the External Editing tab, and at the bottom of the dialog, you'll see the Edit Externally File Naming section, where you can choose your own custom name or one of the preset file naming templates.

Cutting Your File's Ties to Lightroom

File	Edit	Image	Layer	Select	Filte
Ne	w			Ħ	N
Op	en			36	0
Bro	owse in	Bridge		7.30	0
Bro	wse in	Mini Bri	dge		
Op	en As !	Smart Ob	ject		
Op	en Rec	ent			•
Shi	are My	Screen			
Cre	eate Ne	w Review	Y		
De	vice Ce	ntral			
Cle)5e			96	w
Clo	se All			N 70	W
Ck	ose and	Go To B	ridge	心 36	W
Sav	/e			耗	S
	/e As			ŵ H	S
	eck In.		~		
5.01	in for \	Noh & De	dear	70.10	ic I

When you move a file over to Photoshop for editing, and you save that file, the saved file comes right back to Lightroom. So, how do you break this chain? When you're done editing in Photoshop, just go under Photoshop's File menu and choose **Save As**, then give the file a new name. That's it, the chain is broken and the file won't go back to Lightroom.

▼ Get Rid of Those Old PSD Files

File Type		Camera
All (4 File Types)	212	All (2 Cameras)
JPEG	134	NIKON D3
Photoshop Document (PSD)	17	NIKON D700

If you upgraded from Lightroom 1, do you remember how each time you jumped over to Photoshop, it created a copy of your photo and saved it alongside the original (in PSD format), even if you never made a single change to it in Photoshop? If you're like me, you probably had a hundred or more PSD photos with no visible changes, just taking up space on your drive and in Lightroom. If you still haven't gotten rid of them, go to the Library module, and in the Catalog panel, click on All Photographs. Then, up in the Library Filter, click on Metadata. In the first field on the left. click on the header and choose File Type from the pop-up menu. It will list how many PSDs you have in Lightroom, and if you click on Photoshop Document (PSD), it will display just those files, so you can see which ones you never used or just flat out don't need, and you can delete them so you get that space back.

 How to Get Photos Back Into Lightroom After Running an Export Action

If you created an action in Photoshop and saved it as an export action in Lightroom (see page 259), when your photos leave Lightroom and go to Photoshop to run the action, that's the "end of the line" (the photos don't come back to Lightroom). However, if you want those processed photos to be automatically imported back into Lightroom, do this: Use Lightroom's Auto Import feature to watch a folder (see Chapter 1), and then when you write your Photoshop action, have it save your processed files to that folder. That way, as soon as the action is run, and the file is saved out of Photoshop, it will automatically be re-imported into Lightroom.

Getting Consistent Color Between Lightroom and Photoshop

If you're going to be going back and forth between Lightroom and Photoshop, I'm sure you want consistency in your color between the two programs, which is why you might want to change your color space in Photoshop to match Lightroom's default color space of ProPhoto RGB. You do this under Photoshop's Edit menu: choose Color Settings, then under Working Spaces, for RGB, choose Pro-Photo RGB. If you prefer to work in the Adobe RGB (1998) color space in Photoshop, then just make sure you send your photo over to Photoshop in that color space: go to Lightroom's Preferences dialog, click on the External Editing tab up top, then under Edit in Photoshop, for Color Space, choose AdobeRGB (1998).

▼ Getting Much Better Looking

High Dynamic Range Images Although in this chapter I showed you how to jump from Lightroom to Photoshop to create High Dynamic Range (HDR) photos, unfortunately if you're not using Photoshop CS5, Photoshop's built-in HDR feature isn't the greatest (and that's being kind). Every pro photographer I know who is into creating HDR images without CS5 uses a program called Photomatix Pro (you can download a free trial version from their website at www.hdrsoft.com). Try it once, and I doubt you'll use Photoshop's old HDR feature again.

Chapter 9 Converting from Color to Black and White

In Black & White converting from color to black and white

I have a secret. It's not about becoming a better photographer. It's about making other people think you have become a better photographer. It's how to make your friends, associates, family members, your pet, and in particular, any of your photographer friends see you in an entirely different light. The secret is to start converting some of your color images to black and white, but what really takes this over the top is to make a physical B&W print and show it around. The good news is that you don't have to do this in a traditional darkroom; you're doing to do this in Lightroom, and then either print it on your own inkjet printer, or upload your image to an online photo lab, but either way, you are literally just a chapter, a few sliders, and a piece of photo paper away from elevating your status as a serious photographer to an entirely new level. That's because photographers inherently love B&W prints, and by proxy, those who make them, as well. Yes, the entire thing is a psychological phenomenon, but that doesn't make it any less real. So, I'm going to teach you how to make great looking B&W images from your color photos, and then you can jump to the printing chapter to find out how to print one out (or save it as a JPEG to send to a lab). That's it. That's how close you are to getting photographer street cred on a level that will send your status soaring. This is the equivalent of joining a street gang and robbing your first liquor store. You do this, and you're "in." Also, it's time to start referring to your photography as "my work" (i.e., "I've been looking a lot at my past work..."), and it also doesn't hurt to make fun of other photographers, who've never done any B&W, in a way that makes the use of color sound like a crutch (this is more than 62% of the fun of shooting in B&W, so don't overlook it). Now you know "The Secret."

How to Find Which Photos Might Look Great as Black-and-Whites

I absolutely love B&W photos (I think most photographers are secretly B&W freaks), but unfortunately, not every color photo makes a good black and white (in fact, some photos that look great in color look just dreadful in black and white. Of course, at the same time, some photos that look boring in color look stunning as B&W images). So, before I start actually converting photos to black and white in the Develop module, I use this Library module technique to quickly see which photos from a shoot might look great in black and white.

Step One:

Start in the Library module: click on the collection you want to test to see which ones in that collection might make nice B&W photos. Press **Command-A (PC: Ctrl-A)** to select all the photos in that collection and press the letter **V** on your keyboard to temporarily convert all the photos to black and white, as seen here. Now, press **Command-D (PC: Ctrl-D)** to deselect all the photos.

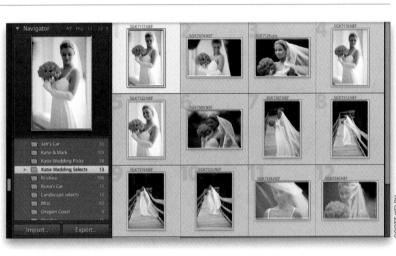

Step Two:

Double-click on the first photo in the collection to zoom in to Loupe view and use the **Right Arrow key** to quickly move through all the images in your collection (if you want, press Shift-Tab to get all the panels out of the way). Each time you see one that looks really good in black and white, press the letter **P** on your keyboard to mark it as a Pick, as shown here. (Note: If you already have images flagged as Picks in this collection, then use something else, like the press the number 6 to add a Red color label, or 5 to rank it as a five-star image.) This takes much less time than you might think, because a photo either looks great as a black-and-white image or it doesn't, so you won't have to spend more than a second or two per image. Also, at this point, we haven't done a full high-contrast B&W conversion or anything like that (you'll learn that next)-this just gives us a rough idea if the photo might make a great black-and-white or not. So, if it looks good at this stage, it'll look great after you do the full conversion the right way.

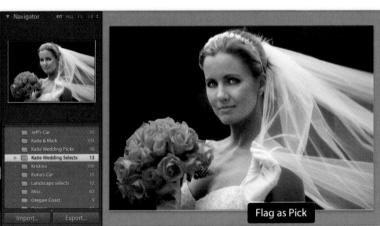

brarv Dev

Develop

Slideshow Print

Lightroom File Edit Library Photo Metadata View Window Help ¥Z Undo Selection ① 第Z Redo LIGHTROO Library 35X Cut 980 Copy Paste 36 V Delete Select All *A Select None *D Invert Selection Select Only Active Photo **企業D Deselect Active Photo** Select Flagged Photos T #A Deselect Unflagged Photos **Y** 介業D Select by Flag Select by Rating Unflagged . Select by Color Label Þ Rejected Spelling . Add to Selection Subtract from Selection **Special Characters** 7.#T Intersect with Selection 13

	Undo Toggle Black White Redo	第2 - Adobe Photoshop Lie 第2	ghtroom – Library	
Lr ADORE PHOTOSHIC LIGHTROOI	Cut Copy Paste Delete	SRX SC SC SGR2074.vef	SGU2024 net	how Print
	Select All Select None Invert Selection	жа жD	1	29
	Deselect Active Photo Select Flagged Photos	2 %D / C%A SGK7118.net	SGK7122.nef	5647300 ref
 Image Collection 	Select by Flag Select by Rating Select by Color Label		est.	3
 Sports 	Spelling	+ 1 X		
Caddies	Special Characters	СЖТ		
Cymnastes He Models Models Orsolya Outer Banks	NEW MARKEN FOR PARAMETER	SGR/302.net	SGK2312.net	SGC719.net

Step Three:

Press **G** to return to Grid view. Now, go under Lightroom's Edit menu, under Select by Flag, and choose Flagged (as shown here), or just choose Select Flagged Photos from the Edit menu. This selects the images you flagged as Picks (if, instead of using flags, you added a color label or star rating, then under the Edit menu, go under Select by Color Label or Select by Rating). By the way, selecting like this is different than turning on the Picks filter down above the Filmstrip or by using the Library Filter, because if we did that, you'd only see the Picks. We want to see all the images, but we want our Picks selected, as if we had Command-clicked (PC: Ctrl-clicked) on them. Now that the photos that would make nice B&W images are selected, press Command-' (apostrophe; PC: Ctrl-') to make virtual copies of just these images. These copies appear right beside the originals. Don't deselect just yet.

Step Four:

Now go back under the Edit menu, but this time, choose Invert Selection to select every photo but those virtual copies. Press the letter V on your keyboard, again, and all the images in that collection (except the virtual copies) are now returned back to full color (that's what I meant earlier when I said this was temporary). Now, in your collection, you have (1) all the original color photos and (2) B&W virtual copies of the ones that'll make good B&W images. Click on any one of those virtual copies and jump over to the Develop module, where you'll start converting these to high-contrast stunning B&W images, using the methods you'll learn starting on the next page.

TIP: Grayscale Preview in the Develop Module

We just learned that, in the Library module, you can quickly see how your selected photos would look as B&W photos by pressing the letter **V**. This shortcut works in the Develop module, too, but only on the selected photo showing in the center Preview area.

Better Black and White By Doing It Yourself

There are two auto conversion methods for converting your images from color to black and white (one in the Basic panel and another in the HSL/Color/B&W panel), and no matter where you choose to do it from, the results are the same. Now, to me they just look really flat, and I honestly think you can do much better by doing it yourself. We'll start with my preferred method for most color-to-black-and-white conversions, which lets you build on what you've already learned in the Develop module chapter of this book.

Step One:

In the Library module, find the photo you want to convert to black and white, and first make a virtual copy of it (if you haven't already) by going under the Photo menu and choosing **Create Virtual Copy**, as shown here (the only reason to do this is so when you're done, you can compare your do-it-yourself method with Lightroom's auto-conversion method side by side. By the way, once you learn to do the conversion yourself, I doubt you'll ever want to use the auto method again). Press **Command-D (PC: Ctrl-D)** to deselect the virtual copy, and then go down to the Filmstrip and click on the original photo.

Step Two:

Now press **D** to jump to the Develop module, and in the right side Panels area, scroll down to the HSL/Color/B&W panel and click directly on B&W on the far right of the panel header (as shown here). This applies an automatic conversion from color to black and white, but sadly it usually gives you the flat-looking B&W conversion you see here (consider this your "before" photo). The idea here is that you adjust the B&W auto conversion by moving the color sliders. The thing that makes this so tricky, though, is that your photo isn't color anymore. Go ahead and move the sliders all you want, and you'll see how little they do by themselves. By the way, if you toggle the panel on/off button (circled here in red), you can see how bad this black-and-white would have looked if Lightroom didn't do the auto conversion for you using the default conversion settings.

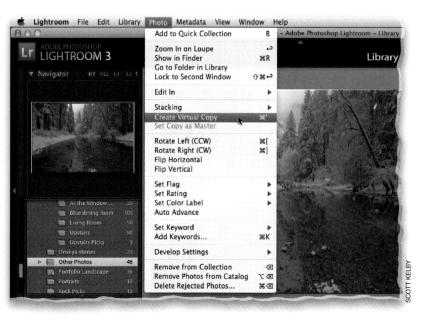

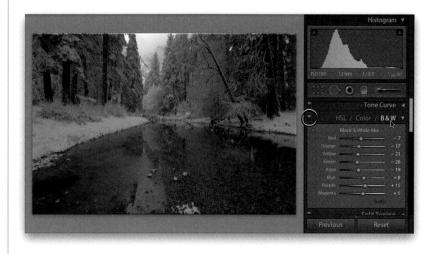

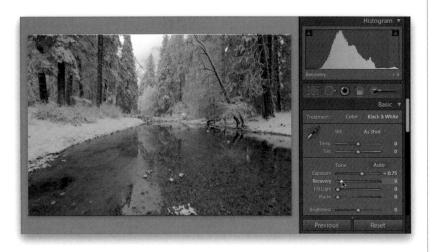

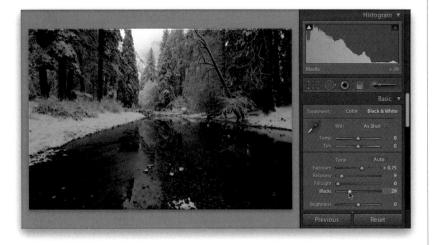

Step Three:

Now, press the Right Arrow key on your keyboard to switch to that virtual copy you made, and I'll show you my preferred do-it-yourself method. Go to the Basic panel (at the top of the right side Panels area), and in the Treatment section at the top, click on Black & White, and you get another flat-looking image (but that's about to change). Most photographers want to create a really rich, high-contrast B&W image, so the first thing to do is make sure we've gotten all we can out of the highlights in the photo, so drag the Exposure slider over to the right until the moment the "white triangle of death" (in the upper-right corner of the histogram) appears, then stop. Next, drag the Recovery slider just a tiny bit to the right until that white triangle turns dark gray again. Now you know you've gotten the maximum amount of highlights without clipping any of them away.

Step Four:

Next, drag the Blacks slider over to the right until the photo doesn't look so flat and washed out (as shown here). Now, there are those who believe that you should never let any part of your photo turn solid black, even if it's a non-essential, low-detail area like a shadow under a rock. I'm not one of those people. I want the entire photo to have "pop" to it, and in my years of creating B&W prints, I've found that your average person reacts much more positively to photos with high-contrast conversions than to the flatter conversions that retain 100% detail in the shadows. If you get a chance, try both versions, show your friends, and see which one they choose. Of course, once you darken the shadows, the whole photo is going to look quite a bit darker, so you might have to increase the Brightness amount to open up the midtones a bit (just keep an eye out on the highlightsthey can still blow out, even when just using the Brightness slider).

Step Five:

We're going for a high-contrast black and white, so we can add more contrast by clicking-and-dragging the Clarity slider quite a bit to the right (here I dragged to +75, the top end of the amount of Clarity I'd apply to about any photo), which gives the midtones much more contrast and makes the overall photo have more punch.

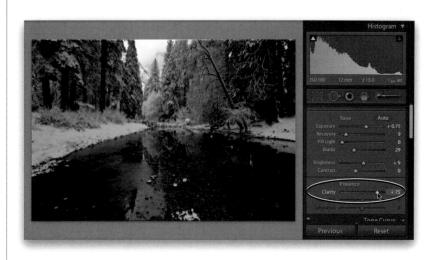

Step Six:

Now we're going to pump up the overall contrast, but we're not going to use the Contrast slider (it's just too broad, so I generally don't use it). Instead, scroll down to the Tone Curve panel and, from the Point Curve pop-up menu at the bottom, choose Medium Contrast to make your highlights brighter and your shadows deeper (as shown here). I'm only choosing Medium Contrast because this is a JPEG image, and some contrast was already applied when the JPEG was originally made from the RAW photo. If this was a RAW photo, I would have chosen Strong Contrast instead, because the default amount of contrast for RAW images is already Medium.

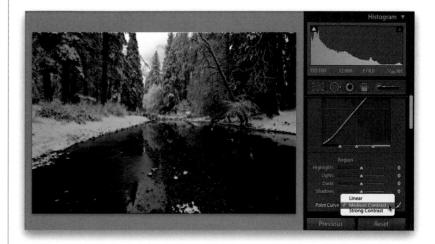

Develop

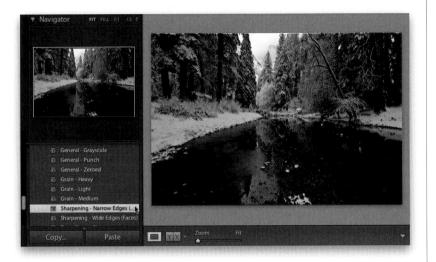

Step Seven:

The final step is to add some sharpening. Since this is a landscape photo, the easiest thing to do is to go over to the left side Panels area, in the Presets panel, and choose Sharpening - Narrow Edges (Scenic) from the built-in presets (as shown here on the left side of the window) to apply a nice amount of sharpening for landscapes. So that's it. It's not that much different from adjusting a color photo, is it? But you can see how much more dramatic the results are in the before/after images shown below. Now, all your changes have affected the entire image, but what if you wanted to lighten just the water? You'll learn that next.

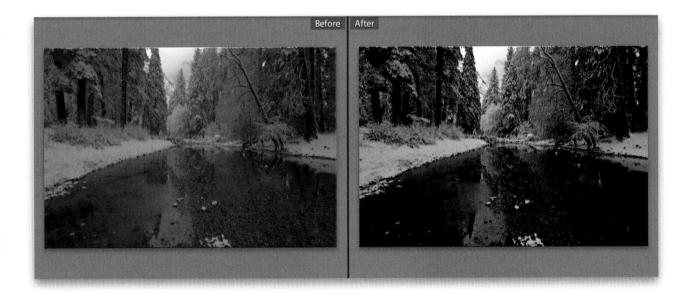

How to Tweak Individual Areas When You Convert to Black and White

The method you just learned is how I do 95% of the color-to-black-and-white conversions I do in Lightroom, but sometimes there's a particular area of the photo you want to adjust during this conversion process, and that can be done in the Develop module's HSL/Color/B&W panel. I usually still do the conversion the way I showed you on the previous pages, but when I see an area that needs adjusting, I head straight for the HSL/Color/B&W panel, because it's usually the quickest and easiest way to get the job done.

Step One:

Start off in the Library module by selecting your photo and then making a virtual copy of it, so we can see a before/after like we did in the last project. Rather than digging through the menus, you can just press Command-' (apostrophe; PC: Ctrl-'), which is the shortcut for making a virtual copy of your currently selected image. Now, click back on the original, press D, to go to the Develop module, and in the Treatment section at the top of the Basic panel, click on Black & White. Then press the Right Arrow key on your keyboard to switch to your virtual copy and click the Black & White button again (as shown here).

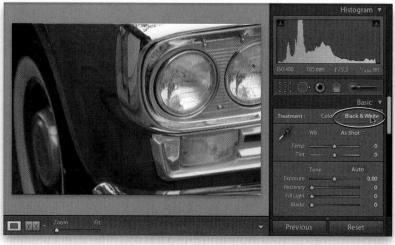

Step Two:

The photo looks flat and washed out, so do pretty much the same steps that we did in the previous project (Steps Three through Five), to make this photo look nice and rich (as shown here). Here, I increased the Exposure amount until it clipped the highlights, then I brought back those highlights using the Recovery slider, and then I increased the Blacks amount a bit. I also increased the Clarity amount to +75.

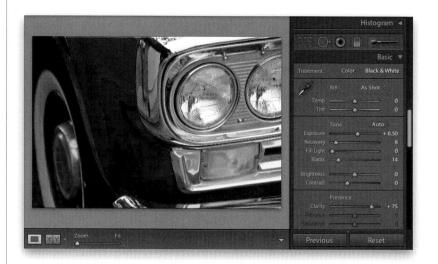

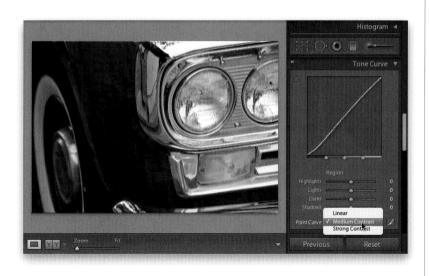

\sim	ISL / Color / B	&W ▼
⊚	Black & White Mix	
Red		- 11
Orange		- 20
Yellow		- 24
		- 27
Aqua	<u> </u>	- 18
Blue		+ 11
Purple	<u> </u>	+ 16
Magenta	<u></u>	+ 3
	Auto	

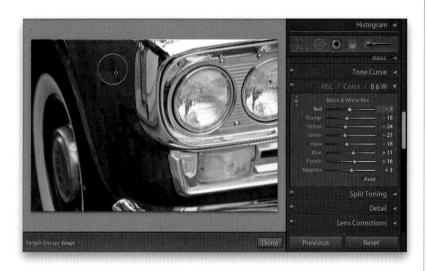

Step Three:

To add more overall contrast, scroll down to the Tone Curve panel and, from the Point Curve pop-up menu at the bottom. choose Medium Contrast (as shown here). Like I did in the last project, I'm choosing Medium because this is a IPEG image, and contrast was already applied when the IPEG was made from the original RAW photo. If this were a RAW photo. I would have chosen Strong Contrast, instead. So the photo now looks better, but the side of the car still looks really weak. This is the kind of situation—where one part of the photo needs tweaking-where I know I need to go to the HSL/Color/B&W panel, because it lets me adjust individual colors.

Step Four:

Go to the HSL/Color/B&W panel and click on B&W, on the far right of the panel header, to bring up the Black & White Mix sliders. If you know exactly which sliders you need to adjust, have at it—start draggin'—but honestly, I think it's much easier to use the Targeted Adjustment tool (the TAT), which is found in the upper-left corner of the panel. Just click on it to select the tool (it's shown circled here in red).

Step Five:

Now move your cursor out over your image, right over the area you want to adjust (in this case, we want to brighten the side of the car, so move the TAT out over the car body, as shown here). If you look closely at the TAT's cursor, you'll see it has a circle with one triangle pointing upward, and one pointing down. That's there to tell you that you use this tool by clicking-and-dragging it up or down. Click the TAT on the car and drag straight upward, and the TAT automatically moves all the sliders necessary to adjust the colors in the area under your cursor.

Step Six:

You can't see much difference in that last step, so let's click-and-drag the TAT a little farther upwards, so you can really see the effect. Look at what this did for the side of the car, which is now much lighter. In fact, it's too light and looked better before, so press **Command-Z (PC: Ctrl-Z)** to undo this extreme lightening.

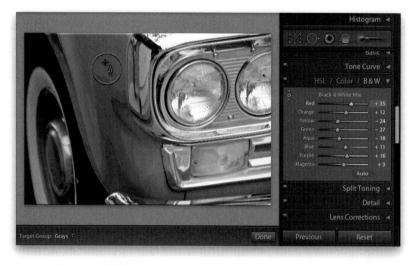

Step Seven:

Now move the TAT over the headlight (as shown here), then click-and-drag downward to darken its highlights a bit, which are pretty bright on that chrome (once again, it knows which sliders control the colors under your cursor, and automatically moves those sliders as you drag—the more you drag, the larger the adjustment). Remember that when you make adjustments with the TAT, it moves one or more sliders; if those same colors appear in other places, those areas will get adjusted, too, as you see in the after image below, where I clicked on another part of the headlight and it darkened the side of the car a little. Just so you know.

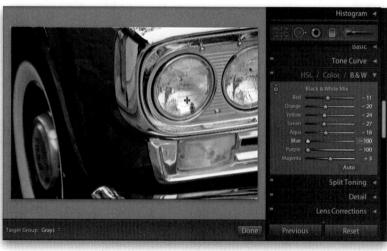

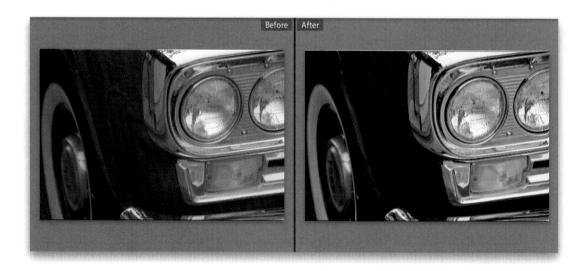

Okay, I need to clarify here a bit: The trick is for "Great-Looking Duotones," but I also cover how to do a split-tone effect, since it kind of uses the same controls. A duotone generally starts with a B&W photo, then you expand the visual depth of the image with a deep color tint. Split toning is where you apply one color tint to the highlights and another to the shadow areas. We'll cover duotones first, because not only are you more likely to do a duotone, they just look better (I'm not a big splittoning fan myself, but hey, I'm still happy to show ya how to do one, just in case).

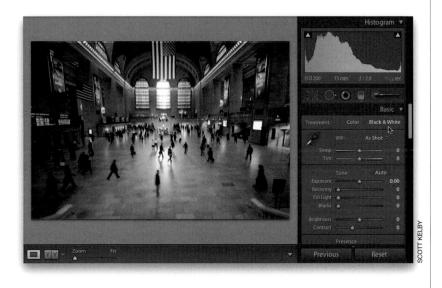

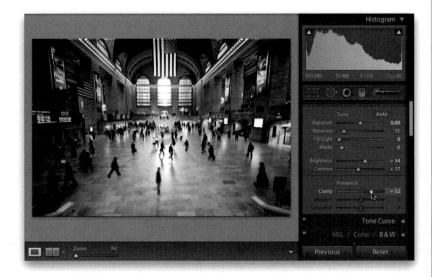

The Trick for Getting Great-Looking Duotones (Plus Split Toning)

Step One:

Here's our original color image, shown in Lightroom's Develop module. Although the actual duotone or split tone is created in the Split Toning panel (in the right side Panels area), you should probably convert the photo to black and white first. (I say "should," because you can apply a splittoning effect on top of your color photo, but...well...yeech!) Start in the Basic panel (at the top of the right side Panels area), and in the Treatment section, click on Black & White to convert the photo to black and white.

Step Two:

You can do a little tweaking to the photo to make it nice and contrasty, as I did here, by increasing the Blacks amount, the Clarity amount to give it some snap (I took it to +52 here), and the Recovery amount just a bit to reduce the glare outside the window in the center. I also increased the Brightness setting a bit. Although I don't use the Contrast slider very often, for a quick tweak it doesn't hurt, so I dragged it a little to the right, too. Now that we've toned the image a bit, it looks better, but it looks a little cold (when you convert from color to black and white, you often lose the visual depth the color provides. Adding a duotone brings some of that back without bringing back all the original color, which is what I love about adding the effect).

Step Three:

The trick to creating duotones is actually incredibly simple: you just add the color tint in the shadows, and you leave the highlights untouched. So, go to the Split Toning panel, in the right side Panels area, and start by dragging the Shadows Saturation slider to around 25, so you can see some of the tint color (as shown here. As soon as I started dragging the Saturation slider, the tint appeared, but the hue is the default reddish color).

TIP: Reset Your Settings

If you don't like what you're seeing, and want to start over, press-and-hold the Option (PC: Alt) key, and the word "Shadows" in the Split Toning panel changes to "Reset Shadows." Click on it to reset the settings to their defaults.

Step Four:

Now, drag the Shadows Hue slider to the color you want (I usually drag it somewhere between 30 and 45—drag it lower than 30, and things look too red; drag it higher than 45, and it starts to get a greenish look. I'm usually looking for more of a classic, mild sepia-tone look something more brownish—and it seems like this puts it somewhere between 30 and 45, depending on the photo). Here's our image with a Shadows Hue setting of 41 and Saturation of 25.

TIP: See the Saturation

If you press-and-hold the Option (PC: Alt) key and then drag the Hue slider, it acts like you just bumped up the Saturation amount to 100%, so you can easily see which color tint you're choosing (the Saturation slider doesn't actually move, but the effect is the same—you see the tint at 100% saturation until you release the Option key, then it returns to normal).

reset Name: Scot	t's Duoton	e Buodenningeren er en	
Folder: Use	r Presets		
Auto Settings			
Auto Tone		Auto Black & White Mix	
Settings			
U White Balance		🗹 Treatment (Black & White)	Lens Corrections
Basic Tone		🔲 Black & White Mix	Lens Profile Corrections
Exposure Highlight Re Fill Light	covery	Split Toning	Chromatic Aberration
Black Clippin	ng	Graduated Filters Noise Reduction	Effects Post-Crop Vignetting
Contrast			Crain
Tone Curve			 Process Version Calibration
Clarity			
Sharpening			
Check All) (Che	ck None		Cancel Create

Step Five:

If you like this setting (or experiment and find one you do like), I would go ahead and save this as a one-click preset right now. Just go to the Presets panel over in the left side Panels area, and click the + (plus sign) button to add a new preset. When the New Develop Preset dialog appears, you just have to do two things: (1) click the Check None button at the bottom, then (2) turn on the checkboxes for Treatment (Black & White) and Split Toning. That's it, and now a great duotone is just one click away. Now that you've learned this technique, creating a split-tone effect is a breeze.

Step Six:

To create a split-tone effect, start with a good-looking B&W photo (you know how to convert from color to black and white in the Basic panel now), then scroll down to the Split Toning panel. You're going to do the same thing you did to create a duotone, but you're going to choose one hue for the highlights and a different hue for the shadows. That's all there is to it (I told you this was easy). Here, I set the Highlights Hue to 45 and the Shadows Hue to 214. I set both Saturation sliders to 27 (a little bit higher than usual, just to add more color).

Step Seven:

You can also choose your colors from a color picker: click on the color swatch next to Highlights to bring up the Highlights color picker. Along the top are some common split-tone highlight colors. Click the yellowish swatch (the second swatch from the left, as shown here) to apply a yellow tint to the highlight areas in your photo (you can see the result in the Preview area). To close the color picker, click on the X in the upper-left corner.

Step Eight:

Now click the color swatch in the Shadows section to bring up the Shadows color picker. From the swatches at the top of the picker, click on the blue swatch (as shown here) to assign a blue color to the shadow areas. You can see the completed split-tone effect right onscreen, as soon as you click this blue swatch. The Balance slider (found between the Highlights and Shadows sections) does just what you'd think it would-it lets you balance the color mix between the highlights and shadows. For example, if you want the balance in your image more toward the yellow highlights, you'd just click-anddrag the Balance slider to the right. Again, if you've created a particular split-tone combination that you like, save it as a preset now (using the technique you learned in Step Five).

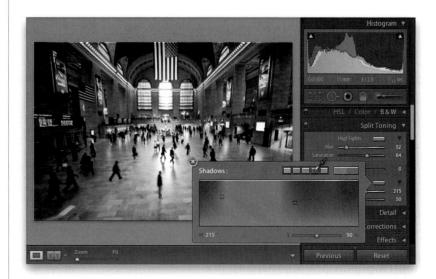

Slidesho

Web

Lightroom Killer Tips > >

Separating Your Virtual Black & Whites from the Real Black & Whites

To see just your virtual B&W copies, go up to the Library Filter bar (if it's not visible, press the \ **[backslash] key**), and then click on Attribute. When the Attribute options pop down, click on the little curled page icon at the far right of the bar to show just the virtual copies. To see the real original "master" B&W files, click the filmstrip icon just to the left of it. To see everything again (both the virtual and original masters), click the None button.

 Getting a Before/After of Your B&W Tweaking

You can't just press the \ (backslash) key to see your before image after you've done the edits to your B&W image, because you're starting with a color photo (so pressing \ just gives you the color original again). There are two ways to get around this: (1) As soon as you convert to black and white, press Command-N (PC: Ctrl-N) to save the conversion as a snapshot. Now you can get back to your B&W original anytime by clicking on that snapshot in the Snapshots panel. Or, (2) after you convert to black and white, press Command-' (PC: Ctrl-') to make a virtual copy, and then do your editing to the copy. That way you can use \ to

compare the original conversion with any tweaks you've been making.

▼ Tip for Using the Targeted Adjustment Tool (TAT) If you're using the HSL/Color/B&W panel's TAT to tweak your B&W image, you already know that you click-anddrag the TAT within your image and it moves the sliders that control the colors underneath it. However, you might find it easier to move the TAT over the area you want to adjust, and instead of dragging the TAT up/down, just use the Up/Down Arrow keys on your keyboard, and it will move the sliders for you. If you press-and-hold the Shift key while using the Up/Down Arrows, the sliders move in larger increments.

Painting Duotones

Another way to create a duotone effect from your B&W photo is to click on the Adjustment Brush, and then in the options that pop down, choose Color from the Effect pop-up menu. Now, click on the Color swatch to bring up the color picker, choose the color you want for your duotone, and close the picker. Then,

	+ 💽 🛽			
				Edit
				. v
Exposure	-			0.00
	C	-		
Contrast				
	<u>, 1</u>	<u> </u>		
Clarity	-	<u> </u>		
		-0		
Brush :	A B		Erase	*
	_			16.0
				
				86
0				
Density				100
			Reset	Close

turn off the Auto Mask checkbox and paint over the photo, and as you do, it will retain all the detail and just apply the duotone color.

B&W Conversion Tip

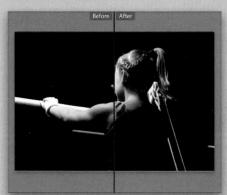

If you click on B&W in the HSL/Color/ B&W panel, it converts your photo to black and white and it's kind of a flatlooking conversion, but the idea is that you'll use those color sliders to adjust the conversion. The problem is, how do you know which color sliders to move when the photo is now in black and white? Try this: once you've done your conversion and it's time to tweak those color sliders, press Shift-Y to enter the Before & After split-screen view (if it shows a side-by-side view instead, just press Shift-Y again). Now you can see the color image on the left side of the screen, and black and white on the right, which makes it much easier to see which color does what.

▼ Using the HSL/Color/B&W Panel? Color Correct Your Photo First

If you're going to be using the B&W panel to make your B&W conversion, before you go there, start by making the color image look right first (balance the exposure, blacks, contrast, etc., first, then you'll get better results from the B&W panel).

Chapter 10 Creating Presentations of Your Work

Slideshow creating presentations of your work

You know what's harder than creating a compelling screen presentation of your work, coupled with a moving and emotionallycharged background music track? It's finding a song, TV show, or movie title that uses the word "Slideshow." By the way, I can't tell you the amount of angst the word "slideshow" has caused my beloved editor, Kim Doty, because, really, the word slideshow is two words (slide show), but in Lightroom, Adobe chose to name the module with just one word—Slideshow. Well, when the Lightroom 2 version of this book came out, I noticed that Kim had taken all uses of the word "slideshow" and changed it to "slide show," except when it referred to the actual module name itself. So, in this edition. I asked to Kim to make it consistent and always refer to it as one wordslideshow. This didn't go over very well with Kim, which troubled me because Kim, by

nature, has the happiest, bubbliest demeanor of not only any editor in the editing world, but of most people on the entire planet. So, I thought I could kind of joke around about it and Kim would change it all back to one word, and she begrudgingly said "OK" and went back to her office. But then, as we were wrapping up the book, Kim came to my office, sat down, and I could tell something was wrong. This is a rare moment indeed, so I gave her my full attention. She went on to let me know how much the single-word thing was bothering her, and we went back and forth for about 10 minutes, until she pulled out a knife. I clearly didn't realize how much this meant to Kim, so of course, I relented and the chapter has been adjusted so the two-word "slide show" appears where appropriate. Also, the other good news is: the doctor says my stitches should be out within two weeks.

Creating a Quick, Basic Slide Show

Here's how to create a quick slide show using the built-in slide show templates that come with Lightroom. You'll probably be surprised at how easy this process is, but the real power of the Slideshow module doesn't really kick in until you start customizing and creating your own slide show templates (which we cover after this, but you have to learn this first, so start here and you'll have no problems when we get to customizing).

Step One:

Start by jumping over to the Slideshow module by pressing Command-Option-3 (PC: Ctrl-Alt-3). There's a Collections panel in the left side Panels area, just like there is in the Library module, so you have direct access to the photos in any collection. First, click on the collection that has the photos you want to appear in your slide show, as shown here. (Note: If the photos you want in your slide show aren't in a collection, it will make your life a lot easier if they are, so head back to the Library module [press the letter G], and make a new collection with the photos you want in your slide show, then jump back over to the Slideshow module, and click on that collection in the Slideshow's Collections panel.)

Step Two:

By default, it's going to play the slides in the order they appear down in the Filmstrip (the first photo from the left appears first, the second photo appears next, and so on), with a brief dissolve transition between slides. If you only want certain photos in your collection to appear in your slide show, then go to the Filmstrip, select just those photos, and choose **Selected Photos** from the Use pop-up menu in the toolbar below the center Preview area (as shown here). As you can see, you can also choose to have just flagged photos in your slide show.

Step Three:

If you want to change the order of your slides, just click-and-drag them into the order you want them. (In the example shown here, I clicked on the ninth photo and dragged it over so it was the first photo in the Filmstrip.) So, go ahead and do that now—click-and-drag the photos into the order you'd like them to appear in your slide show. (*Note:* You can always change your mind on the order any time by clicking-and-dragging right within the Filmstrip.)

Step Four:

When you first switch to the Slideshow module, it displays your photos in the default slide show template, which has a light gray gradient background and your Main Identity Plate in the upperleft corner in white letters (now this is not to be confused with the Default template in the Template Browser, and yes, it usually looks pretty bad, as seen here, but we'll deal with that later on). Click on any other photo in the Filmstrip to see how that slide will look in the current slide show layout.

Step Five:

If you want to try a different look for your slide show, you can use any of the built-in slide show templates that come with Lightroom (they're in the Template Browser in the left side Panels area). Before you start clicking on them, however, you can get a preview of how they'll look by just hovering your cursor over their names in the Template Browser. Here, I'm hovering over the Caption and Rating template, and the Preview panel shows that template has a light gray gradient background, and the images have a thin white stroke and a drop shadow. While this is similar to the default template, with this template, if you've added a star rating to your photo, the stars appear over the top-left corner of your image, and if you added a caption in the Library module's Metadata panel, it appears at the bottom of the slide. Let's go ahead and try this one.

Step Six:

To see a quick preview of how your slide show will look, go to the toolbar below the center Preview area, and click the Preview button (it's a right-facing triangle—just like the Play button on a DVD player). This plays a preview of your slide show within that center Preview area, and although the slide show is the exact same size in that window, you're now seeing it without guides, with transitions, and with music (if you chose to add music, which we haven't covered yet, so you probably haven't, but hey, ya never know). To stop your preview, press the square Stop button on the left side of the toolbar; to pause it, press the two vertical lines where the Play button used to be (as shown here).

TIP: Life Is Random

Your slides play in the order that they appear in the Filmstrip, but if you want your slides to appear in a completely random order, go to the Playback panel in the right side Panels area and turn on the Random Order checkbox.

Slideshow

Web

Step Seven:

If you want to remove a photo from your slide show, just remove the photo from your collection by clicking on it in the Filmstrip and pressing the Delete (PC: Backspace) key on your keyboard (or choose Selected Photos from the Use pop-up menu in the toolbar and just make sure you don't select that photo). Here I removed that photo shown in Step Six from the slide show by hitting the Delete key, so the next photo in the Filmstrip is now displayed. By the way, this is another advantage of collections vs. folders. If you were working with a folder here, instead of a collection, and you deleted a photo, it would actually remove it from Lightroom and from your computer. Yikes!

Step Eight:

When you're done tweaking things, it's time to see the full-screen final version. Click the Play button at the bottom of the right side Panels area, and your slide show plays at full-screen size (as shown here). To exit full-screen mode and return to the Slideshow module, press the Esc key on your keyboard. Okay, you've created a basic slide show. Next, you'll learn how to customize and create your own custom slide shows.

TIP: Creating an Instant Slide Show I mentioned this in an earlier chapter, but you can create an impromptu slide show anytime without even going to the Slideshow module. Whichever module you're in, just go to the Filmstrip, select the photos you want in your slide show, then press Command-Return (PC: Ctrl-Enter), and it starts—full screen, using whatever template and settings you used last in the Slideshow module.

Customizing the Look of Your Slide Show

The built-in templates are okay, but after you create a slide show or two with them, you're going to be saying stuff like, "I wish I could change the background color" or "I wish I could add some text at the bottom" or "I wish my slide show looked better." Well, this is where you start to create your own custom look for your slides, so not only does it look just the way you want it, your custom look is just one click away from now on.

Step One:

Although you might not be wild about Lightroom's predesigned slide show templates, they make great starting points for creating your own custom look. Here, we're going to create a wedding slide show, so start by going to the Slideshow module's Collections panel (in the left side Panels area) and click on the wedding collection you want to use. Then, go up to the Template Browser and click on Exif Metadata to load that template (seen here, which puts your photos over a black background with a thin white border, info about your photo in the top right, bottom right, and below your photo, and your Identity Plate in the upper-left corner).

Step Two:

Now that we've got our template loaded, we don't need the left-side panels anymore, so press **F7** (or **Fn F7**) on your keyboard to hide them. The first thing I do is get rid of all the EXIF info (after all, your wedding clients probably won't care what your ISO or exposure settings were), so go to the right side Panels area, to the Overlays panel, and turn off the Text Overlays checkbox (as shown here). Your Identity Plate will still be visible, but the info in the upper- and lower-right corners and below the photo is now hidden.

TIP: Resizing Custom Text

Once you create custom text, you can change the size by clicking-and-dragging the corner points outward (to make it larger), and inward (to make it smaller).

<u>Slideshow</u>

Web

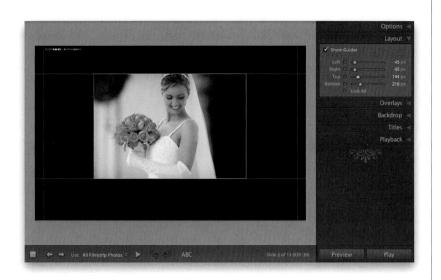

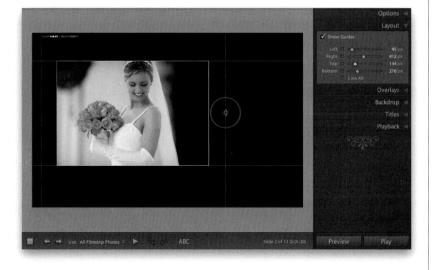

Step Three:

Now let's choose how big your photos are going to appear on the slide. For this design, we're going to shrink the size of the photos a bit, and then move them up toward the top of the slide, so we can add our studio's name below them. Your photo is positioned inside four page margins (left, right, top, and bottom), and you can control how big/small these margins are in the Layout panel found in the right side Panels area. To see the margins, turn on the Show Guides checkbox. By default, all four margin guides are linked together, so if you increase the left margin to 81 pixels, all of the other margins adjust so they're 81 pixels, as well. In our case, we want to adjust the top and bottom separately, so first click on Link All to unlink the margins (the little "lights" beside each margin go out). Now, click-and-drag the Bottom margin slider to the right to 216 px and the Top margin slider to 144 px, and you'll see the photo scale down in size inward, leaving a larger margin below the photo (as shown here).

TIP: Moving Guides

You don't actually resize the photos on your slide—you move the margin guides and your photo resizes within the margins you create. You can do this visually (rather than in the Layout panel) by moving your cursor over a guide, and you'll see it change into a "moving bar" cursor (by the way, I have no idea if "moving bar" is its official name, but it is a double-headed arrow), and now you can click-and-drag the margins to resize the photo. If you move your cursor over a corner (where two guides intersect) you can drag diagonally to resize those two guides at the same time.

The Adobe Photoshop Lightroom 3 Book for Digital Photographers

Step Four:

Now that our photo is in position, let's move our studio name Identity Plate below the photo. Click on it (up in the top-left corner of your slide) and drag it so it appears under your photo (when you drag it, it does this weird Spiderman thing of clinging to the edges. This is supposed to help you center your text by having it snap to the edges. At least, that's the theory).

TIP: Zoom to Fill Frame

If you see a gap between the edges of your photo and the margin guides, you can fill that gap instantly with a very cool feature called Zoom to Fill Frame. Turning on this checkbox (found in the Options panel at the very top of the right side Panels area) increases the size of your photos proportionally until they completely fill the area inside the margins. Give this a try—you'll probably use it more than you'd think.

Step Five:

To customize your Identity Plate text, go to the Overlays panel, click on the little triangle in the bottom-right corner of the Identity Plate preview, and choose Edit to bring up the Identity Plate Editor (seen here). Type in the name you want to appear below each photo (in my case, I'm using my Main Identity Plate, where I typed in Scott Kelby | Photography in the font Futura Book and Futura Bold at 24 points—you get that little bar by typing Shift-\ [backslash] on your keyboard. I clicked on the color swatch here and changed the font color temporarily to black, to make it easier to see), and click OK. Choosing the right point size isn't so critical, because you can change the size of your Identity Plate by either using the Scale slider (in the Overlays panel), or by clicking on your Identity Plate text on the slide and then clicking-and-dragging any corner point outward (which scales the text up).

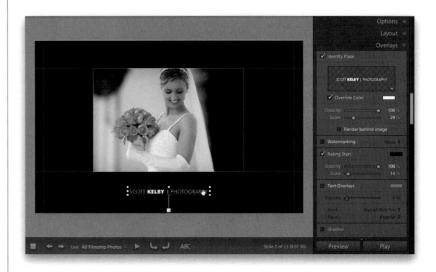

Use a styled text ide	ntity plate 🔘 Use a graphical identity p	late
SCOTT KELBY PH	OTOGRAPHY	
Futura	Book	€ 12 •

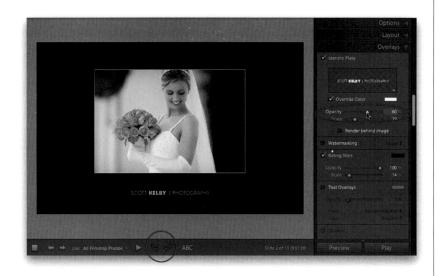

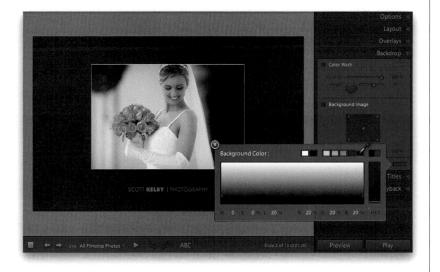

Step Six:

Let's take a look at how our custom slide layout is coming together by hiding the margin guides-press Command-Shift-H (PC: Ctrl-Shift-H), or you could go to the Layout panel and turn off the checkbox for Show Guides. If you look at the text below the photo, you can see it's not bright white—it's actually a very light gray (I like that better, because it doesn't draw the eye as much if it's not solid white), and to get this more subtle light gray look, you just lower the Opacity amount up in the Identity Plate section of the Overlays panel (here you can see I've got the Identity Plate Opacity lowered to just 60%). Also, if you want to rotate your Identity Plate text, click on it first, then use the two Rotate arrows found down in the toolbar (I've circled them here in red for you).

Step Seven:

You can change the background color of your slide to any color you'd like, so let's change it to a dark gray. Go down to the Backdrop panel, and to the right of the Background Color checkbox, you'll see a color swatch. Click on that swatch and the color picker appears, where you can choose any color you'd like (I chose a dark gray from the swatches at the top of the picker, as seen here). For more on customizing your background, go to the next project.

TIP: Add a Shadow to Your Identity Plate Text

If your slide has a lighter background color, you can add a drop shadow to your Identity Plate text. Just go to the bottom of the Overlays panel and turn the Shadow checkbox on. You can now control the opacity, how far offset your shadow is from your text, the radius (softness) of your shadow, and the angle (direction) of the shadow. *Note:* As of the writing of this book, this feature is not available in the PC version of Lightroom.

The Adobe Photoshop Lightroom 3 Book for Digital Photographers

Step Eight:

Now that we're on a gray background, rather than black, you can see that this Exif Metadata template actually has a drop shadow on the image included in the design, but of course you can't see it when you're on a solid black background (which makes you wonder why Adobe had that feature turned on in the first place, eh?). Anyway, you can control the size, opacity, and direction of the drop shadow (see page 312 for more on drop shadows) in the Options panel, but for now we'll just increase the Radius to soften the shadow and lower the Opacity a bit to give us the look you see here.

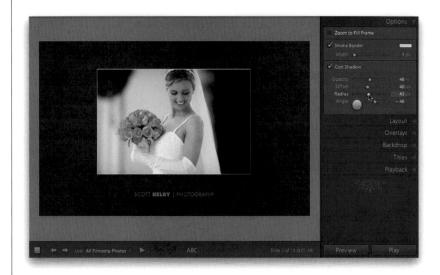

Step Nine:

Let's give this layout a little more of a fine art slide show feel by making the image area square. It's not real obvious how to do this, but luckily it's fairly easy. You start by moving the guides, so they make a square. This makes perfect sense at first, but once you see that it just resizes your photo, at the same aspect ratio, inside that square cell (rather than cropping it to square), you start scratching your head (well, I did anyway, but it was only because my head was itchy. That was pretty bad. I know). The trick is to go up to the Options panel and turn on the checkbox for Zoom to Fill Frame. That fills the square cell with your image, and now you get the square look you see here. While we're here, let's go and add a thicker stroke around the image using the Stroke Border Width slider in that same panel (more on adding a stroke on page 312).

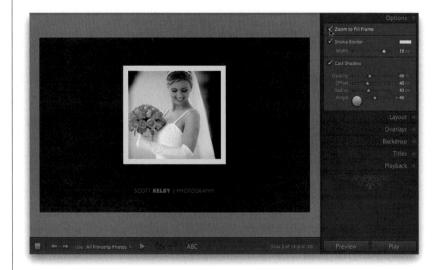

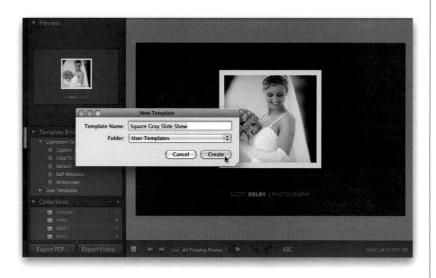

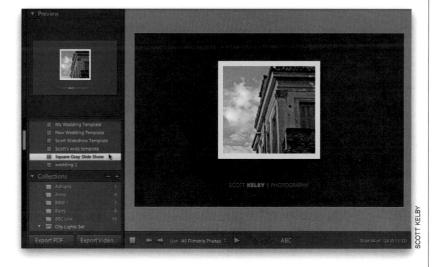

Step 10:

Now we're going to save our template, so in the future we can apply it with just one click in the Template Browser (it remembers everything: the text, the background color, the opening and closing title slides [more on those on page 314]-you name it). To do this, press F7 to make the left side Panels area visible again, then go to the Template Browser and click on the + (plus sign) button on the far right of the panel header. This brings up the New Template dialog (shown here), where you can name your template and choose where you want to save it (I save mine in the User Templates folder, as shown here, but you can create your own folders and choose to save into one of them by choosing it from the Folder pop-up menu).

Step 11:

Now that you've saved your custom slide design as a template, you can apply this same exact look to a totally different set of images by going to the Slideshow module, and in the Collections panel, clicking on a different collection. Then, in the Template Browser, under User Templates, click on Square Gray Slide Show, and this look will be instantly applied to your collection of photos (as shown here).

Getting Creative with Photo Backgrounds

Besides a solid color and a gradient fill, you can choose a photo as your slide background, and you can control the opacity of this background photo, so you can create a backscreened effect. The only downside is that the same background appears on every slide (except the title slides, of course), so you can't vary the background effect from slide to slide. Here, we're going to look at a simple photo background, then take it up a notch, and then finally pull a few tricks that will let you create some very creative slide show layouts.

Step One:

First a little setup: go to the Template Browser and click on the template named Caption and Rating. Now, let's simplify the layout: In the Options panel (at the top of the right side Panels area), turn on the Zoom to Fill Frame checkbox, then click on the bottom-right corner of the guides and drag inward until your photo is smaller with a wide aspect ratio (like the one shown here. After I did this. I turned off the Show Guides checkbox in the Layout panel). In that same panel, change the Stroke Border color to black and increase the stroke width to 2 pixels, then turn off the checkbox for Cast Shadow. Now go down to the Overlays panel and turn off both the Text Overlays checkbox and the Star Ratings checkbox (so we don't see stars over our photo).

Step Two:

Go to the Backdrop panel, and turn the Color Wash checkbox off, so you no longer have a gradient over the background. Now, go to the Filmstrip and drag-and-drop the photo you want to use as a background image onto the Background Image well in the Backdrop panel (as shown here; you may have to turn the Background Image checkbox on first), and that image now appears as the background behind your currently selected photo. The background photo appears at 100% opacity, which usually means it's going to compete with your foreground photo, and for that reason we usually create a "backscreened" effect for the background photo, so it appears washed out and more subtle, and your main image stands out again.

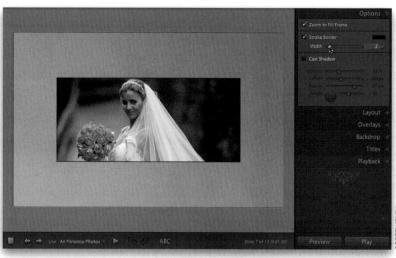

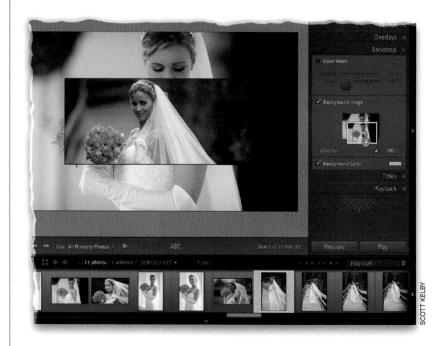

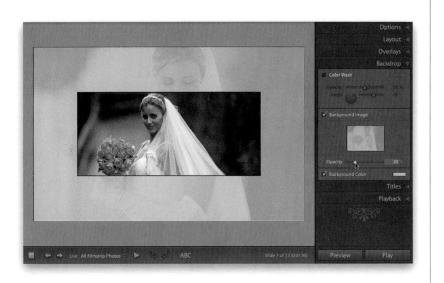

Step Three:

To create that backscreened effect, lower the Background Image Opacity to 20% (as shown here), and the photo fades to gray. If you prefer to have a white backscreened look, set your Background Color to white (click on the color swatch, then choose white in the color picker), or if you want a black backscreened look (rather than gray or white), set the Background Color to black (which color looks best kind of depends on the photo you choose).

Step Four:

When you click the Preview button (as I did here), or the Play button, you'll see the slides play with the photo you chose as the background image (as I mentioned in the intro, this same background will appear behind each photo).

Step Five:

Now, thus far, we've just used one of our regular photos from the shoot as our background image, but if you use images that were designed to be backgrounds, you get an entirely different look. For example, the image shown here is a background image I bought from iStockphoto. I just went to their site (www.istockphoto.com), did a search for "photo frames," and this came up as one of the results. So I bought it, then imported it into Lightroom. Once it appeared in Lightroom, I dragged it into the collection where I wanted to use it. then I dragged it onto the Background Image well in the Backdrop panel for the effect you see here. (Note: I buy royaltyfree stuff like this from either iStockphoto or Fotolia [www.fotolia.com], but almost every microstock site has lots of frames and borders you can buy for just a few bucks.)

OTT KELBY AND ©ISTOCKPHOTO/NARVIKK

Step Six:

Here's another example of the kind of simple backgrounds you can download for your slide shows. Once you've imported the background image into Lightroom, remember to drag that image into the collection where you want to use it, then drag it onto the Background Image well in the Backdrop panel. Now, as your slide show plays, the images will appear inside the phone. The only tricky part of this is getting the image to fit right inside the phone. The trick is to (1) go to the Options panel and turn on the Zoom to Fill Frame checkbox. Then, (2) go to the Layout panel, click on Link All to turn this off, make your guides visible, and move them so they're just about the same size (on all sides) as the phone's window. It's easier than it sounds, since you can just drag the guides around right in the Preview area.

Library Develop

<u>Sli</u>deshow

nt Web

O Use a styled text identity plate 💿) Use a graphical identity plate
Locate File	(Clear Image)

Step Seven:

Here's a workaround background trick that lets you put a photo inside your background (complete with a shadow): instead of using a graphic as a background image, use it as an Identity Plate. That way, you can have the background image appear in front of (or over) your photo rather than behind it. Here's a slide mount image I bought from iStockphoto. I took it into Photoshop, selected the slide and put it on its own layer, then selected the box in the center, and deleted it (to make the slide opening see-through). Next, I added a drop shadow in the opening, deleted the Background layer, and saved the file as a PNG, to maintain its transparency when I bring it into Lightroom as a graphical Identity Plate. To bring it in, go to the Overlays panel, turn on the Identity Plate checkbox, click on the triangle at the bottom right of the Identity Plate preview, and chose **Edit** from the pop-up menu. When the Identity Plate Editor appears (shown here), click on the Use a Graphical Identity Plate radio button, then click on Locate File to find your slide file, and click OK. Once it appears in the Preview area, resize both the Identity Plate (by dragging the corner points) and the image (by dragging the margin guides). Also, be sure to have the Zoom to Fill Frame checkbox turned on in the Options panel.

BONUS VIDEO:

I did a bonus video for you, to show you step by step how to create Identity Plate graphics with transparency like you see here. You'll find it at **www.kelbytraining** .com/books/LR3.

Step Eight:

Here's another variation using a picture frame I bought from iStockphoto. The only difference is that I changed the Background Color (in the Backdrop panel) from gray to white. Now that you're seeing the potential of these backgrounds and Identity Plates, let's put the two together for some really creative layouts.

Step Nine:

For this layout, let's start from scratch. Go to the Template Browser and click on the Caption and Rating template, then go to the Overlays panel and turn off the checkboxes for Rating Stars and Text Overlays, and be sure the Identity Plate checkbox is turned off, as well. Go to the Backdrop panel and turn off Color Wash, then go up to the Options panel and turn off the Cast Shadow and Stroke Border checkboxes. Now, use the margin guides to resize your image to give us the simple, clean look you see here.

Step 10:

I went and downloaded an old map from iStockphoto (believe it or not, I searched for "old map" and this is what came up as the first result. Perfect!). Import that old map image into Lightroom, then drag it into the collection you're working with. Once it's there, drag that old map image into the Background Image well in the Backdrop panel (as seen here) to make the map the background for the slide. So far, so good.

Step 11:

When I searched "photo frame" in iStockphoto earlier, I found this antique-looking photo frame. We're going to use this as a graphical Identity Plate, but before we do that, you'll need to use the same Photoshop technique I mentioned in Step Seven (and showed you in the bonus video), to make the center and surrounding area transparent (if we don't do that, you'd see a white box inside and around your frame, instead of the background around the frame, and inside being transparent, so it would totally wreck the look). Also notice how a slight drop shadow appears inside the frame, so it appears the photo is actually inside the frame. Anyway, once you've done the Photoshop transparency trick, go to the Overlays panel, turn on the Identity Plate checkbox, click on the triangle in the bottom-right corner of the Identity Plate preview, and choose Edit from the pop-up menu. When the Identity Plate Editor appears, click on the Use a Graphical Identity Plate radio button, then find your frame file, and click OK. Once it appears in the Preview area, resize both the Identity Plate and the image for the look you see here.

Step 12:

Make sure you have the Render Behind Image checkbox turned off, if you want the photo frame to appear in front of your image (like it does in Step 11), or for a slightly different look, turn it on (as shown here), so the image appears on top of the frame—you won't get the drop shadow appearing on the inside of your image, adding depth. The final layout is shown here (or in Step 11, depending on whether you turned the Render Behind Image checkbox on or off). I hope these few pages spark some ideas for you of what can be done with background images, Identity Plates, and using both together.

Working with Drop Shadows and Strokes

If you're building a slide show on a light background, or on a photo background, you can add a drop shadow behind your image to help it stand out from the background. You also have the option of adding a stroke to your images. While most of the built-in templates already have these features turned on, here we'll look at how to add them and how to make adjustments to both.

Step One:

To add a drop shadow, go the Options panel in the right side Panels area, and turn on the Cast Shadow checkbox. Most of the built-in templates, like Caption and Rating (shown here), already have the drop shadow feature turned on. The two controls you're probably going to use the most are Opacity (how dark your drop shadow appears), and Radius (which controls how soft your drop shadow is. So why don't they just call it "Softness?" That's because then it would be too obvious and easy [wink]). The Offset setting controls how far the shadow appears from the photo, so if you want it to look like your photo is higher off the background, increase the Offset amount. The Angle setting determines where the light is coming from, and by default, it positions your shadow down and to the right.

Step Two:

Let's tweak the drop shadow a bit: lower the Opacity amount to 18%, so it's lighter, then increase the Offset amount to 100%, so it looks like the photo is an inch or two off the background. Next, lower the Radius to amount 48%, so it's not quite as soft, and lastly set the Radius to -41°, just to tweak its position a bit. Turning on the Stroke Border checkbox (at the top of the Options panel) puts a color stroke around your image. In this built-in template (and a couple of the others), the stroke is already on, but it's white and only 1-pixel thick, so you can hardly see it. To change the color, click on the color swatch, then choose a new color from the color picker (I chose black here). To make the stroke thicker, drag the Width slider to the right (I dragged mine to 12 px).

Besides adding text using the Identity Plate, you can add other lines of text to your photo (either custom text that you type in, or info that Lightroom pulls from the photo's EXIF data, or any metadata you added when you imported the photos, like your copyright info). You can also add a watermark to your slide show images, in case you're sending this slide show to a client or posting it on the Web.

Adding Additional Lines of Text and Watermarking

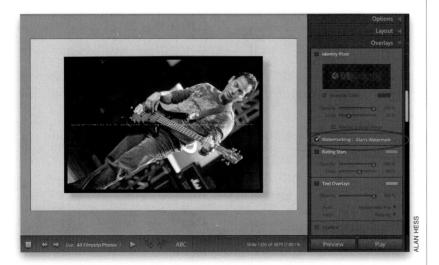

Step One:

To add text, click on the ABC button down in the toolbar (shown circled here in red). and a pop-up menu and text field will appear to the right of it. The default setting is Custom Text, and you can simply type the text you want in the text field, and then press the Return (PC: Enter) key. Your text appears on your slide with a resizing border around it. To resize your text, click-and-drag on any corner point. To move the text, just click right on it and drag it where you want it. If you click-and-hold on the words Custom Text in the toolbar, a pop-up menu appears that lets you choose text that may be embedded into your photo's metadata. For example, if you choose Date, it displays the date the photo was taken. If you choose any of the other options, it only displays that info if it's in the file (in other words, if you didn't add caption info in the Metadata panel, choosing Caption here won't get you anything).

Step Two:

If you set up a watermark (see page 230), you can add that, as well (or instead of the additional text). Go to the Overlays panel and turn on the Watermarking checkbox, and then choose your watermark preset from the pop-up menu (you can see the watermark here across the center of the image). The advantage of using a watermark (rather than custom text) is that you can use pre-made templates, where you also can lower the opacity so it's seethrough, and doesn't fully cover the image behind it.

Adding Opening and Closing Title Slides

One way to customize your slide show is to create your own custom opening and closing title slides (I usually only create an opening slide). Besides just looking nice, having an opening slide serves an important purpose—it conceals the first slide in your presentation, so your client doesn't see the first image until the show actually begins.

Step One:

You create opening/closing slides in the Titles panel (found in the right side Panels area in the Slideshow module). To turn this feature on, turn on the Intro Screen checkbox and your title screen appears for just a few seconds (as seen here), then the first photo appears again. (Arrggghh!!! It makes working with titles really frustrating, however, here's a cool trick I stumbled upon to make it stick around as long and whenever you want: just click-and-hold directly on the Scale slider [as shown here] and it assumes you're going to use it, so the title screen stays visible until you let go.) The little color swatch to the right lets you choose a background color (by default, the background color is black). To add text, you add your Identity Plate text (or graphic) by turning on the Add Identity Plate checkbox (shown circled in red here), and your current Identity Plate text appears (as seen here).

Step Two:

To customize your Identity Plate text, click on the little triangle in the bottom-right corner of the Identity Plate preview and choose **Edit** from the pop-up menu that appears to bring up the Identity Plate Editor, seen here. Now you can highlight the existing text, type in any text you'd like (in this case, I added the bride's name), and choose a different font from the Font pop-up menu (I used "Satisfaction" from MyFonts [www .myfonts.com]). Click OK to apply this text to your intro slide. *Note:* If you make your text white, it's impossible to see in this dialog, so I highlight it before I start typing and then again when I'm done, as seen here.

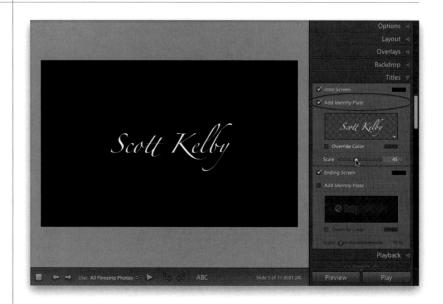

• Use a styled text identit	y plate 🔘 Use a graphical identity	plate
Satisfaction	Pro	\$ 36 ▼ □
Satistaction		

Step Three:

You can control the color of your Identity Plate text by turning on the Override Color checkbox (found under the Identity Plate preview). Once you turn that on, click once on the color swatch to its right and a color picker appears (shown here). At the top are some handy color swatches in white, black, and different shades of gray. You can choose one of those, or drag the bar up/down on the far right to choose a hue, and then you can choose your color's saturation from the large color picker gradient (here, I'm choosing a gray color, and you can see that color instantly reflected in the text). You can also control the size of your Identity Plate text by using the Scale slider at the bottom of the Intro Screen section.

Step Four:

To change the color of the intro screen's background, just click on the color swatch to the right of the Intro Screen checkbox. In this case, I changed the background to a maroon color just to show you what it looks like (I also changed the color of my Identity Plate to match the background). Once all your title text is formatted the way you want it (good luck on that, by the way, because editing text in the Identity Plate Editor is...well...it's clunky as heck, and I didn't want to say heck), you can preview the slide show in the Preview area. The Ending Screen works the same way: to turn it on, you turn on the Ending Screen checkbox in the Titles panel, and you can choose that screen's background color, Identity Plate size, etc., just like you did with the intro screen.

Adding Background Music

The right background music can make all the difference in a slide show presentation, and if you get a chance to see the pros show their work, you'll find they choose music that creates emotion and supports the images beautifully. Lightroom lets you add background music to your slide shows, and in Lightroom 3 you can even embed that music into slide shows you can save outside of Lightroom in multiple formats. More on that later, but for now, here's how to add background music to your slide shows.

Step One:

Go to the Playback panel at the bottom of the right side Panels area (shown here). Start by turning on the Soundtrack checkbox shown circled here in red, then click the Select Music button (as shown). A standard Open dialog will appear, where you choose which music file you want to play behind your slide show, so find your song and click Choose.

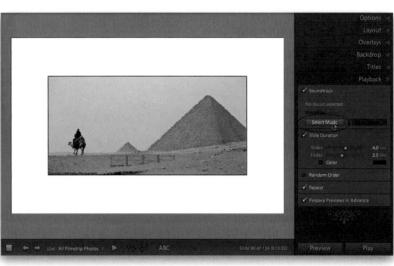

Note: Lightroom requires that your music file be in MP3 or AAC format, so it won't recognize WAV files. If you have Apple's iTunes, it can convert a music file to AAC format for you. In your Music Library, click on the song you want to convert, then go to iTunes' Advanced menu and choose **Create AAC Version**, and you'll see the converted version of your song appear directly below the original (these files are located in your iTunes folder in your Music folder).

Slideshow

t Web

	Playback 🔻
Soundtrack	
La Neige Dantans.mp3 Duration: 0:02:07 Select Music	Fit to Music
Slide Duration	
Slides Fades Color	26.8 sec 2.5 sec
Random Order	
Repeat	
Y Prepare Previews in A	dvance

IBRARY	4	n Music M	lovies 👘 🦾	V Shows App St	ore Podcasts	Aud	licbooks	Sign In
Movies Tv Shows Podcasts Goods Apps Arganose Xradio	ġ.		Scott's I Average Retro (Di voles) Teak 6 song 56.24		RATINO **** **** *** *** *** ***		IIX NOTES is a the collection of some revinced in my book, that background music behave designed. It's work change designed they were change designed they were change designed they were change designed they were change designed to be an an an an an an estimate of the source of the publicity to the weat TELL A PRIEND	of musical to not get to 'emi:-)
Tunes Store							HOW DO I MAKE AN IMIX?	
Purchased	C						HOW DO I MAKE AN IMIX?	
Purchased	A Nar	ne	Tim	e Artist	Album	10	HOW DO I MAKE AN IMIX?	
Purchased SHARED	A Nar 1 Aria			e Artist 3 Acoustic Alchemy (Price	
B Purchased SHARED GENIUS	1 Aria		O 4:5 O 5:0	Acoustic Alchemy	The Very Best of		Price \$0.99 RUY SONG \$0.99 AUT SONG	
Purchased SHARED GENIUS Senius	1 Aria 2 Hea 3 Whi	ane art of a Child ipping the Horse's Eyes	O 4:5 O 5:0 O 1:2	Acoustic Alchemy Jon Schmidt Calexico	The Very Best of August End Feast of Wire	Acoust C	Price 50.99 Rev Sonc 50.99 Aut Sonc 50.99 Rev Sonc	
SHARED GENIUS	1 Aria 2 Hea 3 Whi 4 Farr	ane art of a Child ipping the Horse's Eyes nily Portrait	O 4:5 O 5:0 O 1:2 O 5:4	Acoustic Alchemy Jon Schmidt Calexico Rachel's	The Very Best of August End Feast of Wire Music for Egon S	Acoust C	Price 50.99 BUY SONG 50.99 BUY SONG 50.99 BUY SONG 50.99 BUY SONG 50.99 BUY SONG	
Purchased SHARED GENIUS Genius Genius Mixes	1 Aria 2 Hea 3 Whi 4 Farr 5 The	ane art of a Child ipping the Horse's Eyes nily Portrait e Great Wall	O 4:5 O 5:0 O 1:2 O 5:4 O 4:4	3 Acoustic Alchemy 7 Jon Schmidt 4 Calexico 1 Rachel's 5 David Arkenstone	 The Very Best of August End Feast of Wire Music for Egon S Citizen of Time 	Acoust C	Price 1 50.99 RUY SONC 2 50.99 RUY SONC 3 50.99 RUY SONC 3 50.99 RUY SONC 3 50.99 RUY SONC 3 51.99 RUY SONC 3 51.99 RUY SONC 3 51.29 RUY SONC	
Purchased ► SHARED ▼ GENIUS Strain Genius	1 Aria 2 Hea 3 Whi 4 Farr 5 The	ane art of a Child ipping the Horse's Eyes nily Portrait	O 4:5 O 5:0 O 1:2 O 5:4 O 4:4	Acoustic Alchemy Jon Schmidt Calexico Rachel's	The Very Best of August End Feast of Wire Music for Egon S Citizen of Time	Acoust C	Price 1 50.99 Rev Sonc. 2 50.99 Rev Sonc. 3 50.99 Rev Sonc. 3 50.99 Rev Sonc. 3 51.99 Rev Sonc. 3 51.99 Rev Sonc. 3 51.99 Rev Sonc. 3 51.29 Rev Sonc.	

000

Step Two:

Now when you start your slide show (or even just preview it in the Preview area), the background music will play behind it. If you want to automatically have Lightroom adjust the length of your slide show so it matches the length of the song you chose, just click the Fit to Music button (as shown here). What this actually does is adjusts the duration and fade time of your slides, based on how long the song is (so basically, it does the math for you).

BONUS TIP: Background Music Ideas I put together an iTunes iMix with some great slide show background music for you. You get a 30-second preview of each song, and if you find one you like, you can buy it right on the spot from Apple (I don't get a commission, kickback, etc., I just know how hard it is to find great background music, so thought you might find this handy). To get to my iMix, launch your Web browser and type in this address: http://phobos.apple.com/WebObjects/ MZStore.woa/wa/viewPublishedPlaylist ?id=222715, or just go to the iTunes Music Store, click on iMix under More to Explore at the bottom right of the page, and then search for my iMix by its name, "Scott's Slideshow Mix."

Choosing Your Slide Duration and Fade Length

Besides choosing your music, Lightroom's Playback panel in the Slideshow module is where you choose how long each slide stays onscreen, how long the transition (fade) between slides is, and even the color of the transition. You can choose to play your slides in order or randomly, whether you want your slide show to repeat after your last slide or end at the last slide, and if you want your previews prepared in advance, so that your slide show doesn't get interrupted waiting for image data to render to the display.

Step One:

To choose how long your slides stay onscreen, go to the Playback panel, turn on the Slide Duration checkbox, then choose how many seconds each image should appear onscreen (using the Slides slider), and how long the fade transition between images should last (using the Fades slider). We're going to skip over the fade color for now, so there are just three other controls to mention: (1) By default, your slides play in the order they appear in the Filmstrip, unless you turn on the Random Order checkbox. (2) Also by default, when you reach the last slide in the Filmstrip, your slide show will loop around and play the whole thing again (and again, and again), unless you turn off the Repeat checkbox. And lastly (3), with the Prepare Previews in Advance checkbox turned on, your previews will be prepared in advance, so your slide show won't get interrupted waiting for image data to render to the display.

Step Two:

Now, back to the fade color, where you choose the color of the dissolve transition between slides. By default, your slide fades to black before the next slide appears (which looks very natural, since we're all used to seeing that). If you decide you want unnatural-looking transitions (hey, it could happen), turn on the Color checkbox, then click on the color swatch to its right, and a color picker pops up where you can choose a different solid color (in this example, your slide would briefly fade to a bluish purple before the next slide appears. Hey, I told you it was unnatural).

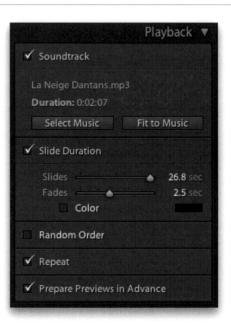

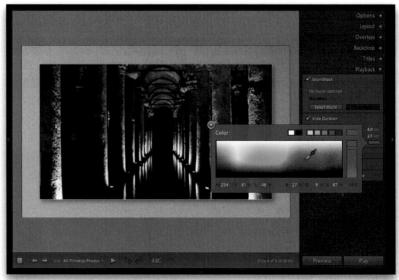

Web

If you want to show someone your slide show and they happen to be nearby, then no sweat—you can show it right within Lightroom. But if they're not standing nearby (perhaps it's a client across town or across the country), you can output your slide show in a number of different formats, like Windows Movie Format, QuickTime, Flash, and H.264, and these'll include your images, layout, background music, and transitions. Sweet! You can also save your slide show in PDF format, but if you do, sadly, it won't include your background music.

Sharing Your Slide Show

Ibrary Develop Sideshow Print Web Preview Options Option Option Option Opti

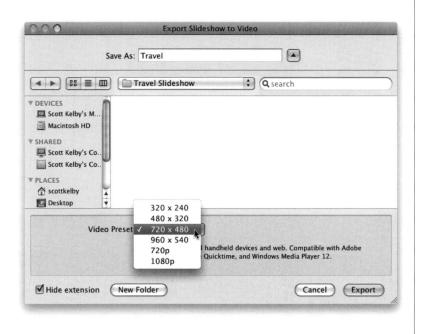

Step One:

To save your slide show in a video format (with background music), click on the Export Video button at the bottom of the left side Panels area (as shown here).

Step Two:

This brings up the Export Slideshow to Video dialog (shown here), where there's a Video Preset pop-up menu listing different sizes for your video. When you choose a preset size, it tells you right below the menu what that size works best for, and what type of devices (or software) will read the file. So, name your slide show, and then just choose the size you want, then click the Export (PC: Save) button and it creates the file for you, in the size you choose, and in a compatible format for that type of video.

Step Three:

The other export option is to save your slide show in PDF format. PDF is ideal for emailing because it compresses the file size big time, but of course the downside is that it doesn't include any background music you've added, which is a deal breaker for a lot of users. If that's not an issue for you, then it's worth considering. Just click the Export PDF button at the bottom of the left side Panels area, to bring up the Export Slideshow to PDF dialog (shown here). Go ahead and name your slide show, then at the bottom of the dialog, you'll see the Quality slider-the higher the quality, the larger the file size (which is a consideration when emailing). I usually use a Quality setting of 80 and I also always turn on the Automatically Show Full Screen checkbox, so the recipient can see the slide show without any other onscreen distractions. The width and height dimensions are automatically inserted in the Width and Height fields, but if you need the images to be smaller for emailing, you can enter smaller settings and Lightroom will automatically scale the photos down proportionally. When you're done, click the Export (PC: Save) button (as shown here).

Step Four:

When your client (friend, relative, parole officer, etc.) double-clicks on your PDF, it will launch their Adobe Reader, and when it opens, it will go into full-screen mode and start your slide show, complete with smooth transitions between slides.

TIP: Adding Filenames to a PDF

If you're planning on sending this PDF slide show to a client for proofing purposes, be sure to go to the Slideshow module first and make the filename text overlay visible before you make the PDF. That way, your client will be able to tell you the name of the photo(s) they've approved.

000	Export Slideshow to PDF	
Save	As: Egypt and Greece	
	Travel Slideshow	
DEVICES Scott Kelby's M Macintosh HD StARED Scott Kelby's Co Scott Kelby's Co PLACES A scottkelby		
Qua	ity: 80 Width:	2400
	Automatically show full screen Height:	2400
	Common sizes: Other	•
No	es: Adobe Acrobat transitions use a fixed speed. Music is not saved in PDF Slideshows.	

brarv Deve

Slideshow

- Web

Lightroom Killer Tips > >

One of my biggest slide show complaints about Lightroom 1 was that when you started your slide show, the person viewing it always saw the first slide onscreen before the slide show even started (so, if you're showing a bride and groom the photos from their wedding, when they sit down, they see the first image onscreen, without any music, any drama, etc., which totally kills any emotional impact). You saw earlier in this chapter that you can have opening and closing title slides in Lightroom now, right? So, go ahead and set up a title slide (or just leave it black, but turn on the title slide feature in the Titles panel). Now, here's the tip: When you make a slide show presentation for a client, before the client is in front of your monitor, start the slide show, and as soon as it appears onscreen, press the Spacebar to pause it. Now when your client sits in front of your screen, they don't see your first photo-they see a black screen (or your title screen). When you're ready to begin your presentation, press the Spacebar again and your slide show starts.

▼ Detailed Slide Design Although you can create your slide shows from scratch in Lightroom, there's nothing that says that you have to design your slides in Lightroom. If there are things you want to do that you can't do in Lightroom, just build the slides over in Photoshop, save them as JPEGs, then re-import the finished slides into Lightroom, and drop those into your slide show layout, add your background music, etc.

Preview How Photos Will Look in Your Slide Show

On the far-right side of the toolbar that appears under the center Preview area, you'll see some text showing how many photos are in your current collection. If you move your cursor over that text, your cursor turns into a scrubby slider, and you can click-and-drag left or right to see the other photos in your slide

Slide 1291216 (0.01:50)

show appear in your current slide show layout (it's one of those things you have to try, and then you'll dig it).

▼ What Those Rotate Arrows Are For

If you look down in the toolbar, you'll see two rotation arrows, but they're always grayed out. That's because they're not for rotating photos, they're for rotating any custom text you create (you add custom text by clicking on the ABC button in the toolbar).

Collections Remember Which Template You Used Last

The Collections panel also appears in the Slideshow module (which you learned about in this chapter), but these collections have memorythey automatically remember the last slide show template you used for the photos in that collection. However, they don't remember the exact photos you used-they just remember the template itself, so your layout looks the same, but if you originally selected just a few photos in that collection for your slide show (and changed the Use pop-up menu to Selected Photos in the toolbar at the bottom of the Preview area), they don't remember those. So, you'll want to Right-click on the collection, and choose Create Slideshow from the pop-up menu. This creates a new collection with just the photos you used in that particular slide show, in the right order, along with the template, so when you want that exact same slide show again (same look, same photos, same order), you're one click away.

Chapter 11 Printing Your Photos

The Big Print printing your photos

Remember back in the black & white chapter, when I told you how important it was that you make a black & white print for your street cred as a photographer? That's because most of what we do today after we press the shutter button happens on a computer screen. Let's put this in perspective: It takes us 1/2000 of a second to take the shot, but then we spend 10 minutes in Lightroom processing the image, so the majority of our work takes place after the photo is taken. However, in real life, when we talk about a photo, your average person thinks of the 1/2000 of a second part of the photograph much more than they do the 10 minutes we spent on the computer balancing, sharpening, dodging and burning, etc., part. So, to them, the 1/2000 of a second part is the "real" part and the rest they (thankfully) don't really think that much about. So, when

you show them a picture onscreen, it kind of reminds them that this is all software based. because your image is trapped inside a computer screen, and images in a Web gallery are in "a cloud," so they aren't real. To most nonphotographers, an image becomes "real" when you make a print. Otherwise it's just some manipulated image on a computer. Think about it. So, you are kind of like a modernday Dr. Frankenstein, in that you have created this thing, but you need to flip a switch (the printing switch), to give your creation life. Now, when you print, it's not entirely necessary to look toward the heavens, laugh an evil laugh, and yell, "It's alive!" but I can tell you that most of the pro photographers I know do exactly that (but you also should know that they generally wait to do all their printing on a dark, stormy night). Now you know.

Printing Individual Photos

If you really like everything else in Lightroom, it's the Print module where you'll fall deeply in love. It's really brilliantly designed (I've never worked with any program that had a better, easier, and more functional printing feature than this). The built-in templates make the printing process not only easy, but also fun (plus, they make a great starting point for customizing and saving your own templates).

Step One:

Before you do anything in the Print module, click on the Page Setup button at the bottom left, and choose your paper size (so you won't have to resize your layout once it's all in place). Now, start in the Template Browser (in the left side Panels area) by clicking on the Fine Art Mat template. The layout you see here should appear, displaying the first photo in your current collection (unless you have a photo selected—then it shows that one). By the way, there's a Collections panel here, too, so if you want to change collections, you can do so in the left side Panels area. A few lines of info appear over the top-left corner of your photo. It doesn't actually print on the photo itself, but if you find it distracting, you can turn this off by pressing the letter I on your keyboard, or going under the View menu and choosing Show Info Overlay.

Step Two:

If you want to print more than one photo using this same template, go down to the Filmstrip and Command-click (PC: Ctrl-click) on the photos you want to print, and it instantly adds as many pages as you need (here, I've only selected one photo, but if I had selected 26, you'd see Page 1 of 26 down in the toolbar). There are three Layout Styles (in the Layout Style panel at the top right), and this first one is called Single Image/ Contact Sheet. This works by putting each photo in a cell you can resize. To see this photo's cell, go to the Guides panel and turn on the Show Guides checkbox. Now you can see the page margins (in light gray), and your image cell (outlined in black, as seen here).

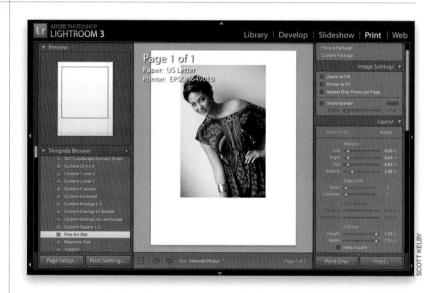

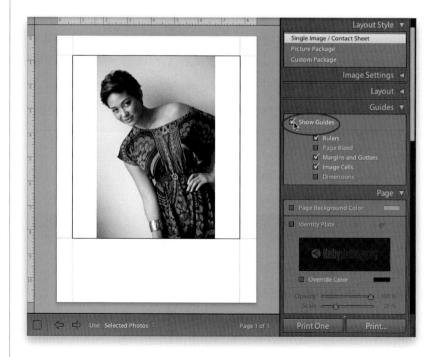

Print

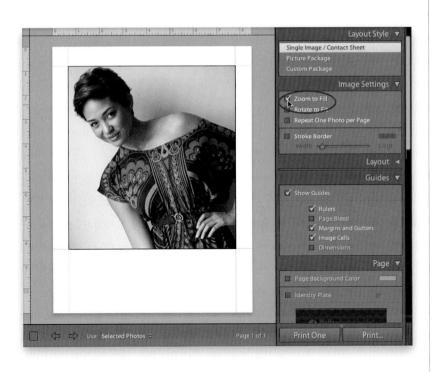

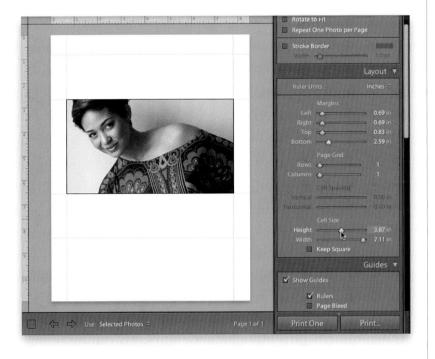

Step Three:

If you look back at the layout in Step Two, did you notice that the image fit the cell top-to-bottom, but there was a gap on either side? That's because, by default, it tries to fit your image in that cell so the entire image is visible. If you want to fill the cell with your photo, go to the Image Settings panel and turn on the Zoom to Fill checkbox (as shown here), and now your image fills it up (as seen). Now, of course, this crops the image a bit, too (well, at least with this layout it did). This Zoom to Fill feature was designed to help you make contact sheets, but as we go through this chapter, I bet you'll totally start to love this little checkbox, because with it you can create some really slick layouts—ones your clients will love. So, even though it does crop the photo a bit, don't dismiss this puppy yet—it's going to get really useful very soon.

Step Four:

Now, let's work on the whole cell concept, because if you "get" this, the rest is easy. First, because your image is inside a cell and you have the Zoom to Fill checkbox turned on, if you change the size of your cell, the size of your photo doesn't change. So, if you make the cell smaller, it crops off part of your image, which is really handy when you're making layouts. To see what I mean, go to the Layout panel, and at the bottom of the panel are the Cell Size sliders. Drag the Height slider to the left (down to 3.87 in), and look at how the top and the bottom of the cell shrink inward, kind of giving you a "letter box" view of your image (HD movie buffs will totally get that analogy).

Continued

Step Five:

Now drag the Height slider back to the right, kind of where it was before, then drag the Width slider to the left to shrink the width. This particular photo is tall (in portrait orientation), so moving the top and bottom of the cell just crops things down, but when you drag the Width slider like we are here, it starts to shrink the entire image size down right away, until it reaches its original unzoomed width, then the sides of the cell move inward without changing the size further (this will all make sense in a minute). See how the left and right sides of your cell have moved in, creating the tall, thin cell you see here? This tall, thin layout is actually kind of cool on some level (well, it's one you don't see every day, right?), but the problem is that most of her face is off the left side of the frame. We can fix that.

Step Six:

One of my favorite things about using these cell layouts is that you can reposition your image inside the cell. Just move your cursor over the cell, and your cursor turns into the Hand tool. Now just click-anddrag the image inside the cell to the position you want it. In this case, I just slid the photo over to the right a bit until her face was nearly in the center.

Step Seven:

At the bottom of the Cell Size section is a checkbox called "Keep Square." Go ahead and turn on this checkbox, which sets your Height and Width to the exact same size, and now they move together as one unit (since it's perfectly square). Let's try a different way of resizing the cell: clickand-drag the cell borders themselves, right on the layout in the Preview area. You see those vertical and horizontal lines extending across and up/down the page showing the boundaries of your cell? You can clickand-drag directly on them, so go ahead and give it a try. Here, I'm clicking on the top horizontal guide (shown circled here in red), and dragging downward to shrink my square cell (and the photo inside it). So, by now you've probably realized that the cell is like a window into your photo.

TIP: Rotating Images

If you have a tall photo in a wide cell (or on a wide page), you can make your photo fill as much of that page as possible by going to the Image Settings panel, and turning on the Rotate to Fit checkbox.

Step Eight:

Let's finish this one off with one of my favorite new printing features in Lightroom 3: the ability to change the color of your page background. To do this, just go to the Page panel, turn on the Page Background Color checkbox, and click the color swatch to the right of it to bring up the Page Background Color picker (seen here). In this case, I'm choosing a dark gray, but you can choose any color you'd like (black, blue, red—you name it), then close the color picker. Also, you can put a stroke around your image cell by going up to the Image Settings panel, turning on the checkbox for Stroke Border, then choosing a color (just click on the color swatch), and choosing how thick you want your stroke using the Width slider.

Creating Multi-Photo Contact Sheets

The reason you jumped through all those hoops just to print one photo was because the whole Single Image/Contact Sheet was really designed for you to have quick access to multi-photo layouts and contact sheets, which is where this all gets really fun. We're picking up here, with the same set of photos, to show you how easy it is to create really interesting multi-photo layouts that clients just love!

Step One:

Start by clicking on any of the multi-photo templates that come with Lightroom 3 (if you hover your cursor over any of the templates in the Template Browser, a preview of the layout will appear in the Preview panel at the top of the left side Panels area). For example, click on the 2x2 Cells template, and it puts your selected photos in two columns and two rows (as shown here). Here, I selected nine photos, and if you look at the right end of the toolbar, you'll see Lightroom will make three prints, though only two will have four photos each-the last print will just have that one leftover photo. The layout you see here doesn't look that good, because we're mixing tall photos with a horizontal photo, but we can fix that.

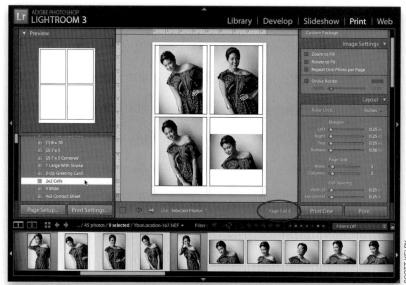

Step Two:

Of course, just printing all your tall photos on a page with tall cells, and then creating a second template with wide cells, would fix this, but an easier way is to go to the Image Settings panel and turn on the Zoom to Fill checkbox (as shown here). This zooms all the images up to fill the cells, so that wide photo in the bottom-right corner zooms in, and how it fills the cell looks uniform (as seen here). Plus, you can reposition the images in their cells by clicking-anddragging them. However, turning on Zoom to Fill cropped a tiny bit off of the three tall shots, and quite a bit off the wide shot, changing the whole look of the photo (luckily, there is a way around this, too).

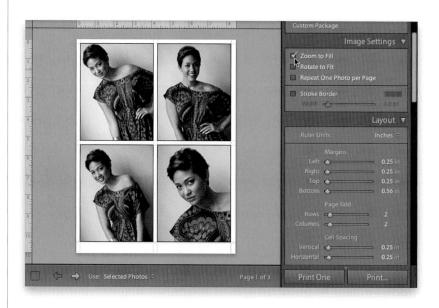

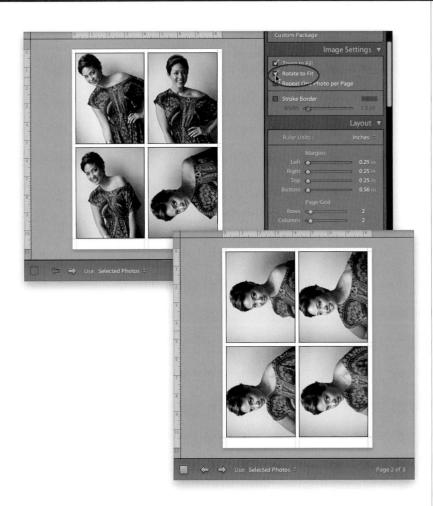

Step Three:

What you need is a way to print the tall images and the wide image at nearly full size, without much cropping. The trick is to turn on the Rotate to Fit checkbox (shown circled here in red, in the Image Settings panel), which rotates the wide photo so it best fills the tall cell (as seen here at the top, where the bottom-right image is a wide photo, but now it's turned sideways to fit in the cell as large as possible. When you turn on Rotate to Fit, it applies that to all your pages, so if you have other wide photos on other pages, it will rotate them, as well (as seen in the bottom graphic here, showing the second page of photos, and they're all rotated sideways. To see your other pages, click on the Right Arrow button on the left side of the toolbar).

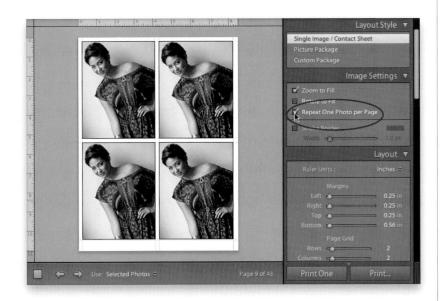

Step Four:

If you want to print the same photo, at the same exact size, multiple times on the same page, then you can go to the Image Settings panel and turn on the checkbox for Repeat One Photo per Page, as shown here. If you want to print the same photo multiple times on the same page, but you want them to be different sizes (like one 5x7" and four wallet-size photos), then turn to page 342 for details on how to set that up.

Step Five:

If you click on a different multi-photo layout, like the 4x5 Contact Sheet (as shown here), your photos instantly adjust to the new layout. Once nice feature of this template is that the names of your images appear directly below each image. If you want to turn this feature off, go to the Page panel, and near the bottom of the panel, turn off the Photo Info checkbox. By the way, when you have this checkbox turned on, you can choose other text to appear under your images from the popup menu to the right of the words Photo Info. Once again, because I was mixing tall and wide photos, the layout looked a little funky, so I turned on the Zoom to Fill checkbox, but of course, that's totally optional-if you don't want your images cropped, then you should leave Zoom to Fill turned off.

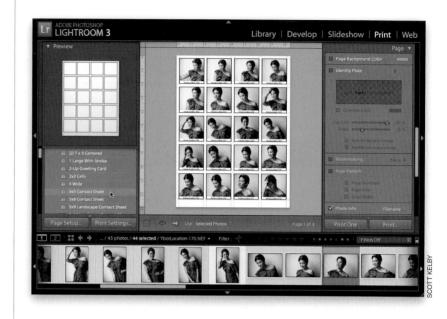

Step Six:

So far, we've been using Lightroom's built-in templates, but half the fun of this process is building your own, and it's surprisingly easy, as long as you don't mind having all your cells being the same exact size, which is the limitation of using the Single Image/Contact Sheet type of layout. You can't have one photo that's square, and two that are rectangular. They're either all square or all rectangular, but don't worry, we'll tackle how to create multiple photos at any size you want a little later. For now, we'll use this contact sheet power to create some cool layouts. Start by selecting some photos (eight or nine should be fine), then click on the template called "Maximize Size," as shown here (it's a decent starting place for building your own templates). Since we're going to be adding photos, I turned off the Rotate to Fit checkbox (it's on by default in this template) in the Image Settings panel.

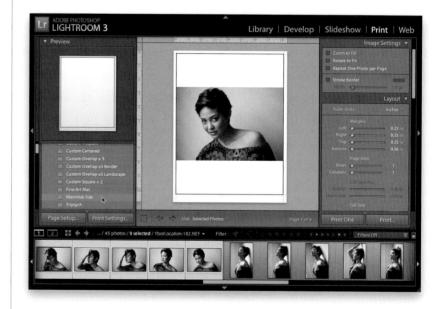

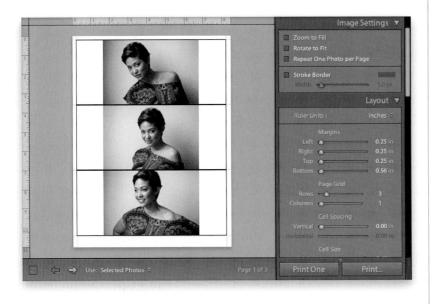

Step Seven:

You create custom multi-photo layouts in the Layout panel. There's a Page Grid section, which is where you pick how many rows and columns you want in your layout, so start by dragging the Rows slider over to 3, so you get three photos in a row (like you see here). You'll notice that the three photos are stacked one on top of another with no space between them. (Note: The black lines you see around the cells are just guides, so you can easily see where the cell borders are. You can get rid of these in the Guides panel by turning off the Image Cells checkbox. I usually leave these off, because you can still see the cell borders in light gray, as you'll see in the next step, where I have those black Image Cell borders turned off.)

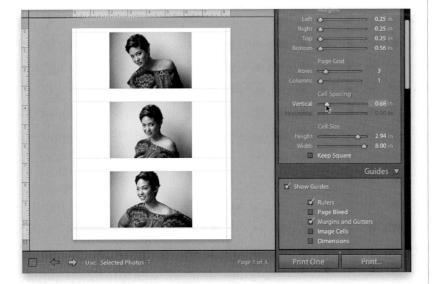

Step Eight:

To create some vertical space between your photos, go to the Cell Spacing section and click-and-drag the Vertical slider to the right (as shown here, where I dragged it over to 0.68 in to put a little more than a half-inch of space between the photos). Now let's take things up a notch.

Continued

Step Nine:

Now go to the Page Grid sliders and increase the Columns to 3, so now you have this layout of three columns wide by three rows deep. Of course, since the default setting is to not have any space between photos, the columns of photos don't have any space between them horizontally.

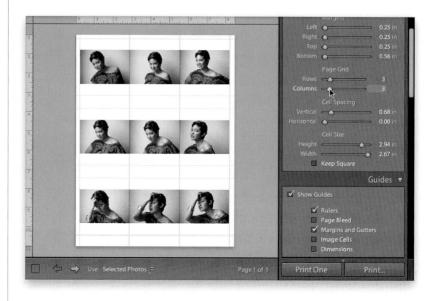

Step 10:

You add space between the photos in columns by going to the Cell Spacing section, and clicking-and-dragging the Horizontal slider to the right (as shown here). Now that you've got space between your columns, take a look at the page margins. There's lots of space at the top and bottom, and just a little bit of space on the sides of the page.

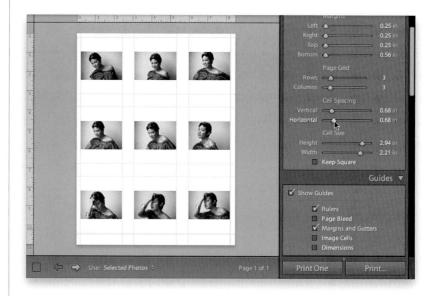

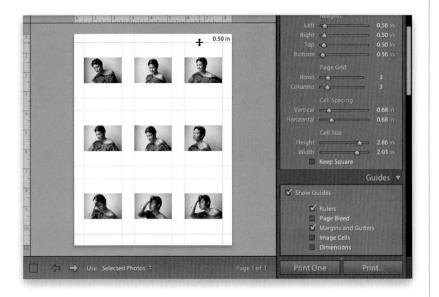

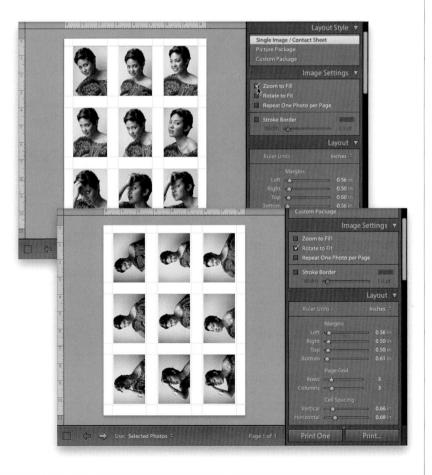

Step 11:

Although you can drag the Margins sliders to adjust the page margins (right there in the Layout panel), you can also just click directly on the margins themselves and drag them (as shown here). Here, I clicked-and-dragged the top, bottom, and side margins in to where they were about a half-inch from the edge of the page.

Step 12:

If you look back in the image shown in Step 11, you can see your images are all wide, but they're in tall cells. To get the images larger, you can go back up to the Image Settings panel and either: (a) turn on the Zoom to Fill checkbox (as shown here at the top) to fill the cells with your images (don't forget, you can reposition your images inside those cells by just clicking-and-dragging on them), or (b) turn on the Rotate to Fit checkbox, in which case, all the photos would be turned on their sides so they fit larger in the cells you've created (seen here at the bottom).

Continued

Step 13:

Let's wrap this section up with a few examples of cool layouts you can create using these Contact Sheet style layouts (all based on an 8.5x11" page size, which you can choose by clicking the Page Setup button at the bottom of the left side Panels area). Start by going up to the Image Settings panel and turning on the Zoom to Fill checkbox. Now, go to the Lavout panel, under Page Grid, then change the number of Rows to 1 and the number of Columns to 3. Under Cell Size, turn off the Keep Square checkbox. Drag the Left, Right, and Top Margins sliders to around 0.75 in, and set the Bottom Margins slider to 2.75 in (to leave lots of room for your Identity Plate). Now, jump down to the Cell Size, and for the Height, drag it to around 7.50 in, and set the Width at only around 2.20 in, which gives you very tall. narrow cells (as shown here). Now, select three photos and turn on the Identity Plate feature (in the Page panel), make it larger, and click-and-drag it so it's centered below your images, giving you the look you see here (I also turned off the Show Guides checkbox to get rid of the distracting guides).

Step 14:

Now let's create four panorama layouts in one photo (you don't need to use real panos-this creates fake panos instantly from any photo you select). Start by setting your Rows to 4 and Columns to 1. Then set your Left and Right Margins to 0.50 in, and set the Top to around 0.75 in or 0.80 in. Set your Bottom margin to 1.50 in. Make sure the Keep Square checkbox is turned off (under Cell Size), then increase your Cell Size Width to 7.33 in, and your Cell Size Height to 1.83 in to give you thin, wide cells. Now, set the space between your fake panos using the Vertical slider (set it to around 0.50) to give you the layout you see here. I went and clicked on four travel photos, and got the instant pano layout you see here.

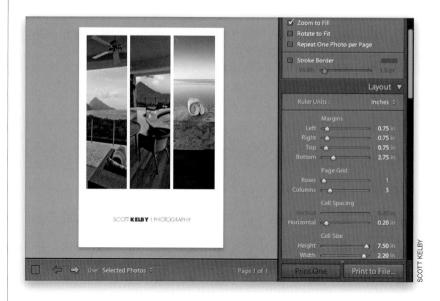

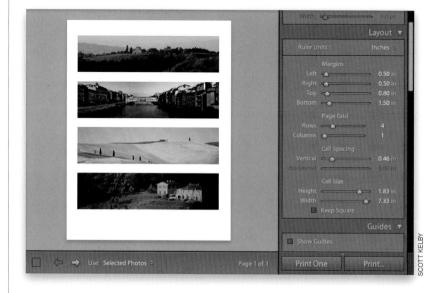

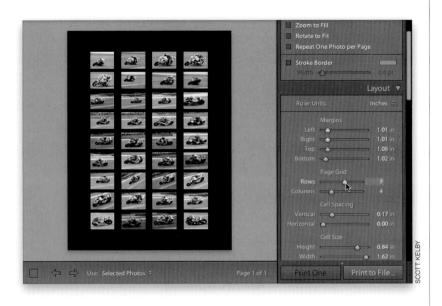

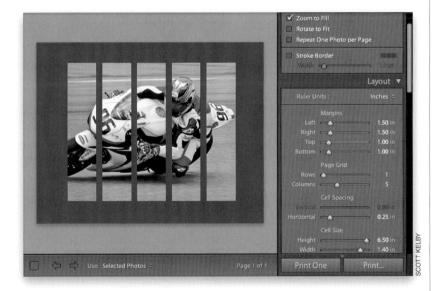

Step 15:

How about a poster, on black, with 36 wide images? Easy. Start by creating a collection made up of only wide images. Then go to the Image Settings panel and turn off the Zoom to Fill checkbox. Go to the Layout panel and set a 1-inch margin all the way around the page, using the Margins sliders. Now, set your Page Grid to 9 Rows (as shown here), and 4 Columns, so you have four tall columns like you see here. Keep your Horizontal Cell Spacing at 0 in, then put just enough Vertical Cell Spacing to make the space between the photos about half the size of the horizontal spacing. Lastly, head down to the Page panel, turn on the checkbox for Page Background Color, then click on the color swatch to the right of it, and choose black for your background color.

Step 16:

Okay, this one's kinda wild—one photo split into five separate thin vertical cells. Here's how it's done: You start by clicking the Page Setup button (at the bottom left), and set your page to be Landscape orientation. Then Right-click on a photo in the Filmstrip and choose Create Virtual Copy. You need to do this three more times, so you have a total of five copies of your photo. Now, in the Image Settings panel, turn on Zoom to Fill, then in the Layout panel, set your Margins to 1.50 in on the sides, and 1.00 in for the Top and Bottom. For your Page Grid, choose 1 Rows and 5 Columns. Add a little Horizontal Cell Spacing-around 0.25 in. Then set your Cell Size Height to 6.50 in, and the Width to only 1.40 in. In the Page panel, turn on the Page Background Color checkbox, click on the color swatch, and change your background color to dark gray. Select all five photos in the Filmstrip, then you'll click-and-drag each of the five images around inside their cells-dragging left and right—until they appear to be one single image (like you see here).

Creating Custom Layouts Any Way You Want them

In Lightroom 3, Adobe now gives you the option to break away from the structured cell layouts of previous versions, to create your own custom cell layouts in any size, shape, and placement, using a Print layout style called "Custom Package." Here's where you can create photos in any size and any layout you want, without being tied into a grid.

Step One:

Start up at the top in the Layout Style panel by clicking on Custom Package (we want to start from scratch, so if you see any cells already in place, go to the Cells panel and click the Clear Layout button at the bottom of the Add to Package section). There are two ways to get photos onto your page: The first is to go down to the Filmstrip and simply to drag-and-drop images right onto your page (as seen here). The image appears inside its own fully resizable cell, so you can just drag one of the corner handles to resize the image (the image you see here came in pretty small, so I resized it to nearly fill the bottom of the page). It will resize proportionally by default, but if you turn off the Lock to Photo Aspect Ratio checkbox (at the bottom of the Cells panel), then it acts like a regular cell with Zoom to Fill turned on, in that you can crop the photo using the cell. More on that in a minute.

Step Two:

Go ahead and hit the Clear Layout button, so you can try the other way to get your images into your layout, which is to create the cells first, arrange them where you want, then drag-and-drop your images into those cells. You do this by going to the Cells panel, and in the Add to Package section, just click on the size you want. For example, if you wanted to add a 3x7" cell, you'd just click on the 3x7 button (as shown here) and it creates an empty cell that size on the page. Now you can just click inside the cell and drag it anywhere you'd like on the page. Once it's where you like it, you can drag-and-drop a photo into that cell from the Filmstrip.

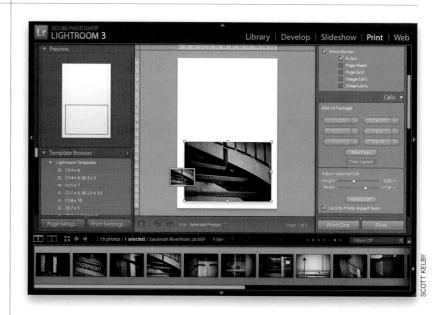

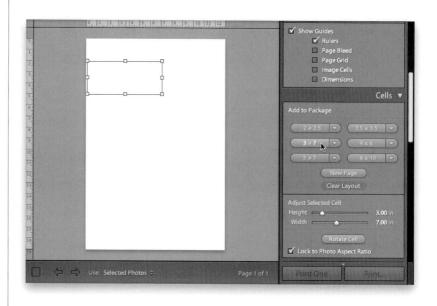

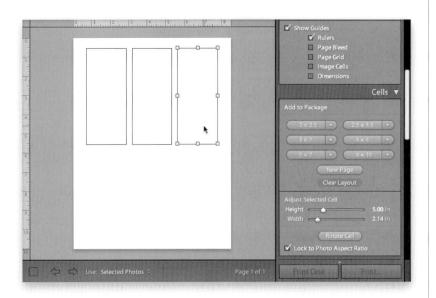

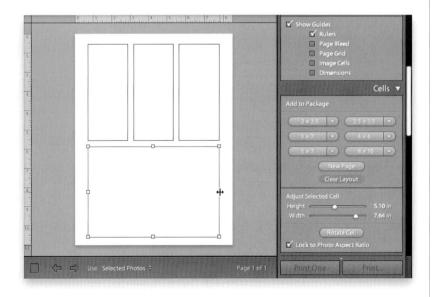

Step Three:

Let's go ahead and create a layout using these cell buttons, so hit the Clear Layout button to start from scratch again. Click the 3x7 button to add a long, thin cell to your layout, but then go down and click the Rotate Cell button to make this a tall, thin cell. This cell is actually pretty large on the page, but you can resize it by grabbing any of the handles, or going down to the Adjust Selected Cell sliders and choosing any size you'd like (in our case, shrink your Height to 5.00 in). Now, we need to make two more cells just like this one, and the quickest way to do that is just press-and-hold the Option (PC: Alt) key, then click inside the cell and drag to the right to make a copy. Do this twice until you have three cells, like you see here, and arrange them side by side, as shown (as you drag these cells, you'll feel a little snap. That's it snapping to an invisible alignment grid that's there to simply help you line things up. You can see the grid by going to the Rulers, Grid & Guides panel and turning on the checkboxes for Show Guides and Page Grid).

Step Four:

Next, let's add a larger photo to the bottom of our layout. Click the 4x6 button and it adds a larger cell to the layout, but it's not quite as wide as our three thin cells above, so just grab any point and drag until this cell is as wide as the three at the top of the page (as seen here). The layout's done, but before you start dragging-anddropping images, there are two things you need to change first: (1) because the cells at the top are tall and thin, you need to turn off the checkbox for Lock to Photo Aspect Ratio. Otherwise, when you dragand-drop photos into those thin cells, they will just expand to the full size of the photo.

Continued

The Adobe Photoshop Lightroom 3 Book for Digital Photographers

Step Five:

Now you're ready to start dragging-anddropping photos into your layout. If you drag one that doesn't look good in your layout, just drag another right over it. You can reposition your photo inside a smaller cell by pressing-and-holding the Command (PC: Ctrl) key, then just dragging the image left/right (or up/down), so just the part you want is showing.

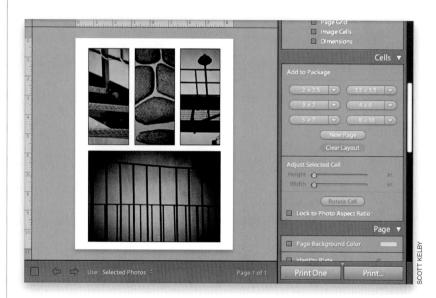

Step Six:

You can stack images so they overlap, almost like they're Photoshop layers. Let's start from scratch again, but first click the Page Setup button (at the bottom left), and turn your page orientation to Landscape. Now go back to the Cells panel, click the Clear Layout button, then click the 8x10 button, resize it so it's a wide image, and position it so it takes up most of the page (as shown here). Now, click the 2x2.5 button three times, make each cell a little wider (like the ones seen here), and position them so they overlap the main photo, as shown. Drag-and-drop photos on each cell. You can move the photos in front or behind each other by Right-clicking on the photo, and from the pop-up menu, choosing to send the photo back/forward one level or all the way to the bottom/top of the stack. If you want to add a white photo border around your images (like I have here), go up to the Image Settings panel and turn on the Photo Border checkbox. Also, when you're done, try switching your Page Orientation back to Portrait and see how that looks-you might be surprised. For example, I switched it, and thought it might make a good wedding book layout, so I swapped out the photos, rotated the small cells, then added a fourth small cell, and made the main photo a little thinner (as shown on the bottom left). It only took about 30 seconds. I also tried just rotating the three small cells and making the main photo fill the page (as shown on the bottom right).

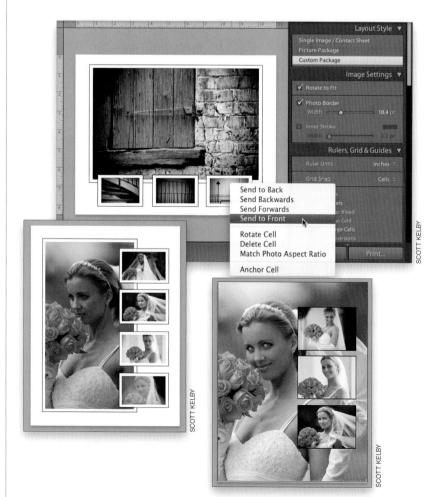

p Slideshow

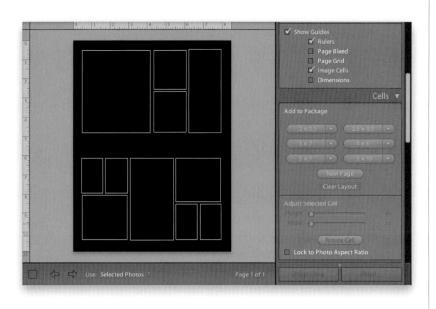

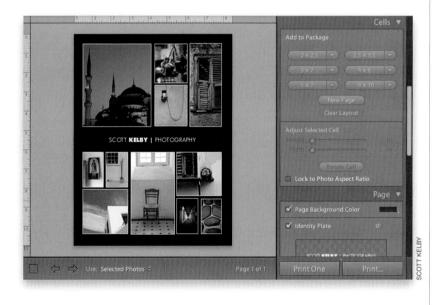

Step Seven:

Okay, let's start from scratch again and shoot for something pretty ambitious (well, as far as layouts go anyway). Clear your layout again, then go to the Page panel, turn on the checkbox for Page Background Color, click on the color swatch, and choose black as your background color. Now, make sure the Lock to Photo Aspect Ratio checkbox is turned off, then just go to the Cells panel and click the buttons to add a bunch of cells, and resize them so your layout looks kinda like what I have here, with a gap between the top and bottom set of images (so you can add your Identity Plate).

Step Eight:

Now, go ahead and drag-and-drop your photos into these cells. By the way, the thin white border you see around your cells is just there to show you where the cell borders are—those don't actually print in the final image. If you want a white stroke around your images, go up to the Image Settings panel and turn on the checkbox for Inner Stroke, then click on the color swatch to the right and set the color to white. For the image shown here, I switched to a collection of travel shots, then I dragged some of those images into the cells. Lastly, to have your studio name appear between the images, go to the Page panel and turn on the checkbox for Identity Plate, then turn on the Override Color checkbox, click on the color swatch and choose white as your Identity Plate color. You can drag your Identity Plate anywhere on the page, but for this layout, just drag it to the center and you're done.

Adding Text to Your Print Layouts

If you want to add text to your print layouts, it's pretty easy, as well, and like the Web and Slideshow modules, you can have Lightroom automatically pull metadata info from your photos and have it appear on the photo print, or you can add your own custom text (and/or Identity Plate) just as easily. Here's what you can add, and how you can add it:

Step One:

Select a photo, then choose the Fine Art Mat template in the Template Browser and turn on the Zoom to Fill checkbox. Now, the easiest way to add text to your print is to go to the Page panel and turn on the Identity Plate checkbox, and your nameplate appears on your print (jump back to Chapter 3 for how to set it up). Once it's there, you can click-and-drag it right where you want it (in this case, drag it down and position it in the center of the space below the photo, as shown here). Here's how I got two lines of text with different fonts (Trajan Pro on top; Minion Pro Italic on the bottom): Once you set the top row of text (I hit the spacebar once between each letter), then press Option-Return (PC: Alt-Enter) twice to move down two lines. Then, hit the Spacebar 20 times (to center the text) and type the second line. Then highlight everything under the first line, and change the font. It's a workaround, but it works.

Step Two:

Besides adding your Identity Plate, Lightroom can also pull text from your metadata (things like your exposure settings, camera make and model, the filename, or caption info you added in the Metadata panel of the Library module). You do this in the Page panel by turning on the Photo Info checkbox and choosing which type of info you want displayed at the bottom of your cell from the pop-up menu on the right (as shown here). You can change the size of your text right below it, but the largest size is 16 points, and on a large print, it's pretty tiny.

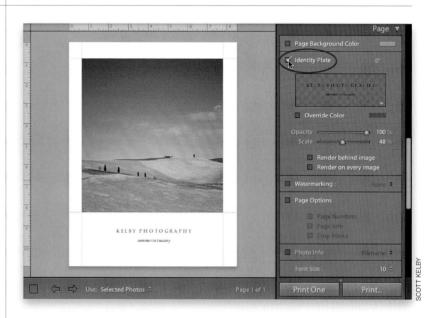

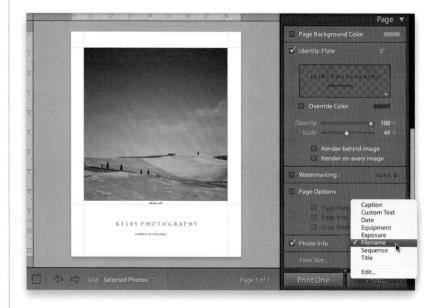

Preset:	Custom Text (edited)		
Example:	Asciano-45 1/200 sec at f /	16 ISO 200 92 mm	
Filenan Focal L		60 Speed Rating 🕗	
Image Name	2		
	Filename	insert	
	Original filename	t Insert	
Numbering			
	(Image # (1)	insert	
	Date (YYYY)	t Insert	
EXIF Data			
	Exposure	(Insert	
	ISO Speed Rating	(Insert	
	Focal Length	Insert	
IPTC Data			
	Title	\$ Insert	
	Caption	insert	
	Copyright	insert	
Custom			
	Custom Text	Insert	

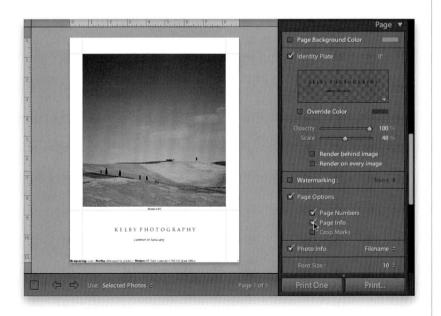

Step Three:

Now, besides just pulling the filename and metadata stuff, you can also create your own custom text (but it's going to show up at the bottom of the cell and this text is stuck there—you can't reposition it like you can the Identity Plate text, which is why I usually use that instead). If you choose Custom Text from the Photo Info pop-up menu, a field appears below it, so you can type in your custom text. You can also choose Edit from that same pop-up menu to bring up the Text Template Editor (shown here), where you can create your own custom list of data that Lightroom will pull from each photo's metadata and print under that photo. In this case, I chose to add text showing the filename, exposure, ISO, and the focal length of the lens by clicking the Insert button beside each of these fields in the Editor or choosing them from the pop-up menus. I can't imagine why anyone would want that type of information printed beneath the photo. But you know, and I know, there's somebody out there right now reading this and thinking, "All right! Now I can put the EXIF camera data right on the print!" The world needs these people.

Step Four:

If you're printing pages for a photo book, you can have Lightroom automatically number those pages. In the Overlays panel, turn on the Page Options checkbox, then turn on the checkbox for Page Numbers. Lastly, if you're doing a series of test prints, you can have your print settings (including your level of sharpening, your color management profile, and your selected printer) appear on the bottom-left side of the print (as seen here) by turning on the Page Info checkbox.

Printing Multiple Photos on One Page

You saw earlier in this chapter how to print the same photo, at the same exact size, multiple times on the same print. But what if you want to print the same photo at different sizes (like a 5x7" and four wallet sizes)? That's when you want to use Lightroom's Picture Package feature.

Step One:

Start by clicking on the photo you want to have appear multiple times, in multiple sizes, on the same page. Go to the Template Browser in the left side Panels area and click on the built-in template named (1) 4x6, (6) 2x3, which gives you the layout you see here. If you look over in the Layout Style panel at the top of the right side Panels area, you'll see that the selected style is Picture Package (as seen circled here in red).

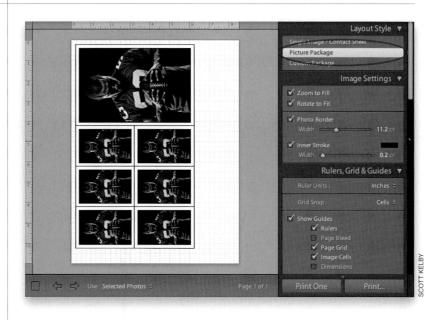

Step Two:

If you look at the Preview area in Step One, you can see that, by default, it puts a little white border around each photo. If you don't want the white border, go to the Image Settings panel and turn off the Photo Border checkbox (as shown here). Also, by default, the Zoom to Fill checkbox is turned on, so your photo is cropped in a little bit. If you don't want your photo cropped like that, turn the Zoom to Fill checkbox off.

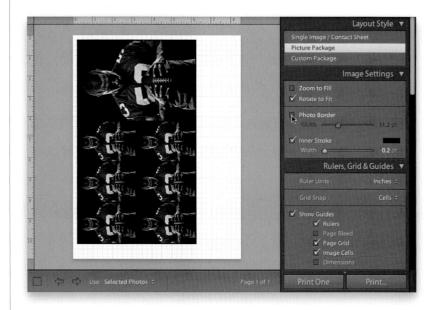

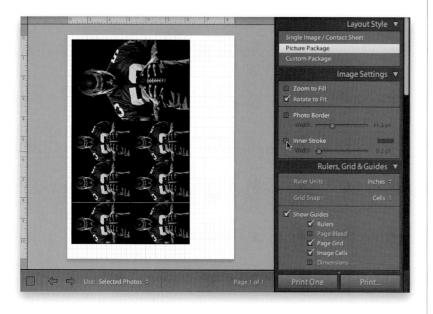

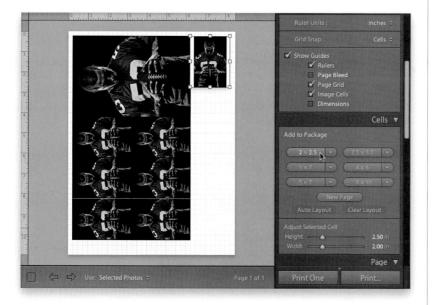

Step Three:

Another option it has on by default is that it puts a black stroke around each image (you can control the size of this stroke, using the Width slider right below the Inner Stroke checkbox). To remove this stroke, turn off the Inner Stroke checkbox (as shown here. You'll still see a thin stroke that separates the images, but does not print). Now your images are back to their original cropping, they're right up against each other (there's no extra white border), and you've removed the black stroke around the photos (by the way, if you like this layout, don't forget to save it as your own custom template by clicking on the + [plus sign] button on the right side of the Template Browser header).

Step Four:

Adding more photos is easy—just go to the Cells panel (in the right side Panels area) and you'll see a number of pillshaped buttons marked with different sizes. Just click on any one of those to add a photo that size to your layout (I clicked on the 2x2.5 button, and it added the new cell you see selected here). So, that's the routine: you click on those buttons to add more photos to your Picture Package layout. To delete a cell, just click on it, then press the Delete (PC: Backspace) key on your keyboard.

Continued

Step Five:

If you want to create your own custom Picture Package layout from scratch, go to the Cells panels and click on the Clear Layout button (as shown here), which removes all the cells, so you can start from scratch.

Step Six:

Now you can just start clicking on sizes, and Lightroom will place them on the page each time you click one of those Add to Package buttons (as shown here). As you can see, it doesn't always place the photos in the optimum location for the page dimensions, but Lightroom can actually fix that for you.

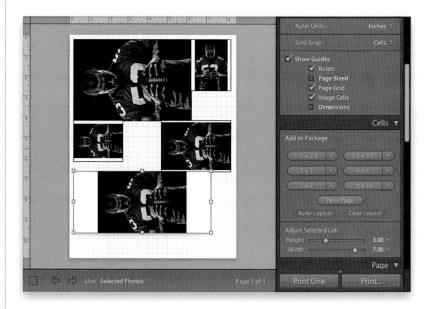

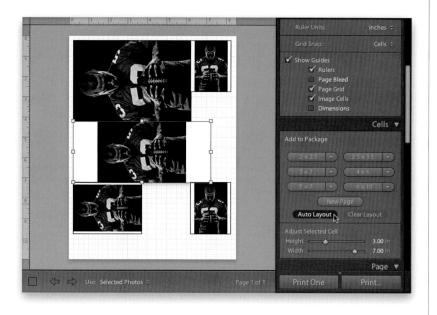

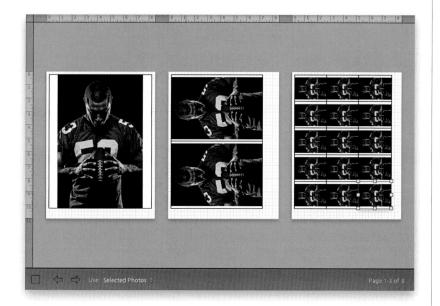

Step Seven:

If you click on the Auto Layout button, at the bottom of the Add to Package section (as shown here), it tries to automatically arrange the photos so they fit more logically, and gives you extra space to add more photos. Okay, hit the Clear Layout button and let's start from scratch again, so I can show you another handy feature.

TIP: Dragging-and-Copying

If you want to duplicate a cell, just pressand-hold the **Option (PC: Alt) key**, clickand-drag yourself a copy, and position it anywhere you'd like. If one of your photos overlaps another photo, you'll get a little yellow warning icon up in the top-right corner of your page.

Step Eight:

If you add so many cells that they can't fit on one page, Lightroom automatically adds new pages to accommodate your extra cells. For example, start by adding an 8x10, then add a 5x7 (which can't fit on the same letter-sized page), and it automatically creates a new page for you with the 5x7. Now add another 5x7 (so you have two-up), then a 2x2.5 (which won't fit on the same page), and it will add yet another page. Pretty smart, eh? (By the way, I think this "automatically do the obvious thing" is a big step forward in software development. In the past, if something like this happened, wouldn't you have expected to see a dialog pop up that said, "This cell cannot fit on the page. Would you like to add an additional page?") Also, if you decide you want to add another blank page yourself, just click on the New Page button that appears below the Add to Package buttons.

Continued

Step Nine:

If you want to delete a page added by Lightroom, just hover your cursor over the page you want to delete, and a little red X appears over the top-left corner (as seen here, on the third page). Click on that X and the page is deleted. Now, on the page with the two 5x7s, click on each of the 5x7s, press the Delete (PC: Backspace) key to remove them, and then go and turn on the Zoom to Fill checkbox up in the Image Settings panel.

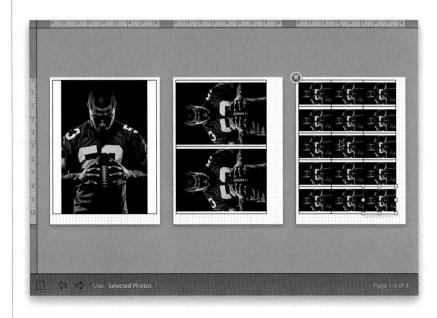

Step 10:

You can also manually adjust the size of each cell (which is a handy way to crop your photos on the fly, if you have Zoom to Fill turned on). For example, go ahead and add two 3x7 cells on this second (now empty) page, which gives you a tall, thin, cropped image. Click on the bottom image (to bring up the adjustment handles around the cell), then click-and-drag the bottom handle upward to make the cell thinner (as seen here). You can get the same effect by clicking-and-dragging the Adjust Selected Cell sliders, at the bottom of the Cells panel (there are sliders for both Height and Width). There's only one real downside, and that is you can't have different photos at these different sizes-it has to be the same photo repeated for each different size (interestingly enough, this Picture Package feature was borrowed from Photoshop, but Photoshop actually does let you use different photos in your cells, not just one repeated).

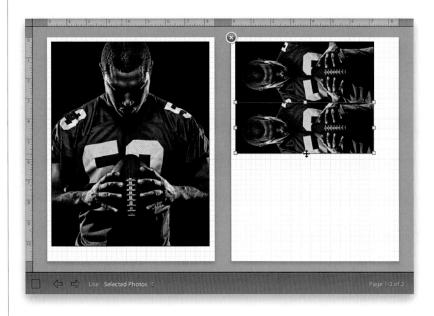

If you've come up with a layout you really like and want to be able to apply it at any time with just one click, you need to save it as a template. But beyond just saving your layout, print templates have extra power, because they can remember everything from your paper size to your printer name, color management settings, the kind of sharpening you want applied—the whole nine yards!

Saving Your Custom Layouts as Templates

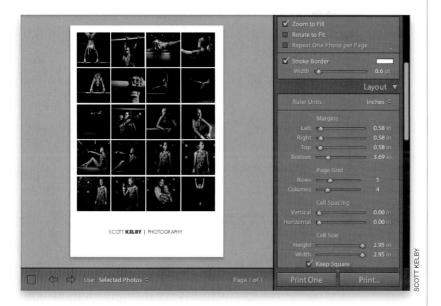

000	New Template
Template Name:	20 Photo Grid
Folder:	User Templates
	Cancel Create
000	New Template
Template Name	New Template New Folder
	·

Step One:

Go ahead and set up a page with a layout you like, so you can save it as a print template. The page layout you see here is based on a 13x19" page (you choose your page size by clicking the Page Setup button at the bottom of the left side Panels area). The layout uses a Page Grid of 5 Rows and 4 Columns. The cell sizes are square (around 3 inches each), and the page has a $\frac{1}{2}$ " margin on the left, right, and top, with a 3.69" margin at the bottom. I turned on the Stroke Border checkbox and changed the color to white, and turned on my Identity Plate. Also, make sure the Zoom to Fill checkbox (in the Image Settings panel) is turned on.

Step Two:

Once it's set up the way you like it, go to the Template Browser and click the plus sign (+) button on the right side of the header to bring up the New Template dialog (shown here). By default, it wants to save any templates you create into a folder called User Templates (you can have as many folders of print templates as you like to help you organize your templates, so for example, you could have one set for lettersized templates, one set for 13x19" templates, one set for layouts that work with portraits, and so on). To create one of these new template folders, just click on the Folder pop-up menu (shown here at bottom), and choose New Folder. Give your template a name, click Create, and now this template will appear in the folder you chose. When you hover your cursor over the template, a preview of the template will appear up in the Preview panel at the top of the left side Panels area.

Having Lightroom Remember Your Last Printing Layouts

The Collections panel in the Print module has a hidden feature it remembers the last print layout you used for each collection (even if you created it from scratch, and didn't save it as a template). However, there is one big "Gotcha!" and you're about to learn how to avoid it.

Step One:

First, click the Page Setup button (at the bottom of the left side Panels area), and choose a 13x19" page size. Then, in the Print module's Collections panel, click on a collection, and in the Filmstrip, Command-click (PC: Ctrl-click) on three photos you want to appear in your print layout. In the Layout panel, set your Left, Right, and Top Margins to 0.75 in, and your bottom to 5.00 in. Set your Page Grid to 1 Rows and 3 Columns. Now, set your cell Height to around 13.25 in, Width to 3.64 in, and Horizontal Cell Spacing to 0.27 in. In the Image Settings panel, turn off the Rotate to Fit checkbox, but turn on the Zoom to Fill checkbox. Go to the Page panel and turn on your Identity Plate, and position it like you see here. Let's say, at this point, you either made a print of this layout, or saved it as a JPEG file (it's actually not necessary to print it now, but this is the point where you'd normally print, right?).

Step Two:

Now switch to a different collection of images, select one or more photos down in the Filmstrip, then go up to the Template Browser and click on Fine Art Mat (as seen here). So far, so good. Now, if you were to go to the Collections panel and click on that same collection you used in Step One, it actually remembers which layout you used last with that collection of photos—even if you didn't save it as a template (go ahead and try that now, and you'll see what I mean). This is a good thing, but there's a "gotcha" that might getcha if you don't take things one step further.

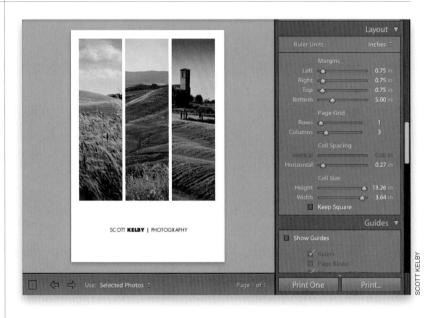

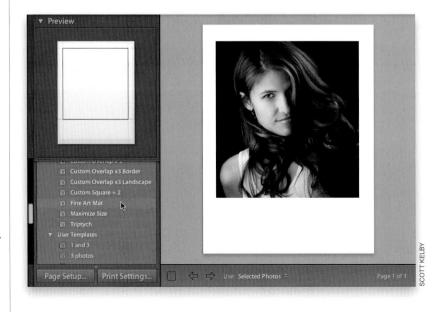

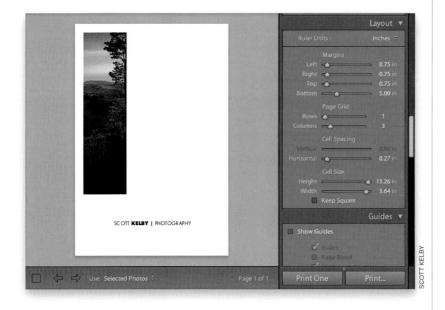

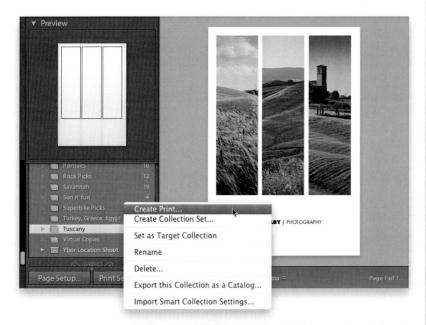

		Create Print	
Name:	3-Up Final Print		
Set:	None		
Print O	ptions		
11112 No. 1111	ude selected photos Make new virtual copie		
			Cancel Create

Step Three:

Let's say you printed that tall, three-image layout you created in Step One for a client. A month or so goes by, and they email you to ask for a reprint. You think, "Greatno problem-I'll just go back to that collection and it will remember the layout." So, you click on that collection, and sure enough, it remembered the layout, but (here's the gotcha) it doesn't remember which three photos you used in that layout (instead, it just shows you one photowhatever the first one in the Filmstrip for that collection happens to be, like you see here). So now what do you do? Have the client take a photo of the layout and email it to you, so you can see which three photos you used, and their order and position in each cell? See? It's a pretty big gotcha.

Step Four:

Here's how you avoid all this: Once you make a print, and you're happy with the final image, Right-click on that collection (over in the Collections panel) and from the pop-up menu that appears, choose Create Print (as shown here) to bring up the Create Print dialog. The key thing here is to make sure the Include Selected Photos checkbox is turned on. That way, when you create this new collection, only the three photos that are actually in this print are saved in this new print collection. By the way, Print collections look just like any other collections, but by default it adds the word "Print" to the end of the collection name, and I recommend that you leave that in place, so you'll quickly know which collections are regular and which are just used when you're printing. So, click the Create button, and now when you click on that Print collection, you'll see just those photos, in the order they appear in the layout. All you have to do is select all three in the Filmstrip, and they pop right back into the layout, in the right order and placement within the print cells (as shown here).

Creating Backscreened Wedding Book Pages

For all the wonderful things Lightroom 3's Print module does, one thing it won't let you do is backscreen a photo (a staple in most wedding albums). So, I had to come up with a workaround. Well, three actually, because it also doesn't want you to put a different smaller photo on top, let alone add a drop shadow, but you're about to learn how to do all three things. Also, don't let all the steps fool you—this is really easy to do.

Step One:

Choose the photo you want to use as your backscreened image, then go to the Develop module's Tone Curve panel. Make sure the Point Curve is visible (if yours has more sliders below it, and doesn't look like the one you see here, just click on the little Point Curve icon at the bottomright corner of the Tone Curve panel).

Step Two:

To create the backscreened look, clickand-drag the bottom-left corner point straight up along the left edge until it's about ³/4 or so of the way up to the top (as shown circled here in red).

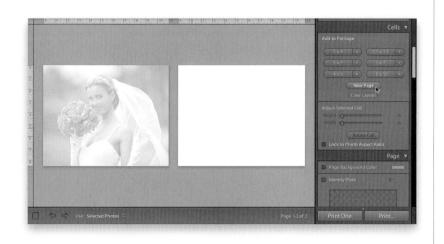

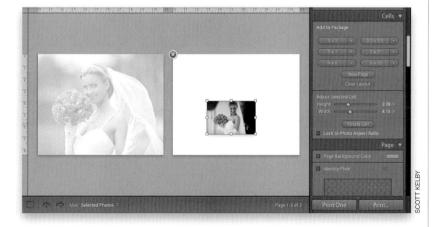

Step Three:

Now switch to the Print module. Click on the Page Setup button and choose an 8.5x11" landscape page. Unfortunately, we can't just drag-and-drop another photo on top of this photo, because Lightroom figures you want to replace the background photo (instead of letting you put another smaller photo on top of the background photo), which is why I came up with this workaround to let you do just that. So, click on Custom Package in the Layout Style panel at the top of the right side Panels area, then scroll down to the Cells panel. Click the Clear Layout button, then make sure the Lock to Photo Aspect Ratio checkbox is turned off. Drag-and-drop your backscreened photo onto the page, then click on the corner handles and drag until the photo fills the entire page. (You may need to also turn off the Rotate to Fit, Inner Border, and Inner Stroke checkboxes, depending on your last settings here.) Now, click on the New Page button to add a new blank page (as shown here).

Step Four:

Now that you have this blank page, go down to the Filmstrip at the bottom and drag-and-drop the photo you want to appear on top of your backscreened photo onto this blank page (as seen here).

Step Five:

Now click-and-drag that photo from the blank page onto the backscreened page (as shown here), and since the photo is coming from a different page, in a separate cell, Lightroom doesn't try to replace the background, but instead just puts it on top (I know, it's weird, but this is the only way I could come up with to make this work). Now you can delete the blank page on the right, so just move your cursor over the blank page, and a red X button will appear in the top-left corner. Click on it to delete that extra page. Then you can drag the photo, position it where you want, and resize it by pressing-and-holding the Shift key while dragging one of the corner points in/out.

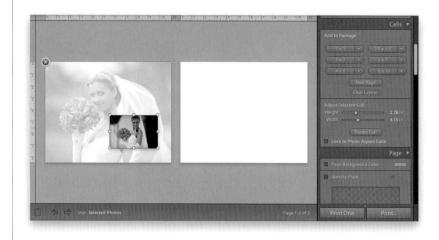

Step Six:

Now we want to have a drop shadow behind that photo, but since Lightroom doesn't let you add a drop shadow behind a photo in the Print module, instead we'll create a drop shadow using Photoshop (or Photoshop Elements), and then import the drop shadow as an Identity Plate (yupit's another workaround, but it works). In Photoshop, create a new document that's 6x4" at a resolution of 150 ppi (you don't need a very high resolution for a drop shadow). Go to the Layers panel and click on the Create a New Layer icon. Now, switch to the Rectangular Marquee tool (M) and drag out a rectangular selection like the one you see here. Once your selection is in place, press the letter **D** on your keyboard to set your Foreground color to black, then fill your selected area with black by pressing Option-Delete (PC: Alt-Backspace). Now you can Deselect by pressing Command-D (PC: Ctrl-D).

Step Seven:

Go under the Filter menu, under Blur, and choose Gaussian Blur. Enter 17 as your Radius (okay, it doesn't have to be 17—choose any amount of blur you like. The higher the number, the softer your shadow will be). Now click OK to soften the edges of your black rectangle.

Step Eight:

Now take the Rectangular Marquee tool again and draw a rectangular selection that's offset up and to the left from the black rectangle (as shown here). Then, press the Delete key to knock that area out of the black rectangle (as I did here). Now you can deselect.

Step Nine:

When you bring this drop shadow over to Lightroom, you're going to want the background behind that shadow to be transparent (or you'll bring a big white background into Lightroom along with it). Luckily, this is easier than it sounds: just drag the Background layer onto the Trash icon at the bottom of the Layers panel, and-voilá-the area around and behind your drop shadow is transparent. To keep this drop shadow's transparency when you bring it into Lightroom, you'll need to save the file in PNG format, so go ahead and choose Save As from the File menu and save it as a PNG. A little dialog will pop up with PNG Options for Interlacing. Just leave it set to None and click OK.

Step 10:

Okay, back to Lightroom. Go to the Page panel, turn on the Identity Plate checkbox, then click on the little triangle in the bottom-right corner of the Identity Plate preview, and choose **Edit** to bring up the Identity Plate Editor. Click the Use a Graphical Identity Plate radio button, then click the Locate File button and find that drop shadow PNG file you created in the previous step. Click on it (as shown here), then click the Choose button, and click OK in the Identity Plate Editor.

Step 11:

When you click OK, your Drop Shadow (with it's transparent background) appears on your page, but of course, it probably won't be the right size, so press-and-hold the Shift key, grab a corner point (as shown here), and drag inward (or outward) to scale the shadow down (or up) until it fits the size of your photo.

Print

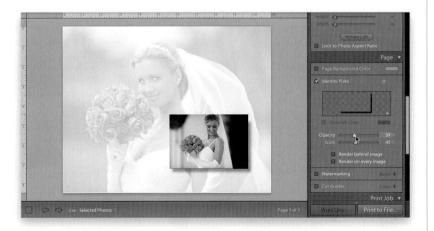

Step 12:

Position this drop shadow so it's below and to the right of your photo. Make sure the hard edge of the shadow lines up snugly with your photo, so there's no gap between them (as seen here). Although I had already lowered my Identity Plate opacity by using the Opacity slider in the Page panel, you can lower it more to make your drop shadow lighter. Now that your page is designed, you can save the entire page as a high-resolution JPEG image by going down to the Print Job panel, and next to Print To, choose JPEG File from the pop-up menu (this changes the Print button to Print to File). That's it! So, after all this, you're probably thinking, "You can add drop shadows in the Slideshow module. Why can't we just add one here in the Print module?" Ya know, I ask myself that same question all the time [insert crickets sound effect here].

The Final Print and Color Management Settings

Once you've got your page set up with the printing layout you want, you just need to make a few choices in the Print Job panel, so your photos look their best when printed. Here are which buttons to click, when, and why:

Step One:

Get your page layout the way you want it to look. In the capture shown here, I clicked on Page Setup at the bottom of the left side Panels area and set my page to a wide [landscape] orientation, and then I went to the Template Browser and clicked on the Maximize Size template. I set my Left and Right Margins sliders to 1.87 in, my Top Margins slider to 0.41 in, and my Bottom Margins slider to 4.13 in. Lastly, I added my Identity Plate below the photo (like the one we created earlier in this chapter). Once that's done, it's time to choose our printing options in the Print Job panel, at the bottom of the right side Panels area.

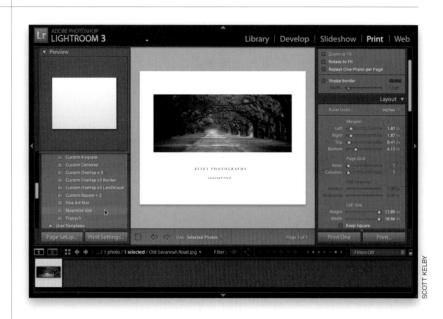

You have the choice of sending your image to your printer, or just creating a high-resolution JPEG file of your photo layout (that way, you could send this finished page to a photo lab for printing, or email it to a client as a high-res proof, or use the layout on a website, or...whatever). You choose whether it's going to output the image to a printer or save it as a JPEG from the Print To popup menu, at the top right of the Print Job panel (as seen here). If you want to choose the Print to JPEG File route, go to the next tutorial in this chapter for details on how to use the JPEG settings and export the file.

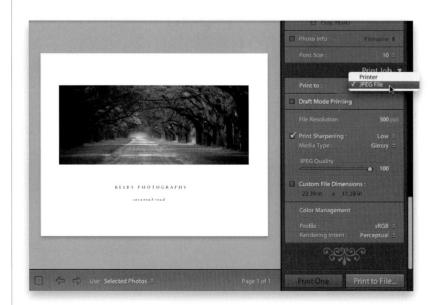

	Print Job 🔻
Print to :	Printer ¢
Draft Mode Printing	
Y Print Resolution	180 <u>opi</u>
Print Sharpening : Media Type :	Low ÷ Glossy ÷
16 Bit Output	
Color Management	4
Profile : Manag Rendering Intent :	

Step Three:

Since we've already started at the top, we'll just kind of work our way down. The next setting down in the panel is a checkbox for Draft Mode Printing, and when you turn this on, you're swapping quality for speed. That's because rather than rendering the full-resolution image, it just prints the low-res JPEG preview image that's embedded in the file, so the print comes out of your printer faster than a greased pig. I would only recommend using this if you're printing multiphoto contact sheets. In fact, I always turn this on when printing contact sheets, because for printing a page of small thumbnail images, it works beautifullythe small images look crisp and clear. Notice, though, that when you turn Draft Mode Printing on, all the other options are grayed out. So, for contact sheets, turn it on. Otherwise, leave this off.

Step Four:

Make sure the Draft Mode Printing checkbox is turned off, and now it's time to choose the resolution of your image. If you want to print at your file's native resolution, then turn the Print Resolution checkbox off. Otherwise, when you turn the checkbox on, the default resolution is 240 ppi (fine for most color inkjet printing). I use Epson printers, and I've found resolutions that work well for them at various sizes. For example, I use 360 ppi for letter-sized or smaller prints, 240 ppi for 13x19" prints, or just 180 ppi for a 16x20" or larger. (The larger the print size, the lower the resolution you can get away with.) In this instance, I'm printing to an Epson Stylus Pro 3880 on a 17x22" sheet, so I would highlight the Print Resolution field and type in 180 (as shown here), then press the Return (PC: Enter) key. Note: If printing at 180 ppi freaks you out, just leave it set to the default of 240 ppi, but at least try 180 ppi once on a big print, and see if you can tell a difference.

Step Five:

Next is the pop-up menu for Print Sharpening, and in Lightroom 2, Adobe really made this a powerful tool (the output sharpening in earlier versions was just too weak for most folks' tastes). Now when you tell Lightroom which type of paper you're printing on and which level of sharpening you'd like, it looks at those, along with the resolution you're printing at, and it applies the right amount of sharpening to give you the best results on that paper media at that resolution (sweet!). So, start by turning on the Print Sharpening checkbox (I always turn this on for every print, and every JPEG file), then choose either Glossy or Matte from the Media Type pop-up menu. Now choose the amount of sharpening you want from the Print Sharpening pop-up menu (I generally use High for glossy and Standard for matte paper, like Epson's Velvet Fine Art). That's all there is to it-Lightroom does all the work for you.

Step Six:

The next checkbox down reveals another feature: 16-bit printing, which gives you an expanded dynamic range on printers that support 16-bit printing. (Note: At the time this book was published, 16-bit printing in Lightroom 3 was only available for Mac OS X Leopard or higher users, but, of course, that is subject to change if Adobe releases an update for Windows.) So, if you're running Mac OS X Leopard or higher, and you have a 16-bit-capable printer, like some of the newer Canon printers (or if you've downloaded a 16-bit printer driver, like the ones Epson released in early 2008 that make your current printer 16-bit capable), then you should turn the 16 Bit Output checkbox on (as shown here).

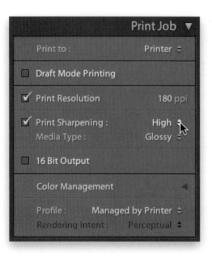

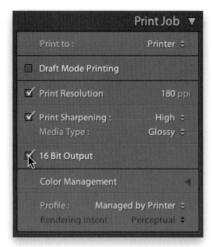

Print Slideshow

Web

	Print Job 🔻
Print to :	Printer 🗘
Draft Mode Printing	
YPrint Resolution	180 ppi
Print Sharpening : Media Type :	High ≑ Glossy ≎
🗹 16 Bit Output	
Color Management	4
Profile : 🗸 Manageo Renderi Other	l by Printer

		United States Search	
ducts	Ink Paper Drivers & Support Learn & Create Epson Sto	re About Home	
	Sign In i Track My Order i My Account Reorder List Produ	ct Registration Help 🖙 Shopping Cart	
a > Sunn	ort > Epson Stylus Pro 3880 > Drivers & Downloads		
son S	tylus Pro 3880	* en-science//////////////////////////////////	W
		Support Links	
	Drivers & Downloads	Epson Stylus Pro 3880 Support	1.5
		Drivers & Downloads	
F	NOTE: View our <u>Windows 7</u> and <u>Mac OS X Snow Leopard</u> support pages.	FAQs for this Product	
	NOTE: Visit our ICC Profile DAmnioads page for access to	Documents & Manuals	
	Premium ICC profiles produced by Epson America, Inc. In most cases, these custom ICC profiles will provide more	Contact Support	
	accurate color and black and white reproduction than with	Quick Links	
	the standard profiles already shipping with the printer.	More on this Product	
	Macintosh Operating Systems 👻 😡 Go	Register Your Product	
	, , , 1	Buy Ink for this Product	. A
	Show All Collapse All	User Replaceable Parts	*
	and the Line (Frank Star (Mar / Mar All and Mid Star Mar all a sea		
Er	CC Profiles: Epson Profession oson Stylus Pro 3880, Driver Image in CC Profiles: Epson Profession oson Cold Press Natural Paper		
Ef Ef	CC Profiles: Epson Professio oson Stylus Pro 3880, Driver CC Profiles: Epson Profession		
Ep Po Th	CC Profiles: Epson Profession ason Stylus Pro 3880, Driver CC Profiles: Epson Profession CC Profiles: Epson Profession	al Ø	
Ep Pc	CC Profiles: Epson Profession pson Stylus Pro 3880, Driver CC Profiles: Epson Profession CC Profiles: Epson Profession (CC	aL (2)	
Er Er Er Bo Th Ep Sł	CC Profiles: Epson Professio ason Stylus Pro 3880, Driver CC Profiles: Epson Profession broken Cold Press Natural Paper broken Cold Press Natural White.dmg - 2.64 MB broken Cold Cold Press Natural White.dmg - 2.64 MB broken Cold Cold Press Natural White.dmg - 2.64 MB broken Cold Cold Press Natural White.dmg - 2.64 MB broken Cold Cold Press Natural White.dmg - 2.64 MB broken Cold Cold Press Natural White.dmg - 2.64 MB broken Cold Cold Press Natural White.dmg - 2.64 MB broken Cold Cold Press Natural White.dmg - 2.64 MB broken Cold Cold Press Natural White.dmg - 2.64 MB broken Cold Cold Press Natural White.dmg - 2.64 MB broken Cold Cold Press Natural White.dmg - 2.64 MB broken Cold Cold Press Natural Vertex MB broken Cold Press Natural Vertex MB broken Cold Cold Press Natural Vertex MB broken Cold Cold Press Natural Vertex MB broken Cold Press Natural Vertex M	aL (2)	
Ep PC Ep PC TC Ep SA Ep PC	CC Profiles: Epson Profession Soon Stylus Pro 3880, Driver CO Profiles: Epson Profession Coson Cold Press Natural Paper Soon Stylus Pro 3880 Cold Press Natural White dmg - 2.64 MB Soft on 2010-03-10 Is DMG file contains the ICC profiles(s) and PDF Documentation for use with the Son Photographic Printer Driver on Mac Operating Systems. Chibition Fiber Paper P3880 ExhibitionFiber v. 0.zip - 847k Soft of a 2009-11-11	e standard Download Now	
Ep Po Es Po Do Po Do Do Do Do Do Do Do Do Do Do Do Do Do	CC Profiles: Epson Professio ason Stylus Pro 3880, Driver CC Profiles: Epson Profession broken Cold Press Natural Paper broken Cold Press Natural White.dmg - 2.64 MB broken Cold Cold Press Natural White.dmg - 2.64 MB broken Cold Cold Press Natural White.dmg - 2.64 MB broken Cold Cold Press Natural White.dmg - 2.64 MB broken Cold Cold Press Natural White.dmg - 2.64 MB broken Cold Cold Press Natural White.dmg - 2.64 MB broken Cold Cold Press Natural White.dmg - 2.64 MB broken Cold Cold Press Natural White.dmg - 2.64 MB broken Cold Cold Press Natural White.dmg - 2.64 MB broken Cold Cold Press Natural White.dmg - 2.64 MB broken Cold Cold Press Natural White.dmg - 2.64 MB broken Cold Cold Press Natural Vertex MB broken Cold Press Natural Vertex MB broken Cold Cold Press Natural Vertex MB broken Cold Cold Press Natural Vertex MB broken Cold Press Natural Vertex M	e standard Download Now	

Step Seven:

Now it's time to set the Color Management options, so what you see onscreen and what comes out of the printer both match. (By the way, if you have any hope of this happening, you've first got to use a hardware monitor calibrator to calibrate your monitor. Without a calibrated monitor, all bets are off. I use the X-Rite i1Display 2 to calibrate my monitor.) There are only two things you have to set here: (1) you have to choose your printer profile, and (2) you have to choose your rendering intent. For Profile, the default setting is Managed by Printer (as shown here), which means your printer is going to color manage your print job for you. This choice used to be out of the question, but today's printers have come so far that you'll actually now get decent results leaving it set to Managed by Printer (but if you want "better than decent," read on).

Step Eight:

You'll get better looking prints by assigning a custom printer/paper profile. To do that, first go to the website of the company that manufactures the paper you're going to be printing on. On their site, find the ICC color profiles they provide for free downloading that exactly match (a) the paper you're going to be printing on, and (b) the exact printer you're going to be printing to. In our case, I'm printing to an Epson Stylus Pro 3880 printer, and I'm printing on Epson's Exhibition Fiber Paper. So, I went to Epson's website and, under Drivers & Support for Printers & All in Ones, I found the 3880 downloads for a Macintosh. At the top of that page, I clicked on ICC Profile Downloads, then clicked on the Download Now button for Exhibition Fiber Paper under Stylus Pro 3880, and installed the free color profile for my printer. On a Mac, the unzipped file should be placed in your Library/ ColorSync/Profiles folder. In Windows Vista or Windows 7, Right-click on the unzipped file and choose Install Profile.

Step Nine:

Once your color profile is installed, click-and-hold on the Profile pop-up menu (right where it says Managed by Printer), and choose Other. This brings up a dialog (shown here) listing all the color profiles installed on your computer. Scroll through the list and find the paper profiles for your printer, then find the profile(s) for the paper(s) you normally print on (in my case, I'm looking for that Epson Exhibition Fiber Paper, or EFP for short), and then turn on the checkbox beside that paper (as shown here). Once you've found your profile(s), click OK to add it to your pop-up menu.

Choose Profiles Choose profiles to appear in Custom Profile popup: Epson Stylus Pro 388... /Library/Printers/EPSON/InkjetPrinter/ICCProfiles/Pro3880... Epson Stylus Pro 388... /Library/Printers/EPSON/InkjetPrinter/ICCProfiles/Pro3880... Epson Stylus Pro 388... /Library/Printers/EPSON/InkjetPrinter/ICCProfiles/Pro3880... Epson Stylus Pro 388... /Library/Printers/EPSON/InkjetPrinter/ICCProfiles/Pro3880.... Epson Stylus Pro 388... /Library/Printers/EPSON/InkjetPrinter/ICCProfiles/Pro3880... Epson Stylus Pro 388... /Library/Printers/EPSON/InkjetPrinter/ICCProfiles/Pro3880.. Epson Stylus Pro 388... /Library/Printers/EPSON/InkjetPrinter/ICCProfiles/Pro3880... Epson Stylus Pro 388... /Library/Printers/EPSON/InkietPrinter/ICCProfiles/Pro3880. Epson Stylus Pro 388... /Library/Printers/EPSON/InkjetPrinter/ICCProfiles/Pro3880... RR UPSatin 2.0 Ep380... /Library/ColorSync/Profiles/RR UPSatin 2.0 Ep3800.icc SP3800_EFP_PK_2880 /Library/ColorSync/Profiles/SP3800_EFP_PK_2880.icc M SPR2400 MtteScrpbk ... /Library/ColorSync/Profiles/SPR2400 MtteScrpbk BstPhoto.ic SPR2400 PremGlsy Bs... /Library/ColorSync/Profiles/SPR2400 PremGlsy BstPhoto.icc SPR2400 PremGlsy P... /Library/ColorSync/Profiles/SPR2400 PremGlsy Photo.icc SPR2400 PremGlsy P... /Library/ColorSync/Profiles/SPR2400 PremGlsy PhotoRPM.icc SPR2400 PremLuster ... /Library/ColorSync/Profiles/SPR2400 PremLuster BstPhoto.icc SPR2400 PremLuster ... /Library/ColorSync/Profiles/SPR2400 PremLuster Photo.icc Include Display Profiles

Cancel

OK

Step 10:

Return to that Profile pop-up menu in the Print Job panel, and you'll see the color profile for your printer is now available as one of the choices in this menu (as seen here). Choose your color profile from this pop-up menu (if it's not already chosen; in my case, I would choose the SP3880 EFP PK 2880v1.icc, as shown here, which is Epson's secret code for the Stylus Pro 3880, Exhibition Fiber Paper, PK, at 2880 dpi). Now you've set up Lightroom so it knows exactly how to handle the color for that printer on that particular type of paper. This step is really key to getting the quality prints we're all aiming for, because at the end of the day, it's all about the print.

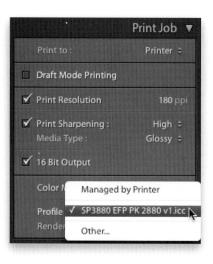

	Print Job 🔻
Print to :	Printer 🗧
Draft Mode Printing	
✓ Print Resolution	180 ppi
✓ Print Sharpening : Media Type :	High ≑ Glossy ≑
🗹 16 Bit Output	
Color Management	4
Profile : SP3880 EFF Rendering Intent	

Print	
Printer: EpsonStylusPro3880–1E Presets: Standard	8107 :
Copies: 1 Collated	
Pages: All From: 1 to:	1
Layout Pages per Sheet:	
Layout Direction:	2 5 4 2
Border: Two-Sided:	
	Reverse Page Orientation
PDF • Preview Supplies	Cancel Print

Step 11:

Under Rendering Intent, you have two choices: (a) Perceptual, or (b) Relative (Colormetric). Theoretically, choosing Perceptual may give you a more pleasing print because it tries to maintain color relationships, but it's not necessarily accurate as to what you see tonally onscreen. Choosing Relative may provide a more accurate interpretation of the tone of the photo, but you may not like the final color as much. So, which one is right? The one that looks best on your own printer. Relative is probably the most popular choice, but personally, I usually use Perceptual because my style uses very rich, saturated colors, and it seems that Perceptual gives me better color on my particular printer. So, which one should you choose? The best way to know which one looks best for your printer is to print a few test prints for each photo—try one with Perceptual and one with Relative-when the prints come out, you'll know right away which one works best for your printer.

Step 12:

Now it's time to click the Print button at the bottom of the right side Panels area. This will bring up the Print dialog (shown here. If you're using a Mac, and you see a small dialog with just two pop-up menus, rather than the larger one you see here, click the little arrow button to the right of the Printer pop-up menu, shown circled here in red, to expand the dialog to its full size, more like the one shown here).

Step 13:

Click-and-hold on the dialog's main section pop-up menu, and choose **Printer Settings** (as shown here). By the way, the part of this dialog that controls printer color management, and your pop-up menu choices, may be different depending on your printer, so if it doesn't look exactly like this, don't freak out. On a PC, click on the Properties button next to the Printer Name pop-up menu to locate it instead.

	Print	
Printe	EpsonStylusPro3880-1E8107	
Preset	:: Standard	•
Copie: Page:	:: 1	_
	✓ Layout Color Matching Paper Handling Cover Page Scheduler	
	AdobePDFPDE800 AdobePDFPDE900	
	Printer Settings Page Layout Settings Advanced Media Control Additional Settings	Page Orientation
(?) (PDF •) (Pr	Supply Levels Summary	Cancel Print

Step 14:

When the Printer Settings options appear, under Color Mode, your printer's color management will probably be turned on. Since you're having Lightroom manage your color, you don't want the printer also trying to manage your color, because when the two color management systems start both trying to manage your color, nobody wins. So, choose **Off (No Color Management)** from the pop-up menu (as shown here). On a PC (this may be different, depending on your printer), in the Media Settings section, under Mode, click the Custom radio button and choose **Off (No Color Adjustment)** from the pop-up menu.

Printer:	EpsonStylusPro3880-1E8107	
Presets:	Standard ‡	
Copies:	1 Collated	
Pages:	Commission and Commis	
ruges.	O From: 1 to: 1	
	Printer Settings	
	Basic Advanced Color Settings	
Page Setup:	Sheet Feeder - Borderless (Retain Size)	
Media Type:	Ultra Premium Photo Paper Luster	\$
	Ink: Photo Black	\$
Print Mode	Color Controls	Dutput
Color Mode	/ Off (No Color Management)	
Output Resolution:	SuperPhoto – 1440 dpi	
	High Speed	
	Flip Horizontal	
	Finest Detail	
Print quality in the t depending on the m Please refer to your		smeared
PDF PDF	iew Supplies Canc	

Library Dev

Develop Sli

Slideshow Print

Web

Printer:	EpsonStylusPro3880-1E8107
	Standard
Presets:	standard
Copies:	1 Collated
Pages:	All From: 1 to: 1
	Printer Settings
(Basic Advanced Color Settings
Page Setup:	Sheet Feeder – Borderless (Retain Size)
Media Type:	Ultra Premium Photo Paper Luster
	Ink: Photo Black 🗘
Print Mode:	AccuPhoto HD2
Color Mode:	Off (No Color Management)
Output Resolution:	SuperPhoto – 1440 dpi 🛟
	High Speed
	🗍 Flip Horizontal
	Finest Detail
depending on the m Please refer to your	manual for details.
depending on the m	redia. manual for details.
depending on the m Please refer to your	redia. manual for details.
depending on the m Please refer to your	redia. manual for details.
depending on the m Please refer to your	redia. manual for details. riew Supplies Cancel
depending on the m Please refer to your	redia. manual for details. riew Supplies Cancel
depending on the m Please refer to your	redia. manual for details. riew Supplies Cancel
depending on the m Please refer to your	redia. manual for details. riew Supplies Cancel
depending on the m Please refer to your	redia. manual for details. riew Supplies Cancel
depending on the m Please refer to your	redia. manual for details.
depending on the m Please refer to your	redia. manual for details. riew Supplies Cancel
depending on the m Please refer to your	redia. manual for details.
depending on the m Please refer to your	redia. manual for details.
depending on the m Please refer to your	redia. manual for details.
depending on the m Please refer to your	redia. manual for details.

Step 15:

Now, also in the Printer Settings section (or Media Settings on a PC) of the Print dialog (again, your pop-up menus may be different, and on a PC, these will be in the Properties dialog for your printer), for Media Type, choose the exact paper you'll be printing to from the pop-up menu (as shown here, where I chose Ultra Premium Photo Paper Luster, which is what Epson recommends for printing on their Exhibition Fiber Paper).

Step 16:

In that same Printer Settings section, for Output Resolution, choose SuperPhoto - 1440 dpi from the pop-up menu, and turn off the High Speed setting checkbox (if it's turned on. As seen in the previous step. Again, this is for printing to an Epson printer using Epson paper. If you don't have an Epson printer...why not? Just kidding-if you don't have an Epson printer, you're probably not using Epson paper, so for Print Quality, choose the one that most closely matches the paper you are printing to). Turn on the 16-Bit Output checkbox if you're doing 16-bit printing. On a PC, under Print Quality, choose Quality Options from the pop-up menu. In the resulting Quality Options dialog, you can turn off the High Speed checkbox and choose your Print Quality by setting the Speed slider. Now sit back and watch your glorious print(s) roll gently out of your printer.

Saving Your Page Layout as a JPEG

You can save any of these print layouts as JPEG files, so you can send them to a photo lab, or have someone else output your files, or email them to your client, or one of the dozen different things you want JPEGs of your layouts for. Here's how it's done:

Step One:

Once your layout is all set, go to the Print Job panel (in the right side Panels area), and from the Print To pop-up menu (at the top right of the panel), choose **JPEG File** (as shown here).

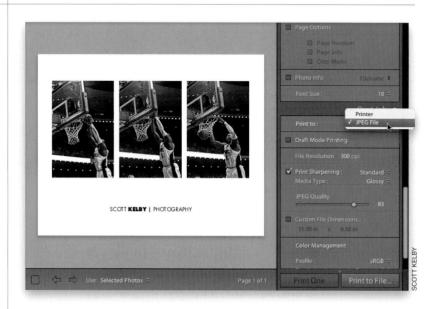

Step Two:

When you choose to print to a JPEG, a new set of features appears. First, ignore the Draft Mode Printing checkbox (it's just for when you're actually printing contact sheets full of small thumbnails). For File Resolution, the default is 300 ppi, but if you want to change it, move your cursor directly over the File Resolution field (the 300), and your cursor will change into a "scrubby slider" (it's that hand with the two arrows, as seen here). Now you can click-and-drag left to lower the resolution amount, or click-anddrag right to increase it.

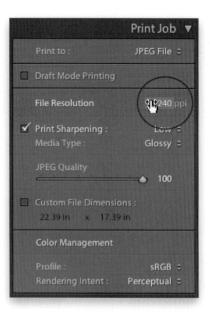

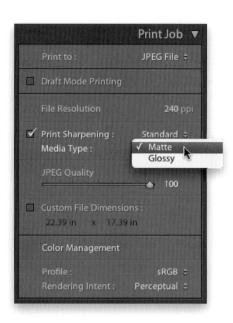

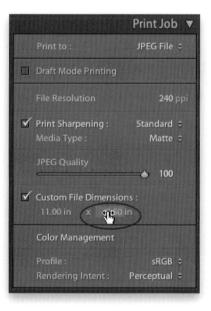

Step Three:

Next is the pop-up menu for Print Sharpening. What you do here is tell Lightroom which type of paper you'll be printing on (Matte or Glossy), and which level of sharpening you'd like applied (Low, Standard, or High). Lightroom looks at your choices (including resolution) and comes up with the optimum amount and type of sharpening to match your choices. So, start there (I apply this print sharpening to every photo I print or save as a JPEG). If you don't want this output sharpening applied to your exported JPEG, just turn off the Print Sharpening checkbox.

Print

Step Four:

You've got a couple more choices to make before we're done. Next, is IPEG Quality (I usually use 80, because I think it gives a good balance between quality and compression of the file size, but you can choose anything you want, up to 100). Below that is the Custom File Dimensions section. If you leave the checkbox turned off, it will just use whatever page size you had chosen in the Page Setup dialog (in this case, it was an 11x8.5" lettersized page). If you want to change the size of your JPEG, turn on the Custom File Dimensions checkbox, then move your cursor over the size fields and use the scrubby slider (shown here) to change sizes. Lastly, you set your Color Management Profile (many labs require that you use sRGB as your profile, so ask your lab). If you want a custom color profile, go back to the last tutorial for info on how to find those, and you can find info on the Rendering Intent setting there, too. Now just click the Print to File button at the bottom of the right side Panels area to save your file.

Adding Custom Borders to Your Prints

I wish Lightroom had the built-in ability to add custom borders, edges, and frames around your photos, but unfortunately it just doesn't. However, you can do a little workaround that lets you use your Identity Plate, and a special option in the Identity Plate section, to get the same effect right within Lightroom itself. Here's how it's done:

Step One:

Just like the slide show borders we did in Chapter 10, we'll start in Photoshop with the edge border you see here that I downloaded from iStockphoto.com (you can download it for free from this book's website, mentioned in the introduction). The edge comes flattened on the background, so select the entire black area. Then press Command-Shift-J (PC: Ctrl-Shift-J) to put it up on its own separate layer. Cut a rectangular hole out of this solid black edge graphic (so our photo can show through) using the Rectangular Marquee tool (M), then press the Delete (PC: Backspace) key. Our file can't have a solid white background, though, or it will cover our photo in Lightroom-instead it has to be transparent. So, go to the Layers panel and click-anddrag the Background layer into the Trash (at the bottom of the panel). Now, save the file in PNG format.

Step Two:

All right, that's all the prep work in Photoshop—now back to Lightroom. Click on the photo you want to have an edge frame, then jump over to the Print module. In the Page panel, turn on the Identity Plate checkbox. Then, in the Identity Plate pop-up menu, choose Edit to bring up the Identity Plate Editor you see here. In that dialog, click on the Use a Graphical Identity Plate radio button (because we're going to import a graphic, rather than using text), then click on the Locate File button, locate your saved PNG frame file, and click Choose to load it into your Identity Plate Editor (you can see the top of our edge frame in the small preview window shown here).

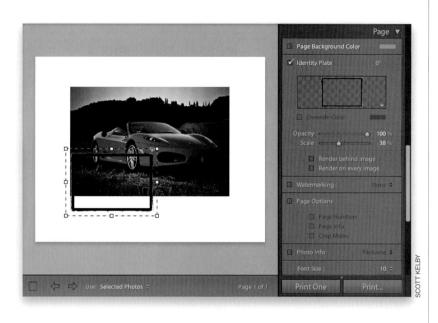

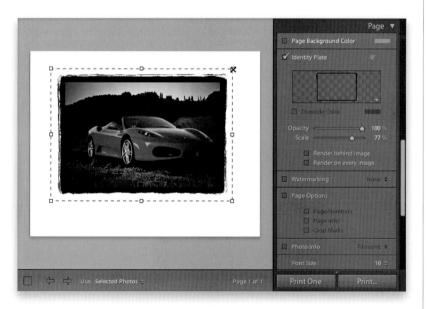

BONUS VIDEO:

I did a little bonus video for you, to show you step by step how to create Identity Plate graphics with transparency. You'll find it at **www.kelbytraining.com/ books/LR3**.

Step Three:

When you click OK, your edge frame will appear, hovering over your print (almost like it's on its own layer). The size and position won't be right, so that's the first thing you'll want to fix (which we'll do in the next step, but while we're here, notice how the center of our frame is transparent—you can see right through it to the photo below it. That's why we had to save this file without the Background layer, and as a PNG—to keep that transparency intact).

Step Four:

To resize your border, you can either click-and-drag a corner point outward (as shown here), or use the Scale slider in the Page panel. Once the size looks about right, you can reposition the frame edge by simply clicking-and-dragging inside its borders. You may need to resize your image, as well, using the Margins sliders in the Layout panel.

Step Five:

When it's right where you want it, just click your cursor outside the border and it will deselect. The final photo with the edge frame border is shown here. Now, if you decide you want to keep this border and use it in the future, go back to the Identity Plate Editor and from the Custom pop-up menu at the bottom-left corner of the dialog, choose **Save As** to save this frame border as an Identity Plate you can use anytime to add a quick border effect.

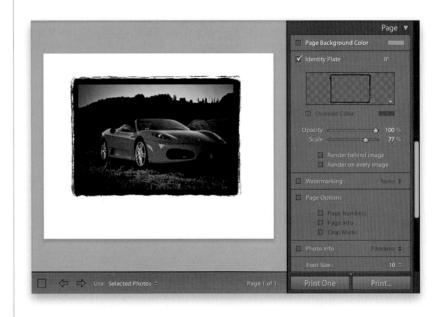

Step Six:

We created a horizontal frame, but how do you add this frame edge to a vertical photo, like the one shown here? If you change your page setup to Portrait (by clicking on the Page Setup button at the bottom of the left side Panels area), the Identity Plate will rotate automatically. If you are printing a vertical photo in a Landscape setup, you can rotate the Identity Plate by clicking on the degree field that appears to the right of the Identity Plate checkbox in the Page panel and choosing the rotation angle (as shown here). You'll probably have to resize and reposition the frame (as I did here) to make it fit just right, but now your single frame edge is doing double duty.

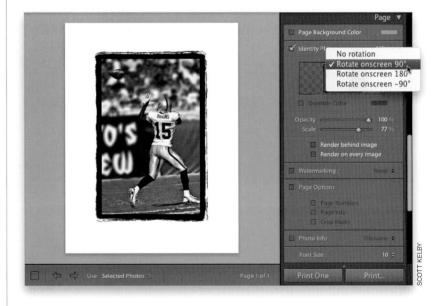

Here Are Some of My Own Print Layouts for You to Use

I wanted to share some of my most popular multi-photo print layouts with you (clients love these types of layouts). I show the panels needed for the layout, and an example of what each creates. These all use a 13x19" final page size, so click the Page Setup button and set that first. Also, for the tenth layout, set your page margins to 0.00". I did a short video tutorial for you on how I created the Identity Plates I used in these examples at **www.kelbytraining.com/books/LR3**. Enjoy!

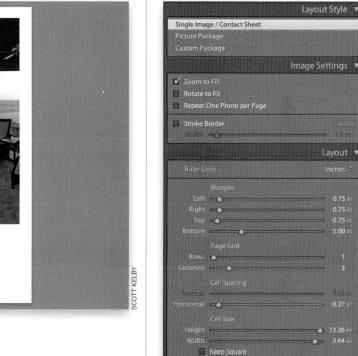

The Adobe Photoshop Lightroom 3 Book for Digital Photographers

		yout Style 🔻
Single Image	/ Contact Sheet	
Picture Pack		
Custom Pack	age	
	lmag	e Settings 🔻
🔲 Zoom to i		
🔲 Rotate to	Fit	
Repeat Or		
Stroke Bo	rder	and the second
Width =		
		Layout 🔻
Ruler Uni		Inches 🗧
Left a	۲	
Right e	<u>ن</u>	0.91 in
Top =	<u> </u>	—— 1.63 in
Bottom •	Ò	2.61 in
Į		
Rows (<u>)</u>	
Columns (<u>)</u>	
Vertical e		
Horizontal e		====> 0.00 in
(
Height -		🗕 🕹 8.71 in
Width •		

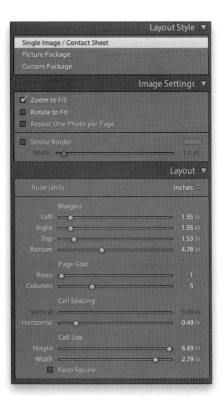

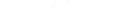

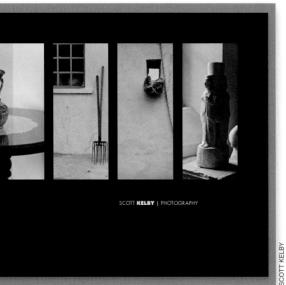

Library Develop

Slideshow

Print Web

Image Settings 🔻 Rotate to Fit 🔲 Repeat One Photo per Page Width 📥 Margins Left — 💧 Тор 📥 4.31
 4.31

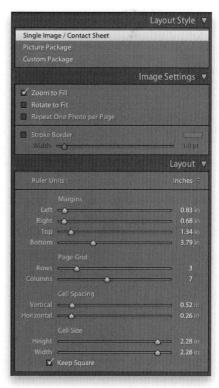

SCOTT KELBY

The Adobe Photoshop Lightroom 3 Book for Digital Photographers

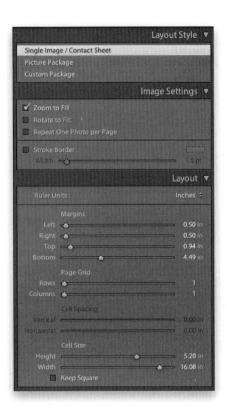

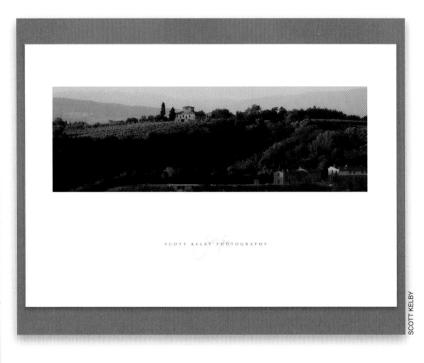

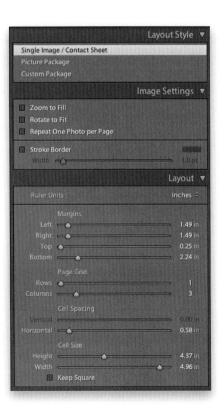

SCOTT KELBY | PHOTOGRAPHY

SCOTT KELBY

Click the Page Setup button to set your page margins to 0.00" all the way around for this full-bleed look

	Layout Style 🔻
Single Image / Con	tact Sheet
Picture Package	
Custom Package	
	Image Settings 🔻
Zoom to Fill	
Rotate to Fit	
🔲 Repeat One Pho	oto per Page
Stroke Border	
Wolls -	1.0 pt
	Layout 🔻
Ruler Units :	Inches ‡
Margin	s
Left	4.03 in
Right	◆ 4.07 in
Top 👈	
Bottom	● 2.46 in
Page G	
Rows 🔶	
Columns 🥧 🍐	- 3
Cell Sp	acing
Vertical comme	0.00 in - 1
Horizontal 👝	0.54 in
Cell Siz	e
Height 🦛	3.27 in
🗹 Keep Se	quare

		Layout Style 🔻
Single Ima	ge / Contact Sheet	
Picture Pa	ckage	
Custom Pa	ickage	
		Image Settings 🔻
🗹 Zoom t		
🔲 Rotate t	o Fit	
🔲 Repeat	One Photo per Page	
Stroke E	Border	
Wadeh	-C	
		Layout 🔻
Ruler U		
Left		0.00 in
Right	0	0.00 in
Тор	`	
Bottom		3.29 in
Rows	Ö	
Columns	C	
Verticas		
Honzontal	Contraction of the local division of the	••••••••••••••••••••••••••••••••••••••
Height		📥 15.71 in
Width	C	🔶 13.00 in

The Adobe Photoshop Lightroom 3 Book for Digital Photographers

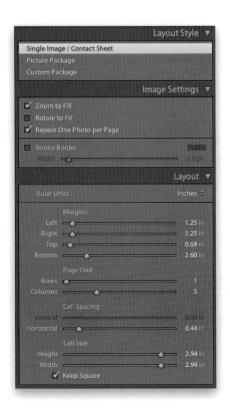

Single Imag	e / Contact Sheet	Layout Style 🔻
Picture Pac	kage	
Custom Pa		
		mage Settings 🖪
Zoom to		
🔲 Rotate te		
🗹 Repeat 0)ne Photo per Page	
🛄 Stroke B		
	ن	t.ept
		Layout 🖪
	Margins	
		0.50 in
		0.50 in
	<u></u>	
		5
		0.49 in
		2.00 in
		→ 3.50 in
	Keep Square	

This is a single business card, designed in Photoshop, saved as a JPEG, imported into Lightroom, and set up as a contact sheet (notice the crop marks added in the Page panel)

Single Ima	ge / Contact Sheet		
Picture Pac Custom Pa			
		Image Set	tings
Zoom to	Fill		
🔲 Rotate t			
🔲 Repeat (One Photo per Page		
Stroke 8	order		
Width	-0		1.0 pt
		La	yout
Ruler U	iits :	I	nches 3
	Margins		
			0.50 ii
	<hr/>		0.56 ii
	- <u>`</u>		0.94 in
	Ò		2.41 ii
	<u> </u>		
	Cell Spacing		
			0.19 ii
			0.18 in
	Cell Size		
			4.73 ii
	c		5.86 ii
	Keep Square	-	

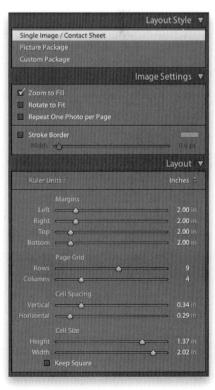

The Adobe Photoshop Lightroom 3 Book for Digital Photographers

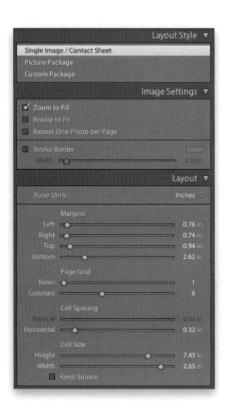

SCOTT KELBY | PHOTOGRAPHY

SCOTT KELBY

		Layout Style 🔻
F THE PROPERTY AND THE	ge / Contact Sheet	
Picture Pac		
Custom Pa	ckage	
		Image Settings 🔻
🗹 Zoom to		
🔲 Rotate t		
🔲 Repeat (
5troke B	order	
Width	-QQQQ	1.0 pt
		Layout 🔻
Ruler Ur		Inches 🤤
	Margins	
Left		0.25 in
Right	<u></u>	0.25 in
Тор		0.25 in
Bottom		2.96 in
Rows	C	1
Columns	O	1
		Carlos and and the second
Vertical	Commission of the local division of the loca	0.00 in
Horizontal		0.00 lin
Height		6.93 in
Width		6.93 m
Contraction in the second		

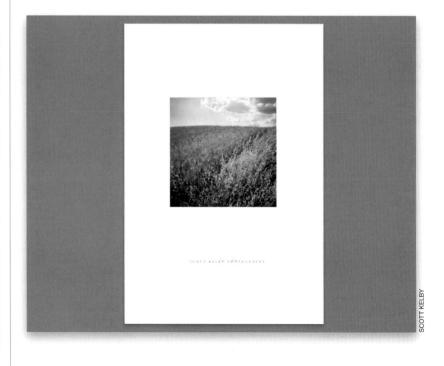

p Slideshow

v Print

Web

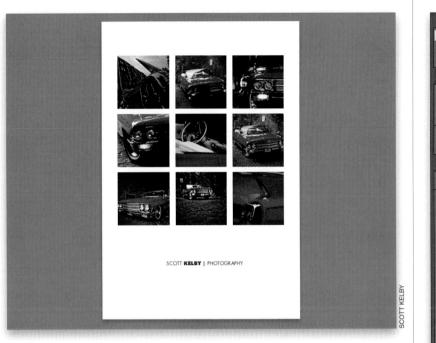

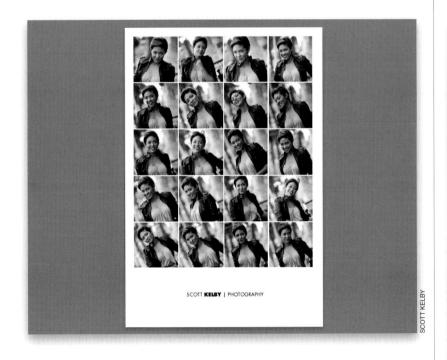

Image Settings V Image
Layout V
Layout V
Layout V
Layout 🔻
Inches 🗧
1.08 in
1.02 in
2.21 in
5.96 in
3
3
0.35 in
📥 3.38 in
3.38 in
A REAL PROPERTY AND ADDRESS OF AD

	Layout Style 🔻
Single Image / Contact Sheet	STALL BARRIER
Picture Package	
Custom Package	
The second s	age Settings 🔻
	age settings v
Zoom to Fill	
Rotate to Fit	
Repeat One Photo per Page	
🗹 Stroke Border	
Width 🐟	
	Layout 🔻
Ruler Units :	Inches \$
Margins	
Left 📣	
Right 📥	0.58 in
Тор 🐟	0.58 in
Bottom 📥 💧	
Page Grid	
Rows 🦾	5
Columns	<u> </u>
Cell Spacing	
Vertical 🐣	0.00 in
Horizontal	
Cell Size	
Height	2.95 in
Width -	📥 2.95 in
Keep Square	

The Adobe Photoshop Lightroom 3 Book for Digital Photographers

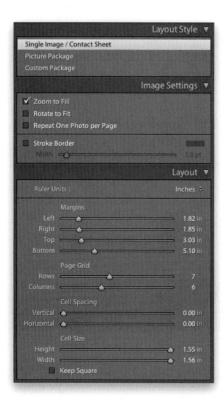

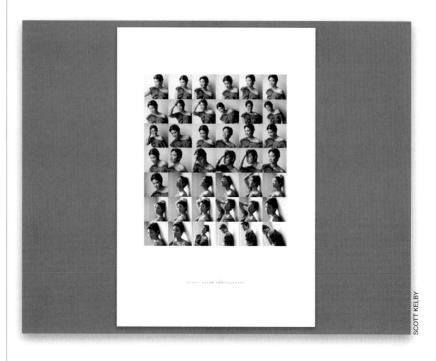

		Layout Style
Single Imag	ge / Contact Sheet	
Picture Pac	kage	
Custom Pa	ckage	
		Image Settings
🖌 Zoom to	o Fill	
🗌 Rotate t	o Fit	
Repeat (One Photo per Page	
Stroke B	order	
	-0	
		Layout 1
Ruler U	nits :	Inches ÷
	·	
	·	2.50 in
		
Columns		2
		ni 00.0
		0.82 in
	rischen Kache Sterfet	8.25 in
Wiath	Keep Square	▲ 5.69 in
	Neep Square	

Library I

Develop

Slideshow

Web

Lightroom Killer Tips > >

▼ Can't See Your Rulers?

If you're pressing **Command-R** (PC: **Ctrl-R)** and you can't see your printing rulers (the ones that appear above the top of your photo, and along the left side), it's because you have to make your guides visible first. Press **Command-Shift- H** (PC: **Ctrl-Shift-H**) or just choose **Show Guides** from the View menu. Now when you use that shortcut, you'll be toggling the rulers on/off.

Changing Your Ruler Units

To change the unit of measure for your rulers, just Right-click on either ruler, and a pop-up menu of measurements (Inches, Centimeters, Millimeters, Points, and Picas) will appear, so you can choose the one you'd like.

You can change the color of the gray canvas area that surrounds your printed page. Just Right-click anywhere on that gray background area and a pop-up menu will appear where you can choose different colors.

Adding Photos to Your Printing Queue

Adding more photos to print couldn't be easier—just go to the Filmstrip and Command-click (PC: Ctrl-click) on any photo you want to add to your print queue, and Lightroom instantly creates another page for it in the queue. To remove a photo from the print queue, it's just as easy: go to the Filmstrip and Command-click (PC: Ctrl-click) on any already selected photo to deselect it (Lightroom removes the page from your queue automatically, so you don't print a blank sheet).

Precise Margins Way Quicker Than Using the Margins Sliders

If you need to reposition your image on the page, you can adjust the Margins or Cell Size sliders. But if your guides are visible, it's easier just to click-and-drag a margin guide itself, because as soon as you start dragging, the position of the guide (in inches) appears above the top of the guide, so it's easy to quickly set two side or top and bottom margins to the exact same amount.

Sending Prints to a Lab?

If you use Lightroom's ability to save a page layout to JPEG, so you can send your prints to a lab for final printing, then here's a great tip: make a new template that has your usual page size, layout, etc., but make sure you set your color profile to the color space your lab prefers (which is usually sRGB for color labs). That way, when you save it as a JPEG, you won't forget to embed the right color space.

Print

Enabling 16-Bit Printing

If your inkjet printer was made in the last few years, it probably supports 16-bit printing, but to take advantage of it, make sure you have the latest printer driver (which can be downloaded for free from your printer manufacturer's website). *Note:* 16-bit printing currently only works for Mac users, and only those using Mac OS X Leopard or higher.

Choosing How the Identity Plate Prints

There are two other options for how the Identity Plate is used in multi-photo layouts. If you choose Render on Every Image, it puts your Identity Plate right smack dab in the middle of each photo, in each cell (so if you wanted to use your logo as a watermark by lowering the opacity of that Identity Plate, that would work). If you choose Render Behind Image, it prints on the background, as if it was a paper watermark (scale it up so it is slightly larger than your image).

▼ Nudging the Identity Plate In the Print module, you can move the position of your Identity Plate graphic (or text) by small increments by using the **Arrow keys** on your keyboard.

Photo by Scott Kelby Exposure: 1/640 Focal Length: 160mm Aperture Value: f/2.8

Chapter 12 Getting Your Photos on the Web

Web Galleries getting your photos on the web

As serious photographers, we make a lot of photographs during our journey, and every once in a while we just absolutely nail one. You know what I'm talking about—that moment where we see an image we took that looks better than what we think we're capable of taking. Well, once you get one of those, the first thing you want to do is have other people see it, so you email it to all your family members, and you post it on your Facebook page, but it's not enough. You know that this photo is "the one," and then it takes hold-that nagging inner voice that says, "This image needs a wider audience. This image needs to be published!" Getting published in a magazine, and having people all over see and enjoy something you created, is every photographer's dream. The only problem is that somebody else is in charge of our dream. No matter how good we (and

our friends and family) think that photo is, it will still ultimately be up to a photo editor to decide if our image is worthy of inclusion in their magazine. At that moment, they hold our dream in their hands. That's why, if I submit an image to a photo editor, they hold something else in their hands-a crisp one-hundred-dollar bill. That's because at the end of the day, photo editors have bills to pay just like anybody else, and with rising gas prices, and soaring food prices, and the tough economy, sometimes paper-clipping a Ben Franklin to your print is the difference between your image reaching that wider audience, or spending its life wallowing in utter obscurity. Of course, you could always self publish by creating a Web gallery of your images, and instantly reach a global audience of viewers tonight, but of course having that much control over your dream is like cheating. Makes you stop and think, doesn't it?

Building a Quick, Simple, Online Photo Gallery

Want to put up a quick online photo gallery of your vacation photos, or want to put proofs up online for a client's approval? It's easier than you'd think: you start with a built-in template and then add your little tweaks to customize it your way. The nice thing is you do most of your editing right on the page itself, so all your changes happen live, in real time. It's this live onscreen editing that makes the process so easy, and even if you have no Web design experience whatsoever, you'll be able to create a great-looking gallery in about five minutes. Here goes:

Step One:

Start by going to the Web module, and in the Collections panel in the left side Panels area, click on the collection of photos you want to put in your online gallery. Lightroom instantly puts them into a Web gallery (seen here in the center Preview area). The default Web Gallery template is a gray HTML webpage with thumbnails (seen here), and when you click on a thumbnail, it displays a larger version of the photo. The photos appear in your gallery in the same order they appear in the Filmstrip below, so to change their order, just dragand-drop them into the order you want in the Filmstrip.

Step Two:

By default, this template displays your thumbnails in three columns and three rows (as seen in Step One), but you can change this really easily. Just go to the Appearance panel (in the right side Panels area) and in the Grid Pages section, there's a mini-preview of your thumbnail grid that's more than a preview—it's live! Just move your cursor out over the grid and click-and-drag out how many rows and columns you want (I dragged over so there would be four columns, and the Web gallery instantly adjusted, as seen here). This is such an intuitive way to choose your columns and rows, and the fact that it updates live really makes it fun.

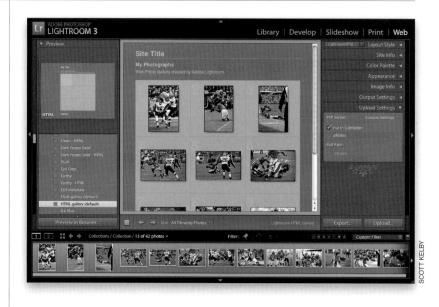

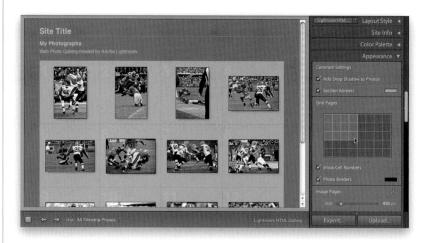

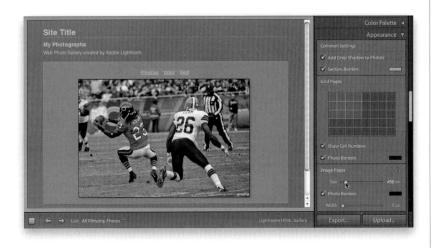

At this point, we've just been working with thumbnails, but when you (or your client) click on a thumbnail, it will be displayed at a larger size (as seen here). How large will it appear? That's up to you. By default, it appears at 450 pixels wide, but you can choose the size you'd like in the Appearance panel, in the Image Pages section, using the Size slider. (Note: There is no option for changing the size of the thumbnails with HTML templates. Just thought I'd keep you from pulling your hair out looking.) Right below that is a checkbox for toggling on/off a stroke border around this larger image, and you get to choose the width and color of the stroke border there, as well. At the top of this panel is a checkbox for turning on/off the drop shadow behind your photo. The Section Borders checkbox turns on/off the little lines that appear between your site title and the text below it at the top of the page, and the line between your photo and your contact info at the bottom of the page (you can choose the color of those section border lines, as well). There's one more section in this panel (Grid Pages), but it's for the thumbnails, not the larger-size previews.

Step Four:

You edit the text on your webpage right on the page itself, which makes this process fast and easy. You just click on the placeholder text that's there, it highlights, and you type in your new text, then press the Return (PC: Enter) key to lock in your changes. Here, I've changed the site title.

Continued

Step Five:

Basically, that's the plan—you click on placeholder text, right there on the page itself, and type in your own custom text. So, go ahead and enter the information you want on your webpage by clicking on the placeholder text, typing in your new text, and then hitting the Return (PC: Enter) key on your keyboard to lock in your changes. Here, I've updated my page with the information I might put on a typical online proofing page for a client. So now you've got your own text in place, you've chosen how many rows and columns you want for your thumbnails, and how large your larger images will appear on the page. You can go with this default HTML page, but Lightroom comes with some pretty decent built-in templates-and not just in HTML format, there are a number of Flash-based templates, as well.

Step Six:

To get a preview of these built-in templates, go to the Template Browser (in the left side Panels area) and just hover your cursor over a template, and a preview of that template will appear in the Preview panel at the top (as seen here). If the template is Flash-based, you'll see the a little "f" appear in the bottom-left corner of the preview; otherwise you'll see "HTML" there instead. To apply one of these templates, just click on it (here, I've clicked on the Paper White template, which has a white background, your thumbnails appear on the left in a scrolling list, and you have slide show controls below the larger image in the center). Note: One advantage of these Flash-based templates is that they have built-in slide show capabilities, with smooth transitions between each image. Also, people viewing your page can't just click-and-drag your photo onto their computer, like they can with HTML-based pages.

Slideshow Print Web

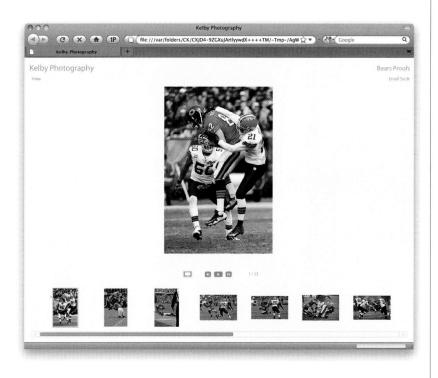

Step Seven:

While you can't control the number of rows or columns, there are different layouts you can choose from with these Flash-based templates. Go to the Appearance panel (in the right side Panels area), then at the top of the panel, in the Layout section, clickand-hold on the pop-up menu on the right side (as shown here), and choose **Scrolling**, which instantly reconfigures your page with the scrolling list of thumbnails at the bottom (as seen here). You can see a few other controls in this Appearance panel, including pop-up menus where you can choose your large image size and your thumbnail image size.

Step Eight:

Once you've chosen your final template, chosen the sizes you want for everything, chosen your layout, and added your custom text, make sure you test your final webpage by clicking on the Preview in Browser button at the bottom of the left side Panels area. This launches your Web browser, and displays your gallery as it will be seen on the Web (as shown here), so click on a few thumbnails to make sure it works the way you want it to. If you're ready to upload your gallery to the Web, jump over to page 396, but before you do that, there's still plenty you can do to customize the look and feel of your page (that's coming up), and there are some absolutely kick-butt built-in Flash-based templates that aren't found in the Template Browser (you access them in a totally different way), which we're going to cover later in this chapter.

Adding an Email or Website Link

If you're using Lightroom's Web gallery for online client proofing, you're probably going to want your client to be able to email you right from the page, or you might want to have a link to your main homepage, or your studio's website, etc. Here you'll learn how to do both (it's easier than you'd think).

Step One:

Although we've been editing our text right on the webpage itself, adding an email link to your page is one thing you have to go to the right side Panels area to do. So, go to the Site Info panel (shown here), and you'll see that the top section of this panel shows you all the text fields for the custom text you can add directly on the page itself (so technically, you could add the text here instead, but it's just easier to do it on the page). However, there is an extra feature here: Lightroom remembers the info you last added in each of these fields, and adds them to a pop-up menu, so you can quickly choose that same info again in the future (click on one of the little triangles at the top right of each text field to access that menu).

Step Two:

Right below Web or Mail Link, by default, it reads "mailto:user@domain." To add your email link, you just have to change the "user@domain" to your email address (in my case, it would read, "mailto:skelby @photoshopuser.com," as shown here, with no spaces in between anything), then press the Return (PC: Enter) key to lock in your change. *Note:* If, instead of an email link, you want to add a link to a webpage, just type the full URL in this field (like http://www.scottkelby.com).

The default text for this webpage or email link on your Web gallery reads, "Contact Name," but you can change it to whatever you'd like in the Contact Info field (which is right above the Web or Mail Link field). Just click on it and type in what you'd like your webpage or email link to say (I just use either "Contact Scott," as shown here, or "Email Scott," but choose whatever works best for you).

Step Four:

Here's how the page will look in your Web browser (I used the default Flashbased template, Flash Gallery, and then just clicked the Preview in Browser button at the bottom of the left side Panels area), and up in the top-right corner, there it is—my Contact Scott link. If your client clicks that link, it will launch their email application and open a new email message already addressed to you. All they have to do is enter a subject, jot you a quick note, and click Send.

Customizing Your Gallery Layout

So far, we've done just the basics: we used a built-in template as a starting point, we changed the text, picked the size and number of our thumbnails and larger images, and added a contact link. However, you can take the customizing process a lot further using the controls in the right side Panels area.

Step One:

One thing you can do to customize your page is to have your Identity Plate replace the site title text that appears in the top-left corner. Earlier we just typed in the name of our studio, but now we're going to add a logo graphic to replace it. (Here, I have chosen the Ivory template from the Template Browser in the left side Panels area.)

Step Two:

Go to the Site Info panel in the right side Panels area and turn on the Identity Plate checkbox, then click on the down-facing triangle in the bottom-right corner of the Identity Plate preview, and choose **Edit** from the pop-up menu to bring up the Identity Plate Editor (shown here). Click on the Use a Graphical Identity Plate radio button at the top of the dialog, then click the Locate File button, and find the logo you want to use as your Identity Plate. Once you've chosen your graphic, click the OK button.

Clear Image

Here's the page with the Identity Plate graphic in place. *Note:* You can't resize the Identity Plate here in the Web module, so make sure you make your graphic the right size to fit your page before you place it into Lightroom.

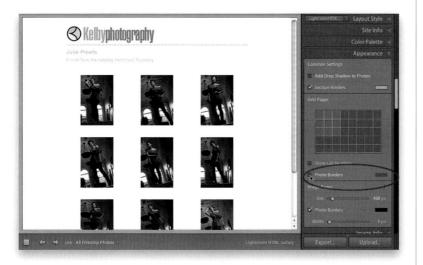

Step Four:

If you look at the page, there is a problem: although we brought this Identity Plate in to replace our site title, the old site title text is still there. Because the Identity Plate graphic says the same thing that I would have typed in for the site title, we need to remove the old site title text. So, in the Site Info panel, just delete the text in the Site Title field (you can see how much better the page looks here, compared to the one in Step Three). To finish things off here, I updated the other two text fields (as seen here) by clicking on them and typing in some custom text.

Step Five:

You can also customize how the thumbnails look. In the Appearance panel, you can turn off the stroke border around your photos by turning off the Photo Borders checkbox in the Grid Pages section (shown circled here). By the way, if you like the borders, you can choose which color you'd like them to be by clicking on the color swatch to the right of the Photo Borders checkbox. At the top of this panel, there's a checkbox for toggling on/off the drop shadow that appears behind your thumbnails (here's how the page looks with the thin black stroke around the photos and the drop shadow both turned off).

Continued

Step Six:

Just like in the Print module, you can add a visible watermark to your Web images (since these images are going to the Web, this may be the most important place to add your watermark). If you haven't set up a watermark yet, jump back to Chapter 7 to learn how to set up and save your own custom watermark. Then, you can apply a visible watermark by going to the Output Settings panel, turning on the Watermarking checkbox, and choosing it from the pop-up menu to its right (as shown here).

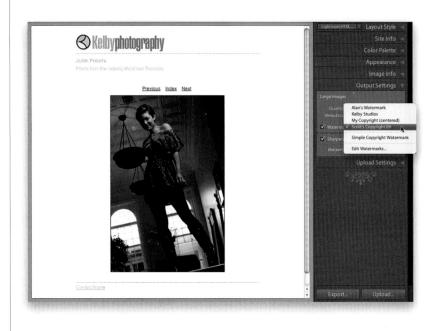

If your watermark is too large for this Web-sized image or you want to update it, choose **Edit Watermarks** to bring up the Watermark Editor, where you can change your text, size, and color, then save your changes as a new Watermark preset (also shown here). (*Note:* I hid the toolbar beneath the Preview area above, so I'd have a larger view of my page, by pressing **T**.)

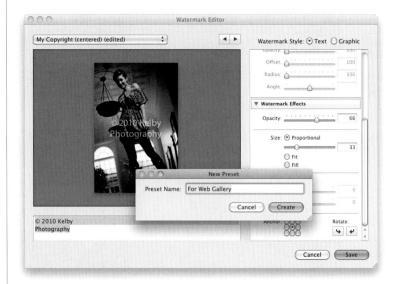

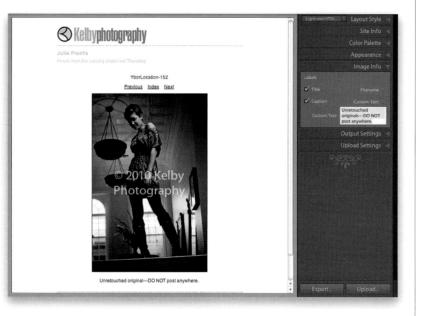

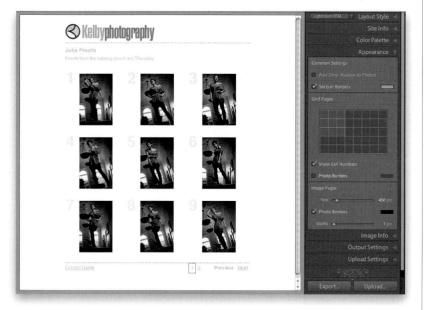

Step Seven:

If you're using this gallery for online proofing, the next two features might come in handy. You can have each photo's filename displayed above the photo (well, you can actually choose other options besides the filename), and you can add a caption (pretty much whatever you want) below the photo. You turn these text features on in the Image Info panel. The Title checkbox turns on the text above the photo, and you use the pop-up menu to the right of it to choose what info gets displayed up there (you can choose to have the filename appear up top, as I have here, or the date the photo was taken, the exposure, etc.). The Caption checkbox works the same way, but that text appears below your photo. In the example here, I chose Custom Text from the pop-up menu, which brought up a text field right beneath it (highlighted here), where I typed in my own custom text to appear beneath each photo.

Step Eight:

There are a couple more tweaks you can make here. Up in the Appearance panel, if you want, you can turn off the little horizontal divider lines that separate your Identity Plate from the text below it, and that appear across the bottom of your page, by turning off the Section Borders checkbox. Also, the Show Cell Numbers checkbox in the Grid Pages section puts a large sequential number in each cell, as shown here (this makes it easy for the client to tell you, "I like numbers 5, 8, 14, 22, and 23"). (Note: I turned off my watermark for this gallery at this point.) When you've finished tweaking your Web gallery, you might want to save it as a template (I sure would), so you can reapply it any time with just one click. Go to the Template Browser and click the + (plus sign) button to add the current look as a template.

Changing the Colors of Your Gallery

If there's a color that appears on your Web gallery, you can change it. From the background color, to the color of your cells, to the text, to the borders, you can change pretty much everything, and that applies to both HTML and Flash-based templates. Here's how it's done:

Step One:

If you scroll down to the Color Palette panel in the right side Panels area, you'll see you have color control over, well... just about everything. Here's the default Flash-based template (called Flash Gallery) and it features a medium-dark gray background, a black bar across the top, dark gray slide show controls, and light gray text.

Step Two:

We'll start by changing the color of the header at the top of the page. In the Color Palette panel, click on the color swatch to the right of Header. When the color picker appears, click on a lighter gray color (or one of the lighter gray color swatches at the top of the picker) to change the header at the top to light gray (as shown here).

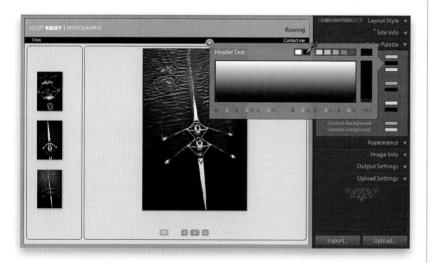

Changing the background color is just as easy. Click on the color swatch to the right of Background, then when the color picker appears, choose the color you'd like for your background (here, I chose kind of a light tan/beige look). By the way, if the color picker appears and the large gradient in the center only shows black, white, and grays, that's only because the color bar (at the far-right side of the color picker) is set all the way at the bottom. To reveal full-color gradients, click on the little rectangular knob (I know, it's not a knob, but I don't know what else to call it), drag it straight upward, and the colors will be revealed. The higher you drag the slider upward, the more vivid and saturated the colors will look.

Step Four:

Our last color tweak here is for the text in the header and in the menu bar right under it. The word Rowing at the right side of the header is a bit too light, so go to the Color Palette panel, click on the color swatch to the right of Header Text, and in the color picker, click on the black color swatch at the top of the picker (as shown here). Then, do the same thing for the menu text (I chose a lighter shade of gray for my menu text, so it's easier to read over that black menu bar). You also get to choose the color for the background of the slide show controls, and the color of the little icons inside the control buttons. Here, I chose a light gray for the button background (from the Controls Background color picker) and a lighter gray for the icons (from the Controls Foreground color picker). So, that's pretty much the deal-just go to the Color Palette panel, click on the color swatch beside the area you want to adjust, and when the color picker appears, choose a new color. Pretty quick and easy.

Using Cooler Flash Templates

Remember earlier when I mentioned that there were actually some really cool builtin Flash-based templates, but you didn't access them from the Template Browser? These three templates are found in the Layout Style panel (at the top of the right side Panels area), and they were created by a company called Airtight Interactive (www.simpleviewer.net). These guys have developed a number of very cool, free, Flash-based templates, and back in Lightroom 1.3, Adobe included these right in Lightroom for us, and I just love 'em! Here's how to put them to work:

Step One:

To get to these other Flash-based templates, go up to the Layout Style panel at the top of the right side Panels area (shown here) and first click on Airtight AutoViewer. This creates a slide show gallery, with the current image highlighted, and the previous and next image partially visible, but dimmed (as shown here, in the Preview in Browser view). In the Color Palette panel you can choose the background and border colors. In the Appearance panel, you can control the width of the border around each photo, and the Padding slider lets you choose how much space is between each photo. You can use the navigation arrows that appear on the left and right of your page to move backward and forward through your photos, and to play the slide show, just click the Play button that appears at the bottom of the page when you move your mouse anywhere on the page.

Step Two:

Now click on Airtight PostcardViewer in the Layout Style panel, and your images appear as small postcards on the page. In the Postcards section of the Appearance panel, you can choose how many columns you want, how thick the borders are, and how much space there is between the photos.

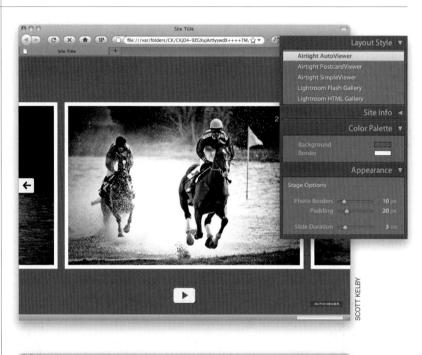

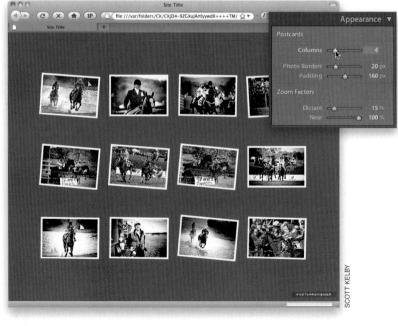

Develop

Print Web Slideshow

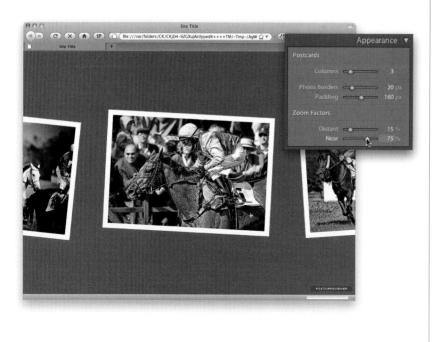

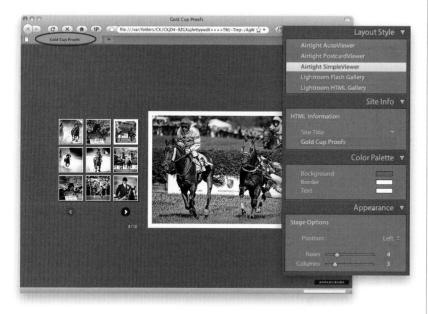

Step Three:

When you click on one of these tiny postcards, that postcard zooms to a larger size and comes "front and center" (as seen here). In the Zoom Factors section of the Appearance panel, the Distant slider controls how big the small thumbnail postcards will be (the default setting of 15% means they'll appear at 15% of their actual size). The Near slider controls how big the photo will appear when you click on one of those small postcards. The default 100% setting means it will appear as large as it can and still fit within the webpage window. So if you set this to a smaller size, like 75%, it will only scale to 75% as large as it could in the current window. If you click on the large-view image, it returns to the smaller postcard thumbnail view. Also, once the page has been created, people viewing your gallery can navigate around using the Arrow keys on their keyboard.

Step Four:

The last one of these Airtight Flash galleries is called Airtight SimpleViewer (and it's the one I probably use the most). It creates a simple grid of thumbnails on the left side of the page, and when you click on a thumbnail, a larger version is displayed on the right. In the Color Palette and Appearance panels, you get to adjust page colors and the number of rows and columns for your grid, as well as its position. The Site Info panel (which is available for all three of these Airtight galleries) lets you type in a title of your gallery, which will appear in the tab at the top of your Web browser's window (it will replace the default phrase "Site Title," which I have circled here in red). So there you have it—three other very cool Flash-based templates hidden over in the Layout Style panel.

Putting Your New Gallery on the Web

The last part of this process is actually getting your new gallery up live on the Web. You can either export your gallery to a folder and then upload it yourself, or use the Web module's built-in FTP capabilities for uploading your gallery to a Web server. If you don't already have a company that hosts your website on their server, that will be your first order of business. Try Googling "free Web hosting," and in about two seconds, you'll find loads of companies that are willing (read as: dying) to host your new site absolutely free.

Step One:

Now that your Web gallery is complete, you have two choices for getting your finished gallery up on the Web: (1) Export the files to a folder and upload the contents of that folder to your website (this is the method required by many Web hosting companies and almost all of the free hosting services, who have you do your uploading directly from a regular Web browser). Or if you're a bit more Web savvy, you can (2) use Lightroom's built-in FTP uploader to send your gallery right from Lightroom straight to your Web server (if you're wondering what FTP means, then you definitely want to go with Option #1). For now, we'll assume you're going with the first option (exporting to a folder), so click the Export button at the bottom of the right side Panels area (as shown here).

Step Two:

This brings up a Save Web Gallery dialog (shown here), where you name your exported gallery folder and choose where you want it saved. So give your folder a name, then click the Save button (as shown here).

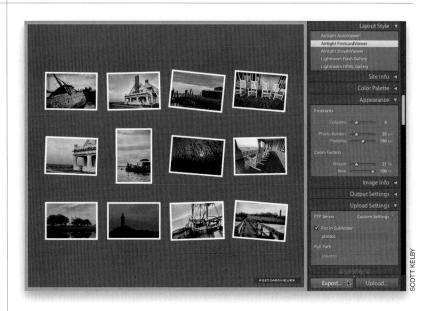

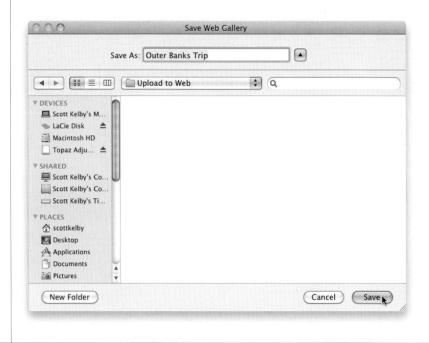

Library D

Develop

Slideshow 👘 Print

We<u>b</u>

				Layout Style
			Airtight A	
				ostcardViewer mpleViewer
				mpieviewer 5 Flash Gallery
K		ANNU - M		
- An	And Alt			Color Palette
Carlos and	Co	onfigure FTP File Transfer		Appearance
	Preset: Custom			
	Server: u654743@ftp.kelbymedia2	2.com		les - 20 px
	Username: skib	Password:		ing 🌰 🧑 160 px
		Store password in preset		
Part Section				
	Server Path: /server/mainsite/portfolio		Browse	ear 🔸 🔶 100 %
				lmage Info
	Protocol: FTP + Port: 2	Passive mode for data transfers: Passiv	re 🔅	Output Settings
and the		Cancel	OK	Edit -
- 2000				ifolder :
		NEW MARKEN	photos	
			Full Path :	
			photol	
				N/97C920
		POSTCANDVIEWER		

Step Three:

Once you click the Save button, Lightroom generates the webpage(s), and optimizes the photos for the Web for you (you can see the progress in the top left of Lightroom's taskbar). Once it's done, look in the folder you chose to save it in and you'll see the files and folders needed for your webpage. The file named index.html is your homepage, and the additional folder and files contain your web-optimized photos and other pages and resources your site needs. You'll need to upload everything in this folder to your website for your gallery to go live on the Web. Now, if instead you went with the second option (you're Web server savvy, and comfortable with FTP uploads and server protocols), then you'll need to configure your FTP upload first. So, scroll down to the Upload Settings panel in the right side Panels area, and from the FTP Server pop-up menu, choose Edit.

Step Four:

This brings up the Configure FTP File Transfer dialog (shown here), where you enter your server name, password, and the path to your homepage folder on the Web. Once you've entered this info, I recommend saving this as a preset (so you don't have to enter it again) by going to the Preset pop-up menu up top and choosing Save Current Settings as New Preset. By the way, if you don't choose the Store Password in Preset option, when you upload, it will ask you for your password again. Once you've entered your FTP info, click OK, and then click on the Upload button (at the bottom of the right side Panels area), and Lightroom will generate your webpage(s), optimize your photos for the Web, and upload the whole thing to your Web server, so your new gallery goes live on the Web.

Lightroom Quick Tips > >

▼ Hiding the Border Around Each Cell

Many of the HTML templates that come with Lightroom have borders around each cell. However, if you want to customize any of the other HTML templates, there is no checkbox to turn the cell borders on/ off. The trick is to go to the Color Palette panel, click on the Grid Lines color swatch, and choose the exact same color for the grid lines as the background color of the cells, and they'll disappear. Want to take it a step further? You can do the same trick with the cell color. Click on the Cells color swatch in the Color Palette panel, make the cell color the same as the background color of the page, and now your photos have no grid lines and no cells-they just appear right on the background, giving you an airy, uncluttered look.

Sampling Colors from Another Webpage

If you find a page on the Web that has a color scheme you really like, you can use the exact colors on your page really easily. Just go to the Color Palette panel and click on the color swatch of whatever you want to change. For example, let's say you want to change your background color, so click on the Background color swatch and, when the color picker appears, your cursor changes into a large eyedropper. Normally, you'd click on a color in the color picker itself, but if you click-and-hold, you can actually leave Lightroom (keep holding the mouse button down) and move this cursor out over that webpage, and as you move it, it samples the color of whatever's beneath it. When you get the new background color you like, just release the mouse button. Of course, to make this work, you'll have to be able to arrange your windows to see Lightroom and your Web browser onscreen at the same time.

Saving a Specific Gallery Design, and the Photos In It

Just like in the Print and Slideshow modules, the Collections panel in the Web module lets you save a Web gallery collection, which includes both the layout and the specific photos, in the same order, that you used to create your current gallery. That way, if you ever need to go back to that exact gallery, with the same layout and photos already in order, you can. To do this, just Right-click on a collection and, from the pop-up menu that appears, choose **Create Web Gallery**.

Save Time Using the Site Info Panel's Pop-Up Menus

Lightroom keeps track of any text you add in the title fields, contact field, Web or Mail Link field, and the description field, so rather than typing in the same stuff all over again, each time you create a Web gallery, you can just go to the Site Info panel (in the right side Panels area) and at the top right of each field, you'll see a little triangle. Click on it and a pop-up menu of the most recent text you entered in that field appears. Choose the one you want, and Lightroom enters it for you.

 What to Do If You See a Warning Icon Above the Image Pages Size Slider

The Image Pages slider (in the middle of the Appearance panel) lets you choose the size of the preview (larger) image _ibrary

Develop

Slideshow

Web

Print

Lightroom Quick Tips > >

people see when they click on a thumbnail. However, if you're in thumbnail view, and look at the top right of the Image Pages slider, you'll always see a little warning icon. That's letting you know that before you try to use this slider, you should click on a thumbnail first, so you can see the larger preview image (which is what that slider adjusts), because without seeing the larger size, you're kind of just dragging that slider blindly.

Save Space by Hiding the Upload Settings Panel

If you're not using Lightroom's builtin FTP feature to upload your Web gallery directly to your server, then you might as well hide the Upload Settings panel, so your right side Panels area is shorter and you spend less time scrolling. To do that, Rightclick on the panel header, and a popup menu appears, where you'll see checkmarks beside each visible panel. To hide the Upload Settings panel, just choose it from the menu. To get it back, choose it again.

You Can't Always Change the Size of Your Thumbnails

Although you do get the option of choosing the size of the preview (largersize) image people see when they click on a thumbnail, there is no option for changing the size of the thumbnails themselves in an HTML template (just thought I'd help keep you from pulling your hair out looking for it). But you do get the option with Flash-based templates (using the Size pop-up menu in the Thumbnail Images section of the Appearance panel).

Removing a Photo

By default, your Web gallery will include all the photos in your selected collection. To remove a photo from your gallery, you'll have to delete it from your collection or choose **Selected Photos** from

the Use pop-up menu at the left side of the toolbar beneath the center Preview area, so only your selected photos will appear in your gallery.

♥ Web Links

If you're using a gallery for client proofing, chances are it will be a page within your current website, and not your entire site itself. That's why you might want to consider having a Web link back to your main homepage. For example, let's say I posted a proofing page at www.scottkelby.com/ hapa. Then, in the Site Info panel, I would add a Web link back to www.scottkelby .com, and I would change the Contact Info text to read "Home Page."

Contact Info Home Page Web or Mail Link www.scottkelby.com

 Getting More Cool Flash-Based Web Galleries

If you're looking for more Lightroom Web galleries, my favorite site for them is LightroomGalleries.com. They have a number of free downloadable Web galleries you can access from right within Lightroom's Layout Style panel (you can find template installation instructions on their website). Also, for \$35, you can get the most sophisticated gallery out there: SlideShowPro (from http:// slideshowpro.net). (*Note:* We cannot guarantee the fitness of these websites. Please download at your own risk.)

Chapter 13 My Step-by-Step Process from the Shoot to the Final Print

My Portrait Workflow my step-by-step process from the shoot to the final print

If you've come to this chapter, you've either already invested a lot of time and energy in learning these techniques, or you just bought the book, and flipped right to this chapter, in which case you're one of those rabble-rousers who flaunt the time-honored tradition of book reading (where you start at Chapter 1 and work your way tirelessly through the book), and instead just jump to where the "good stuff" is hidden in the back. I'm going to assume you're not that person. Instead, I'll pretend you worked hard to get here, and therefore deserve a treat (Who's a good boy? Who's a good boy?). Thus far, the book has been one chapter on this topic, and another on that—one on importing, and another on editing; one on organizing, and another on printing. But I thought it would be helpful for you to see it all come together-to see the entire process from beginning to end-and I thought I would even include the details of the photo shoot. Why? Because it takes up more pages, and publishers love that, because they think what readers want is more pages. In fact, if you tell them, "I'm going to add a page with just random words," they get absolutely giddy. If you tell them you're including a few pages that say "This page intentionally left blank," they black out for a few moments, and have to be revived with smelling salts-this is the Holy Grail of book publishing. Now, I have no idea if, when this book was printed, they added some blank pages, but I can tell you this: if they did, they added page numbers to them, then ran around their offices high-fiving everybody in sight. Welcome to their world.

Workflow Step One: It All Starts with the Shoot

This is the workflow I use for shooting portraits. In this example, I'm doing a beauty-style headshot (using two studio strobes), so we'll start here with the shoot itself. I shoot tethered (where I connect the camera to my laptop and shoot directly into Lightroom itself) any chance I get, because you see your image at full-screen size rather than just on the tiny 3" LCD on the back of your camera.

Step One:

Before I set up the lighting, I use the USB cable that came with my camera to connect my Nikon DSLR to my laptop. Once connected, I launch Lightroom 3, then go under the File menu, under Tethered Capture, and choose **Start Tethered Capture**. I enter what I need to in the Tethered Capture Settings dialog (like where I want to save the images on my laptop), click OK, and it brings up the floating window you see here. Now, I'm ready to go (for all the details on setting up Lightroom's tethered capture, check out Chapters 1 and 4).

Step Two:

I used two lighting strobes for this shoot: The main light is on a boom stand—up high above my subject's head, and aiming back at her at a 45° angle (as seen here). On the front of this main light, I have a beauty dish attachment, which looks like a really large reflector. It's perfect for this type of shot, because the light is a little punchier than a softbox, without creating harsh-looking hard light (inside the dish, there's a little round metal reflector in front of the flash bulb. The light hits that metal reflector, which sends it back inside the dish to spread and soften it when it heads back toward your subject).

Note: There are two things you need to have your subject do to prepare for a beauty-style headshot: (1) have them wear an off-theshoulder top, and (2) have them pull their hair back into a pony tail, as seen here.

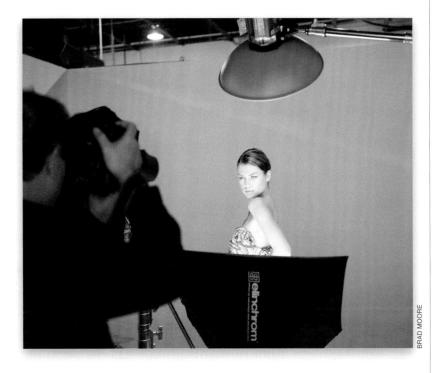

The second light is just supposed to fill in the shadows (so your subject doesn't have dark circles under her eyes and chin), so I position it low, aiming up at the subject's face at a 45° angle. I want this fill light softer than my main light, so instead of using another beauty dish attachment, I use a small softbox (this one is a 24" square softbox). If you look back at the production photo in Step Two, you'll see one light is up high, aiming down at a 45° angle, and the other is low, aiming up at a 45° angle. You then position yourself so you're shooting right in between these two lights (as shown here. You sometimes hear this lighting setup called either a "clamshell," because it kind of looks like a clamshell, or an "over-and-under" lighting setup).

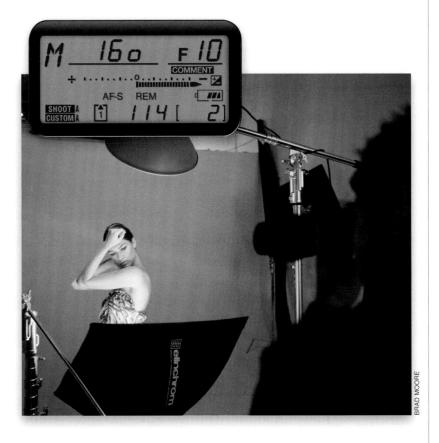

Step Four:

For this shoot, I used a full-frame Nikon D3 with a 70–200mm f/2.8 lens, and I shoot usually out around 200mm. I always shoot in Manual mode when I'm using studio strobes, and for this shoot, my starting place was f/5.6, at 1/160 of a second, and to keep my images looking as clean as possible, I used the lowest native ISO setting on my camera, which for the D3 is 200 ISO. I fired the strobes wirelessly, using Elinchrom Skyport wireless triggers.

Workflow Step Two: Right After the Shoot, Do This First

Once the shoot is over, before you start the sorting/editing process in Lightroom and Photoshop, you've got some absolutely critical "first-things-first" stuff to do, and that is to back up your photos, right now, before anything else—I actually back up even when I'm on location shoots (using two OWC Mercury On-The-Go High-Speed 80-GB portable hard drives). Here's the step by step on backing up:

Step One:

When you shoot tethered (directly from your camera to your laptop, like I did at this shoot), your photos are already in your computer, and they're already in Lightroom, but they're not backed up anywhere yetthe only copies of those photos are on that computer. If anything happens to your laptop, those photos are gone forever. So immediately after the shoot, I back up those photos. Although you can see the photos in Lightroom, you need to back up the photo files themselves. A quick way to find that folder is to go to Lightroom and Right-click on a photo from that shoot and choose Show in Finder (PC: Show in Explorer) from the pop-up menu, as shown here.

Step Two:

This opens a Finder (PC: Windows Explorer) window of the folder with your actual photo files inside, so click on that folder and drag the whole thing to your backup hard drive (this has to be a separate external hard drive—not just another partitioned disk on the same computer). If you don't have an external drive with you, then at the very least, burn that folder to a CD or DVD.

Okay, your photos are in Lightroom, they're backed up to a separate hard drive (or CD/DVD), so now it's time to make a collection of the keepers from the shoot, and get rid of the shots that are out-of-focus, the flash didn't fire for, or are just generally messed up (the Rejects). We're going to make our lives easy by creating a collection set right off the bat, and then we'll make other collections inside that set for our Picks and Selects (the final images we'll show to the client).

Workflow Step Three: Finding the "Keepers" & Making a Collection

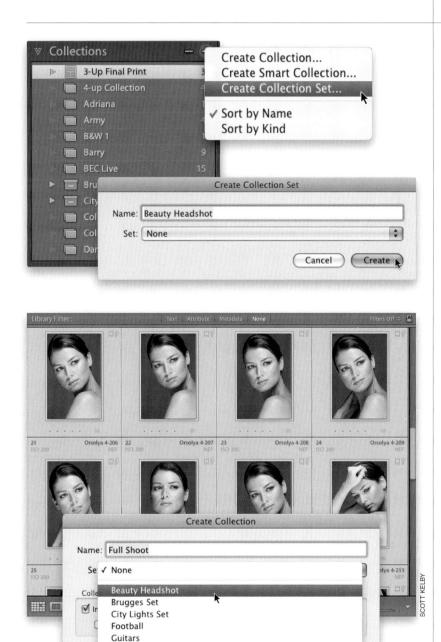

Orsolya Location

Ybor Location Shoot

Step One:

In the Library module, go to the Collections panel (in the left side Panels area), click on the + (plus sign) button on the right side of the panel header, and choose Create **Collection Set** from the pop-up menu. When the Create Collection Set dialog appears, name your new collection "Beauty Headshot," and then click the Create button. We've now got a set where we can save our Picks and our final images to show to the client. My workflow is just a little bit different when I shoot tethered like this, because I can't just click on Previous Import (at the top of the Catalog panel) and see all the photos I just imported, like I do when I'm importing from a memory card. So, I have a quick extra step, which sends me to the folder where I saved these shots, but don't worry, we're only there for quick minute.

Step Two:

Go to the Folders panel (in the left side Panels area), and click on the folder of photos from the studio shoot. Press **Command-A (PC: Ctrl-A)** to select all these photos you took during the shoot, then press **Command-N (PC: Ctrl-N)** to make a collection of these shots. When the Create Collection dialog appears, name your collection "Full Shoot," then choose Beauty Headshot from the Set pop-up menu (that way, this is saved under the main Beauty Headshot collection set, and we can keep all our beauty headshots within one big collection. This will make more sense in just a minute).

Continued

Now I go through the process of finding the keepers from the shoot. Go to the Collections panel, expand the Beauty Headshot collection set, and inside you'll see your Full Shoot collection. Click on it, then in the Grid view, double-click on the first photo (so it zooms into Loupe view), and start the process of flagging your Picks by pressing the letter **P** on your keyboard each time you see one, and your Rejects (shots that are out-of-focus, badly composed, messed up, etc.) by pressing the letter **X** when you see one of those. Use the Arrow keys on your keyboard to move through all your images (remember, just Picks and Rejects-no star ratings, etc.). For more on Picks and Rejects see page 53 in Chapter 2.

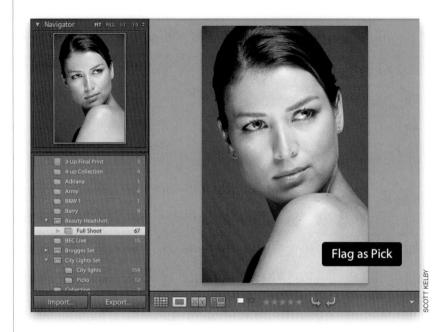

Step Four:

Once you've chosen your Picks (and deleted your Rejects by choosing Delete Rejected Photos from the Photo menu), go up to the Library Filter above the Preview area, click on Attribute, and then click on the white Picks flag to filter your images so only the Picks are showing. Now, press Command-A (PC: Ctrl-A) to select all the Picks, and then press Command-N (PC: Ctrl-N) to create a new collection. When the dialog appears, name this collection "Picks," from the Set pop-up menu, choose the Beauty Headshot set, make sure the Include Selected Photos checkbox is turned on. and click the Create button. This saves your Picks into their own collection inside your Beauty Headshot set (shown circled here in red). For more on collections, see page 52 in Chapter 2).

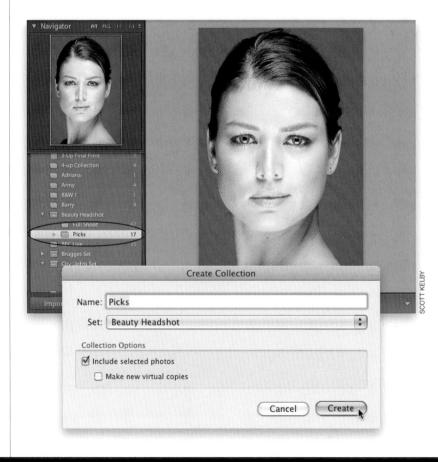

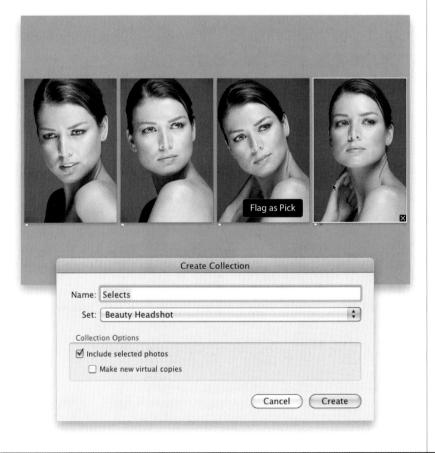

Step Five:

So these are the keepers from the shoot, but I like to narrow things down even further to just the ones I want my client to see. To get down to the "best of the best," I select all the images with a particular pose, then I try to just find the best shots of that pose. I have 17 photos total in my Picks collection (out of the 67 that I shot), but I want to get it down to just eight or nine of the very best shots. Here, I selected nine photos that all have a similar pose, then pressed the letter N to enter Survey mode, which makes narrowing things down much easier. I usually do the process of elimination at this point, starting up at the top left. I look at the shot and ask myself "Is this one of the best here?" If not, I move my cursor over the photo and an X appears in the bottom-right corner (as seen here). Click that X and the photo is taken out of contention (it's not deleted, just removed from this screen to help you narrow things down).

Step Six:

Here I narrowed it down to just the best four out of the nine. Now click on each photo, then press the P key to mark them as Picks (when you created your Picks collection, it automatically removed all the Picks flags, so now you can use them again). When you're done, press G to return to the normal Grid view, pick a group of the next pose, and do the same thing until you've gone through your entire Picks collection. Now, just turn on the Picks Flag filter (like we did in Step Four) and your very best shots are what you see onscreen. Select all these shots, and then create another new collection, name it "Selects," and save it in your Beauty Headshot collection set (as shown here). Now, those are the ones the client will actually get to see (and the only ones you're going to work on from here on out).

Workflow Step Four: Editing Your Selects

Now that you've whittled things down to the images you're going to show the client, it's decision time: are you going to let your client look at the proofs "as is," or do you want to tweak 'em a bit first in Lightroom's Develop module? If you're leaving them "as is," jump over to page 410. But, if you want to take a couple of minutes and tweak the white balance, exposure, and other simple adjustments, then stick with me here. By the way, these are just some quick tweaks—we don't want to invest a bunch of editing time now, because the client is probably only looking for a couple final images.

Step One:

These shots need a white balance adjustment, so go to the Develop module's Basic panel. We fixed another photo from this shoot on page 124 in Chapter Four, so you can go there for more details, but I shot our subject on a gray background that looks kind of brownish here (and her skin tones look kind of yellowish). Since they all have a similar icky white balance, press Command-A (PC: Ctrl-A) to select all the images (as you see here). Get the White Balance Selector tool (W) and click it on the background in one of those photos, and now they've all got the right white balance. Actually, for this beauty look, I like the white balance a tiny bit colder, so I dragged the Temp slider to the left a tiny bit (as shown here). By the way, if you have all the photos selected, and you set the white balance for one, and the others don't change, you don't have the Auto Sync button turned on (see page 157 on Auto Sync).

Step Two:

The exposure's okay for most of these photos (though I had to increase the Exposure a bit for one), but I normally would brighten the whites of the eyes before I send them (see page 180 in Chapter 5). Here's another way to brighten the eyes: grab the Adjustment Brush **(K)**, and paint a little more Exposure over just the whites of the eyes (as shown here). Depending on the photo, you might then click the New button, choose **Contrast** from the Effect menu, increase the Contrast amount, and paint over the iris and pupil (in this case, I'm okay with it for a proof). Now do the same whitening on the other eight images.

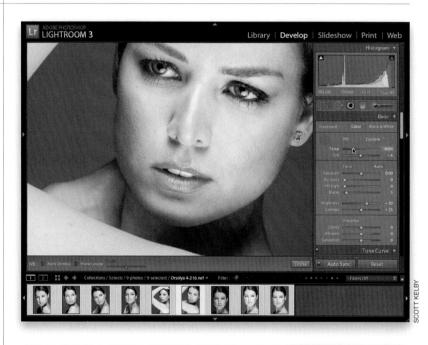

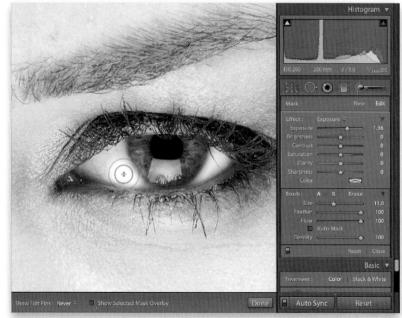

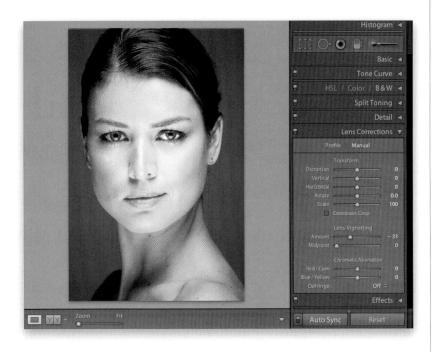

Lastly, you might add a very light vignette effect to darken the edge areas of the photo, and really focus the attention on her face. Go to the Lens Corrections panel and at the top, click on Manual. Then, in the Lens Vignetting section, set the amount to -33, and the Midpoint (how far the darkening extends into your image) to 0 (the maximum amount) to get the subtle effect you see here. That's all the tweaking I'd do at this point, but of course, when the client makes their final decision, then I'd come back and really work on the eyes, remove any blemishes (using the Spot Removal tool), add some dodging and burning to enhance the shadows and highlights on her face (with the Adjustment Brush), etc., but that's all I would do in Lightroom at this point.

BONUS VIDEO:

Even though they're not part of my initial Lightroom workflow, I did a bonus video for you with those retouches to this photo. You can find it at **www.kelbytraining** .com/books/LR3.

Workflow Step Five: Letting Your Clients Proof on the Web

At this point, we've got the photos we want to show our client tweaked (or you're showing them pretty much "as is"), and it's time to put these proofs on the Web so the client can make a decision. We're going to use Lightroom to create a simple proofing webpage—the same one I use myself for client proofing and it just takes a couple of minutes to get it up and running, because we're going to customize one of the built-in templates that come with Lightroom 3.

Step One:

Go to the Web module, and in the Collections panel in the left side Panels area. click on your Selects collection. This loads your photos into whichever Web template you used the last time you were here in the Web module. Also, in the toolbar, make sure that All Filmstrip Photos is selected in the Use pop-up menu (as shown here). We're going to customize one of the built-in templates, so go to the Template Browser panel in the left side Panels area and click on HTML Gallery (Default), shown here. One of the main reasons I like using this particular template for proofing is that it puts a large number in the top-left corner of each cell, which makes it easier for clients to tell you which photos they've approved.

Step Two:

Let's spend two minutes customizing the look and text of this template. First, if you have an Identity Plate with your studio's name, turn that on (as shown here, in the Site Info panel in the right side Panels area). If not, just click directly on the words "Site Title" (right on the webpage itself) and type in your studio's name. Then add any other lines of text you want by clicking on the placeholder text and adding your own. Also, add your email address in the Web or Mail Link field, beneath the Contact Info field, in the Site Info panel (all this is explained in detail back in Chapter 12). Plus, you might want to change "My Photographs" to something a bit more meaningful, eh?

One thing I always change in this default template is the color (darkness) of the numbers. I've had clients mention that they really didn't notice them at first, so I always make them a little darker. Scroll down to the Color Palette panel (in the right side Panels area), and you'll see a Numbers color swatch. Click on it to bring up the Numbers color picker, and click on a darker gray color swatch at the top (as shown here). You see a live preview as you choose different shades of gray, so just pick one that contrasts with the background enough that the numbers easily stand out, then close the color picker by clicking on the little X in the upper-left corner.

Step Four:

You're pretty much ready to go, but at this point, I always preview the webpage to see how the final will look (and to test everything to make sure it works, including my email link). So, click the Preview in Browser button at the bottom of the left side Panels area, and it will launch your Web browser and open your proofing page, so you can see a real preview of the final working webpage (as seen here). I click on the thumbnails to see if I like how the larger-sized previews look (if this larger preview seems too small, you can change the size in the Appearance panel), and I always check the email link to see if it launches my email program and puts in the right email address. If everything looks good, click the Export button at the bottom of the right side Panels area to save your HTML webpage for uploading to the Web. If you're hosting your own website on your server, you can direct Lightroom to an FTP site by clicking the Upload button instead (right next to the Export button. Again, more on all of this stuff back in Chapter 12).

Workflow Step Six: Making the Final Tweaks & Working with Photoshop

Once the client gets back to me with their picks, then I start working on the final images—first in Lightroom, and then, if necessary, I jump over to Photoshop. In this case, since we'll be doing some more involved portrait retouching, we'll jump over to Photoshop for that stuff, but the process always starts here in Lightroom.

Step One:

Once the client emails me their picks, I go back to the Selects collection in the Library module and I either flag just those images as Picks, or I label them as Red by pressing the number 6 on my keyboard (I don't usually do this, but you could even make a separate collection with just their final picks and name it "Client Selects," but that's totally up to you). In this case, the client only chose two shots (which I marked with a Red label), and they'll both get very similar retouches. There are two little tweaks I want to make here in Lightroom, before heading over to Photoshop: The first is to increase the Exposure amount just a little, so the image looks nice and bright (which is typical of beauty-style headshots), so go to the Basic panel in the Develop module and drag the Exposure slider to the right just a little bit (here I increased it to +0.40).

Step Two:

The second thing I would do is darken her shoulder and the back of her neck. Her face is the focus of the image, and the eye is naturally drawn to the brightest thing in the photo first, and we don't want that to be her shoulder, right? So, get the Adjustment Brush (K), choose **Exposure** from the Effect pop-up menu (to reset all your brush sliders to zero), drag the Exposure slider a little to the left so it darkens the image, then paint over her shoulder and the back of her neck (as shown here) to darken those areas. Remember, after you paint, you can always go back and change the Exposure amount so it looks just right.

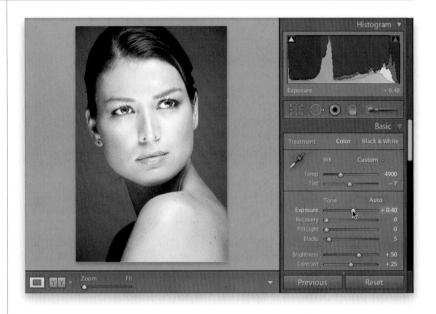

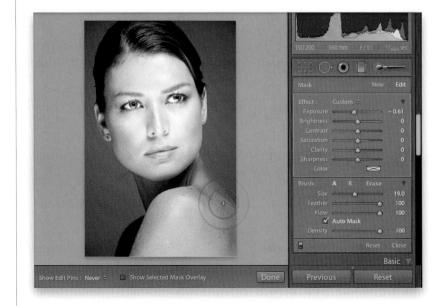

Slideshow

Web

Print

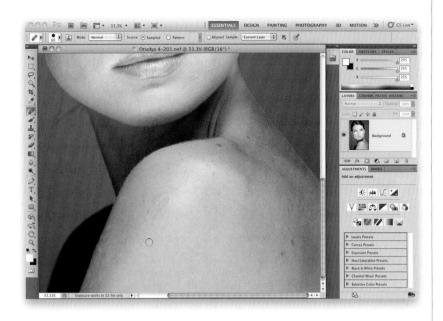

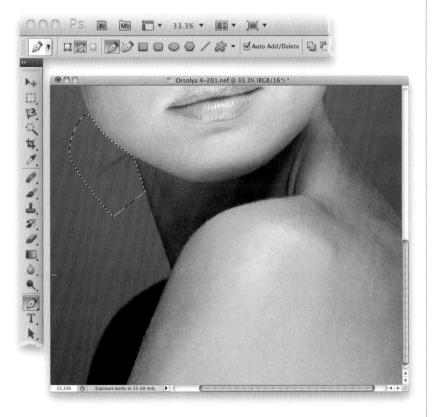

Step Three:

Now, let's head over to Photoshop. Press Command-E (PC: Ctrl-E) and in a few moments, your image will appear in Photoshop (as shown here). Of course, that's providing you have Photoshop (if you're using Photoshop Elements instead, it will open in Elements). I always start a retouching project by removing blemishes first. Technically, I could have removed these in Lightroom, using the Spot Removal tool, but I'm faster with Photoshop's Healing Brush, and I like to use Photoshop's Patch tool for larger blemishes. So, if I'm going to Photoshop anyway, I do the blemish removal there. Get the Healing Brush (press **Shift-J** until you have it), make your brush size a little larger than the blemish you want to remove, then put your brush cursor over a clean spot near the blemish. Option-click (PC: Alt-click) on the clean spot, then move your cursor over the blemish, and click once to remove it. Don't paint—just click.

Step Four:

If you want to remove a scar, or a bigger blemish (or a group of them), switch to the Patch tool (press Shift-J until you have it) and draw a loose selection around the blemishes. Click inside the selection, drag it to a clean area of skin, and release the mouse button. It snaps back into position, and your blemishes are gone. Here, you see the image after about 60 seconds with the Healing Brush and Patch tools. Let's move on to the next thing: some strands of hair from her ponytail are sticking out. You'd use the Clone Stamp tool to remove this (it's an easy retouch), but you don't want to accidentally erase part of her cheek or neck, so I always start by putting a selection around the area I'm going to clone away first. Then you can only clone inside that selected area, so you can't accidentally clone outside it and damage her cheek or neck (I made the selection here using the Pen tool, then converted it to a selection, but use any selection tool you like).

Continued

Step Five:

With your selection in place, get the Clone Stamp tool (S) and Option-click (PC: Alt-click) on a nearby clean area of the background. Then, just paint over the stray hairs within your selection (as shown here). Again, with the selection in place, you can't accidentally clone outside of it onto her cheek or neck. When you're done, press **Command-D** (PC: Ctrl-D) to Deselect.

Step Six:

When you do a beauty headshot like this, you always wind up doing some retouching to the hair. In this case, there are some little hair indents (you can see them here right above her ear), but we can even those out so they're not noticeable. Go under the Filter menu and choose **Liquify** (the retoucher's secret weapon). This brings up the Liquify dialog, with its own set of tools and controls (don't worry—we're only going to use one tool here, and we're not even going to touch the controls on the right side of the dialog).

Slideshow Print

Web

Step Seven:

Click on the Forward Warp tool (the first tool in the Toolbox in the top-left side of the dialog), and make your brush a bit larger (use the Left and Right Bracket keys on your keyboard to change your brush size) than the area you want to move around (yup, you're going to move her hair into place). Then, take the brush, click at the bottom of the "dip" in her indent, and literally just push it out (as shown here) until it's even with the rest of her hair. It may take you a few different pushes to get it nice and even like this, but once you work with it for a minute or two, you'll totally get the feel for how it works. Basically, it lets you move things around like they're liquid (not water—it's more like moving maple syrup, but that's what you want). When you're done with this side of her hair, you'll see some other indents on the other side of her head, so fix those as well (using the same tool), then click OK to apply these changes.

Step Eight:

You can see in the image shown here, her hair looks much more even now. So, switch to the Healing Brush again, and let's remove those tiny wrinkle lines under her eyes (they're pretty darn minor, but that's what retouching usually is—fixing a lot of little tiny things). Move the Healing Brush to a smooth area right near the left side of her wrinkle, Option-click (PC: Alt-click) to choose that as your sampling point, then paint over the wrinkle, and it's gone. There are two under each eye, so just carefully heal them away (ahhh, if it was only this easy in real life, eh?).

Continued

Step Nine:

Okay, let's add some highlights to her hair. Duplicate the Background layer by pressing Command-J (PC: Ctrl-J), then change the blend mode for this layer from Normal to Screen. This makes the photo really bright. Now, press-and-hold the Option (PC: Alt) key, and click on the Add Layer Mask icon at the bottom of the Layers panel (shown circled in red here) to hide this brighter layer behind a solid black mask. Now, get the Brush tool (B), choose a soft-edged brush (from the Brush Picker up the Options Bar), set your Foreground color to white (press the letter **D**), and then paint over the highlights already in her hair. It'll look too bright at first, but you can control how bright they are using the Opacity slider for this layer. Lower it to around 60% (as shown here) to make the highlights look more natural.

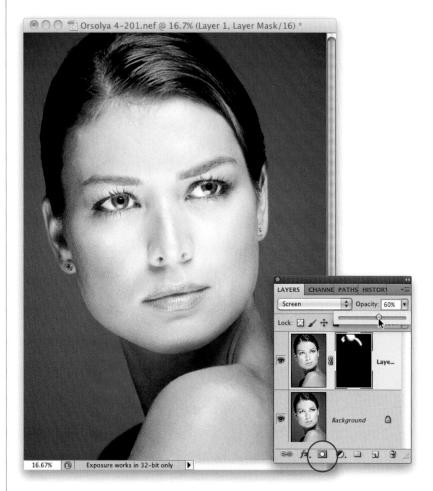

Step 10:

Next, let's get really nitpicky. There are two wrinkles on her neck, because she's twisting her head toward the camera (look back at the image in Step Nine). Zoom in tight so you can really see them clearly. Then press Command-Option-Shift-E (PC: Ctrl-Alt-Shift- E) to make a new layer that is a flattened version of your image (this leaves your other layers intact, just in case you need to go back to them later. We're not going to, but ya know—just in case). Now, get the Patch tool and draw a selection around the first wrinkle. Click inside the selected area and drag it to the right to an area that doesn't have a wrinkle, then release the mouse button and it's gone! Do both wrinkles and if it leaves anything behind, switch to the Healing Brush and remove anything left over.

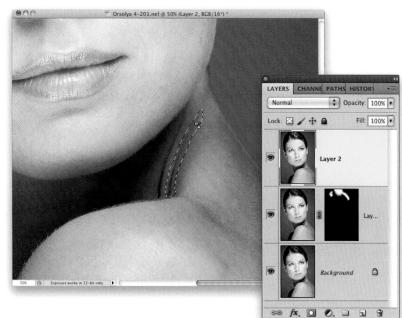

Slideshow Print Web

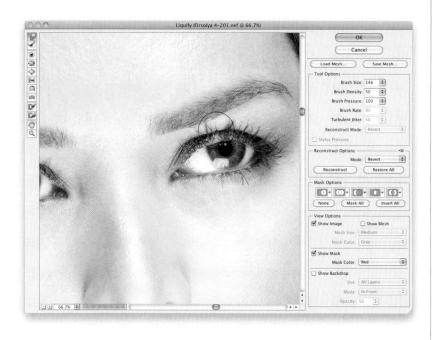

Step 11 :

Nitpicky, part 2: her eyelid on the right side of the image is kind of droopy, so go back to the Liquify filter, get the Forward Warp tool, put your cursor just above her eyelid, and click-and-drag upward (be careful not to drag her iris, or her eye will start to look like an oval). It may take a few little nudges upward to get this just right, but just remember to use small little nudges, and you'll get there. When you're done, click OK to apply your retouch to the eyelid.

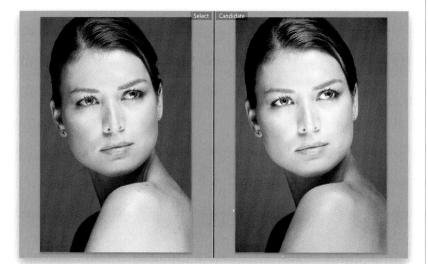

Step 12:

Once all your editing in Photoshop is done, you have two important steps left: (1) Save the image by pressing Command-S (PC: Ctrl-S). Don't rename it. Don't choose a new place to save it. Don't choose Save As. Just a simple Command-S Save is all you need. And (2) close the image. That's itdo just those two things, and the edited image will appear in Lightroom right beside the original unedited image with "-Edit" at the end of its filename (here I've put the two side by side, so you can see the differences between them, which include the fixed stray hairs, a brighter face, the removal of blemishes, brighter and more contrasty eyes, the removal of wrinkles from her neck, the darkened shoulder and neck that puts the emphasis on her face, and the enhanced highlights in her hair). Next, we'll look at how to deliver the finished files to your client.

Workflow Step Seven: Delivering the Finished Images

Once both of your images have been retouched, it's time to deliver the final images to the client, and these are most often delivered in one of three ways: (1) you make final prints for the client, (2) you email high- or low-resolution copies of the final images to the client, or (3) you burn the final images to CD/DVD and deliver them the old-fashioned way. Here's a quick look at all three, with printing it yourself, of course, being the one that takes the most work, so we'll start with the two easier ones first.

Step One:

To save your images to a CD/DVD, start by pressing Command-Shift-E (PC: Ctrl-Shift-E) to bring up the Export dialog (seen here). In the list of Lightroom Presets on the left, click on Burn Full-Sized JPEGs. Under File Naming, choose and enter a Custom Name, then in the File Settings section, for the JPEG quality, I normally choose 80. Make sure the Sharpen For checkbox in Output Sharpening is turned on (I chose Glossy Paper and Standard Amount), then turn on the Minimize Embedded Metadata checkbox in the Metadata section, so your personal camera info is removed (but not your copyright info). Also choose whether you want a watermark included on your image, then click Export, and get a blank disc ready to insert into your CD/DVD drive.

Step Two:

If you're going to email the images, then click on the For E-Mail preset (in the Lightroom Presets on the left side of the Export dialog; or just choose the Send in Email preset we made back in Chapter 7), and you'll see that at the top of the dialog, the Export To pop-up menu now reads Hard Drive, so it just saves the files on your computer, rather than burning them to disc automatically. I usually increase the File Settings Quality to 80 here, as well, but if file size is a big concern, leave it set at 50. By default, this preset shrinks the physical size of the photos you're going to email, so if you want your images to arrive at their full size, then turn off the Resize to Fit checkbox in the Image Sizing section.

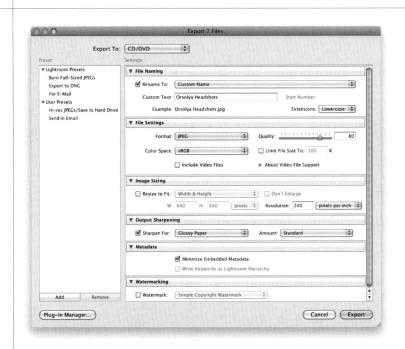

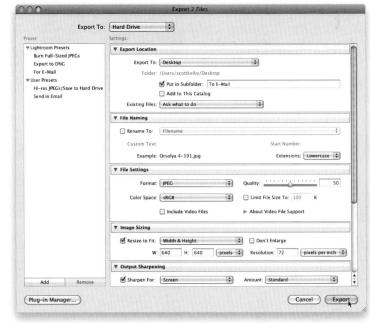

Develop

Slideshow

Web

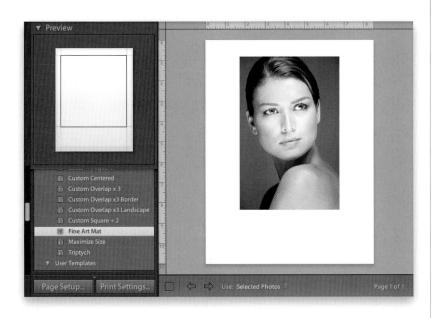

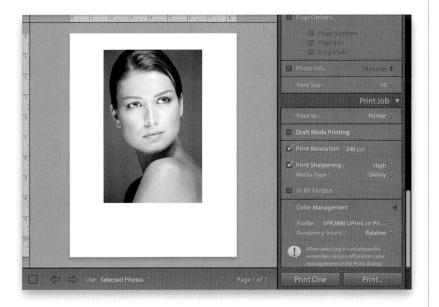

Step Three:

If, instead, you're going to output prints yourself, first jump over to the Print module and, in the Template Browser in the left side Panels area, click on whichever template you want to use (I chose the Fine Art Mat template for the image you see here). The default page setup for this template is US Letter (8x11"), so if you need a different size, click the Page Setup button (at the bottom of the left side Panels area) and choose your size there. When the dialog appears, choose the printer, paper size, and orientation, then click OK to apply these settings. You might need to tweak the margins a bit after choosing a new page size, since it doesn't automatically adjust everything, so the layout looks the same.

Print

Step Four:

Now it's time to print the image (this is covered in-depth starting back on page 356 in Chapter 11). Scroll down to the Print Job panel (in the right side Panels area), and from the Print To pop-up menu at the top, choose Printer. Then for Print Resolution, since I'm printing to a color inkjet printer, I can leave it at 240 ppi. Make sure the Print Sharpening checkbox is turned on, choose the amount of sharpening from the popup menu on the right (I generally choose High for glossy prints), and then choose the type of paper you'll be printing on from the Media Type pop-up menu (I chose Glossy here). If your printer supports 16-bit printing, then you can turn on the 16 Bit Output checkbox (at this point, only Macs running OS X Leopard or higher support 16-bit printing). Then, in the Color Management section, choose your Profile and set your Rendering Intent (again, covered in Chapter 11). I chose Relative here.

Continued

Step Five:

Now click the Print button at the bottom of the right side Panels area, and the Print dialog appears (the one shown here is from a Mac, but the Windows print dialog has the same basic features, just in a different layout). Choose Print Settings from the pop-up menu in the middle of the dialog, and in the Basic tab, under Color settings, turn your printer's color management off by choosing Off (No Color Adjustment), as shown here (the last thing you want is two color management schemes, both trying to determine the right color, and then it's "Lightroom vs. Printer" and nobody wins). Choose the type of paper you're printing to from the Media Type pop-up menu, then under Print Quality, I use SuperFine – 1440dpi with the High Speed checkbox turned on.

Step Six:

Now, just click the Print button, sit back, and wait for that puppy to roll out of the printer. If the image comes out too light, I take the photo back to the Develop module, increase the Brightness in the Basic panel a little, and make another test print-I keep tweaking the amount of Brightness until it looks dead on. If the image looks too red, or too blue, etc., in the Develop module, I go to the HSL panel, and lower the amount of Saturation for the color I'm seeing too much of in the print, then I make another test print (the key to getting a great print is to start by making a test print, evaluate how the image looksversus how it looks onscreen—then tweak the image a bit, make another test print, and so on). There you have it: my portrait workflow, from beginning to end. Remember, this workflow stuff is at the very end of the book for a reason—because it only makes sense after you've read the rest of the book first. So, if anything didn't make sense, make sure you go back and reference the page numbers I gave you here, so you can learn about anything you might have skipped over, or didn't think you'd need, earlier in the book.

	Print	
Printer:	O EPSON Stylus Photo R2880	
	Standard	•
Copies:	1 Collated	
Pages:		
	O From: 1 to: 1	
	Print Settings	•
	Basic Advanced Color Setting	gs
Page Setup :	Manual - Roll	•
	Color Controls PhotoEnhance ✓ Off (No Color Adjustment) SuperFine - 1440dpi €	ter 🗘
	High Speed	
	 Mirror Image ✓ Finest Detail 	
	These Decan	
? PDF v Pre	view Supplies	Cancel Print
	1	
E	632	
	9765 97768	
		A CONTRACTOR
the start of the s		

Chapter 14 My Seven Points in Lightroom

7-Point System my seven points in lightroom

One of the most successful books I've ever written was Scott Kelby's 7-Point System for Adobe Photoshop CS3. But, it originally wasn't going to be called that. The original idea came from my brother Jeff, who said he'd love to see me write a book where I did nothing but start off with a crappy (his words) image, straight out of the camera, and then take that image through all the steps, in detail, of making it into an image that would be worthy of making a framed print. I liked his idea and so I started collecting problem images in a folder-images that had good composition, but had other problems, like massive white balance or exposure problems, or anything I thought I could fix to save what otherwise would have been a discarded image. After a while, I had a bunch of images, so I started writing the book. Each chapter would be me taking a problem photo from beginning to end. About eight or nine

chapters in, I suddenly realized that, although these images had different problems, I was still using just the same few tools in Photoshop to fix them. I was actually psyched, because I realized that if I could teach people just those seven points, they'd be able to tackle virtually any problem, so I changed the book to focus on just those seven points, and luckily it really clicked with users. Well, that was written for Photoshop CS3 (gasp!), and in the years since then, I've now streamlined my 7-Point System to where it all happens in Lightroom's Develop module, using just seven tools there. So here, I wanted to share with you my updated 7-Point System for Lightroom, so you can focus on getting really good at just these seven points (and refer back to the Develop chapters earlier in the book for more details). Get good at these seven points, and you'll agree-"you can't beat the system." ;-)

The 7-Point System: Project One

The First Point: Choose a Camera Profile

Here's the original RAW photo, straight out of the camera (I know-yeech!). The first point in the 7-Point System is to go to the Develop module and choose a better starting place with your image for your editing (so you start with a photo that looks more like the already processed JPEG—see page 122 for more). Go to the Camera Calibration panel and try out some of the camera profiles in the Profile pop-up menu near the top of the panel (by the way, you only get to choose camera profiles for images you shot in RAW mode, because JPEGs already have an embedded camera profile, but RAW photos don't). I usually wind up using either: Camera Landscape, Camera Vivid, or Camera Standard.

Here's the image after choosing Camera Vivid. It's hard to tell, because the white balance is so far off on this particular photo, but take a look at the sides of the clock and you'll see it's more contrasty, it looks sharper, and the colors are more vivid (in other words, it looks more like the image you saw on the back of your camera). This one adjustment can often make a huge difference in your image, but in this particular one, the white balance is just off by so much, it's pretty subtle, but usually, this change will appear more dramatic, and that's why it's the first thing I do when editing images. After using Lightroom for years now (this is my third book on the application), I've realized that although there are a ton of editing adjustments you can do to your photos in Lightroom, I wind up doing the same seven things to nearly every photo I touch. So, if you can get really good at just these seven things, you'll be a Develop module shark, because there won't be any photo where you just don't know what to do first, or what to do next. The first image we'll take through my 7-Point System is a travel photo.

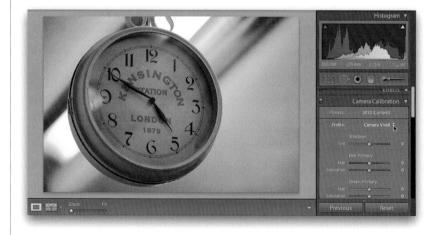

🚼 🔶 424 🔶 🛛 Chapter 14 / My Seven Points in Lightroom 🛲

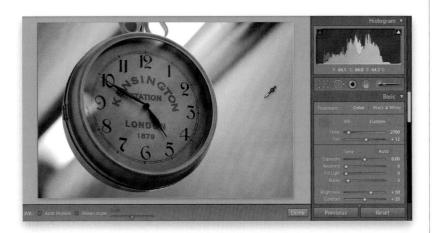

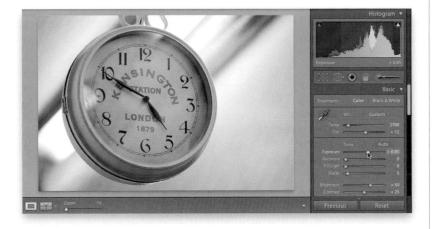

The Second Point: Adjust the White Balance

It was a very cloudy day outside when I took this shot, so I had my camera's white balance set to Cloudy. It eventually started raining, so we ducked inside a nearby coffee shop, and while waiting for our coffee to arrive, I looked up at the ceiling and saw this clock that looked kind of out of place in a coffee shop in Bruges, Belgium, so I grabbed a quick shot of it. My white balance was still set on Cloudy that's why the shot looks so orange/yellow, but that's easily fixed in one of three ways in the Basic panel (covered on page 124): (1) try one of the built-in White Balance presets (Tungsten seems to look the best for this photo), (2) drag the Temp slider toward blue until the yellow color goes away, or (3) do what I did here, and grab the White Balance Selector tool, click it on something you think is supposed to be light gray (I clicked on the wall to the right of the clock here), and the white balance is fixed.

The Third Point:

Adjust the Overall Exposure The third point of the 7-Point System is about adjusting the overall exposure using the Basic panel's Exposure, Recovery, Brightness, Fill Light, and Blacks (shadows) sliders. The photo looks kind of dark, so we'll start by dragging the Exposure slider to the right, so the whole image is brighter (as shown here). If you look in the top-right corner of the histogram, you can see that we have a clipping warning (see page 135), and if you click on it, you'll see that what's clipping is the lights in the ceiling behind the clock. The background's out-of-focus, and this isn't an area of important detail, so I wouldn't sweat trying to fix it (you can drag the Recovery slider to the right a bit, but you'll see that it's too blown out to be fixed. Luckily for us, like I said, it's not an area of important detail).

Continued

Since there is bright light behind our subject (the clock), you might want to bring up the Fill Light a little bit to brighten the clock (as shown here). Just remember, if you drag this slider pretty far to the right, you'll also have to drag the Blacks slider to the right a bit to keep things from looking too washed out (and the photo looks a little washed out to begin with, so we don't want to make things worse, right?).

You can fix the washed out overall look by bringing back some color saturation and depth in the shadow areas. Just drag the Blacks slider to the right until the color looks nice and rich, and the photo doesn't look washed out any longer (as shown here, where I dragged the Blacks slider over to 30).

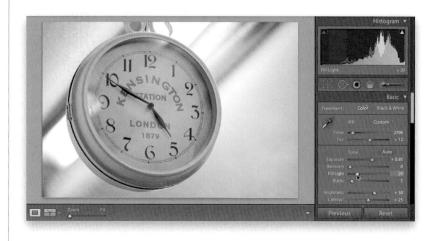

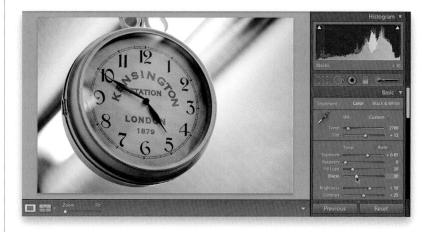

The Fourth Point: Adding Contrast

The next point is to add more contrast to the photo, since most RAW photos tend to look a little flat (maybe that's why Adobe has the Point Curve set to Medium Contrast by default for all RAW images. For JPEGs, there's no contrast added at all-the Point Curve is set to Linear). Go to the Tone Curve panel, and choose Strong **Contrast** from the Point Curve pop-up menu (as shown here). If that's enough contrast, you're set. If not, just make the curve steeper to add more contrast (click on the second point from the top, then use the **Up Arrow key** to move it higher and increase the highlight areas in your photo. Then click on the second point from the bottom of the curve, and press the Down Arrow key on your keyboard a couple of times to increase the blacks. I didn't think I needed it with this one, but now you know just in case. More on this on page 142).

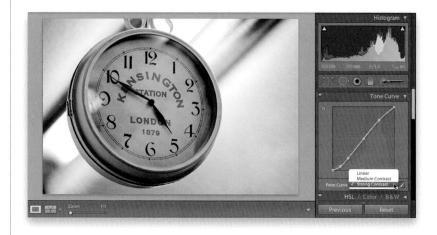

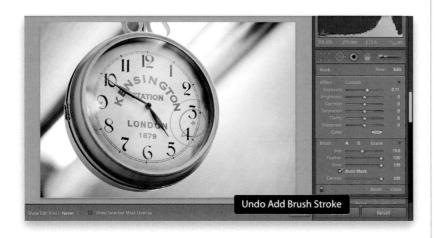

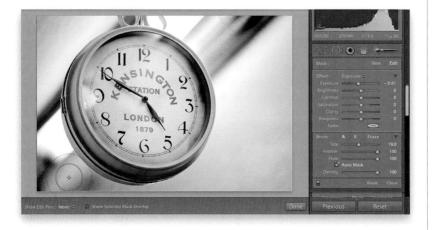

The Fifth Point: Local Adjustments

Local adjustments are anything you do that affects just one part of your photo, and the tools that do this are found right below the Histogram panel (more on this in Chapter 5). For example, to make just the face of the clock brighter (without affecting anything else), click on the Adjustment Brush, then choose Exposure from the Effect pop-up menu that appears in the Adjustment Brush options panel (it appears below the brush when you click on it). Drag the Exposure slider to the right a bit, then take the brush and paint over just the face of the clock (as you see here). If you make a mistake, press Command-Z (PC: Ctrl-Z) to undo your stroke (as shown here), then start again. Also, make sure the Auto Mask checkbox is turned on—it helps keep you from accidentally painting outside the face of the clock. After you've painted over the face, you can still adjust the exposure by dragging the slider.

Now let's use the same tool to darken parts of the background, so the clock really stands out (in the last step we "dodged," making certain areas of the image brighter, and now you're going to "burn," making parts darker). Click on New at the top of the options panel, drag the Exposure slider to the left to -75, then start painting on the diagonal bar behind the clock (as shown here). If, after painting, you think it looks too dark, just raise the Exposure amount, like I did here where I raised it a little to -61.

Continued

The Sixth Point:

Adding Punch and Enhancing Color

At this point, we've done most of the major editing, and now we're going to fine-tune the image by adding some punch (using the Clarity slider), and we're going to enhance the color (using the Vibrance slider). Since this image has lots of well-defined edges and detail (it's a clock, after all), you can apply a lot of clarity, so drag the Clarity slider over to around +70 to add midtone contrast and punch (more on the Clarity slider back on page 140). To make the colors pop a little more, drag the Vibrance slider over to the right just a little to +10 (as shown here. More on this back on page 141).

The Seventh Point: Finishing Effects

The finishing effects you use will depend on what type of image you're working on. The one I would choose for this image is the vignette effect, which intentionally darkens the edges of the image, focusing the attention on the subject (see page 149 for more on vignetting). Go to the Lens Corrections panel and click on Manual at the top, then drag the Lens Vignetting Amount slider to the left to -56 (as shown here), and the Midpoint slider all the way to the left (so the darkening extends in toward the center as much as possible) to create the final image you see here. A before/after, using just these seven points, is shown below. Now, onto another project (repetition is what makes the seven points really stick).

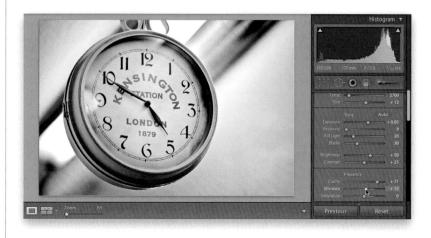

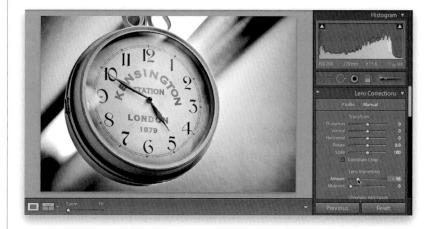

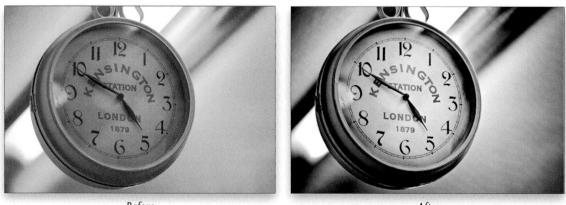

Before

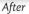

This is a fashion shot, and you'll use the same seven points in the same way. That's the thing about "The System"—you pretty much use the same things, the same way, every time. The reason I give you totally different images for each projects is: (a) so you can see it's actually the same seven points, and (b) the more you practice, the better you'll get at them, and soon it'll be automatic. When you get to the stage where you don't have to look at the book to know what to do next, then you'll know you've got it!

The 7-Point System: Project Two

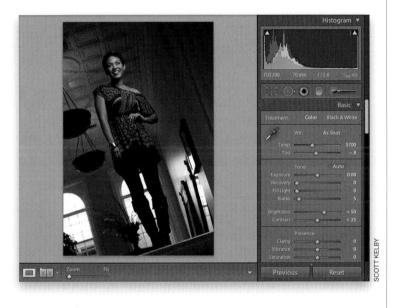

The First Point: Choose a Camera Profile

Here's the original RAW photo, straight out of the camera, and it actually doesn't look too bad (besides being a little bit dark and the white balance being a bit too warm). The first step is to choose a better starting place, so go to the Develop module, then go down to the Camera Calibration panel and try out some of the different profiles.

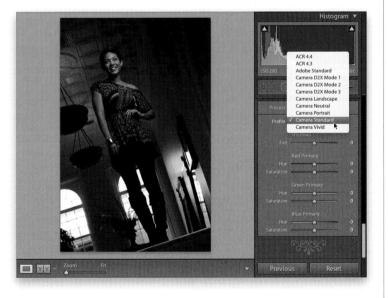

I tried my two first-choice profiles, Camera Landscape and Camera Vivid, and neither of them looked that great, but Camera Standard seemed to look much better for the flesh tones, so I went with that (as shown here).

Continued

The Second Point: Adjust the White Balance

Now go up to the Basic panel and start by choosing a preset white balance to see if that'll work for you. In this case, I chose Auto and that actually looked pretty darn good, so I stopped my search right there. If I thought I might be able to do better, I'd use the Auto setting as my starting place, and then I'd tweak the Temp and Tint sliders, or better yet, I'd click the White Balance Selector tool **(W)** somewhere in the ceiling (most likely), but Auto looked good to me, so this was an easy fix.

The Third Point: Adjust the Overall Exposure

The photo is kind of dark overall, so clickand-drag the Exposure slider to the right to around +0.75 (shown here) to brighten things up. You can see in the histogram that the highlight clipping warning is on, but if you click on it, you'll see the parts that are clipping are outside the windows in the background, so you can choose to either reduce that blown-out area a little or not at all. Either way, those aren't areas of important detail, so I'll let those just stay as-is.

I positioned the light in this shot so it had a lot of falloff (meaning that her head and shoulders were well lit, but then the light fell off from there, getting progressively darker as it moved toward her boots), but I also want to make sure we have plenty of detail in her outfit, so let's go ahead and increase the Fill Light a little bit (drag it to the right to 17, as shown here). If you drag much farther, you'd have to bring up the Blacks a little bit to keep things from looking washed out, but things look pretty good so far, so this Fill Light adjustment should do the trick.

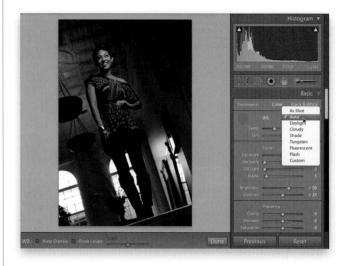

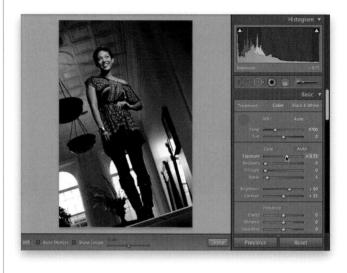

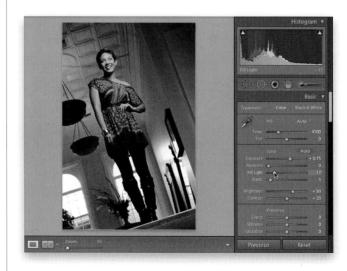

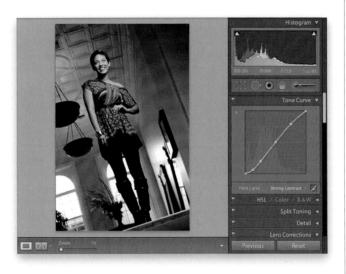

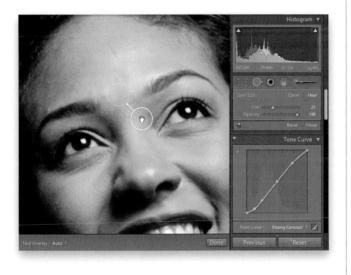

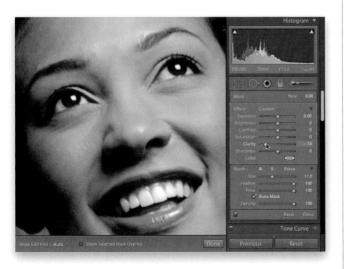

The Fourth Point: Adding Contrast

To enhance the contrast a bit, go to the Tone Curve panel, and choose **Strong Contrast** from the Point Curve pop-up menu (shown here). If we make it any more contrasty, the shadows might start to get too dark, so this is as far as we'll take the contrast for now, but if you feel you need more, you know what to do (we covered it in the first project with the clock photo).

The Fifth Point: Local Adjustments

Instead of dodging and burning for our local adjustments, this time we'll do some portrait retouching. We'll start by removing any skin blemishes, so click once on her face to zoom in (if you need to get closer, just go to the top of the Navigator panel in the left side Panels area and click on 2:1, as I did here), then get the Spot Removal tool (Q) from the toolbox below the Histogram panel. Resize your brush tip (using the Left and Right Bracket keys on your keyboard), so it's just a little larger than the blemish you want to remove, position it directly over the blemish, and just click once to remove it. Every time you see a blemish, just move over it and click, until they're all removed. If you click and the result looks bad, you can reposition the sample circle by just clicking-and-dragging it to a new area (as shown here).

Now switch to the Adjustment Brush **(K)**, choose **Clarity** from the Effect pop-up menu near the top of the panel (this resets all the other sliders to zero), then lower the Clarity amount to around –75. This creates negative clarity, which you can now use to soften the skin (and it does a surprisingly decent job at it). Take the brush and paint over all the skin areas, but be careful not to paint over anything that's not supposed to be soft, like the eyes, eyelashes, eyebrows, the nostril openings, lips, hair, and the edges of her face. If this amount looks too soft (I think it does) just back it off a little bit (try –50 and see how that looks).

Continued

In the Adjustment Brush options, click the New button, so we can adjust a different area without disturbing what we just did. Choose **Exposure** from the Effect pop-up menu, and drag the Exposure slider over to around +1.18, shrink your brush size down (use your Left Bracket key), then paint over the whites of her eyes (not the iris, just the whites, as shown here). Now zoom back out to a Fit in Window view, and see if the eyes don't look a bit too bright. If they do, lower the Exposure amount for this adjustment to around +0.50 and see how that looks.

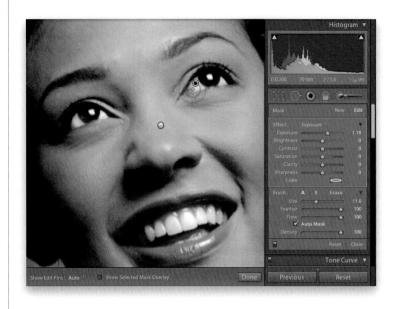

Although I usually add a Clarity amount of around +25 to each image I process, in this case, I just smoothed her skin and don't want to turn around and make her skin have more detail and texture, so here's what we're going to do: we're going to apply clarity just to her blouse, boots, and hair using the Adjustment Brush. Click the New button again, choose Clarity from the pop-up menu, then set the Clarity amount to +50 and paint over her blouse, pants, boots, and hair to make them punchier.

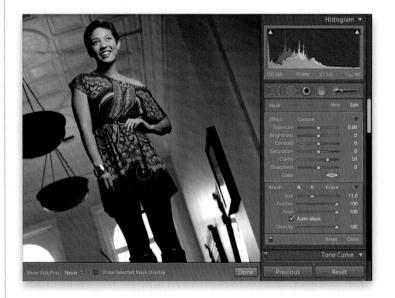

Develop

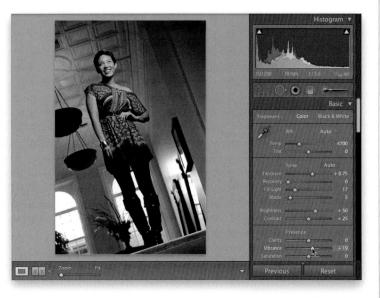

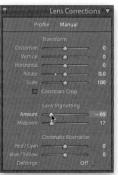

Before

The Sixth Point: Adding Punch a

Adding Punch and Enhancing Color We already added our punch using the Adjustment Brush's Clarity control, so here we're just going to pump up the color a bit by increasing the Vibrance amount to +19 in the Basic panel (as shown here), which makes the colors in the background come out more (her top was already pretty vibrant, so it's affected less than the background colors, which were more muted). Compare the yellow wall on the right here, with the one in the previous images.

The Seventh Point: Finishing Effects

Since we brightened the image so much, the natural vignette that was in the original image is pretty much gone, so to add a vignette back in, go to the Lens Corrections panel, click on Manual at the top, then click-and-drag the Lens Vignetting Amount slider to the left to -69 (as shown here), and the Midpoint slider to 17. A before/after, using just these seven points, is shown here (you can't really see the effect of the retouching in an image this small, but you'll see it very clearly when you try it for yourself). The changes to this image weren't as drastic as they were to the clock image (in the first project), but this is more likely to be how most of your corrections will be-not huge fixes, but more subtle fixes and tweaks. Now, onto another project.

After

The 7-Point System: Project Three

Here, you're going to use "The System" in a different way—on a landscape shot that is so dark that there's not much you can do with it. The sun looks okay, but everything else looks pretty bad, so you'll use The System to bring out some detail in the sand and dune, you'll enhance the color, make it punchier, add more contrast, and generally wind up with a much better final image.

The First Point:

Choose a Camera Profile Here's the original RAW photo, straight out of the camera (it has some potential, but at this point, it's just a pretty blah image). Let's get a better starting place for this image by going to the Develop module and trying out some of the different profiles in the Camera Calibration panel.

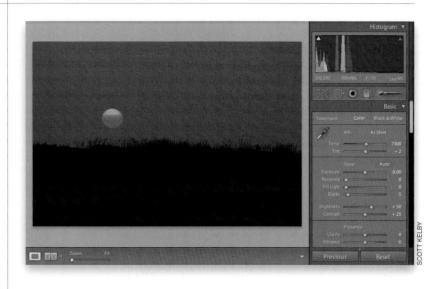

Here, I chose the Camera Landscape profile, and the image already looks a little better (remember, this just gives us a better starting point).

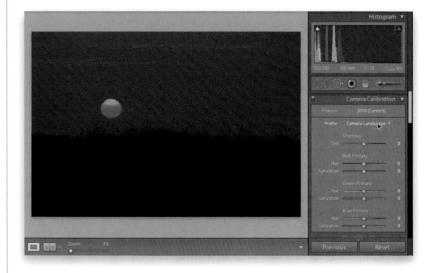

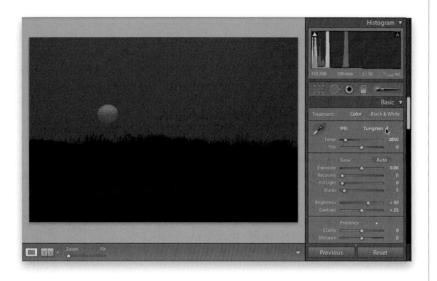

The Second Point: Adjust the White Balance

I think the white balance actually looks pretty good (after all, it's a sunset shot), but just for fun, go up to the Basic panel and try out some of the other White Balance presets—not to get an accurate white balance, but instead to try a creative white balance. For example, try Tungsten and you get the blue image you see here, which I have to tell ya, looks pretty good to me, but for the sake of our project, we'll keep it set at the As Shot white balance and not change it at all.

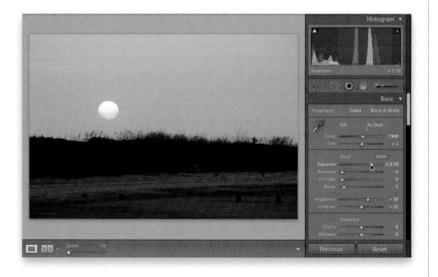

The Third Point:

Adjust the Overall Exposure Now that the white balance is reset to the original As Shot setting, we can work on the exposure. There are two things I wish were different in this photo (well, in the photo shown in the First Point anyway): (1) I'd like the beach area to be much lighter, which I did here by increasing the Exposure to +2.10, and (2) I'd like the sky to be much darker (there are a couple of different ways to get there, and we'll cover those in a moment, but for now, just drag the Exposure slider to the right to +2.10 to brighten the entire image, so now you can see the beach clearly).

Continued

The Fourth Point: Adding Contrast

We normally add contrast at this point, but here I went to the Tone Curve panel and this time I tried all three of the Point Curve presets. The one that looked the best for this particular image, rare though it may be, was Linear, which means "no added contrast" (which is why the curve itself is a flat diagonal line). I have to admit, I hardly ever run into an image where turning off the contrast like this looks better, but that's the thing about all of this—it always depends on the image.

Note: Although there are seven points to the 7-Point System, the fewer points you have to use, the better, so don't let it freak you out if you get to a point and it doesn't need adjusting. For example, not every image needs local adjustments, or finishing moves, so just know that skipping a point, if the photo doesn't need it, is perfectly fine. In fact, it's great—less is more!

The Fifth Point: Local Adjustments

We're going to use a different local adjustment to darken the sky-the Graduated Filter. Click on it in the toolbox below the Histogram panel (it's to the left of the Adjustment Brush), lower the Exposure amount to -2.31 and the Brightness to -92. Then press-and-hold the Shift key (to keep your gradient straight), and starting at the top center of your image, click-anddrag the filter down until you reach the beach (as shown here. For more on this filter, jump back to page 182). Then switch to the Adjustment Brush (K), so we can brighten the grass. Choose Brightness from the Effect pop-up menu, set the Brightness slider to +78, then paint over the rocks and the grass (you'll see the result in the next image). Also, if you wanted to remove the posts on the beach, you could do that with the Spot Removal tool, although I'm not doing that here. Click on Close at the bottom right of the tool options when you're done.

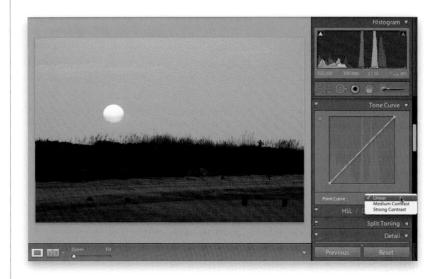

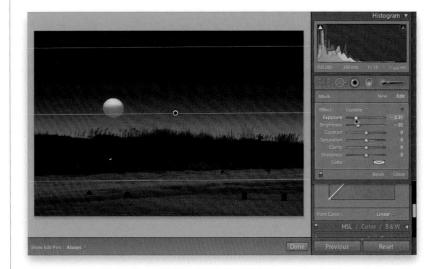

Web

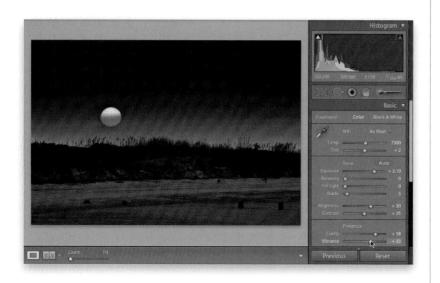

The Sixth Point:

Adding Punch and Enhancing Color Now that everything else is pretty much in place, let's add a little punch to the beach and rocks (notice how the rocks and grass look since we brightened them with the Adjustment Brush in the previous step?) using the Clarity slider in the Basic panel. Click-and-drag the Clarity slider over to the right to around +58, then to make the colors a little more vibrant, increase the Vibrance amount to +33 (as shown here).

The Seventh Point: Finishing Effects

This image looks about done, so there's really no finishing effect needed, though I would have you try two things just for fun: (1) change the white balance to Fluorescent (I'll let you see what it does on your own), and (2) press the letter \mathbf{V} to see the image as black and white. When you're done, just press Command-Z (PC: Ctrl-Z) to return to your finished image (a before/after is shown below).

The 7-Point System: Project Four

For our last project, you're going to take a sports shot from beginning to end. This is the most subtle of the four projects, which is more like what you'll probably run into on a day-to-day basis—you'll use "The System" to make subtle improvements and tweaks to your images, rather than rescuing really bad photos (if you find that you do more rescuing than just tweaking, perhaps Lightroom isn't your biggest problem. Wink, wink).

The First Point:

Choose a Camera Profile

Here's an original JPEG photo, straight out of the camera. There's a player on the far right side who's kinda cut in half, so before we get to "The System," let's go ahead and crop him out of the image, and just generally crop in a little tighter on the action. Click on the Crop tool in the toolbox below the Histogram panel, then grab the corners and drag inward to crop the image nice and tight like you see here, and press Return (PC: Enter) to lock in your crop. Since this is a JPEG image, it already has a camera profile embedded into it, and Lightroom doesn't let you apply one, so you'll skip the first point if you're working on a JPEG image.

The Second Point: Adjust the White Balance

Another difference with JPEG images is that you only have one White Balance preset in the pop-up menu, and that's Auto. That's why, when it comes to JPEG images, I usually just set it myself using the White Balance Selector tool. Get the tool (in the Basic panel, or press **W**), and click it directly on a light gray area of the player's shirt (as shown here), and as you can see, it warms the image up quite a bit, and removes the slightly blue color cast the image had from the As Shot white balance.

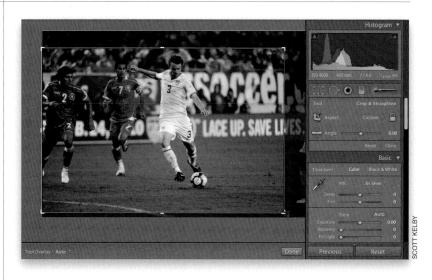

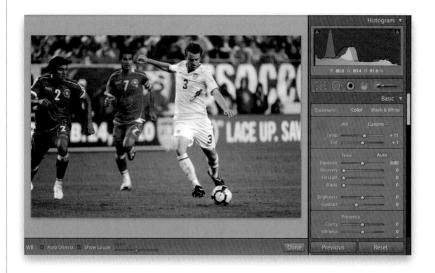

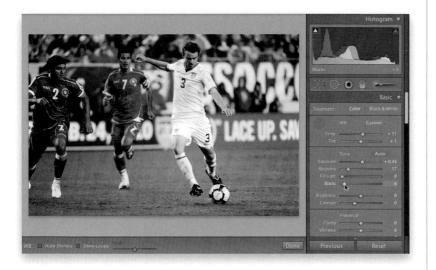

The Third Point: Adjust the Overall Exposure

The overall image seems a little bit dark, so (still in the Basic panel) let's increase the Exposure to about +0.35. When you do this, you'll see the clipping warning appear (the player in the front has a white shirt, and that baby's just ready to clip), so once you see it, increase the Recovery amount until the white triangle up in the histogram turns black again (I took it to 17), signaling your clipping has been fixed. You also might bring up the Blacks just a little bit to make the colors in the shadow areas richer (I raised mine to 6).

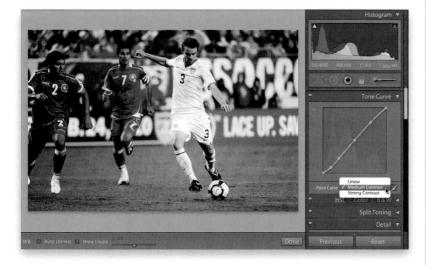

The Fourth Point: Adding Contrast

When you're editing a JPEG image, Lightroom doesn't apply contrast automatically, because your camera already applied it when it processed your image. If you'd like to add more (I sure would), just go to the Tone Curve panel and change the Point Curve pop-up menu at the bottom of the panel from Linear (no contrast) to Medium Contrast, as shown here.

Continued

The Fifth Point: Local Adjustments

Here, you're going to greatly accentuate the detail and contrast in their uniforms, making every little wrinkle and ripple really stand out. You do that by getting the Adjustment Brush **(K)**, choosing **Clarity** from the Effect pop-up menu, then setting your Clarity to 100, and painting over their uniforms (as shown here), along with their socks and shoes. Avoid their skin altogether, because it intensifies any blemishes or hot spots they have. When you're done, click Close at the bottom right of the tool options.

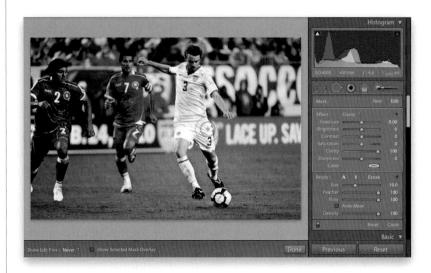

The Sixth Point:

Adding Punch and Enhancing Color Now let's add a little punch using the Clarity slider in the Basic panel. Click-anddrag it over to the right to +31, then to make the colors a bit more vibrant, increase the Vibrance to +29, as shown here.

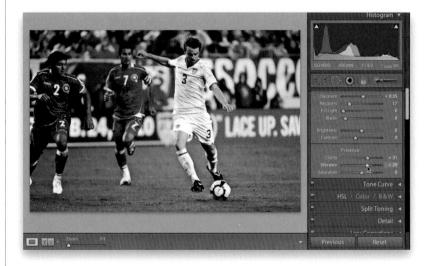

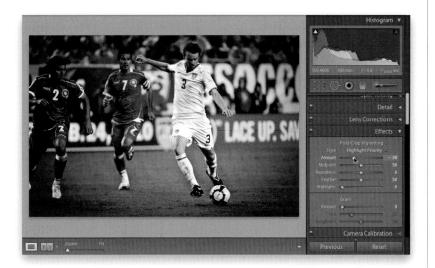

The Seventh Point: Finishing Effects

For our finishing effect, let's add an edge vignette, so the focus is really on the player kicking the ball. We've cropped this image, so we'll need to use Post-Crop Vignetting instead of Lens Vignetting. So, go to the Effects panel, choose Highlight **Priority** from the Style pop-up menu (more on vignettes back on page 150), drag the Amount slider to the left to -38 (as shown here), then leave the Midpoint slider at 50. A before/after is shown below. Of course, the goal of all this is to get you to apply the system to your own photos, and while every once in a while, you'll have to use another part of the Develop module (like the HSL/ Color/B&W panel, for example), I think you'll find that the majority of what you need to do day in and day out is found in these seven points.

Before

After

Where to Go Next for More Lightroom Learning

Photoshop User Magazine (The How-to Magazine for Adobe[®] Photoshop[®] Users)

I'm Editor and Publisher of *Photoshop User* magazine, and in each issue we have a magazine within a magazine—a special section of the publication dedicated to teaching you the latest techniques in Lightroom. *Photoshop User* magazine is sent free to all members of the National Association of Photoshop Professionals (NAPP). It's also available at newsstands all over the U.S. and Canada. You can find out more about *Photoshop User* magazine and NAPP at www.photoshopuser.com. So, you've made it to the end of the book and now you can see how Lightroom has changed the digital photography workflow forever. Well, if you're hungry for more Lightroom learning, I put together a couple pages of different resources that I'm involved with, so even though you've finished the book, we don't have to stop learning about Lightroom together.

Adobe[®] Photoshop[®] Lightroom[®] Killer Tips Videocast and Blog

Each week my buddy (and my co-host of *Photoshop User TV*) Matt Kloskowski hosts *Adobe Photoshop Lightroom Killer Tips*—a free tips and tricks videocast for Lightroom users. Check it out at www.kelbytv.com. You can subscribe for free in Apple's iTunes Store and then watch it right from within iTunes, or you can watch it right there on the website. In addition to the videocast, Matt also posts lots of cool Lightroom tutorials, news, tips, timesaving shortcuts, downloadable presets, photographic inspiration, and undocumented tricks on his accompanying blog. You can find it at www.lightroomkillertips.com.

My Adobe Photoshop Lightroom[®] Live! Seminar Tour:

When the original version of Lightroom shipped, I launched a nationwide one-day Lightroom Live! seminar tour that goes to major cities across the U.S. The tour is sponsored by Adobe Systems, Inc., and produced by NAPP, and it starts with a live on-location shoot, right there in the class, with full studio lighting and all the info on how we're shooting it, the equipment used, etc. Then we take these shots into Lightroom, and you see the whole step-by-step workflow unfold live in front of your eyes. It's kind of like a live version of this book, but it all happens in just one day-there's never been a tour like it, so I hope you'll join us when we come out your way. For info, or to sign up, visit www.kelbytraining.com. If you can't make it to a seminar, check out the website anyway. You'll find lots of online training for not only Lightroom, but for Photoshop and photography, as well.

The National Association of Photoshop Professionals (NAPP): The Photoshop Lightroom Authority!

This is the world's largest photography, graphics, and digital imaging professional association in the world, with nearly 60,000 members in the U.S. and 221 countries around the world. They were nice enough to support this book, because, well...I'm their President. I started the organization 11 years ago because there was no central resource for learning about Photoshop 365 days a year. Now, we've expanded our training to include Lightroom, and besides including a special Lightroom section in each issue of Photoshop User magazine, we also produce the world's largest Photoshop event, The Photoshop World Conference & Expo, where we've added a full conference track and a pre-conference workshop just for Lightroom users. Find out more at www.photoshopworld.com.

Develop

Print

Index

[] (bracket) keys, 172, 185, 202
1:1 previews, 11, 45
7-Point System, 423–443
16-bit printing, 358, 379
32-bit mode, 42–43
64-bit mode, 42
100% view, 116

A

A/B brushes, 176, 184, 185 actions creating in Photoshop, 259-264 Export, 234, 235-237, 264, 277 Actions panel, 259, 261 Adjustment Brush. 170 Auto Mask feature, 171, 178, 180, 185 Auto Show option, 219 brush options for, 176, 184 creative effects using, 178-179 dodging and burning with, 170-174 Edit Pins, 174, 177, 181, 184 interactive adjustments, 175 mask overlay preview, 175 painting duotones with, 293 portrait retouching with, 180-181, 412 project examples, 427, 431-432, 436, 440 resizing, 172, 176 tips on using, 177, 184-185 Adobe Photoshop. See Photoshop Adobe Photoshop Lightroom. See Lightroom Adobe Photoshop Lightroom Killer Tips videocast and blog, 442 Adobe Premiere Pro, 21 Adobe RGB color space, 277 Affected Folders Only command, 14 After Export pop-up menu, 236, 263, 264 Airtight Interactive templates, 394-395 alias icons. 235-236 Amount slider Adjustment Brush, 177 Detail panel, 212 Appearance panel, 382, 383, 385, 389, 391, 394-395 Apply During Import panel, 13-14, 17 artifact removal, 201-204 Aspect pop-up menu, 196 attributes finding photos by, 81 sorting photos by, 55, 59, 63, 293 viewing common, 117 Auto Advance Selection option, 45, 97 Auto Dismiss checkbox, 128 Auto Hide & Show feature, 37 Auto Layout button, 345 Auto Mask feature, 171, 178, 180, 185 Auto Sync mode, 157 Auto Tone button, 139

В

Backdrop panel, 306, 308, 310 backgrounds photos as, 306-311, 350-355 print, 327, 350-355, 370, 379 slide show, 303-304, 306-311 Web gallery, 393 backing up catalog database, 89-90, 93 and deleting old backups, 117 photos during import, 12, 43 presets, 97 workflows for, 404 backlit photos. 188-189 backscreened effect, 307, 350-355 Balance slider, 292 Basic panel, 124 Auto Tone button, 139 B&W conversions, 283, 286, 289 Blacks slider, 137 Brightness slider, 137 Clarity slider, 140 Contrast slider, 137, 142 Exposure slider, 134-136 Fill Light slider, 188-189 Recovery slider, 135, 136 Saturation slider, 141 Temp slider, 126 Tint slider, 126 Vibrance slider, 141 white balance controls, 124-128 before-and-after views, 131, 166, 293 Black & White button, 286 Black & White Mix sliders, 287 black-and-white conversions, 279-293 adjusting individual areas of, 286-288 Develop module used for, 282-285 duotones created from, 289, 290-291 film grain effect and, 164 killer tips about, 293 selecting images for, 280-281 split-tone effect and, 289, 291-292 blackout modes. 40 Blacks slider, 137, 189, 283 Blue/Yellow slider, 216 blurring effect, 185, 353 borders cell, 331, 398 frame, 366-368 bracket ([]) keys, 172, 185, 202 Brightness slider, 137 browser preview option, 385 brushes size adjustments, 172, 176 softness adjustments, 185 burning and dodging, 170-174

С

calibrating monitors, 359 Camera Calibration panel, 122-123, 217-218, 424, 429, 434 cameras default settings for, 166-167 filtering photos by, 82 fixing problems caused by, 216, 217-218 importing photos from, 5-15 profiles for, 122-123, 166, 424, 429, 434 tethered shooting from, 22-25 Candidate image, 61 captions, 391 capture sharpening, 211 Catalog panel, 69 Catalog Settings dialog, 11, 32, 77, 89 catalogs, 84-90 backing up, 89-90, 93 creating, 84-85 exporting, 86-88, 246 optimizing, 90 repairing corrupt, 93 restoring, 90, 93-94 selecting, 85 syncing, 86-88 tip on using, 42 CD/DVD, burning photos to, 418 Cell Size sliders, 325, 379 Cell Spacing sliders, 331, 332 cell views, 39 Cells panel, 336, 343 chromatic aberrations, 216 Clarity slider, 140, 284, 428, 431, 432, 437, 440 clipping warnings hiding/showing, 166 highlight, 135, 136 shadow, 137 Clone option, 202 collection sets, 64-65, 96, 405 collections, 55-57 adding photos to, 95 creating, 55-56, 60, 406 deleting, 95 finding photos in, 80 locating for photos, 96 making in a set, 97 naming/renaming, 60, 95 playlists compared to, 56 portrait workflow, 406, 407 print layouts for, 348-349 Quick Collections, 68-69 saving as favorites, 97 sets of, 64-65, 96, 405 slide show, 296, 321 Smart Collections, 21, 66-67, 95 subcollections of, 65 thumbnail badge for, 117 Web gallery, 382, 398 **Collections** panel Develop module, 121

Library module, 56, 405 Print module, 324, 348-349 Slideshow module, 296, 321 Web module, 382, 398, 410 color fringe, 216 color labels finding photos by, 82 marking photos with, 63 naming/renaming, 116 color management, 362 color noise, 190 Color Palette panel, 392-393, 394, 395, 398 color picker, 292, 392 Color Priority style, 151 color profiles, 359-360 Color Space settings, 247, 250, 277 colors adjusting individual, 147-148 camera calibration, 217-218 Lightroom background, 117 print background, 370, 379 slide show background, 303 Web gallery, 392-393, 398 Colors panel, 113 **Common Attributes feature.** 117 Compare view, 61-63 comparing photos Compare view for, 61-63 Survey view for, 57-58 contact information, 13, 35 contact sheets, 328-335, 357, 374 contrast adjustments Contrast slider, 137, 142 Tone Curve panel, 142-146, 284, 287, 426, 431, 436 Contrast slider, 137, 142 **Convert Photo to DNG option, 44** Copy as DNG option, 7, 43 Copy button, 7, 132, 166 Copy Settings dialog, 132, 166, 204 copying-and-pasting settings, 132-133 copyright information, 13, 35, 76 correcting problem photos. See fixing problem photos corrupt catalogs, 93, 94 Create Collection dialog, 56, 60, 64, 405, 406 **Create Collection Set dialog**, 64 Create Droplet dialog, 262 **Create Folder with New Catalog dialog, 84** Create Print dialog, 349 Crop Frame tool, 196 Crop Overlay tool, 194–196, 197, 198, 199, 219 cropping photos, 194-197 canceling crops, 195 Lights Out mode for, 197 locking in crops, 195, 196 post-crop vignetting, 150 project example of, 438 curves control. See Tone Curve panel Custom Package layout style, 336-339 customizing

background color, 117 color label names, 116 Dual Display, 107–110 Filmstrip, 111 Grid view, 102–105 Loupe view, 100–101 panel end marks, 117

D

Darken slider, 205 Darks slider, 146 database backups, 89-90 Date Format pop-up menu, 9 date information choosing format for, 9 file naming with, 27-28 organizing photos by, 43 searching for photos by, 82 Defringe pop-up menu, 216 deleting collections, 95 corrupt catalogs, 94 keywords, 73, 95 local adjustments, 185 old backups, 117 PSD files, 277 rejected photos, 54, 406 user presets, 160 virtual copies, 156 See also removing Density slider, 177 **Destination Folders view,** 8 Destination panel, 8, 9, 14 **Detail** panel Noise Reduction sliders, 190-191, 219 preview zoom options, 166, 211 sharpening sliders, 212-214 spot removal using, 219 Detail slider, 212 Develop module, 119-167 Adjustment Brush, 170-181 Auto Sync mode, 157 Basic panel, 124 before-and-after views, 131, 166 black-and-white conversions, 282-285 Camera Calibration panel, 122-123, 217-218 Collections panel, 121 contrast controls, 142-146 copying-and-pasting settings, 132-133 Crop Overlay tool, 194-196, 197, 198, 199 Detail panel, 166, 190-191, 211-215 editing multiple images, 132-133 Effects panel, 164-165 exposure controls, 134–139 Fill Light slider, 188-189 Graduated Filter tool, 182-183 Histogram panel, 138 History panel, 192-193

HSL panel, 147-148 killer tips about, 166-167, 184-185, 219 Lens Corrections panel, 149-152, 206-210, 216 local adjustments, 169-185 presets, 158-161 Red Eye Correction tool, 205 Reset button, 147 Spot Removal tool, 200, 202-204 Tone Curve panel, 142-146 virtual copies, 155-156 white balance controls, 124-128 Develop Settings pop-up menu, 13 dimmed mode, 40 distortion, lens, 206-209 DNG (Digital Negative) format advantages of, 33 converting photos into, 7, 43, 44 exporting files in, 222 metadata info and, 77, 247 **DNG Profile Editor,** 123 dodging and burning, 170-174 Doty, Kim, 295 double-processing photos, 265-269 Draft Mode Printing option, 357, 364 drag-and-drop adding keywords via, 73 importing photos via, 42 drop shadows, 303, 312, 352-355 droplets, 262-263 Dual Display feature, 107-110 duotone effect, 289, 290-291, 293 duplicate photos, 12, 17, 42 dust removal, 200

Ε

edge frame borders, 366-368 edge vignetting adding, 149-152 fixing, 210 Edit Metadata Presets dialog, 35 Edit Photo with Adobe Photoshop dialog, 251 Edit Pins, Adjustment Brush, 174, 177, 181, 184 editing History feature for, 192-193 multiple images, 132-133 photos in Photoshop, 252-257, 413-417 portrait workflow for, 408-409, 412-417 undoing edits, 192-193, 219 Effect pop-up menu, 170, 173 effects Adjustment Brush, 178-179 Effects panel, 164-165 Graduated Filter, 182-183 Effects panel, 164-165 email sending photos via, 234-237, 418 Web gallery links to, 386-387 Embedded & Sidecar preview, 10, 45

embedded metadata, 75-76 end marks for panels, 117 Erase button, 184 EXIF metadata, 75, 76, 206, 207 Export Actions folder, 236, 264 Export as Catalog dialog, 87 Export dialog, 222-229, 418 exporting actions for, 234, 235-237, 264, 277 catalogs, 86-88, 246 emailing after, 234-237, 418 keywords, 95 killer tips about, 246-247 photos as JPEGs, 222-229, 418 plug-ins for, 237, 247 presets for, 223, 227-229, 246 publishing and, 240-245, 247 RAW images, 238-239 slide shows, 319-320 Smart Collection settings, 95 video clips, 21, 225 watermarking and, 226, 230-233 Web galleries, 396-397 Exposure slider, 134-136, 283, 425, 430, 432, 435, 439 **External Editor options, 250** external hard drives backing up photos to, 12, 43 photo library storage on, 2 space remaining on, 96

F

fashion photo project, 429-433 favorites, 97 Feather slider Adjustment Brush, 176 Lens Corrections panel, 152 File Handling panel, 10-12, 17 File Naming templates, 26-29, 74 File Renaming panel, 12, 26 Filename Template Editor, 26-28 Fill Light slider, 188-189, 426, 430 film grain effect, 164-165 Filmstrip customizing display of, 111 filtering photos from, 55, 96 filters attribute, 55 Filmstrip, 55, 96 Library Filter, 80-83, 406 locking in, 97 turning on/off, 95-96 finding catalog files, 94 missing files/folders, 50, 91-92 photos via search process, 80-83 Fit in Window view, 38 fixing problem photos, 187-219 artifact removal, 201-204

backlit subjects, 188-189 camera calibration issues, 217-218 chromatic aberrations, 216 cropping images, 194-197 dust spot removal, 200 edge vignetting, 210 killer tips about, 219 lens distortion problems, 206-209 noise reduction, 190-191 RAW images, 122-123 red eye removal, 205 retouching portraits, 180-181 sharpening images, 211-215 straightening images, 198-199 undoing edits, 192-193 flagging photos, 53-54, 96 Flash-based templates, 384-385, 394-395, 399 flattening images, 269, 271 Flickr website, 240-245, 247 Flow slider, 176 folders creating, 14 exporting as catalogs, 86-88 finding missing, 50, 91-92 hiding unnecessary, 45 importing photos into, 8-9, 44 moving photos between, 49 organizing photos in, 3-4, 9, 44 removing from Lightroom, 51 subfolders in, 9 synchronizing, 50-51 Folders panel, 48-51, 96, 405 Font Size pop-up menu, 113 frame borders, 366-368 FTP uploader, 396, 397 full-screen slide show, 299, 320

G

global adjustments, 170 Google Maps, 79 GPS data, 78–79 gradients applying, 182–183 inverting, 184 Graduated Filter tool, 182–183, 184, 436 grain effects, 164–165 grayscale conversions. *See* black-and-white conversions Grid view, 39 customizing, 102–105 keyboard shortcut, 39 thumbnail size, 43 Guides panel, 331

Н

halo prevention, 212 Hamburg, Mark, 200 hard drives. *See* external hard drives

HDR (High Dynamic Range) images, 273–276, 277 Heal option, 202 hiding

clipping indicators, 166 folders, 45 menu bar, 41 panels, 36-37, 106 taskbar, 95-96 Tethered Bar, 23 toolbar, 39, 41 window title bar, 41 high-contrast effect, 153-154 Highlight Priority style, 150 highlights adjusting, 134-136 clipping warning, 135 color picker, 292 Histogram panel, 138 History panel, 192-193, 219 HSL panel, 147-148 HSL/Color/B&W panel, 147, 282, 286 HTML templates, 384, 398 **Hue sliders** Camera Calibration panel, 218 HSL panel, 147 Split Toning panel, 290, 291

ICC color profiles, 359-360 Identity Plate Editor, 112-115, 309, 314, 366, 388 Identity Plates, 112-115 frame borders saved as, 368 graphical, 114-115, 309, 388 printing photos with, 334, 340, 379 saving custom, 113 slide shows and, 302-303, 314-315 text for, 117, 302, 303, 314-315 video tutorial on, 309, 367, 369 Web galleries and, 388-389 Image Info panel, 391 Image Pages slider, 398-399 Image Settings panel, 327, 329, 335 Import button, 5, 15, 84 Import window, 5, 16, 18-19, 42 importing photos, 5-19 backup process, 12, 43, 44 canceling imports, 5 Develop settings, 13 drag-and-drop for, 42 file handling options, 10-12, 17 folder organization, 3-4, 9 keyword assignments, 14 killer tips about, 42-43 located on your computer, 16-17 metadata options, 13, 32, 34-35 naming/renaming options, 12, 26-29 preference settings, 30-32 presets used for, 18-19

preview rendering options, 10–11, 45 selection process for, 7 shooting tethered and, 22–25 storage location for, 2, 8–9, 16 viewing images before, 6, 8, 16 **importing video clips**, 20–21 **impromptu slide shows**, 69, 299 **interactive adjustments**, 175 **Into Subfolder checkbox**, 9 **IPTC metadata**, 35 **iTunes iMix**, 317

J

JPEGs editing in Photoshop, 251 exporting photos as, 222–229 printing to, 364–365, 379 white balance presets for, 167

К

Keep Square checkbox, 327 keyboard shortcuts before-and-after views, 131 cell views, 39 panel navigation, 164 show/hide options, 37 speed editing, 136 zooming in/out, 96, 201 Keyword List panel, 72 keyword sets, 72 Keywording panel, 70, 71 keywords, 70-73 assigning, 14, 70-73, 95 choosing, 44 deleting, 73, 95 exporting, 95 Painter tool, 71–72 removing from photos, 73 sets of, 72 sub-keywords and, 73, 95 suggested, 97 Kloskowski, Matt, 161, 218, 442

L

labels. *See* color labels landscape photo project, 434–437 Layout panel Print module, 334, 335 Slideshow module, 301, 308 Layout Style panel Print module, 324, 336, 342 Web module, 394, 399 layouts print, 324–339, 348–349 slide show, 300–305 Web gallery, 382–385, 388–391 Lens Corrections panel chromatic aberration fixes, 216 creating vignettes in, 149-152, 409, 428, 433 fixing vignettes in, 210 lens distortion fixes, 206-209 Lens Profile Creator utility, 208 lenses correcting vignetting from, 210 filtering photos by, 82 fixing distortion from, 206-209 profiles for, 206, 207-208, 209, 216 Library Filter, 80-83, 406 Library module, 47-97 B&W conversions in, 280 catalogs, 84-85 collections, 55-57, 64-69 Compare view, 61-63 database backup, 89-90 exporting photos from, 222 Filmstrip, 55, 96, 111 finding photos in, 80-83 Folders panel, 48-51 GPS data in, 78-79 Grid view, 39, 102-105 keywords used in, 70-73 killer tips about, 95-97 Loupe view, 38, 100-101 metadata options, 75-79 moving photos in, 49 Publish Services panel, 240, 242, 243, 244-245 Quick Collections, 68-69 Quick Develop panel, 162-163 relinking missing photos in, 50, 91-92 renaming photos in, 74 Smart Collections, 66-67 sorting photos in, 52-63 Survey view, 57-59 view options, 38-41 Library View Options dialog Grid view options, 102-105 Loupe View options, 100-101 Lightroom background color, 117 dual-monitor setup, 107-110 interface tips, 36-37 Photoshop integration, 251-258, 413-417 Process Version updates, 120-121 resources for learning about, 442-443 Lightroom LIVE! seminar tour, 443 Lightroom Publishing Manager dialog, 240-241 Lights Dim mode, 40 Lights Out mode, 40-41 Compare view and, 61 controlling, 41 cropping photos in, 197 Survey view and, 58 tethered shooting in, 25 Lights slider, 146 linking/relinking photos, 50, 91-92

local adjustments, 169-185 creative effects, 178-179 dodging and burning, 170-174 gradient filter effects, 182-183 interactive, 175 killer tips about, 184-185 portrait retouching, 180-181 previewing, 175 project examples, 427, 431, 436, 440 Locate dialog, 92 Loupe view, 38 customizing, 100-101 keyboard shortcuts, 38, 116 LRCAT files, 88, 90 luminance noise, 191 Luminance sliders, 148

Μ

Make Select button, 62 MapiMailer plug-in, 237 margins print, 333, 373, 379 slide show, 301 Masking slider, 213-214 Match Total Exposures option, 167 McNally, Joe, 22 memory cards ejecting, 44 importing photos from, 5-15 numbering photos from multiple, 43 previewing photos on, 6, 8 menu bar, 41 Merge to HDR Pro dialog, 273 metadata embedded, 75-76 finding photos by, 81-83 GPS data, 78-79 minimizing, 226 preferences, 32 saving to a file, 32 synchronizing, 96 templates, 13, 34-35, 76 XMP sidecar files, 32, 33, 77 Metadata panel, 75-76, 78 Metadata pop-up menu, 13 Minimal preview, 10, 11, 45 missing files/folders, 50, 91-92 modules navigating between, 36 See also specific modules monitors calibration of, 359 Dual Display feature, 107-110 movie camera icon, 20 music in slide shows, 316-317 My Lightroom Photos folder, 3, 9 My Pictures folder, 3

Weh

Ν

naming/renaming collections, 60, 95 color labels, 116 exported photos, 224, 228 imported photos, 12, 42 photos in Lightroom, 74 Photoshop edited files, 277 presets, 159 template for, 26-29 National Association of Photoshop Professionals (NAPP), 442, 443 Navigator panel history states in, 192 viewing photos in, 38-39 white balance adjustments and, 128 New Action dialog, 259 New Develop Preset dialog, 160, 218, 291 New Metadata Preset dialog, 34-35 New Smart Object via Copy option, 266-267 New Template dialog, 347 Nikon cameras, 45 Noise Reduction sliders, 190-191, 219 Noiseware Professional, 219 numbering photos, 28, 43

0

Opacity setting background image, 307 Identity Plate, 303, 355 watermark, 231 **Optimize Catalog option**, 90 organizing photos collections for, 55-57, 64-69 color labels for, 63 date feature for, 43 flags for, 53-55 folders for, 3-4, 9, 44, 48-51 importing and, 9 keywords for, 70-73 metadata info for, 75-79 multiple catalogs for, 84-85 Ouick Collections for, 68-69 renaming process for, 74 shooting tethered and, 23 Smart Collections for, 66-67 star ratings for, 52-53 workflow for, 405-407 **Output Settings panel, 390** output sharpening, 226, 365 **Overlays** panel Print module, 341 Slideshow module, 300, 302, 303

Р

Page panel, 335, 340, 354, 366 Paint Overlay style, 151 Painter tool, 71-72, 97 panels end marks, 117 expanding all, 116 hiding, 36-37, 106 keyboard shortcuts, 164 linking, 116 opening/closing, 166 resizing, 95 Solo mode, 106 See also specific panels panoramas stitching, 270-272 testing, 246-247 paper selection options, 363 paper/printer profiles, 359-360 PDF slide shows, 320 Perceptual Rendering Intent, 361 photo frames, 311 Photomatix Pro, 277 Photomerge feature, 247, 270-272 Photorealistic preset, 276 Photoshop color space in, 250, 277 creating actions in, 259-264 double-processing photos in, 265-269 edge border preparation in, 366 editing photos in, 252-257, 413-417 jumping to/from, 251-258 killer tips on using, 277 merging HDR images in, 273-276 Photomerge feature, 247, 270-272 preparing files for, 250 saving edits in, 258, 417 sharpening images in, 212 Smart Object feature, 265-269 **Photoshop Elements**, 43 Photoshop Lightroom. See Lightroom Photoshop User magazine, 442 Photoshop World Conference & Expo, 443 Picks collections from, 55-56 filtering, 55, 96 flagging photos as, 53-54, 96, 406 Survey view of, 59 Picture Package feature, 342-346 Pictures folder, 3 Playback panel, 316, 318 playing slide shows, 299 plug-ins, export, 237, 247 Point Curve presets, 142, 287 portrait workflow, 401-420 backing up the photos, 404 client proofing via Web gallery, 410-411 creating collections of photos, 406, 407 delivering final photos, 418-420

portrait workflow (continued) editing for initial presentation, 408-409 final editing process, 412-417 organizing the photos, 405-407 printing the photos, 419-420 shooting the photos, 402-403 portraits retouching, 180-181, 431-432 sharpening, 213-214 workflow for, 401-420 post-crop vignetting, 150, 441 Preferences dialog, 30-31 presets applying, 159 backing up, 97 built-in, 158-159 camera calibration, 218 creating your own, 160-161 Develop module, 158-161 downloading/importing, 161 duotone, 291 email, 234 export, 223, 227-229, 246 file naming, 26-29, 74 import, 18-19 metadata, 34-35, 76 previewing, 158, 161 renaming, 159 saving, 29, 97, 160 search, 97 sharpening, 215 updating, 167 vignette, 167 white balance, 167 Presets panel, 158, 160, 215 Preview in Browser button, 385 previewing B&W conversions, 280-281 local adjustments, 175 photos to import, 6, 8 presets, 158, 161 rendering options for, 10-11, 17, 45 second monitor, 110 slide shows, 298, 321 video clips, 21 Web galleries, 385 zoom ratios for, 166 Print dialog, 361-363, 420 Print Job panel, 355, 356-361, 364-365 Print module, 324-379 Cells panel, 336, 343 Collections panel, 324, 348-349 Guides panel, 331 Image Settings panel, 327, 329, 335 Layout panel, 334, 335 Layout Style panel, 324, 336, 342 Overlays panel, 341 Page panel, 335, 340, 354, 366 Print Job panel, 355, 356-361, 364-365

Template Browser, 324, 328, 342, 347 print queue, 379 printer/paper profiles, 359-360 printing, 323-379 16-bit, 358, 379 backgrounds for, 327, 370, 379 backscreened effect, 350-355 collections, 348-349 color profiles for, 359-360 contact sheets, 328-335, 357, 374 custom layouts for, 336-339, 347 edge frame borders, 366-368 examples of layouts for, 369-378 Identity Plates, 334, 340, 379 to JPEG files, 364-365, 379 killer tips on. 379 layouts used for, 324-339, 348-349 multiple photos per page, 328-335, 342-346 quality settings for, 357, 363, 365 Rendering Intent options for, 361 resolution settings for, 357, 364 saving print layouts, 347, 364-365 setting options for, 356-363 sharpening photos for, 358, 365 templates for, 324, 328 text added for, 340-341 workflow for, 419-420 problem photos. See fixing problem photos Process Versions of Lightroom, 120-121 Profile pop-up menu, 360 profiles camera, 122-123, 166, 424, 429, 434 lens, 206, 207-208, 209, 216 printer/paper, 359-360 ProPhoto RGB color space, 250, 277 PSD files, 44, 222, 277 Publish Services panel, 240, 242, 243, 244-245 publishing photos, 240-245, 247 Pupil Size slider, 205

Q

Quality slider, 224, 236, 320 Quick Collections, 68–69 adding photos to, 68 markers for, 103 removing photos from, 69 saving as regular collections, 69 Quick Develop panel, 162–163

R

Radius slider, 212 Range sliders, 146 rating photos, 52–53, 81 RAW photos camera profiles for, 122–123 converting to DNG format, 7, 43, 44 editing in Photoshop, 251, 413–417

exporting, 238-239 metadata info for, 32, 33, 77 Record button, 259 Recovery slider, 135, 136, 283 Red Eye Correction tool, 205 Red/Cyan slider, 216 **Region sliders**, 145 Rejects deleting, 54, 406 flagging, 53-54, 406 **Relative Rendering Intent, 361** removing artifacts from photos, 201-204 dust spots from photos, 200 folders from Lightroom, 51 keywords from photos, 73 photos from Survey View, 58, 97 red eye from photos, 205 slide show photos, 299 Web gallery photos, 399 See also deleting **Rename Photos dialog**, 74 renaming. See naming/renaming Render Previews pop-up menu, 10-11, 17 **Rendering Intent options, 361** Reset button, 147, 160, 219 resizing. See sizing/resizing resolution settings, 250, 357 restoring catalogs, 90, 93-94 retouching photos Adjustment Brush for, 180-181, 431-432 See also fixing problem photos Rotate to Fit checkbox, 327, 329, 333 rotating images, 327, 329 text, 303, 321 Roundness setting, 152 rule-of-thirds grid, 194, 195 rulers, 379

S

Saturation sliders Basic panel, 141 Camera Calibration panel, 218 HSL panel, 147-148 Split Toning panel, 290, 291 saving collections as favorites, 97 frame borders, 368 Identity Plates, 113 metadata files, 32 photos as JPEGs, 222-229 Photoshop edits, 258, 417 presets, 29, 97, 160 print layouts, 347, 364-365 slide shows, 305 templates, 29, 305 Web galleries, 396-397, 398

Scale slider, 314, 315, 367 searching for photos, 80-83, 97 Segment Photos By Shots feature, 22-23, 25 Select Catalog dialog, 85 Select image, 61 shadows adjusting, 137 clipping warning, 137 color picker, 292 Shadows slider, 146 sharpening images, 211-215 B&W conversions and, 285 exporting and, 226, 247 Photoshop used for, 212 presets for, 215 print settings for, 226, 358 shooting tethered. See tethered shooting shortcut icons, 235-236 Shot Name dialog, 25 Show Cell Numbers checkbox, 391 Show Fewer/More Options button, 19 Show Grid Extras checkbox, 105 Show Guides checkbox, 324 Show Info Overlay checkbox, 100 Show Selected Mask Overlay checkbox, 175 Single Image/Contact Sheet layout, 324, 328 Site Info panel, 386-387, 388, 389, 395, 398, 399 Size slider Adjustment Brush, 176 Spot Removal tool, 202 sizing/resizing brushes, 172, 176 exported photos, 225 frame borders, 367 panels, 95 slideshow photos, 301 spot removal cursor, 202 thumbnails, 6, 16, 38, 43, 399 sky darkening technique, 182-183 slide shows, 295-321 backgrounds for, 303-304, 306-311 creating collections for, 296 customizing slides for, 300-305 drop shadows and strokes in, 312 duration options, 318 exporting, 319-320 full-screen, 299, 320 Identity Plates in, 302-303, 314-315 impromptu, 69, 299 killer tips on, 321 music added to, 316-317 ordering photos for, 297 PDF format, 320 playing, 299 previewing, 298, 321 random order option, 298, 318 removing photos from, 299 resizing photos in, 301 selecting photos for, 296

slide shows (continued) templates for, 297, 298, 300 text used in, 300, 313-315 title slides for. 314-315. 321 transitions for, 318 video format, 319 sliders navigation shortcuts, 136 resetting, 139, 166 See also specific sliders Slideshow module, 295-321 Backdrop panel, 306, 308, 310 Collections panel, 296, 321 Layout panel, 301, 308 Options panel, 302, 304, 308, 312 Overlays panel, 300, 302, 303 Playback panel, 316, 318 Preview area, 298, 321 Template Browser, 298, 300, 305 Titles panel, 314-315, 321 Smart Collections, 21, 66-67, 95 Smart Objects, 265-269 snapshots, 167, 193, 293 Solo mode, 106 sorting photos, 52-63 See also organizing photos sound options, 31 Soundtrack checkbox, 316 **Split Toning panel** duotone creation, 290-291 split-tone effect, 291-292 sports photo project, 438-441 spot removal artifact removal, 201-204 dust removal, 200 Spot Removal tool, 200, 202-204 sRGB color space, 247, 365, 379 Standard preview, 11, 45 star ratings, 52-53, 81 straightening photos, 198-199 Stroke Border checkbox, 312, 327 Style pop-up menu, 150-151 subcollections. 65 subfolders, 9 sub-keywords, 73, 95 Survey view, 57-59 Pick flags used in, 59 removing photos from, 58, 97 reordering photos in, 58 Swap button, 62 Sync Settings button, 163 Synchronize Folder dialog, 51 Synchronize Settings dialog, 163 synchronizing catalogs, 86-88 folders, 50-51 metadata, 96 Quick Develop edits, 163

Т

tagging photos, 70-73 **Targeted Adjustment tool (TAT)** B&W panel, 287-288, 293 HSL panel, 148 Tone Curve panel, 144 taskbar, 95-96 Temp slider, 126 **Template Browser** Print module, 324, 328, 342, 347 Slideshow module, 298, 300, 305 Web module, 384, 391 templates file naming, 26-29 metadata, 13, 34-35, 76 print, 324, 330, 347 saving, 29, 305 slide show, 297, 298, 300 Web gallery, 382, 384-385, 394-395, 399 Tethered Capture Settings dialog, 22, 129 Tethered Capture window, 23-24, 130 tethered shooting, 22-25, 402 Nikon cameras and, 45 white balance settings for, 129-130 text Identity Plate, 117, 302, 303, 314-315 print layout, 340-341 searching by, 80 slide show, 300, 313-315 watermark, 230-232, 390 Web gallery, 383-384, 391, 393 **Text Template Editor, 341** thumbnails badges in, 103, 117 preview, 6, 10-11 resizing, 6, 16, 38, 43, 399 Web gallery, 383, 389, 399 Thumbnails slider, 6, 16, 38 TIFF files, 167, 222, 251 **Tint slider** Basic panel, 126 Camera Calibration panel, 217 title bar, 41 Titles panel, 314-315, 321 Tone Curve panel, 142-146 contrast adjustments, 142-146, 284, 287, 426, 431, 436 keyboard shortcuts, 143, 144 Point Curve presets, 142 Range sliders, 146 Region sliders, 145 Targeted Adjustment tool, 144 toolbar, 39, 41, 96 travel photo project, 424-428 type. See text

Develop

templates for, 382, 384-385, 394-395, 399

Print

U

Uncheck All button, 7 underexposed photos, 167 undoing edits, 192–193, 219 Update Process Version dialog, 120–121 Upload Settings panel, 397, 399 uploading Web galleries, 396, 397

۷

Vibrance slider. 141, 428, 433, 437, 440 video clips displaying, 45 exporting, 21, 225 importing, 20-21 video slide shows, 319 viewing photos. 38-41 blackout modes, 40-41 Compare view, 61-63 Grid view. 39. 102-105 Loupe view, 38, 100-101 Survey view, 57-59 zooming in/out, 96 vignettes adding, 149-152, 409, 428, 433, 441 fixing, 210 preset for, 167 virtual copies, 155-156 B&W conversions and, 281, 282, 286, 293 resetting, 219 Volume Browser, 96

W

warning triangles, 135, 136, 166 Watermark Editor, 230-233, 390 watermarks, 226, 230-233, 313, 390 WB pop-up menu, 124 Web galleries, 381-399 cell numbers in, 391 client proofing via, 410-411 collections for, 382, 398 color options, 392-393, 398 customizing, 388-391 downloadable, 399 email links in, 386-387 exporting, 396-397 Identity Plates in, 388-389 layouts for, 382-385, 388-391 previewing, 385 quick tips about, 398-399 removing photos from, 399 saving, 396-397, 398 site titles in, 388-389

text in. 383-384, 391, 393 thumbnails in. 383, 389, 399 uploading, 396, 397 watermarking images in, 390 Web links in. 386-387. 399 Web module, 382-399 Appearance panel, 382, 383, 385, 389, 391, 394–395 Collections panel, 382, 398, 410 Color Palette panel, 392-393, 394, 395, 398 Image Info panel, 391 Lavout Style panel, 394, 399 Output Settings panel, 390 Site Info panel, 386–387, 388, 389, 395, 398, 399 Template Browser, 384, 391 Upload Settings panel, 397, 399 white balance preset creation, 167 project examples, 408, 425, 430, 435, 437, 438 steps for setting, 124-128 tethered shooting and, 129-130 White Balance Selector tool, 127-128, 130, 408, 425 workflows 7-Point System, 424-441 portrait photography, 401-420

X

XMP sidecar files, 32, 33, 77, 238, 239

Z

zoom ratios, 166, 211 Zoom to Fill checkbox, 325, 328, 333, 342, 346 Zoom to Fill Frame checkbox, 302, 304, 308 zooming in/out, 96, 116, 201

Watch. Learn. Create!

THE ADOBE® PHOTOSHOP® CS5 7-POINT SYSTEM FOR CAMERA RAW WITH SCOTT KELBY Imagine being able to open any image in Photoshop CS5's Camera Raw, and know exactly what to do first, what to do second, and how to take it all the way from flat to fabulous, just like a pro. That is the groundbreaking premise behind this DVD!

Your Price: \$6999

NAPP Member Price: \$5499

visit www.kelbytraining.com/dvds for more information on this and other outstanding DVD courses featuring photography, creative design, Web development, Adobe® Photoshop®, and the entire Adobe® Creative Suite®—CS through CS5.

for more info visit www.kelbytraining.com/DVDs or call 800.201.7323

THE WORLD'S MOST POPULAR PHOTOSHOP & PHOTOGRAPHY SEMINARS With over 40,000 photographers and creatives attending our events each year, it's easy to see why Kelby Training LIVE is the most popular seminar tour in the world! Learn from the most gifted and talented photographers and creative gurus on the planet, all sharing their latest tips, tricks and advanced techniques for photography, Photoshop, InDesign, Lightroom, and more. For locations, dates & tour info visit www.KelbyTrainingLIVE.com or call 800.201.7323.

Adobe, Lightroom, InDesign and Photoshop are registered trademarks of Adobe Systems Incorporated.

Live Tour with Scott Kelby

Scott Kelby's Adobe Location Lighting Tour Photoshop for Digital Photographers Tour with Joe McNally

Photoshop for Photogra phers Tour with Ben Willmore

Learn ONLINE with the Pros

Kelbytraining.com's online courses bring you the best photographers, Photoshop experts, Web developers and creative design gurus on the planet. Join Scott Kelby, Joe McNally, Moose Peterson, James Schmelzer, David Ziser, David Cuerdon and many others as they teach you the hottest and latest tips, tricks and essential techniques for dramatically boosting your skills.

Adobe and Photoshop are registered trademarks of Adobe Systems Incorporated.

Scott Kelby

The Photoshop CS5 7-Point System for Camera Raw

Scott reveals his 7-Point System for Camera Raw that not only breaks things down to just seven simple (yet powerful) techniques, but he's found a proven method to make it really stick.

White Balance Exposure Contrast Clarity/Vibrance Fill Light Finishing Effects Double Processing And Much More!